Arts & Ideas

Volume 1

TENTH EDITION

Mary Warner Marien
Syracuse University

William Fleming

THOMSON
™
WADSWORTH

Australia • Canada • Mexico • Singapore • Spain
United Kingdom • United States

THOMSON

✳

™

WADSWORTH

Publisher: Clark Baxter
Acquisitions Editor: John R. Swanson
Development Editor: Sharon Adams Poore
Assistant Editor: Amy McGaughey
Editorial Assistant: Brianna Brinkley
Technology Project Manager: Melinda Newfarmer
Marketing Manager: Mark Orr
Marketing Assistant: Annabelle Yang
Signing Representative: Tim Kenney
Senior Project Manager, Editorial Production: Paul Wells
Art Director: Maria Epes
Print/Media Buyer: Karen Hunt

Permissions Editor: Stephanie Lee
Production Service: Graphic World Inc.
Text Designer: Sue Hart
Photo Researcher: Sandra Lord
Copy Editor: Graphic World Inc.
Cover Designer: Jeanne Calabrese
Cover Image: Michelangelo. *Delphic Sybil,* detail of Sistine Chapel ceiling, 1509. Fresco. Vatican Museums, Rome. Photo: Vatican Museums.
Cover Printer: Phoenix Color Corp
Compositor: Graphic World Inc.
Printer: Courier Corporation/Kendallville

For more information about our products, contact us at:
Thomson Learning Academic Resource Center
1-800-423-0563
For permission to use material from this text or product, submit a request online at
http://www.thomsonrights.com.
Any additional questions about permissions can be submitted by email to thomsonrights@thomson.com.

Library of Congress Control Number: 2004107622
Student Edition: ISBN 0-534-61382-9
Instructor's Edition: ISBN 0-534-61390-X

Thomson Wadsworth
10 Davis Drive
Belmont, CA 94002-3098
USA

Asia
Thomson Learning
5 Shenton Way #01-01
UIC Building
Singapore 068808

Australia/New Zealand
Thomson Learning
102 Dodds Street
Southbank, Victoria 3006
Australia

Canada
Nelson
1120 Birchmount Road
Toronto, Ontario M1K 5G4
Canada

Europe/Middle East/Africa
Thomson Learning
High Holborn House
50/51 Bedford Row
London WC1R 4LR
United Kingdom

Latin America
Thomson Learning
Seneca, 53
Colonia Polanco
11560 Mexico D.F.
Mexico

Spain/Portugal
Paraninfo
Calle Magallanes, 25
28015 Madrid, Spain

CREDITS

BRIEF CONTENTS

CONTENTS

Chapter 12
The Venetian Renaissance and the Rise of International Mannerism 326

Lists of Maps and Chronologies

MAPS

CHRONOLOGIES

PREFACE

At the beginning of the twenty-first century, scientists began vigorously debating an idea that humanists have long assumed to be true: we became fully human when we became creative and capable of symbolic thinking. This does not mean that the arts made, or make, us human but rather that we have been art-makers for as long as we have been human. Of course, scientists frame the argument differently than humanists. They focus on image and symbol making as indicators of advanced brain development. We look at early human artifacts, such as the piece of red ocher from South Africa (Fig. P.1) that dates to about 77,000 years ago and recognize deliberate repetition of overlapping triangular patterns as evidence of self-consciousness and intentional composition. Here is a design that surpasses the fulfillment of immediate needs such as food and shelter. These marks, whether they were intended to record time, convey religion, or even if they are merely fanciful doodles, are recognizably human. They sprang from a self-identity that early primates do not seem to have possessed. Humans and some animals make tools and adapt their environment to make it more hospitable and safe. Humans and some animals indulge in play, for its own sake, and not as practice for skills such as hunting. But only humans create symbols for themselves and for other humans.

The first art that we know about is probably not the first art to be created. Decorations placed on bodies or on clothing would have perished, along with many kinds of transformed organic materials, such as wood. But rocky overhangs and caves in Africa, Asia, and Europe preserved decorated tools, jewelry, sculpture, and of course, some astonishing paintings.

With the first art came cultural centers. Semi-nomadic Ice-Age dwellers returned for hundreds of years to the same locations. They decorated the walls of rocky overhangs with animal sculptures, and although they did not live in the caves, they kept up the paintings there and often added to them. Caves were cultural centers like the more diverse Gothic cathedral towns. Nevertheless, they may have served many of the functions found in later, larger cultural centers. They were hubs for multiple kinds of human expression, ranging from family or clan identity to religion, storytelling, political persuasion, record storage, and entertainment. Throughout history, cultural centers have been places where artists and audiences came together to create interpretations of human experience and the world around them. *Arts & Ideas* dwells on the visual art, music, literature, and architecture created in cultural centers in the West, and it identifies concepts underlying these expressions. One cannot pursue meaning in the art of the present or the past without taking into consideration the nature of the art medium. As the arts evolved, so too did their vocabulary. Throughout this text, art terms are defined in relation to spe-

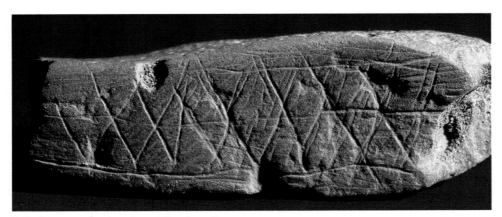

P.1 Engraved ochre from Blombos Cave.

cific art works so that students can see and hear what a term means and how it is used. A glossary is included at the end of the book, and students can access art terms, as well as other learning aids online.

This book is a place to begin to recognize the historical and social interactions of the arts in Western culture. The arts may not make us human, but they can make us aware of how humans have understood their lives, their societies, and the world. To ask what is art is to find out what is human.

NEW TO THIS EDITION

■ Thoroughly revised and updated, the text reflects current research and works. A new Introduction provides students with a thorough background to understanding the arts. Increased coverage of women and other marginalized authors, artists, and works is also presented.

■ More than 200 new works of art and a predominantly 4-color design provides a beautiful presentation.

■ New maps better illustrate the discussions of important historical places.

■ New discussions of photography, film, and mass media add to the book's currency.

■ Boxed sections present contrasts between the past and the present, giving students a more historical perspective.

■ A resource list at the end of each chapter directs students to valuable resources.

AN EXPANDED SUPPLEMENT PACKAGE

FOR STUDENTS

■ *Exploring Humanities CD-ROM* Packaged free with every new copy of this book, the Exploring Humanities CD-ROM includes a collection of interactive learning modules, online timelines, and links to Web sites that focus on a full range of humanities topics—music, literature, theater, philosophy, and art.

■ *Audio CD* Also available is a text-specific audio CD that contains the music discussed in the text.

■ *Study Guide* This brief new addition to the supplements package includes chapter-by-chapter

reviews and questions to help students absorb and comprehend the material.

■ *InfoTrac® College Edition Workbook* Covering many of the core topics discussed in *Arts & Ideas,* this booklet provides in-depth exercises that ask students to use their free subscription to the *InfoTrac College Edition* online library.

■ *InfoTrac® College Edition* Instructors and students automatically receive 4 months of FREE access to *InfoTrac College Edition,* an online library that offers complete articles from nearly 5,000 scholarly and popular publications. Updated daily and going back more than 20 years, *InfoTrac College Edition* is a great homework tool or for catching up on the news. NEW! Students now have instant access to critical thinking and paper writing tools through *InfoWrite.*

■ *Book Companion Web Site,* **http://art.wadsworth.com/fleming10/** The new Book Companion Web Site for *Arts & Ideas,* **Tenth Edition,** offers students numerous resources to help their study of the humanities. Students will find tutorial quizzing; *InfoTrac College Edition* exercises; Internet activities; chapter-specific links to readings covered in the text; a glossary and flashcards with pronunciations; annotated Web links; and other music, art, and philosophy-related resources.

■ *The Museum Experience* This is a practical handbook that will enrich students' understanding of the museum experience, including a primer on museum etiquette, a guide to writing an exhibition review, and an extensive listing of museums across the United States.

■ *ArtBasics: An Illustrated Glossary and Timeline* This handy reference includes a brief introduction to basic terms, styles, and time periods.

FOR INSTRUCTORS

■ *WebTutor™ Advantage . . . on Blackboard and WebCT* Ready to use as soon as you log on, *WebTutor Advantage* is a complete course management and communication tool preloaded with content from *Arts & Ideas,* organized by chapter for convenient access. It includes illustrations, outlines and summaries, practice quizzes, online tutorials, interactive modules in art and literature, and much more.

■ *Instructor's Manual and Test Bank* The *Instructor's Manual* provides a summary of the lecture content for each chapter, key words,

and topics for discussion. The *Test Bank* includes multiple-choice, essay, and identification questions.

- **Slide Set** The slide set contains seventy-five carefully selected, high-quality images from the text.

- **ExamView®** *ExamView* computerized testing (on a cross-platform CD-ROM) allows instructors to easily customize the *Test Bank* provided in the *Instructor's Manual* or create tests.

ACKNOWLEDGMENTS

William Fleming's classic text, *Arts & Ideas,* was one of the first works to introduce college students to the interplay of philosophy and art practice that occurs in the creation, performance, and viewing of the arts. The many letters he received during his nearly 90 years indicate that generations have been enriched by Fleming's learning and perceptions.

I was one of his students who later became his friend. Yet, like many who knew him as a teacher, he remained my mentor. I struggled to call him Bill, but it ultimately seemed too presumptuous. He was Professor Fleming, and I was honored beyond words when he asked me to take on the next edition of *Arts & Ideas.*

No book of this scope can be revised and updated without taxing the goodwill of scholarly friends. My greatest debt is to Professor Frank Macomber, who collaborated with Professor Fleming on their book, *Musical Arts and Styles.* Frank's enthusiasm for music is matched by his extraordinary command of the literature and by a penetrating wit that readily deflates the pomposity of those who would make the arts obscure. The revised music sections owe to his scholarship. Throughout the updating of this book, Dr. Randall I. Bond, librarian extraordinaire, never failed to find a fact, suggest a book, or point me toward an informative Web site. His recent retirement leaves many of us to ponder how fortunate we were to interact with him professionally and to know him as a friend. Edward Gokey, an able member of Randy's staff in the Syracuse University library, came to my rescue many times and took on the task of date-checking with his customary skill and good humor. Similarly, the library's Laura Levin sprang into action when she received yet another of my phone inquiries.

In the Department of Fine Arts at Syracuse University, Professor Wayne Franits not only let me learn from his then-unpublished book, *Dutch Seventeenth-Century Genre Painting: Its Stylistic and Thematic Evolution,* but also in his role as chair allowed me to take the time necessary to launch this edition. Linda Straub and Corinne Willis made it possible for me to continue as the department's Graduate Director while in the midst of writings.

Thomson Wadsworth drew together a talented group of individuals that I came to think of as the Thomson Team. In the book's initial stages, John Swanson, Rebecca Green, and Brianna Brinkley were helpful—and patient beyond the call of duty. Sharon Adams Poore, who took on the role, if not the title, of development editor, coached, cajoled, and best of all, slew all the dragons, great and small, that sprang up to interrupt the writing of the book. Carolyn Smith edited the initial text with an enviable eye and ear for clear language. Paul Wells supervised the book's production process, and Suzanne Kastner, no stranger to dragon slaying, ably wedded words and images as she prepared the manuscript for print. She was ably assisted by John May, who typeset each page with unparalleled attention to detail. Sandra Lord, ably assisted by Cheri Throop, fearlessly tracked down new and better images from a large number of sources. And, as always, I am awed by the keen eye and mind of Michael Marien, my live-in editor, who managed to proof most of the book in airport lounges and the tight confines of tourist-class seats.

I am also indebted to the following reviewers, who carefully considered the book and gave me many suggestions.

James S. Allen, Southern Illinois University–Carbondale

Carole C. Barnett, Jacksonville University

Beth D. Biron, Dalton State College

Robert W. Brown, University of North Carolina–Pembroke

James Busby, Houston Baptist University

Allen J. Christenson, Brigham Young University

Ann Fairbanks, University of St. Thomas

Gary M. Guinn, John Brown University

Catherine Hubbard, State University of New York, College at Brockport

Gerard P. NeCastro, University of Maine at Machias

Peter G. Potamianos, College of DuPage

Robert Prescott, Bradley University

Benjamin W. Redekop, Kettering University

Daniel Robinson, Penn State University

Doris L. Salis, The University of Findlay

Thomas E. Schirer, Lake Superior State University

Jon M. Suter, Houston Baptist University

Joan M. Watson, Virginia Polytechnic Institute and State University

Edward W. Wolner, Ball State University

INTRODUCTION

Imagine a tightrope walker gracefully and confidently treading a wire strung between two poles. Now let's add two more poles and string another wire about a foot from the first. The tightrope walker easily takes up the dare and hops from wire to wire. But we're not finished testing this performer's agility. Bring on more poles and more wire, and put one new wire higher than the existing two and one lower. The shrewd performer calls for a balance beam; but as long as the four wires run in the same direction, the tightrope walker can negotiate turns and jump from level to level. What we need to create a taxing challenge are many more wires, running at odd angles through the existing four. At the sight of them, the tightrope walker drops the balance beam. In the irregular web we have concocted, it has become a liability that could easily flick our performer to the ground. Navigating this multidimensional network, the tightrope walker will have to rely on many resources: skill, training, judgment, and balance.

Just looking and listening to the arts is like walking a single wire. It requires careful attention and offers rewards. But adding more wires—that is, accounting for the multiple, crisscrossing aspects of art-making—brings increased challenges, which, in turn, yield greater understanding of other people, times, and places and a deeper sense of accomplishment.

Everyone readily agrees that humans absorb the ideas of their time. How else would we conduct our daily lives and communicate with others? Language itself is time bound: it is of a place and a particular moment. Look at the opening line of John Dowland's love song, composed more than 400 years ago: "My thoughts are wingde with hops" (see Fig. 11.17). Because spelling was not standardized then, it was acceptable to write "winged" as "wingde." But what about "hops"? Is the singer really sending warm thoughts to a lover with a package of the grain used as the basic flavoring ingredient of beer? Unlikely. "Hops" is an alternative spelling of "hopes"; thus the singer's thoughts are winged with hopes. Like language, the vocabularies of all the visual and tonal arts are needed to be understood as they were in their times.

A related question concerns the extent to which an artist's personal thoughts and unique experiences counter the tug of the dominant culture. For art—and life—this remains an intriguing conundrum, but we can illuminate some of its features.

During much of Western history, visual artists, architects, composers, and playwrights were considered craftspeople who worked for royals, leaders, and the wealthy. The struggle for individual recognition began in earnest during the Renaissance, but the patronage system was still thriving in the eighteenth century, especially in music, where it hung on longer than in the other arts. For example, during his short life, Mozart struggled against the constraints of patronage, but he did not succeed in making a living without giving music lessons and taking on commissions from royals who felt free to criticize his compositions. His most famous complaint came from Emperor Joseph II, who is said to have grumbled, "too many notes, my dear Mozart, too many notes." Of course, society has recognized some extraordinarily talented individuals in the past, like Imhotep in Egypt and Praxiteles in Greece (Fig. Intro.1), who were singled out for special treatment and acclaim. But the average artist could look forward to an apprenticeship with a master artist, much as a would-be carpenter would train in the workshop of an accomplished woodworker. The young artist might eventually gain a small commission for a specific work, such as a portrait, and would have to pay close attention to the patron's instructions about how to paint it. Similarly, a composer or a poet had to heed carefully the suggestions of the patron for a specific form of music or literature, such as an epithalamium, which is a song or an poem for a wedding, or an elegy, which is a reflection on sorrow written to memorialize someone who has died. In works such as these, self-expression or social commentary were either out of the question or driven so deep into the work's symbols and juxtapositions that their meaning was obscured.

In prohibitive circumstances such as these, artists, writers, and composers tended to distinguish themselves through technical excellence: for example, Praxiteles developed ways to make marble look like flesh, and Zeuxis is said to have achieved such an illusion of reality in one of his paintings that the birds came to peck at a bunch of grapes he depicted.

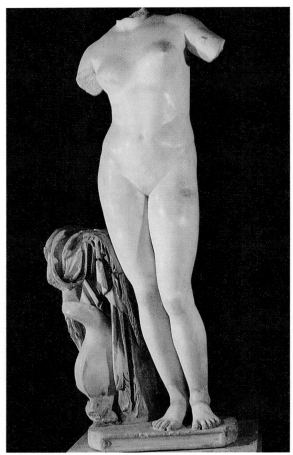

Intro.1 *Aphrodite of Cyrene.* Roman copy of c. 100 BCE. After Praxitelean original, found at Cyrene, North Africa. Marble, height 5′. Museo Archeologio Nazionale, Rome.

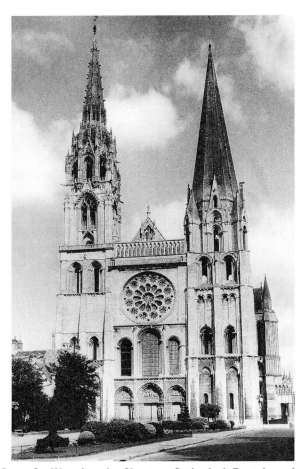

Intro.2 West facade, Chartres Cathedral. Portals and lancet windows, c. 1145; south tower (right), c. 1180, height 344′; north spire (left), 1507–1513, height 377′. Length of cathedral 427′, width of facade 157′.

If we want to understand how art is an expression of the ideas and values of the time in which it was created—indeed, how the arts actively shaped the perceptions of people living in a particular historical period—we must consider that for most of Western history, the arts have been an indirect account of the worldview held by a powerful few and interpreted through the talents of anonymous others. Unidentified persons built the pyramids and the Gothic cathedrals (Fig. Intro.2). From time to time, they slipped in a fanciful figure, but mostly, they labored under the direction of a builder. The builder took orders from a master-builder, who paid close attention to the whims and wishes of a member of the court or the church.

As wealth spread to more people, especially people who were outside court and church circles, the arts found that new patrons and artists often could entertain new ideas and technical approaches. One sees the influence of freshly minted wealth in the art of seventeenth-century Holland, where merchants and bankers identified themselves as a class different and more progressive than the landed aristocracy (Fig. Intro.3). Painters became entrepreneurs like their new patrons. They developed signature styles and worked in particular genres, such as portraiture or landscape painting. They also began a practice that is universal today: they made paintings "on spec," meaning they created canvases before they knew whom the buyers would be.

One of the greatest changes in Western art occurred in the late eighteenth and early nineteenth centuries, during the Romantic Movement, when artists, writers, and composers actively redefined themselves as people whose art sprang from special sensibilities and deep feelings. Because the Romantics believed art was rooted in their uniqueness, they did not want to be told how and what to create. This revolution could not have taken place without the multifaceted social upheaval in which the power of the aristocracy and the church were rapidly replaced by the increasing middle class, who demanded political power and educational

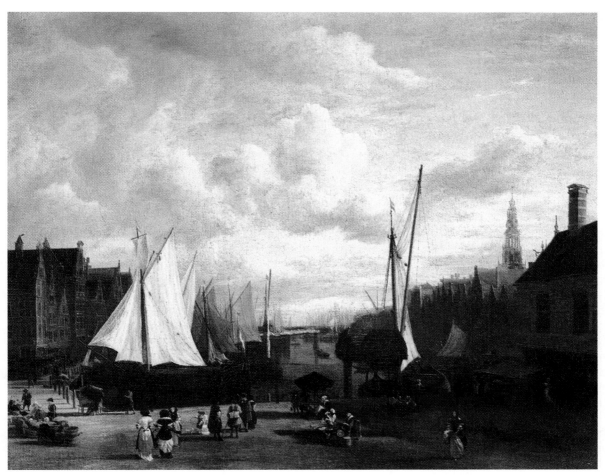

Intro.3 Jacob van Ruisdael. *Quay at Amsterdam,* c. 1670. Oil on canvas, 1′8¾″ × 2′2″.

advantages in accord with their commercial success and industrial ingenuity. In an important sense, the middle classes were the first Romantics, relying not on tradition but on imagination. Despite the poet William Butler Yeats's 1931 assertion that he and his generation of writers were the last Romantics, Western culture is still enamored by the self-made individual who appears to be a pathbreaker. The transition from the Romantic poet to the Romantic engineer and the Romantic computer geek has been a smooth one. Artists today mostly operate with the Romantic assumption that their work needs to be different—to have a signature style—that stood apart from that of other artists. For most of the past, this idea would have been judged foolish or fanatical.

No one has defined the number of people necessary to promote the development of art. Bands of seminomadic Ice-Age people may have included no more than thirty individuals, yet they generated extraordinary art and kept it going for centuries. This book is organized around the notion of cultural centers, such as cities, palaces, churches, and monasteries, where some of the most influen-

tial Western art and music was created. In recent decades, cultural historians have looked beyond many of the dominant towns and courts, identifying art, architecture, and music of significant originality created outside the most studied cultural centers, such as Paris, London, Rome, and New York. They have invented a lively new history and sociology of the arts that is enriching and enlarging the humanities.

They have also made it difficult to imagine how a history of the arts of the West could fit between two covers! *Arts & Ideas,* then, is not intended as an exhaustive survey but rather as a sampling of the ways in which the Western arts interacted and how they reverberate with the central ideas of specific times and places. As William Fleming explained in the ninth edition of this book: "the whole concept is not to present a chronologically complete history, but to select and study in depth the major styles and works within the periods and cultures that produced them." Readers should keep in mind that this approach and scope represent a fraction—albeit a familiar one—of the world's art.

Studying the Western arts in this way is not, in itself, a slight to other art practices and histories. Most of the readers of this text live in the midst of Western culture and values. Consequently, they need the analytical and critical tools with which to understand how cultural history continues to have a bearing not only on the arts today but also on contemporary society. By emphasizing how various cultural centers defined and developed the arts, *Arts & Ideas* becomes a platform from which readers can proceed to look at Western and non-Western art without falling prey to the prejudice that art is a universal impulse that fully transcends the boundaries of time and culture. Indeed, recent scholarship suggests that our sense of fair play, combined with our excitement about the arts in other cultures, has led to a serious, if well-meaning, distortion of art-making in those very cultures. For example, as Craig Clunas argues in his study on the arts of China, the notion of a collective entity called the arts is a relatively recent invention there. No one living during that land's long history before the nineteenth century would think of putting painting, sculpture, and ceramics in the same field of inquiry, even though China has a venerable tradition of arts criticism and collecting.[1]

Although this book highlights the intellectual terrain shared by artists and their times, it is important to keep in mind that sharing ideas does not mean that art objects are otherwise alike. Art media, like cultures, differ. They respond to, present, and inhabit ideas differently. When writers, composers, and architects create, they generally do so with the expectation that they can enlarge themes over time. In effect, they orchestrate the emergence of ideas for listeners and viewers. By contrast, many sculptors and painters plan their works to be taken in their entirety, and then, perhaps, examined in their particular parts. Of course, there are similarities between these two groups. The facade of a building may be viewed much as a painting is, and a series of sculptures or paintings may be programmed much in the way a play is. Nevertheless, in some of the most meaningful art, form cannot be separated from idea. Splashes of blood-red paint spattering a canvas carry meanings for which there are no words (Fig. Intro.4). The triumphant thump of a dancer's feet hitting the stage's floor is heard by the ear and perceived by the kinesthetic sense, that is, the body's awareness and identification with another human form. The scintillating, verbal barrage of a play by Shakespeare is simultaneously an auditory and intellectual experience in which form and idea have merged. Different art media exist because the scope of human responsiveness and the intricacy of thought are so broad that one or two media would fail to express their range or subtleties. The arts, developed so closely in relation to the senses, are remarkably alike across cultures, even though the contexts in which they are practiced vary widely, for instance, from religion to entertainment.

When he wrote *Arts & Ideas,* William Fleming used the word style in a particular sense, defined by cultural historian Meyer Schapiro. Rather than suggesting superficial fashion, style is "a system of forms with a quality and a meaningful expression through which the personality of the artist and the broad outlook of a group are visible." It is also, Schapiro wrote, "a vehicle of expression within the group, communicating and fixing certain values of religious, social, and moral life through the emotional suggestiveness of forms."[2] At the same time, the lifetimes of the ideas and art forms related by style do not necessarily correspond with momentous historical events. For instance, Renaissance experimentation with perspective and study of the human form continued despite wars that toppled the rulers of Italian regions and cities. Moreover, in any historical moment, the arts are not synchronized like a row of clocks. Conventions—think of the wedding march by Felix Mendelssohn—become entrenched and are expected to be part of ceremonies that take place decades, even centuries later. As a result, some arts remain closely tied to tradition, while social circumstances allow others to be more innovative. Also, contact between and among the arts, especially before modern communications and transportation, cannot be assumed. For centuries, artists in Ireland were unaware of Greek sculpture. Conversely, the frequent, multiple invasions of Cyprus gave artists Phoenician, Greek, and Roman influences, to name just a few.

Whether through custom or taste, certain art objects are considered to transcend their immediate purposes and circumstances. Ever since Rome, Greek art, literature, and philosophy have been deemed enduringly worthwhile and ripe for reinterpretation through contemporary thoughts and conditions. For example, in 2003, more than 1,000 readings of Aristophanes's ancient Greek play, *Lysistrata,* were performed in fifty-nine countries in a global antiwar effort. Audiences today find Mozart's music a profound humanistic statement that was probably not there for his eighteenth-century listeners, perhaps because they felt free to talk, flirt, or eat during the per-

[1]Craig Clunas, *Art in China* (New York: Oxford University Press, 1997), pp. 9–15.

[2]Meyer Schapiro, "Style" in *Theory and Philosophy of Art: Style, Artist, and Society* (New York: George Braziller, 1994), pp. 51–52.

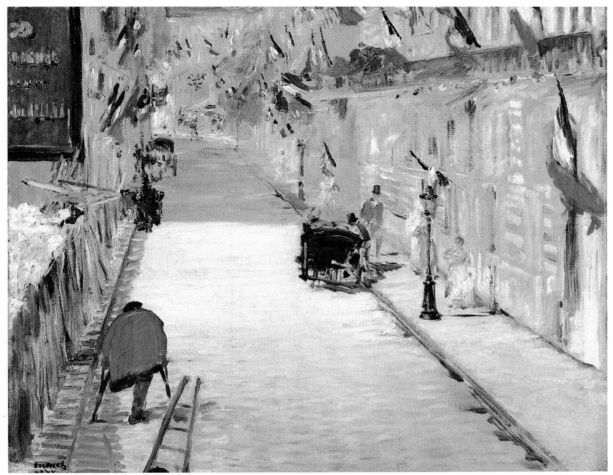

Intro.4 Édouard Manet. *Rue Mosnier, Paris, Decorated with Flags on June 30, 1878,* 1878. Oil on canvas, 2′1½″ × 2′7½″.

formances. Perhaps the greatest examples of timeless art are Shakespeare's plays. *Romeo and Juliet* has been made as a film about contemporary life several times. During the rise of Hitler, *Richard III* was set in a future fascist England; and *Macbeth* was staged during the Vietnam War, with the characters dressed in modern military garb.

As compelling and imaginative as these efforts are, they belong more to the present that recasts them than to the past that invented them. As Erwin Panofsky, one of the most influential cultural historians, wrote, to be a historian one must remain sharply aware that one's "cultural equipment . . . would not be in harmony with that of people in another land and of a different period."[3] Few of us today would argue that the cultures and values that shape the people of the world could be easily disregarded. But when it comes to comprehending the past, and the arts in particular, we are often willing to believe that understanding art is simply a matter of reacting to it. No one can deny that powerful emotional reactions to paintings, music, theater, architecture, film, photography, dance, and the other arts are sometimes life-altering experiences that draw us in and make us want to know more. Yet to grant a work of art its due means attempting to recreate the circumstances of its creation, knowing full well that—barring the invention of a time machine equipped with instant language translators—one will always fall short of complete understanding.

Aboard a 5AM plane to Egypt's Luxor and the Valley of the Kings, watching the dawn color the Nile River, or standing on the windswept hill of Pergamon in western Turkey, where the Altar of Zeus once stood high above the sea, are exhilarating experiences that I recall with great contentment. Equally thrilling was the way in which reading the works of the pioneering Egyptologists and classicists enriched and broadened my understanding of those places and their pasts. History, as William Fleming wrote, can be joyous and adventuresome. It is my hope that this book brings you knowledge mixed as it ought to be with pleasure and excitement.

[3]Erwin Panofsky, "The History of Art as a Humanistic Discipline," in *Meaning in the Visual Arts* (Garden City, NJ: Doubleday Anchor, 1955), p. 17.

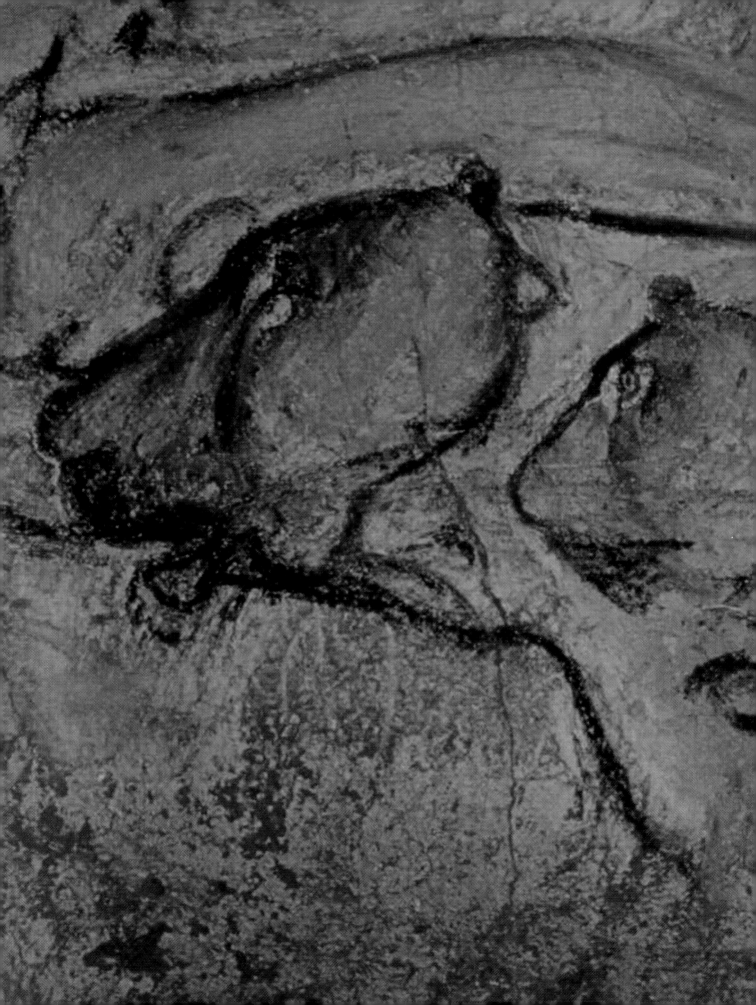

THE ORIGINS OF WESTERN ART

THE FIRST ART MAY be older than we humans are. Millions of years ago, a proto-human living in Africa or Asia might have pick up a stick and admired it, not as a tool but as an object of pleasing proportions. That same stick may have served to remind the *hominid,* as proto-humans are called, of an event in the past, or it might have signified a force of nature, such as lightning. Scholars think that certain very early tools were shaped with such attention to design that the craft of making them developed into an art before hominids became fully human.

Some questions about the origins of art may never be answered. The earliest instance of art made by *Homo sapiens*—that is, people like us—is only a little clearer. The skeletal remains of *Homo sapiens* have been dated to about 100,000 years ago in Africa and a bit later in southwestern Asia. If these people fashioned images in sand or wood, decorated their bodies with paint, or contrived intricate dances, their efforts necessarily perished in the course of time. The first imagery that survived in abundance was made by a group of humans called *Cro-Magnons,* named after the town in France where their remains were found in 1868.

THE CRO-MAGNONS

The Cro-Magnons lived a seminomadic life in the cold climate of the Ice Age, whose glaciers had already waxed and waned for more than 1.5 million years. People of this Ice Age followed the seasonal migrations of herds of animals, such as reindeer, goats, and bison. They used stone-tipped lances to hunt, sharpened stone blades for cutting, and fashioned bone harpoons to spear fish. They also gathered fruits and seeds. Humans during this time discovered how to make fire to warm the shallow cavelike areas beneath rocky overhangs, in which they lived and to which they seem to have returned over many generations as they coped with the advancing and retreating ice shield that drove the animals they hunted to new grasslands.

Despite the name given them in the nineteenth century, Cro-Magnons did not arise in what is now France; rather, they seem to have originated in western Asia. In fact, several types of early humans may have coexisted in Europe, Africa, and Asia. One of the mysteries of the past is what ultimately became of these people. For example, a less developed group of humans was named *Neanderthal* for the place in Germany where evidence of their existence was located in 1856. Like the Cro-Magnons, they lived not only in Europe but also in parts of central and southwestern Asia. Recent evidence from Neanderthal dwelling sites indicates that they were not the savage brutes of horror movies and cartoons. They enjoyed family relations that included caring for disabled and elderly members of their clans. Research suggests that Cro-Magnons and Neanderthals lived in Europe at the same time, about 40,000 years ago, and that they had contact with each other. Neanderthals seem to have died out about 30,000 years ago, just at the point when the Ice Age art of the Cro-Magnons appeared. They may have been destroyed by the Cro-Magnons, or they may have perished because they could not compete with the Cro-Magnons for scarce resources. Another possibility is that they were simply absorbed into the Cro-Magnon population. Much speculation has centered on whether the Neanderthals had the physical and mental capacity for complicated speech and symbol-making that the Cro-Magnons enjoyed. Amid so much conjecture, we are certain of one profound difference between the Neanderthals and the Cro-Magnons. Both groups developed tools, used fire, decorated their bodies with red ochre, lived migratory lives, and buried their dead, sometimes leaving small memorials. But only the Cro-Magnons created an extensive art that is rich in signs and description. Recent theories suggest that the great concentration of European cave art was created in the most populated areas. Thus, the repeated images and symbols could indicate that the people in the area shared cultural values and ideas.

CAVE ART

Deep inside the twisting limestone caves of south-central France, cave artists drew what they saw with such accuracy and immediacy that later literate societies have never surpassed the sheer strength of the pictorial record they left. The herds of beasts painted and carved on cave walls and ceilings capture the essence of animality and the precarious place of these people in a world dominated by brutish forces. At Lascaux (Fig. 1.1), lively animals, seen mostly from the side, face off in a circular space that was continually repainted for hundreds of years by artists using bits of moss and naturally occurring mineral pigments and working by the light of small, hand-held oil lamps. They placed puzzling dots of pigment above the nose of the spotted bovine and what looks like a representation of a spear on the shoulder of the huge facing bull.

The 1994 discovery of the Chauvet cave in France also revealed paintings in a sophisticated style (Fig. 1.2). Forms are shaded and overlap one another to give the appearance of **perspective.** In addition, the areas above the lions' heads were deliberately scraped down to the cave's white, chalky walls to create contrast with the broad black outlines. The artists often took advantage of the natural contours of the cave surfaces so that the animal figures appear in **relief.** It is as if the natural formations of the stone suggested the particular animal forms. Like those at Lascaux, the walls at Chauvet display abstract signs such as dots and stripes.

Why were these images created? There is no convincing evidence that the people of the Ice Age actually lived in the decorated areas of the caves. In fact, the decorated areas may have been difficult to reach. Many scholars believe that the animals may have been symbols representing the processes of nature. The making of such lifelike images might have been a means to discuss, understand, and pass down ideas about the world. The caves may also have been sanctuaries for magical rituals or initiation ceremonies for young hunters as they reached maturity and independence.

Signs that lances were hurled at the paintings point to primitive hunting rites. For the cave people, the images may have been substitutes for the animal themselves. By assaulting these images with their spears, the hunters may have hoped that they could magically subdue their real quarry. Other theories hold that the paintings may have constituted a record of seasonal animal migrations or that the beasts may have been totemic figures representing various tribal families, just as modern sports teams adopt the names of animals to symbolize strength and endurance. In addition, one cannot rule out the possibility that these amazing images may have been created simply for the sheer pleasure of making a likeness of the world the artists saw around them. In any case, the people of the Ice Age

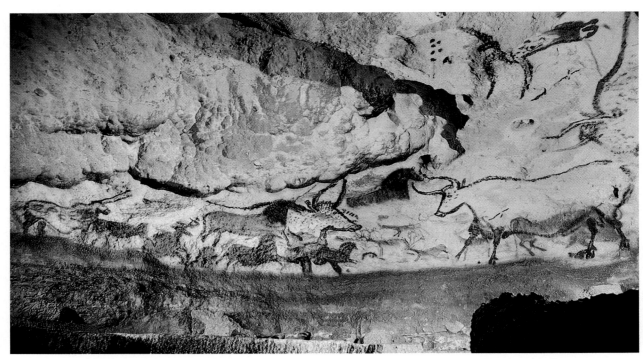

1.1 Hall of Bulls (left wall), c. 15,000–10,000 BCE. Largest bull approx. 11′6″ long, Lascaux (Dordogne), France.

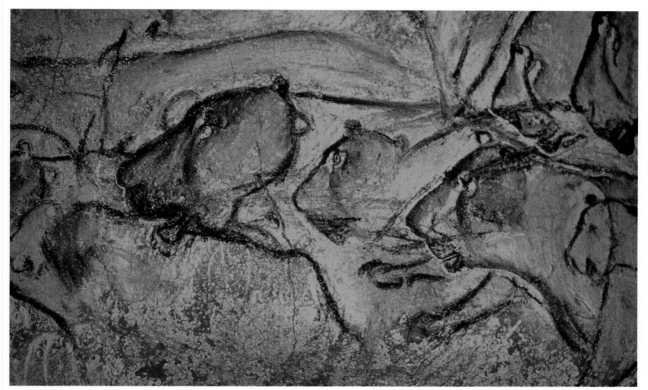

1.2 Detail of group of lions at Chauvet-Pont-d'Arc Cave. Lions hunting on the main panel in the End Chamber, Chauvet Cave, France. Scenes are rare in Paleolithic art. This one is unique.

produced art that embraced naturalism and realism, abstraction and expressionistic distortion.

Cave paintings have been discovered primarily in France and Spain, but decorated tools and portable works of art have been found throughout the huge landmass that extends from Europe to the far reaches of Siberia. A fascinating piece of broad reindeer antler found in the French Pyrenees (Fig. 1.3) is sensitively engraved with the image of deer that seem to be crossing a waterway while salmon are

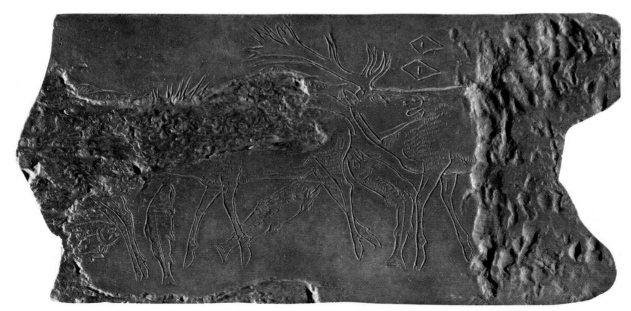

1.3 Reindeer antler decorated with a procession of stags with salmon jumping between their limbs. Musée des Antiquites Nationales, Saint-Germain-en-Laye, France.

swimming upstream. Like cave images, this picture does not have a ground line or background, yet the artist carefully etched tiny lines around the shoulders of the deer and on the fish to indicate the texture of hair and scales. To create this image, the artist must have keenly observed animal appearance and behavior. The large deer turns its head and opens its mouth, perhaps to make a sound to those who follow. This pose is repeated in other instances of Ice Age art. Above the deer's shoulder are two diamond shapes containing a small, single vertical line. Such combinations of natural observation and abstract symbols occur regularly. Although it may not constitute writing, the choice of a particular seasonal moment and the use of signs suggest that the intent was to communicate.

THE WOMAN OF WILLENDORF

Throughout the Ice Age, representations of humans are rare compared with animal images and signs. When people do appear, they usually are not treated as naturalistically as the animals. One figure, less than 5 inches tall, is the Woman of Willendorf (Fig. 1.4). Her head is crowned with small stylized curls or braids above a featureless face. She clasps huge breasts with tiny arms as she gazes downward at her swollen, possibly pregnant belly. These exaggerated sex characteristics suggest how much early people, who struggled with scarcity, would have valued health and fertility. The statue also alludes to aesthetic values. The whole compact composition can be seen as a set of cones, curves, and spheres. Even more abstract female figures than the Woman of Willendorf have been found through Europe and Russia, hinting that early people may have had contact with each other through seasonal migrations and trade.

THE TRANSITION TO AGRICULTURE

In the nineteenth century, the term **Paleolithic,** meaning "old stone," was used to describe the culture of the people of the Ice Age. These nomadic hunter-gatherers made stone tools but lacked features of more advanced life, such as pottery, settled communities, and elaborate systems of writing. However, a steady stream of research findings suggests that Paleolithic people, although they did not permanently settle in one place, regularly returned to sites such as Lascaux, used as-yet-undeciphered symbols in a manner approaching writing, and may even have done some rudimentary farming and taming of animals. Al-

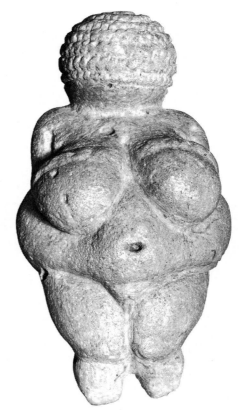

1.4 *Woman of Willendorf,* c. 30,000–25,000 BCE. Limestone, height 4¼". Naturhistorisches Museum, Vienna, Austria.

though now proved to be inaccurate, the term *Paleolithic* continues to be used because it provides a rough contrast between people of the Ice Age and the cultures that developed in the **Neolithic,** or "new stone" age, when farming, domestication of animals, and comprehensive systems of writing were developed. Of course, this vast transition, sometimes called the *agricultural revolution,* took place slowly and unevenly over thousands of years. Some remote cultures did not emerge from the Paleolithic until the twentieth century.

In an area known as the *Fertile Crescent* (see Map 1.1), the soil was more productive than that in the surrounding areas and the climate was favorable to irrigation-assisted agriculture. The Fertile Crescent extended from the Persian Gulf through the land between the Tigris and Euphrates Rivers, and then turned south, running along the Mediterranean coast and down the Nile valley. This area witnessed the transition from hunting and gathering to the beginnings of agriculture and town life.

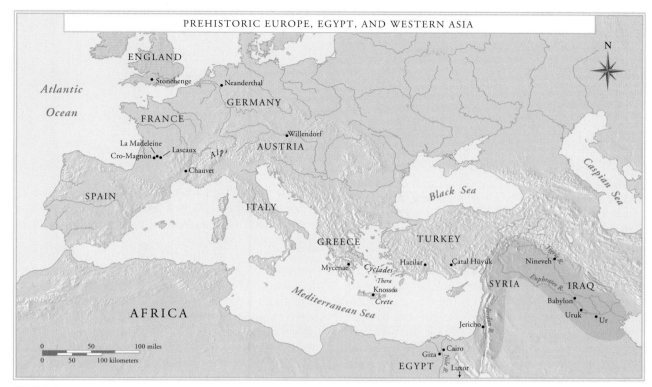

PREHISTORIC EUROPE, EGYPT, AND WESTERN ASIA

MAP 1.1

Over the course of millennia, plant cultivation and animal husbandry gradually replaced hunting and food gathering, with the result that people could live year-round in stable settlements. Similar development took place about 4,000 years ago in the Indus River valley in what is now Pakistan, as well as in the river valleys of China.

Excavations at Jericho near the Jordan River reveal that people may been attracted to the site by a natural spring thousands of years before they settled there permanently and built mud-brick houses, in about 7000 BCE. The area's location in a fertile river valley and along trade routes may have encouraged village life and the diverse occupations that come with it. The residents of Jericho built thick protective walls (although these are not the walls that came tumbling down in the Bible story) and a stone tower. Agricultural life and trade allowed citizens to accumulate surplus wealth that they needed to protect themselves from invaders, hence the walls and tower. This wealth also led to the development of more elaborate burial practices. For example, human skulls were carefully filled in and modeled with plaster. They were given seashell eyes, and pigment was sometimes added to simulate living flesh and hair (Fig. 1.5).

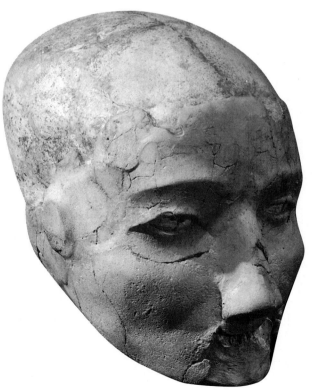

1.5 Modeled head from Jericho, c. 7000–6000 BCE, Archeologicial Museum, Amman, Jordan.

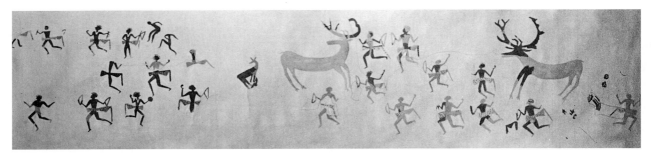

1.6 Deer hunt, detail of a copy of a painting from Level III, Çatal Hüyük (modern Turkey), c. 5750 BCE.

Whereas Ice Age art was concerned largely with renderings of animals and signs, human images appeared more frequently in these early settlements. At Çatal Hüyük, the largest known Neolithic settlement in what is now Turkey, 8,000 people built 2,000 houses with shared walls. The houses could be entered only through openings in the flat roofs. Invaders would have to drop down into the houses, where they might be trapped. Some of the houses at Çatal Hüyük seem to have been used as shrines, where artists represented groups of people in what seems to be an early attempt to tell a story (Fig. 1.6). Some anthropologists estimate that the wall paintings at Çatal Hüyük were repainted more than 100 times. One theory holds that as the sedentary lifestyle of agricultural people became more common, occupational specialization and specific gender roles became more pronounced. But at Çatal Hüyük, recent excavations in the 1990s revealed no conclusive evidence that gender determined roles in society.

Outside the Fertile Crescent, hunting and gathering may have supplemented agriculture for a long time before settled town life appeared. Across the same large European and Asian landmass where Ice Age female figures were found—but several millennia later when the climate had moderated—people built intriguing stone structures. One of these, con-centric stone circles in southern England known as Stonehenge (Fig. 1.7), was laid out so as to allow the sun to rise over a special stone on the first day of the summer solstice.

Of course, an agricultural people would be interested in observing and predicting the seasons, but would they have labored for years simply to construct a device that would be just as useful if it were smaller? Stonehenge would have taken many years and a great deal of labor, far more effort than would logically have been expended for a calendar. Some of Stonehenge's **megaliths,** or large stones, were brought almost 200 miles to the site. The stones were shaped, and a peglike projection was fashioned on the top of each. The stones were then set up vertically, perhaps by first dragging each stone into a pit and then pulling it upright. Capping stones, with holes that fit the projections on the tops of the upright stones, were raised and placed snugly down on the pegs. This type of construction is called ***post and lintel.***

MESOPOTAMIAN CIVILIZATIONS

The earliest Near Eastern settlements were established in the region known as Mesopotamia, a Greek word meaning the land between the two

1.7 Stonehenge, c. 2550–1600 BCE. Circle is 97′ diameter; trilithons approx. 24′ high. Salisbury Plain, Wiltshire, England.

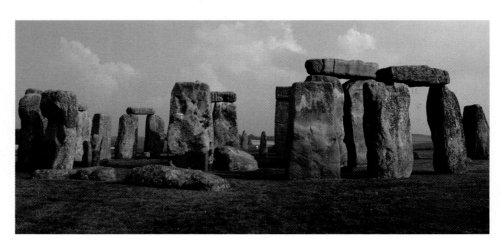

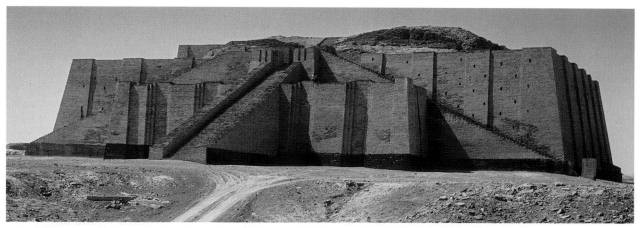

1.8 Ziggurat (northeastern facade with restored stairs), Ur (modern Tell Muqayyar), Iraq, c. 2100 BCE.

rivers, specifically, the Tigris and Euphrates, whose generous waters were brought under control by a system of dikes and irrigation canals. In about 4000 BCE, the land of Sumer (in what is now southern Iraq) was inhabited by a people who developed a highly organized society capable of public works projects such as dams. The Sumerians invented an early numerical system and also devised a form of writing on clay tablets with wedge-shaped characters called **cuneiform.**

THE SUMERIANS

The Sumerians believed in a pantheon of gods who personified the creative and destructive forces of nature. In their cities they typically built low temple complexes at ground level and a high temple called a **ziggurat,** which means "mountain" or "pinnacle." These massive, terraced structures were conceived as dwelling places of the gods who watched over the fortunes of the town. They were also the center of a powerful priesthood, where scribes kept records, accounts, and inventories of food and supplies. In the flat surrounding countryside, these multistoried structures rose so high that they were thought, as recorded in the Bible (Gen. 11:3–4), to "reach unto heaven." The nearly 300-foot ziggurat at Babylon, the tallest ever built, was the legendary Tower of Babel, but only the foundation remains. The ziggurat at Ur (Fig. 1.8), dating from about 2100 BCE, was also an imposing pile. The broad base of the ziggurat did not have interior rooms but was usually filled with rubble and faced with decorative brickwork. It was approached by three great stairways of 100 steps, each leading to the gatehouse some 40 feet above ground level. The corners of the massive oblong base are oriented toward the four points of the compass. Inward-sloping walls rise to

make a platform for the second stage, which in turn supported a now ruined temple at the top.

Beginning in 1922, a rich treasure of art came to light during archeological digs at the royal tombs of Ur, the biblical Ur of the Chaldees and traditional birthplace of Abraham. The jewelry, headdresses, musical instruments, and other artifacts reveal an extraordinary quality of craftsmanship. The reconstructed harp (Fig. 1.9) has a marvelously wrought

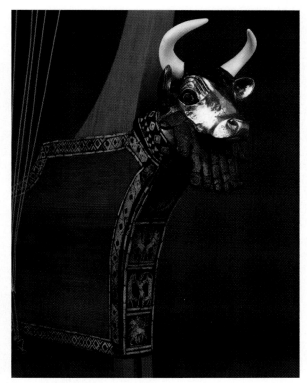

1.9 Bullheaded lyre or harp, from Ur, c. 2600–2400 BCE. Wood with gold, lapis lazuli, and shell inlay. British Museum, London, England.

golden bull's head facing the sound box. The tips of the horns, the hair, the eyes, and the human beard are carved of lapis lazuli, a precious blue stone imported from Afghanistan. The four panels below are decorated with a delicate inlay of shell and gold leaf depicting mythological scenes.

Other excavations have unearthed statuettes that were probably left by worshippers at shrines and temples (Fig. 1.10). Made of gypsum, these votive figures are not portraits but stand-ins who were to continue praying after the worshiper had left a sacred site. Their wide eyes, filled with bits of shell or lapis lazuli are characteristic of Mesopotamian art. Their large eyes have never been fully explained, but they may have been intended to register an intense religious experience. The statues are **stereotyped,** that is, made in a similar pattern. The different sizes may indicate the greater or lesser social status of the worshipers. Gudea, the devout ruler of the city of Lagash, is shown in Figure 1.11, depicted in one of many such statues that were set in temples around his city. The work is carved of diorite, a hard stone that takes a high polish and resists decay and destruction. From all accounts, Gudea was a serious but benevolent man who considered himself the "faithful shepherd" of his people. He is always shown as pensive or prayerful. In one version he is depicted with a building plan, probably the wall of a temple precinct, on his lap.

Later, from about 1791 to 1750 BCE, Hammurabi ruled a kingdom that united most of Mesopotamia. He commands a secure place in history as the codifier of the influential body of laws that were inscribed on a tall **stele** of polished black stone (Fig. 1.12). The top is a sculptured relief of Hammurabi as "the favorite shepherd" of the enthroned, flame-shouldered sun god Shamash, whose wishes were that "justice should prevail in the land" and that "the strong might not oppress the weak." Hammurabi's code did not strictly enforce equal justice for all: the upper classes and the royals enjoyed greater privileges and leniency. Slaves could be bought, sold, and readily killed. However, the code was designed to protect widows and orphans and to see that children supported their aged parents. Although a woman's first duty was to give her husband legitimate offspring, she was otherwise an independent person, free to borrow and lend money as well as to own, buy, and sell land; in some instances, women even ran businesses. Adulterous wives and their lovers, however, were sentenced to be lashed together and drowned in the river.

In Sumerian literature, the outstanding *Epic of Gilgamesh* predates Homer's *The Iliad* by some 1,500 years, and it still makes for compelling reading. Gilgamesh was a legendary hero who ruled at Uruk, the biblical Erech, in about 2700 BCE. The story is about the age-old human quest for the meaning of life in the face of death, the conflict be-

1.10 Statuettes of worshippers from the Square Temple at Eshnunna (modern Tell Asmar), Iraq, c. 2700 BCE. Gypsum inlaid with shell and black limestone, tallest figure approx. 2′6″ high. Iraq Museum, Baghdad, and Oriental Institute, University of Chicago.

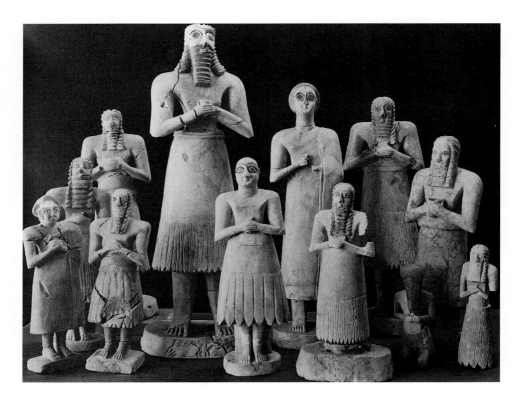

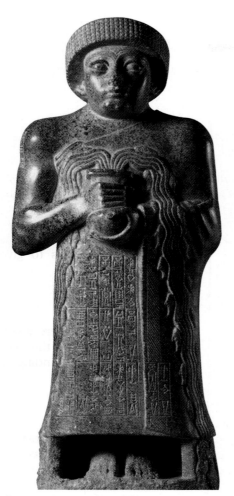

1.11 Green calcite statue of Gudea, Diorite, c. 2150 BCE, height 2′4″. Louvre, Paris, France.

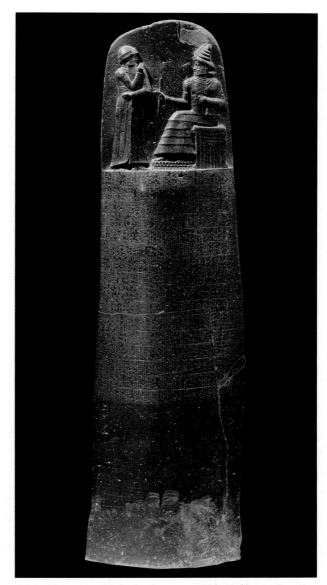

1.12 Hammurabi Stele, Susa, c. 1792–1750 BCE. Basalt, height of entire stele 7′4″. Louvre, Paris, France.

tween gods and mortals, and the consolations of love and friendship. While searching for his lost youth and immortality, Gilgamesh encounters Utnapishtim, who has survived a mighty flood by building an ark and assembling all manner of birds and beasts within it. From him Gilgamesh receives a miraculous plant that magically restores youth, only to have a wily serpent snatch it from his grasp. The epic ends with the words, "He was wise, he saw mysteries and knew secret things, he brought us a tale of the days before the flood. He went a long journey, was weary, worn out with labour, and returning engraved on a stone the whole story."

Thus, the journey ends tragically in death and disillusionment as Gilgamesh "goes back through the gate by which he came." The reader is left with the impression that the purpose of the journey may have been the journey itself and that in such a quest for self-understanding it is perhaps better to ask

questions than to receive answers. It is interesting to note that some of these tales and images would later find their way into the Book of Genesis. Among them are the stories of Noah and the flood, Nimrod the hunter, and the building of the Tower of Babel.

Music played a strong role in Mesopotamian life, from the songs of shepherds to the music rooms found in some temples. Like other rulers, Gudea encouraged musical performances. Early Mesopotamian music is represented by a complete song dating from about 1400 BCE. It was discovered in archeological excavations at ancient Ugarit (the modern Ras Shamra on the Mediterranean coast of

Syria). Recorded in cuneiform script on clay tablets, the lyrics are in the Hurrian language, which has yet to be fully deciphered. Enough is known, however, to reveal that the song is a cult hymn in praise of the mother goddess Nikkal, wife of the moon god. Texts dealing with various tuning systems for musical instruments, dating to about 1800 BCE and found in the excavations at Ur, proved helpful to the musicologists who reconstructed the melodic intervals of the song. Quite surprisingly, the scale closely approximates our major mode, that is, the modern arrangement of musical notes in an octave. Even more astonishing was the discovery that there were two different pitches meant to be sounded simultaneously: one for the voice, with words, and the other for an accompanying stringed instrument such as a harp or lyre (Fig. 1.13). Before this discovery it had been assumed that all music before the medieval invention of counterpoint was **monophonic,** that is, music consisting of a single line.

THE ISRAELITES

After the fall of the Sumerians, Mesopotamia was dominated in turn by the Akkadians and the Assyrians. Meanwhile, nearer the Mediterranean coast the Hebrew-speaking nomadic tribe of Israel, a small but tenacious people, established a kingdom under Saul and his successors David and his son Solomon, who built a noted temple and an impressive palace in Jerusalem. After Solomon's death the kingdom was divided in two; the northern part was called Israel and the southern part Judah. In 722 BCE, Israel was conquered by the Assyrians, while Judah fell in 587 BCE to the Babylonians under Nebuchadnezzar: "And he burnt the house of the Lord, and the king's house, and all the houses of Jerusalem, and every great man's house burnt he with fire" (II Kings: 25:8–9). Among the captured Israelites was their king Jehoiachin and the prophet Ezekiel. Their lament is echoed eloquently in the words of Psalm 137:

> By the rivers of Babylon, there we sat down,
> yea, we wept, when we remembered Zion.
> We hanged our harps, upon the willows in the
> midst thereof.
> For there they that carried us away captive
> required of us a song; and they that wasted
> us required of us mirth, saying, Sing us one
> of the songs of Zion.

Music making under such circumstances can be seen in the carved panel relief from Ashurbanipal's palace at Nineveh (Fig. 1.13). At this time,

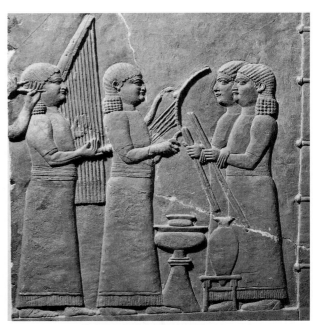

1.13 *Musicians Playing at Ashurbanipal's Banquet,* detail of a relief from the North Palace of Ashurbanipal at Nineveh, 668–627 BCE. Limestone, 1′11″ × 4′7″. British Museum, London, England.

Nebuchadnezzar's Babylon had once again become a prosperous and resplendent city, with its fabled Hanging Gardens. There were also a grand royal palace and an impressive temple complex surrounded by a magnificent wall and approached by spacious processional ways. The surviving Ishtar Gate (Fig. 1.14) was faced with enameled and molded brick that gleamed in the sun. The portal is decorated with fabulous beasts, with the dragon of Marduk and the bull of Adad, in white with yellow details, marching in solemn procession.

But as ever, pride goes before a fall. As the prophet Daniel declaimed:

> The king spake, and said, Is not this great
> Babylon, that I have built for the house of
> the Kingdom by the might of my power, and
> for the honour of my majesty?
> While the word was in the king's mouth, there
> fell a voice from heaven, saying, O king
> Nebuchadnezzar, to thee it is spoken; The
> kingdom is departing from thee. (Dan. 4:30–31)

True enough, after the king's death the city was soon under siege, and this time the Neo-Babylonian empire fell to the Persians under Cyrus.

In the arts the Israelites were bound by the commandment from God to Moses: "Thou shalt not make unto thee any graven image, or any like-

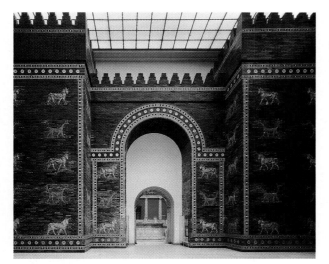

1.14 Ishtar Gate (restored), from Babylon, Iraq, c. 575 BCE. Enameled baked brick, height 48′9″. Antikensammlung, Staatliche Museen zu Berlin, Berlin, Germany.

ness of any thing that is in heaven above, or that is in earth beneath, or that is in the water under the earth" (Ex. 4:20). This effectively ruled out the representative arts of sculpture and painting. The Israelites did, however, build temples and palaces, all of which have perished in the course of time. Their creative thinking was channeled into the world of letters with the compilation of the Old Testament, the first part of which, from the Book of Genesis to II Kings, achieved its present form in the late fifth century BCE.

THE EGYPTIANS

Through monumental buildings, magnificent statues and murals, and representations of priestly ceremonies and royal processions, the Egyptians dramatically portrayed the concepts of divinity, kingship, and priestly authority. Egyptian artists, like those in Mesopotamia, were compelled to follow formulas in depicting the body and indicating social rank. Nevertheless, the paintings on the walls of Egyptian tombs show a keen eye for informal activities and naturalistic detail. As can be seen in the tomb of Nebamun (Fig. 1.15), the artist was concerned mostly with the picture plane, not with creating illusions of depth, modeling the figures in three dimensions, or showing them against a background. In accordance with the formulas, the heads are always drawn in profile, but the eyes are represented as if facing forward. The torsos are frontal, but the arms and legs offer a side view. Although the figures are shown from the side, they

have two left feet so that both big toes are toward the front. If a pool or river is included in a landscape, the view of it is from above, but fish, ducks, plants, and trees in and around it are shown sideways. Important persons always appear larger than their families, followers, or servants.

Once these formulas are taken into consideration, the scenes appear remarkably lifelike. Naturalistic detail is rendered so accurately that botanists and zoologists can recognize each species of plant or animal life represented. The Egyptian artist also knew how to portray the fur and feathers of animals and birds by breaking up the color surfaces with minute brushstrokes of various hues. When Nebamun, an Egyptian official, had himself depicted hunting fowl in the marshes, he was demonstrating that he would eternally enjoy sports while fulfilling his obligation to maintain the waterways and keep them free from crocodiles and hippopotamuses. Egyptian tomb art is thus a re-creation of life as it was experienced in the flesh, and these still-vital, colorful murals provide an amazingly complete and comprehensive picture of how people behaved in an ancient civilization.

SOCIAL STRUCTURE

Together with literature and other types of written records, tomb decorations offer a glimpse of everyday life. As might be expected, peasants spent much of their time in farming, herding, housekeeping, and food preparation. Although

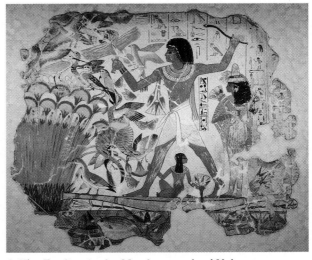

1.15 *Fowling in the Marshes*, tomb of Nebamun, Thebes, Egypt, Dynasty XVIII, c. 1400–1350 BCE. Fresco on dry plaster, approx. 2′8″ high. British Museum, London, England.

women in all classes of society achieved part of their status through male relatives, they also had legal rights of inheritance like Mesopotamian women. Land and wealth passed down through the female line, and women could manage property independent from their spouses. Powerful Egyptian gods were female as well as male. Occasionally a woman like Queen Hatshepsut ruled the country, in fact if not in title. Often, women were represented as having lighter skin than men (see Fig. 1.18). The custom probably indicated that affluent women did not work in the fields, where the sun would darken their skin like that of peasant women. On the other hand, women of all classes were not restricted to the home but were seen in markets, shops, and public events. They were depicted in wall paintings and other media accompanying men to review farm and labor activities, as well as celebrating at feasts and funerals. Women worked as priests, midwives, professional mourners, and musicians and dancers.

Egyptian society was like a pyramid. At the base were the peasants, then came the landowners and nobility, near the top was the priestly caste, and at the apex, the pharaoh. Because they were viewed as gods, pharaohs were also burdened with the responsibility to keep the universe balanced and orderly. They could be blamed for droughts and famines. Sometimes pharaohs responded to the obligation by creating socially beneficial public works, like the building of canals and irrigation systems along the Nile, which overflowed its banks each year and deposited rich, black soil on the adjacent farmland. The famous pyramids at Giza, outside the modern city of Cairo, were built not only as the most imposing structure in a complex of buildings used for the pharaoh's funeral rites and burial but probably also as a project to keep a large part of the population actively employed and fed during the annual Nile flood.

The Pyramid of Khufu (*Cheops* in Greek) is the largest and grandest of funerary monuments, meant to last forever (Fig. 1.16). Its statistics are staggering. Combining the basic geometrical forms of the square and the triangle, it was built of 2.3 million blocks of stone, each weighing about 2.5 tons. The stupendous structure covers more than 13 acres, encloses a volume of 85 million cubic feet, and is completely solid except for two small burial chambers. To line it up with the four corners of the world, it was surveyed so accurately that each of its 755-foot sides faces one of the cardinal points of the compass. The stone is so skillfully cut that joints are scarcely visible. For centuries the pyramids served as convenient quarries, so now the original smooth facing of varicolored sandstone and granite remains in only a few places.

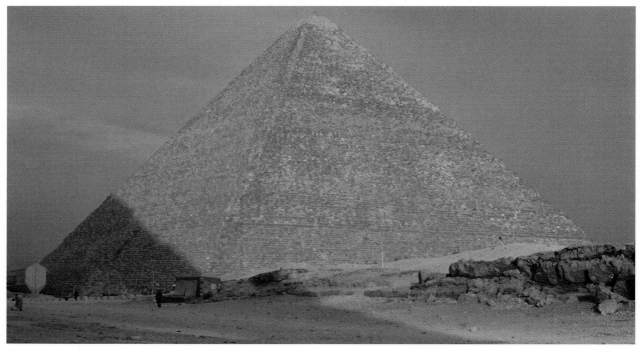

1.16 Pyramid of Khufu, Giza, Egypt.

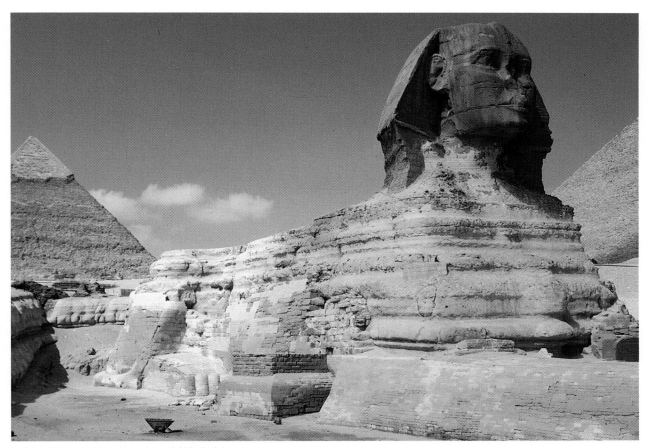

1.17 *Sphinx,* Giza, Egypt, c. 2520–2494 BCE.

The companions of this mighty monument are the pyramids of Khufu's dynastic successors and lesser members of the royal line, along with the Sphinx (Fig. 1.17), which combines the crouching body of a lion with a human head. It was placed near a temple that was connected to the pyramid of King Khafre, son of Khufu. Facing the rising sun, the Sphinx's body symbolizes immortality, while the face is thought to be a portrait of the deified King Khafre.

CONCERN WITH DEATH AND THE AFTERLIFE

The dominant concern of upper-class Egyptians was death and the afterlife. Their most important surviving literary legacy is the *Book of the Dead.* Their art forms, including mummy cases, stone sarcophagi, death masks, sculptured portraits, pyramids, temples, and tombs, were all associated with death. The main purpose of this art was not to gladden the eye of the living but to provide for the needs of the dead in the after-

life. Death for prominent Egyptians did not mean extinction but rather a continuation of life beyond the grave. To achieve immortality the body had to be preserved and, especially in later dynasties, the tomb elaborately furnished. The inner walls, floors, and ceilings were covered with hieroglyphic inscriptions that identified the deceased, recounted his or her titles and honors, and portrayed the deceased surrounded by family and friends or occupied with his or her favorite pursuits. The activities of everyday life—sowing and reaping crops, caring for farm animals, baking bread—were commonly depicted because these activities were to continue as usual in the afterlife. The wealthy and powerful had themselves depicted in various pursuits, such as hunting and fishing, supervising work in the fields, and making offerings to the gods.

After the mummy itself, the next most important object in the tomb was the image of the deceased. Such a statue was considered the vessel of

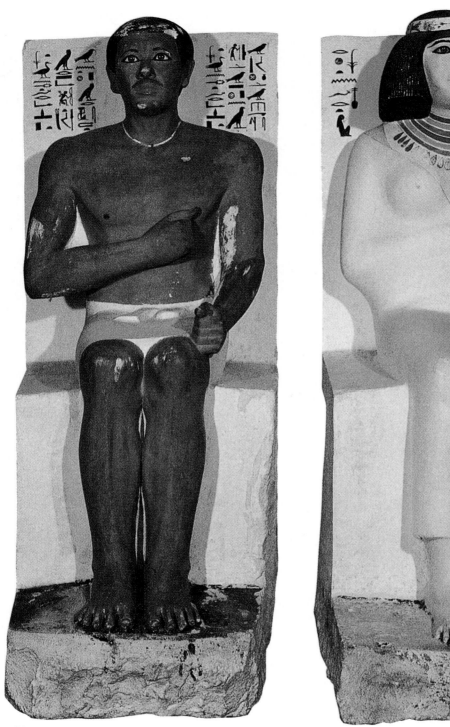

1.18 (A) Prince Rahotep and (B) Nofret, c. 2610 BCE. Painted limestone, height 3′11¼″. Egyptian Museum, Cairo, Egypt.

the deceased's immortal other self, or *ka.* A pair of these ka statues represent Prince Rahotep and his wife Nofret (Fig. 1.18). Even after thousands of years, they preserve their original freshness. Statues like these might have found a temporary spot in a royal home, but these works were intended primarily for the tomb.

TEMPLES AND TEMPLE DECORATION

The priestly caste had a major influence on the design and decoration of Egypt's temples. From its origins in the practice of occult magic, this group gradually gained in scientific knowledge and social influence. The priests were skilled in

geometry and mathematics, knew the heavens and the movements of stars, and could predict the time when the Nile would overflow and bring renewed life to fields and gardens. Only the priests and the well-to-do were allowed within temple precincts. The privileged worshipers approached the temples by broad avenues and entered through massive **pylons,** or gateways, into a forecourt. **Hypostyle** halls of giant columns lay beyond. These columns were often carved with hieroglyphic inscriptions, as in the Temple of Amon (Fig. 1.19). The colossal statues of Ramses II flanking the entrance to this temple typify the aloof, rigid, unchangeable images of the pharaohs. These sculptured forms provide no suggestion of movement to disturb their majestic calm, on which the tranquility of the universe was thought to depend. Strict convention dictated the pose, with its severe frontality, stylized ceremonial beard, and hands placed upon the knees. As the direct descendant of Horus, god of the skies, the pharaoh appeared as the absolute ruler.

AKHENATON AND TUTANKHAMEN

An exception to these rigid and stylized representations of pharaohs occurred during the reign of Amenhotep IV, who rejected the many gods and rituals of his ancestors, adopted monotheism, and changed his name to Akhenaton ("Beneficial of the Aton," the universal and sole god of the sun). Akhenaton's vision is expressed in his eloquent *Hymn to the Sun,* which begins:

> Thou appearest beautifully on the horizon of
> heaven, Thou living Aton, the beginning
> of life.
> When thou art risen on the eastern horizon,
> Thou hast filled every land with thy beauty.
> Thou art gracious, great, glistening, and high
> over every land; Thy rays encompass the
> lands to the limit of all thou hast made.

An unfinished bust of Akhenaton's beautiful queen, Nefertiti, was found at Tel el Amarna, the new town Akhenaton built to give a fresh start to his religion (Fig. 1.20). Despite the royal

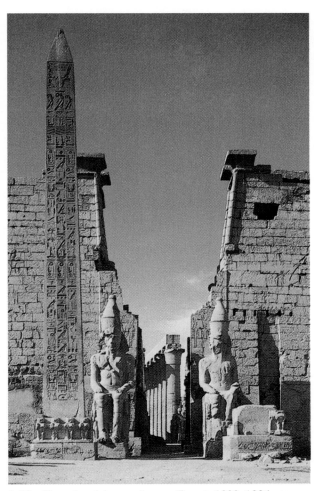

1.19 Temple of Amon. Luxor, Egypt, 1290–1224 BCE.

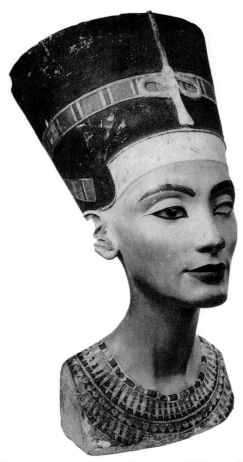

1.20 Thutmose. *Queen Nefertiti,* c. 1340 BCE. Painted limestone with inlaid glass eye, height 1′8″. Aegyptische Sammlung, Staatliche Museen, Berlin, Germany.

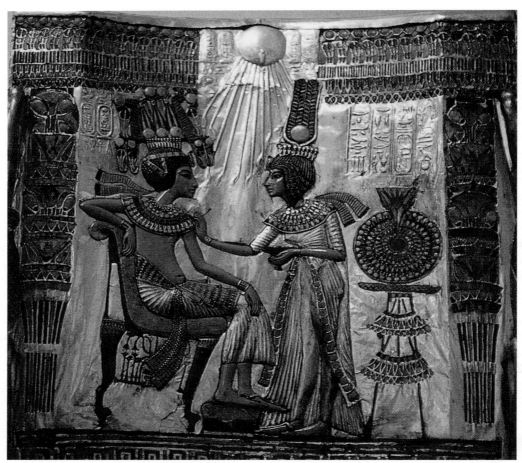

1.21 Back of Tutankhamen's throne, from Thebes, c. 1300 BCE. Wood covered with gold leaf and colored inlays of faience, glass, and stone; back width 1′9″. Egyptian Museum, Cairo, Egypt.

headdress, regal dignity, conventional elongated neck, and bright paint, the queen's official sculptor, Thutmose, let the personality of his subject show through. Breaking with precedent, Akhenaton allowed himself to be portrayed informally as he offered his queen a flower and caressed his baby daughter, with Nefertiti holding two infant princesses on her lap.

Akhenaton's death resulted in the restoration of polytheism as Egypt's official religion, but the relative informality of the art he preferred carried over briefly into the reign of his successor, King Tutankhamen, famous because his is the only Pharaonic tomb found in modern times almost intact and unplundered. On the back of Tutankhamen's throne (Fig. 1.21), the king is shown in a relaxed attitude talking with his wife while the sun god bestows his divine blessing with many raylike hands.

THE AEGEAN

Other important ancient civilizations arose in the Aegean region: the Minoan on the island of Crete as well as on the Cycladic Islands, and later the Mycenaean on the Peloponnesian peninsula of mainland Greece. The residents of Crete were mobile, seafaring folk who developed a prosperous import–export economy based on trade. The gentle Mediterranean climate enabled them to produce enough food to be self-sufficient, and even to create surplus products. They traded olive oil, wine, pottery, and finely wrought crafts such as gold and silver cups, jewelry, and vases for other supplies. In the process they also gathered knowledge about other civilizations, their histories and lore, and their ideas and ways of life.

THE MINOANS

About 1700 BCE, the people known as Minoans for the mythological king Minos began to rebuild palaces that had been destroyed by an earthquake. These palaces functioned both as royal residences and as business centers. The palace complex at Knossos was constructed around a rectangular central courtyard that could be entered only by circuitous routes through the rooms surrounding it. This confusing layout may have given rise to the legend of the labyrinth or maze that was thought to have contained an inner courtyard where the Minotaur, a half-man/half-bull monster who fed on hapless youths, was found and slain by the Athenian hero Theseus with the help of a thread spun by the Minoan princess Ariadne.

Large areas of the palace were set aside for storage of wine and oil. Its interior walls were decorated with lively *frescoes,* including a fascinating scene that seems to show a bronze-skinned acrobat tumbling over the back of a bull (Fig. 1.22). The much-restored wall painting portrays light-skinned figures, possibly women, on either side of an animal that looks more like a child's rocking horse than the aggressive bulls of Ice Age art. If the two light-skinned figures are female and the tumbler male, the artist has employed the conventional body colors used in Egyptian art to signify that males worked outdoors in the sun while upper-class women were sheltered in the home.

Unlike the people of Mesopotamia and Egypt, the people of Crete and the Cycladic Islands did not have to fear invasion by land armies. Although their palaces did not include large defensive barriers, some fortifications have been found for protection against naval attacks. They do not seem to have had an organized religious life, as the Egyptians did. Along roadsides, in caves, or on mountaintops there were small shrines with votive figures dedicated to heroes or local deities.

Minoan culture, and perhaps political and economic dominion, spread northward to the Cycladic Islands. There the Minoans would have encountered traces of an agricultural people whose artists had been creating marble figures ranging in size from a few inches tall to life size.

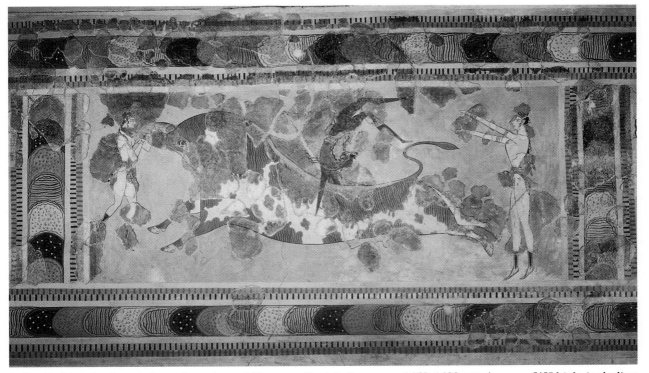

1.22 *Bull-leaping* fresco, from the palace at Knossos (Crete), Greece, c. 1450–1400 BCE. Approx. 2′8″ high, including border. Archeological Museum, Herakleion, Greece.

The statues (Fig. 1.23), which were first made about 3000 BCE, were shaped like flattened ovals. Moreover, they could not stand on their own. Like the ka statues of Egypt, they were mostly found in tombs. Their strange, shield-shaped faces tilt back in the manner of the heads of Mesopotamian worshipping figures. Most of the

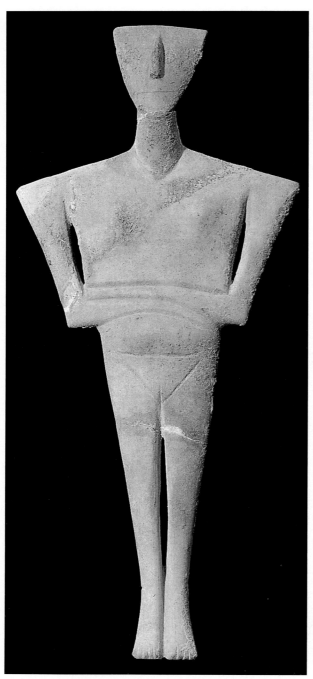

1.23 Cycladic figure, Greece, c. 2500–2300 BCE. Marble, approx. 1′6″ high. National Archaeological Museum, Athens, Greece.

pigment that was applied to the figures has worn off, and we cannot guess how they were painted. Were these carved figures goddesses, fertility cult forms, guides to the underworld, or spirits of the dead?

On the island of Thera (also called Santorini), frescoes at the town now named Akrotiri are among the best preserved Minoan examples. Entering some of the rooms must have been like walking into a flower garden filled with songbirds on the wing (Fig. 1.24). In some scenes, one sees cats chasing ducks on riverbanks or lion and bull hunts in progress. Other scenes depict dancing figures in gauzy drapery. The subjects were mostly everyday events, technically known as **genre** scenes: fishing, women at their daily chores, children playing, and sporting activities such as a youthful boxing match. All are done with a lightness of touch, a lively line, a love of bright colors, and a fondness for capturing the fleeting moment.

THE MYCENAEANS

The decline of the Minoan civilization, once thought to have been provoked by a violent volcanic explosion on Thera about 1500 BCE that darkened the area with ash for hundreds of miles, was accompanied by the rise of the Mycenaeans on the Greek mainland. The Mycenaeans challenged the Minoan command of the seas and eventually took over Crete, apparently without much of a struggle. Mycenaean culture was shaped by their harsh environment and the need to defend themselves on land by the sword. Stout fortifications enclosed their palace complexes; the farming folk lived outside the walls in mud-brick or wooden houses with earthen floors. Among the most renowned Mycenaean structures still surviving is the Lion Gate at Mycenae (Fig. 1.25), which dates from about 1250 BCE. It was the entrance portal to the fortified citadel. Twin rampant lions carved in bold relief appear above the doorway. The workmanship seems rough, but the heraldic image signifying power and strength undoubtedly outweighed the need for sculptural refinement. The nearby beehive-shaped royal tombs, however, with their 44-foot-high domes, are marked by finely dressed and skillfully joined stone masonry, obviously built to last for the ages.

Mycenae flourished during the period vividly described in Homer's epic poems about the Trojan War. The descendants of the royal line founded by King Atreus of Mycenae found their way into Greek

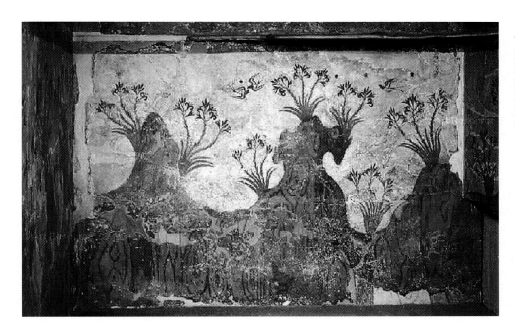

1.24 Mural from Thera. Room with landscape frescoes, House Delta, Thera. Minoan, c. 1500 BCE. National Archaeological Museum, Athens, Greece.

legends and folklore, and especially the plays of the major Athenian dramatists—Aeschylus, Sophocles, and Euripides. Their monumental tragedies tell how one of Atreus's sons, Agamemnon, married his cousin Clytemnestra and fathered Orestes, Electra, and Iphigenia. The other son, Menelaus, married the beauteous Helen, who was abducted by the Trojan prince Paris; this action was the reputed cause of the Trojan War as described by Homer in *The Iliad*.

When the Dorian Greeks migrated from the north in the twelfth century BCE, the Mycenaean settlements were burned and pillaged, thus bring-ing their culture to an abrupt end. In historical perspective, Mycenaean civilization can be considered either as a postscript to the Minoan or as a transitional time pointing toward the classical period of Greek and Roman civilization.

IDEAS

We may never know how and where art first began, but once it was established, Western art's early uses were remarkably alike across cultures and time periods. From cave paintings to the

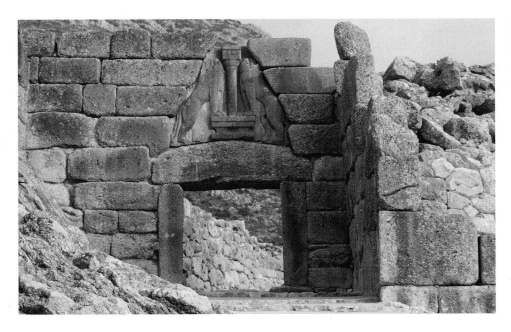

1.25 Lion Gate at Mycenae, Greece, c. 1300–1250 BCE. Limestone, relief panel approx. 9′6″ high.

Bull Leaping fresco at the Minoan palace of Knossos (Fig. 1.22), art was closely related to religious activity, ceremonies of initiation, and group identity. Art was also used to show power, wealth, and position in society. Someone approaching the Ishtar Gate of Babylon (Fig. 1.14) could not help but be struck by the figures of dragons and bulls alternating on its facade and, by implication, the authority of the city's ruler to command that such works be created.

The physical appearance and distinctive character traits of individuals were seldom the subjects of early art. The Woman of Willendorf is not a particular person but a symbol of human regeneration. Sumerian worshipper figures (Fig. 1.10) are somewhat differentiated in their appearance and garb, yet their faces and expressions are very similar. Even the slim, modeled face of Nefertiti (Fig. 1.20), which looks so much like a modern woman, may have resulted from the art principles of the time, which required artists to elongate forms, especially the head and neck.

In early societies, individuals seem to have been selected at a young age for their ability to draw, sculpt, plan buildings, or play music. Pharaohs and kings fostered training in the arts and sponsored schools where techniques were passed from one generation to the next. Along with olive oil and wine, the Minoans traded useful and decorative pottery and fine gold pieces treasured throughout the Aegean area. Eventually, Minoan artists also migrated to fulfill demand for their jewelry.

It is reasonable to assume that being an artist was one of the earliest occupations. Nevertheless, artists and musicians were considered workers. Their low status is evidenced by the fact that they usually did not sign their work. On the other hand, pharaohs like Akhenaton wrote poetry, and well-to-do Mesopotamians prided themselves on their ability to compose music.

Naturalism—that is, depiction of the world as the eye sees it—made a fleeting appearance in Egyptian art, for instance, in the birds and foliage portrayed in the wall painting from the tomb of Nebamun (Fig. 1.15). It also arose sporadically in classical art, but it did not begin its steady development until the Renaissance. In other words, realistic representation is relatively new in Western art. Its development took place in tandem with the advancement of science and technology, as well as with the expansion of Western commercial interests in other parts of the world.

For much of human history, naturalistic depiction was rejected in favor of rich symbolic meaning and suggestion. For some, realistic description was a distraction from the search for eternal truth; for others, it was an insult to the Creator. In sum, the idea that one should paint a bird that could fool the eye would have been as ill-considered as making music that only imitated birdsong.

YOUR RESOURCES

- ***Exploring Humanities CD-ROM***

 ○ Interactive Map: Prehistoric Europe and the Near East

 ○ Readings—*Epic of Gilgamesh, The Iliad, The Odyssey, Law Code of Hammurabi*

- ***Web Site***

 http://art.wadsworth.com/fleming10

 ○ Chapter 1 Quiz

 ○ Links

ORIGINS OF WESTERN ART (ALL DATES APPROXIMATE)

	Key Events	Architecture	Visual Arts	Writing	Music
,000 BCE / **4000 BCE**	250,000–10,000 **Paleolithic Period** (Old Stone Age); Cro-Magnon peoples 6,000–3,000 **Neolithic Period** (New Stone Age)	Houses of brick and mud; wattle and daub construction 7700–5700 **First cities** appear at Çatal Hüyük (Turkey), Jericho (Palestine)	30,000 **Woman of Willendorf** 15,000–10,000 **Cave paintings and carvings** **Stone carving** (weapons and flint axes)		Bone whistles, primitive drums

Mesopotamia

	Key Events	Architecture	Visual Arts	Writing	Music
4000 BCE / **333 BCE**	3000–2000 **Sumerian Kingdom** 2000 **Old Babylonian empire** 1792–1750 **Hammurabi** reigned 1600–1200 **Hittite empire** 2000–612 **Assyrian empire** 612–539 **Neo-Babylonian empire** 625–539 **Nebuchadnezzar II** reigned	2100 **Ziggurat** at Ur built 575 **Ishtar Gate** at Babylon built	Beginnings of **Sumerian art;** metalworking, bronze casting 3300 **Female head** from Uruk carved 2100 **Gudea** from Tello carved 1760 **Stele of Hammurabi** carved	2400 **Cuneiform writing** invented 1750 **Law Code of Hammurabi** 1500 **Alphabetic writing** invented in Syria 1200 *Epic of Gilgamesh* recorded 650 **King Ashurbanipal** collected library of 22,000 clay tablets	2600 **Sumerian harp** from royal tombs at Ur 1800 **Test for tuning system** written on clay tablets 1400 **Cult song from Ugarit** written with notation on clay tablets

Egypt

	Key Events	Architecture	Visual Arts	Writing	Music
3000 BCE / **30 BCE**	3000 **Egypt** united under one pharaoh 2575–2150 **Old Kingdom** 2008–1630 **Middle Kingdom** 1540–1075 **New Kingdom** 1479–1458 **Queen Hatshepsut** reigned 1353–1336 **Amenhotep IV** reigned 1332–1323 **Tutankhamen** reigned 1279–1213 **Ramses II** reigned 304–30 **Ptolemaic Dynasty**	2630 **Imhotep built step pyramid** for King Zoser 2551–2528 **Pyramid of Khufu** built 2520–2494 **Pyramid of Khafre** built 1473–1458 **Temple of Amon** at Karnak built 1390 **Temple of Amon** at Luxor built 1350 **New capital** at Tel el Amarna built 323 **City of Alexandria** built	2580 **Statues of Prince Rahotep and wife Nofret** carved and painted 2520–2494 **Great Sphinx** carved 2040–1640 **Golden age** of arts and crafts 1360 **Bust of Queen Nefertiti** carved and painted 1330 **Tutankhamen's throne** constructed 1260 **Colossal statues of Ramses II** carved	3100 **Hieroglyphic writing** invented 2600–2300 **Collections of Egyptian religious literature** carved in pyramids 1580–1350 *Book of the Dead* existed in pyramid inscriptions 663–525 *Book of the Dead* assumed present form 1350 **Akhenaton's** *Hymn to the Sun* written 320 **Great library of Alexandria** assembled	4000–3500 **Harps and flutes** played in Egypt 3500–300 **Lyres and reed instruments** added 1420 **Musicians** playing instruments painted for Tomb of Nakht

Cycladic Islands, Crete, and Mycenae

	Key Events	Architecture	Visual Arts	Writing	Music
3000 BCE / **1000 BCE**	2500–1400 **Minoan culture** flourished 1400–1100 **Mycenaean culture** flourished 1230 **Troy** destroyed by Mycenaeans 1100 **Dorian** invasion of Greece 1100–750 **Dark Age**	1750 **Early palace** built at Knossos, Crete 1250 **Lion Gate** of palace at Mycenae built	3000–2000 **Cycladic Island idols** carved	2000 **Phoenician alphabet** developed 700 **Homeric poems** *The Iliad* and *The Odyssey* composed	

Israel

	Key Events	Architecture	Visual Arts	Writing	Music
1025 BCE / **587 BCE**	1025–1000 **Saul** 1000–968 **David** 968–937 **Solomon** 922–597 **Two kingdoms;** Israel to 437, Judah to 589 722 **Israel** conquered 587 **Judah fell to Babylonians**	950 **Temple of Solomon** built	700 **Frieze for Sennacherib's palace** at Nineveh carved depicting procession of war prisoners, including Palestinians	587 **Early books of Old Testament** assembled during Babylonian captivity	1000 **David's Psalms** sung with lyre accompaniment

35,000 BCE

Late Paleolithic period, c. 35,000 BCE
First Paleolithic paintings and sculptures, c. 30,000 BCE

3500 BCE

Invention of the wheel, c. 3500 BCE
Union of Upper and Lower Egypt, c. 3000–2920 BCE
Development of writing and the beginnings of recorded history, c. 2900 BCE
Khufu, Khafre, and Menkaure, builders of the Great Pyramids, c. 2551–2472 BCE

1800 BCE

Hammurabi, r. c. 1792–1750 BCE
Hatshepsut, r. 1473–1458 BCE
Akhenaton and the Amarna period, 1353–1335 BCE
Tutankhamen, r. 1333–1323 BCE
Ramses II, r. 1290–1224 BCE

800 BCE

First Olympic Games, 776 BCE
Foundation of Rome by Romulus, 753 BCE
Homer, fl. c. 150–100 BCE
Tarquinius Priscus, first Etruscan king of Rome, 616 BCE

500 BCE

Darius I, r. 522–486 BCE
Xerxes, r. 486–465 BCE
Socrates, 469–399 BCE
Peloponnesian War, 431–404 BCE
Plato, 429–347 BCE

300 BCE

Aristotle, 384–322 BCE
Alexander the Great, r. 336–323 BCE
Alexander the Great conquers Persia and Egypt, 332 BCE
Battle of Issus, 331 BCE
Death of Alexander the Great, 323 BCE

31 BCE

Battle of Actium, 31 BCE
Augustus, first emperor of Rome, r. 27 BCE–14 CE
Vitruvius, *The Ten Books of Architecture,* c. 25 BCE

CLASSICAL PERIOD

The Greco-Roman era, later called the classical period, spanned about 1,000 years. It began with the age of Pericles, when Greek culture reached its zenith; witnessed the expansion of Greek settlements far and wide under Alexander the Great; saw the rise of Roman power, the grandeur of the Roman Empire, and its eventual decline and fall; and ultimately beheld the rise of Christianity as a social, political, and religious force. The period may be divided into a purely Hellenic phase, a more expansive and widespread Hellenistic continuation, the era of the Roman Republic and Empire, and the Early Christian period.

Instead of blindly accepting mythological and religious explanations of their world, Greek philosophers examined the physical world for themselves. In the sixth century BCE, Pythagoras proposed that there was a unity in nature based on numbers. As the heavenly bodies described their mathematically predictable orbits, they were thought to create a musical harmony of the spheres. Socrates's eloquent pursuit of the goals of truth, goodness, and beauty inspired his pupil Plato, for whom the world of ideas was preeminent. Aristotle's more down-to-earth approach brought together all current knowledge of logic, ethics, politics, poetics, physics, and metaphysics. His thinking was to remain influential for the next 2,000 years.

The Romans, in turn, were adept at applying general principles to practical problems. They developed public works projects and architectural engineering. At the pinnacle of its power, Roman practicality and administrative ability brought most of Europe and parts of Asia and Africa under its dominion. In later antiquity, Roman forms and institutions found their way into the Early Christian tradition in both the eastern Byzantine sector at Constantinople and the Western section with its capital at Ravenna.

Throughout these phases and in various cultural centers, the arts flourished and interacted brilliantly. In architecture, the Greeks carried the post-and-lintel system to perfection in their gleaming temples. The Romans, building for larger cities and populations, brought the arch-and-vault method to its peak. Sculpture, based on the expressive power of the human body, achieved lifelike plasticity and fluidity, and large-scale murals and mosaics provided a pictorial dimension.

Music played a prominent role in ancient social and religious life. Greek musical theory laid the basis for all future musical development in the West. Greek and Roman epic, lyric, and dramatic writing mirrored the ancients' search for self-understanding and self-awareness. Drama in particular provided insights into human character and its motivations. Greek tragedy explored the heights and plumbed the depths of human potential and spirit.

In Western thought, the period was given the title "classical," for the excellence of its art, philosophy, and literature. To this day, classical architecture endures as a model and a set of ideas to be emulated.

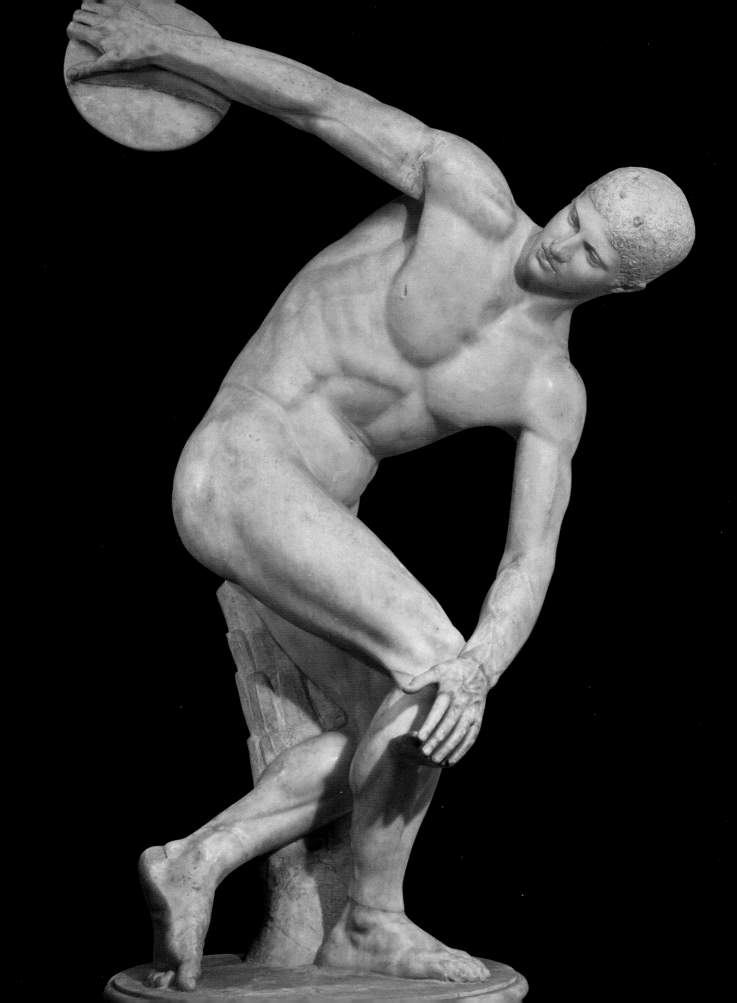

CHAPTER

ATHENS IN THE
FIFTH CENTURY BCE

IN THE LAND OF HELLAS, as the Greeks called their country, a small city-state dedicated to Athena, goddess of wisdom, saw the birth of a new spirit. There for a brief time were concentrated the creative energies of many outstanding politicians, philosophers, and artists. Among them were leaders who secured victory for Athens in the struggle to dominate the Mediterranean world (Map 2.1); statesmen with the perception to make Athens a protodemocracy in an era of tyrants; philosophers committed to the search for an understanding of the physical, social, and spiritual nature of the environment

they lived in; and artists who conceived daring expressions in stone, word, and tone. Here the statesman Pericles and the philosopher Socrates heard the wisdom of Anaxagoras, who taught that the universe was governed by a supreme mind that brought form out of the chaos of nature. He also taught that people, by thinking for themselves, could likewise bring order into human affairs.

Without hereditary rulers, the government of Athens rested on the shoulders of the citizen class, and rule by the **demos,** the "people," was the order of the day. Unique in its time, Athenian

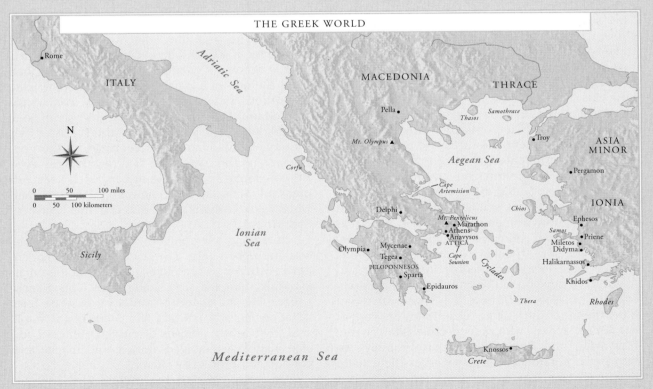

THE GREEK WORLD

MAP 2.1

citizenship was still limited. As inspiring as it has been in Western culture, Athenian democracy extended only to property-owning men. In effect, democracy was enjoyed by only 25,000 to 30,000 people, ranging from the wealthy to the marginally successful. Women, foreign nationals, and slaves were not legally allowed to participate in Athenian democracy. Paradoxically, citizenship depended on a child being born of two Athenians, putting women in the odd legal situation of both being and not being Athenians.

Other contradictions characterized life in Athens, some of them having to do with notions of gender. A powerful female goddess, Athena, watched over the city. Indeed, Greek mythology teemed with strong women, although they were occasionally dangerous, like the all-female barbarians called Amazons or the beautiful Pandora, who unleashed evil on humankind. Plato considered women capable of being Guardians, leaders of the ideal society he depicted in *The Republic.* In Aristophanes's comedy *Lysistrata,* married women from several Greek cities, including Athens, join forces and capture the Athenian Acropolis. From this hilltop stronghold of Athenian politics and religion, they create a strike, refusing men sexual favors until the men choose peace rather than war. Pitched against these favorable, or at least vivid images of active, outgoing women, there are multiple text sources that paint a different picture. They suggest that Athenian women, at least those above the poverty level, were not allowed to leave their homes. Indeed, researchers once concluded that the Athenians considered women a burden— required for reproduction and housework, but little else.

These contradictions have absorbed contemporary scholars. They question the idea that women did not cross the threshold of the house and did not participate in the economic, civic, and cultural life of the Athenian city-state. Insights from anthropology and other fields suggest a gap between what was sometimes written about women and how women actually lived. With that concept in hand, thinkers are now conjecturing a fuller life for Athenian women. For example, women were often responsible for weaving and might have developed the craft into an art. Moreover, in his *Natural History,* the Roman historian Pliny the Elder intriguingly described the work of six female artists who gained fame later, in the Hellenistic and Roman eras. Unfortunately, we may never confidently know whether the artistic talents of some Athenian women were encouraged and developed. In the fifth century BCE, most works of art and craft were not signed.

ATHENS REBUILDS

In 480 BCE, Athens drove its powerful Persian enemies from the Greek mainland and the Aegean Sea. During the war with Persia, Athens's monuments had been reduced to rubble. After the war, many Greek states and islands formed an alliance to protect themselves from further Persian invasions. They called themselves the Delian League, after the sacred island of Delos. With funds that the League stored in Athenian treasuries, Pericles launched a new building program, one that would serves as a model for Western architecture to this day.

Like many other ancient cities, Athens had developed around an *acra,* or "high place," originally found suitable as a military vantage point. Victory centuries earlier on this fortified hilltop, known as the **Acropolis** (Fig. 2.1), had been attributed to the help of the gods. This caused the people to regard the acra as a sacred place, one that should be crowned with appropriate monuments. In Greece, religious sites such as the Athenian Acropolis were also public spaces and symbols of civic pride. As buildings, palaces, and temples were erected on the Acropolis, the people in the city below looked up toward the structures that recorded their history; represented their aspirations; and had become the center of their religious, cultural, and civic ceremonies.

From the beginning, the Athenian Acropolis was never static, and its successive buildings reflected the city's changing fortunes. Once it had been the site of a palace for the legendary king Erechtheus. Later it was transformed from a military citadel and royal residence into a religious shrine, sacred especially to Athena, the city's protector. This change is described by the poet Homer in *The Odyssey:* "Therewith gray-eyed Athene departed over the unharvested seas, left pleasant Scheria, and came to Marathon and wide-wayed Athens, and entered the house of Erechtheus."

Spreading out from the base of the Acropolis was the ***agora*** (Fig. 2.2), a meeting and marketplace, with rows of columns, public buildings, market stalls, gardens, and shade trees. This 10-acre square was the center of the city's bustling business, social, and political life. Here country folk sold their wares, citizens discussed the news, foreign visitors exchanged stories, and magistrates conducted routine city affairs.

On a typical day, the philosopher Socrates could be heard arguing with the Sophists, whom he called "retailers of knowledge." As his pupil,

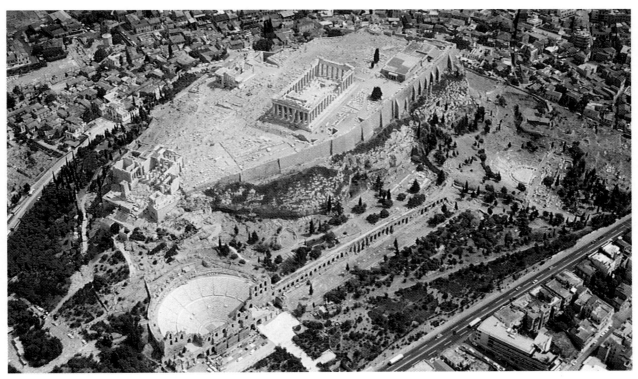

2.1 Aerial view of the Acropolis, Athens, Greece.

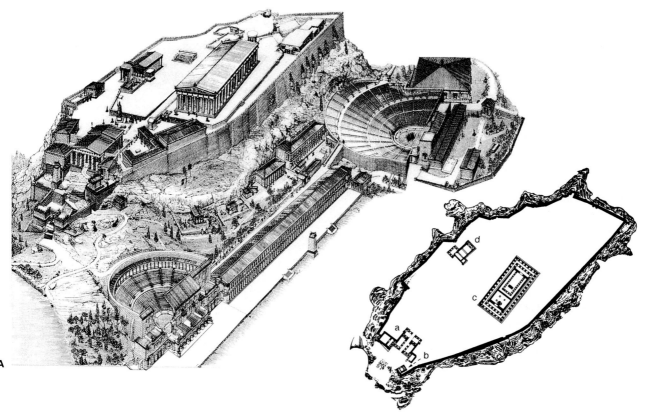

A

2.2 *Acropolis, Athens.* Reconstruction drawings as of the end of the second century CE. (A) Upper right, Theater of Dionysus, fourth century BCE; lower left, Odeion of Herodes Atticus, second century CE. Reconstruction by A. N. Oikonomides. (B) Plan of Athenian Acropolis, with Propylaea (a), Temple of Athena Nike (b), Parthenon (c), and Erechtheum (d).

Plato, would eventually point out, merchandizing in the agora was "partly concerned with food for the use of the body, and partly with food of the soul which is bartered and received in exchange for money." The Sophists were concerned primarily with the art of persuasive speech, but some professed to teach wisdom as well. As manipulators of public opinion, they often became intellectual opportunists who would use any argument to make a point. In his disputations, Socrates showed that sophistry was more a matter of quibbling over words than of penetrating the world of ideas. By pricking some of the Sophists' pretensions with the sting of his wit, Socrates gained his immortal reputation as the "gadfly" of Athens.

On the southern slope of the Acropolis was the Theater of Dionysus (Fig. 2.2, upper right), a sanctuary dedicated to the god of wine and revelry, who was also the patron deity of drama. Here, more than 2,000 years before Shakespeare, the Athenians gathered to marvel at plays that mirrored their worldview in dramatic form. Annually, through their applause, they chose the winner of the coveted poetry prize, which had been won no less than thirteen times by Aeschylus, the founder of heroic tragedy. Sophocles, his successor and the principal poet of the Periclean period, quickened the pace of Greek drama by adding more actors and action. Euripides, the last of the great tragic poets, explored the full range of emotions, endowing his plays with such passion and pathos that they rose to the heights and plumbed the depths of the human spirit. After the Periclean age, the comedies of Aristophanes, such as *Lysistrata,* proved that the Athenians still were able to see the humor and absurdity of life. Today we are likely to read Greek plays rather than see them performed, which makes it easy to forget that the Greek dramatists were more than writers—they were also directors who had to choreograph the movements of actors and the entrances of the chorus while keeping in mind the diverse interests of the audience.

Above the theater, on the rocky plateau of the Acropolis, was a site about 1,000 feet long and 445 feet wide where the temples were constructed (Fig. 2.2). Under Cimon and his successor Pericles, this was a place of ceaseless activity by builders, sculptors, and painters. Later the Roman historian Plutarch declared in his biography of Pericles that as the buildings rose, stately in size and fair in form, the artists were "striving to outvie the material and the design with the beauty of their workmanship, yet the most wonderful thing of all was the rapidity of their execution. Undertakings, any one of which

singly might have required . . . for their completion, several successions and ages of men, were every one of them accomplished in the height and prime of one man's political service." This rivalry among artists reflected the dominant spirit of the period, in which mental gymnastics and intense debate helped refine philosophy, science, and mathematics. The cultural emphasis on intelligence and reasoning shows how the Athenians put their faith in human abilities. They fashioned accounts of human nature, society, and the material world that were not due to the unpredictable actions of the gods.

Pericles had the wisdom to foresee that the unity of a people could rest on philosophical ideas and artistic leadership as well as on military might and material prosperity. A seafaring folk, the Athenians had always looked beyond the horizon for ideas as well as goods to enrich their way of life. In the Delian League, once the Persian threats ended, the Athenians joined with the broader community of Greek-speaking peoples of the mainland, the Aegean Islands, and the coast of Asia Minor to defend themselves and achieve cultural unity.

Athens quickly became a city whose acknowledged wealth consisted not only of material goods but also of its intellectual and artistic riches: the dramatists Aeschylus, Sophocles, and Euripides; the architects Ictinus, Callicrates, and Mnesicles; the sculptors Myron and Phidias; and painters such as Polygnotus and Apollodorus.

The Acropolis itself was both the material and spiritual treasury of the Athenians, the place that held both their worldly gold reserves and their religious and artistic monuments. Work continued with undiminished enthusiasm until the end of the fifth century BCE. By then, the Acropolis had become a sublime setting, one worthy of the goddess of wisdom and beauty. It was also the pedestal that proudly bore the shining temples dedicated to her.

In this chapter, we examine the major arts from the era called Hellenic (from the word *Hellenes,* by which the Greeks referred to themselves). The principal ideas that thread their way through the arts are summarized and coordinated. We will see that **humanism**—the idea that human beings are the primary measure of all things—is one of the underlying principles of Hellenic art; even the Greek gods are conceived of in human form. We will also see how **idealism** is exalted over reality, as revealed in perfect forms that exclude blemishes and shortcomings in representing the human figure, and how **rationalism** and eternal principles prevail over the emotional and transitory phases of human life.

ARCHITECTURE

THE ACROPOLIS AND THE PROPYLAEA

On festive occasions, the Athenians would leave their modest homes to walk along the Panathenaic Way (Fig. 2.2), the main avenue of their city, toward the Acropolis. A panel from the ionic frieze on the Parthenon probably portrays this event. Towering above the celebrants was the supreme shrine—the Acropolis—where they worshiped their gods, commemorated their heroes, and recreated themselves. Accessible only by a single zigzag path up the western slope, the ascent was never easy. In *Lysistrata,* a chorus of old men bearing olive branches to kindle the sacred fires chants as they mount the hill: "But look, to finish this toilsome climb only this last steep bit is left to mount. Truly, it's no easy job without beasts of burden and how these logs do bruise my shoulder!"

As the procession nears the top, the exquisite little Temple of Athena Nike appears on a parapet to the right (see Fig. 2.10). Ahead was the mighty Propylaea, the imposing gateway to the Acropolis (Fig. 2.3). Pericles entrusted the design of this entranceway, undertaken shortly after the completion of the Parthenon, to the architect Mnesicles. The principal architect of the Parthenon, Ictinus,

also may have had a hand in planning the Propylaea, whose aesthetic relationship to the Parthenon is revealed in the proportions of its forms, in the presence of certain features of the **Ionic** order in a dominantly **Doric** structure (see Fig 2.9), and in the main axis that the Propylaea shares with the larger monument.

The Propylaea was built mainly of Pentelic marble from nearby Mt. Pentelicus, except for some dark, contrasting Eleusinian stone. It was a spacious gateway with wings extending on either side to an overall width of about 156 feet. An enclosure on the left was a picture gallery, and an open room on the right contained statues. In the center was the porch, consisting of six Doric columns with the middle two spaced more widely apart, as if to invite entrance. Between the columns looking toward the city and the corresponding ones on the opposite side facing the Acropolis plateau was an open vestibule with columns of the more slender Ionic order, which permitted greater height and space for exhibitions and the waiting crowds (Fig. 2.3).

Through the gateway of the Propylaea the procession entered the sacred area. Amid the revered monuments to the gods and heroes and looming above them was a colossal gold and ivory statue of Athena, said to have been fash-

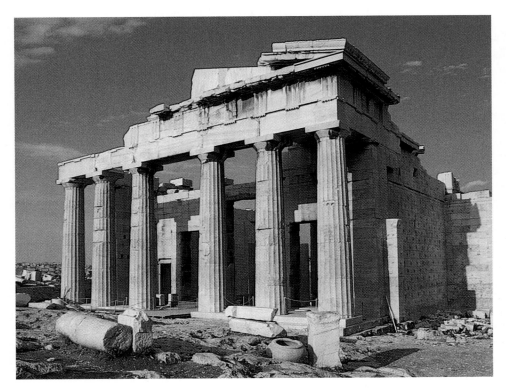

2.3 *Mnesicles,* Propylaea (view from the northeast). Acropolis, Athens, Greece, 437–432 BCE.

ioned by Phidias from the bronze shields of defeated Persian enemies. The tip of her spear is said to have gleamed brightly enough to guide homecoming sailors over the seas toward Athens. On the right was the majestic Parthenon; on the left, the graceful Erechtheum.

THE PARTHENON

DORIC ORDER. At first glance, the Parthenon seems to be a typical Doric temple (Fig. 2.4A). Such a shrine was originally conceived of as an idealized dwelling to house the image of a deity. Under a low-pitched gabled roof, the interior was a windowless rectangular space called the *cella,* which sheltered the cult statue of the deity to whom the temple was dedicated. The *portal,* or doorway, to the cella was on one of the short ends, which extended outward in a *portico,* or porch, faced with columns to form the *facade,* or front. Sometimes columns were erected around the building in a series known as a *colonnade.* (For other details, see Fig. 2.4B.)

The strict rules of the Doric order were based on a ratio of 1:2. According to the philosopher Pythagoras, who worked out the proportions of the musical intervals (see p. 50), the harmony of the universe was based on the perfect interval of the octave (1:2). Therefore, a temple dedicated to a divinity should reflect these perfect proportions. This meant that the ground plan should be twice as long as it was wide. When the front had four columns, the side must have eight, and so on with all the details of the building.

The harmonious proportions of the Parthenon have long been attributed to some subtle and obscure system of mathematical ratios. But despite close study and analysis, no geometric formula has so far been found that fits all the evidence, and the scholarly discussion continues to this day. However, the proportion 9:4 occurs repeatedly. This proportion has been noticed in the length of the building (228 feet relative to its width of 104 feet), when measured on the **stylobate,** or top step; in the width of the **cornice** contrasted to the height of the **raking cornice** at the center; in the distance between the center of one column and that of the next (about 14 feet) as compared with the diameter of the column at its base; and in the bottom diameter of the columns relative to the width of the **triglyphs.**

DEVIATIONS FROM REGULARITY. At the same time, many irregularities defy mathematical logic. Any visitor to the Parthenon can observe that the columns stand somewhat closer together at the corners. Also apparent is the gentle arching of the stylobate from corner to corner. Above the columns, the **architrave** supporting the **entablature** echoes this curve. Noticeable too is the slight outward swelling of the column shafts as they rise and a tapering off toward the top, producing a curved effect known as *entasis.* Entasis creates the impression of elasticity, as if the "muscles" of the columns bulged a bit in bearing the load imposed by the building's superstructure (Fig. 2.4B). Because the Parthenon was to serve both as a shrine to Athena and as a treasury of the Delian League, the plan called for a double cella, that is, two inner rooms. The larger room on the east was to house Phidias's magnificent gold-and-ivory statue of Athena, and the room on the west was to

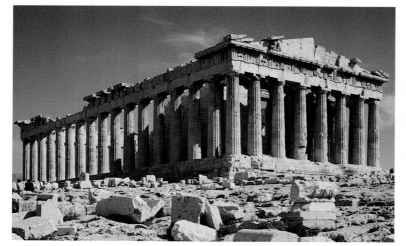

A B

2.4 (A) *Ictinus and Callicrates,* Parthenon, Athens, 447–432 BCE. Pentelic marble; height of columns 34 feet, length 228′ × 104′. (B) Schematic rendering of the Parthenon exaggerating the curvature and irregularities in the scale.

be the treasury. It was this western cella that technically was the ***parthenon,*** or chamber of the virgin goddess. Later the name was given to the whole building. The outer four walls of the cella were embellished by a continuous frieze, a decorative device borrowed from the Ionic order.

The master builder Ictinus labored to avoid the rigidity and repetitiousness of the strict Doric order and to make the Parthenon organically coherent rather than merely mechanically regular. The building can be thought of as a monumental sculpture, compact and firmly structured but resilient and elastic in the relationships among its component parts. This invests the whole with an organic quality like that of life itself. Considered in this way, the Parthenon becomes more visual than logical, more the work of inspired stonemasons than that of mathematicians. Far from being a cold abstraction, the Parthenon is a work of art.

Except for such details as the wooden roof beneath the marble tiles and the wooden doors with their frames, the entire Parthenon was built of Pentelic marble. When freshly quarried, this fine-grained stone was cream colored, but as it has weathered through the centuries, its minute veins of iron have oxidized, so today the color varies from light beige to darker golden tones, depending on the light.

In the original design, bright colors played an important part. Ancient sources tell us that the triglyphs were tinted dark blue and parts of the molding were red. The sculptured parts of the **metopes** were left cream colored, but the backgrounds were painted. In the frieze along the cella walls, the reins of horses were bronze additions, and the draperies of figures here and on the **pediments** were painted. Facial features such as eyes, lips, and hair were done in natural tints.

For the sheer technical skill of its construction, the Parthenon is astonishing. No mortar was used; the stones were cut so exactly that when fitted together they form a single smooth surface. The columns, which appear to be monoliths of marble, actually are constructed of sections called **drums,** so tightly fitted by square plugs in the center that the joinings are scarcely visible.

In its time the Parthenon stood out as a proud monument to Athena and her people and the attainment of Pericles's ideal of "beauty in simplicity." Begun in 447 BCE as the first edifice in the building program, it was dedicated during the Panathenaic festival 10 years later. It and its companion buildings on the Acropolis would be standing today, with only the usual deteriorations of time, were it not for a disaster that occurred in 1687. At that time, a Turkish garrison was using the Parthenon for ammunition storage. During a siege by the Venetians, a random bomb ignited the stored gunpowder, blowing out the temple's central section. Ever since, the Parthenon has been a noble ruin. Today, after numerous partial restorations, its outline is still clear. In its incomparable proportions and reserved poise, it remains one of the great achievements of the human mind.

Other impressive Doric temples can be found as far afield as Agrigento in Sicily and Paestum in southern Italy (Fig. 2.5). In Athens itself, on a low hill near the Acropolis, is the Hephaesteum, one of the best preserved of all Greek temples. It overlooks the quarter where the metal workers and potters had their shops. Appropriately, it was dedicated to both Hephaestus, the blacksmith of the gods, and Athena, the goddess of knowledge.

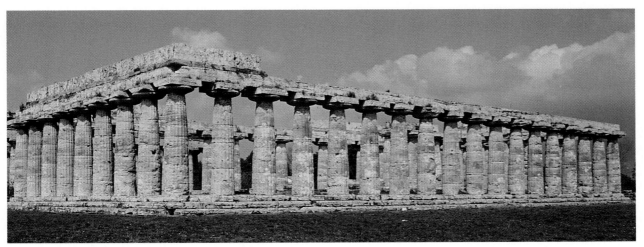

2.5 Temple of Hera at Paestum, Italy, c. 550 BCE.

2.6 *Mnesicles (?),* Erechtheum, Athens, Greece, c. 421–405 BCE. Pentelic marble; length 37′, width 66′.

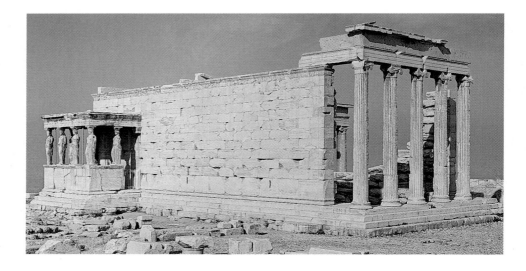

THE ERECHTHEUM

After Phidias's gold-and-ivory statue was so handsomely housed in the Parthenon, the city's leaders wished to provide a place for an older wooden statue of Athena that was thought to have fallen miraculously from the sky. They also wished to venerate the other heroes and deities that formerly shared the Acropolis with her. Hence, they erected a new building of the Ionic order (Fig. 2.6), described in the city records as "the temple in the Acropolis for the ancient statue."

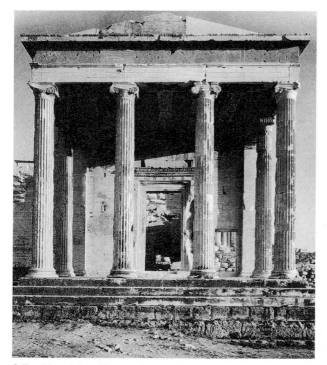

2.7 *Mnesicles (?),* north porch of Erechtheum, Athens, Greece. Width 35′2″.

The site chosen was where Erechtheus, the legendary founder of the city, had once dwelt. As recounted by Homer, Erechtheus was born from Earth, the grain giver, and was befriended and fostered by Athena, who "gave him a resting place in Athens in her own rich sanctuary; and there the sons of the Athenians worship him with bulls and rams as the years turn in their courses."

The Erechtheum, as the building was called, was also the spot where Athena and the sea god Poseidon were said to have held their contest for the patronage of Athens and the surrounding area called Attica. This story is depicted in the sculptures on the west pediment of the Parthenon. As the two deities asserted their claims, Poseidon brought down his trident on a rock, from which sprang a horse, his gift to humanity. A spring of saltwater gushed forth to mark the event. When Athena's turn came, she produced an olive tree, and the gods awarded her the victory. Later, Erechtheus, whom she protected, tamed the horse and cultivated an olive that gave the Athenians oil for cooking, a spread for their bread, ointment for their bodies, and fuel for their lamps.

Because the sacred olive tree, the salt spring, the mark of Poseidon's trident on the rock, and the tomb of Erechtheus were all in the same sacred precinct but not on the same plane, the architect, thought by some scholars to be Mnesicles, had to design a multileveled temple. Combining these areas makes the plan of the Erechtheum as complex as that of the Parthenon is simple. The rectangular interior had four rooms for the various shrines, which were built on two different levels. Projecting outward from three of the sides were porticoes, each different in size and design. The east porch has a row of six Ionic columns almost

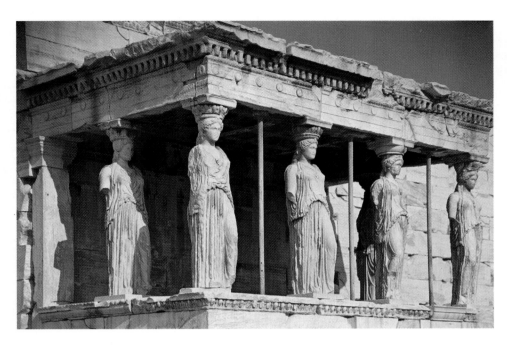

2.8 Mnesicles (?). South porch of Erechtheum, Athens, Greece. Height of caryatids 7′9″.

22 feet high. The north porch (Fig. 2.7) has a like number, but with four in front and two on the sides, while the smaller porch on the south (Fig. 2.8) is famous for its six ***caryatids,*** the sculptured maidens who replace the customary columns.

THE IONIC ORDER

Ionic columns (Fig. 2.9), unlike those of the Doric order, are more slender and have their greatest diameter at the bottom. Their shafts rest on a

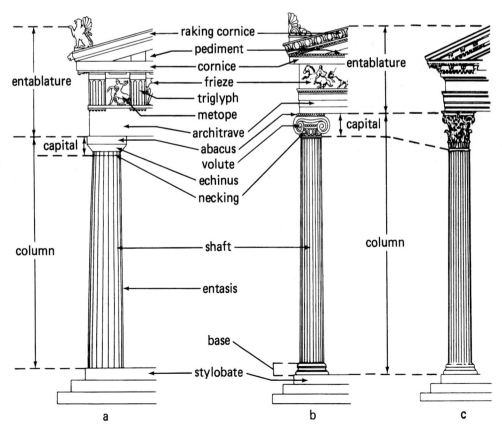

2.9 Comparison of Greek orders: Doric (a), Ionic (b), Corinthian (c).

molded base instead of directly on the stylobate, and they have 24 flutings instead of 20. Most striking, however, is the Ionic capital with its **volutes,** or scroll-like ornaments. The fine columns of the north porch (Fig. 2.7) rest on molded bases carved with a delicate design. The necking has a band decorated with a leaf pattern. Above this is a smaller band decorated with the egg-and-dart motif, followed by the volutes and then a thin **abacus** carved with eggs and darts. The columns support an architrave that is divided horizontally into three bands, each receding slightly inward. The architrave thus consists of a continuous carved frieze rather than the alternating triglyphs and metopes of the Doric order. Above rises a shallow pediment without sculpture. A richly decorated doorway leads into the cella of the Erechtheum. The lintel above it is framed with a series of receding planes and combines the decorative motifs that appear elsewhere in the building.

SOUTH PORCH. Facing the Parthenon, the south porch of the Erechtheum, with its caryatids (Fig. 2.8), is smaller than the others. Above three steps rises a parapet on which the six maidens, about one and a half times larger than life, are standing. To preserve the proportions of the building and not appear to overburden the figures, the frieze and pediment were omitted.

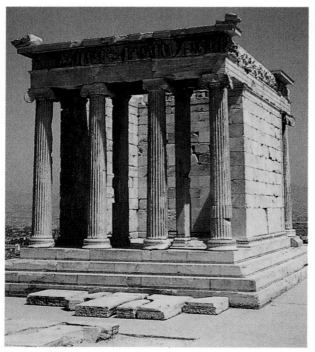

2.10 *Callicrates,* Temple of Athena Nike, Athens, Greece, c. 427–424 BCE. Pentelic marble; length 17′9″, width 26′10″.

Grouped as if in a procession, the figures seem engaged in a stately forward motion, with those on one side lifting their right legs and those on the other, their left. They originally carried libation bowls in their right hands. The folds of their draperies suggest the fluting of columns. Although the maidens seem solid enough to carry their loads, there is no stiffness in their stance.

On the Acropolis, the Athenians brought to the highest point of development two distinct Greek building traditions—the Doric with the Parthenon and the Ionic with the Erechtheum and the Temple of Athena Nike (Fig. 2.10). By combining the two architectural orders in the Propylaea and displaying them separately in the Parthenon and the Erechtheum, the Athenians made symbolic reference to their city as the place where the Dorian people of the Greek mainland and the Ionian people of the islands and the coast of Asia Minor had lived together in relative peace and harmony for centuries.

THE CORINTHIAN ORDER

In the following century, another order was added: the Corinthian (Fig. 2.9). The columns of the Corinthian order are taller and more treelike than the Ionic. They are distinguished by their ornate capitals with double rows of acanthus leaves and fernlike fronds rising from each corner and terminating in miniature volutes. Too ornate for the generally restrained Hellenic taste, the Corinthian order had to wait for Hellenistic and Roman times to reach its full development, as can be seen in the ruins of the Temple of Olympian Zeus (Fig. 2.11).

SCULPTURE

THE PARTHENON MARBLES

The Parthenon sculptures rank high among the surviving originals of the fifth century BCE. The statuary that has survived falls into three groups: the high-relief metopes of the Doric frieze, the low-relief cella frieze, and the freestanding pediment figures. Phidias's celebrated gold-and-ivory cult statue of Athena has long since disappeared, and inferior later copies convey little of the splendor attributed to it by ancient sources.

As architectural sculpture, the friezes and pediments should not be judged apart from the building they embellished. By providing curved and diagonal accents and irregular masses, as well

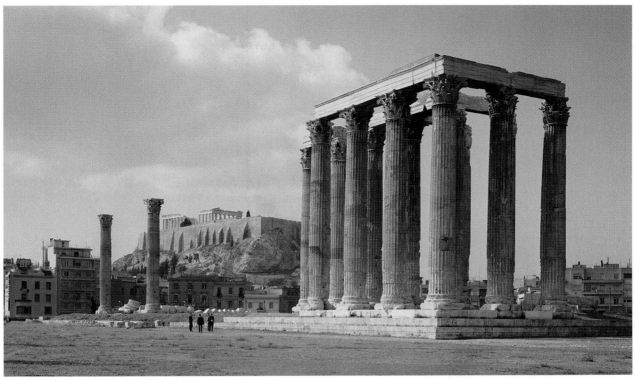

2.11 *Temple of Olympian Zeus,* Athens, Greece, 174 BCE–130 CE. Pentelic marble; height of columns 56′6″.

as figures in motion, they offset the vertical and horizontal balance of the structural parts. The original location of these sculptures must also be kept in mind: they were meant to be seen outdoors in the intense Greek sunlight and from the ground some 35 feet below. Although some of the frieze work is still in place, most of it is now in museums, where it is seen in dim artificial light and at eye level.

THE METOPES OF THE DORIC FRIEZE. The metopes of the Doric frieze play an important part in the architectural design of the Parthenon: they provide a welcome variety of figures to relieve the structural unity. Their predominantly diagonal lines contrast well with the alternating verticals of the triglyphs and the long horizontals of the architrave and cornice just below and above them. To take full advantage of the bright sunlight, the sculptors chiseled these metopes in **high relief,** a technique by which the figures are deeply carved so as to project boldly outward from the background plane.

The subject of the figures in the south frieze is the battle of the Lapiths, legendary people who lived in the north of Greece, and centaurs, powerful half-man/half-horse creatures. The battle took place after a drunken centaur kidnapped a Lapith bride at a wedding feast. In one of the most skillfully executed metopes (Fig. 2.12), the rich spreading folds of the mantle form a fine unifying framework for the splendid human figure. In turn, both make a striking contrast with the awkward centaur.

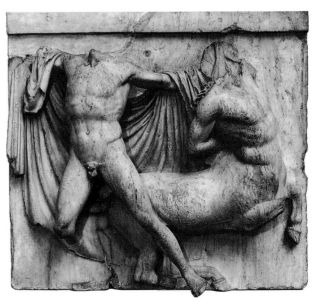

2.12 *Lapith and Centaur,* metope from Parthenon frieze, 447–441 BCE. Marble, 3′11″ × 4′2″. British Museum, London, England.

2.13 *Horsemen,* detail of Parthenon north frieze, c. 447–438 BCE. Marble, height 3′6″. British Museum, London, England.

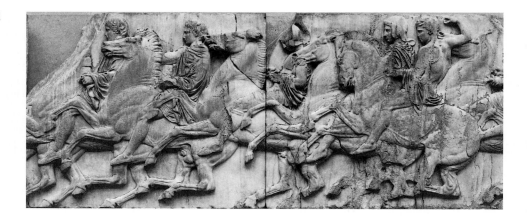

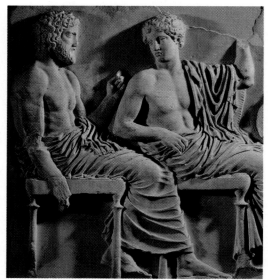

2.14 *Poseidon and Apollo,* detail of Parthenon east cella frieze, c. 440 BCE. Marble, height 43″. Acropolis Museum, Athens, Greece.

THE CELLA FRIEZE. The inner frieze (Figs. 2.13 and 2.14) that ran along the outer walls of the cella was a continuous band that included some 600 figures. Because this frieze was placed behind the colonnade and directly below roof level, where it had to be viewed from up close and at a steep upward angle, some sculptural adjustments were called for. The technique used was **low relief,** in which the figures are shallowly carved. The handling of space, however, is so deft that as many as six horsemen are shown riding abreast without confusing the separate spatial planes. All the heads, whether the figures are afoot or on horseback, have been kept on the same level to preserve unity of design and to provide a parallel with the horizontal lines. (This principle, known as **isocephaly,** will also be encountered later in Byzantine art [see Figs. 5.15 and 5.16]).

The cella frieze, unlike the traditional mythological subjects portrayed elsewhere in the

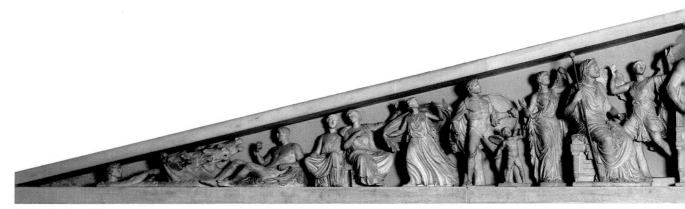

2.15 *Birth of Athena.* Reconstruction of Parthenon east pediment. Acropolis Museum, Athens, Greece.

Parthenon sculptures, depicts the Athenians themselves participating in the festival of their goddess. One of the oldest and most important festivals, the Panathenaea, took place every 4 years. Larger than the annual local procession because it included delegations from other Greek cities, the Greater Panathenaea was a prelude to poetical and oratorical contests, dramatic presentations, and games.

On the western side (Fig. 2.13) of the Parthenon, last-minute preparations for the parade are in progress as the riders ready their horses. The action, appropriately enough, starts just at the point where the live procession, after passing through the Propylaea, would have paused to regroup. The parade then splits in two, one file moving along the north side and the other along the south. The charioteers follow the bareback riders, and as the procession approaches the eastern corners, the marshals slacken the tempo to a more dignified pace. Here are musicians playing lyres and flutes, youths bearing wine jugs for libations, and maidens walking with stately steps. The two files meet again on the east side, where magistrates would be waiting to begin the ceremonies.

Even the gods, as seen in the panel depicting Poseidon and Apollo (Fig. 2.14), are present to bestow their Olympian approval on the proceedings. The high point of the ritual comes in the center of the east side with the presentation of the **peplos,** the saffron and purple mantle woven by chosen maidens to drape over the ancient image of Athena.

Several scholars have recently questioned whether the procession on the frieze represents the Panathenaea. They suggest that it may depict the bloodcurdling story of King Erechtheus, who was told by the oracle at Delphi that he must sacrifice his three daughters if he wished to secure Athens's triumph over an invader. In this alternative interpretation, the peplos of Athena becomes the cloth in which the daughter will be brought to the altar for sacrifice.

THE PEDIMENTAL SCULPTURES. In contrast to the friezes, the pedimental sculptures are freestanding figures, carved in the round and placed in the pediment. The themes of both pediments have to do with Athena. The one on the west, facing the city, depicts her triumph over Poseidon. The one on the east (Fig. 2.15) recounts the amazing story of her birth, the event that was celebrated each summer at the Panathenaea. Although only a few fragments of the Western pediment remain, enough of its eastern counterpart survives to allow us to estimate what might be represented. But because individual statues or groups may have been given by different patrons, a specific narrative was probably not depicted.

From various sources, it is known that the eastern scene is Mount Olympus and that Zeus, the father of the gods, was seated in the center. On one side stood the fire god Hephaestus, who is splitting open the head of Zeus to let Athena spring forth fully grown and fully armed. The sudden appearance of the goddess of wisdom, like a brilliant idea from the mind of its creator, disturbs the Olympian calm. As the news spreads from the center to the sides, all the figures affected by the presence of divine wisdom in their midst,

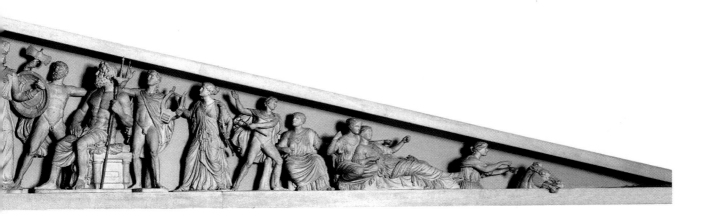

2.16 *Demeter, Persephone, and Iris.* From Parthenon east pediment, c. 438–432 BCE. Marble, larger than life-size. British Museum, London, England.

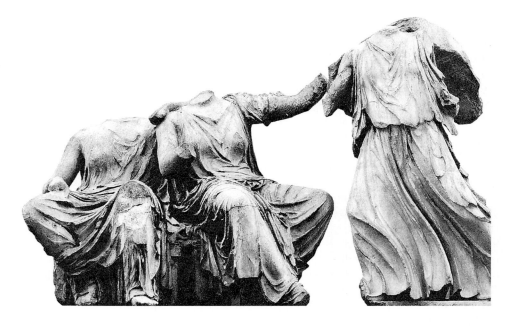

Iris, the messenger of the gods, who often traveled on a rainbow (Fig. 2.16), rushes toward the left with a rapid motion revealed by her wind-swept drapery. Seated on a chest, Demeter and Persephone turn toward her, and the rich folds of their costumes reflect their attitudes and interest. The reclining figure, usually identified as Dionysus, with his panther skin and mantle spread over a rock (Fig. 2.17), is awakening and looking toward the sun god Helios, the horses of whose chariot are just rising from the foaming sea at dawn.

Three goddesses (Fig. 2.18) on the opposite side have postures that bring out their relationship to the composition. The one nearest the center of the pediment, aware of what has happened, is about to rise. The middle figure is starting to turn

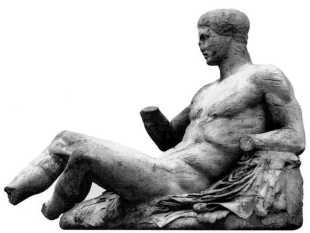

2.17 *Dionysus/Hercules,* from Parthenon east pediment, c. 438–432 BCE. Marble, larger than life-size. British Museum, London, England.

toward her. The reclining figure at the right, still in repose, is unaware of the event, as is her counterpart, Dionysus, on the far left. Like the female group on the left, these figures form a unified episode in the composition, and their relationship to the whole is made clear in the lines of their flowing robes. This undulating linear pattern and the way it reveals the anatomy of the splendid bodies beneath mark a high point in the art of sculpture.

At the far right of this group, the chariot of the moon goddess Selene is seen descending. Now only the expressive downward-bending horse's head (Fig. 2.19) remains to show by his spent energies that it is the end of the journey.

Perhaps the most admirable aspect of the entire composition is the ease and grace with which each piece fills its assigned space. Fitting suitable figures into a low isosceles triangle while maintaining an uncrowded yet unified appearance was a problem that long occupied Greek designers. An oversized standing figure usually dominated the center, with seated or crouching figures on either side and reclining ones in the acute side angles. Here the chariots of the rising and setting sun and moon define the time span as that of a single day. Moreover, the background of Mount Olympus and the single event portrayed identify time, place, and action, in keeping with the classical unities (a principle that will be discussed more fully later in the chapter).

The ascending and descending chariots give a contrasting upward and downward movement on the extreme ends, while the reclining and seated figures lead the eye to the apex, where the climax takes place.

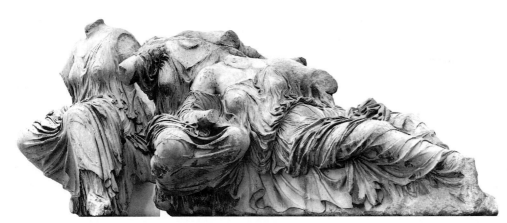

2.18 *Three Goddesses* from Parthenon east pediment, c. 438–432 BCE. Marble, life-size. British Museum, London, England.

THE OVERALL SCULPTURAL PROGRAM. Taken as a whole, the Parthenon marbles present the scope of fifth-century aspirations. The Athenians tried to interpret ancient myths in the light of their history and philosophy.

The metopes on the east frieze portray the primeval battle between gods and giants for control of the world. The triumph of the Olympian gods hailed the coming of order out of chaos. The metopes on the south frieze show the oldest inhabitants of the Greek peninsula, the Lapiths, subduing the half-human/half-horse centaurs with the aid of the Athenian hero Theseus. This victory signaled the ascendancy of human ideals over the animal side of human nature. In the north group, the Homeric epic of the defeat of the Trojans by the Greeks is told, while in the west metopes, the Greeks are seen overcoming the Amazons, female warriors who symbolized the Greeks' Asiatic enemies and, in this case, who allude to the Athenian defeat of the Persians at Marathon. In the east pediment, the birth of the city's patroness, Athena, is seen, while the west pediment tells the story of the rivalry of Athena as goddess of the intellect and Poseidon as patron of maritime trade, suggesting a conflict between two ways of life—the search for wisdom and the pursuit of material wealth.

The Panathenaic procession portrayed on one of the cella walls brings Greek history up to date by depicting a contemporary subject. Here the proud Athenians could look upward and see their own images carved on a sacred temple, an echo of the living procession that marched along the sides of the temple on feast days. The climax came after they had gathered at the east porch and the portals of the temple were opened to the rays of the rising sun, revealing the image of the goddess herself. With Athena's help, Greek civilization had overcome the ignorance of the barbarians. The bonds between the goddess and the citizens of

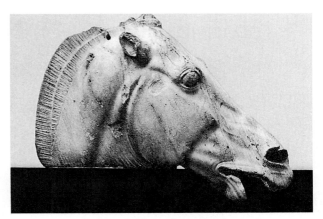

2.19 *Moon Goddess's Horse,* from Parthenon east pediment, c. 438–432 BCE. Marble, life-size. British Museum, London, England.

her city were thus periodically renewed, and the Parthenon as a whole glorified not only Athena but the Athenians as well.

THE RETURN OF WAR

Dark clouds began to gather on the Athenian political horizon, even while the buildings on the Acropolis were being erected. By developing an empire and expending the funds of the Delian League on the Acropolis, Athens excited the wrath of some of the rival city-states. Their exaltation of themselves over other Greeks and the depiction of themselves in the presence of the Olympian gods in the Parthenon frieze added fuel to the argument. When Phidias carved Pericles's and his own self-portrait on the sacred shield of the cult statue of Athena, he went too far, even for an Athenian. Such demonstrations of Athenian military power and political dominance laid the foundation for the Peloponnesian

War between Athens and Sparta, which broke out only 1 year after the Parthenon was completed.

Another, more modern battle involving the Athenian Acropolis continues today. Figures from the east pediment (see Figs. 2.16, 2.17, and 2.18) of the Parthenon as well as from the building's friezes were brought to England by Lord Elgin in 1801–1803, when Greece was under the rule of the Ottoman Empire. The so-called Elgin Marbles were likely saved from ruin during a period of strife. The return of the collection, now exhibited in London's British Museum, has long been sought by Greece, most recently in heated exchanges during preparations for the 2004 Olympic games in Athens.

THE COURSE OF HELLENIC SCULPTURE

A tremendous change took place in Greek sculpture from the archaic, or preclassical, phase to the end of the Hellenic period in the midfourth century. It can best be illustrated by comparing examples from successive periods.

MALE FIGURES. The *kouros* (plural, *kouroi*) (Fig. 2.20) is an archaic sculptural type depicting a youthful nude male. During the 150 years of its popularity, beginning in the midseventh century, it may have served multiple purposes: as a funeral memorial, a **votive** statue, or an acknowledgment of victory in athletic games. The large feet, the advancing left leg, and the clenched hands attached to the body are reminiscent of Egyptian sculpture, in which movement was more symbolic than physically accurate.

Nevertheless, the nude body did not occur in conventional Egyptian sculpture. Moreover, Egyptian figures were more naturalistically depicted. Here, the long vertical line from the neck to the navel divides the chest, while the diamond-shaped abdomen is defined by four almost-straight lines, a heritage of the formal geometric conventions of the preclassical, archaic period. The wide shoulders and long arms provide a rectangular framework for the statue. About a century later, a similar figure (see Fig. 2.36) reveals how the rigid posture has been softened, the muscles relaxed, and the spirit enlivened.

In contrast, the *Doryphorus,* or *Spear Bearer,* by Polyclitus (Fig. 2.21) moves with great poise and freedom. Originally in bronze, it is now known only through marble copies. Polyclitus won fame in ancient times for his attempts to formulate a **canon,** or body of rules, for the proportions of the human figure. Exactly how Polyclitus's theory worked is not known, but the Roman architect

Vitruvius mentions that beauty consists "in the proportions, not of the elements, but of the parts, that is to say, of finger to finger, and of all the fingers to the palm and wrist, and of these to the forearm, and of the forearm to the upper arm, and of all . . . to each other, as . . . set forth in the Canon of Polyclitus."

Whether the **module** (unit of measure) was the head, the forearm, or the hand apparently varied from one statue to another. Yet once the module was adopted, the whole and all its parts could be expressed in multiples or fractions of it. As Vitruvius

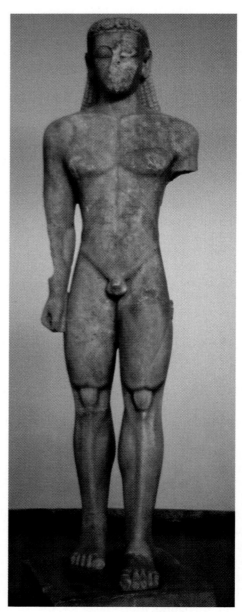

2.20 Kouros from Sounion, c. 615–590 BCE. Marble, height 11′. National Archaeological Museum, Athens, Greece.

illustrated the canon, the head would be one-eighth the total height. The face would be one-tenth, subdivided, in turn, into three parts: forehead, nose, and mouth and chin. The forearm would be one-fourth the height, and the width of the chest would be equal to this length of forearm. Like the optical refinements of the Parthenon, however, Polyclitus's canon was not a strict mechanical formula. It allowed for some flexibility; the dimensions could be adjusted for a figure in movement or for one designed to be seen from a certain angle.

The poised and polished *Hermes and the Infant Dionysus* (Fig. 2.22), which has traditionally been attributed to Praxiteles, was sculpted at the close of the Hellenic period. The sculptor was reputed to be among the wealthiest of Athenians. Unlike other artists, who worked from one commission to the next, Praxiteles could afford to make models for statues before they were commissioned by a patron. Praxiteles's good fortune indicates the rising status of artists in late Hellenic times.

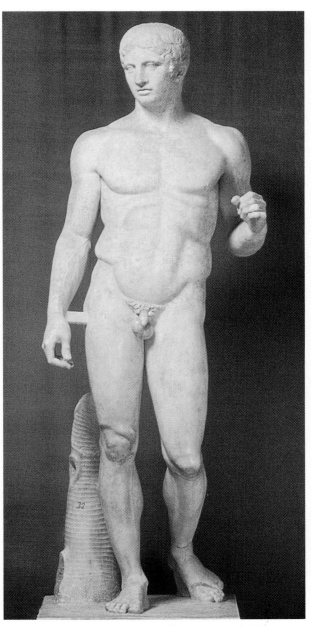

2.21 Polyclitus. *Doryphorus (Spear Bearer).* Roman copy of original of c. 450–440 BCE. Marble, height 6′6″. Museo Nazionale, Naples, Italy.

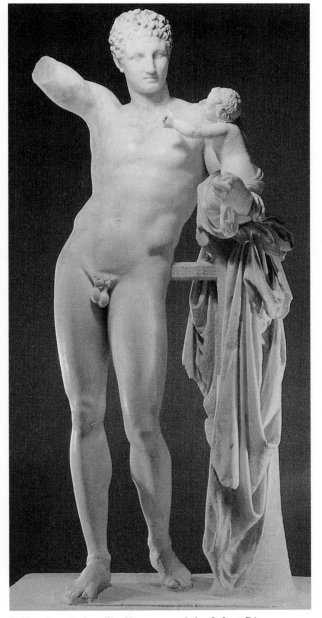

2.22 Praxiteles (?). *Hermes and the Infant Dionysus,* c. 340 BCE. Marble, height 7′1″. Archaeological Museum, Olympia, Greece.

Unlike the rather restrained *Doryphorus,* Praxiteles's Hermes rests his weight easily on one foot. The relaxed stance throws the body into the familiar S-curve, a Praxitelean pose that was widely copied in later Hellenistic and Roman statuary. From the stiffness of the stolid archaic *Kouros* and the strength of the stocky *Doryphorus,* Praxiteles arrived at a more sensual treatment of his material. Through the soft modeling and suave surface treatment, he suggests the blood, bone, and muscles beneath the skin and gave his cold marble material the vibrancy and warmth of living flesh.

Two rare Hellenic bronze originals, the *Charioteer* found buried in the ruins of Delphi (Fig. 2.23), and the *Zeus* found in the sea off Cape Artemision (Fig. 2.24), along with the Roman marble copy of Myron's lost bronze *Discobolus,* or *Discus Thrower* (Fig. 2.25), reveal a transition in style from quiet monumentality to energetic action that took place within a 20-year span in the midfifth century. The splendid *Charioteer* once was part of a larger group that included a chariot and several horses. Although in action, the figure has something of the monumentality and equilibrium of a fluted column due to the vertical folds of its lower garment. The statue probably commemorated an individual's win in a chariot race and also served to honor the god Apollo.

The commanding figure of *Zeus,* poised to throw a thunderbolt, reveals in its powerful musculature the massive reserves of strength of a truly godlike physique. In Greek religion and art,

2.23 *Charioteer.* From Sanctuary of Apollo, Delphi, Greece, c. 470 BCE. Bronze, height approx. 5′11″. Archeological Museum, Delphi, Greece.

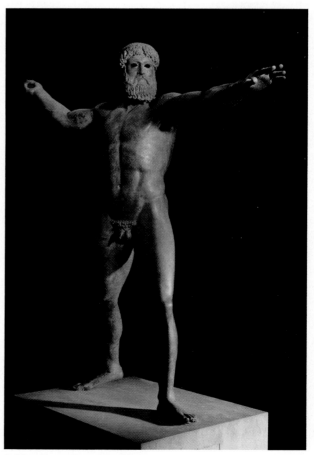

2.24 *Zeus (Poseidon?),* from the Artemisium at Cape Sounion, c. 460–450 BCE. Bronze, height 6′10″. National Archaeological Museums, Athens, Greece

the gods were envisioned as humans, not forces of nature or combinations of human and animal aspects, as in Egypt and Mesopotamia. Some contemporary scholars speculate that many statues of Zeus about to throw his thunderbolt were placed at Olympia, the site of the original Olympic games. One punishment for athletes who cheated at the games was being required to commission such a statue and have pious statements inscribed on it.

In his *Discobolus,* Myron faced the challenge of expressing movement in static terms. His inspired solution was to choose a pose in which the taut yet elastic muscles of the athlete are poised momentarily after his backswing and before his forward lunge. The whole backward–forward movement is thus captured in this one "Myronic moment." The vigorously stretched tight point in the action is admirably displayed by the tension between the curving arch of the body and the extended curve of the outstretched arms.

FEMALE FIGURES. The so-called Lady of Auxerre, named for the French town in whose museum she was mysteriously found in 1909 (Fig. 2.26), may have originated in Crete during the early seventh century. Her cinched waist is reminiscent of the body as it was portrayed by the Minoans (see Fig. 1.22), and her large wig recalls an Egyptian

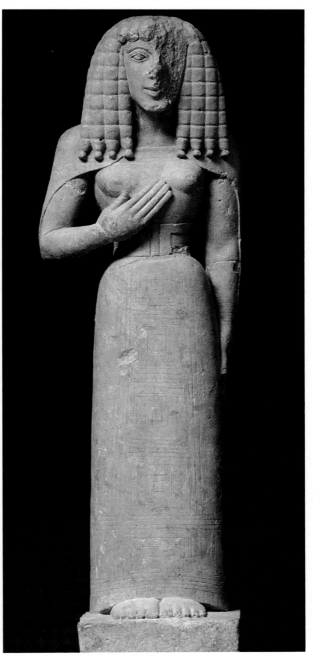

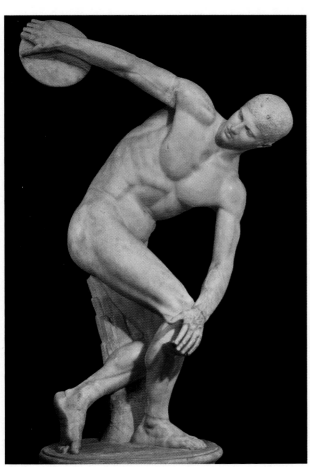

2.25 Myron. *Discobolus (Discus Thrower).* Roman copy after bronze original of c. 450 BCE. Marble, life-size. Museo Nazionale Romano, Rome, Italy.

2.26 *Lady of Auxerre,* statue of a goddess or kore, c. 650–625 BCE. Limestone, approx. 2′1½″ high. Louvre, Paris, France.

hairstyle. The mix of styles used indicates how cosmopolitan life was for the seafaring Greeks, especially those who lived and operated trading stations on the many islands that stretch south and west from the Greek mainland to what is now modern Turkey. The purpose of this statue is unknown, but her large hand, which is attached to the body, may have been posed as if to suggest that she was extending it forward. The awkward gesture might be read as a greeting or a plea, in which case the statue could be a votive figure placed at the shrine of a god or goddess.

At about the same time, life-size and larger than life-size figures of clothed girls and women called *kore* (plural, *korai*) were first made. An archaic *Kore* from Samos (Fig. 2.27) is one of many figures of girls or women, originally in a temple courtyard, carrying small animals as votive offerings. Inscriptions tell us that she was dedicated to the goddess Hera. The statue's severely cylindrical figure is quite abstract. Everything extraneous has been eliminated and only the essential formal and linear elements have been retained. The rhythmically repeated lines of the skirt contrast with the curves of the upper drapery to create a pleasing linear design.

It is interesting to note that the kore figures are more varied, especially in dress, than the *kouros* figures, leading some scholars to speculate that the male figures had a more universally understood meaning, perhaps as symbols of mental and physical excellence. The korai statues, on the other hand, may have had meanings specific to their garb.

The *Athena Lemnia* (Fig. 2.28) is a marble copy of Phidias's original bronze statue, which once

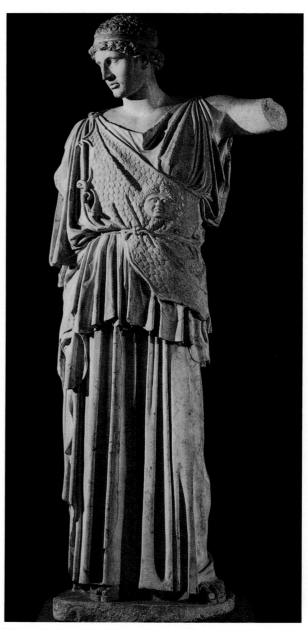

2.28 Phidias (?). *Athena Lemnia.* Roman copy after original of c. 450 BCE. Marble, height 6′6″. Body, Albertinum, Dresden, Germany; head, Museo Civico, Bologna, Italy.

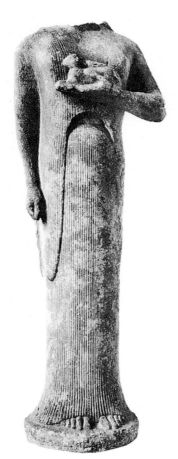

2.27 Kore from Samos, c. 550 BCE. Marble, height 5′3″. Antikensammlung, Staatliche Museum, Berlin, Germany.

stood on the Athenian Acropolis. In it Phidias created a mood that is more lyrical than heroic. In ancient sources, the original statue was often referred to as "the beautiful." The serene profile, softened by the subtle modeling, approaches the ideal of chaste classical beauty.

Praxiteles's *Aphrodite of Cnidos* was proclaimed by Greco-Roman critics to be the finest statue in existence. Known only through inferior copies such as the one shown in Figure 2.29, the statue may have been the first large female nude in Greek art. The "smile playing gently over her parted lips" and the "soft melting gaze of the eyes with their bright and joyous expression" that the Roman writer Lucian so admired in the original can now only be imagined. Praxiteles, however, departed from the draped goddesses of the previous century by boldly portraying the goddess of love in the nude. By so doing, he created a **prototype,** or original model, that influenced all subsequent treatments of the undraped female figure.

VASE PAINTING

Like early Greek sculpture, early Greek pottery depicted rigid angular human figures. However, the shape of early painted vases and other pottery forms was often very graceful and sophisticated. The *François Vase* (Fig. 2.30), found in an Etruscan tomb (see pp. 92–93), was not meant for everyday use but rather was a ritual object and an art form. Its Athenian painter, Kleitias, and potter, Ergotimos, both signed the work, indicating the extent to which they had achieved a reputation for uniqueness and excellence. Created at about the same time as the Kouros from Sounion (Fig. 2.20), the black figures on the François Vase share with the kouros a stiffness and simplification of muscle structure.

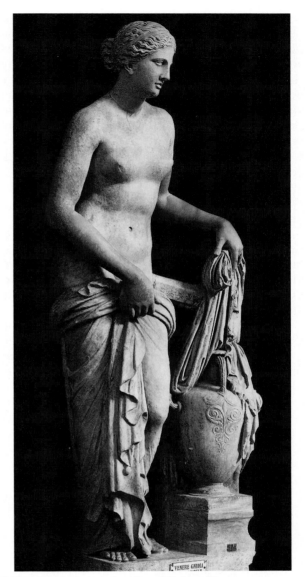

2.29 Praxiteles. *Aphrodite of Cnidos.* Roman copy after original of c. 340 BCE. Marble, height 6′8″. Vatican Museums, Rome, Italy.

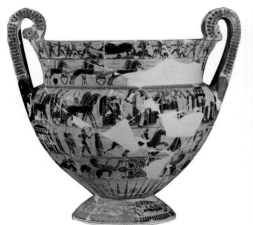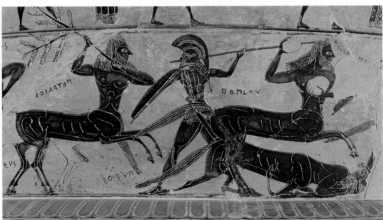

2.30 *François Vase.* Its Athenian painter, Kleitas, and potter, Ergotimos, both signed the work. From Chiusi, Italy, c. 570 BCE. Museo Archeologico, Florence, Italy.

Later potters developed a technique that rendered the figures red. Red-figure pottery often simplified the narrative to one crucial scene. Its figures are agile and better proportioned anatomically than those of the François Vase. Facial and drapery details are picked out in thin black lines. Because virtually no wall painting remains from classical Greece, we have only ancient texts and the indirect, controversial evidence of painted pottery to testify to the quality and interests of Greek painters (Figs. 2.31 and 2.32).

DRAMA

Greek drama was a distillation of life represented in poetic form on the stage. Through the **chorus,** members of the audience became vicarious participants in events happening to a group of people at another time and in another place.

Like all great works of art, Greek drama can be approached on many different levels. At one level, it can be a thrilling story of violent action and bloody revenge. At another, it is a struggle between human ambition and divine retribution or a conflict between free will and predestined fate. At still another level, it becomes a moving experience that affects the viewer through fine language and inspired poetry.

Plots were taken from mythology, heroic legends, or stories of royal houses. Because these age-old themes were forms of popular history, known in advance to the audience, the dramatist could concentrate more on poetry than on plot, provide dramatic commentaries on old tales, and reinterpret them in the light of recent events. The playwright could thus inspire by conjuring up the heroic past, as Aeschylus did in *The Persians;* express individual sentiments in the light of universal experience, as Sophocles did in *Antigone;* invite reexamination of ancient superstitions, as Euripides did in *The Bacchae;* or place current problems in broader historical perspective.

THE ORIGINS OF GREEK DRAMA

Greek drama had its roots in the ancient tradition of heroic verse, in which the storyteller might impersonate an epic hero. It was also associated with the worship of Dionysus (Bacchus in Roman mythology), the god of wine and revelry, whose cult festivals coincided with planting and harvesting seasons. Beginning as primitive magical practices, the rituals became more refined until they became a vehicle for powerful creative expression. When theaters were built, they were located in a precinct sacred to Dionysus. His altar occupied the center of the circular **orchestra,** where the chorus sang and danced. The audience paid tribute to him by their presence.

The theater of Dionysus at Athens (Fig. 2.2), like the better-preserved one at Epidaurus (Fig. 2.33)

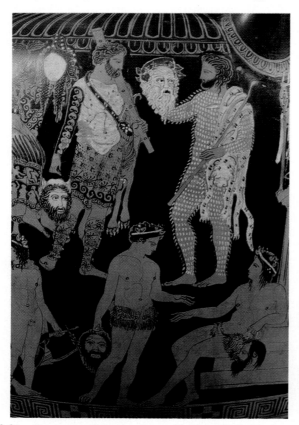

2.31 Pronomos Painter. *Actors Holding Their Masks.* Detail of red-figured painting showing the cast of a satyr play on exterior of volute krater. Ruvo, Italy, c. 410 BCE. Terra cotta, height 2′5½″. Museo Nazionale Archeologico, Naples, Italy.

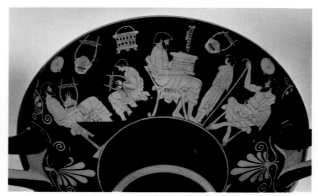

2.32 Douris. *Instruction in Music and Grammar in an Attic School.* Red-figured painting on exterior of kylix, from Cerveteri, c. 480 BCE. Clay, 11³⁄₁₆″ diameter. Antikensammlung, Staatliche Museum, Berlin, Germany.

on the Peloponnesus, was built around the time of Alexander the Great (see pp. 63–64). It had an **auditorium** hollowed out of a hillside that could accommodate approximately 12,000 spectators. The semicircular tiers of seats half surrounded the orchestra and faced the ***skene,*** a permanent architectural facade with three doors for the actors. The chorus entered and exited at the corners below.

The stylized facade of the skene, suggesting a temple or palace, was suitable for most dramatic situations, because the action almost always took place in the open. The chorus, for example, usually represented worshipers at a shrine, townspeople or petitioners before a palace, a mob, or a group of prisoners. The actors moving in and out of the portals above took the parts of priests, heroes, or members of royal families. When the situation demanded another setting, the chorus or an actor would "paint" the scene with a few words, so other sets were not necessary.

THE STRUCTURE AND SCOPE OF GREEK DRAMA

A typical Greek play opens with a **prologue** spoken by one of the actors. The prologue sets the scene, outlines the plot, and provides a taking-off point for the action. The substance of the drama then unfolds in a sequence of alternating choruses and episodes (usually five episodes enclosed by six choruses) and concludes with the **exodus** of the chorus and an **epilogue.** Actors wore masks (Fig. 2.31) of general types that the audience could recognize instantly. The size and outdoor location of the theaters made facial expressions ineffective, and the swift pace of Greek drama required the player of a king or shepherd to establish a type and character instantly. Masks also proved useful when an actor took more than one part, bringing him immediate acceptance in either role.

Restraint and simplicity were the rule in Greek staging. As with the later Elizabethan theater, scenery was conspicuous by its absence. The only visual illusion seems to have been the ***mechane,*** a crane that lowered to the stage actors who were portraying gods. In later times, this ***deus ex machina,*** or "god from the machine," became an easy way of solving dramatic problems that were too complex to be worked out by normal means.

Direct action never occurred onstage. Any violent deed took place elsewhere and was reported by a messenger or another character. The plays proceeded by narration, commentary, speculation, dialogue, and discussion. All these devices—

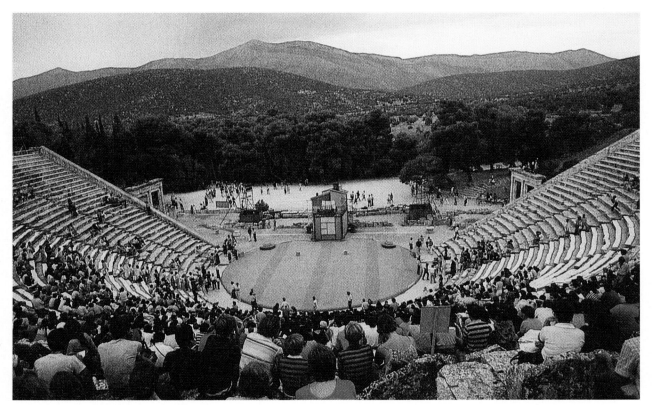

2.33 Polyclitus the Younger. Theater, Epidaurus, Greece, c. 440 BCE. Diameter 373′, orchestra 66′ across.

plot known in advance, permanent stage setting, use of masks, offstage action—served two principal purposes: to accentuate the poetry of the play and to give the greatest possible scope to the spectator's imagination. Greek drama unfolds as a sequence of choral song, group dances, mimed action, and dialogue coordinated into a dramatic whole. Poetry, however, always remains the central dramatic agent.

The scope of Greek drama was tremendous. It extended from majestic tragedy of heroic proportions, through the pathos of **melodrama** (in its proper meaning of "drama with melody"), all the way to the riotous **comedies** of Aristophanes. Conflict, however, was always the basis for dramatic action. The playwrights created tensions between such forces as murder and revenge, crime and retribution, cowardice and courage, protest and resignation, and pride and humility. When, for instance, a hero is confronted with his destiny, the obstacles he encounters are insurmountable and yet must be surmounted. In the conflict that follows, the play runs the gamut of human emotions and explores the heights to which human life can soar and the depths to which it can sink. In Sophocles's *Oedipus the King,* the hero starts at the peak of his kingly powers and ends in the abyss of human degradation. In Euripides's *Bacchae,* Pentheus, a pillar of respectability, is first made ridiculous and then destroyed.

The **protagonist,** or central character, of a Greek play can fulfill the requirements of tragedy only when portraying some noble figure—one who is "highly renowned or prosperous," as Aristotle argues—who is eventually brought to grief through a personal flaw or by some inevitable stroke of fate. The reasons for this must be made apparent to the audience gradually through the process of "causal necessity." A common person's woes might bring about a pathetic situation but not a tragic one in the classical sense. When a virtuous hero is rewarded or the evil designs of a villain receive their just desserts, obviously there is no tragic situation. When a blameless person is brought from a fortunate to an unfortunate condition or when an evil person rises from misery to good fortune, there is likewise no tragedy because the audience's moral sense is outraged.

AESCHYLUS. According to its founder Aeschylus, Greek tragedy was an instrument through which mortals might comprehend the mystery of the divine will. In his *Oresteia,* a trilogy (three related plays), gods and mortals interact as they seek vengeance for real and perceived wrongs. By establishing a working relationship between mortals and gods, Aeschylus's tragedies also sought to find a basis for personal and social justice. The implications of the early Aeschylean tragedy were thus strongly ethical, showing clearly that in his mind the drama was still identified with theological thought.

SOPHOCLES. The forms of Sophocles's plays were distinguished by their flawless construction, while their lofty content was based on the course of human destiny as seen in light of the moral law of the universe. Aristotle hailed *Oedipus the King* as the greatest of Greek tragedies, both for the nobility of its conception and for the inexorable logic of its plot. Because everyone in Sophocles's audience knew the story, he was free to write a new play on an old theme.

Unknown to himself at the time, Oedipus had violated two of the most basic taboos in any society—murdering his father and marrying his mother. Modern audiences may find this all the more shattering because of Freud's teaching that this dilemma mirrors our own secret desires and fears. "It is that fate of all of us," wrote Freud in his *Interpretation of Dreams,* "to direct our first sexual impulses towards our mother and our first hatred and . . . murderous wish against our father [the Oedipus complex]. Our dreams convince us that this is so."

Like Pericles, Oedipus was a master politician in full control of the state. But he was determined to seek the truth about his origins. The heroic aspect of Oedipus's character is not that his life is predestined by fate or by the will of the gods but that he is free to pursue the truth wherever it might lead. Oedipus commands both admiration and sympathy as he brings the full force of his intelligence, courage, and relentless perseverance to the quest. In this progressive unmasking of himself, the audience sees the hero as his own destroyer, as a detective who discovers that the criminal is himself. The closer he comes to his imminent downfall, the higher his stature rises. The true tragic grandeur then comes when he and the audience recognize that he must bear full moral responsibility for his life and acts. To make amends for his crimes, he calls for his sword to kill himself. Then, in a moment of bitter irony, he seizes his wife Jocasta's golden pin and pierces his eyeballs, saying that when he could see he was blind, so only in blindness can he really see: "Be dark from now on, since you saw before what you should not, and knew not what you should."

The audience in fifth-century Athens was inevitably caught up in the web of the plot, enthralled with its relentless progress while identifying with the plight of the characters whose fate

was unraveling. When the awful truth was revealed, Oedipus's catastrophe was perceived as the tragedy of the Athenians themselves as they in turn became aware of their own ignorance. Instead of humans being the measure of all things, perhaps it was they who were being measured, tried in the balance, and found wanting.

EURIPIDES. Aristotle observed that Euripides sought to show people as they are, whereas Sophocles had depicted them as they ought to be. In some ways, the works of Euripides may not be so typical of the Hellenic style as those of Aeschylus or Sophocles, but his influence on the subsequent development of the drama, both in Hellenistic and in later times, was incalculably greater.

The *Bacchae,* the last of Euripides's surviving plays, was written toward the end of the disastrous Peloponnesian War, a time of disillusionment for Athenian intellectuals. In it he gives voice to some of the doubts and uncertainties of his time. The play's theme is the complex interplay between the human and divine wills, as well as between the known and the unknown. The pale self-righteousness of Pentheus is crushed by the implacable, terrifying wrath of the god Bacchus. Agave, Pentheus's mother, is led to murder her own son because she voluntarily surrenders her reason to an irrational cult. Pentheus's downfall comes because his reason is not strong enough to comprehend the emotional and irrational forces that motivate the members of his family and his subjects. Because Pentheus cannot understand these forces, he cannot bring them under control and thus lacks the wisdom and tolerance required of a successful ruler.

Like most masterpieces, the *Bacchae* is in some respects atypical, but in others it seems to stem from the deepest roots of theater. Despite some inner inconsistencies and a certain elusiveness of meaning, the *Bacchae* has all the formal perfection and poetic grandeur of the loftiest tragedies. The strange, wild beauty of its choruses and the magic of its poetry give this drama all the necessary ingredients of theater at its best.

ARISTOTLE ON THEATER. After the great days of Aeschylus, Sophocles, and Euripides had passed, Aristotle, with knowledge of their complete works instead of the relatively few examples known today, wrote a perceptive analysis of tragedy and more broadly of art in general. In his treatise *Poetics,* he argues that true drama—and indeed all works of art—must have form in the sense of a beginning, a middle, and an end.

Unity of time, place, and action is also desirable. Sophocles's *Oedipus Rex,* for example, takes place in a single day (albeit a busy one); all the scenes are set in front of the palace at Thebes; and the action is direct and continuous, without subplots. Other Greek plays encompass a longer span of time and have several settings. As Aristotle pointed out, these unities were useful but by no means hard-and-fast rules.

Custom held that three actors onstage at one time was the maximum desirable. If the play required six parts, the roles were usually apportioned among three actors. As the action proceeds, the conflict between protagonist and antagonist emerges, and the play rises to its climax in the middle episode. Through the tragic necessity, the hero's downfall occurs because he carries the seeds of his own destruction within his breast. After this turning point, the well-planned anticlimax resolves the action into a state of equilibrium.

Tragedy, according to Aristotle, had to be composed of six necessary elements, which he ranked as follows: *plot,* "the arrangement of the incidents"; *character,* "that which reveals moral purpose"; *thought,* "where something is proved to be or not to be"; *diction,* "the metrical arrangements of the words"; *song,* which "holds the chief place among the embellishments"; and *spectacle.* Finally, Aristotle summed up his definition of *tragedy* as "an imitation of an action that is serious, complete, and of a certain magnitude; in language embellished with each kind of ornament, the several kinds being found in separate sections of the play; in the form of action, not of narrative; with incidents arousing pity and fear, wherewith to accomplish its **katharsis** ["purgation"] of the emotions."

MUSIC

The word *music* implies a fully mature and independent art. It must be remembered, however, that symphonies, chamber music, and solo instrumental compositions, in which the focus is almost entirely on abstract sound, are relatively modern forms. *Music* covers the union of sound with many other elements, as in the case of popular songs, dance music, military marches, and church hymns. It also describes the combination of sound with lyric and narrative poetry, as in songs and ballads; with step and gesture, as in dance; and with drama, as in opera.

In ancient Greece, music in its broadest sense meant any of the arts and sciences that came under the patronage of the Muses, mythological maidens who were the daughters of the heavenly Zeus and the earthly Mnemosyne. Because Zeus was the creator and Mnemosyne, as her name implies, the personification of memory, the

Muses and their arts were thought to be the results of the union of the creative urge and memory, half divine, half human. This was a way of saying that the arts were thought of as recorded inspiration.

As Greek civilization progressed, the number of Muses gradually increased to nine, all of whom were under the patronage of Apollo, god of prophecy and enlightenment. The arts and sciences over which they presided came to include all the intellectual and inspirational disciplines that sprang from the fertile minds of a creative people—lyric poetry, tragic and comic drama, choral dancing, and song. Astronomy and history were also included. The visual arts and crafts, on the other hand, were protected by Athena and Hephaestus—symbolizing intellect tempered by fire. Plato and others placed music in opposition to gymnastic or physical pursuits, and its meaning in this sense was as broad as our use of the general terms *liberal arts* or *culture.*

The Greeks also used *music* more narrowly, in the sense of the tonal art. But music was always intimately bound up with poetry, drama, and dance and was usually found in their company. At one place in the *Republic,* Socrates asks: "And when you speak of music, do you include literature or not?" The answer is yes. Thus, although the Greeks did have independent instrumental music apart from its combination with words, evidence suggests that the vast body of their music was connected with literary forms.

This does not imply, of course, that music lacked a distinct identity or that it was swallowed up by poetry—rather it had an important and honored part in poetry. Plato, for instance, remarks: "And I think that you must have observed again and again what a poor appearance the tales of the poets make when stripped of the colours which music puts upon them, and recited in simple prose. . . . They are like faces which were never really beautiful, but only blooming; and now the bloom of youth has passed away from them."

MUSIC AND LITERATURE

Greek music must therefore be considered primarily in its union with literature, as illustrated in the vase painting *Instruction in Music and Grammar in an Attic School* by Douris (Fig. 2.32). The clearest statement of this is found in the *Republic,* where it is pointed out that "melody is composed of three things, the words, the harmony [the sequence of melodic intervals], and the rhythm." In discussing the relative importance of each, Plato states that "harmony and rhythm must follow the

words." The two arts thus are united in the single one of **prosody**—that is, the melodic and rhythmic setting of a poetic text.

Greek melodies and rhythms are known to have been associated with specific moods, or **modes**—scales constructed by adjusting the pitch of tones within the octave. The modern major scale, or mode, can be found on the piano by playing the white keys from middle C to the next C above (eight tones, or an **octave**). Similarly, the melodic minor scale, or mode, goes from A (two white keys below middle C) to the A above. The ancient Greek Dorian mode can be approximated by the white keys from E (two white keys above middle C) to the E an octave above.

The great variety of Greek modes allowed poets and dramatists to elicit a wide range of emotional responses from their audiences. Although ethical and emotional orientations have changed over the centuries, the basic modal and metrical system of the Greeks has, in effect, continued through all subsequent periods of Western music and poetry.

Music, in both its broadest and narrowest senses, was woven into the emotional, intellectual, and social life of the ancient Greeks. The art was also considered to have a fundamental connection with the health and well-being of individuals, as well as with their social and physical environment. There is no more eloquent tribute to the power of art in public affairs than that attributed to Socrates: "When modes of music change, the fundamental laws of the State always change with them."

Ideal education for young people in Greece consisted of a balanced curriculum of music for the soul and gymnastics for the body. Even the welfare of the soul after death had musical overtones, because to many Greeks immortality meant being somehow in tune with the cosmic forces and being at last able to hear the "music of the spheres."

All these notions had to do with the physical world being in some way in harmony with the world of the spirit—the metaphysical world—and the soul was in tune with the body. According to the Greek myth of Orpheus, who is depicted in a fine red-figured vase of the early fifth century BCE (Fig. 2.34), music even had the miraculous power to overcome death.

MUSIC THEORY

The Greeks' most important contribution to music is without doubt a theoretical one—that of coordinating the mathematical ratios of melodic inter-

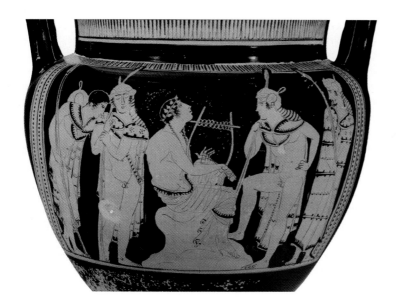

2.34 *Orpheus among the Thracians.* Attic red-figure vase, c. 440 BCE.

vals with their scale system. The discovery, attributed to Pythagoras, showed that intervals such as the octave, fifth, and fourth have a mathematical relationship (Fig. 2.35). This can easily be heard when a tuned string is stopped off exactly in the middle. The musical interval between the tone of an unstopped string and the one that is divided into two equal parts is an octave, and the mathematical ratio is $1:2$. If a segment of the string divided into two parts is compared with a segment of a string divided into three parts, the resulting interval will be a fifth, and the ratio, $2:3$. If one compares the tone of the triply divided string with that of a string divided into four parts, the interval will be a fourth, and the ratio $3:4$. Hence, $1:2$ mathematically equals the octave; $2:3$, the fifth; $3:4$, the fourth; $8:9$, the whole tone; and so on. Because of these mathematical relationships, to Pythagoras and his followers music was synonymous with order and proportion, and it rested on a demonstrably rational basis.

MUSIC AND DRAMA

Knowledge of Greek music must be gleaned from a variety of sources, such as occasional literary references, poetry and drama, visual representations of musical instruments and music making in sculpture and painting, theoretical treatises, and some very fragmentary surviving examples of the music itself. When all the sources are combined, we can gain a faint notion of what Greek music was actually like. Music's highest development undoubtedly was in its union with the drama. Athenian dramatists were by tradition responsible for the

2.35 Demonstrating the octave.

music, the training of the chorus, and the staging of their plays, as well as for the writing of the script. In addition, they often played some of the roles. With all their other activities, the great dramatists had to be composers as well as poets, actors, playwrights, and producers.

In reconstructing the Greek drama, one must imagine an audience to whom the drama was a lively audio and visual experience, consisting of choral singing and dancing, vocal and instrumental music, as well as dialogue and dramatic sequences. Music itself was a full partner in conveying the poet's meaning. Today, with the choruses and dances missing, a performance of a play like *The Suppliants* by Aeschylus is like the text of an opera being read instead of sung. In Euripides's *Bacchae,* the emotional intensity of the individual scenes often rises to such a pitch that music must take over where the words leave off—just as when a person is so overcome with feeling that words fail and inarticulate sounds and gestures are all that remain.

THE CHORUS. The weight of musical expression fell primarily on the chorus, which was the original basis of the dramatic form and from which all

the other elements of the drama evolved. The chorus performed both in stationary positions and in motion. As the chorus circulated around the altar of Dionysus in the center of the orchestra, its song was accompanied by appropriate gestures. The forms of the choruses were metrically and musically very elaborate and were written with such variety and invention that repetitions, either within a single play or in other plays by the same poet, were very rare.

Interestingly enough, the sole surviving relic of Greek music from the fifth century BCE is a fragment of a choral ***stasimon,*** or "stationary chorus," from Euripides' *Orestes.* All ancient Greek manuscripts have come down through the ages from the hands of medieval scribes, who omitted the musical notation of earlier copies because it was no longer comprehensible to them. In the Euripides fragment, the musical notation was included, but all that is left is a single sheet of poorly preserved papyrus.

Fragmentary though this scrap of evidence is, these few notes are enough to tell their own story. Euripides's choruses were musically complex, requiring highly skilled singers who could master the Mixolydian mode, which Aristotle described in his *Politics* as "mournful and restrained." The words that accompany the fragment perfectly express this sentiment, and when properly performed, the fragment still conveys this mood. Other than this single relic of choral recitative, the music of the fifth century must remain mute to our ears.

IDEAS

Each of the arts—architecture, sculpture, painting, poetry, drama, and music—is a distinct medium of expression. Each has its own materials, whether stone, bronze, pigments, words, or tones. Each has its skilled artists, who have disciplined themselves through years of study so that they can mold their materials into meaningful forms. But every artist, whether architect, sculptor, painter, poet, dramatist, or musician, also lives in a specific time and place.

No art exists in isolation, and thus it is no accident that the Greeks thought of the arts as a family of sister Muses. Architecture, to complete itself, must rely on sculpture and painting for embellishments. Sculpture and painting must search for congenial architectural surroundings. Drama embraces poetry, song, and dance in the setting of a theater.

This interdependence of the arts was quite clear in ancient times, as Plutarch quoting Simonides indicates: "Painting is silent poetry; poetry is painting that speaks." When Plato and Aristotle examined the arts, they looked for common elements that applied to all. And they were just as keen in their search for unity in the arts as they were for unity among all the other aspects of human experience.

Certain recurring themes appear in each of the arts of the Hellenic period as artists sought to bring their ideals to expression. Out of these themes emerges a trio of ideas—humanism, idealism, and rationalism—that recur continually in Athenian thought and action. These three ideas, both separately and in their interaction, provide a framework that surrounds the arts and encloses them in such a way that they come together into a significant unity.

HUMANISM

"Man," said Protagoras, "is the measure of all things." And as Sophocles observed, "Many are the wonders of the world, and none so wonderful as man." This, in essence, is humanism. The Greeks conceived their gods and goddesses as idealized beings, immortal and free from physical infirmities but, like themselves, subject to human passions and ambitions. The gods, likewise, were personifications of human ideals: Zeus stood for masculine creative power, Hera for maternal womanliness, Athena for wisdom, Apollo for youthful brilliance, and Aphrodite for feminine desirability. Because of this perceived resemblance to the gods, the Greeks gained greatly in self-esteem.

The principal concern of the Greeks was with human beings—their social relationships, their place in the natural environment, and their stake in the universal scheme of things. In such a small city-state as Athens, civic duties fell upon the individual. Every responsible citizen had to be concerned with politics, which Aristotle considered the highest of all pursuits. Participation in public affairs was based on the need to subordinate personal aspirations to the good of the state. A person endowed with great qualities of mind and body was honor-bound to exercise these gifts in the service of others. Aeschylus, Socrates, and Sophocles were men of action, who served Athens on the battlefield as well as in public forums and theaters. One responsibility of a citizen was to foster the arts. Under Athenian democracy, the state itself, meaning the citizenry, became the principal patron of the arts.

Politically and socially, the life of Athenian citizens was balanced between aristocratic conservatism and liberal individualism, a balance that

was maintained by the democratic institutions of their society. Their arts reflected a tension between this aristocratic tradition, which resisted change and emphasized austerity, restraint, and stylization in the arts, and the new dynamic liberalism, which put greater emphasis on emotion, the desire for ornateness, and a taste for naturalism. The genius of Phidias was his ability to achieve a middle road between these opposites; the incomparable Parthenon was the result.

Humanism also expressed itself in kinship with nature. Although they conceived their gods in the image of humans, the Greeks also tried to come to terms with unpredictable natural phenomena and explain the inexplicable, **personifying** many animate and inanimate entities. Their forests were populated with elusive nymphs and satyrs, their seas with energetic tritons, and their skies with capricious zephyrs. All were imaginative explanations and personifications of forces beyond their control. Attempting to create an imaginary world that is also a poetic image of the real world will always be one of the chief pursuits of the artist. Moreover, the Greeks thought of art as a ***mimesis***— that is, an imitation or representation of nature. Because this also included human nature, it implied a re-creation of life in the various mediums of art.

The art of sculpture was congenial to this humanistic mode of thought. With the human body as the point of departure, divinities such as Athena and Apollo appeared as idealized images of perfect feminine and masculine beauty. Equally imaginative were such deviations from the human norm as the goat-footed Pan, the half-human/half-horse centaurs, and the many fanciful creatures and monsters that symbolized the forces of nature.

The Greeks were more thoroughly at home in the physical world than the later Christian peoples, who believed in a separation of flesh and spirit and strongly favored the spirit. The Greeks greatly admired the beauty and agility of the human body at the peak of its development. In addition to studying literature and music, Greek male youths were trained from childhood for competition in the Athenian and Olympic games. Women may have been allowed to train, but they could not enter the games. Because it was through the perfection of their bodies that human beings most resembled the gods, the culture of the body was a spiritual as well as physical activity.

The nude male body in action at gymnasiums was a fact of daily experience, and sculptors had ample opportunity to observe its proportions and musculature. The *Kritios Boy* (Fig. 2.36), a kouroi found on the Athenian Acropolis, is one of the rare marble originals of this period. The slight turn of

the head and the easy stance with the weight placed on one foot give the figure a supple grace and animation. In Western art appreciation, he became a symbol of the balance between body and soul so admired by the Greeks. In a lesser way, this idea was also attributed to well-known examples such as the *Doryphorus* (Fig. 2.21) and the *Discobolus* (Fig. 2.25). As an instrument of expression, the male nude reached a high point in the fifth century BCE. The female form, however, had to wait until the next century for similar inspired treatment.

Any humanistic point of view assumes that life here and now is good and is meant to be enjoyed.

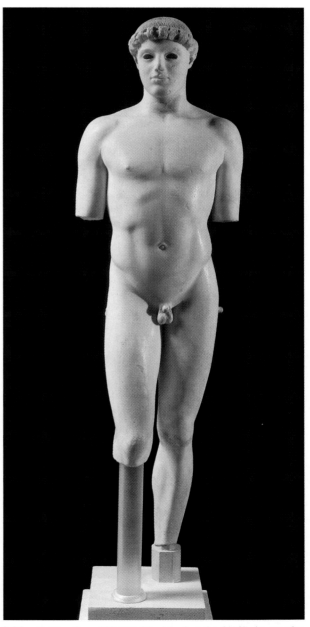

2.36 *Kritios Boy,* 480 BCE. Marble, height 2′10″. Acropolis Museum, Athens, Greece.

This attitude is the opposite of medieval self-denial, which viewed the joys of this life as snares of the devil (see Fig. 6.1) and held that true good could be attained only in the unseen world beyond the grave. Although the Greeks had no single belief about life after death, a typical one is found in the underworld scene of Homer's *The Odyssey,* in which the spirit of the hero's mother explains that "when first the breath departs from the white bones, flutters the spirit away, and like to a dream it goes drifting." In the same scene, the ghost of Achilles tells Odysseus that he would rather be the slave of the poorest living mortal than reign as king over the underworld. Greek *steles,* or gravestones, usually depicted the deceased in some characteristic worldly attitude—a warrior in battle, a hunter with his favorite horse or dog, or a lady choosing her jewelry for the day's adornment (Fig. 2.37). The grave stele or grave marker of Hegeso offers an idealization of a good wife and mother, who produced model Athenian citizens. She is more elaborately dressed and coifed than the woman, probably a slave, who assists her. At the same time she is calm and introspective, showing some of the serenity of the three goddesses from the Parthenon (Fig. 2.18).

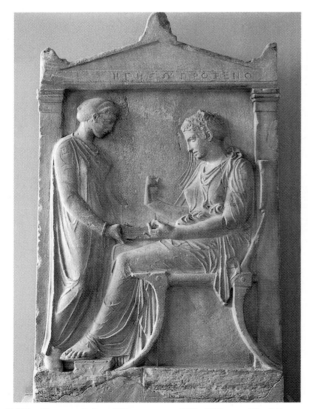

2.37 Grave stele of Hegeso, c. 410–400 BCE. Marble, height 4′11″. National Archaeological Museum, Athens, Greece.

The spiritual kingdom of the Greeks was definitely of this world. They produced no major religious prophets and had no divinely imposed creeds, no sacred scriptures as final authority on religious matters, and no single organized priesthood. The mottoes inscribed on the sacred stones of Delphi, such as "Know thyself" and "Nothing in excess," were suggestions that bore no resemblance to the thunderous "Thou shalt nots" of Moses's Ten Commandments.

Knowledge of their gods came to the Greeks from Homer's epics and Hesiod's book of myths. The character and action of these gods, however, were subject to a variety of interpretations, as is clear from the commentaries of the fifth-century drama. This nonconformity indicated a broad tolerance that allowed free speculation about the nature of the universe. Indeed, the Greeks worked hard to penetrate the divine mind and to interpret its meaning in human affairs. Ultimately, their ethical principles were embodied in four virtues: *courage,* meaning physical and moral bravery; *temperance,* in the sense of nothing too much or, as Pericles put it, "our love of what is beautiful does not lead us to extravagance"; *justice,* which meant rendering to each person what was due him or her; and *wisdom,* the pursuit of truth.

HUMANISM AND THE ARTS. Just as Greek religion sought to capture the godlike image in human form, so the arts tried to bring the experience of space and time within human grasp. Indefinite space and infinite time meant little to the Greeks. The modern concept of a nation as a territorial or spatial unit, for instance, did not exist for them. Expansion of their city-state had less to do with lines on a map than with a cultural unit consisting of independent people who shared a common language and set of ideals. The Greeks had little knowledge of or concern with an accurately dated historical past. This is seen in the imperfection of their calendar and in the fact that their best-known historians, Herodotus and Thucydides, were really chroniclers of almost-contemporary events.

For the Greeks, geometry was designed to measure static rather than moving bodies, and their visual arts emphasized poise and calm. Greek architecture humanized the experience of space by organizing it so that it was neither too complex nor too grand to be comprehended fully. The Parthenon's success rests on its power to humanize the experience of space. Through its geometry, such visual facts as repeated patterns, spatial progressions, and distance intervals are made easy to see and understand. The simplicity and clarity

of Greek construction were always evident to the eye, and by defining the indefinite and imposing a sense of clarity and order on the chaos of space, the architects of Greece made their conceptions of space both articulate and intelligible.

Just as architecture humanized the perception of space, so the arts of dance, music, poetry, and drama humanized the experience of time. These arts fell within the broad meaning of *music,* and their humanistic connection was emphasized in the education of youth. For as Plato said, "rhythm and harmony find their way into the inward places of the soul, on which they mightily fasten, imparting grace, and making the soul of him who is rightly educated graceful."

The triple unities of time, place, and action observed by the dramatists brought the flow of time within definite limits and are a striking contrast to the shifting scenes and continuous narrative styles of later periods. The essential humanism of Greek drama is found in its creation of distinctive human types; in its use of the chorus to provide a collective commentary on the actions of gods and heroes; in its treatment of human actions in such a way that they rise above individual limitations to the level of universal principles; and above all, in the creation of tragedy, in which the great individual is shown rising to the highest estate and then plunging to the lowest depths, thereby spanning the limits of human experience.

In sum, all the arts of Greece became the generating force by which Athenians consciously or unconsciously identified with other citizens and with the entire rhythm of life around them. Through the arts, human experience was evaluated and dignified.

IDEALISM

When artists face the practical problem of representation, they may follow one of two courses. They can choose to represent objects either as they appear to the physical eye or as they appear to the mind's eye. In one case, they would emphasize nature, in the other, imagination; in one the world of appearances, in the other, the world of essences; in one, the real, in the other, the ideal. The avowed realist is more concerned with rendering the actual, tangible object, with all its particular and peculiar characteristics. The idealist, on the other hand, accents abstraction, eliminating all extraneous accessories and concentrating on the essential qualities of things. A realist, in other words, seeks to represent things as they are, an idealist, as they might or should be. Idealism as a creative viewpoint gives precedence to

the idea or mental image, tries to transcend physical limitations, aspires toward a fulfillment that goes beyond actual observation, and seeks a concept closer to perfection.

Both courses were followed in the Hellenic style. One of Myron's most celebrated works was a bronze cow said to be so natural that it aroused amorous reactions in bulls and calves tried to suckle it. Such a work would certainly have been in line with the Greek definition of art as the imitation of nature. The striving to represent the world of natural appearances is well exemplified in the astonishing likeness of a warrior, a fifth-century BCE Greek original bronze found off the coast of southern Italy (Fig. 2.38). The naturalistic

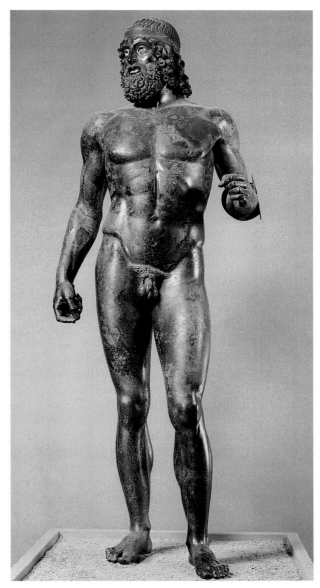

2.38 *Warrior,* fifth century BCE. Bronze with glass, bone, silver, and copper inlay, height 6′6″. Museo Archeologico Nazionale, Reggio Calabria, Italy.

representation is fortified by the use of bone and glass for the eyes; copper for the eyelashes, lips, and nipples; and silver for the teeth. These embellishments remind us that the Greeks preferred polychrome, or colored statues, and that the association of pure white marble with Greek civilization is a much later, and mistaken, impression.

The distance from stylization to realism can be measured by comparing the bronze warrior with the earlier kouros (Fig. 2.20). On the other hand, the difference between realism and idealism can also be seen when this warrior is compared with the representation of Zeus in Figure 2.24.

PLATO AND ARISTOTLE'S IDEAL FORMS. The case for idealism is argued in depth in Plato's dialogues. He assumes a world of eternal verities and transcendental truths but recognizes that perfect truth, beauty, and goodness can exist only in the world of forms and ideas. Phenomena observed in the visible world are but lesser versions of these invisible forms.

Plato's *Republic* is an attempt to describe an ideal society and explore its consequences. No one knew better than Plato that such a society did not exist and probably never would. But this did not lessen the value of imagining it and discussing it. The important thing was to establish goals that would approach Plato's ideal more closely than did any existing situation. "Would a painter be any the worse," he asks, "because, after having delineated with consummate art an ideal of a perfectly beautiful man, he was unable to show that any such man could ever have existed? . . . And is our theory a worse theory because we are unable to prove the possibility of a city being ordered in the manner described?"

Plato's idealistic theory, however, leads him into a rather strange position regarding the activities of artists. When, for instance, they fashion a building, a statue, or a painting, they are imitating, or representing, specific things that, in turn, are imitations of ideal forms; hence their products are thrice removed from the truth. The clear implication is, of course, that art should try to get away from the accidental and accent the essential to avoid the transitory and seek the permanent. This point was also made in the *Republic,* in the allegory of the cave. Plato asks us to imagine a dark cavern in which prisoners are chained in such a way that they cannot turn around and look toward the daylight outside. They are forced to watch stories told by shadow puppets. Just as these tales become real to the prisoners, so the experience of everyday life seems real to us. But neither the shadow puppets nor what we see with our eyes is eternal.

Aristotle, on the other hand, distinguished among various approaches in art. In his *Poetics* he observes that "we must represent men either as better than in real life, or as worse, or as they are. It is the same in painting. Polygnotus depicted men as nobler than they are, Pauson as less noble, Dionysius drew them true to life. . . . So again in language, whether prose or verse unaccompanied by music. Homer, for example, makes men better than they are; Cleophon as they are; Hegemon the Thasian, the inventor of parodies, . . . worse than they are." Aristotle applied the same standard to drama, pointing out, "Comedy aims at representing men as worse, Tragedy as better than in actual life." In the visual arts, he distinguishes between an idealized image, a realistic image, or a caricature. Aristotle clearly implies that idealism, as expressed in Homer's heroic poetry, Polygnotus's noble paintings, and Sophocles' moving tragedies, constitutes the highest form of art.

IDEALISM AND THE ARTS. At its high point in the second half of the fifth century BCE, Hellenic art was dominated by idealism. The Greek temple was designed as an idealized dwelling place for a perfect being. Through its logical interrelationship of lines, planes, and masses, it achieves a sense of permanence and stability in the face of the transitory and random state of nature.

In portraying an athlete, a statesman, or a deity, the Hellenic sculptor concentrated on typical or general qualities rather than on the unique or particular. This was in line with the Greek idea of personality, which was thought to be better expressed in the dominating traits than in individual oddities.

In sculpture, as in all the other arts, the goal was to rise above transitory sensations and capture the permanent, the essential, the complete. Thus, the sculptor avoided representing the human being in infancy, infirmity, or old age, because such representations would imply incompleteness or imperfection and hence were incompatible with the concept of ideal types. The range of representations extends from athletes in their late teens through images of Hermes, Apollo, and Athena, who are conceived of as being in their early maturity, to Zeus, father of the gods, who appears as the fully developed patriarch in all the power of mature manhood. It must also be remembered that few of the Hellenic sculptors' works were intended to represent human beings as such. Most were fashioned to represent gods, who, if cast in

human form, must have bodies of transcendent beauty.

In some way, even the intangible tones of music participated in the ideal world by way of the mathematical relationships on which they are based. A melody, then, might have something more permanent than its fleeting auditory nature would indicate.

One of the main functions of drama was to create ideal types, and although the typical was always opposed to the particular, somehow the one arose from the other. The interpretation of this interplay was assigned to the chorus, and the drama as a whole shared with the other arts the power of revealing how the permanent could be derived from the impermanent; how the type could be found in the many specific cases; and how the **archetype,** or highest type, could arise from the types.

In the extreme sense, the ideal and real worlds represent perfect order and blind chaos. Because the one was unattainable and the other intolerable, it was necessary to find a middle ground. Glimpses of truth, beauty, and goodness could be caught occasionally, and these glimpses should help people steer a course from the actual to the ideal. By exercising the faculties of reason, judgment, and moral sense, human beings could subdue the chaotic conditions of their existence and come closer to perfection.

The Socratic theory of education, expressed in the balance between gymnastics for the body and music for the soul, was designed as a curriculum leading toward this end. The Greek temple, the nobly proportioned sculptural figures, the hero of epic and tragedy, and the orderly relationships of the melodic intervals in music are all embodiments of this ideal. As Socrates said, "Let our artists rather be those who are gifted to discern the true nature of the beautiful and graceful; then will our youth dwell in a land of health, amid fair sights and sounds, and receive the good in everything; and beauty, the effluence of fair works, shall flow into the eye and ear, like a health-giving breeze from a purer region, and insensibly draw the soul from earliest years into likeness and sympathy with the beauty of reason."

RATIONALISM

Rationalism is a concept and a way of life that rests on the idea that the rule of reason should prevail in human affairs. In the *Republic,* Plato sought to demonstrate that the mind could illuminate the ways and means of ordering human life

as well as governing the state through the application of reason. He divided the human constitution into three parts—appetitive, emotional, and rational—which were located in the abdomen, the chest, and the head, respectively. Likewise, human life could rise from its initial stage of ignorance, through a period of constantly changing opinion, to the final security and stability of knowledge together with the contemplation of the eternal verities—truth, goodness, and beauty. The clear implications are that the intellect is the highest human faculty and that through education men and women can rise to the point where reason rules their lives.

From the time Pythagoras discovered the exact mathematical ratios of the musical intervals, Greek thinkers were convinced that the universe was knowable because it was founded on rational and harmonic principles. Plato recounts in the *Republic* the story of a fallen warrior, Er, who returned to life and told of what he had seen in the otherworld. He said that he had beheld the heavenly bodies moving together to form a single harmony, "and round about, at equal intervals, there is another band, three in number, each sitting upon her throne: these are the Fates, daughters of Necessity, . . . Lachesis and Clotho and Atropos, who accompany with their voices the harmony of the sirens—Lachesis singing of the past, Clotho of the present, Atropos of the future."

Following the Pythagorean theory that "all things are numbers," Socrates and Plato taught that human inquiries and endeavors could serve as a mirror of the cosmic order. It also followed that beyond the changing and shifting world of appearances there was an underlying permanent and orderly continuity in both cosmic and human affairs and that it was based on logic and reason.

In the Hebraic and Christian traditions, original sin lay in breaking the moral law, but to the Greeks, the greatest error was lack of knowledge. The tragedy of Oedipus in Sophocles's *Oedipus the King* is his ignorance, because it prevents him from knowing that he is murdering his father, marrying his mother, and begetting children who are also his siblings. His downfall therefore comes through his ignorance, and his fate is the price he has to pay for it. The entire Greek philosophical tradition concurred in the assumption that without knowledge and the free exercise of reason, there is no ultimate happiness.

By thinking for themselves in the spirit of free intellectual inquiry, the Greeks, to a great extent, formulated rules for the conduct of life and its creative forces. This faith in reason also imparted to

the arts an inner logic of their own, because when an artist's hands are guided by an alert mind, the work can penetrate the surface play of the senses and plunge to deeper levels of universal experience. For later periods, this balance between the opposites of reason and emotion, form and content, reality and appearance becomes the basis for revivals of classical style. For subsequent classical movements such as those of the Renaissance and the late eighteenth and early nineteenth centuries, the guiding principles were symmetry, proportion, and unity based on the interrelationship of parts with one another and with the whole.

HARMONIC PROPORTIONS. In the *Timaeus,* Plato theorized that God had created the world by making successive divisions of matter and placing in space the seven heavenly bodies known to the Greeks. As the planets moved in their orbits, they were thought to create cosmic music in the manner of the division of the octave into the seven tones of the diatonic scale. All this accorded with the discoveries of Pythagoras and the doctrine of the music of the spheres. This doctrine survived into the Middle Ages and the Renaissance through the writings of Galileo and Kepler (see pp. 411–412), who still maintained that the planets created a music of the spheres in a kind of sonic counterpoint to the laws of planetary motion. According to Plato, God created the human soul as the mirror image of this universal soul and endowed human beings with rational faculties so that they could aspire to immortality "by learning the harmonies and revolutions of the universe."

Because God composed the universe according to musical and geometric laws, it followed that human architecture and sculpture ought to mirror the cosmic order. At Agrigentum in Sicily, the largest of all Doric temples was dedicated to Zeus. Zeus was the lord of the skies, hence the two porches have seven columns each (an allusion to the seven planets) and the lateral columns number fourteen in the octaval proportion of 1:2. Near Athens on the island of Aegina, a temple to a local goddess, Aphaia, is also in the Doric order and has six columns on the front and back and twelve on the sides, again in the proportion of 1:2. On the mainland, however, by the midfifth century the proportions had shifted to 1:2 plus 1, possibly for greater elegance and less rigid mathematical regularity. This is seen in the temple of Zeus at Olympia and the Hephaesteum in Athens. Both are framed by six frontal and thirteen lateral columns in the ratio of 6:13; the ratio of columns in the Parthenon is 8:17. Later, the geometry of the Pan-

theon in Rome was also based on exact harmonic proportions (see Fig. 4.22A).

Polyclitus thought along the same lines when he formulated a rational theory of the proportions of the human body. It was based on a modular system in which all parts become multiples or fractions of a basic common measure. His long-lost book was known to the Roman architectural theorist Vitruvius, who pointed out that because the head would be one-eighth the total height of an idealized figure, the human body itself would fit into the octave relationship of the musical intervals.

Vitruvius, for his own part, showed how the human body fits into the two most perfect geometric forms: the circle and square. The drawing in Figure 2.39 by Leonardo da Vinci is based on the theories of Vitruvius. Both hark back to Plato's *Timaeus,* in which the cosmic soul is the macrocosm of the universe and the human soul the microcosm.

RATIONALISM AND THE ARTS. Hellenic artists were as much concerned as were Plato and Aristotle with the pursuit of an ideal order, which they believed could be grasped by the mind through the medium of the senses. Greek architecture, in retrospect, turns out to be a high point in the rational solution for building problems. The post-and-lintel system of construction, as far as it goes, is reasonable and completely comprehensible. All structural members fulfill their logical purpose. The orderly principle of repetition on which Greek temple designs are based is as logical in its way as one of Euclid's geometry propositions or Plato's dialogues. It accomplishes for the eye what Plato tries to achieve for the mind.

The tight unity of the Greek temple met the Greek requirement that a work of art be complete in itself. Its carefully controlled but flexible relationships of verticals and horizontals, solids and voids, structural principles and decorative embellishments give it a relentless internal consistency. Moreover, the harmonic proportions of the Parthenon reflect the Greek image of a harmoniously proportioned universe quite as much as a logical system does.

Sculpture likewise avoided the pitfalls of rigid mathematics and succeeded in working out principles adapted to its specific needs. When Polyclitus said that "the beautiful comes about, little by little, through many numbers," he was stating a rational theory of art in which the parts and whole of a work could be expressed in mathematical proportions. But he also allowed for flexible application

2.39 Leonardo da Vinci. *Study of Human Proportions According to Vitruvius*, c. 1485–1490. Pen and ink 1′1½″ × 9¾″. Galleria dell'Accademia, Venice, Italy.

of the rule, depending on the pose or line of vision. By such a reconciliation of the opposites of order and freedom, he reveals the kinship of sculptors with their philosophical and political colleagues who aspired to do the same for other aspects of Athenian life.

Rational and irrational elements were present in both the form and content of Greek drama, just as they were in the architecture of the time. In the Parthenon, the structurally regular triglyphs were interspersed with panels showing centaurs and other mythological creatures. The theme of these sculptures was the struggle between the Greeks as champions of enlightenment and the forces of darkness and barbarism. In the drama, the rational Apollonian dialogue existed alongside the Dionysian chorus, with its interests in altered states of consciousness. In the union of mythological and rational elements, tragedy could mediate between the irrational and rational, that is, the Dionysian and Apollonian principles.

Yet the intricate metrical schemes and the complex arrangements partake of rationalism and convey the dramatic content in a highly ordered composition. In the dialogue of a Greek tragedy, the action of the episodes must lead inevitably and inexorably toward the predestined end. The different elements must achieve a coherence that meets Aristotle's critical standard of "a single action, one that is a complete whole in itself with a beginning, middle, and end, so as to enable the work to produce its proper pleasure with all the organic unity of a living creature."

Just as the harmony of the Parthenon depended on the module taken from the Doric columns, so Polyclitus derived his proportions for the human body from the mathematical relationships among its parts. In similar fashion, melodic lines in music were based on the subdivisions of the perfect intervals derived from the mathematical ratios of the fourth, fifth, and octave. So also the choral sections of the Greek drama were constructed of intricate metrical units that added up to the unity of the drama. In none of these cases, however, were rational proportions the whole story. In the architecture of the Hellenic style; in the statues of Polyclitus; in the dramas of Aeschylus, Sophocles, and Euripides; and in the dialogues of Plato, the rational approach was used as a process for presenting human and aesthetic dilemmas, not as a goal in itself.

It was also the Greeks who insisted that music, like drama and the other arts, was a midpoint between the divine madness of an inspired musician, such as Orpheus, and the solid mathematical basis on which the art rested. The element of inspiration had to be tempered by an orderly theoretical system that could demonstrate mathematically the arrangement of its melodic intervals and metrical proportions.

Finally, it should be remembered that the chief deity of Athens was the goddess of knowledge and wisdom. Even the veneration of Dionysus tended constantly toward increased rationalism and abstract thought. Although Athena, Dionysus, and Apollo were all born out of myth, their destinies found a common culmination in the supreme rationalism of Socrates and Plato, who eventually concluded that philosophy was the highest music.

THE HELLENIC HERITAGE

"We are all Greeks." So said Shelley in the preface to his play *Hellas.* "Our laws, our literature, our religion, our arts, have their roots in Greece." Merely the mention of such key words as *mythology, philosophy,* and *democracy* points immediately to their Greek source. Similarly, the familiar forms of architecture, sculpture, painting, poetry, drama, and music began in Hellas, the land where the Hellenic style was nurtured and brought to fruition. Although circumstances conspired to bring about a decline of its political power, Athens was destined to remain the teacher of Greece, Rome, and later Western societies. Ultimately, Hellas was not simply a country or even a time period, but a worldview that focused on the nature of human civilization.

———— YOUR RESOURCES ————

- *Exploring Humanities CD-ROM*
 - Interactive Map: The Greek World
 - Readings—Plato, *Republic;* Aristotle, *Politic;* Sappho, *Four Poems*
 - Philosophers and Their Works

- *Web Site*

 http://art.wadsworth.com/fleming10
 - Chapter 2 Quiz
 - Links

THE HELLENIC PERIOD

Key Events	Architecture and Visual Arts	Literature and Music
c. 800–c. 650 **Geometric period;** Homer; Eastern contacts		
776 **First Olympic games;** beginning of Greek calendar		c. 750 **Hesiod** ◆
c. 750 **Hesiod** wrote *Theogony* (basis of Greek mythology)		c. 700 **Homer** ◆
c. 650–c. 500 **Archaic period**	c. 650 **Ionic temple of Artemis** built at Ephesus	
	c. 600 **Kouroi (youths) from Sounion** carved	c. 600 **Sappho** ◆
	570–560 **Kleitias** ▲, painter, primarily of pottery	c. 582–c. 507 **Pythagoras** ○
	570–560 **Ergotimos** ▲, potter	c. 525–456 **Aeschylus** ◆
	c. 550 **Korai (maidens) of Samos** carved	
	c. 530 **Archaic Doric temples** built at Athens, Delphi, Corinth, Olympia	
c. 494 **Persians** under Darius invaded Greece	c. 490–c. 432c. **Phidias** ●	c. 500–c. 428 **Anaxagoras** ○
c. 490 **Athenians** defeated Persians at Marathon	c. 489 **Doric treasury of Athenians** built at Delphi	c. 496–406 **Sophocles** ◆
480 **Persians** under Xerxes defeated Spartans at Thermopylae	c. 480 **Temple of Olympian Zeus** built at Agrigentum, Sicily	c. 495–c. 425 **Herodotus** ✪
Athens sacked and burned; Athenians defeated Persian fleet at Salamis	c. 480–430 **Polygnotus** ▲ noted for perspective drawing	c. 485–411 **Protagoras** ○
477 **Delian League** against Persians set up under Athenian leadership	c. 475 ***Charioteer of Delphi*** cast in bronze	c. 480–406 **Euripides** ◆
468–450 **Cimon** (c. 510–450), general leader of conservative aristocratic party, dominated Athenian politics	c. 465–c. 457 **Temple of Zeus** built at Olympia	c. 469–c. 399 **Socrates** ○
	c. 460 ***Zeus*** cast in bronze	c. 460–c. 395 **Thucydides** ✪
456 **Athenian land empire** reached greatest extent	c. 460–c. 450 **Myron active** ●	
454 **Delian League treasury** moved to Athens	c. 460–c. 440 **Polyclitus active** ●	
449–429 **Pericles** (c. 490–429), leader of popular party, ruled Athens	c. 450 **Myron** cast *Discobolus* in bronze	
	c. 450 **Phidias** carved *Athena Lemnia*	
	450 **Phidias** appointed overseer of works on Athenian Acropolis	
	448–440 **Temple of Hephaestus (Theseum)** built	
	447–432 **Parthenon** built by Ictinus; Parthenon sculptures carved under Phidias: metopes, 447–442; inner frieze, 442–438; Phidias' cult statue of Athena dedicated in 438; pediments, 438–332	c. 444–c. 380 **Aristophanes** ◆
	c. 440 **Apollodorus** ▲, the shadow painter, modeled figures in light and shade, flourished	
431–404 **Peloponnesian War** between Athens and Sparta	437–432 **Propylaea** built by Mnesicles	c. 434–c. 355 **Xenophon**
	427–424 **Temple of Athena Nike** built by Callicrates	427–347 **Plato** ○
	421–409 **Erechtheum,** thought by some to have been built by Mnesicles	
413 **Athenians** defeated at Syracuse, Sicily		
404 **Athens** fell to Sparta; end of Athenian Empire		
399 **Socrates** sentenced to death	c. 390–c. 330 **Praxiteles** ●	384–322 **Aristotle** ○
387 **Plato** founded Academy		**Plato's dialogues and Aristotle's treatises** deal extensively with musical theory, practice, and ethical implications of music in education and life
359–336 **Philip of Macedon** gained control of Greek peninsula	c. 350–c. 300 **Lysippus active** ●	
336 **Alexander the Great** succeeded Philip as king of Greece	c. 340 **Praxiteles** carved *Hermes and Infant Dionysus, Aphrodite of Cnidos*	
335 **Aristotle** founded Lyceum	334 **Choragic monument of Lysicrates** built; first external use of Corinthian order	c. 321 **Aristoxenus of Tarentum** ◆, wrote treatise on Greek music
335–323 **Alexander** conquered Near East, Asia Minor, Persia; India reached		c. 300 **Euclid** ◆, wrote treatise on music
146 **Corinth** destroyed by Romans		
86 **Athens** sacked by Romans under Sulla		

▲ - Painter ○ - Philosopher ● - Sculptor ◆ - Writer ✪ - Historian

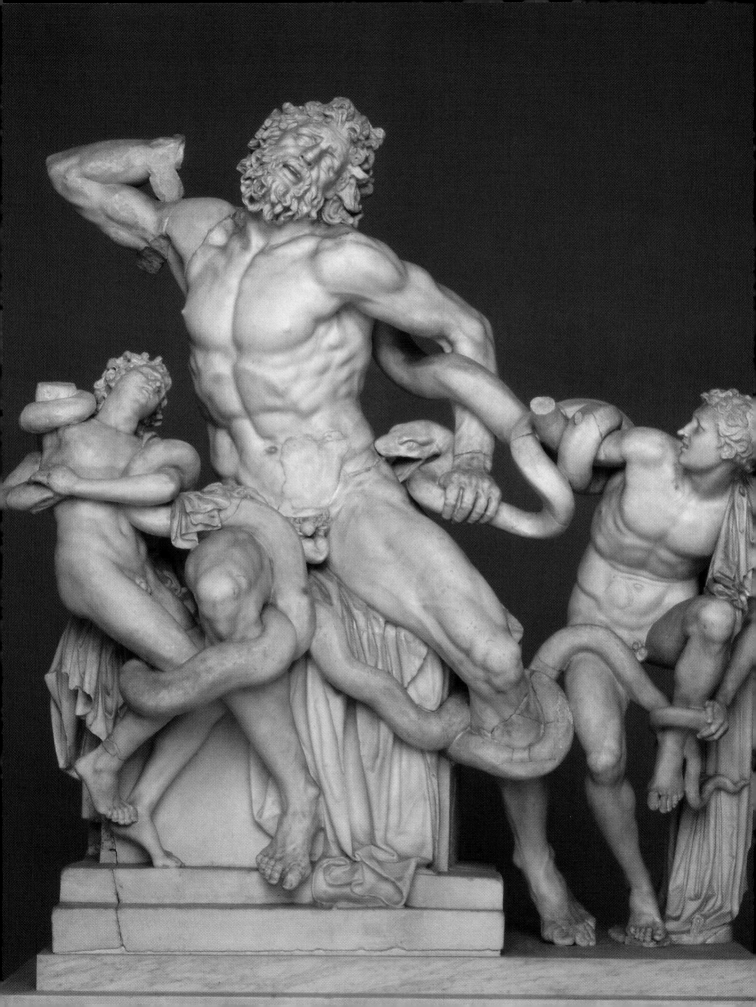

HELLENISTIC STYLE

ATHENS WAS THE ACKNOWLEDGED CENTER of the Greek world in the fifth century BCE, but after the defeat of Athens by the Spartans in 404 BCE, a new political and cultural hub arose: Macedon. The Macedonians may have been a Greek tribe, like the people who founded Athens. They spoke and wrote in Greek, prized Greek art, and hosted the famous Greek painter Zeuxis and the playwright Euripides. The celebrated Greek painter Apelles is thought to have painted portraits of both King Philip and his son, Alexander.

At Pella, the capital, mythological scenes were depicted in floor mosaics made from water-smoothed river pebbles (Fig. 3.1). One of these scenes was signed by its designer, Gnosis, indicating that the skill had become so advanced that it boasted well-known craftspeople. The Macedonian admiration for Greek sculptural form is evident in the careful modeling of the bodies of the hunters, which have been outlined with thin strips of lead

and clay. Nevertheless, the action and fierceness of the hunters' attack is foreign to the Athenian preference for restraint and tranquility. Lion hunting was a popular theme in the art of rulers in the Asian territories to the east of Greece. Its presence in the Macedonian capital may indicate contact with these people—and perhaps their defeat at the hands of the Greeks. The scene hints at the aggressive consolidation strategy advocated by King Philip of Macedon. He assembled a disciplined, well-equipped army and united the entire Greek peninsula into one kingdom, bringing to an end the independent rule of the city-states.

The precocious Alexander accompanied his father on his campaign in southern Greece, learning the art of war along the way. Alexander the Great's exploits became legendary (Fig. 3.2). He is said to

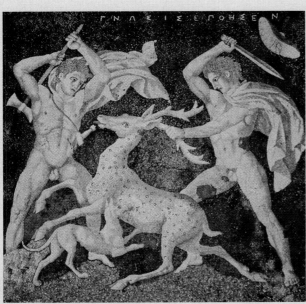

3.1 Gnosis, Stag Hunt, from Pella, Greece, c. 300 BCE. Pebble mosaic, figural panel 10′2″ high. Archeological Museum, Pella, Greece.

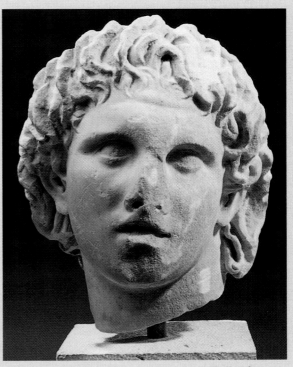

3.2 Head of Alexander the Great, from Pella, Greece, c. 200–150 BCE. Marble, approx. 1′ high. Archeological Museum, Pella, Greece.

have tamed the wild horse Bucephalus, whereupon his father lightheartedly observed that Alexander would have to conquer his own kingdom because Macedonia was too small for both of them.

Alexander was tutored in his youth by the philosopher Aristotle, who may have given the boy his copy of *The Iliad,* Homer's epic poem about the Trojan War. When his father was assassinated in 336 BCE, Alexander set out to quell rebellion in the south and ultimately to conquer his own kingdom. Legend has it that throughout his travels, he carried Aristotle's copy of *The Iliad* with him. Eventually the vast territory from Egypt and Mesopotamia to Persia and the borders of India succumbed to his rule. One of the shrewdest generals of all time, Alexander also saw himself as the champion of Hellenism, and he brought the authority of Greek culture with him wherever he went. Greek art influenced Buddhist stone reliefs and sculpture in what is now Pakistan and Afghanistan. Indian figures of the Buddha took on the facial expressions and drapery of Greek sculpture, which, in turn, migrated farther east into China, Korea, and Japan.

When Alexander died at Babylon in 323 BCE, his empire was divided among his generals—the Ptolemies in Egypt and the Seleucids in Babylonia and Anatolia. After breaking away from the Seleucids, the Attalid dynasty, named for the ruler Attalus I, developed a flourishing economic and cultural capital city at Pergamon. The height of the Hellenistic period spans the time from the death of Alexander to the Roman conquest of Corinth in 146 BCE. During these two centuries, cultural leadership remained in the hands of the Greeks, but as they came in contact with the variety of influences in the lands they controlled, their culture became progressively more multiethnic. They picked up ideas from Asia and Africa and adapted them to their Greek heritage. Hence we make the distinction between the earlier and self-consciously purer Hellenic culture of Greece, and the later, more eclectic Hellenistic or Greek-like styles that arose in Asia Minor. Although in decline, the Hellenistic period continued through a transitional Greco-Roman era until 31 BCE, when Rome became master of the Western world.

During the Hellenistic period the Hellenic emphasis on eternal truths yielded to more practical and hedonistic philosophies. Idealism shifted toward realism, and rationalism gave way to more emotional expression.

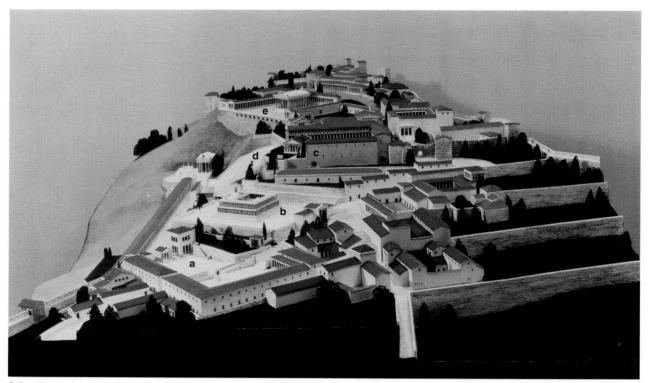

3.3 Reconstruction model of the Acropolis at Pergamon. Complete view from the south, 3 CE. (a) Upper Agora. (b) Altar of Zeus. (c) Temple of Athena Polias, courtyard, and library. (d) Theater. (e) Temple of Trajan and palace precinct. Antikensammlung, Staatliche Museen zu Berlin, Berlin, Germany.

PERGAMON: SECOND CENTURY BCE

Like the earlier city of Athens, Pergamon (or Pergamum) in Asia Minor developed around its acra, the high, fortified hilltop that one ancient writer described as being shaped like a pineapple. The Pergamene acropolis, a site with even greater natural advantages than the Acropolis of Athens, played a significant role in the growth of the city. Strategically located on a plain near the Aegean Sea, Pergamon developed a prosperous export trade. The fertile plain, formed by the flowing together of three rivers, was easily defensible from the hill. The city itself, surrounded as it was by the sea, high mountains, and precipitous ravines, was unassailable except from the south. Here, in an unusually dramatic setting, grew the cultural center that was to play such an important role in the Hellenistic period.

Unlike the Athenian Acropolis, which was primarily a religious and civic site, the acropolis in Pergamon was where the city's rulers built palaces, temples, gymnasiums, and public markets (Fig. 3.3). New plays were performed in the theater, poets read their works aloud, and philosophers presented their ideas. Unlike Athens, Pergamon integrated religious, civic, cultural, educational, and daily life. The city also welcomed non-Greeks more readily than Athens had in the fifth century.

The planning of Greek cities apparently goes back no further than the middle of the fifth century BCE. The fame of "wide-wayed Athens" rested on its Panathenaic Way, a street about 12 feet wide. Just large enough for five or six people to walk abreast, it was the route followed by processions to the Acropolis, theaters, and marketplace. Athens's other streets were narrow alleys barely broad enough to permit the passage of a driver with a donkey cart. Wide, open spaces could be found only in the agora and on the Acropolis, but even here buildings were planned with more attention to their individual logic than to their interrelationships as a group.

Hellenistic city plans, although a vast improvement over their haphazard predecessors, were based on the application of a crisscrossing grid pattern that paid little or no attention to the irregularities of the natural site. When a hill was within the city limits, the streets sometimes became so steep that they could be climbed only by series of stairways. Greek cities in Asia Minor, such as Miletus and Priene, were rebuilt according to this grid system (Fig. 3.4). The residential sections of the ancient city of Pergamon also tried to follow a regular plan. Under Eumenes II, the city reached its greatest extent, and the thick wall he built around it enclosed more than 200 acres of ground—more than four times the territory included by his

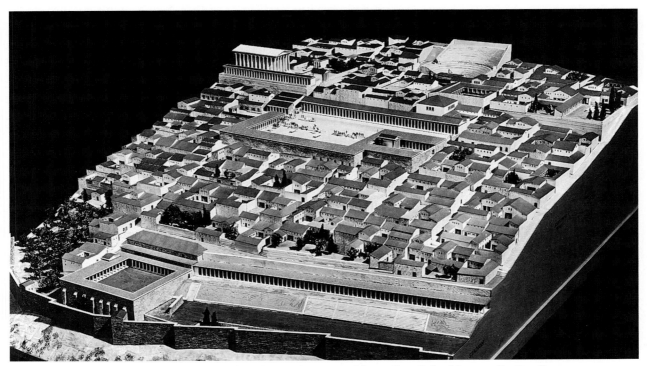

3.4 Model of the City of Priene, Turkey, fourth century BCE and later. Staatliche Museen, Berlin, Germany.

predecessor. Aqueducts brought in ample water from nearby mountain springs to supply a population of 120,000. The system was the greatest of its kind prior to the Roman aqueducts.

The main entrance to Pergamon was from the south, through an impressive arched gateway topped by a pediment with a triglyph frieze. Traffic was diverted through several vaulted portals, which led into a square where a fountain refreshed travelers. From here the road led past the humbler dwelling places toward the lower marketplace, which bustled with the activities of peddlers and hucksters of all sorts. This market was a large open square surrounded on three sides by a two-story colonnade, behind which were rows of rooms that served as shops. Moving onward, the road went past buildings that housed the workshops and mills for pottery, tiles, and textiles. The homes of wealthier citizens were located higher on the hill off the main streets, and they overlooked the rest of the city. At the foot of the acropolis was another square, which boasted a large fountain and a fine view.

Then, on a dramatic, windswept site almost 1,000 feet above the surrounding countryside, rose the Pergamene acropolis (Fig. 3.3), a stronghold that ranked among the most imposing in the Greek world. Up the slopes of the hill, on terraces supported by massive retaining walls and fortifications, were the buildings and artifacts that gave the city its reputation as a second Athens. Through the ingenious use of natural contours, the Pergamenes had developed attractive settings for a number of buildings, which not only were outstanding as individual edifices but also were grouped into a harmonious whole by means of connecting roadways, ramps, and open courtyards. On a succession of rising levels were marketplaces, gymnasiums, athletic fields, temples, public squares, wooded groves, and an amphitheater. Above them all, flanked by watchtowers, barracks, arsenals, storage houses, and gardens, stood the residence of the kings of Pergamon.

ARCHITECTURE

THE UPPER AGORA AND THE ALTAR OF ZEUS

Approaching the acropolis was the highest of the marketplaces (Fig. 3.3A), an open square that served both as an assembly place and as a market for quality merchandise, such as the renowned Pergamene pottery and textiles. Above this agora spread the broad marble-paved terrace on which stood a great altar that tradition and scant textual sources suggest was dedicated to Zeus (Fig. 3.3B);

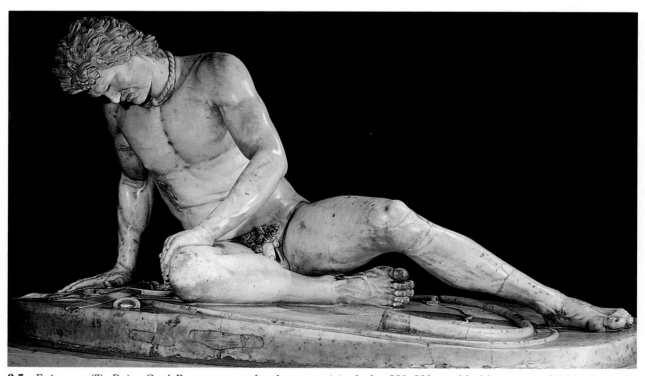

3.5 Epigonos (?). *Dying Gaul.* Roman copy after bronze original of c. 230–220 BCE. Marble, approx. 3′½″ high. Museo Capitolino, Rome, Italy.

its famous frieze depicted the battle of the gods as personifications of light and order against the giants as representatives of darkness and chaos. Conventionally dated from about 180 BCE, this artistic triumph of the reign of Eumenes II was considered by some Hellenistic and Roman authorities to be one of the seven wonders of the ancient world. Because both its structure and sculptures are of major importance, this edifice will be discussed in more detail later in the chapter.

THE ATHENA PRECINCT AND THE THEATER

Above the Altar of Zeus was a precinct dedicated to Athena Polias, or Athena, protectress of cities and guardian of laws and city life. Her shrine (Fig. 3.3C) was a graceful Doric temple, smaller than the Parthenon, with six-columned porches on either end and ten columns on each side. The temple was framed by an L-shaped, two-story colonnade that formed an open courtyard in which stood the bronze monument that celebrated the victory of Attalus I, Eumenes' father, over the Gauls (Figs. 3.5 and 3.6). This colonnade also served as the facade of the great library of Pergamon, which appropriately was placed here in the precinct of Athena, goddess of reason, learning, contemplation, and wisdom. The most precious part of the library was housed in four rooms on the second level that stretched over an area about 145 feet long and 47 feet wide. On their stone shelves, some of which still exist, rested the ancient scrolls, estimated to have numbered about 200,000 at the time of the Attalids.

The Pergamon library ranked with that of Alexandria in Egypt as one of the two greatest libraries of antiquity. The English word *parchment* derives from the Latin word *pergamena*. It is said that parchment originated in Pergamon when the Ptolemies in Alexandria, jealous that the Pergamon library would exceed their own, refused to send additional papyrus. Later, after the major portion of the Alexandria library's collection of half a million volumes was burned in an uprising against Caesar, Mark Antony made a gift to Cleopatra of the entire library of Pergamon.

Below the Athena precinct was the theater (Fig. 3.3D), constructed under Eumenes II about 170 BCE. The auditorium, with 80 semicircular tiers of stone seats, was carved out of the hillside and could hold 10,000 spectators. In the center was a circular section of the orchestra, where the chorus performed around a small altar dedicated to Dionysus, and a rectangular scene platform for the actors.

THE ROYAL RESIDENCE

Just as the Attalid kings dominated the life of their city and constituted the apex of the Pergamene social pyramid, the royal residence crowned the highest point in their capital city. Later, after the realm came under the domination of Rome, part of the palace was destroyed to make way for a large Corinthian temple honoring the Emperor Trajan (Fig. 3.3E).

From their hilltop residence, the kings of Pergamon could survey much of their rich domain. The mountains to the north yielded silver and copper for their coins, which were essential for promoting trade and paying soldiers. From the same region came supplies of pitch, tar, and timber—needed for building ships—as well as marble for buildings and sculptures. A panorama thus unfolded around the people of Pergamon, starting with the heights of Mount Ida and the surrounding range all the way to the bright waters of the Aegean Sea, beyond which lay the shores of the Greek mainland.

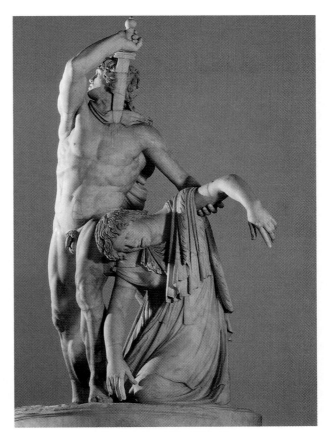

3.6 Epigonos (?). *Gaul and His Wife.* Roman copy after bronze original of c. 230–220 BCE. Marble, height approx. 6′11″. Museo Nazionale Romano-Palazzo Altemps, Rome, Italy.

The planning of Pergamon cleverly promoted the idea of the monarchy towering above it. At the top, topographically as well as politically, stood the king, aloof from his people and associated by them with the gods. Even while living, he was accorded such divine prerogatives as a cult statue with perfumed grain burning on an altar before it and an annual celebration in his honor. This semi-divine status, connected with the king's right to rule, served the practical social purposes of commanding obedience to his laws, facilitating the collection of taxes (often under the guise of offerings to the deities), and uniting the peoples and factions who lived under him. Assisting in this deification were the scholars and artists he attracted to his court, whose works were regarded with awe by locals and foreigners alike.

The pomp and display that marked Hellenistic life was a distinct departure from the simplicity and nobility of the more austere fifth century BCE. Grandeur became grandiosity, and many monuments were erected not to revere the gods but to honor kings. The accent was no longer on abstract ideals but on the glorification of individuals.

With the changing times, however, definite advances in the art of building were taking place. Domestic architecture was emphasized, and Pergamene architects went beyond the simple post-and-lintel system of the Hellenic period and employed the arch and vault in city gates and underground water and sewer systems. Architecturally as well as culturally, Pergamon forged an important link between the Greek idealism and Roman practicality.

SCULPTURE

Although sculptural works of all kinds existed in profusion throughout Pergamon, the examples that claim the attention of posterity were located on two terraces of the acropolis. In the Athena precinct just below the royal residence, bounded by the temple on one side and the L-shaped colonnade of the library on two others, was a spacious courtyard in which Attalus I erected sculptural monuments commemorating his victories. The groups he commissioned were in place during the last quarter of the third century BCE. In the first quarter of the second century BCE, his son and successor Eumenes II built the Altar of Zeus (see Fig. 3.7), with its famous frieze on the terrace below.

The two periods have been distinguished as the First and Second Schools of Pergamon. Because they were separated by less than half a cen-

tury, however, some sculptors may have worked on both projects; if not, they must have had a hand in training their successors. All the bronze originals of the First School have disappeared and can be studied only in marble copies made by later Hellenistic or Roman artists. Most of the sculptures from the Second School survive and may be seen today in the Pergamon Museum in Berlin.

THE FIRST SCHOOL

The principal works of the First School were two large monuments in bronze, each composed of many figures. One commemorated the victories of Attalus over the neighboring Seleucid kingdom. Only a few details of this group survive. The other honored his earlier and greater victory over the nomadic tribes of Gauls, who swept down from Europe across the Hellespont (as the Greeks called the Dardanelles, the narrow waterway that divides Europe from Asia) and into the region north of Pergamon. From this province, called Galatia after them, the Gauls were a constant threat to the Greek cities to the south. While his predecessor had bought them off by paying tribute, Attalus I refused to do so. He met their invasion with an army, and the outcome of the battle was decisive enough to repel the Gauls for a generation. The consequences were felt far and wide, and all the cities and kingdoms of the Greek world breathed a little easier.

The fierce Gauls had inspired such general terror in the popular mind that their defeat came to be seen as an extraordinary event. The name of Attalus was everywhere acclaimed as *Soter* ("Savior," the victor), and after incorporating the lands he had gained, he assumed the title of king. Thereafter, as King Attalus the Savior, he continued to capitalize on his fortunes by embarking on a program to beautify the city, enlisting the services of the best available Greek artists. Sharing the same patroness, Athena, Pergamon began to acquire the status of a second Athens, and its ruler, that of a political and cultural champion of Hellenism.

Parts of the monument that Attalus erected to commemorate his victory over the Gauls can be seen in numerous museums. The *Dying Gaul* (Fig. 3.5) and the *Gaul and His Wife* (Fig. 3.6) survive in Roman copies of what were likely bronze originals. The *Dying Gaul* is a fine example of Hellenistic emotional expression. He is the trumpeter who sounded the call for relief. Mortally wounded, the warrior has agonizingly dragged himself out

of the battle to struggle alone against death. His eyes are fixed on the ground, where his sword, the trumpet, and other pieces of his equipment are lying. He supports himself weakly with one arm, proud and defiant to the end, while his life's blood flows out of the gaping wound in his side. The anguished expression on his face has an intensity not encountered in prior Greek art, which prized emotional balance and composure. The strong but rough musculature of his powerful body, so different from that of the supple Greek athletes, marks him as a barbarian. Further evidence of his origin is found in the collar of twisted gold he wears around his neck and in the look of his hair, which is greased so heavily that it is almost as thick as a horse's mane.

All these carefully recorded details show the interest of the period in individuals as such, in the features that distinguish one person or group from another, and in the portrayal of non-Greek types as heroic in size and fearsome in battle. The very strength and bravery the Pergamenes attributed to their enemies made their victory seem all the more impressive. In addition, the artist tried to awaken the sympathy of the observer and thereby involve him or her in the situation. The viewer might have felt both attraction and repulsion toward such a subject and hence might have experienced a strong emotional reaction. The sword and trumpet lying beside the Gaul, as well as other realistic details, convey a sense of immediacy to the beholder. At the same time, the viewer is invited to look beyond the physical wounds and behold the spiritual anguish of the proud but defeated warrior, so reluctant to accept his fate.

The expressive impact of the *Gaul and His Wife* (Fig. 3.6) is no less powerful. It was customary for women and children to travel with the Gauls on their campaigns. Realizing his defeat and being too proud to be taken as a slave, this Gaul has just killed his wife. He looks apprehensively over his shoulder at the approaching enemy as he plunges his sword into his own neck. The mood of despair is heightened by the sweeping lines of the woman's drapery, which droops downward in deep folds, casting dark shadows. Strong feeling is aroused in the observer by these noble figures who stare death in the face so directly and courageously.

THE SECOND SCHOOL AND THE ALTAR OF ZEUS

To the Second School of Pergamon are assigned all the works that fall within the reign of Eumenes II, the patron under whom Pergamon achieved its greatest power and glory. Like his father before him, Eumenes II had victories over the Gauls, and in the Altar of Zeus (Fig. 3.7) he continued the tradition of erecting commemorative works. The altar was at once the city's greatest single monument and one of the supreme architectural and sculptural works of the Hellenistic period. It was intended to glorify Eumenes' contribution to Hellenism in the struggle against the barbarians.

Beginning in 1873, each fragment was unearthed, and after a half-century of study, the entire monument was reconstructed in the Pergamon Museum in Berlin. As with the Parthenon sculptures in the British Museum (see Figs. 2.16 and 2.17), cultural ownership of the Altar of Zeus is loudly contested. Just as contemporary Greece strongly wants the Parthenon sculptures returned, so too do modern Turks and Greeks lay claim to the Altar of Zeus. Famed throughout the ancient world, the altar was described in the early

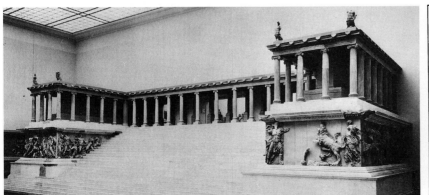
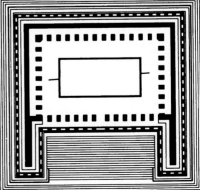

A B

3.7 (A) Altar of Zeus, Pergamon (restored). Begun c. 180 BCE. Marble. Antikensammlung, Staatliche Museen zu Berlin, Berlin, Germany. (B) Plan of Altar of Zeus.

years of the Christian era by St. John as "Satan's seat" (Rev. 2:13). The reference seems to have been prompted by the structure's resemblance to an immense throne and by the animated pagan gods and demons depicted in the frieze.

THE STRUCTURE. The actual altar on which animal sacrifices and other offerings were burned was a large stone podium standing in the inner courtyard (Fig. 3.7A). The building rested on a **podium,** or platform, with five steps, above which was the great frieze, more than 7 feet high and 450 feet long. It ran continuously around the entire podium, bending inward on either side of the stairway and diminishing in size as the steps rose. Below, the frieze was framed by a molding; above, by a **dentil range** (Figs. 3.8 and 3.9), that is, a series of small projecting rectangular blocks. These bricklike blocks served also to support an Ionic colonnade that surrounded the structure and paralleled the frieze. Above the colonnade appeared a

friezeless entablature with a second dentil range supporting the roof. Crowning the whole was a series of freestanding statues of deities and mythological animals placed at various points along the outer edges of the roof.

The concept of space that informed the Altar of Zeus differs from that of the fifth century. In the earlier period, the altar was placed outside the temple and rituals took place against the exterior colonnades. In the Hellenistic period, the new concept of space included a greater interest in depth. Thus, in the Altar of Zeus the spectator looked into a courtyard that enclosed the altar, not toward a background plane. The wider space between the columns also invited the eye toward the interior, whereas the more closely spaced columns of the fifth century promoted the continuity of the plane.

The general effect produced by the Altar of Zeus is that of a traditional Greek temple turned upside down. The simple formality of older Doric

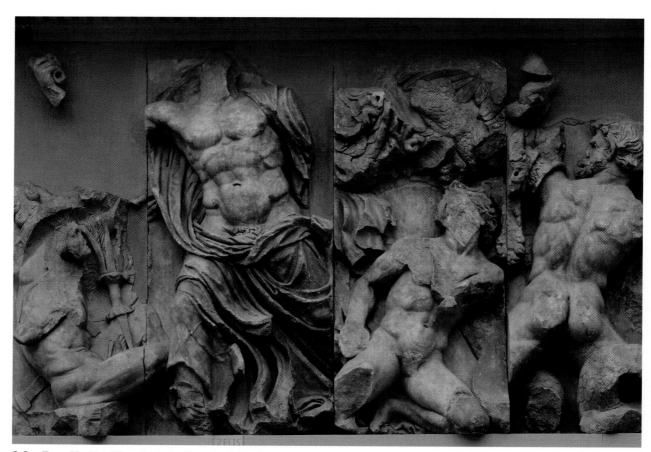

3.8 *Zeus Hurling Thunderbolts.* Detail of Altar of Zeus frieze, c. 180 BCE. Marble, height 7′6″. Antikensammlung, Staatliche Museen zu Berlin, Berlin, Germany.

temples—the Parthenon, for example—depended on the structural and visual integration of their parts. The columns served the logical purpose of supporting the upper members, and the sculptured sections were high above, where they embellished but did not dominate the design. At Pergamon, the traditional order was inverted. Considered more important than the columns, the decorative frieze was put a little above eye level in order to be seen more easily. For the sake of tradition, the colonnade was included, but it was placed above the frieze, where it had no structural purpose. The guiding principle of structural clarity yielded to decoration for its own sake, and the art of architecture gave way to the art of sculpture. In the Parthenon, the decorative frieze was included to give some variety to what might otherwise have been monotonous unity. In the Altar of Zeus, on the other hand, the variety of the frieze was so overwhelming that the regularity of a colonnade was needed to preserve unity.

THE FRIEZE. The subject of the frieze is the familiar battle between gods and giants. In the typical depiction of this scene, it was customary to include the twelve Olympians and an equal number of opponents, but here the unprecedented length of available space demanded more participants. Perhaps scholars working in the library were called on to compile a catalogue of divinities, together with their attendants and attributes, in order to have enough figures to go around. Lettered inscriptions were liberally used to identify the less familiar figures and to make the narrative more vivid. These program notes supplied many associational meanings and made it possible to both read the frieze and view it.

Scholarly influence is also suggested in the allegorical treatment of the ancient battle theme. In Pergamon, literal belief in the gods was largely a thing of the past, and local scholars interpreted the gods as personifications of benign and orderly forces of nature. By contrast, the giants represented

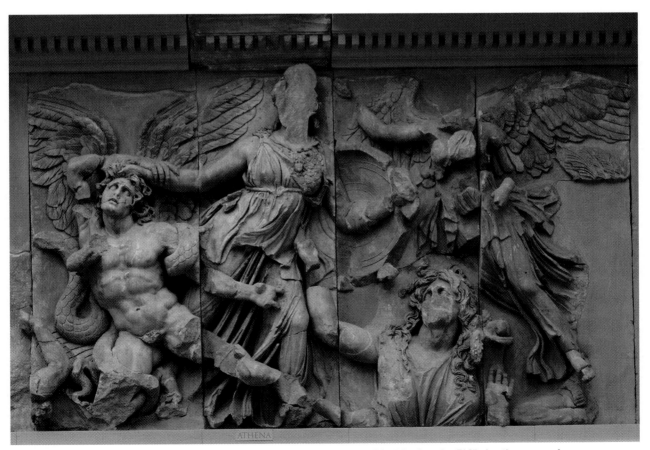

3.9 *Athena Slaying Giant.* Detail of Altar of Zeus frieze, c. 180 BCE. Marble, height 7′6″. Antikensammlung, Staatliche Museen zu Berlin, Berlin, Germany.

such calamities as earthquakes, hurricanes, and floods. In addition, the battle scenes make implicit reference to the fifth-century defeat of the Persians by the Athenians and the warding off of the Gauls by Attalus I.

The narrative begins on the inner part of the right podium, facing the stairs. Moving parallel with the descending stairs, it proceeds along the south side and around the corner to the east. Along the way the principal characters in the drama are introduced: Zeus and his fellow gods in mortal combat with Chronos, father of Zeus, and his supporters, the wicked titans and giants. There are also Helios, the sun god; Hemera, the winged goddess of day; her brother Aether, the spirit of air; and the moon goddess. Hecate, goddess of the underworld; Artemis, the heavenly huntress; and Hercules, father of Telephus, the legendary founder of Pergamon, are included as well. The struggle is between the forces of darkness and the spirits of light.

In the four panels reproduced in Figure 3.8, Zeus is seen, appropriately, in combat with no less than three titans at once. His powerful figure, wrapped in a swirling mantle, is rearing back to smite the giants with his spear and thunderbolts. Most of Zeus's right arm is missing, but his hand is seen in the upper left corner of the panel. The titan in the lower left has already been overcome by a thunderbolt, which is shown as a pointed spear with a handle of acanthus leaves. The second giant is on the other side, his body tense with terror before the blow falls. In the slab to the right, Porphyrion, king of the titans, is shown from the back. From his animal ears to his serpent legs, he is a fearsome sight as he shields himself with a lion skin from both Zeus's eagle above and the additional thunderbolts that the mighty god is about to hurl.

Next is the final group, depicting the part played by Athena, protectress of Athens and Pergamon (Fig. 3.9). Her figure is shown in the second slab. Bearing a shield on her left arm, she grasps a winged giant by the hair with her right hand and forces him to Earth, where her sacred serpent can inflict the mortal wound. A moment of pathos is provided by the giant's mother, the earth goddess Gaea, who is seen as a torso rising from the ground. Although she is on the side of the gods, she implores Athena with her eyes to spare the life of her rebellious son. Gaea's attributes are seen in the horn of plenty she carries in her left hand, a cornucopia filled with the fruits of the earth: apples, pomegranates, and grapes with vine leaves and a pine cone. The goddess Nike, symbolizing victory, hovers over Athena.

From this climax in the sky, the action on the shadowy north side of the frieze gradually descends into the realm of the water spirits. They drive the fleeing giants around the other corner of the stairway into the sea, where they drown. Here, likely enough, are representations of the rivers of Greece. Around the face of the west side and up the stairs are other creatures of the sea. The tumultuous action opens on the right side with the divinities of the land and ends on the left with those of the sea. They are separated by the wide stairs as well as by their placement at the beginning and end of the dramatic conflict between the forces of good and evil.

The frieze as a whole is a technical feat of the first magnitude. It was executed by a school of sculptors, many of whose names are inscribed below it. In addition to the figures, details such as swords and belt buckles, saddles and sandals, and clothing are carved and polished to simulate the textures of metal, leather, and textiles, respectively. The bold high-relief carving, the deep undercutting that allows the figures to stand out almost in the round, and the rich modeling effects that make full use of light and shadow reveal complete mastery of the material.

The swirl of struggling forms and violent movement is sustained over the entire frieze. By contrast, the traditional Doric frieze depended for unity on the alternation of action in the metopes with calm in the triglyphs. At Pergamon, unity is generated by the continuity of the motion itself. The slashing diagonal lines and sharp contrasts of movement are grouped into separate episodes by the device of coiling snakes. Winding in and out, they are at once the visual punctuation marks that separate the scenes and the connecting links of the composition. They lead the eye from one group to another and promote a sense of constant writhing motion. Athena's posture was taken directly from that on the Parthenon's east pediment; that of Zeus is derived from the Poseidon of the west pediment. There the Athenians had defeated the Persians, while here the Pergamenes had vanquished the Gauls. In both instances the cities and their rulers had become the champions of Greek culture against barbarian invasion. Pergamon was pictured as the new Athens, a shining cultural center directly under the protection of the goddess Athena.

EVOLUTION OF STYLE

Comparing the great frieze with the *Dying Gaul* and the *Gaul and His Wife,* one notes a change in style from the First to the Second School. Both allude to the constant wars between the Pergamenes and Gauls, but in contrast to the earlier monuments' preoccupation with pain, the gods on the Altar of Zeus slay the giants with frenzied aban-

don. Instead of having sympathy and even admiration for their enemies, the viewer now marvels at the many ingenious ways in which the gods dispatched their foes.

All the monuments accentuate pathos, but whereas in the earlier examples the compassion of the observer is awakened simply and directly, the great frieze deals with its subject as a thinly disguised allegory for the war between the Pergamenes and the Gauls. In the guise of the gods, the Pergamenes become superhuman figures, whereas the giants, whose features closely resemble earlier Gallic and other non-Greek types, are rendered as monsters.

Instead of the frank realism of the previous generation, the tale is told in the language of melodrama accompanied by visual bombast. It is put on the stage, so to speak, with theatrical gestures and postures. The emotional range is correspondingly enormous, beginning with the stark horror of monsters with enormous wings, animal heads, snaky locks, long tails, and serpentine legs. After being terrorized by the sight of such bestial forms, viewers must have melted into sympathy for the earth mother pleading for mercy for her monstrous offspring, and perhaps gone from tears to laughter at the inept antics of some of the clumsy giants. And after hissing the villains, they may have applauded the gods coming to the rescue. This theatrical exaggeration of reality extends to the representation of bodily types. The functional physique of the *Dying Gaul* has evolved into the power of the professional strongman who finds himself more at home in the arena than on the battlefield.

The perception of deeper space entered into the sculptural composition of the Altar of Zeus as well as into its architectural composition. Just as when viewing the architectural composition the eye is drawn into an enclosed interior, when viewing the sculpture the eye not only moves from side to side, as in a plane, but is constantly led back and forth into spatial depth. To escape the plane, some of the figures project outward in such high relief as to be almost in the round; others even step outward from the frieze and support themselves by kneeling on the edge of the steps. The heavy shadows cast by the high-relief carving intensify this effect. At Pergamon, the two-dimensional plane of the Hellenic style was expanded here to suggest more recession in depth.

A general comparison of Hellenistic art with the Athenian art of the fifth century BCE leaves one with the impression of discord rather than harmony; emotionalism in the place of a rational presentation; virtuosity triumphing over dignified refinement; melodrama superseding drama; variety in the place of unity. The Athenian culture, in short, placed its trust in exceptional human beings; the Hellenistic, in superbeings. No longer the masters of their fate, Hellenistic people seem engulfed in the storms and stresses of circumstances beyond their control.

PAINTING AND MOSAIC

As a consequence of the enduring qualities of stone, more ancient sculpture has survived than art works in any other form. Buildings were torn down for their materials and replaced by others. Statues of bronze, precious metals, and ivory were often too valuable in their essential materials to survive. Libraries either were burned or saw their volumes disintegrate over time, so their books survive only in imperfect copies made by medieval scribes or as fragmentary quotations in other volumes. The musical notation contained in ancient manuscripts could not be understood by these copyists, who eventually omitted it. Mosaics and pottery have fared better, but for the most part they, too, were either broken up or carried off by conquerors and collectors.

PERGAMENE PAINTING AND ROMAN ADAPTATIONS

Of all the major visual arts in antiquity, painting has suffered most from the ravages of time. So few examples survive that we can gain only a hint of what this art must have been at its best, and it is easy to arrive at the incorrect impression that sculpture was the most important of all the arts. Literary sources, however, verify the effectiveness of painting and the high esteem in which it was held.

Pausanias, a writer of Roman times, described the works of the legendary fifth-century BCE Athenian painters Polygnotus and Apollodorus. The former worked out the principles of perspective drawing, and the latter was renowned for his use of light and shadow and fine gradations of color. Pausanias also mentioned many paintings at Pergamon, including some by Apollodorus. The excavated fragments there reveal that the interior walls of temples and public buildings frequently were painted with pictorial panels and had streaks of color that imitated the texture of marble. Other scattered fragments of paintings show that the Pergamenes favored bright colors, such as yellows, pinks, and greens, which contrasted with deep reds, blues, and browns.

The palace paintings used motifs of actual animals, such as lions and charging bulls, and

imaginary ones, such as tritons and griffins. Interiors of rooms were often decorated with painted friezes similar to sculptural ones, and walls, especially of small rooms, were painted with panels and columns that included realistic shadows to create the illusion of spaciousness. The writers of antiquity mention that the subjects of paintings were often drawn from mythology or from literary sources such as Homer's *The Odyssey.* It is also known that Hellenistic painting commonly dealt in **genre scenes,** that is, casual, informal subjects from daily life.

3.10 *Hercules Finding His Infant Son Telephus,* c. 70 CE. Fresco from Herculaneum, probably a copy after a Pergamene original of second century BCE. Museo Archeologico Nazionale, Naples, Italy.

Although the original paintings no longer exist and only fragments of mosaics and vase painting survive, well-preserved copies of Pergamene work have been found in the Greek cities of southern Italy, notably Herculaneum. This city supposedly was founded by Hercules, whose son Telephus founded Pergamon. A "family" relationship thus existed between the two centers. Herculaneum, in fact, became a later middle-class version of the earlier aristocratic Pergamon.

Both Herculaneum and nearby Pompeii were suddenly buried in a rain of cinders and a hail of volcanic stone that accompanied the eruption of Mount Vesuvius in 79 CE. When rediscovered in the eighteenth century, the two cities yielded many paintings and mosaics preserved almost intact. The prevailing taste was Hellenistic, and the well-to-do patrons, preferring traditional subjects, usually commissioned copies of famous paintings rather than original works of art.

Hercules Finding His Infant Son Telephus (Fig. 3.10) is an adaptation of a Pergamene original. The winged figure in the upper right is pointing out to Hercules his son Telephus, who is seen in the lower left among wild animals, suckling a doe. The place is the legendary fertile land of Arcadia, personified by the stately seated figure. Beside her are the fruits of the land, and at her back a playful faun is holding a shepherd's crook and blowing the pan-pipes. The coloring for the most part is sepia and reddish brown, relieved by lighter blue, green, and whitish tints. The figures appear against the background plane of the sky, which projects them forward in the manner of relief sculpture. The drapery and modeling of the flower-crowned Arcadia recall the carving of a marble relief, while the powerful musculature of Hercules's body is cast in the manner of a bronze statue in the round.

Because ancient sculpture usually was painted in vivid colors and reliefs sometimes had landscapes painted in their backgrounds, the arts of painting and sculpture obviously were closely identified in the Hellenistic mind, and they should perhaps be thought of more as complementary arts than as independent media. Paintings were more adaptable to interiors, whereas weather-resistant stone made marble reliefs better for the open air. The existing evidence clearly shows that the visual intention and expressive effect of both arts were closely associated and that neither could claim aesthetic supremacy over the other.

MOSAIC

Mosaic, an art that dates to remote antiquity, was highly favored at Pergamon for the flooring of interiors and for wall paneling. As with later Roman work, geometric patterns were often preferred for floors, whereas representations of mythological subjects, landscapes, and genre scenes were used for floors and murals. Such compositions are formed of small cubes or pieces of stone, marble, or ceramic, known as **tesserae,** which are set in cement.

A mosaic by the artist Hephaistion covered the entire floor of a room (Fig. 3.11). It has a blank center surrounded by a colorful geometric design

3.11 Hephaistion. Mosaic from Palace of Attalus II at Pergamon, c. 150 BCE, 28′. Antikensammlung, Staatliche Museen zu Berlin, Berlin, Germany.

3.12 After Sosus. *Unswept Dining Room Floor.* Detail of later Roman copy of original Pergamene mosaic of second century BCE. Museo Gregoriano Profano, Vatican Museums, Rome, Italy.

of black, gray, red, yellow, and white marble tesserae. Beyond this is a wavelike pattern of black and white. Enclosing the whole is a border about a yard wide with a foliated, or leaflike, design of such rich variety that in its 44-foot expanse there is no repetition. Against a dark background are intertwined colored flowers, exotic lilies, vine leaves, and various fruits, all with delicate shadings. In some places, grasshoppers are feeding on acanthus leaves; in others, small winged ***putti,*** or Cupid-like boys symbolizing love, are playing among the vines.

According to the Roman writer Pliny the Elder, the most famous mosaicist of antiquity was Sosus, who worked at Pergamon. Among his most widely copied designs was one of doves drinking from a silver dish. A favorite design of his for the floors of dining rooms showed vegetables, fruit, fish, a chicken leg, and in the lower left corner, a mouse gnawing on a nut (Fig. 3.12). Shadows and highlights increase the illusion of three-dimensionality.

A quality mosaic copy of an earlier Hellenistic painting was found at Pompeii. It depicts the youthful Alexander's triumph in the *Battle of Issus* (Fig. 3.13), a scene of epic sweep and unprecedented vividness. The subject is the climactic moment when the Persians realize that defeat is imminent and are about to turn and flee. The dauntless Alexander advances on his horse, Bucephalus (whose name means ox head). The inside of the horse's ear has been rendered in white to resemble an ox horn. Alexander presses forward directly into the phalanx of bending spears. Darius, the king of kings, looks older and frightened. He extends his hand in a gesture that indicates a plea for mercy, while his charioteer's whip gives the signal for retreat. The brilliant lighting allows the swords and armor to gleam and the skillfully modeled figures to cast shadows on the ground. Note also the fallen Persian warrior on the right, cowering between the two horses and staring at his own face reflected in his polished bronze shield.

MUSIC

Pergamon adapted the musical traditions of the nearby region of northern Asia Minor known as Phrygia, which had its own characteristic idioms, modes, rhythms, scales, and instruments. As early as the fifth century BCE, Athenians were divided regarding the merits of the Dorian musical tradition of the Greek mainland and were increasingly influ-

3.13 *Battle of Issus,* from House of the Faun, Pompeii, Italy, c. 310 BCE. Mosaic, 8′10″ × 16′9″. Mosaic copy of painting from c. 320–311 BCE. Museo Nazionale, Naples, Italy.

enced by the music of foreign cultural centers. During the Hellenistic period, the exciting music of Phrygia gained popular favor.

PHRYGIAN VERSUS DORIAN MUSIC

Melodies in the Phrygian mode apparently induced strong emotional reactions. The musical instrument called the Phrygian pipe was said to stir the senses. This pipe, known as the *aulos,* was a reed instrument with a peculiarly penetrating sound. English translations from ancient Greek incorrectly render the aulos as a "flute." Marsyas plays a double version in Figure 3.14, at the right. Dorian music, by contrast, was associated with stringed instruments such as the lyre and the *cithara* (Fig. 3.14, left), the latter often mistranslated as a "harp."

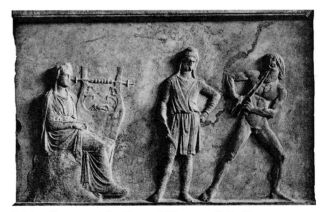

3.14 *Contest of Apollo and Marsyas.* Relief from Mantineia, Greece, c. 350 BCE. Marble, height 38′¼″. National Museum, Athens, Greece.

Both the lyre and the cithara in the Dorian musical tradition and the aulos in the Phrygian were used principally to accompany songs, melodies, and choruses and, to a much lesser extent, were played as solo instruments by skilled performers. In the Dorian tradition, lyre playing was especially associated with the cult of Apollo. The Greeks attributed to this body of music the quality of *ethos,* or ethical character. The aulos, the instrument of Dionysus, was associated with *pathos,* or strong emotional feeling, and had a sensuous quality conducive to enthusiasm. To the Athenians, this indicated a division in their aspirations and ideals: one instrument and mode of singing were associated with clarity, restraint, and moderation, the other with emotional excitement and aroused passions.

MUSICAL CONTESTS. This division of musical opinion was expressed in the many sculptural representations of the musical contest between the Olympian Apollo and the Phrygian satyr Marsyas. According to myth, Athena was the inventor of the aulos. One day as she was playing, however, she caught sight of her reflection in a pool of water. She was so displeased with the facial grimaces the aulos caused her to make that she threw it away in disgust. Marsyas, happening along, found it and was so enchanted by its sounds that he challenged Apollo, the immortal patron of the Muses, to a contest. The god chose to play on the dignified lyre, won the contest easily, and proved once again that mortals are no match for the gods. As a punishment, Apollo had his challenger skinned alive.

A relief from Mantineia, of the school of Praxiteles, represents the contest in progress (Fig. 3.14). On one side, calmly awaiting his turn, is the seated Apollo with his lyre; on the other, Marsyas is ecstatically blowing on the aulos. Between them is the judge, or music critic, standing patiently but with knife in hand.

MUSIC IN HELLENISTIC LIFE

Although there are few remnants of the actual musical life of Pergamon, it is known that here, as in other Hellenistic centers, the practice of music was given a high place in the arts. Gymnastic and musical festivals in honor of the Pergamene kings were held annually. Both boys and girls received musical instruction and sang hymns as they marched in processions or participated in religious observances. The curriculum included musical notation and the chanting of poetry to the accompaniment of the cithara. Among his other duties, the chief educator of the city, the ***gymnasiarch,*** was expected to arrange for appearances by visiting poets and musicians.

Tralles, a city of the Pergamene kingdom, provides one of the best examples of ancient music. A tombstone bearing an inscription consisting of some four lines of poetry accompanied by musical notation was unearthed there. The inscription, an epitaph by a man named Seikilos for the departed Euterpe, turned out to be the words and music of a short but intact tune in the Phrygian mode from the first century BCE. Unlike the typical wild and orgiastic Phrygian music, the mode of this song is melancholy. The little song, almost 2,000 years old, was of a popular type known as a ***skolion,*** or drinking song. It urged listeners, "Oh laugh while you may / Keep toil and trouble at bay. / For life is short and in its day / the night of death soon takes you away." The song was sung

after dinner by the guests as a cup was passed around for toasts and offerings to the gods.

The word *skolion* is derived from the Greek meaning "zigzag." It referred to the manner in which the lyre and cup were passed back and forth, crisscrossing the table as each of the reclining guests sang in turn. The simplicity of this song marks it as the type of tune expected in the repertory of every acceptable guest rather than as one of the more elaborate ballads intended to be sung by professional entertainers. In spirit and mood it is not unlike the New Year's Eve song, "Auld Lang Syne."

IDEAS

There were many striking differences between the Hellenistic and earlier Hellenic styles. Although both styles are Greek, the Hellenic was a more concentrated development in the small city-states of the Greek mainland, whereas the Hellenistic is a combination of native Greek and regional influences from western Asia, North Africa, Sicily, and Italy. In fact, the spread of Hellenistic art over several centuries and the entire Mediterranean world makes any quest for stylistic unity difficult.

The contrast between Hellenic and Hellenistic styles resembles a tilting of the cultural scale in one direction or another. The generalized social humanism of Athens becomes the particularized **individualism** of Pergamon and other centers. Hellenic idealism breaks down into a **realism** that looks at the world more in terms of immediate experience than under the aspect of eternity. The uncompromising rationalism of Socrates and Plato yields to the **empiricism** of scientists, scholars, and artists who are interested more in the development of methods and techniques and the application of knowledge to practical affairs than in the spirit of free inquiry. The tendencies that underlie the various art enterprises at Pergamon in particular and the Hellenistic period in general, then, are to be found in a pattern of interrelated ideas, of which individualism, realism, and empiricism are the most significant parts.

INDIVIDUALISM

The individualistic bias of Hellenistic life, thought, and art was an aspect of humanism, but it contrasted with that of the Hellenic period. In politics, rough-and-tumble public discussions of Athenian citizens and decisions arrived at by voice vote were superseded at Pergamon by the rule of a small group headed by a king who enjoyed semidivine status. Another indication of Hellenistic individualism was the cult of hero worship that started with

Alexander the Great and continued with the kings who succeeded him in the various parts of his far-flung empire. It was reflected in the popular biographies of great men and in the building of lavish temples and monuments glorifying not the ancient gods but monarchs and military heroes. The famous Mausoleum (Fig. 3.15) for King Mausolus of Halicarnassus, thought to be one of the wonders of the ancient world, is a good example. Individualism was also reflected in the sculptor's accent on individual characteristics, personality traits, and ethnic differences. In the earlier Hellenic centers, poets, playwrights, and musicians were mainly skilled amateurs; even in sports the emphasis was on active participation. In the Hellenistic period, however, a rising spirit of professionalism can be seen in the fame of individual writers, actors, musical performers, and athletes. As a result, more people became passive spectators rather than active participants.

STOICISM AND EPICUREANISM. Two contrasting philosophies—Stoicism, with its emphasis on world order and determinism, and Epicureanism, with its accent on chance and personal freedom—dominated Hellenistic thought. The founder of Stoicism was Zeno, who taught in the stoa of the Athenian agora and whose thought took the greatly expanded world of Alexander's empire into account. Hellenistic Greece was no longer a collection of city-states with a common language and geography. Instead, it was an empire that dominated the known parts of western Asia, North Africa, and Mediterranean Europe.

Like Plato in his *Timaeus,* Zeno believed that the human race had been fashioned by the creator in the image of the world soul. He envisaged humanity as one people, citizens of one state, with each individual as part of the world soul observing universal laws and living in harmony with fellow beings. As his follower, the Phrygian philosopher Epictetus, observed, every person is like an actor in a play in which God has assigned the parts, and it is our duty to perform our parts worthily, whatever they may be.

With a world empire to be taken into account, the Stoic ideal of kinship with nature and world

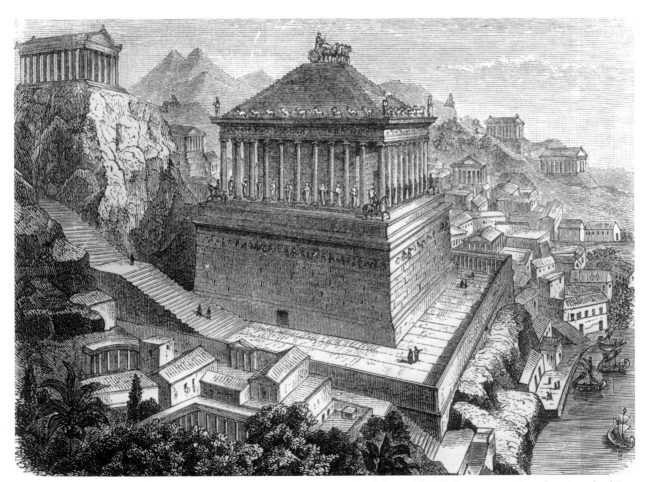

3.15 Pythios. Mausoleum at Halicarnassus, 359–351 BCE. Length 106′, width 86′. Reconstruction drawing. Archiv fur Kunst und Geschichte, Berlin, Germany.

citizenship found fertile soil in later Roman thought. Seneca, a dramatist, politician, and philosopher, counseled that a wise man cannot meet with misfortune because all experience of evil is only an instrument to train the mind. Evil is also a challenge to exercise the powers of endurance and a means of showing the world a person's indifference to external conditions. Later, the Roman emperor Marcus Aurelius, in his *Meditations,* attempted to rationalize his philosophy with his exalted position by declaring that he was *in* the world, not *of* it. His thought embraced recognition of the interdependence of all people and the cultivation of fortitude and endurance. In sum, the Stoics believed that true good lies within oneself. Only by cultivating virtue, accepting duty, and maintaining human dignity in the face of adversity can true freedom and mastery of life be attained.

Epicurus's theory that pleasure was the highest good found ready acceptance in the rich cities of Asia Minor. His materialistic worldview was based on **atomism,** the belief that all is brought about by the haphazard collision and conjunction of tiny particles. Everything is perpetually changing as atoms come together and then separate to form new patterns. There is, then, no afterlife, no future reward or punishment, because death is simply the dissolution of a person's collection of atoms. The life here and now should thus be lived to the fullest, and the object is "freedom from trouble in the mind and from pain in the body."

The lofty idealism and rigorous logic of Socrates gave way to a tendency toward a comfortable **hedonism,** the belief that pleasure is the chief goal in life. But because too much physical pleasure can lead to pain, moderation should prevail. And because some pleasures exceed others, the mind and critical faculties are needed to identify those that give more lasting satisfaction. Epicurus also held that happiness for the individual lay in the simple life, self-sufficiency, and withdrawal from public affairs. This view in effect denied the social responsibilities of citizenship and encouraged escapism and extreme individualism. These different philosophies had considerable influence on the various modes and manners of depicting both gods and men and their expressive attitudes.

PHILOSOPHY AND THE ARTS

Because the state was wealthy, many Hellenistic people could enjoy comfortable personal and home lives. By contrast, poverty, or at least self-deprivation, was considered honorable in ancient Athens, where both rich and poor lived as neighbors in modest homes. Hellenistic prosperity, however, allowed a more luxurious standard of living for a larger percentage of the population. Hellenistic architects took a special interest in domestic dwellings. Painters and mosaicists were called on to decorate the houses of the well-to-do. Sculptors created figurines with informal, sometimes humorous, subjects, because they were more adaptable to the home than the monumental formal works found in public places. Together with potters and other craftspeople, artisans contributed to the life of luxury and ease of a frankly pleasure-loving people.

Hellenistic artists were interested in exceptions more than rules, in the abnormal more than the normal, in diversity more than unity. In portraiture, they noted the physical peculiarities that set an individual apart more than those he or she shared with others. Even the gods were personalized rather than generalized, and the choice of subjects from daily life showed artists' increased preoccupation with informal, casual, everyday events. They were also more concerned with societal influences on the human condition than with the ability to rise above one's limitations. Hellenistic artists, by recognizing the complexity of life, gave their attention

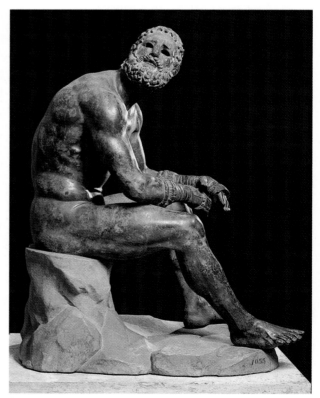

3.16 Seated Boxer, c. 100–50 BCE. Bronze, approx. 4'2½". Museo Nationale Romano, Rome, Italy.

to shades of feeling and to representing the infinite variety of the world of appearances.

Hellenistic thought was oriented toward emotional life. Instead of looking for universal aspects of experience that could be shared by all, Hellenistic philosophers held that each person has feelings, ideas, and opinions that are entirely different from those of others. Thus, each must decide what is good and evil, true and false. Instead of seeking a golden mean between opposites such as harmony and discord, as did their Hellenic predecessors, Hellenistic philosophers became psychologists, analyzing the self and laying bare the causes of inner conflict, as in the expression of the *Seated Boxer* (Fig. 3.16). He sits partially slumped, displaying facial wounds, a broken nose, and missing teeth. Bright drops of copper blood drip down his face. This is not a calm, fearless Hellenic athlete such as the *Doryphorus* (see Fig. 2.21), but a defeated competitor conscious of his slacking powers. The self-satisfaction and pride of accom-

plishment with which the Hellenic gods and athletes were depicted were social emotions to be shared by all. The sorrow, anguish, and suffering of Hellenistic wounded warriors and defeated giants were private, personal feelings that separated a person from the group and invited inward reflection. At the same time, Hellenistic representations of conquest, or even old age (see Fig. 3.18) invite a voyeuristic fascination with imperfection and misery that Hellenic culture disparaged.

Exploring this orientation, Hellenistic artists turned from the ideal of self-mastery to that of self-expression, from the concealment of inner impulse to outbursts of feeling—in short, from ethos to pathos. It was said of Pericles that he was never seen laughing and that even the news of his son's death did not alter his dignified calm. A strong contrast to this Olympian attitude is provided by the *Laocoön Group* (Fig. 3.17), in which reason seems about to be overcome by emotion. Recent speculation on the long-debated originality of the piece

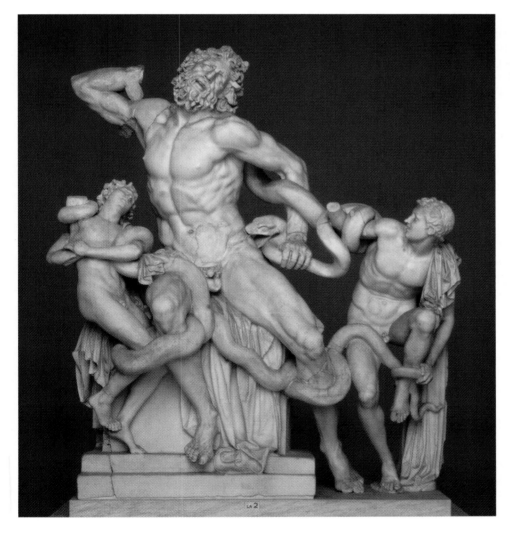

3.17 Agesander?, Athenodorus?, and Polydorus of Rhodes? *Laocoön Group.* Early first century CE. Marble, height 8′. Vatican Museums, Rome, Italy.

argues that it is not a copy, but a late Hellenistic work. It shows the torment of Laocoön, a priest of Troy whom the gods are punishing for warning citizens that the Greeks, whom the gods favored, had sinister motives for leaving the now-famous wooden Trojan horse to tantalize them just outside the gates of Troy. The scene, which seems to have been taken directly from Virgil's *Aeneid,* shows the priest and his sons mortally attacked by fierce, venomous sea snakes. Translated into marble, the blood-curdling event from Virgil's text seems somewhat restrained in its depiction of agony. However twisted in pain, the bodies recall the Hellenic idea. Yet the subject of physical and psychological agony is purely Hellenistic. Could it be, as the eighteenth-century German critic Gotthold Lessing suggested, that Greek culture had a more permissive attitude toward the depiction of pain in literature and plays than in the visual arts? Whatever the cause, the *Laocoön Group* seems to hover between Hellenic idealism and Hellenistic realism.

The preoccupation of Pergamene artists with painful and agonizing subjects such as the defeated Gauls, the punishment of Marsyas, and the battle of gods and giants reveals the deliberate intention to involve the spectator in a kind of emotional orgy. Misfortune becomes something that can be enjoyed by the fortunate, who participate in the situation with a kind of morbid satisfaction.

In the spirit of Stoic philosophy, life and suffering were to be endured with a benign resignation and acceptance of misfortunes that one can do nothing about. The artists of the frieze of the Altar of Zeus, for instance, were incredibly inventive in the ways they found for the gods to inflict pain and death. The composition approaches encyclopedic inclusiveness in the various modes of combat by the gods and the capacity for suffering by the giants. Nothing like it appears again until the Romanesque Last Judgments (see Fig. 6.1) and Dante's *Inferno* (see pp. 232–234).

REALISM

The increasing complexity and quicker pulse of Hellenistic life weakened the belief in the underlying unity of knowledge and abiding values that had produced the poise of Hellenic figures and the unemotional calm of their facial expressions. The world of concrete experience was more real to the Hellenistic mind than the world of abstract ideals. Taking a more relativistic view of things, people now looked to variety rather than unity and took into account individual experiences and differences. The decline of idealism was not so much the result of decadence as it was a matter of plac-

ing human activities in a new frame of reference, reexamining the goals and redefining the basic values of humanity. Confronted with the variety and multiplicity of this world, Hellenistic artists made no attempt to reduce its many manifestations to the simplicity of types and archetypes.

Hellenic artists portrayed their subjects standing aloof and rising above their environmental limitations, but in Hellenistic art, men and women find themselves beset by natural and social forces and are inevitably conditioned by them. The writhing forms on the great frieze reveal some of the conflicts and contradictions of Hellenistic thought. The gods in this work can be seen as projections of human psychological states. The earlier Hellenic gods appeared to have the world well under control, and the calm, poised Zeus in Figure 2.24 exhibits no sign of strain as he hurls his thunderbolt. The deities on the Altar of Zeus, however, are fighting furiously, and the struggle verges on getting out of hand.

3.18 *Old Market Woman.* Second century BCE. Marble, approx. 7′10½″ high. Metropolitan Museum of Art, New York.

REALISM AND ARCHITECTURE. In Athenian architecture of the fifth century BCE, each building, however well suited to its site, was an independent unit, and the architects were little concerned with any precise relationship to nearby buildings. Indeed, to have admitted that one structure was dependent on another in a group would have diminished its status as a self-contained whole and thus rendered it incomplete by Hellenic standards. On the Athenian Acropolis, each temple had its own axis and its independent formal existence, in keeping with the conception that each separate work of art must be a logical whole made up of the sum of its own parts. Only such concessions to nature as were necessary, like the multiple levels of the Erectheum on the Athenian Acropolis, were made. The perfection of each building stood as a monument to the human mind as it rose above its material environment rather than be bound by it.

Hellenistic architecture moved away from the isolated building as a self-contained unit and toward a realistic recognition that nothing is complete in itself but must always exist as part of an interrelated pattern. City planning is in this sense a form of realism, and Hellenistic buildings were considered part of the community as a whole. In the case of the Pergamene acropolis, the position of each building was carefully calculated, with regard to not only its surroundings but also its place in the group.

REALISM AND SCULPTURE. In sculpture, the members of each group were likewise subject to their environment, and the individual was portrayed as an essential part of the surroundings. Incorporating painted backgrounds and higher relief, Hellenistic sculpture relied on changing light and shadow for its expressive effect, allowed for movement in more than one plane, and suggested greater depth in space. In Hellenic sculpture, a figure always bore the stamp of a type, and personality was subordinate to the individual's place in society. A warrior, for example, had a well-developed physique, but his face and body bore no resemblance to those of a specific person. He could be identified by a spear or shield and was more a member of a class than a person in his own right.

The Hellenistic desire to render human beings as unique personalities and not as types required a masterly technique that was capable of reproducing such particular characteristics as the twist of a mouth, wrinkles of the skin, physical blemishes, and individualized facial expressions. Faces, moreover, had to appear animated and lifelike so that the subject of a realistic portrait could be distinguished from all others. Faithfulness to nature also meant accurate rendering of anatomical detail. Like a scientist, the sculptor carefully observed the musculature of the human body so as to render every nuance of the flesh. The *Old Market Woman* (Fig. 3.18), for example, reveals the body of a person worn down by toil. The bent back, sagging breasts, and knotty limbs are the results of the physical and social conditions under which she has had to live. A portrayal such as this would have been unthinkable to an earlier artist, whose clients treasured a state of equilibrium between youth and age.

In the handling of materials, the older Hellenic sculptors never forgot that stone was stone, but their realistic zeal often led later Hellenistic craftspeople to force stone to simulate the softness and warmth of living flesh. The story of the legendary sculptor Pygmalion, who chiseled his marble maiden so realistically that she came to life, could have happened only in the Hellenistic period, and the sensuous figure of the *Aphrodite of Cyrene* (Fig. 3.19) surely bears this out. The easy grace

3.19 *Aphrodite of Cyrene.* Roman copy of c. 100 BCE. After Praxitelean original, found at Cyrene, North Africa. Marble, height 5′. Museo Archeologio Nazionale, Rome, Italy.

with which Praxiteles rendered his gods and goddesses (see Fig. 2.29) reaches a climax in such elegant and polished figures as this Aphrodite and the famous *Apollo Belvedere* (Fig. 3.20). Other masterpieces from this period include the great

Winged Victory of Samothrace and the *Venus of Milo.* Hellenistic emphasis on realism appealed greatly to the forthright Roman conquerors of Greece. Its appeal was largely responsible for the survival of the Pergamene art known to us today.

3.20 *Apollo Belvedere.* Roman copy after Greek original of late fourth century BCE. Marble, height 7′4″. Museo Pio Clementino, Vatican Museums, Rome, Italy.

EMPIRICISM

The rationalism of Hellenic thought as developed by Socrates, Plato, and Aristotle emphasized the spirit of free intellectual inquiry in a quest for universal truth. Epicureanism and Stoicism, by contrast, were practical philosophies for living. The abstract logic of the earlier period yielded to an empiricism that was concerned more with science than with wisdom. It focused on bringing together the results of isolated experimentation and applying scientific knowledge to the solution of practical problems. More broadly, it stressed gathering facts, cataloguing source materials, conducting research, collecting art works, and developing criteria for judging the arts.

Epicurus, by eliminating the notion of divine intervention in human affairs and offering physical explanations of natural phenomena, led the way toward a scientific materialism. The scientific achievements of the period were truly impressive. Hellenistic mathematics extended as far as conic sections and trigonometry, and astronomers and physicists such as Archimedes and Hero of Alexandria knew the world was round and its approximate circumference and diameter. Hellenistic scientists devised a solar calendar of 365¼ days, invented a type of steam engine, and worked out the principles of steam power and force pumps. Similarly, commercial developments led to new sources of wealth. Indeed, more devices might have been developed in Hellenistic times had not slave labor, the product of conquest and expansion, been so cheap and abundant.

The scientific attitude of Hellenistic thought found brilliant expression in the development of the theoretical bases of music. Although philosophers and mathematicians of the earlier period had made many discoveries and had brilliant insights into the nature of music, it remained for the Hellenistic mind to systematize them and construct a full and coherent science of music. Under Aristoxenos of Tarentum, a disciple of Aristotle, and under the great geometrician Euclid, the science of music reached a formulation so complete and comprehensive that it became the foundation for Western music theory. It is impossible to go into the intricacies of the Greek musical system here, but it was in the theoretical field more than any other that the lasting musical contribution of the period was made.

THE RISE OF ANTIQUARIANISM. After establishing his great library, Eumenes II gathered about him many outstanding Greek scholars. They were dedicated to the task of preserving the literary masterpieces of former days, making critical editions of the works of ancient poets and dramatists, selecting material for anthologies, cataloguing collections, copying manuscripts, writing grammatical treatises, and compiling dictionaries. In their scholarly endeavors, they often held earlier works above those of their own time. As a consequence, their literary production began to be addressed to scholars.

This was a period of **antiquarianism,** or concern with things old and rare, of scholarly rather than creative writing, of book learning instead of inspiration. Only systematic, exhaustive research, for instance, could have produced the program of the great frieze encircling the Altar of Zeus, which is a veritable catalogue of Greek mythology, complete with footnotes and annotations. The Attalids not only collected art but actually engaged in archeological excavations, another antiquarian activity. For the first time, living sculptors and painters were confronted with museums filled with noted works from the glorious past. As a result, copying the masterpieces of Myron, Phidias, and others became an industry that thrived throughout antiquity until the coming of organized Christianity. The age raised the social position of the artist. As in literature and music, it established the history of art and formulated aesthetic standards, so now art was worthy of attention in intellectual and social circles.

THE ROAD TO ROME

A reputation for learning had direct bearing on the political purposes of the Pergamene government. The more famous their capital became for its intellectual and cultural enterprises, the higher its prestige in the Greek world would rise. The career of Eumenes II's brother, who eventually succeeded him as Attalus II, is a case in point. As a skillful general, he was invaluable to the Pergamene regime, yet at the conclusion of a successful war, he took 5 years off to study philosophy at the academy in Athens. Moreover, the proudest boast of the Attalids after their military victories was that they had saved Hellenism from the barbarians. This claim, of course, had to be fortified by the development of their capital as a center of arts and letters.

To advertise the cultural achievements of his realm, Eumenes II chose his librarian, the famed grammarian Crates of Mallus, as his ambassador to Rome. By defending humanistic learning and stimulating Roman desire for more knowledge of Greek

3.21 Arch of Trajan. Benevento, Italy, 114 CE.

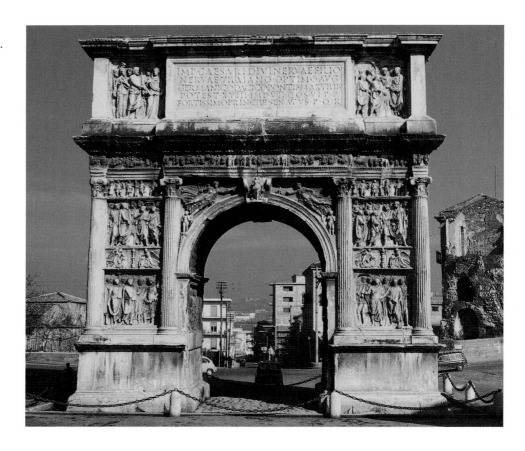

philosophy, literature, and art, Crates made a lasting impression on the future world capital.

With literary talents being diverted to the editing of manuscripts, scholars delving into the history of the past, art collectors digging for buried treasure, and musicians writing theoretical treatises, Pergamon was well on its way to becoming an archive and a museum. In time, this antiquarianism was bound to reduce artistic developments to a system of academic formulas and rules, all of which is symptomatic of a hardening of the artistic arteries and the eventual decline of creative powers. When Attalus III willed his kingdom to Rome in 133 BCE he was actually presenting that city with a living museum. The vast art holdings of the Attalids soon were on their way to Italy, where the interest and admiration they commanded, when shown in public exhibitions, were destined to have a powerful effect on the taste of the Romans. With them went the Hellenistic craftspeople who would embellish the new world capital with a wealth of public buildings, carvings, murals, and mosaics.

Southern Italy and Sicily had long been sites of important Greek settlements. In the sixth and fifth centuries BCE, there were thriving settlements on the mainland, such as Naples, Paestum,

and Tarentum, as well as on Sicily at Syracuse and Agrigentum. Greek influence still prevailed in late Hellenistic times in these places and also at Pompeii and Herculaneum. When Greece came under Roman political control, Greece took over Rome with its philosophy, literature, and art. The emperor Trajan's Arch at Benevento (Fig. 3.21), which celebrated the completion of a highway from Rome to the seaport that linked it with the main centers of the east, is a reminder of the route by which the heritage of the classical Mediterranean world became a part of the Western cultural tradition. The road between Greece and Rome was thus smoothly paved, both literally and figuratively.

YOUR RESOURCES

- **Web Site**

 http://art.wadsworth.com/fleming10

 ○ Chapter 3 Quiz

 ○ Links

- **Audio CD**

 ○ *Skolion of Seikolos*

HELLENISTIC PERIOD, FOURTH TO FIRST CENTURIES BCE

Key Events	Architecture	Visual Arts	Literature and Music
359–336 **Philip of Macedon** in control of Greece			
352–350 **Artemisia,** queen of Caria, reigned	c. 350 **Mausoleum** at Halicarnassus built under Queen Artemisia: Pythios, architect; frieze carved by Scopas and others		
336 **Philip** assassinated; succeeded by son, Alexander the Great			c. 341–c. 270 **Epicurus,** founder of Epicureanism
334–323 **Alexander's conquests** in Near East, Asia Minor, India	350 **Theater at Epidaurus** built by Polyclitus the Younger		c. 336–c. 264 **Zeno of Citium,** founder of Stoicism
333 **Battle of Issus,** conquest of Persia		c. 330 **Apelles,** court painter to Alexander, flourished	c. 321 **Aristoxenus of Tarentum,** musical theorist, flourished
331 **City of Alexandria,** Egypt, founded			
323 **Alexander the Great** died in Babylon			
323–275 **Alexander's generals** divided empire: Ptolemies in Egypt, Seleucids in Syria and Palestine, eventually the Attalids in Pergamon			
323–31 **Hellenistic period;** great centers of culture at Alexandria, Pergamon, Antioch, and Rhodes; 146–31 transitional Greco-Roman period		c. 310 *Battle of Issus* painted, now lost except for mosaic copy from Pompeii	
300			c. 300 **Euclid** flourished
		c. 280 **Colossus of Rhodes** cast in bronze by Chares	c. 287–212 **Archimedes**
269–197 **Attalus I,** king of Pergamon; defeated Gauls in Galatia, allied kingdom with Rome, erected monument commemorating victory over Gauls, patron of First School of Pergamene sculpture		c. 230–c. 220 **First School of Pergamene sculpture:** Attalus I's monument celebrating victory over Gauls	
200			
197–159 **Eumenes II,** king of Pergamon; defeated Gauls, founded Pergamene library, commissioned Altar of Zeus, patron of Second School of Pergamene sculpture. Power of kingdom at zenith	183–179 Eumenes II built **Altar of Zeus at Pergamon:** Menocrates of Rhodes, architect	c. 200 **Boethos** active: Statue of *Boy with Goose*	
		c. 190 *Winged Victory of Samothrace* carved	
159–138 **Attalus II,** king of Pergamon; patron of painting	c. 150 **Stoa of Attalus** built at Athens	c. 180–c. 160 **Second School of Pergamene sculpture:** Altar of Zeus frieze carved	
146 **Roman** conquest of Corinth			
138–133 **Attalus III,** king of Pergamon; willed kingdom to Rome			
129 **Pergamon** became a Roman province		c. 120 *Venus of Milo (Aphrodite of Melos)* carved	
100			
		c. 100 *Laocoön Group* carved	
			c. 50 CE **Skolion of Seikilos,** complete melody with Greek words carved on tombstone
			c. 50–138 CE **Epictetus**
			c. 205–270 CE **Plotinus,** founder of Neoplatonism

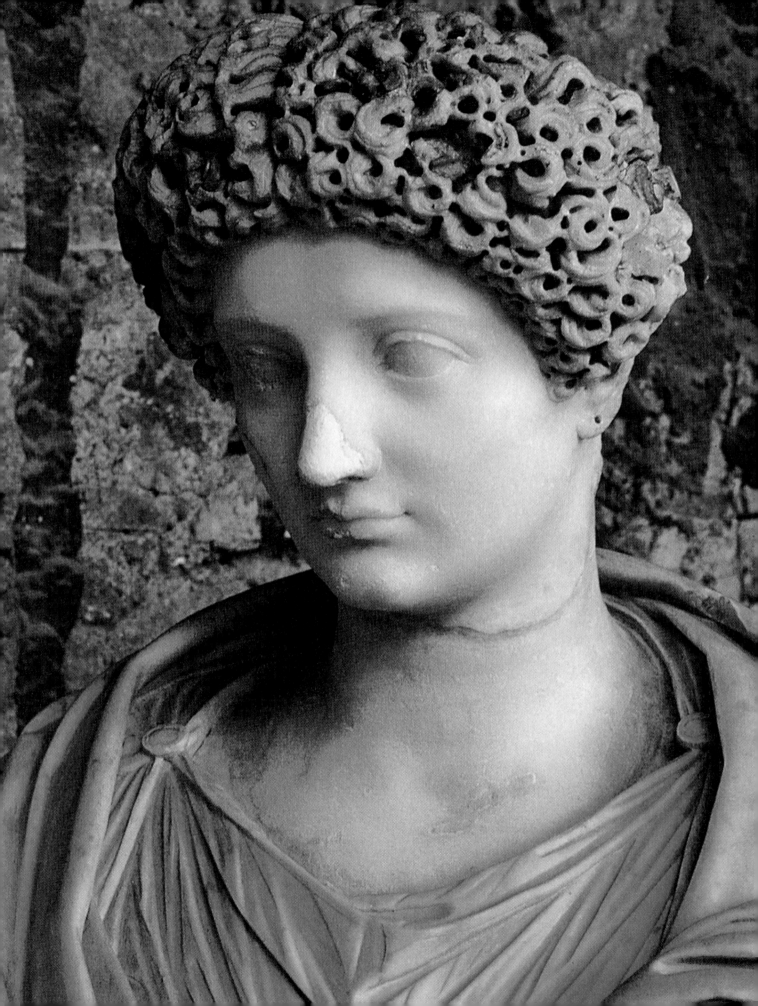

C H A P T E R

4

R O M A N S T Y L E

ROMAN EMPIRE

When Octavian, later Augustus Caesar, defeated the combined forces of Antony and Cleopatra at the Battle of Actium in 31 BCE, he soon became the sole ruler of the Roman world. His early life had been that of a warrior, and that is how he is portrayed in an imposing statue found at Prima Porta (Fig. 4.1). His posture is that of an **imperator,** or commander-in-chief, addressing his troops. Augustus probably stood 5 feet, 7 inches tall, but the statue is almost 7 feet tall. The idealized face and slightly tousled hair recall images of Alexander the Great, whom Roman rulers revered (see Fig. 3.2). Augustus seems to have actively encouraged comparisons between himself and Alexander. Like many men of the Roman elite, he visited Alexander's grave in Egypt. He also used a signet ring with Alexander's portrait to sign official documents.

Carved on the *cuirass,* or metal breastplate, of Augustus's armor are scenes in low relief recounting the outstanding achievements of his reign together with pictures of gods and goddesses who conferred favors upon him. Below is a cupid astride a dolphin, a double reference to the goddess Venus, mother of Aeneas, the legendary founder of Rome to whom Augustus traced his ancestry. The dolphin is a reminder that Venus was born of the sea, and the cupid symbolizes her status as the goddess of love. After Augustus, emperors made frequent use of symbols to indicate their superhuman associations. Indeed, they were like Egyptian pharaohs, controlling the economy and civil life of their huge domain. The power of the Roman Senate, once the governing body of Rome from which its two consuls or ruling magistrates were chosen, significantly diminished.

Augustus sought to establish what came to be known as the **Pax Romana,** a lasting peace after almost a century of civil and foreign wars. Assuming the title Augustus Caesar (he was the grand-nephew of Julius Caesar), he turned his energies to restoring civilian morale and rebuilding the city of Rome. By fostering literature in Latin, rather than

Greek, he awakened the pride of his people in their own historical past and present. One such work was Virgil's *Aeneid,* an epic poem written in the same manner as Homer's *The Odyssey.* Augustus also undertook an ambitious building plan that

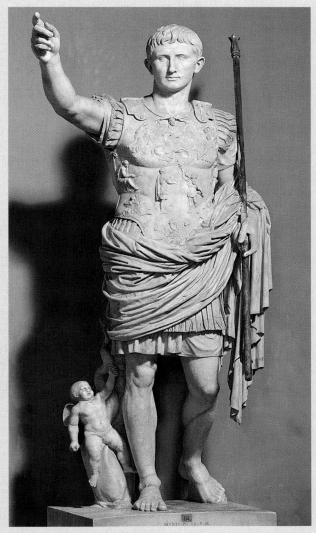

4.1 Augustus of Prima Porta, Italy, early first century CE copy of bronze original c. 20 BCE. Marble, height 6′8″. Vatican Museums, Rome, Italy.

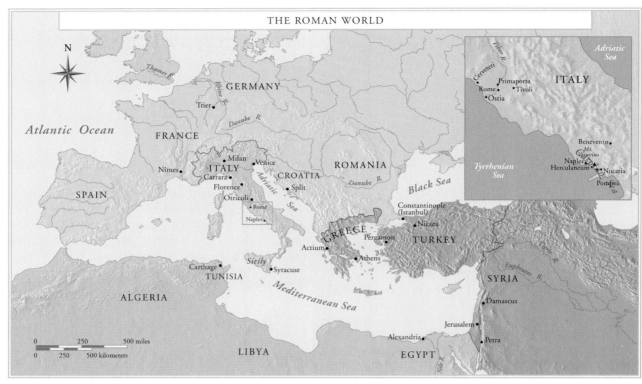

THE ROMAN WORLD

MAP 4.1

included a new forum and numerous other public edifices; the gem among them was the *Ara Pacis Augustae,* an altar dedicated to the spirit of peace.

The frieze on the north and south sides of the *Ara Pacis* (Fig. 4.2) recalls the Panathenaea, the Athenian procession depicted on the Parthenon, as well as figures on the Altar of Zeus at Pergamon (see Figs. 2.13 and 3.7A). Nevertheless, it differs from them in depicting a specific and recent historical event, using portraits of people whom viewers would recognize. The altar's outer walls are embellished by elegantly wrought, high-relief

4.2 *Ara Pacis Augustae* (Augustus's Altar of Peace), c. 13 BCE. Marble, 36′ high, 33′ wide. Museum of the Ara Pacis, Rome, Italy.

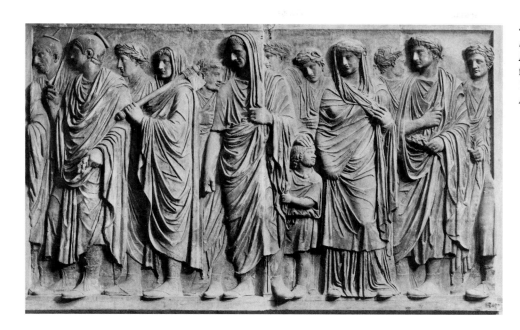

4.3 *Priests and the imperial family led by Marcus Agrippa* (south frieze). Roman relief, 13–9 BCE. Museum of the Ara Pacis, Rome, Italy.

sculptured panels that picture the original dedicatory ceremony. The sculptor of the *Ara Pacis* cleverly implied recessive space by using high relief for the figures closest to the viewer and low relief for those in the background.

Augustus, whose depiction is highly damaged, leads the group, followed by priests who will perform the sacrifice. Farther down the line, the man who has veiled his head is Agrippa, a favorite advisor who died before the altar was dedicated (Fig. 4.3). The child tugging the fabric of Agrippa's garment is probably Gaius, Agrippa's son. When Augustus's second wife was determined to be unable to have children, Augustus asked Agrippa to di-

vorce his wife and marry Julia, Augustus's daughter. Their child, Gaius, was adopted by Augustus as his son and heir. Sadly, however, Gaius died in his early twenties. The woman next to Gaius is probably Julia. The solemnity of the dedication scene is undercut by the restlessness of Gaius. In fact, several children appear on the *Ara Pacis,* suggesting the importance of family lineage in Roman life and politics.

The climax of the handsome design is seen in a panel that may depict the seated earth goddess, Tellus, from whose name the word *Italy* is derived (Fig. 4.4). She is shown in the midst of sheaves of grain, flocks of sheep, and other bounty of the earth. At her breast are two infants, possibly

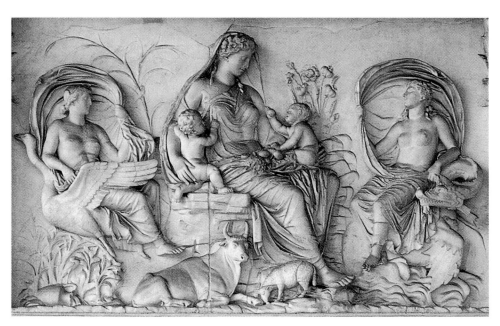

4.4 Female personification (Tellus?), panel from the east facade of the *Ara Pacis Augustae,* Rome, Italy, 13–9 BCE. Marble, height approx. 5′3″.

Romulus and Remus, the legendary founders of Rome. At her left is a bird on the wing and a female figure with a blowing mantle, both representing the sky. On the right, above a gushing stream, reclines a river god. In combination, they represent three of the basic elements: earth, air, and water.

In the second century CE, Rome had a sequence of rulers—Nerva, Trajan, Hadrian, Antoninus Pius, and Marcus Aurelius—who were called the "Five Good Emperors" for their continued support of the public welfare and the arts. In his classic book *The Decline and Fall of the Roman Empire,* historian Edward Gibbon declared that "the empire of Rome comprehended the fairest part of the earth and the most civilized portion of mankind." He attributed Rome's emergence as a cultural center to the Romans' talent for law and order, their cultivation of tolerance and justice, and their capacity for wise government.

ARCHITECTURE AND SCULPTURE

Before the founding of the Roman Republic in about 500 BCE, a thriving but mysterious culture known as the Etruscans flourished in Italy. These people lived in the region between the Tiber River in the south and the Po valley in the north. The area surrounding the modern city of Florence is still known as Tuscany. Eventually Rome prevailed over the Etruscans, and all that remains are the fragments and outlines of their temples and the items found in their excavated tombs, which contain both sculptures and wall paintings. Their pottery techniques were derived from those of the Greeks, who inhabited Italy south of Rome. In fact, the Etruscans were great collectors of Greek pottery and other objects that they encountered during their extensive trading ventures in the Mediterranean Sea, and even into the Baltic Sea. Their temples (Fig. 4.5) bear some resemblance to the Greek Doric order, although they regularly divided the cella (that is, the inner room for cult statues) into three areas, unlike the singular cella usually found in Greek temples. In addition, Etruscan temples were more frontally oriented. They were placed on a raised **podium,** or masonry platform, with only one small stairway allowing visitors to enter the deep porch.

Surviving Etruscan sculpture is mostly **terra cotta,** or baked clay. The forms range from urns made to contain cremated remains to brightly colored funerary **sarcophagi** (singular, **sarcophagus**). A famous example probably represents a husband and wife reclining on a banqueting couch (Fig. 4.6). The man holds his palm up and flat; perhaps some gift or other item was to have been placed on it. The woman may have been holding a round object in her outstretched hand. It is interesting to ponder what their Greek acquaintances would have thought of a representation that showed such public ease and rapport between a man and woman. In Greek society, only men attended banquets. In Rome, women's fate was often determined by the *paterfamilias,* or father of the family. But recent research suggests that Etruscan women enjoyed unprecedented freedom. They are shown in art driving chariots. Moreover, they could run businesses and inherit money.

4.5 Reconstruction of a typical Etruscan temple of the sixth century as described by Vitruvius. Museo delle Antichità Etrusche e Italiche, Università di Roma "La Sapienza," Rome, Italy.

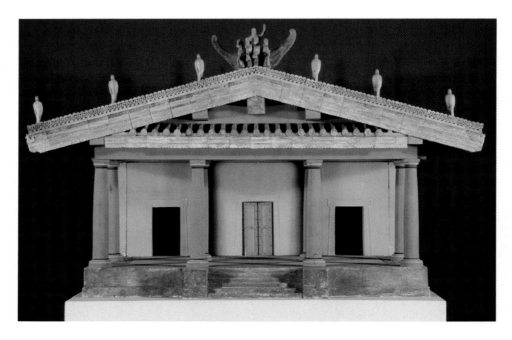

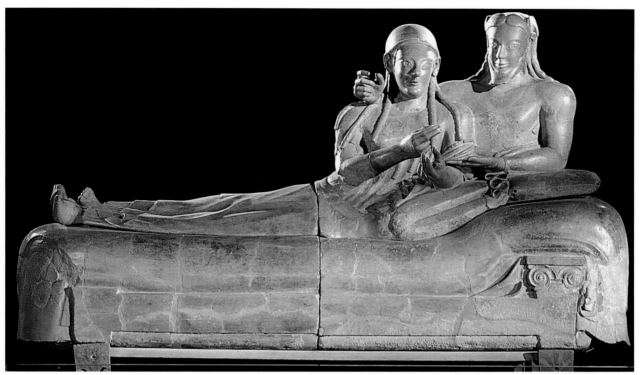

4.6 Sarcophagus, from Cerveteri, Italy, c. 520 BCE. Painted terra cotta, approx. 3′9½″ high. Museo Nazionale di Villa Giulia, Rome, Italy.

When the Romans defeated the Etruscans, much of the Etruscan culture was absorbed into the Roman orbit. Etruscan engineering helped the Romans construct bridges and aqueducts. The architecture of the Romans was thus a synthesis of the Etruscan and Greek traditions, with significant elements and ideas of their own. By Trajan's time, Rome had not only departed from Hellenistic precedents but also absorbed arts and ideas

from the entire Mediterranean world. The result was a new and distinctive Roman style.

THE FORUM OF TRAJAN

Following his accession as emperor in 98 CE, Trajan began a grandiose project in Rome: the construction of a new forum (Fig. 4.7). Just as the empire had grown in his time to its greatest extent, the

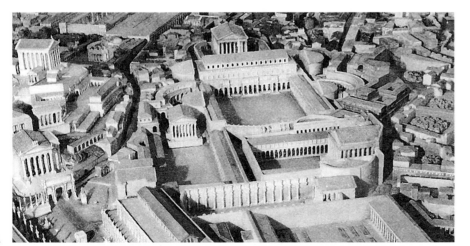

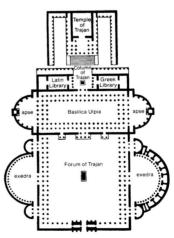

A B

4.7 (A) Apollodorus of Damascus. Forum of Trajan, Rome, c. 113–117 CE. Length 920′, width 51′8″. Reconstruction to scale 1:250 by Italo Gismondi, 1937–1977. Museo della Civiltà Romana, Rome, Italy. (B) Plan of Forum of Trajan.

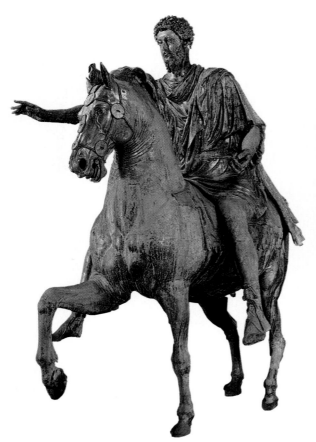

4.8 Equestrian statue of Marcus Aurelius, from Rome, Italy, c. 175 CE. Gilt bronze, approx. 11′6″ high. Musei Capitolini, Rome, Italy.

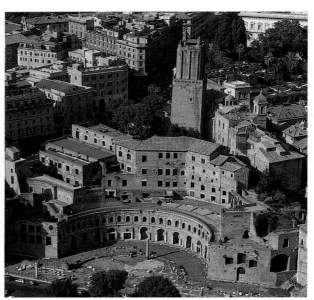

4.9 Apollodorus of Damascus. Forum of Trajan, Rome, northeast exedra and market hall, c. 113–117 CE.

population of Rome had increased to more than 1 million people, creating a need for larger buildings. The old Roman forum of the republic and that of Augustus had long been inadequate. Trajan's project, however, was so ambitious that it equaled all previous forums combined, bringing the total area covered by such structures to more than 25 acres. The magnificence of the new forum was in every way comparable to its size. Trajan entrusted the project to Apollodorus, a Greek architect-engineer from Damascus, who was already famous for the construction of a stone bridge over the widest part of the Danube.

Typically Roman in conception, a forum was a system of interrelated courtyards and buildings. The reconstruction drawing of the Athenian Acropolis (see Fig. 2.2) shows that the Parthenon and Erechtheum had little in common beyond the site on which they stood. But no part of a forum existed in isolation. The whole was conceived organically from the beginning and constructed on a grand scale, with an eye to symmetry and proportion. Trajan's forum, as seen in the ground plan (Fig. 4.7B), was divided by a central axis running

from the center of an arched gateway, through the middle of the open square, through the entrance to the basilica (whose axis is at right angles to that of the whole forum), to the base of the monumental column (see Fig. 4.10A), and finally up the steps of the temple to the altar at the back.

Visitors came into the forum through a majestic triple archway that led to the large paved rectangular courtyard. The courtyard was enclosed on three sides by a wall and colonnade and on the fourth by the Basilica Ulpia, whose entrances stood opposite those of the archway. Standing in the exact center of the open square was an impressive bronze statue of Trajan on horseback. Although no longer in existence, it is known to have resembled the bronze equestrian portrait of Marcus Aurelius (Fig. 4.8), who sits astride his splendid mount with a sense of balance and a thoughtful appearance worthy of the patient Stoic philosopher and author of the *Meditations* (see p. 198). In the original version, a conquered barbarian cowered beneath the horse's raised hoof, offsetting the tranquility of the emperor's face. Many such equestrian statues of emperors and military leaders once existed, and recent scholarship suggests that this fiery steed may have been intended for another, smaller rider. On the other hand, the Romans sometimes used scales symbolically, depicting people as larger than the horses they rode or the boats in which they sailed (see Fig. 4.11).

Flanking the square on the east and west were semicircular recesses known as ***exedrae,*** which were outlined by tall Doric columns. On one side,

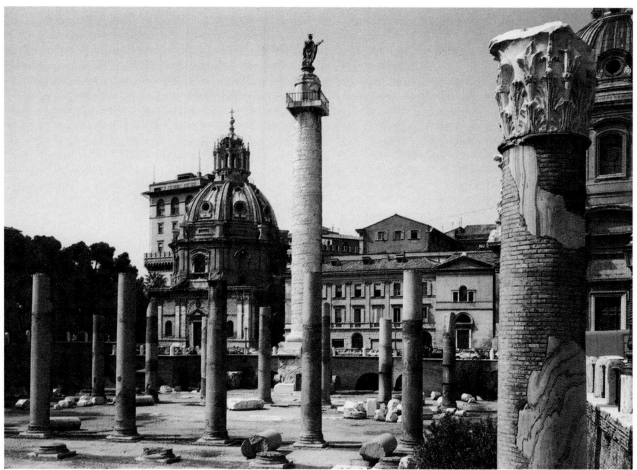

A

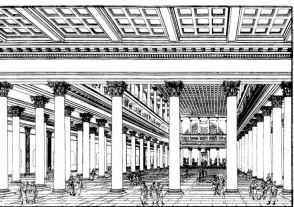

B

4.10 (A) Apollodorus of Damascus. Column of Trajan and ruins of Basilica Ulpia, Rome. Column of Trajan, 106–113 CE. Marble, height of base 18′, height of column 8′1″. (B) Apollodorus of Damascus. Basilica Ulpia, Forum of Trajan, Rome, 113 CE. Reconstruction drawing of interior.

THE BASILICA ULPIA

Adjacent to the open square was the Basilica Ulpia (Fig. 4.10A), of which only rows of broken columns remain. In Roman times, the term ***basilica*** was applied generally to large public buildings. It is approximately equivalent to our use of the word *hall* to refer to a meeting place. Because court sessions were also held in a basilica, the term ***hall of justice*** is likewise related to one of its functions. As an architectural form, the Roman basilica is one link in the long chain of Mediterranean structures that had its beginning with domestic dwellings, Egyptian hypostyle halls, and Greek temples, and continued later with Christian basilicas.

The large rectangular interior of the Basilica Ulpia, named for Trajan's family, was marked by a double colonnade in the Corinthian order that

cut into the Quirinal hill, was a market complex, a precursor of the modern megamall, constructed of brick and rising some six stories (Fig. 4.9). On the first floor were stalls for fresh produce; above were large vaulted halls where wine and oil were stored. Spices and imported delicacies were sold on the third and fourth floors. The fifth floor was used to distribute food and money from the imperial treasury. On the top floor there were tanks that were supplied with fresh water from an aqueduct and that housed live fish to be bought.

ran completely around the building. It supported a balcony and a second tier of columns that, in turn, supported the beams of the timbered roof (Fig. 4.10B). This large central hall served as a general meeting place and a business center. The semicircular interior recesses, called **apses,** housed the law courts. They were probably roofed over with hemispherical vaults, as seen in the reconstruction, and they may have been set apart from the central hall by screens or curtains.

Trajan's Column

Beyond the basilica were two libraries, one for Greek scrolls and the other for Latin scrolls. They were separated by a courtyard that enclosed the base of Trajan's Column. The column's location between two libraries demonstrates the Roman concern for public education and underscores the idea that history could be learned from pictorial sources as well as from Greek and Latin writings.

To commemorate Trajan's victories in the two campaigns to subdue the Dacian people of the lower Danube region, a monumental column was erected in the emperor's forum by the Senate and people of Rome. The structure rose to a height of 128 feet. Inside the column is a circular staircase that winds upward to the top and is lighted by small windowlike slits cut into the frieze. According to tradition, Trajan chose the monument as the site of his burial, and his ashes were placed in a chamber under the column.

The column is constructed in several sections of white marble. A spiral band carved in low relief covers the entire surface. Reading from left to right, the story of the two Dacian campaigns unfolds in a continuous strip about 4 feet, 2 inches wide and 218 yards long. More than 2,500 human figures make their appearance in this visual narrative, in addition to horses, boats, vehicles, and equipment of all kinds.

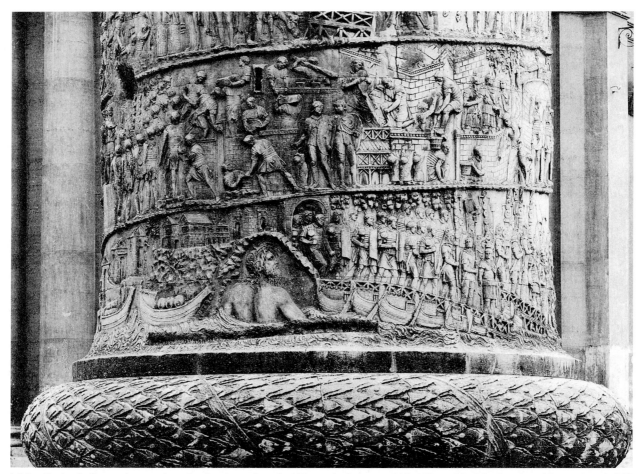

4.11 *Trajan's Campaign against the Dacians,* detail of Trajan's Column, 106–113 CE. Marble, height of frieze band 4'2".

The hero of the story is, of course, the soldierly Trajan, who is shown fulfilling his imperial mission as the defender of Rome against the advances of the barbarians. The empire was always willing to include any people who accepted the values of Mediterranean civilization, but it could tolerate no challenge. When an important barbarian kingdom was founded in Dacia, Trajan regarded it as a threat and set out to bring it under Roman control. It took two campaigns to do the job, and the lasting result of this Romanizing process can be seen in the name of one of the nations of the conquered region: modern Romania.

Trajan's skill as a commander was well known, and on this column and other similar monuments, his reputation did not suffer for lack of public advertisement. In the frieze, he is portrayed as a bold, steady figure in complete command of the situation, whatever its nature. Sharing top billing with their general are the Roman soldiers. Oppo-site them are Trajan's antagonists, the Dacian king Decebalus and his barbarian hordes.

The campaign begins on the banks of the Danube in a Roman camp guarded by sentries and supplied by boats (Fig. 4.11). As the Romans set forth across a pontoon bridge, a river god personifying the Danube rises from a grotto and lends his support by holding up the bridge. From this point the action moves with singular directness toward the inevitable climax: the triumph of Roman arms. The scenes show Trajan holding a council of war, clad in a toga while pouring a sacrificial drink to the gods, and standing on a platform as he addresses his troops (Fig. 4.12). The army is shown pitching a camp on enemy soil, burning a Dacian village, and engaging in battle. At this key moment, Jupiter appears in the sky, throwing thunderbolts at the enemy to disperse them in all directions. The aftermath is then shown, with the victorious soldiers crowding around the

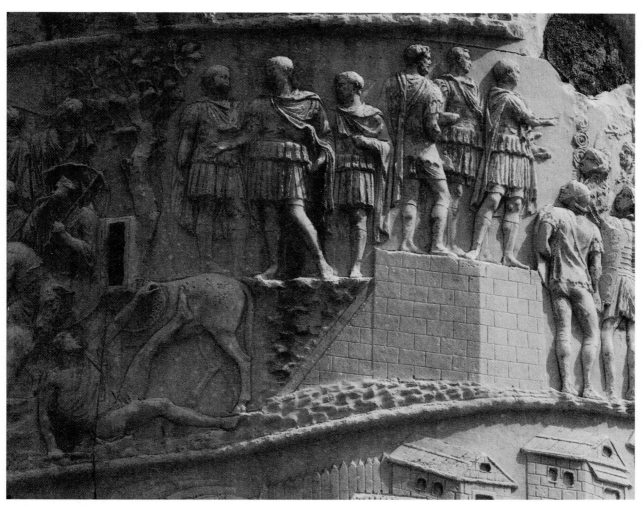

4.12 *Trajan Addressing Assembly of Troops,* detail of Trajan's Column.

emperor and holding up the severed heads of the enemy; surgeons are seen caring for the wounded, and winged Victory makes her appearance.

The scenes are designed to promote the continuous flow of action as smoothly as possible, but for reasons of clarity, the episodes have to be differentiated. The artist does this through some ninety separate portrayals of Trajan, each of which signals a new activity. Other devices used include an occasional tree to distinguish one scene from another, and new backgrounds, such as a mountain or a group of buildings.

This type of spiral relief has been compared with the unfolding papyrus and parchment scrolls that educated Romans were accustomed to reading in the nearby libraries. Trajan is known to have written an account of his Dacian campaigns, much as Julius Caesar had done in the case of the Gallic Wars, but the document is lost. Because commentaries on this bit of history are so fragmentary, the column has become one of the principal sources of information about it. The column may have been originally surrounded by a colonnade that supported an upper gallery from which views of the story in stone could be obtained. For those willing to circle the column again and again, the impression would have been vivid and comprehensive, because the scenes were designed to capture and hold viewers' attention and give them a shorthand experience of having been on the campaign with Trajan.

The reliefs have a definite likeness to literature in their manner of telling a story through visual narration. The methods the Romans used in such cases have been distinguished as the *simultaneous* and the *continuous*. The simultaneous method is the same as that used by the Greeks in the east pediment and frieze of the Parthenon, for example, where all the action takes place at a given moment that is frozen into sculptural form. It thus observes the classical unities of time, place, and action. The Romans developed the continuous, or cyclic, method for just such a series of scenes as Trajan's wars. Unity of action is obtained through the telling of a life story, or as in this instance, it can be broadened to include a couple of military campaigns. The unities of time and place are sacrificed as far as the whole composition is concerned but are preserved in the separate scenes. Whereas the origin of this continuous style is still a subject of scholarly dispute, no one has challenged the effective use the Romans made of it. It reflects their keen interest in

historical and current events, and its value for the purposes of state propaganda is obvious.

Despite the direct narrative content of the spiral frieze, the style is not realistic. For effects, the artist depended on a set of symbols that were as carefully worked out as the words used by writers of epics. A series of undulating lines, for example, indicates water. A jagged outline on the horizon stands for a mountain. A large figure rising up out of the water represents a river. A wall can mean either a city or a camp. A female figure whose draperies are folded in the shape of a crescent moon informs the observer that it is night.

With such symbolism, liberties with perspective inevitably occur, and it is quite usual to find a man taller than a wall or an important figure, such as the emperor, much larger than those around him. This technique does not rule out such clearly recognizable things as the banners of certain Roman legions as well as the details of their shields and armor. The Trajan frieze points unmistakably in the direction of the pictorial symbolism used later by Early Christian and medieval artists, who doubtless were influenced by it.

Much of the work might seem crude to the Hellenistic artists who were still active in Rome, but this relief is an example of Roman popular art. As such it was addressed to the large segment of the populace that was not accustomed to getting its information and enjoyment from books. The elegant and placid forms of Greek gods were not apt to arouse the emotions of ordinary Romans who sought amusement in the gladiatorial contests held in the Colosseum. The Roman Empire needed an educated elite to run its affairs. This minority seems to have admired dignity and restraint in sculpture. Nevertheless, most people were used to being roused by "bread and circuses," that is, free food and fast-paced entertainment. They relished such an energetic, action-filled story as shown in Trajan's frieze, involving people like themselves having adventures. Thus viewed, the frieze is fresh, original, and astonishingly alive.

The artist who designed the frieze was clearly a master of relief sculpture, able to depict with ease, in extremely low relief, whole armies, pitched battles, and the surrounding landscapes and sky. Care was taken in the execution throughout; even though the reliefs at the top were almost certainly out of view, the quality remains the same.

Standing in its prominent location from Trajan's time to the present, this column and the similar one of Marcus Aurelius had an incalculable influence on later art. The continuous mode of visual narration was imitated in the catacomb paintings of the early Roman Christians, as well as in illuminated manuscripts, religious sculptures, and the stained glass of the medieval period. And it can still be found in the comic strips of daily newspapers. Even modern films owe a certain debt to the technique worked out in Rome in the second century CE. Examples of the direct influence of this narrative mode include the Roman Christian tomb of Junius Bassus (see Fig. 5.2); the mosaics relating the story of Christ in the church of Sant' Apollinare Nuovo in Ravenna (see Fig. 5.5); the Bayeux Tapestry, which tells the story of the Norman conquest of England (see Fig. 6.17); and the studious duplication of Trajan's Column made under Napoleon for the Place Vendôme in Paris.

THE TEMPLE OF TRAJAN

After Trajan's death his adopted son and successor, Hadrian, built a Corinthian temple at the end of the main axis of the forum; the temple, dedicated to Trajan, climaxed the grand design and, architecturally, was a version of an earlier Roman temple at Nîmes in southern France, called the *Maison Carrée* (Fig. 4.13). Like other Roman temples, the *Maison Carrée* rested on a podium and had porches only in the front. These porches were much more prominent than those of Greek temples, owing perhaps to the influence of the Etruscans (Fig. 4.5). In the well-preserved example at Nîmes, only the columns of the porch are freestanding; the rest are attached to the cella. This indicates that columns were needed less for structural strength than for embellishment.

The practice of deifying rulers and erecting temples to them was widespread in Hellenistic

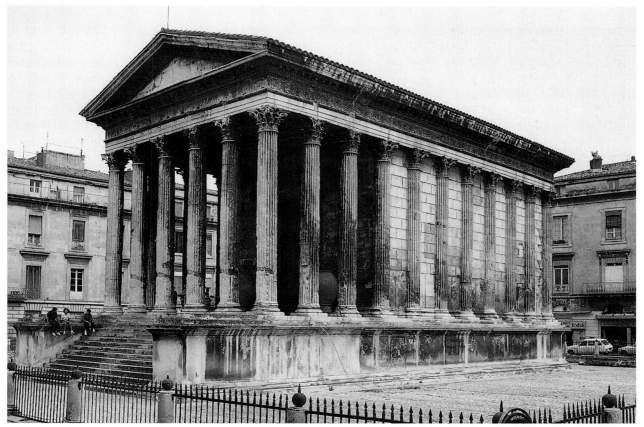

4.13 Maison Carrée, Nîmes, France, 16 BCE. Marble, base 117′ × 59′, height of podium 11′, height of columns 30′6″.

PAST AND PRESENT

Walking to Work

A clerk walking to work in ancient Rome or Ostia, its prosperous harbor city, would encounter several examples of art. Cutting through the forum of Trajan on his way to a government job, the clerk could glance at Trajan's column (see Fig. 4.10) and find among the figures depicted there someone whose garments reminded him of his home in one of Rome's distant provinces. Talking with friends in the office, the clerk might smile as he recalls the spectacular sea battle he saw enacted the day before in the coliseum. On his return home from work, the clerk may notice an advertising sign that shows a woman handing a fruit or vegetable to a customer and he may respond by buying groceries for the evening meal.

A clerk in a modern American city, on her trek from the subway station to the government building where she works, might take a shortcut through a plaza and take a fresh look the contemporary sculpture placed prominently in the center of the plaza. As she walks to the building's elevator, which carries her hundreds of feet above the street level to an office, she might glance into a courtroom where foreigners who had studied the English language and American history are about to be sworn in as citizens. On her walk home from work, the clerk could choose to put on her earphones and adjust her MP3 player to listen to the music she downloaded on her home computer the evening before. Music of all kinds, from rock to classical, is inescapable in the modern city; it plays in elevators, restaurants, offices, and even in the public restrooms. In addition, during her walk to and from the subway, colorful billboards, bus placards, electric signs, newspapers, and magazines—all designed to promote and enhance products, news, and events—compete for her attention.

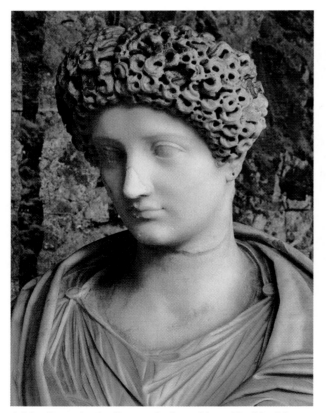

4.14 *Portrait of a Roman Lady,* c. 90 CE. Marble, life-size. Musei Capitolini, Rome, Italy.

times and began in Rome as early as the reign of Augustus. The type of statue that stood in such a temple can be seen in the portrait of Augustus that was found near Prima Porta, the villa belonging to Augustus's wife Livia (Fig. 4.1).

Much of Roman religion was a family affair, honoring the living **paterfamilias,** or "father of the family," as well as near and remote ancestors. A room in every residence was set aside for this purpose, and the custom was responsible for a uniquely Roman type of portrait sculpture. Examples range from the elegantly poised, fashionable young Roman matron (Fig. 4.14) to the calm gravity and dignity of the patrician couple who are the honored elders of their family (Fig. 4.15). In contrast to the generalized and idealized image of Augustus as statesman and imperator, these living likenesses of everyday Roman personalities are remarkably vivid and realistic. Both kinds of sculpture, however, served the same purpose: they were portraits to be honored with reverence and respect.

The emperor was believed to deserve the universal reverence of the whole Roman family because he was considered **pater patriae,** or "father of his country." Erecting a temple to a distinguished Roman emperor was done in much the same spirit as building the Washington Monument

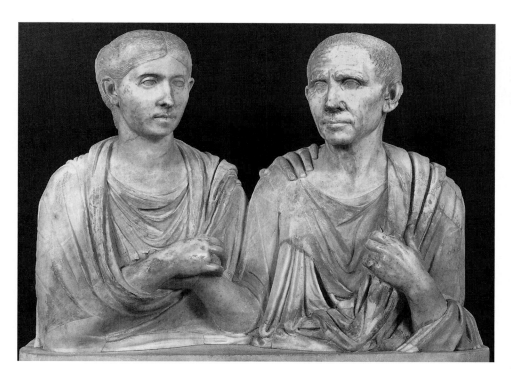

4.15 *Porcia and Cato (?),* portrait of a Roman couple, c. first century BCE. Marble, height 2′3″. Vatican Museums, Rome, Italy.

or the Lincoln Memorial in Washington, D.C. In ancient Rome, certain days were set aside for the offering of food and drink in simple family ceremonies. On the day for honoring the emperor, the rites at his temple were more formal, occasionally including animal sacrifice, a procession, festivities, and amusements. Religion to the Romans was the tradition and continuity of the family and, in the larger sense, the history and destiny of Rome itself.

With the exception of the temple, the Forum of Trajan was completed during his lifetime and was dedicated by him for the use of the people of Rome in 113 CE. Its many parts—the triumphal entrance archway, the courtyard and its equestrian statue, the market buildings, the Basilica Ulpia, two libraries, a monumental column, and the temple—add up to an architectural composition on a grand scale, designed to accommodate activities on many levels. Beginning with a shopping center and place to transact business, the forum continued with a general meeting place and the halls of justice; moved on to places for quiet contemplation, such as study in the libraries or reading history in visual form on the column; and came to rest in the precinct for honoring the emperor and worshiping the gods.

THE IMPERIAL BATHS

One of the duties of every emperor was to provide for public amusement out of his private purse. The ability to provide grand entertainments, such as re-creations of famous sea battles in the **amphitheater,** served to prove the emperor's right to rule. Only the very wealthy could afford entertainment in their own homes, so ordinary people looked beyond the home for recreation. To this end, many public baths, theaters, and stadiums were built throughout the city. To this day, the highest praise that can be given an elaborate public festival is to call it a *Roman holiday.*

The imperial baths provided far more than hot, cold, and tepid swimming pools. They also offered dressing rooms, gymnasiums, restaurants, bars, and shady walks. In addition, guests could attend plays, witness athletic contests, listen to public lectures, read in one of the libraries, or stroll about the galleries or gardens where paintings and statues were exhibited. The baths were, in short, the people's palaces. Favored also as places to show the booty and souvenirs from foreign conquests, they are the sites where much ancient statuary has been found.

Trajan added a large establishment, also built by Apollodorus, to the already existing public

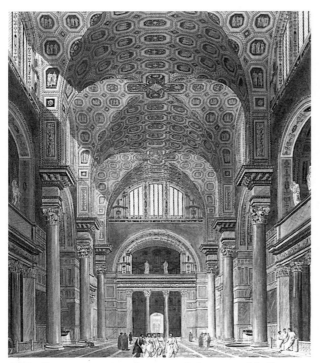

4.16 Reconstruction drawing of the central hall, Baths of Caracalla, Rome, Italy, 212–216 CE. Reconstruction drawing by Spiers.

baths. Although the ruins of his ***thermae*** (baths) are less well preserved than the later Baths of Caracalla and Diocletian, enough is known to establish a clear picture of what they were like. The large central hall was the earliest known use of concrete **cross vaulting,** which can be studied in Figure 4.22 and in the similar central hall of the

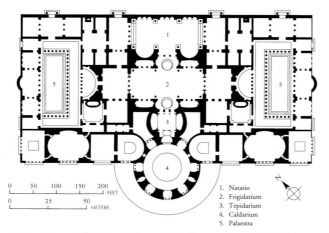

| 0 50 100 150 200 FEET |
| 0 25 50 METERS |

1. Natatio
2. Frigidarium
3. Tepidarium
4. Caldarium
5. Palaestra

4.17 Plan of Baths of Caracalla, Rome. Length 750′, width 380′.

Baths of Caracalla (Figs. 4.16 and 4.17). It measured 183 feet in length and was 79 feet wide. From the illustration, it can be seen that the barrel vault that runs lengthwise is intersected three times at right angles by shorter vaults extending across the width of the hall. Besides spanning larger interior spaces without the obstruction of supporting piers and columns, this type of construction offered the advantage of ample lighting through a **clerestory,** a row of windows in the upper part of a wall, which used thin strips of translucent yellow marble in place of glass. When erecting such huge edifices as Union Station in Washington, D.C., and Grand Central Terminal in New York City, modern architects found no better models among large secular structures than these Roman baths.

THE COLOSSEUM AND THE AQUEDUCTS

The Colosseum (Fig. 4.18), which dates from the late first century, was the scene of flamboyant forms of mass entertainment, including gory gladiatorial contests between men and wild beasts. It was called an *amphitheatre* (from the Greek words for "around" plus "theater") because its oval shape surrounded an arena. The Colosseum covers about 6 acres and could seat about 50,000 spectators. Around its circumference run some eight archways, which served so efficiently as entrances and exits that the entire bowl could be emptied in a matter of minutes. The Roman talent for organization not only is evidenced here in such practical respects but also extends to the structure and decorative design. Three architectural orders are combined in the successive stories of the same building. The attached columns on the lower range are the "homegrown" variation of the Doric, known as the Tuscan. Those on the second tier are Ionic, and those on the third, Corinthian. On the fourth tier, which rises to a height of 157 feet, are shallow, flat piers known as **pilasters,** which were executed in the Corinthian style. Between the pilasters runs a row of sockets for poles over which a canvas awning could be rolled out to protect spectators from sun and rain.

The building material of the Colosseum was a concrete made from broken pieces of brick, small rocks, volcanic dust, lime, and water. Concrete could be poured into molds of any desired shape, including channels for use in aqueducts. Originally, marble facing covered the Colosseum's exterior. The structure would be in good condition had it not been used as a quarry for building ma-

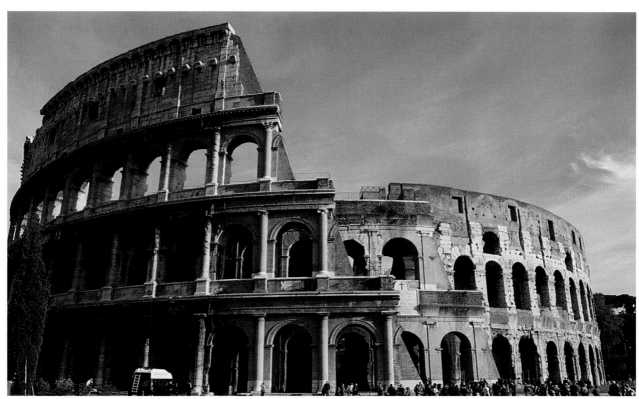

4.18 Colosseum, Rome, 72–80 CE. Long axis 620′, short axis 513′, height 160′.

terials right up to the eighteenth century. Today it is jostled by vibrations from the numerous automobiles that pass nearby. Still, the Colosseum is one of the most impressive ruins to survive from Roman times. One can see its enduring popularity as a model in football stadiums found on college campuses.

To provide enough water for his public bathing establishments, Trajan found it necessary to improve the old system of aqueducts and add a new one 35 miles long. A fine example of a Roman aqueduct is the Pont du Gard at Nîmes (Fig. 4.19), which survives from the first century CE. A system of underground and open concrete channels was

4.19 Pont du Gard, Nîmes, France, early first century. Length 902′, height 161′.

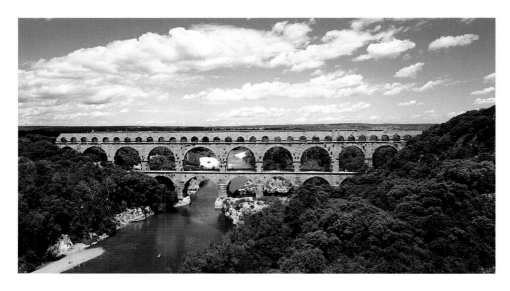

constructed to bring water from mountain sources to the town 25 miles away. Functioning on the principle of gravity, the ducts were sloped in the desired direction. In this instance the water was carried almost 300 yards across the valley at a height of more than 160 feet. The graceful lower range of arches supports a bridge, whereas the upper series of large and small arches carries the water channel.

THE PANTHEON

The Roman sense of social organization extended into the field of religion with the Pantheon (Fig. 4.20). Whereas the name might imply a temple to all the gods, in effect the Pantheon became a mirror of the Roman understanding of ideal world order. Statues were placed in niches to personify the planetary deities: Jupiter, Saturn, Venus, Mars, Mercury, the sun, and the moon. The emperor Hadrian himself is said to have had a hand in the design of this edifice, and he occasionally presided over meetings of the Roman Senate held in its splendid interior.

The Pantheon's geometry is based on the conjunction of the circle, the cylinder, and the sphere. The dome is an exact hemisphere. If completed, the whole sphere would fit precisely into the allotted interior space (Fig. 4.20B and 4.20C). It covers a circular area 144 feet in diameter, and the height of the structure is the same, thus creating the closest of all harmonic proportions, 1:1. The cylindrical base is also the height of its own radius, 72 feet, in the proportion of 2:1, thus yielding the musical octave. The proportions of the Pantheon echo the musical aspect of Plato's universe (see p. 56), as interpreted by the influential Roman author Vitruvius.

The inner surface of the dome is indented with **coffers,** panels that serve the dual purpose of diminishing the weight of the concrete and furnishing the basis for its decorative scheme. In the center of each coffer was a gilded bronze rosette or star, a motif that related the dome to the sky. A column of light descends through the **oculus,** or eye of the dome (Fig. 4.21). Like a searchlight beam signifying the all-seeing eye of heaven, it moves around the interior, varying with time of day and season, illuminating the seven planetary deities on their altars.

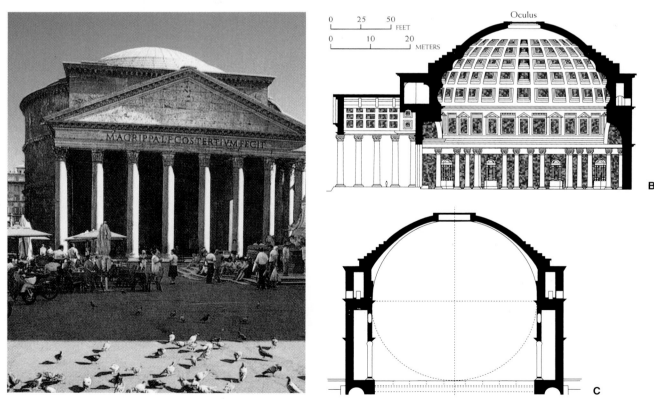

4.20 (A) The Pantheon, Rome, c. 120 CE. Height of portico 59′. (B) Plan of the Pantheon. (C) Cross section of the Pantheon.

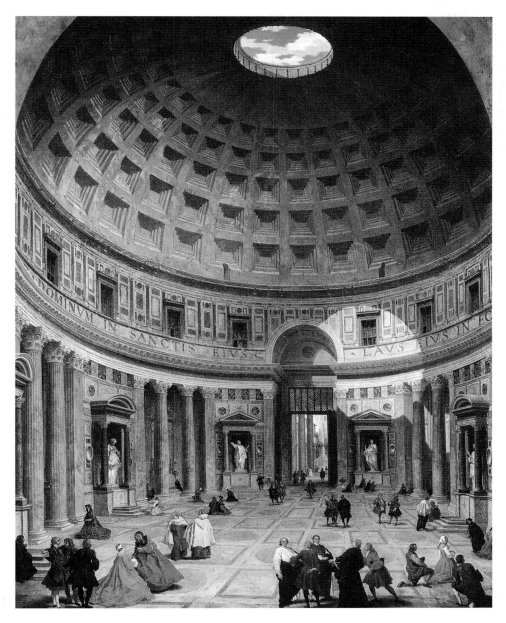

4.21 Giovanni Paolo Pannini. *The Interior of the Pantheon, Rome.* Oil on canvas, 4′2½″ × 3′3″. National Gallery of Art, Washington, D.C., Samuel H. Kress Collection, 1939.

After the fall of the Roman Empire, the Pantheon was converted into a Christian church, which accounts for its fine state of preservation. Much of the once-elegant interior, with its marbles of glowing ocher with red, green, and black contrasts, is still in place. Gone, however, are the gilt bronze rosettes that once spread across the coffered inner dome like an expanse of stars. The exterior marble veneer, the bronze plates of the portico ceiling, and the gilt bronze sheath that once covered the dome's exterior have also long since disappeared, and the stairs used by visitors are now below street level. The Pantheon's appropriateness as a place of worship, whether pagan or Christian, is clear to all who enter. The worshiper

is free to ponder the nature of the seen and the unseen and to contemplate the dome as an image of heaven. Indeed, the dome and half-dome became symbols of the universe, and the forms were incorporated into countless later Christian churches.

Despite the vicissitudes of time, the Pantheon is the best-preserved single building from the ancient world and the oldest structure of large proportions with its original roof intact. It still holds its own as one of the world's most impressive domed buildings, despite such outstanding competition as Hagia Sophia in Constantinople (see Fig. 5.14), the Cathedral in Florence (see Fig. 9.2A), St. Peter's in Rome (see Fig. 10.17), and St. Paul's in London (see Fig. 14.18). Its descendants are

many: the Villa Rotonda (see Fig. 12.4), Thomas Jefferson's home at Monticello, the rotunda he designed for the University of Virginia (see Fig. 17.11), the Pantheon in Paris, certain features of the Capitol rotunda in Washington, D.C., and the Low Memorial Library at Columbia University in New York.

THE ROMAN CONTRIBUTION TO ARCHITECTURE

The Romans' contribution to architecture was fourfold: they excelled in conceptualizing and constructing buildings for practical use. They developed the arch and vault as a structural principle. This, in turn, allowed their buildings to reach new heights. Finally, they designed interiors that responded to particular needs of the people. In the first case, Roman architecture was marked by a shift in emphasis from religious buildings to the civil engineering projects that had such an important bearing on the solutions of the practical problems of the day. Of course, buildings like the Pantheon indicate that the Romans did not neglect their shrines and temples or lack religious feeling. In the practical category, they built basilicas, aqueducts, roads, bridges, and even sewer systems, which admirably met their needs.

Second—and perhaps most important—was the Roman exploitation of the possibilities inherent in the arch. The construction of a true arch by means of wedge-shaped blocks (a process known as *voussoirs*), as well as some of the implications of the system, can be seen more easily in Figure 4.22 than explained in words. When such arches are placed in a series side by side, the resulting **arcade** can be used for such structures as aqueducts and bridges, as seen in the Pont du Gard (Fig. 4.19). When placed in a series from front to back, the result is a **barrel vault** (also called a **tunnel vault**), which can be seen in the Arch of Trajan at Benevento (see Fig. 3.21) and was useful for roofing interiors. When two barrel vaults intersect each other at right angles, as seen in Figure 4.16, the result is a **cross vault** (or **groin vault**). When a series of arches span a given space by intersecting each other around a central axis, the result is a dome, as exemplified in the Pantheon (Fig. 4.22A). Briefly put, these constitute the technical principles behind the Roman architectural achievement.

Third, through their technical advances, the Romans were able to increase the height of their buildings in proportion to the growing size of their large structures. The six-story market buildings of Trajan's Forum were an impressive demonstration of the practical advantages of such verticality, which made possible the combination of many small shops into a single structure in a crowded city location. The multifamily, multistory apartment houses in Rome and its port city of Ostia were also cases in point. The trend was to be seen, too, in the great height of the halls such as the Baths of Trajan and Caracalla and the Pantheon. The pleasing proportions resulting from such height were made possible by cross vaulting and the dome.

Last, the enclosing of large units of interior space was made necessary by the expansion of the city's population. The direction of architectural thought in meeting this need can easily be

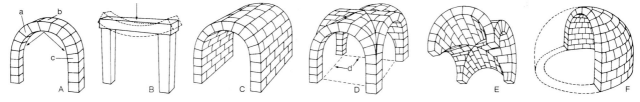

4.22 An arch is a curved structural member used to span a space between two vertical elements, such as posts (piers) or walls (A). Wedge-shaped blocks, called voussoirs (a), give the arch its form and stability by virtue of their compressed relationship to each other and to the keystone (b) at the apex of the semicircle. The curve of the arch rises from the springing on either side of the opening (c). The compression of its stone is better able to resist the downward thrust of the load above than the tensile strength of a lintel on posts (B). It does this by directing the weight in a lateral direction and by transmitting the load to the ground through the arch and the vertical elements supporting it. Placed one after the other, a series of arches make a barrel vault, or tunnel vault (C). Two tunnel vaults intersecting each other at right angles (D) create a cross vault, also known as a groin vault (so called for the groin line [E] along which the vaults join). The square or rectangular space they define is called a bay (d). Intersecting each other around a central axis, a series of arches forms a dome (F).

seen by contrasting a Greek agora (see Fig. 2.1, flat area in the upper left corner) with the Forum of Trajan, a Hellenistic theater (see Figs. 2.33 and 3.3D) with the Colosseum, or the Parthenon with the Pantheon. Special attention to space and lighting are evident in the planning of such interiors as those of the Basilica Ulpia, the Pantheon, and the halls of the great baths. In all instances, the Romans treated space as a tangible reality to be molded into significant designs.

MUSIC

The practice of poetry and music enjoyed higher favor among educated Roman amateurs than did dabbling in the visual arts. Suggesting a plan for a building or some of its decorative details was all right for a member of the patrician, or upper, class, but from then on it was the architect's and carpenter's business. Women of the patrician class may also have participated in such activities. Although women could not marry or divorce without permission from their fathers, they did enjoy authority and influence within the family. The materfamilias might run the family's investments and to a certain extent inherit money. Although there is little reliable evidence about the daily lives of poor women and men, it is certain that members of both sexes worked as artisans and in the manual trades. With sculpture and painting, wealthy people could make an impression as collectors, but the actual chiseling and painting were occupations for artisans and slaves.

When it came to writing verse or singing to the accompaniment of the lyre, however, amateurs were plentiful in the highest ranks of Roman society, including the emperors themselves. Elite women were educated and wrote poetry. Whereas Trajan's recreations seem to have been as strenuous as some of his military activities, those of his immediate successors included literary and musical pursuits. Hadrian wrote poetry in both Greek and Latin, but it remained for Marcus Aurelius to build an enduring reputation as a writer and philosopher. The emperors Hadrian, Antoninus Pius, and Caracalla were proficient on the cithara and hydraulic organ.

INSTRUMENTS AND PERFORMING GROUPS

Whereas much is known about Roman literature, no examples of Roman music survive. Our knowledge about it must be gathered from surviving musical instruments and occasional literary references, as well as portrayals of music-making in sculptures, mosaics, and wall paintings. From these sources, it is clear that the Romans heard a great deal of music and that no occasion, public or private, was complete without it.

A mosaic showing a small Roman instrumental ensemble performing in an amphitheater during a gladiatorial contest was found in excavations in North Africa (Fig. 4.23). One musician is shown playing the long, straight brass instrument known as the

4.23 *Gladiatorial Contest,* showing orchestra with hydraulic organ, trumpet, and horn players. Mosaic from Zliten, North Africa, c. 70 CE.

tuba, or trumpet. Two others are playing the circular **cornu,** or horn. Still another is seated at the **hydraulus,** or water organ. Equipped with a rudimentary keyboard and stops, this highly ingenious instrument produced sounds by forcing air compressed by two water tanks through a set of bronze pipes. Some hydrauli were 10 feet high. They were used mainly in open-air arenas, where their tone must have resembled that of the more modern calliope, which was popular in circus parades and which played tunes for merry-go-rounds.

In keeping with the Roman idea of grandeur, the size of music groups and instruments increased greatly. The writer Marcellinus described an open-air performance by hundreds of players, some of whom were said to have performed on "lyres as big as chariots." An ever-increasing volume of sound was demanded of wind instruments owing to their usefulness in warfare. Battle signals, such as advances and retreats, were relayed by means of trumpet calls. The more numerous the legions, the bigger and brassier the sound. This intensification of sound was verified by the philosopher and teacher Quintilian, who asks a typical rhetorical question and proceeds to answer it with a characteristic flourish: "And what else is the function of the horns and trumpets attached to our legions? The louder the concert of their notes, the greater is the glorious supremacy of our arms over all the nations of the earth."

MUSIC IN SPEECH AND DRAMA

Quintilian also points out some of the practical applications of music to the art of oratory. He particularly emphasizes the development of the voice, because "it is by raising, lowering, or inflexion of the voice that the orator stirs the emotions of his hearers." He describes a great speaker who had a musician standing behind him while he gave his speeches. The musician's duty was to give the speaker "the tones in which his voice was to be pitched."

Music was also a part of every theatrical performance. Whereas the Roman drama omitted the chorus that the Greeks had stressed, its dialogue was interspersed with songs accompanied by the **tibia,** an ancient wind instrument originally fashioned from the leg bone (that is, the tibia) of an animal. Such musical portions, however, were not directed by the dramatists, as they had been in Athenian dramas, but were delegated to specialists. The importance of choruses and bands for military morale was not overlooked, and a func-

tional type of military music existed in addition to trumpet calls. Popular groups played music at games and contests, and strolling street musicians were part of the everyday scene.

The fact that not a single note of any of this music exists today testifies to the fact that Roman music was primarily a performing art. Whereas practicing musicians may have composed their own songs or created variations on traditional tunes, they seem not to have been concerned with writing them down. If they had done so, the later church fathers would very likely have had these pagan melodies committed to the flames. Like much folk music that existed only in oral tradition until the coming of modern notation and recording devices, the art of Roman music died with the people who practiced it.

LITERATURE

Roman literature was slow in gaining momentum during the republic because the educated classes preferred Greek writers. That taste continued during the period of the empire. Although thoroughly Roman in its no-nonsense reflections on duty, the brevity of human life, and aversion to pleasure, Marcus Aurelius wrote his *Meditations* in Greek. Like emperors before him, he appreciatively toured Alexandria and Athens.

Early Roman playwrights, such as Plautus and Terence, wrote plays in the Greek tradition for their Latin-speaking audiences. The outstanding dramatist of the empire, Seneca, also used Greek plays as his models. After the invention of printing in the fifteenth century, these Roman playwrights enjoyed renewed popularity. English translations were made in the Elizabethan era, and Shakespeare paid tribute to Plautus by borrowing material from him for an early play, *The Comedy of Errors.*

Eventually, Roman literature shed some of its slavish imitation of Greek models and came into its own in the early years of the empire. There were philosophical authors, such as Cicero, with his expansive orations and penetrating essays, and Lucretius, with his masterly *On the Nature of Things,* which explored the scientific world in poetic meter and lordly language. There were also numerous historians. Julius Caesar's account of the Gallic Wars and Livy's *History of Rome* were required reading until the end of the nineteenth century. Tacitus provided insights into Roman life and customs, and Suetonius offered anecdotal biographies in *Lives of the Twelve Caesars.* Poetry also

excelled in Horace's lyric odes; Catullus's sensuous love lyrics; and Ovid's *Metamorphoses,* ardent love poems, and erotic *Art of Love,* which tells readers how to attract and keep a lover.

A special Roman development is found in the art of satire, as exemplified in the witty twists of Martial's epigrams and the pungent verses of Juvenal. Satire, with its ironic bite and neat turns of phrase, makes for lively and amusing reading. It also became a potent weapon for writing disguised as social and political criticism. Satiric wit and wisdom continued in the prose of Petronius, who was Emperor Nero's arbiter of elegance. His *Satyricon,* a tale of three adventurers, contains the hilarious scene of Trimalchio's feast. Trimalchio, the object of the lampoon, is a newly rich braggart who provides an extensive meal for his scoffing acquaintances. During the dinner, as he cleans his teeth with a silver toothpick, he bores them with his rags-to-riches story. The *Satyricon* was followed by Apuleius's popular *Golden Ass,* the only Latin novel to survive intact. Both works were commentaries on the follies and foibles of Nero's reign. Later picaresque stories (episodic adventure tales), such as Cervantes's *Don Quixote* and John Fielding's *Tom Jones,* owe much to the techniques developed by Petronius and Apuleius.

The climactic figure of Latin letters, however, was Publius Vergilius Maro, known to history as Virgil. His elegant *Eclogues,* or *Bucolics,* were cast in the form of dialogues sung by idyllic shepherds dwelling in an ideal rural landscape called Arcadia. It became a model for all future pastoral poetry. The *Georgics* were paeans of praise to the beauties of nature, the joy of living and working with the soil, and the importance of the farmer in the social scheme of things. Their visual counterpart can be found in the Tellus panel of the *Ara Pacis* (Fig. 4.4). Both the *Georgics* and Virgil's masterpiece, the *Aeneid,* were commissioned by Augustus, who was seeking to establish a national literature in the native tongue that would rival that of Greece.

The *Aeneid* conjures up a legendary past for Rome through the exploits and adventures of its reputed founder, the Trojan prince Aeneas. As myth has it, Aeneas's father Anchises was so handsome that he attracted the attention of the goddess Venus, and Aeneas was the fruit of their union. After the fall of Troy, the gods commanded Aeneas to abandon the flaming ruins of the city and set forth across the sea to Italy, where he was destined to found a great empire that would one day rule the world. Virgil, who was educated by Greek tutors, found his model in Homer's *The Odyssey,* and like *The Odyssey,* the *Aeneid* may be read as a voyage of the spirit. Aeneas, like Ulysses, is beset on his journey by all manner of ogres and temptresses. Despite such distractions, however, he never loses sight of his stern duty.

The epic opens with the stirring words "Arma virumque cano" (Of war and a man I sing). This opening has gripped readers ever since and is still repeated, in Latin, in contemporary science fiction tales about wars with other galaxies. In contemporary English, the poem reads:

> I sing about war and the hero who first from
> Troy's frontier,
> Displaced by destiny, came to Lavinian shores,
> To Italy—a man much travailed on sea and land
> By the powers above, because of the brooding
> anger of Juno,
> Suffering much in war until he could found a
> city
> And march his gods into Latium, whence rose
> the Latin race,
> The royal line of Alba and the high walls of
> Rome.

Aeneas is telling his tale at a feast given by Dido, the founder of Carthage, where he has been driven by a raging storm stirred up by the jealous goddess Juno. Here, after finding the love of his life, he is once more called on by Jupiter to pursue his destiny and sail onward. Dido then takes her own life, and his ship is lighted out of the harbor by the flames of her funeral pyre. Aeneas later descends into the underworld, where he learns from the shade of his dead father the shape of Rome's future:

> Let others fashion from bronze more lifelike
> breathing images—
> For so they shall—and evoke living faces from
> marble;
> Others excel as orators, others track with their
> instruments
> The planets circling in heaven and predict
> when stars will appear.
> But, Romans, never forget that government is
> your medium!
> Be this your art:—to practice man in the habit
> of peace,
> Generosity to the conquered, and firmness
> against aggressors.

At long last, Aeneas lands on Latium's shore near the mouth of the Tiber to fulfill his mission as an empire builder.

Topical allusions to the Emperor Augustus's times were plentiful in the *Aeneid.* Roman readers would have seen Aeneas as the ancestor of the first emperor, who played the role of pater patriae (Fig. 4.1), while his people became the new Trojans. Dido has been portrayed sympathetically in many later plays and operas (see p. 468) as the tragic queen abandoned by her faithless lover. But to the Romans, she was the temptress who tried and failed to seduce a Roman hero and divert him from his imperial destiny.

In her farewell to her people, Dido cursed Aeneas and called for someone to rise up and avenge her. The Romans had only to recall Hannibal, the fearsome Carthaginian warrior who crossed the Alps with his army (including elephants) on the way to laying siege to Rome itself. They would also have recalled Cato's thunderous words to the Roman senate: "Carthago delenda est" (Carthage must be destroyed). The Romans would have interpreted the burning of the city when Aeneas left as a prophecy of their ultimate victory in the Punic Wars, when Carthage was once more laid in ruins. Dido could also have been seen as a legendary version of Cleopatra, who had seduced another Roman hero, Anthony. In addition, Aeneas's exploits could have been read as an allusion to Augustus's campaign in the east, which included his triumph over Cleopatra at the Battle of Actium. Most critics have pointed out the part the poem played as imperial propaganda. This is true, but it does not dim the conception and the magnificence of the writing. In the Latin original, Virgil's majestic **hexameters** create haunting rhythms akin to magical incantations. The *Aeneid* was aptly hailed by the modern poet T. S. Eliot as the supreme classic of Western literature.

IDEAS

Roman civilization shared many of the basic ideas that produced the Hellenic and Hellenistic styles. In fact, the prevailing philosophy of the Roman patrician class was that of Stoicism and, to a lesser extent, Epicureanism (see pp. 79–80). Here, however, the discussion will center on how Roman thought affected the arts.

The Romans widened the scope of the arts to include not only works aimed at the expert but also those with mass appeal. The two ideas that differentiate the Roman style from earlier classical styles are a genius for organization and a frank spirit of utilitarianism. Both conceived of the arts as a means of popular enjoyment and the solution to practical problems.

ORGANIZATION

The Roman ability to organize is shown in the building of a systematic world order that embraced a single language, a unified religion, a unified body of laws, and a unified civilization. Military conquest was, to be sure, one of the means used. However, the allowance of a maximum of self-government to subject peoples and the latitude given to local customs, even to tribal and cult religions, demonstrate the Romans' realistic approach to governing. Their desire for external unity did not imply internal uniformity, and their frank recognition of this fact was at the root of their success as administrators.

ARCHITECTURE

With their ability to organize religious, legal, social, and governmental institutions, the Romans' greatest contribution in the arts clearly appears in architecture. This organizational spirit, moreover, is revealed most decisively in their undertaking of large public works projects, such as roads, ports, and aqueducts. The expression, "all roads lead to Rome," referred to the fact that a central milestone marked the center of the Roman Empire. Organization is also seen in their manner of grouping buildings on a common axis, as in the Forum of Trajan, which was so directly in contrast to the Hellenic idea of isolated perfection. The technical application and development of all the possibilities of construction inherent in the arch and vault is another example, as is the combination of the Ionic and Corinthian capitals to form the Composite order, the only distinctive Roman contribution to the classical orders. The Roman combination of three orders on the exterior of the same building, as in the Colosseum, also illustrates Roman organization. The development of the multifamily apartment house, the attention given to the efficient assembling and dispersing of large numbers of people in such buildings as the Colosseum, and the invention of the supermarket or mall, as in the six-story market in Trajan's Forum, are equally impressive in this regard. A final example is the erection of a supertemple to the principal gods, as in the Pantheon.

EXPANSION OF INTERIOR SPACE. The same organizational spirit is reflected in the gradual expan-

sion of interior space, as in the Basilica Ulpia, the Pantheon, and the great halls of the baths, to accommodate ever-larger numbers of people. The Greeks had defined space in planes. Thus, the exteriors of their temples were designed as backdrops for processions and religious ceremonies. In this sense, Greek architectural space was not shaped or organized in complex relationships to other buildings. In the Pantheon, however, interior space was enveloped and made palpable. The Romans recognized the possibilities of molding three-dimensional space, enclosing it and giving it significant form.

The Romans sought to enhance this spatial feeling in many ways. They exhibited sensitivity to scale and tended to design buildings in related structural units. They exploited color through the use of **polychrome,** or many-colored, marbles, which enlivened interiors and added to the perception of depth. They used illusionistic wall paintings to suggest the third dimension (Fig. 4.24). Furthermore, they gave increased attention to lighting in buildings and in paintings.

And they accomplished all this without sacrificing the classical clarity of form.

The same attitude was carried over into sculptural reliefs, where the tangibility of the spatial environment is provided in the backgrounds by means of buildings and landscapes that suggest depth. The fifth-century BCE Greek style, by contrast, consciously omitted any such frame of reference. In addition, the organization of time into a continuum, as in the spiral series on the Column of Trajan, shows a new concept of sequential order translated into a pictorial medium.

THE BROADENING APPEAL OF THE ARTS

The Roman organizational ability flourished in programs that catered to a wide range of taste in the arts. There were styles that appealed to the educated elite and styles that held the attention of the middle and lower classes. The conservative tastes of the elite embraced the tried-and-true values of Greek art. Members of the elite either collected antique statues and paintings or

4.24 View of a Garden, c. 20 BCE. Wall painting from Villa of Livia at Prima Porta, height, 6′7″. Museo Archeologico Nazionale, Rome, Italy.

commissioned new works to be executed in the older style. Exquisite Greek craftsmanship held little interest for the majority, who preferred spectacular public objects, like a large bronze equestrian statue or a monumental triumphal arch. In Trajan's Forum, allowances were made for variations in taste. Between the Greek and Latin libraries, Trajan's column told the story of his campaigns in a carefully worked-out popular visual language of symbols designed to engage the curiosity of the multitude.

The disdain of the conservative group for popular art was defended by Athenaeus, a Greek scholar and teacher who lived in Rome around 200 CE. He upheld the virtues of the older cultural tradition and often made unflattering comparisons between the higher standards of past times and those that prevailed in his own day. "In early times," he wrote, "popularity with the masses was a sign of bad art; hence, when a certain aulos-player once received loud applause, Asopodorus of Phlius, who was himself still waiting in the wings, said 'What's this? Something awful must have happened!' The player evidently could not have won approval with the crowds otherwise. . . . And yet the musicians of our day set as the goal of their art success with their audiences."

Just as in the case of architecture, sculpture, and painting, the Romans were heirs to the Greek musical tradition. The ancient theories survived in philosophical speculation, and Greek music teachers were employed in the homes of the wealthy. The only musical compositions to survive from this period are three hymns by Mesomedes, a Greek musician attached to Hadrian's court. Those who cultivated this more austere style believed that music was meant primarily to educate and elevate the mind.

Popular taste lay in quite another direction from the restraint and earnest soul-searching evident in Greek plays (see pp. 46–49). The music that Athenaeus scorned was obviously the very kind that the majority of Romans enjoyed at their public festivals, military parades, games, sporting contests, races, and to some extent, the theater. The modern parallel would be the split that exists between audiences interested in chamber music, symphony concerts, and the opera and those attracted to marching bands, Broadway musicals, rock, and rap. What the Romans' diversity accomplished was to broaden the appeal of the arts and gear them to different types of audiences. They thus succeeded in providing for the entertainment of a large city population, just as their buildings and civil engineering projects took care of the physical needs of the populace.

UTILITARIANISM

Instead of theorizing about the nature of the ideal state, as Plato did, the Romans pursued the practical aspects of governing. Speculating about the eternal verities could uplift the mind, but understanding human behavior had more immediate rewards. The Romans reached a balance based on acceptance of the Stoic doctrine of "live and let live" and the Epicurean idea of pleasure as an index of the highest good. The transfer of these concepts to the forms and policies of government meant a high degree of tolerance and the recognition that the standard of excellence in either a law or a work of art was the greatest good for the greatest number.

The construction of elegantly proportioned temples was therefore less important than the building of bridges (Fig. 4.25). Maintaining a luxurious private palace was secondary to providing public baths and theaters. A private collection of sculpture was subordinate to public exhibitions in city squares and galleries, where the statues could be seen and enjoyed by many. A play, poem, or piece of music that awakened only the sensibilities of the cultured minority did not rank as high

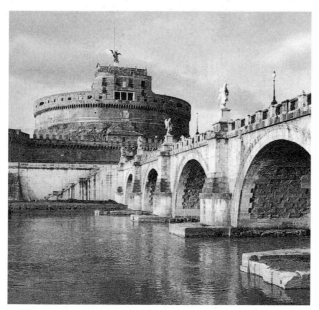

4.25 Bridge of the Angels (Pons Aelius), Rome, 134 CE. Hadrian's Tomb (Castel Sant' Angelo), 135–139 CE.

on this scale as those that were applauded by the multitude. In short, the practical arts were favored over the decorative arts, material goods superseded spiritual blessings, and utility was valued over abstract beauty (although the two are by no means mutually exclusive).

Because the Romans were little concerned with ideal forms, it was not an accident that their greatest successes occurred in the art of government rather than in the fine arts. Consequently, the art that proved most congenial to Roman aspirations was that of architecture, especially its utilitarian aspects. Building a 200-mile highway over the mountains, moving part of a hill more than 100 feet high to make way for a forum, providing a sewer system for a city of more than 1 million inhabitants, bridging the Danube at its widest point, perfecting a new building material such as concrete—all these were taken in stride.

When it came to sculpture, the Romans saw that subject matter served the purposes of the state by praising the virtues and deeds of the emperors. Epic poems such as Virgil's *Aeneid* performed a similar service in the literary medium. As Quintilian pointed out, the loud sounds of brass instruments proclaimed the glory of Roman arms.

Other applications of this utilitarianism are found in the brilliant exploitation of technical devices such as the arch and vault. The Romans' success in solving practical problems is proved by the many surviving roads, aqueducts, and bridges. In sculpture, the application of the continuous-narrative method provided a practical and psychologically functional way of telling a story. This method promoted a sense of continuity in time and anticipated later Christian and secular pictorial forms (see, for example, Figs. 8.1B and 9.19).

Effective as utilitarianism was, it had its price. The Romans built and decorated well, but the two activities somehow failed to achieve a harmonious interrelationship. This is well illustrated by the somewhat hollow claim of Augustus that he found Rome a city of brick and left it a city of marble. Actually, Rome was still a city of brick, stone, and concrete under an Augustan marble veneer. None of these materials needs a disguise, or even an apology, as is proved by the rhythmic grace of the functional arches of the Pont du Gard. Hence, Augustus had no need to imply that Roman structures such as the Pantheon were solid marble like the Greek Parthenon. As a whole, then, Roman architecture was at its best when it stuck to its forthright utilitarianism, undertook vast engineering projects, and successfully solved practical problems of construction.

THE ETERNAL CITY

Rome became an empire long before Augustus assumed the title of emperor. To maintain the lavish lifestyles of the wealthy, the Romans adopted an expansionist policy toward foreign cultures. Expansion allowed the Romans to gather riches in the form of tribute and property, as well as the many foreign slaves who were forced to work the large agricultural estates that provided food for the burgeoning city of Rome. It has been estimated that 2 million of the 6 million inhabitants of Italy were slaves. During the second century, the empire reached its greatest extent, covering most of Europe, North Africa, and western Asia. It influenced even more people beyond its official borders, who were drawn to the outskirts of the empire to provide goods and services for an ever-increasing population.

The more restrained classical purity of older cultural centers, such as Athens and Pergamon, did not exert much influence on the forms of Western art until the archeological discoveries of the eighteenth and nineteenth centuries. All intervening phases of classicism, if not content, were, in effect, revivals of the Roman style. With the establishment of Roman building methods, Western architecture was firmly set on its course, and it steered in substantially the same direction until the technological discoveries of the nineteenth and twentieth centuries made new approaches to architecture possible. Consequently, it must again be emphasized that Rome was the gateway through which all the styles, forms, and ideas of Mediterranean civilization passed in review. After being transformed by the process of selectivity—and flashes of genuine originality—into a uniquely Roman expression, they proceeded by way of the new Roman imperial capitals of Byzantium in the East and Ravenna in the West.

Rome in imperial times was also the western center of Christendom after the first century. Because Christians were occasionally persecuted, Christian art was often hidden in underground passages known as **catacombs.** Later, when Constantine legalized Christianity with the Edict of Milan in 313, large churches known as basilicas

were built. Surviving from this time are many elaborately carved marble tombs, or sarcophagi, depicting biblical subjects (see Fig. 5.2).

When Rome declined as the center of world empire, it still remained the capital of Christendom. As objects of pilgrimages, its architectural, sculptural, and literary monuments were bound to exert a massive influence on those who were drawn toward the city. Because of this enduring preeminence, no important Western city exists without a bit of Rome in it. It is therefore with full justification that Rome has been and continues to be called the Eternal City.

YOUR RESOURCES

- ***Exploring Humanities CD-ROM***

 ○ Interactive Map: The Roman World

 ○ Readings—Virgil, Book 1 *Aeneid;* Horace, *Ode 11;* Livy, Book I of the *Histories;* Tacitus, *Annals of Imperial Rome*

- ***Web Site***

 http://art.wadsworth.com/fleming10

 ○ Chapter 4 Quiz

 ○ Links

CHRONOLOGY

ROMAN PERIOD: REPUBLIC AND EARLY EMPIRE

Key Events	Architecture	Literature
753 BCE Legendary date of **Rome's founding** 616–c. 509 BCE **Etruscan period;** Tarquin kings reigned c. 509 BCE **Roman Republic** founded; Tarquins dethroned		
500		
c. 450 BCE **Romans** colonized Italy 390 BCE **Gauls** sacked Rome 280–275 BCE **Greek power** in Italy weakened 264–241 BCE **First Punic War;** Rome annexed Sicily, Corsica, Sardinia 218–201 BCE **Second Punic War;** Hannibal invaded Italy, Carthage ceded Spain to Rome		c. 254–184 BCE **Plautus,** comic poet and dramatist
200		
150–146 BCE **Third Punic War;** Carthage destroyed, African province created 133 BCE **Pergamon** bequeathed to Rome		c. 185–159 BCE **Terence,** Roman senator and writer of comedies 106–43 BCE **Cicero,** statesman, orator, essayist
100		
100–44 CE **Julius Caesar;** conquered Gaul (58–51); crossed Rubicon, occupied Rome, became dictator (49); founded Julian family dynasty of future emperors; campaigned in Egypt, Asia Minor, Africa, Spain (48–45); Julian calendar (45); assassinated (44) 43 BCE **Second Triumvirate** formed; Anthony, Octavian, Lepidus 31 BCE **Naval battle at Actium; Anthony and Cleopatra** defeated; Octavian master of Rome 27 BCE–14 CE **Roman Empire** founded; **Octavian** reigned as Caesar Augustus 4 BCE **Birth of Jesus**	c. 48 BCE **Forum of Julius Caesar** begun 27 BCE–14 CE **Augustus** built new forum, *Ara Pacis,* Mausoleum of Augustus, Baths of Agrippa, Theater of Marcellus, Basilica Julia c.16 BCE **Maison Carée** built at Nîmes, France	c. 100–44 BCE **Julius Caesar,** military leader and historian, wrote *Gallic Wars* c. 96–55 BCE **Lucretius,** poet, philosopher, wrote *On the Nature of Things* c. 84–54 BCE **Catullus,** lyric poet 70–19 BCE **Virgil,** wrote the *Aeneid, Eclogues, Georgics* 65–8 BCE **Horace,** wrote *Odes* 59 BCE–17 CE **Livy,** wrote *History of Rome* 43 BCE–17 CE **Ovid,** wrote *Art of Love, Metamorphoses* c. 50–c. 10 BCE **Vitruvius** active, wrote treatise *De architectura* 3 BCE–65 CE **Seneca,** philosopher, dramatist
CE		
54–68 CE **Nero** reigned 70 CE **Titus** took Jerusalem; temple destroyed 79 CE **Vesuvius** erupted; destroyed Pompeii, Herculaneum 79–81 CE **Titus** reigned 96–180 CE **Antonine Age,** or "Era of Five Good Emperors"; Roman Empire at height of power 98–117 CE **Trajan** reigned; Dacian campaigns (101–106); conquered Armenia, Parthia; Empire extended to Persian Gulf and Caspian Sea (113–117)	c. 10 CE **Pont du Gard** built at Nîmes, France c. 60 CE **Nero** built Domus Aurea, Baths of Nero c. 80 CE **Titus** finished Colosseum; built Temple of Vespasian, Arch of Titus	c. 20–66 CE **Petronius,** wrote *Satyricon* 23–79 CE **Pliny the Elder,** naturalist, encyclopedist c. 50–138 CE **Epictetus,** Stoic philosopher 35–c. 96 CE **Quintilian,** Institutes of Oratory 40–c. 102 CE **Martial,** epigrammatist c. 46–120 CE **Plutarch,** wrote *Parallel Lives* 55–c. 117 CE **Tacitus,** historian, wrote *Annals, Germania* c. 60–c. 127 CE **Juvenal,** wrote *Satires* 62–113 CE **Pliny the Younger,** writer, administrator; delivered Panegyric to Trajan before Roman Senate (100) c. 67–c. 140 CE **Suetonius,** wrote *Lives of the Caesars*
100		
117–138 CE **Hadrian** reigned 138–161 CE **Antoninus Pius** reigned 161–180 CE **Marcus Aurelius** reigned	c. 100–c. 120 CE **Apollodorus of Damascus,** architect, active c. 50 CE **Harbor at Ostia** constructed 105 CE **Apollodorus of Damascus** constructed bridge over Danube River c. 110 CE **Trajan** constructed Via Trajana from Benevento to Brindisi; Baths of Trajan built; Forum and Column of Trajan erected 113 CE **Arch of Trajan** at Benevento begun 117 CE **Temple of Olympian Zeus** at Athens completed under Hadrian c. 120 CE **Pantheon** built at Rome 120–127 CE **Villa of Hadrian** at Tivoli built 135 CE **Hadrian's Tomb** built in Rome 211–217 CE **Baths of Caracalla** built in Rome c. 298–306 CE **Baths of Diocletian** built in Rome	c. 160 CE **Apuleius** flourished, philosopher, wrote *Golden Ass* c. 175 CE **Marcus Aurelius,** wrote *Meditations*

300

EDICT OF MILAN, 313
FOUNDATION OF CONSTANTINOPLE, 324

400

HONORIUS MOVES CAPITAL OF ROME TO RAVENNA, 404

500

SAINT BENEDICT ESTABLISHES BENEDICTINE RULE FOR MONASTERIES, 529

700

MUSLIMS DEFEAT VISIGOTHS IN SPAIN, 711
CHARLES MARTEL DEFEATS MUSLIMS AT POITIERS, 732
CHARLEMAGNE, R. 768–814, CROWNED EMPEROR IN ROME, 800

900

CLUNIAC ORDER FOUNDED, 910

1000

NORMAN CONQUEST OF ENGLAND (BATTLE OF HASTINGS), 1066
POPE URBAN II PREACHES THE FIRST CRUSADE, 1095
CRUSADERS CAPTURE JERUSALEM, 1099

AFTER ROME: EARLY CHRISTIAN, BYZANTINE, AND MEDIEVAL STYLES

Historians once used the phrase "Dark Ages" to refer to the 1,000-year span between the fall of Rome and the revival of classical learning in the Renaissance. Of course, the era was not dark in the sense of being unknowable or unprogressive. It did, however, seem like a near-void separating the classical world of Greece and Rome from the revival of classical learning in the Renaissance. Happily, the notion of the Dark Ages was whittled away over time as research defined a rich post-Roman era.

This period was characterized by multiple and shifting cultural and political centers, whose instability can be traced to the division of the empire at the height of its powers. In the second century, Emperor Diocletian separated the empire into eastern and western divisions. Soon after Constantine officially recognized Christianity, he moved the capital from Rome to Byzantium, which was renamed Constantinople. The East Roman Empire remained a powerful force until Constantinople fell to the Ottoman Turks in 1453.

The move to the east further weakened the economy and public services of the city of Rome. Germanic tribes, whom the Romans had called barbarians, flourished in proximity to the Empire's margins. As the western Empire weakened and could not defend its borders, the tribes took advantage of the power vacuum and settled in Roman territory. Often, they converted to Christianity. The Germanic tribes moved farther inward as waves of other migratory peoples, such as the Huns, moved into middle Europe. The power of the western empire continued to erode, especially when Emperor Honorius abandoned the city of Rome. Soon after, in 410, one of the barbarian tribes, the Goths, lay siege to Rome and sacked the city.

In the West, the development of Early Christian art overlaps the apex, decline, and fall of the western empire. The history of the former western empire includes an unsettled period of migration and war (550–1100) as Germanic tribes set up kingdoms and people from the north, known as Vikings (or Norsemen, and eventually Normans), plundered the western coasts of Europe. Islam, which dates to 622, when the prophet Muhammad

fled Mecca for Medina, expanded during the next two centuries throughout Arabia and North Africa and extended eastward all the way to India. In Europe, it expanded into Spain and parts of France. In what is now Germany, the Carolingian and Ottonian empires (750–1000) emerged. The Romanesque phase (1000–1150) witnessed the growth of church power throughout Europe. During the next period, the Gothic (1150–1400), the power of the church combined with the influence of prosperous towns to create unique European landmarks known as Gothic cathedrals.

Although imprecise, the word *medieval* is generally used to describe this cluster of developments in western Europe from about 500 to about 1300, which includes the rise of monasticism, feudalism, the building of cities, the beginnings of the Crusades, and the emergence of national monarchies. Art was almost exclusively under the patronage of the church. Yet new voices could be woven around the traditional tunes, a practice that allowed musicians wide latitude.

The Romanesque period saw people embarking on pilgrimages to shrines in Rome, Jerusalem, and Santiago de Compostela. Gothic times witnessed the rise of cities in northern Europe. Here merchants and artisans became distinct social groups, organizing into guilds, similar to trade unions, that regulated prices, established codes governing business practices, and ensured quality of production.

This era mirrors the inventive power and inspired spirit of the people who participated in it. The creation of such marvels as the immense abbey churches, the organization of the Crusades that initiated contact and conflict between the peoples of the Christian West and Muslim East, the building of the soaring Gothic cathedrals, the intricate logic of scholastic treatises that systematized the articles of faith into monumental edifices, the founding of universities, the invention of liturgical dramas and miracle plays, the fiery magic of stained glass that transformed natural light into supernatural visions, and the otherworldly sounds of plainchant all combine into a magnificent panorama of the arts.

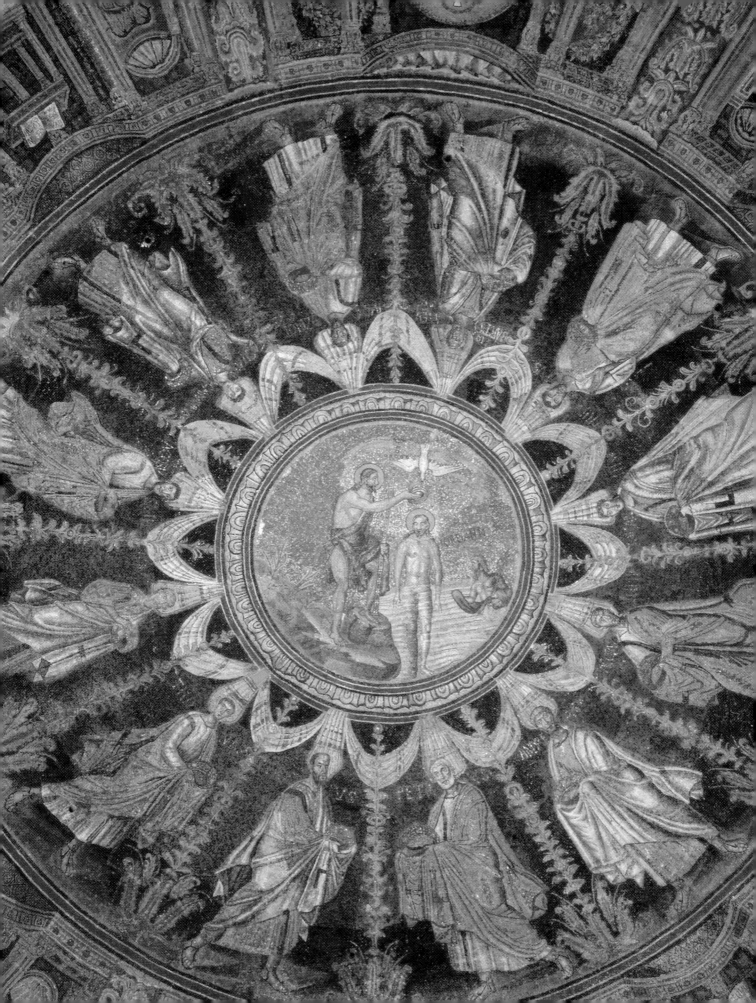

EARLY CHRISTIAN, BYZANTINE, AND ISLAMIC STYLES

IN THE EARLY DAYS OF the empire, Christianity was to the Romans only one of many mystery cults that promised a better life beyond the grave. Eventually it was the only one to survive. It spread gradually beyond Italy into North Africa, Spain, France, and Britain. Early converts were mainly from the dispossessed and downtrodden masses, although some were drawn from the patrician and educated classes. With the acceptance of slaves and women into their communities, Christians gained momentum until their religion became a force to be reckoned with. Because Christians believed in peace and goodwill, most refused to

pay homage to the emperor or serve in the imperial armies. Consequently, they were periodically persecuted.

In 303, in an attempt to stem the rapid spread of Christianity among his subjects, Emperor Diocletian launched the final official suppression of the faith. Just 10 years later his successor, Constantine, issued the Edict of Milan, which recognized Christianity as one of the official state religions of the empire. It was now possible for Christians to worship openly. With Constantine's financial support, an extensive building program was undertaken in Rome that included the

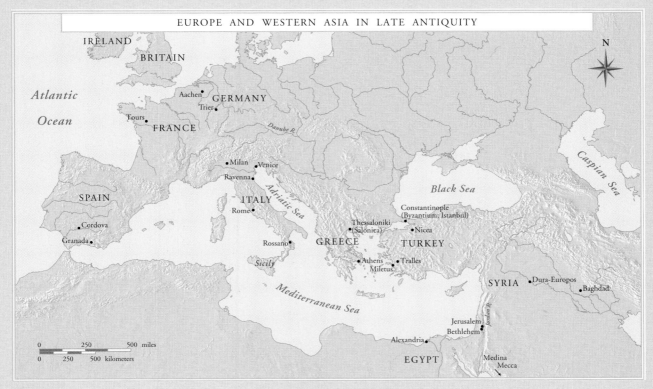

EUROPE AND WESTERN ASIA IN LATE ANTIQUITY

MAP 5.1

basilicas of St. Peter in the Vatican (see Fig. 5.6) and St. Paul Outside-the-Walls. The church of Santa Maria Maggiore, built by Pope Sixtus III, also used the Roman basilica plan. Thus, Christian art, architecture, and music became more visible to the citizens of Rome.

THE ART OF THE EARLY CHRISTIAN ERA

At first, Christianity was of necessity an underground religion, both literally and figuratively. Believing in the resurrection of the body, Christians departed from the Roman practice of cremation. Nevertheless, they followed the Roman practice of extending aboveground cemeteries into underground facilities and dug burial chambers in catacombs. Although meetings were held mostly in private homes, during periods of persecution, the underground burial chambers were also used as meeting places for secret communal meals. Decorative art not only was beyond the financial means of Early Christians but also was considered too worldly. Some slave converts, however, had artistic skills, and they were allowed to paint the walls with Christian symbols and visual versions of Old and New Testament stories that illustrated the teachings of the church for those who could not read (Fig. 5.1).

Favorite subjects were Christ as the good shepherd leading his flock, as in the Twenty-third Psalm, vineyard scenes that referred to the communion wine, and Old Testament stories that were reinterpreted with new meaning. The story of Abraham sacrificing Isaac was seen as a prophecy of Christ's sacrificial mission. The tale of Jonah being thrown overboard, spending 3 days in the belly of a great fish, and finding himself on a peaceful shore under the shade of a green gourd vine was seen as the journey of the soul after death toward refuge in heaven. Daniel's rescue from the lions' den, like that of the three youths from the fiery furnace, meant redemption through suffering and deliverance through the power of faith.

Some sarcophagi carved after Christianity became legal show a consummate craftsmanship

5.1 *The Good Shepherd,* c. fourth century. Painted ceiling, Catacomb of Saints Pietro and Marcellino, Rome, Italy.

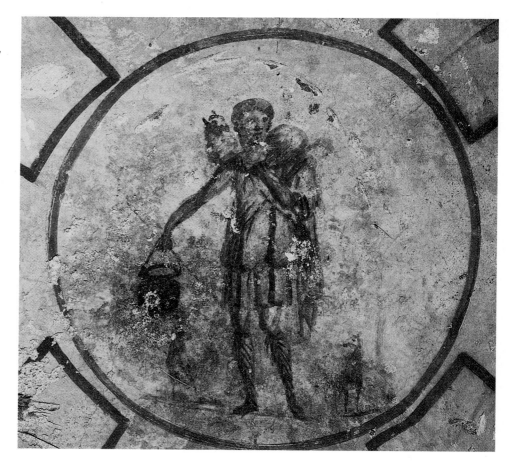

that set them apart from catacomb paintings and forged a link between pagan Roman and Early Christian art. The sarcophagus of Junius Bassus, a Roman prefect, is a prime example (Fig. 5.2). In the upper register, from left to right, are high-relief panels showing Abraham as his hand is stayed by a messenger from God, the arrest of Peter, and Christ enthroned in majesty between Sts. Peter and Paul. Under Christ's feet is the canopied Roman sky god, Coelus, who signified the firmament or, in Christian terms, the heavenly realm. Here, a specific Roman god has been brought into a Christian work. The Roman use of scale to indicate social stature (see p. 89) has been employed, particularly in the image of Christ in the center of the lower register.

The crucifixion of Christ, central to the idea of redemption, was seldom represented in Early Christian art. Still, it was alluded to in the sarcophagus of Junius Bassus, in the upper fourth and fifth panels from the right, which depict Jesus being judged by Pontius Pilate. On the lower left are panels showing Job's sufferings, as well as Adam and Eve with the tree of knowledge and the serpent between them. The scene makes refer-

ence to original sin by showing Adam and Eve nude but ashamed of their bodies, as they were not in Paradise. Next come Christ's triumphal entrance into Jerusalem, Daniel in the lions' den, and finally, St. Paul being led to his execution. For clarity, the scenes are framed by classical colonnettes. All the figures except Adam and Eve are draped in Roman togas. Christ, however, is accorded the honor of the Greek *pallium,* a robe associated in classical times with teachers and philosophers. The youthful representation of Jesus also recalls images of the young Apollo (see, for example, Fig. 3.20).

A decisive event in Early Christian history was the convening of the Council of Nicaea (now Iznik, Turkey) by Constantine in 325. Here the basic tenets of the Christian faith were debated and coordinated by leaders from both the West and the East. The most controversial issues were the nature of the godhead and the doctrine of the Trinity. Was Jesus, as the only begotten son of God, of one substance with the Father and hence purely divine? Or, because he was begotten, was he both divine and human? Or was he all human? As professed in the Nicene Creed,

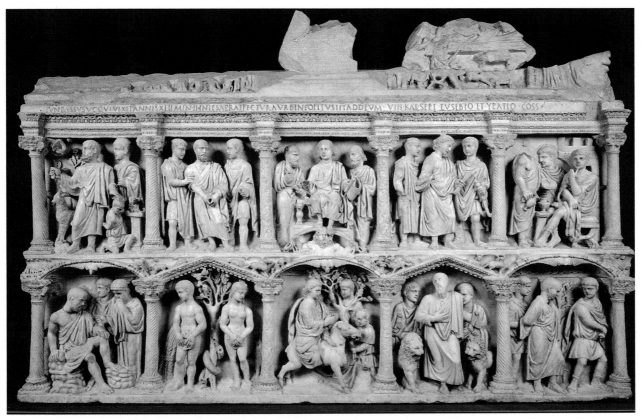

5.2 Sarcophagus of Junius Bassus, c. 359. Marble, 3′10½″ × 8′. Museo Storico del Tesoro della Basilica di San Pietro, Rome, Italy.

Jesus was believed to be "of one substance with the Father, by whom all things were made."

The major dissenter was Arius of Alexandria, who held that Jesus was the most perfect of men but not of one substance with the Father. Arius was excommunicated, and his followers were declared heretics. The Arians, however, continued to make converts, especially among the peoples of the Danube Valley, including the Ostrogoths. Their leaders at the time were Odoacer and Theodoric, who finally brought about the fall of the Western Roman Empire by capturing Ravenna, its capital city. The Eastern Roman Empire survived, but it was challenged by the birth of a powerful new religious movement, Islam. Both religions established a structure that favored authoritarian leadership and, at the same time, relied on otherworldly mysticism.

RAVENNA IN THE LATE FIFTH AND EARLY SIXTH CENTURIES

Many old Roman coins bear the inscription *Ravenna Felix* (Happy Ravenna). By a felicitous stroke of fate, this previously unimportant little town on Italy's Adriatic coast became the cultural center where many of the great political, religious, and artistic dramas of a century and a half of world history were enacted.

Ravenna was, in turn, the seat of the last Roman emperors of the West, the capital of a barbarian Ostrogothic kingdom, and the western center of the Eastern Roman Empire. A more inhospitable site can hardly be imagined. To the east lay the Adriatic Sea, to the north and south were wide deltas of the Po River, and the only land approach was through marshes and swamps. Yet when the barbarian hordes had Rome under almost constant siege, it was this very isolation that led Emperor Honorius to abandon the city in 402 and seek at Ravenna a fortress where his hard-pressed legions could be supplied by the Eastern Roman Empire through the nearby port of Classe.

Even with all its natural advantages, Ravenna could hold out against the barbarians only until 476. Odoacer then succeeded in entering the all-but-impregnable city and putting an end to the Western Roman Empire. The Ostrogothic kingdom of Theodoric, Odoacer's successor, was even more short-lived. Ravenna fell once again in 540, when the armies of the Eastern Roman Empire under Justinian conquered the Italian peninsula and for a brief time reunited the old empire. Meanwhile, a third force, the more enduring

power of the Roman papacy, was becoming increasingly influential. Despite its opposition to the Roman Empire, Catholicism eventually emulated the orderliness and hierarchy that had allowed Rome to maintain its vast domain. With the decline and fall of Rome, the Catholic Church emerged as an international organization, with Latin as its international language and Roman roads providing its means of communication. Like Rome, the Catholic Church struggled with the pressures of diverse cultures and interests.

Distinct historical traditions as well as great distances separated Rome in the west, Byzantium in the east, and the nomadic Ostrogoths in the north. Early in the fourth century, after making Christianity an official state religion, Emperor Constantine moved his court to Byzantium, christening the city the "new Rome." This second capital was later renamed Constantinople in his honor. Soon the Eastern and Western Roman Empires went their separate ways. With the encroachment of northern barbarians, a three-way struggle for power began among Justinian, Theodoric, and the pope.

Much more than the sea stretched between Ravenna and Constantinople; high mountains stood between it and the restless northern barbarians, and great obstacles separated it from Rome. As the foundations of Christian belief were being drawn up, theological barriers, in fact, proved more impassable than seas or mountains. The controversies in Ravenna foreshadowed the later separation of Christianity into Eastern Orthodox and Roman Catholic. Paralleling the political and religious controversies, a conflict of art styles took

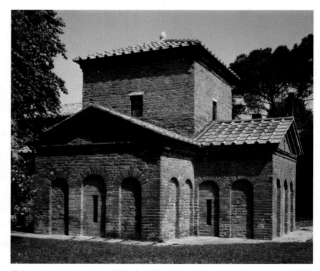

5.3 Mausoleum of Galla Placidia, Ravenna, Italy, c. 425.

place within Ravenna as successive rulers built and embellished the city. In the sixth century, Ostrogothic Arian heretics, Byzantine patriarchs, and members of the Roman hierarchy, together with the schools of artists each patronized, had different cultural heritages, aesthetic goals, and ways of viewing the world.

When the Roman Empire was united, cultural influences came from all parts of the Mediterranean world, and with due allowance for regional diversity, Roman art achieved a recognizable unity. But with the disintegration of Roman power, the adoption of Christianity as an official religion, and the separation of the empire into eastern and western centers, a reorientation in the arts took place. Although they shared a common heritage, two distinct styles began to emerge. The term *Early Christian* designates the Western art of this time, and its Eastern counterpart is referred to as *Byzantine.*

Ravenna's replacement of Rome as the capital city demanded successive building programs, which transformed a minor provincial town into a major metropolis. No ruler could afford to be outdone by his or her predecessors. Each embarked on a vigorous building program. Empress Galla Placidia, for instance, sponsored a church, one part of which was long thought to be her tomb (Fig. 5.3). Although she probably was not buried there, the little chapel continues to be known by its traditional designation. The unadorned brick exterior of the Mausoleum of Galla Placidia does not hint at the ornate interior of this architectural gem, which is completely lined with mosaic work of surpassing brilliance. The area over an entrance is decorated with a portrayal of the youthful Christ as the Good Shepherd in the midst of his flock (Fig. 5.4). Later, when Theodoric came to power, he sought to be more Roman than the Romans. As he wrote to an official in Rome, he wished his age to "match the preceding ones in the beauty of its buildings." After the Byzantine conquest, Justinian made architectural contributions matching his imperial rank.

RECTANGULAR CHURCHES

Theodoric included in his building program a church that would serve his own Arian sect. Originally dedicated by him to "Our Lord Jesus Christ,"

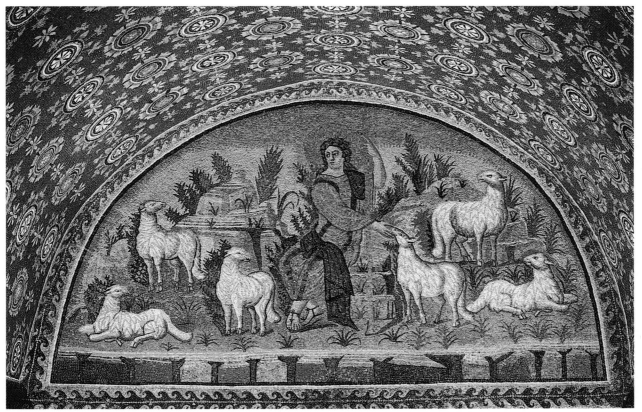

5.4 *Christ as the Good Shepherd,* mosaic above entrance portal, interior of mausoleum of Galla Placidia, Ravenna, Italy, 425–450.

this church (Fig. 5.5A) today bears the name of Sant' Apollinare Nuovo, honoring Apollinaris, the patron saint of Ravenna and, by tradition, a disciple and friend of St. Peter. The floor plan is severely simple (Fig. 5.5B). The space is divided into a vestibule entrance, known as the ***narthex;*** a central area for the congregation to assemble, known as the ***nave,*** which is separated from the side aisles by two rows of columns; and a semicircular ***apse,*** which framed the altar and provided seats for the clergy.

Older pagan temples, with their small, dark interiors, were not suitable models for Christian churches that had to house large congregations. Ancient Greek ceremonies took place outdoors around an altar with the temple as a backdrop. The principal architectural and decorative elements of the classic temples—colonnades, friezes, and pediments—faced outward. The Christian basilica turned the Greek temple outside in, leaving the exterior plain and focusing attention on the interior colonnades and the painted or mosaic embellishments of the walls and semidomed apse.

The most monumental of these Early Christian basilicas was Old St. Peter's (Fig. 5.6), so called because it was destroyed in the sixteenth century to make way for the present basilica created by Bramante, Michelangelo, and Maderno (see Fig. 10.1). Planned from the year 324, when it was dedicated by Constantine, built over the presumed tomb of the Apostle, and the largest church of the period, Old St. Peter's ranked as

the key monument of Western Christendom until its demolition. It could hold 3,000 to 4,000 worshipers, some of whom would have been pilgrims who traveled to see the relics of St. Peter.

To provide for all Christian liturgical activities, Old St. Peter's intertwined elements of Roman domestic, civic, and temple architecture in a new harmonious composition. Approached by a flight of steps, the open **atrium** was entered through an arched gateway. This courtyard, derived from Roman country villas, was surrounded by roofed **arcades,** or series of arches, supported by columns. It provided space for congregations to gather, facilities for the instruction of converts, and offices for church officials. In its center was a fountain for the ceremonial washing of hands. The side of the atrium toward the church became the narthex, which served as a frontispiece to the church proper. Through the portals of the **narthex,** one entered into the nave and the side aisles. This spacious nave was 80 feet wide and resembled the rectangular law courts of Roman public basilicas (see Fig. 4.10B). It was flanked on either side by two aisles, each 30 feet wide, and a procession of columns that led the eye along its 295-foot length to the **triumphal arch** (so called because of its derivation from similar Roman imperial structures, such as that in Fig. 3.21). Beyond this was the wide **transept,** "arms" set at right angles to the nave and an area that functions as a second nave, followed by the semicircular apse. In sum, the ground plan was

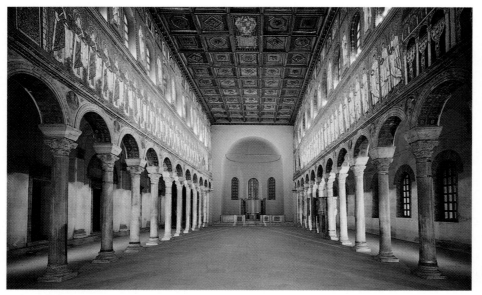

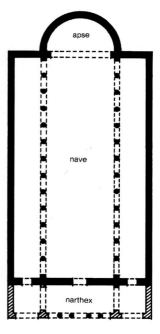

A

5.5 (A) Interior, Sant' Apollinare Nuovo, Ravenna, Italy, c. 493–526. (B) Plan of Sant' Apollinare Nuovo.

B

roughly T-shaped or cruciform, resembling a long Latin cross with short arms. From beginning to end, the design of Old St. Peter's swept along a horizontal axis of 835 feet and opened out at its widest point in the 295-foot transept.

A basilica rises vertically above the nave colonnades through an intermediate area called the **triforium.** Above this is the **clerestory,** with rows of windows to light the interior and masonry to support the wooden beams of the shed roof. In keeping with the sheltered and inward orientation of these early basilicas, no windows offered views of the outside world. Those in the clerestory were too high and deeply set to allow even a glimpse of the sky. It was inner radiance of the spirit rather than natural light that was sought.

EARLY CHRISTIAN AND BYZANTINE MOSAICS

Unlike Old St. Peter's, which had to accommodate a standing congregation of 4,000 or more, Sant' Apollinare Nuovo (Fig. 5.5A) is small. It was originally designed as the private chapel of Theodoric's palace. Only the nave remains intact; all other parts are restorations or later additions. Its modest architecture would attract only passing attention. However, the magnificent mosaics that decorate its nave wall are of major importance in art history.

The art of mosaic depends for its effectiveness on directing the flow of light from many tiny reflectors. After the placement of the panels, the design, and the colors have been determined, the

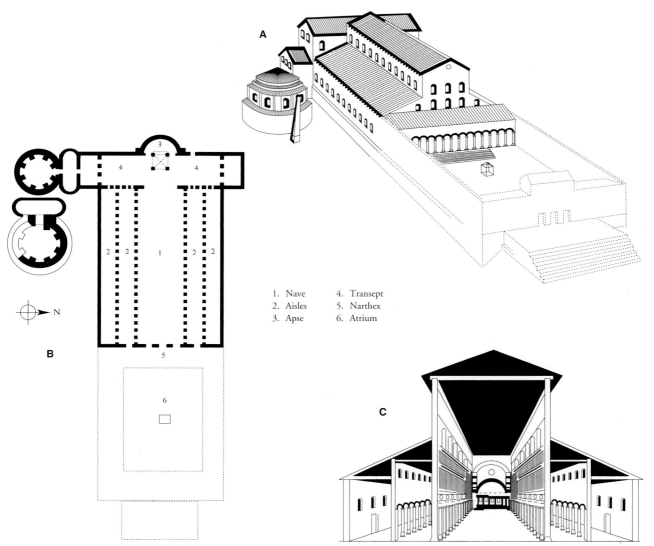

1. Nave 4. Transept
2. Aisles 5. Narthex
3. Apse 6. Atrium

5.6 Reconstruction of Old St. Peter's Basilica, Rome, c. 333. Length of grand axis 835′, width of transept 295′. (A) Restored view. (B) Floor plan. (C) Interior section.

mosaicist must take into account both the natural source of light from windows and artificial sources from lamps or candles. Accordingly, the mosaicist fits each *tessera,* or small cube made of glass, marble, shell, or ceramic, onto an adhesive surface, tilting some this way, others that, so that a shimmering luminous effect is obtained.

Although they present a harmonious design, the mosaics at Sant' Apollinare Nuovo actually were made in two different phases and styles. The mosaics of the earlier period were commissioned by Theodoric and made in the style of Early Christian art in Rome. Through his secretary Cassiodorus, Theodoric wrote to an official in Rome that he should send "some of your most skilled marble workers, who may join together those pieces which have been exquisitely divided, and connecting together their different veins of color, may admirably represent the natural appearance." After Justinian's conquest, the church was rededicated and references to Arian beliefs and Theodoric's reign were removed. Half a century later, part of the frieze above

the nave arcade was replaced by mosaics in the Byzantine style.

Completely covering both walls of the nave, the mosaic work is divided into three bands (Fig. 5.5A). Above the nave arcade and below the clerestory windows, a wide, continuous mosaic strip runs the entire length of the nave in the manner of a frieze. It depicts two long files of saints (the Byzantine part) moving in a majestic procession from representations of Ravenna on one side to its seaport Classe on the other (the Early Christian part). The second band fills the space on either side of the clerestory windows with a series of standing toga-clad figures.

At the top level, panels depicting incidents in the life of Christ alternate with simulated canopy-like niches over the figures standing below. The middle and upper bands are of Roman craftsmanship. The scenes in the upper band constitute the most nearly complete representation of the life of Christ in Early Christian art. On one side, the story of the parables and miracles is told, among them

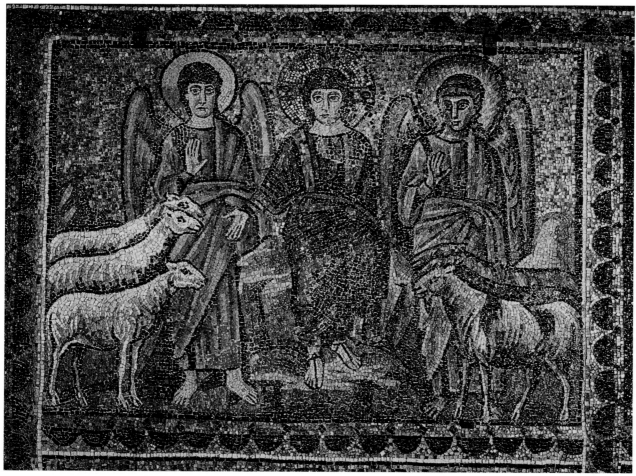

5.7 *Good Shepherd Separating the Sheep from the Goats,* c. 520. Mosaic, Sant' Apollinare Nuovo, Ravenna, Italy.

the *Good Shepherd Separating the Sheep from the Goats* (Fig. 5.7), a reference to the Last Judgment. In this and other scenes, Christ appears youthful and unbearded, with blue eyes and brown hair. The opposite side presents scenes of the Passion and Resurrection. The *Last Supper* (Fig. 5.8) shows Christ as a mature and bearded figure reclining with the apostles in the manner of a Roman banquet. In all instances, Christ has a cruciform halo with a jewel on each arm of the cross to distinguish him from the attending saints and angels. His dignified demeanor and purple cloak show him in royal majesty.

Standing like statues on their pedestals, the figures in the middle band are modeled three-dimensionally in light and shade and cast diagonal shadows. They apparently were once identified by inscriptions over their heads. The removal of their names suggests that they may have been prophets and saints revered by the Arian Christians.

The great mosaic frieze above the nave arcade starts to the left and right of the entrance with representations of Classe and Ravenna, respectively. In a crescent-shaped harbor with three Roman galleys riding at anchor, Classe is seen between two lighthouses. Above the city walls, some of the ancient buildings are discernible, and from the gate issues a procession of virgin martyrs.

On the opposite side is Ravenna, with Theodoric's palace in the foreground. Under the word *Palatium* (palace) is the central arch, where there once was a portrait of Theodoric on horseback. Under the other arches, outlines and traces of heads and hands indicate that members of his court were also portrayed, and Theodoric was again depicted in the city gate at the right. When the Ostrogothic kingdom came to its abrupt end, these personages were replaced by simulated Byzantine textile curtains. Above the palace are several of Theodoric's

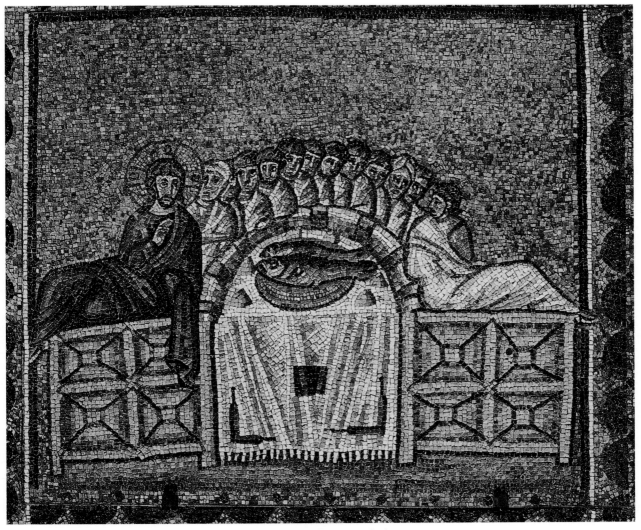

5.8 *Last Supper,* c. 520. Mosaic, Sant' Apollinare Nuovo, Ravenna, Italy.

buildings, with the Church of Sant' Apollinare Nuovo itself on the left.

According to early custom, the congregation gathered in the side aisles, with women on one side and men on the other. At the offertory they went forward through the nave to the altar, carrying gifts of bread and wine for the consecration. In a stylized way, the procession frieze reenacts this part of the service on a heavenly level. On the left, twenty-two virgins are led forward by the Three Wise Men to the throne of the Virgin Mary, who holds the Christ child on her lap. Arrayed in white tunics with richly jeweled mantles, the virgins carry their crowns of martyrdom in their hands as their votive offerings.

In a similar manner, twenty-five male martyrs on the right are escorted by St. Martin of Tours into the presence of Christ, who is seated on a lyre-backed throne. The eye is led along by the upward folds and curves of their costumes as they step along a flowered path lined with date palms, which symbolize both Paradise and their martyrdom. All is serene, and no trace of their earthly suffering is seen. Their heads, although tilted differently to vary the design somewhat, are all on the same level, in keeping with the Greco-Byzantine convention of isocephaly (see p. 36). Only St. Agnes is identified by her attribute, the lamb. Otherwise, the faces reveal so little individuality that they cannot be recognized without the inscriptions above their heads.

When these Byzantine figures are compared with the earlier Roman work in the bands above, the differences between Roman and Byzantine work are revealed. The lines of the Byzantine design form a frankly two-dimensional pattern, whereas the garments of the Roman personages fall in natural folds that model the forms they cover in three-dimensional fashion. All the figures in the upper two bands wear simple unadorned Roman togas, but the saints below are clad in luxurious, ornate Byzantine textiles decorated with gems. The Roman figures appear against natural three-dimensional backgrounds, such as the Sea of Galilee, hills, or a blue sky. The Byzantine virgins and martyrs, however, are set against a shimmering gold backdrop with uniformly spaced stylized palms. By the sixth century, gold was the preferred background, crowding out or pushing to the side naturalistic observations of nature. The candor, directness, and simplicity with which the Roman scenes are depicted contrast strikingly with the impersonal, aloof, and symbolic Byzantine treatment of the nave frieze. Differences in theological outlook also influenced stylistic deci-

sions. The Arian–Roman panels accentuate the Redeemer's worldly life and human suffering, whereas the Byzantine frieze visually stresses his divinity and remoteness from worldly matters.

CENTRAL-PLAN CHURCHES

Little more than a year elapsed between the death of Theodoric and the accession of Justinian as emperor in Constantinople. Almost immediately, Justinian decided to build the church of San Vitale at Ravenna (Fig. 5.9A). In the politics of the times, building a church that would surpass anything undertaken by Theodoric served both as an assertion of Justinian's authority in Italy and as evidence of the weakening power of Theodoric's Ostrogothic successors.

At first, the project languished because Justinian's position in the capital of the Western Roman Empire was anything but certain. Ultimately, he used force to assert his Italian claims, and his armies entered Ravenna in 540. Thereafter, construction of San Vitale proceeded swiftly. Seven years later the church was ready for its dedication by Archbishop Maximian. Its plain red-brick exterior shows that as little attention was paid to the outside of San Vitale as to that of any other church of the period. But with its multicolored marble walls, carved alabaster columns, pierced marble screens, and sanctuary mosaics, the Church of San Vitale is a veritable jewel box.

Architecturally, San Vitale is a highly developed example of the central-plan church (Fig. 5.9B), differing radically from Sant' Apollinare Nuovo. Still, it has all the usual features of the basilica, including a narthex entrance, a circular nave, surrounding side aisles, and a triumphal arch leading into a sanctuary with an apse and two side chambers. The striking difference, however, between an oblong basilica and a centralized church is the direction of its axis. In the former, the axis runs horizontally through the center of the building, dividing the church lengthwise into halves and leading the eye toward the apse. In the central-plan building, the axis is vertical, leading the eye upward from the central floor space to the dome. Were it not for the addition of the oblong narthex on the west and the apse and side chapels on the east, the ground plan of San Vitale would be a simple octagon.

The two side chambers of the apse are usually associated with Eastern Orthodox churches. Their presence here points to the fact that San Vitale was designed as a theater for the Byzantine liturgy. The northern chamber was designated the ***prothesis,*** to indicate its use as the place to prepare the com-

munion bread and wine for the altar. In Eastern Orthodox usage, the sacrificial aspect of the mass assumed a dramatic character, and the sacramental bread was symbolically "wounded, killed, and buried" on the table of the prothesis before it appeared on the altar, where it symbolized the resurrection of the body. The southern chamber was called the **diakonikon.** It served as the vestry and as a place to store the sacred objects used in the orthodox service.

To understand the history of San Vitale and central-plan churches, one must examine similar buildings at Ravenna and elsewhere. Whereas the ancestors of the rectangular basilica were Roman domestic and public buildings, the centralized church is derived from ancient circular tombs, such as Hadrian's colossal monument on the banks of the Tiber. The ancient preference for the circular mausoleum can be explained partly by its symbolism. Immortality was often represented by the image of a serpent biting its tail, that is, a living creature whose end was joined to its beginning. Another ancestor is the round classical temple, such as the Pantheon (see Fig. 4.20A).

The idea of a church built in the same form as a tomb is by no means as somber as it might seem. In the Christian sense, such a church symbolized the Easter tomb, reminding all of the res-

urrection of Christ. Churches were dedicated to martyrs and saints, who were believed to be partaking of the heavenly life with Christ, just as the faithful hoped they themselves would one day be doing. The Roman cult of Orpheus, the Greek god whose music resurrected his wife from the underworld, stressed the idea of the body being the tomb of the spirit. Hence, death and resurrection were aspects of the same idea, and the martyr's death was a mystical union with Christ. Indeed, the altar itself was a tomb or repository for the sacred relics of the saint to whom the church was dedicated. Early altars in the catacombs actually were sarcophagi that also served as communion tables. Thus, in the rites of the church, the earthly past of Christ and his apostles, saints, and martyrs was commemorated, and at the same time the glorious heavenly future was anticipated.

BAPTISTRIES

The eight-sided Christian baptistry was modeled directly on the octagonal bathhouses found in ancient Roman villas. There the bathing pool was usually octagonal, and the structure around it assumed that shape. Early Christian baptisms required total immersion, and the transition from

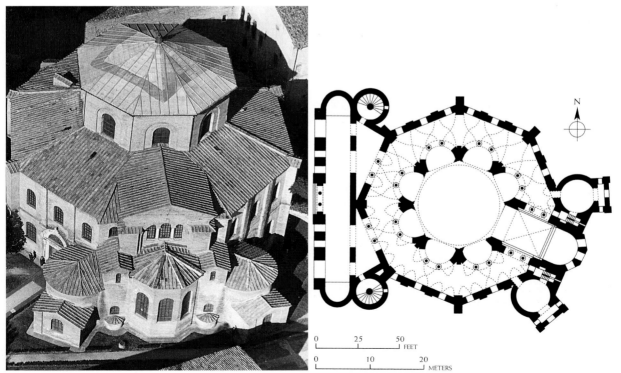

5.9 (A) Exterior of apse, San Vitale, Ravenna, c. 526–547. Diameter 112′. (B) Plan of San Vitale, Ravenna.

bathhouse to baptistry was easy. Because baptism was a personal and family affair, not calling for the presence of a congregation, baptistries usually were small.

The Arian Baptistry was built in Theodoric's time in the same style as the earlier "Neonian" Baptistry of the Roman Christians. Both are domed structures with fine interior mosaics. Both have similar representations of the baptism of Christ on the interior surfaces of their **cupolas,** or domes. That of the Arian Baptistry (Fig. 5.10) shows the ceremony being performed by St. John the Baptist, while the river Jordan is personified as an old man in the manner of the ancient river gods (see Fig. 4.11, lower left).

Around the central scene are the twelve apostles, who move in a procession toward the throne of Christ. Just as the virgins and martyrs reenact the offertory procession above the nave arcade of Sant' Apollinare Nuovo, so the apostles here mirror the baptismal rites on a more heavenly level. They group themselves around the center above, where Christ is being baptized, just as the clergy, family, and sponsors gathered about the font below for the baptism of a Ravenna Christian. Here is yet another example in which the **iconography,** or subject matter, of the decorative scheme reflects the liturgical activity that took place within the building.

DOME CONSTRUCTION

During the sixth century, architects were preoccupied with balancing domes over square or octagonal supporting structures. The Romans had found one solution in the case of the Pantheon—resting the dome on supporting cylindrical walls—but builders in Ravenna found two other solutions. The exquisite little Mausoleum of Galla Placidia (Fig. 5.3), which dates from about 425, was built in the form of an equal-winged Greek cross. Its dome rests on **pendentives,** concave spherical triangles of masonry rising from the square corners and bending inward to form the circular base of the dome (Fig. 5.11). The role of the pendentives is to encircle the square understructure and make the transition to the round domed superstructure. The Ravenna baptistries exemplify the same pendentive solution, but their domes rest directly on octagonal understructures.

Another solution stemming from the same early period is based on a system of **squinches,** pieces of construction placed diagonally across the angles of the square or octagonal walls of the understructure to form a proper base for a dome (Fig. 5.11). This was the method used for the doming of San Vitale. The eight piers of the arcaded central room culminate in an octagonal drum on which, by means of squinches, the dome rests. Above the nave arcade and beneath the dome, the

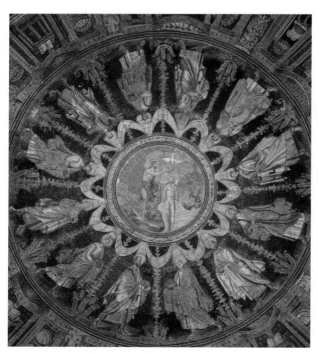

5.10 *Baptism of Christ Surrounded by the Twelve Apostles,* c. 458. Dome mosaic, Baptistry of the Orthodox, Ravenna, Italy.

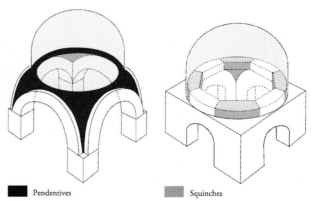

■ Pendentives ▨ Squinches

5.11 Circular domes can be raised over rectangular buildings by *pendentives* or *squinches*. Pendentives are vaults in the form of spherical triangles that connect arches springing from corner piers and unite at the apex of the arches to form a circular base upon which the dome rests. Squinches are stone lintels placed diagonally across corners to form a continuous base for masonry built up in wedge or arch formation.

builders of San Vitale included a vaulted triforium gallery running around the church and opening into the nave (Fig. 5.12). This gallery, which was called the **matroneum,** was for the use of women, who were strictly segregated in Byzantine rites.

Eastern parallels of San Vitale are found in Justinian's churches at Constantinople, including the church of Sts. Sergius and Bacchus. The magnificent Hagia Sophia ("Sancta Sophia," or "Holy Wisdom") is also a central-plan church under a

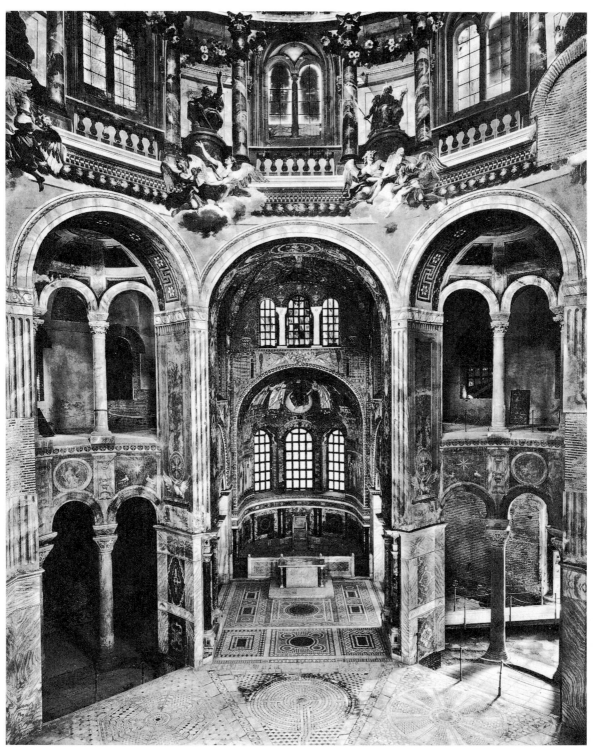

5.12 Interior, San Vitale, Ravenna, Italy, 527–547 (clerestory decorations, eighteenth century).

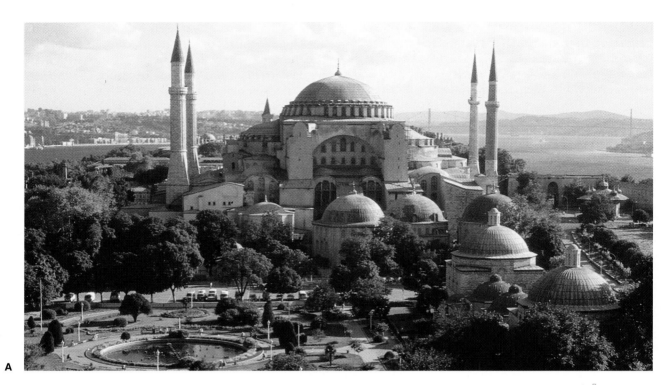

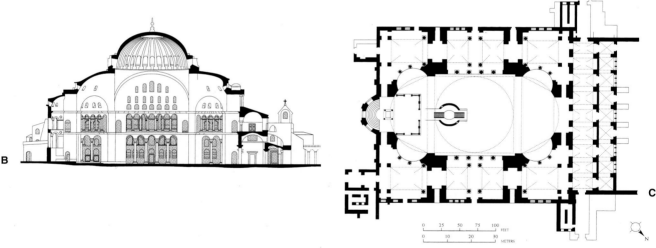

5.13 (A) Anthemius of Tralles and Isidorus of Miletus. Hagia Sophia, Istanbul (Constantinople), Turkey, 532–537 (minarets after 1453), 308′ × 236′. (B) Section of Hagia Sophia. (C) Plan of Hagia Sophia.

large dome. Justinian chose two scholars from the cultural centers of Tralles and Miletus in Asia Minor to help him achieve a dramatic visual statement of his rule. As a combination of great art and daring engineering, the Hagia Sophia, conceived by Anthemius of Tralles and Isidorus of Miletus, remains impressive (Fig. 5.13). Externally, it is practically square, with bulging **buttresses,** or masonry supports, and swelling

half-domes mounting by means of pendentives to a full dome on top. Internally, from the narthex entrance on the west, the space opens into a large nave. Above, the huge dome seems to float on the diffused sunlight brought in by forty windows. Although the eye is led horizontally to the apse in the east (Fig. 5.14), it is important to note that in the rites of the Eastern Church an elaborately embroidered curtain would

have kept the mass from being viewed by congregants other than priests and the emperor. In later Eastern churches, an ***iconostasis,*** or wall, served this function. Whereas the most ambitious Gothic cathedral nave never spanned a width of more than 55 feet, the architects of Hagia Sophia achieved an open space 100 feet wide and 200 feet long.

The psychological effect of the dome in central-plan churches is to bring the separate parts into a unified whole. In the interiors of both Hagia Sophia and San Vitale, the dome and its supports are clearly visible and the structure is therefore self-explanatory. Ironically, the dome of San Vitale can be seen from the interior only because on the outside its octagonal base has

been continued upward and roofed over. Psychologically, the equilibrium found in central-plan churches creates a restful effect that is in direct contrast with the restless interiors of later Gothic cathedrals. In the cathedrals the dynamic surge upward psychologically depends, in part, on the fact that the crucial structural element, the exterior buttressing, is not apparent to the viewer from the inside of the church.

MOSAIC PORTRAITURE

In the apse of San Vitale, facing the altar from opposite sides, are two mosaic panels that portray the leading figures of early Byzantine rule in Ravenna. On one, Emperor Justinian appears in the midst of

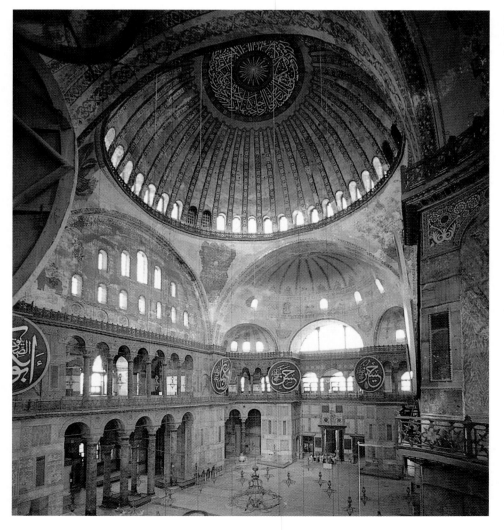

5.14 Interior of Hagia Sophia, Istanbul (Constantinople), Turkey.

his courtiers (Fig. 5.15). On the other, facing him as an equal, is Empress Theodora (Fig. 5.16). They are portrayed as if they were making a procession through the church.

It is significant that the finest existing portrait of the great emperor should be in mosaic rather than in the form of a sculptured bust, a bronze figure on horseback, or a colossal statue as it might have been in Rome. Mosaic conveyed the union of temporal and spiritual power situated at Ravenna. Justinian based his rule on skillful use of legal and theological formulas, as well as on military might. He helped codify Roman law, presided at religious councils, and reconciled different political points of view. He chose to be represented as a symbol of unity between the force of the church on one hand and the power of the state on the other.

Preceding Justinian in the procession are the clergymen, among whom only Archbishop Maximian is identified by name above his head. His crucifix is held up as an assertion of his power as the spiritual and temporal lord of Ravenna. On the emperor's other side are his courtiers and honor guard, holding their jeweled swords aloft. The shield with its Chrismon insignia points to the status of the soldiers as defenders of the faith. The Chrismon was a widely used monogram of the time, made up of the Greek letters *chi* (χ) and *rho* (ρ), which together form the first two letters of the Greek word *Christo,* meaning "anointed one." To those who read Latin, the Greek-derived chi–rho symbol was also interpreted as the word *pax,* or peace. Somewhat more allegorically, the letters of the chi–rho symbol could be viewed as a combination of the cross and the shepherd's crook, which symbolize the Savior's death and pastoral mission. In addition, Christians used the first and the last letters of the Greek alphabet, *alpha* and *omega,* to indicate that their God and their faith encompassed everything.

Justinian stands in the center of the procession, magnificently clothed and crowned with the imperial diadem. The observer knows immediately that this is no ordinary royal personage but rather one who could sign his name as Emperor Caesar Flavius, Justinianus, Alamanicus, Francicus, Germanicus, Anticus, Alanicus, Vandalicus, Africanus, Pious, Happy, Renowned, Conqueror, and Triumpher, ever Augustus. Great as Justinian's military exploits were, however, it is

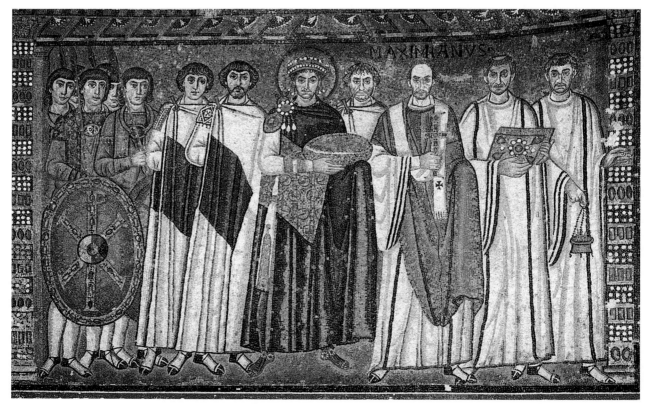

5.15 *Emperor Justinian and Courtiers,* c. 547. Mosaic, San Vitale, Ravenna, Italy.

his works of peace that endured. In addition to a vast building program, the Byzantine emperor is remembered for his monumental code, the *Digest of Laws,* whose influence was felt for centuries throughout the Western world.

On her side, Empress Theodora (Fig. 5.16), richly jeweled and clad in imperial purple, is depicted as she is about to enter the church from the narthex. Possibly because of her humble origins and early career as an actress, Theodora may have wished to appear more royal than the king. Her offering recalls a caustic remark by the hypocritical Procopius, chronicler of Justinian's reign. He said that she fed the geese of the devil while on the stage and the sheep of Christ while on the throne. On the hem of her robe, the offertory motif is carried out in the embroidered figures of the Three Wise Men, the first bearers of gifts to Christ. Because the Wise Men, like Justinian and Theodora, came from the East, this motif served as a reminder to the people of Ravenna that the source of wisdom and power lay in that direction.

These two mosaic portraits are especially valuable because they are among the few surviving visual representations of vanished Byzantine courtly ceremonies. The regal pair appear as if participating in the offertory procession at the dedication of the church, which took place in 547, although neither was actually present on that occasion. Such ceremonial entries were part of the elaborate Byzantine liturgy, and both the emperor and the empress are shown as bearers of gifts. Justinian is carrying the gold ***paten,*** which was used to hold the communion bread at the altar, while Theodora is presenting the chalice that contains the wine. Because their generosity was responsible for the building, decoration, and endowment of San Vitale, the allusion is to gifts of gold as well.

In keeping with the rigid conventions of Byzantine art, all the heads appear in one plane. Those of Justinian and Theodora are distinguished by their halos, which not only refer to their awesome power but also are a carryover of the semidivine status claimed by earlier Roman emperors. Even though they are moving in a procession, Justinian and Theodora are portrayed frontally in the manner of imperial personages accustomed to receiving the homage of their subjects. Despite the stylized medium, the eye can

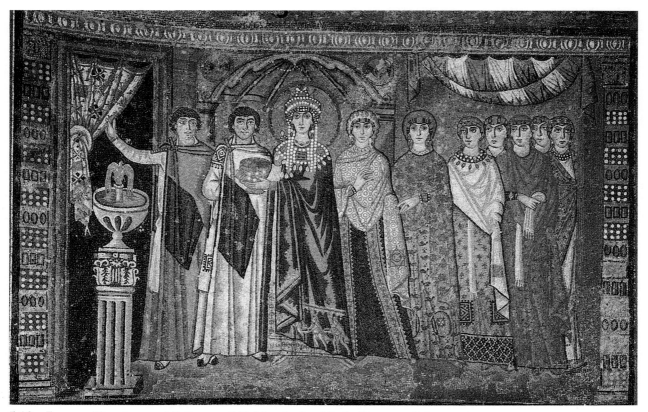

5.16 *Empress Theodora and Retinue,* c. 547. Mosaic, San Vitale, Ravenna, Italy.

follow the procession as it moves in dignified measure, carried forward by the linear pattern in the folds of the garments. The elegant, luxurious costumes add to the richness of the scene.

The decorative design of San Vitale also includes carved alabaster columns, polychrome marble wall panels, pierced marble choir screens, and many other details. The capitals of the columns are carved with intricate patterns (Fig. 5.17). The harmonious proportions of the building as a whole combine with the rich optical effects of the mosaics, polychrome marble, and ornamental sculptures. Along with Hagia Sophia, San Vitale is the high point of Byzantine art in the West.

SCULPTURE

From its status as a major art in Greco-Roman times, sculpture declined to a relatively modest place in the ranks of Early Christian arts. It became primarily the servant of the architectural and liturgical forms of the church. Even its classical three-dimensionality was in eclipse, and sculpture tended

to become increasingly pictorial and symbolic as it assumed a teaching role in Early Christian usage.

When sculpture moved indoors, it underwent necessary changes. For instance, a statue in the round was either placed against a wall or stood in a niche, which prevented its being seen from all sides. The closeness in time and place to the pagan art served to channel Christian visual expression in other directions. With one of the Ten Commandments expressly forbidding the making of

5.18 *Good Shepherd,* c. 300. Marble, height 3′3″. Vatican Museums, Rome, Italy.

5.17 Byzantine capital (with horses), c. 547. San Vitale, Ravenna, Italy.

"graven images," it is remarkable that the art survived as well as it did.

A rare example of three-dimensional Early Christian sculpture is the *Good Shepherd* (Fig. 5.18). Figures of peasants carrying calves or sheep to market are commonly found in ancient Greek and Roman genre sculpture. In the Christian interpretation, however, the shepherd is Christ and the sheep are the congregation of the faithful; when a jug of milk is included, the whole image refers to the Eucharist.

CHRISTIAN FORMS AND SYMBOLS

Architectural sculpture proved adaptable to the new demands placed on it. Capitals of columns, decorative relief panels, carved wooden doors, and to some extent, statues in niches continued, with appropriate Christian modifications. The principal emphasis, however, shifted toward objects that were central to Christian worship, such as altars, pulpits, pierced marble screens, and carved ivory reliefs. Smaller items, such as precious metal boxes for relics, lamps, incense pots, communion chalices, jeweled book covers, and patens, all with delicately worked designs, were closer to the province of jewelry than to that of grand classical art.

One of the strongest influences on Early Christian design was the new orientation of thought toward symbolism. As long as the religions of Greece and Rome were focused on the human form, sculptors could represent the gods as idealized human beings. But Christians were challenged to represent in concrete form such abstractions as the Trinity, the Holy Spirit, the salvation of the soul, and the idea of redemption through participation in the Eucharistic sacrifice. The solution came through the use of parables and symbols. Thus, the Christian idea of immortality could be rendered through several biblical scenes of deliverance: Noah from the flood, Moses from the land of Egypt, Job from his sufferings, Daniel from the lions' den, the youths from the fiery furnace, and Lazarus from his tomb.

In Early Christian relief panels, plant and animal motifs were included less for naturalistic reasons than to convey symbolic meaning. The dove represented the Holy Spirit, the peacock stood for Paradise, and so on. The cross is seldom found in Early Christian art, because it recalled a punishment used for the lowest type of criminal. Instead, the Chrismon symbol already seen on the shield of Justinian's soldiers (Fig. 5.15) was used. A fish, or the Greek word for it, *ichthys,* is often found as a reference to Jesus's making his disciples fishers of men. The letters of the word also constituted an abbreviation for "Jesus Christ Son of God, Savior." In effect, symbols and lettered inscriptions carried special meaning and mystical significance for initiated worshipers.

CARVED STONE TOMBS

One of the chief forms of Early Christian sculpture is the carved stone sarcophagus. A special Christian incentive came from the desire for interment within the sacred precincts of the church. The relics of saints reposed in the altar. Tombs of bishops and other dignitaries were housed in the church. Those of the laity were usually placed in the atrium. The latter custom survives in modern times, with burials of famous people taking place in vaults below the church floor.

A fine example is provided by the sarcophagus of Archbishop Theodore (Fig. 5.19). The front panel shows the combination of the Chrismon symbol with an alpha and an omega, another

5.19 Sarcophagus of Archbishop Theodore, sixth century. Marble, 3′3½″ × 6′9″. Sant'Apollinare in Classe, Ravenna, Italy.

reference to Christ, taken from his statement that he was both the beginning and the end. Their inclusion here on a tomb indicates the end of the earthly life and the beginning of the heavenly one. Flanking the symbols are two peacocks, symbolizing Paradise, and on either side, a graceful vine pattern in which small birds feeding on grapes refer symbolically to communion. The inscription reads in translation, "Here rests in peace Archbishop Theodore." On the lid are repetitions of the Chrismon monogram, surrounded by the conventional laurel wreath symbolizing immortality.

THE ARCHBISHOP'S CHAIR

By far, the most impressive single example of sculpture of this period is a chair that is thought to be that of Archbishop Maximian (Fig. 5.20), Justinian's

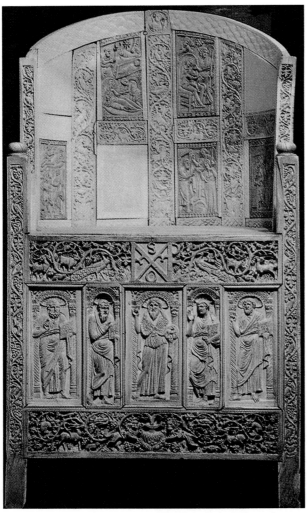

5.20 Cathedra of Maximian, c. 546–556. Ivory panels on wood frame, 5'11" × 1'11⅝". Museo dell'Arcivescovile, Ravenna, Italy.

viceroy, who is portrayed beside him in the mosaic panel in San Vitale (Fig. 5.15). Such an episcopal, or bishop's, throne is called a **cathedra,** and the church in which it is housed is termed a **cathedral.** When a bishop addresses his congregation from it, he is said to be speaking **ex cathedra.** A cathedra may also be called a *sedes* (the Latin word for "seat"), from which is derived the noun *see,* which once meant the seat of a bishop but was extended to indicate the territory in the charge of a bishop. Originally *sedes* meant a chair denoting high position. Roman senators used such chairs on public occasions, and modern politicians still campaign for a "seat" in the senate or legislature. Both Jewish rabbis and Greek philosophers sometimes taught from a seated position, hence the reference in modern colleges to a "chair" of philosophy or history.

Maximian's cathedra consists of a set of ivory panels, delicately carved and carefully joined together. Originally, there were thirty-nine pictorial panels, some of which told the Old Testament story of Joseph and his brethren, and the others, the story of Jesus. The chair is thought to have been presented to Maximian by Justinian, and the different techniques used in the various panels indicate collaboration by craftspeople from Anatolia, Syria, and Alexandria. On the front panel, below Maximian's monogram, is a representation of St. John the Baptist flanked on either side by the Evangelists. The Baptist holds a medallion on which a lamb is carved in relief, and the Evangelists hold the Gospels attributed to them.

The elegant Byzantine carving of the front panel—with its complex grapevine motif intertwined with birds and animals denoting the tree of eternal life, the peacocks symbolizing heaven, the symmetrically arranged saints, and the luxuriant linear pattern of their classical drapery—lends itself best to just such a static, formal, stylized design. In the story of Joseph illustrated on the side panels, however, the overriding concern is with an active narrative related in a series of episodes. Content and vivid detail rise above formal considerations. Because monumentality is neither possible nor desirable in ivory carvings, such details as these, handled with precision, are richer and more satisfying than the work as a whole.

MUSIC

Knowledge about the status of musical thought in sixth-century Ravenna can be gained from the writings of Theodoric's ministers Boethius and Cassiodorus. Both were deeply learned in Greek

and Roman culture, which remained central to the education of elites. Like the writings of the church fathers and other literary figures of the day, however, Boethius and Cassiodorus reveal much about the theory of the art but little about its practice.

THEORETICAL DISCUSSIONS OF MUSIC

Boethius was a tireless translator of Greek philosophical and scientific treatises into Latin, among which were no less than thirty books by Aristotle. When he fell from favor and was imprisoned, Boethius wrote *The Consolation of Philosophy,* which became one of the most influential books of medieval times. The *Consolation* later found its way into English via translation by Chaucer and Queen Elizabeth. Boethius had a universal mind, capable of discoursing on anything from the mechanics of water clocks to the science of astronomy.

Over time, Boethius's treatise on music became the source of most medieval essays on the subject. It transmitted the gist of ancient Greek musical theory and developed into the foundation of Western musical thinking. Like the Greeks, Boethius believed that "all music is reasoning and speculation," and hence he more closely allied with mathematics than with actual musical practice.

Boethius divided music into three classes, the first of which was the "music of the universe," by which he meant the unheard astronomical "music" of planetary motion. The second was "human music," which referred to the attunement of the mind and body, or the rational and irrational elements of the human constitution, in the manner of the Greek notion of the harmony of opposites. The third was instrumental music and song, of which he had the philosopher's usual low opinion, considering only the theoretical aspects of the art as pursuits worthy of a gentleman and scholar. The only true "musician" in Boethius's opinion was one "who possesses the faculty of judging, according to speculation or reason, appropriate and suitable to music, of modes and rhythms and of the classes of melodies and their mixtures . . . and of the songs of the poets."

Cassiodorus, a senator and advisor to Theodoric, wrote in a similarly learned vein. Even after he retired from public life to his monastery at Vivarium, he remained involved in the lives of the powerful. For example, Clovis, king of the Franks, requested that he recommend a **citharoedus,** that is, a singer who accompanied himself on a type of lyre known as the cithara (see Figs. 3.12 and 5.31). In search of such a musician, Cassiodorus turned to Boethius, who was in Rome at the time. His

letter launches into a flowery discourse on the nature of music, which he describes as the "Queen of the senses." It continues with discussions of its curative powers, how David cast out the evil spirit from Saul, the nature of the modes, the structure of the Greek scale system, and the history of the art. It then turns to the lyre, which Cassiodorus calls "the loom of the Muses." After going off on more learned tangents, Cassiodorus finally makes his point. "We have indulged ourselves in a pleasant digression," he writes, making a classic understatement, "because it is always agreeable to talk of learning with the learned; but be sure to get us that Citharoedus, who will go forth like another Orpheus to charm the beast-like hearts of the Barbarians. You will thus obey us and render yourself famous."

CHURCH MUSIC

Knowledge about the church music of Ravenna is based on conjecture and must be gathered from a variety of sources. Church writings demonstrate that great importance was attached to music in connection with divine worship. The problem was how to create a proper body of church music out of the crude idioms of popular music on one hand and the highly developed but pagan art music of Rome on the other. From St. Paul and the Roman writer Pliny the Younger, in the first and second centuries, respectively, scholars once surmised that the earliest Christian music was directly adapted from the ancient Jewish singing of psalms. Recent research questions this sole source.

Nevertheless, a mix of Hebrew, Greek, and Latin sources must have provided the basis for Early Christian music, just as they had done for theology and the visual arts. Out of these diverse elements, along with original ideas of their own, the Christians of the Eastern and Western churches gradually worked out a synthesis that resulted in a musical art of great power and beauty. The sixth century witnessed the culmination of many early experimental phases. At its close, the Western form of the art consisted primarily of **plainsong** or **plainchant.** In its various changes and restorations, as well as in its theoretical aspects, this system remained the official basis of Roman Church music up to the Second Vatican Council, which ended in 1965. Closely related forms are still in use throughout the Christian world, where free adaptations of these melodies have enriched the hymn books and liturgies of nearly every denomination.

ARIAN LITURGY. Knowledge of the Arian liturgy, such as that practiced at Sant' Apollinare Nuovo during Theodoric's reign, is obscure because all sources were destroyed when the Orthodox Christians gained the upper hand and stamped out the Arian heresy. From a few negative comments, however, it is known that hymn and psalm singing by the congregation as a whole was included among Arian practices.

Arius, the founder of the Arian sect, was accused of insinuating his religious ideas into the minds of his followers by means of hymns sung to melodies derived from drinking songs and theatrical tunes. Such hymns were frowned upon because they were too closely allied with popular music. Moreover, the Arian way of singing them was described as loud and raucous, which must have grated on the sensitive ears of the devout Roman Christians.

AMBROSIAN LITURGY. The popularity of Arian musical practices helped the Arians make many converts. In the spirit of fighting fire with fire, St. Ambrose, bishop of Milan, where the Arians were strong, compromised by introducing hymn and psalm singing into the Milanese church service.

A firsthand account of this practice is contained in a passage from St. Augustine's *Confessions.* In the fourth century, when Bishop Ambrose was engaged in one of his many power plays and doctrinal disputes with Byzantine Empress Justina, he and his followers at one point had to barricade themselves in a church for protection. "The pious people kept guard in the church, prepared to die with their bishop," wrote St. Augustine. "At the same time," he continues, "it was here first instituted after the manner of the eastern churches, that hymns and psalms should be sung, lest the people should wax faint through the tediousness of sorrow: which custom being retained from that day to this, is still imitated by divers, yea, almost by all thy congregations throughout other parts of the world."

During the following century, the practice of hymn and psalm singing spread widely and was incorporated into the Roman Catholic liturgy. Because Ravenna was the neighboring see, or bishopric, to that of Milan, musical practices there may have been similar.

Some half-dozen hymns can be attributed to St. Ambrose. Whether he also composed the melodies is not as certain, but they date from his time. The example of *Aeterne Rerum Conditor* confirms the extreme simplicity and metrical regularity of these vigorous Ambrosian hymns, which made them especially suitable for congregational singing.

The psalms were sung either antiphonally or responsorially. When two choruses sing alternate verses, then join together in a refrain on the word *alleluia* after each verse, the practice is referred to as **antiphonal psalmody.** When the priest or leader chants one verse as a solo and the choirs perform the next verse as a choral response, it is called **responsorial psalmody.** Both practices were widespread in the Western church, including Ravenna.

BYZANTINE LITURGY. Because Sant' Apollinare Nuovo and San Vitale were designed for different congregations and liturgies, it follows that their music must also have differed. As part of the Byzantine liturgy, the music heard at San Vitale would have been like that of the cathedral in Constantinople. As in the West, congregational singing was included at first, as part of the offertory procession. When the procession was abandoned, congregational singing was gradually replaced by that of a professional choir. Music for congregational singing must always be kept relatively simple. By contrast, professional groups, which have special musical knowledge and rehearsal time, can explore and develop the art.

San Vitale, like Hagia Sophia, was under the direct patronage of the emperor, and because both formed a part of Justinian's grand design, provision for a group capable of performing the music of the Byzantine liturgy could hardly have been overlooked. The principal difference between the music of the Eastern and Western churches is that between a contemplative and an active attitude. The contemplative aspect of the Eastern liturgy is illustrated by a remark of St. John Chrysostom, who said, "One may also sing without voice, the mind resounding inwardly, for we sing not to men, but to God, who can hear our hearts and enter into the silences of the mind." This attitude contrasts strongly with that of St. Ambrose, who said, in connection with the congregation's participation in

Musical Example 5.1
Aeterne Rerum Conditor (Hymn of St. Ambrose)

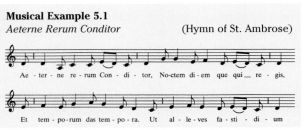

song, "If you praise the Lord and do not sing, you do not utter a hymn. . . . A hymn, therefore, has these three things: song and praise and the Lord."

In a static form of worship, greater rhythmic freedom is possible, whereas the chant that accompanies a procession must have greater metrical regularity. The singing of a professional choir, moreover, implies an elaborate and highly developed art, whereas the practice of congregational singing avoids technical difficulties. The difference, then, is the difference between the sturdy Ambrosian **syllabic** hymn—that is, with a syllable allotted to each note—and the more elaborate **melismatic** alleluia of Byzantine origin—that is, with each single syllable prolonged over many notes in the manner of a **cadenza.**

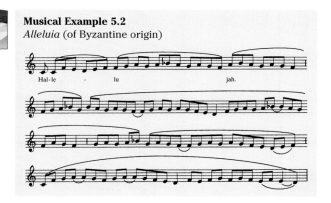

Musical Example 5.2
Alleluia (of Byzantine origin)

Byzantine music had a distinctive style, comparable in this respect to that of the visual arts. The elaborate melismas of Byzantine music would have been heard in San Vitale and other Byzantine churches at the end of the sixth century. It was these florid alleluias that were ruled out by the Gregorian reform that occurred in the early seventh century, which will be discussed later in this chapter.

ISLAMIC STYLE

In the early seventh century, a new dynamic force appeared on the horizon: *Islam,* an Arabic word signifying submission to the word of God. Born around 570, Mohammed, its founder, was a member of a merchant family in Mecca. At about age 40, he experienced a revelation indicating that he had been chosen by God to be the prophet of a new religion. Throughout his lifetime, he continued to receive such revelations, many of which were recorded after his death in the Koran. Written in clas-

sical Arabic, the Koran became the bible of Islam, and like the Bible itself, it became an influential book in world history. For the Islamic faithful, the Koran (Fig. 5.21) was literally the word of God as revealed through the Angel Gabriel to the Prophet Mohammed, who had been chosen as his messenger. It covered all aspects of life—religious, legal, political, social, and personal.

Mohammed held that Jews, Christians, and Arabs were descended from Abraham. He recognized Jesus, along with ancient prophets such as Moses and Isaiah, as authentic prophets and called himself the final prophet. However, he rejected the concept of the Trinity and hence the divinity of Christ. His belief is stated most succinctly in the motto, "There is no God but Allah, and Mohammed is his prophet." In the beginning there was considerable resistance from the then-polytheistic Arabs. Plots on Mohammed's life led him to journey (the famous *hegira*) to the city of Yathrib, which then was renamed Medina, meaning the city of the prophet. The year was 622, a date that later became the first year of the Islamic calendar.

Almost immediately after Mohammed's death, Islam spread with astonishing rapidity in both the

5.21 Illuminated page from Koran, by Ali ibn Hilal, known as Ibn al-Bawwab, Baghdad, Iraq, eleventh century. Paper, 6.9″ × 5.3″. Dublin, Chester Beatty Library, ms. 1431, folio 285 recto.

religious and the military senses. Arab armies swept eastward, capturing Palestine, Syria, Iraq, Persia, and other territories as far as the Indus valley in India. In the West, Egypt and all North Africa fell to them. They then occupied the island of Sicily and most of Spain. After crossing the Pyrenees Mountains in 732, they got as far as Poitiers in France, where they were defeated in a decisive battle by King Charles Martel, Charlemagne's grandfather. Recent research reveals that the Christians living in Islamic strongholds in southern Spain were enthralled with Arab intellectual accomplishments and their fine holdings of books.

To counter Islamic encroachments into Europe, the Normans (see Chapter 6) drove them out of southern Italy and Sicily in the eleventh century. This action was followed intermittently by Crusades that challenged the Islamic conquest of the Holy Land. For a brief time, a short-lived Kingdom of Jerusalem ruled. Thereafter, the city was reclaimed by the Muslims, who continued to besiege Constantine's Byzantine Empire until they finally captured Constantinople in 1453, renaming it Istanbul. In the end, Spain defeated the last Islamic stronghold in Granada in 1492. The rest of the territories in North Africa, the Near East, and Asia have remained dominantly Islamic to this day, except for the establishment of the Jewish state of Israel after World War II.

Islamic civilization sponsored advanced learning that included preserving and translating Greco-Roman treatises. These included the works of Aristotle, Euclid, Archimedes, and Ptolemy. Islamic thinkers covered the scholarly spectrum from astronomy, mathematics, chemistry, pharmacology, and surgery to philosophy and music. In the wake of the Crusades, European scholars found they had much to learn from their Muslim counterparts. Many traveled to Spain to read and translate various treatises into Latin for use in European universities. In mathematics, to cite one vital example, Arabic numerals quickly replaced their clumsy Roman equivalents. Soon Arabic numbers were adopted by merchants and bankers for their calculations; later they were accepted worldwide. Arabic scholars also introduced the concept of *zero,* an Arabic word, as well as such terms as *cypher, algebra, almanac,* and *zenith.*

THE DOME OF THE ROCK AND THE GREAT MOSQUE OF CORDOVA

The first major monument of Islam was the Dome of the Rock (Fig. 5.22A), located at the high point of Mount Moriah in Jerusalem. In Judaic tradition, this was the site where God commanded Abraham to sacrifice his only son, Isaac. At the last moment, Abraham's hand was stayed by an angel. Later the rock was enclosed in the sacred precincts of King Solomon's temple. For Muslims, this was the high point from which Mohammed rose on his fiery steed to make a night's journey into the heavens. The Dome of the Rock functioned as a visible political state-

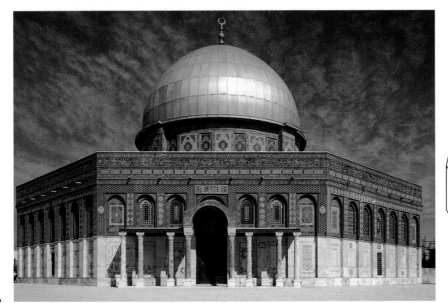

A B

5.22 (A) The Dome of the Rock (Qubbat As-Sakhrah), Jerusalem, late seventh century. (B) Perspective of the Dome of the Rock.

ment that asserted Islamic control of the Holy Land. After Mecca and Medina, Jerusalem became the third most sacred site in Islam and a point of pilgrimage for the faithful.

Caliph Abd al-Malik built the structure, which was completed in 691; it has survived almost intact except for the exterior mosaics. At that early point in history there was no distinctive Islamic architectural style. Here, as elsewhere, Muslim buildings used familiar regional buildings as points of departure. Precedents could be found in the nearby church of the Holy Sepulchre and two edifices of Emperor Justinian's time: Sts. Sergius and Bacchus in Constantinople and San Vitale in Ravenna (see pp. 128–129). Like the floor plans of these structures, the Dome of the Rock (Fig. 5.22B) is octagonal.

Because the Dome of the Rock was conceived of as a shrine rather than a mosque, no large space was needed for prayer and instruction. The interior is a domed rotunda with eight interior columns separating two ambulatories, while four inner pillars surrounding the rock rise to support the gilded wooden dome, which rests on a circular drum (Fig. 5.22B). The interior walls (Fig. 5.23) were decorated with mosaics and

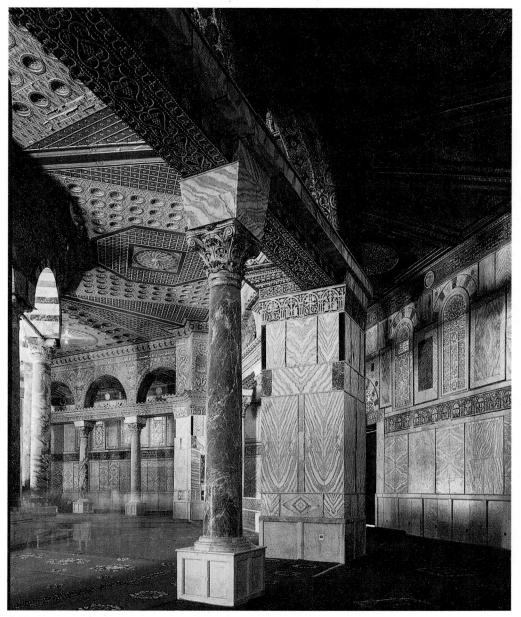

5.23 Interior of the Dome of the Rock. Note colored marble and filigree.

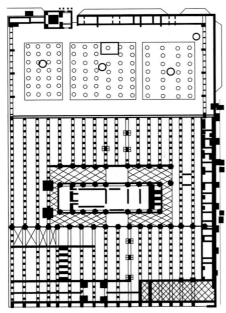

5.24 Plan of the Great Mosque of Cordova.

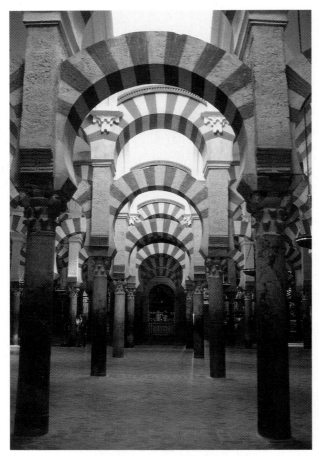

5.25 Interior of the Mosque of Córdoba, Spain, begun 786.

marble paneling. Since Mohammed accepted Moses's commandment forbidding graven images, this ruled out portraiture as well as naturalistic representation. Therefore, here as elsewhere, the decor is based on an infinite variety of geometric principles and ingenious abstract designs. The patterns in this case recall Roman acanthus scrolls and floral patterns similar to those of San Vitale (see Fig. 5.12). One interesting device was cutting slabs of marble in half so that the two halves seem to open like a book.

After the conquest of Spain in 785, Cordova was chosen as the site of a great mosque, which was steadily enlarged in succeeding centuries. The ground plan (Fig. 5.24) shows a large open central courtyard adjacent to a covered hall of prayer. Shapely columns crowned with carved gilded capitals support splendid polychrome arches with alternating red and white marble voussoirs (Fig. 5.25). At regular intervals quartets of columns are surmounted by low-rising cupolas that form the roof. When originally lighted by metallic lamps and with the floor covered with colorful carpets, the interior must have been even more awesome than it is today.

THE ALHAMBRA AND THE TAJ MAHAL

By the fifteenth century, the Islamic rulers in Spain were long past the peak of their power and Christians were gradually reclaiming various territories. One final note of beauty and grandeur, however, was sounded by the Alhambra Palace in the hills above Granada in southern Spain. The stark, fortresslike brick exterior conveys no outward promise of the dreamlike interior, with its exquisite courtyards set amid lush formal gardens (Fig. 5.26). The walls are faced with rhythmic patterns of abstract design in marble and stucco, and fountains and intricately devised waterways cool the courtyards and interior spaces.

One of the most celebrated buildings in the world—India's famed Taj Mahal—is also of Islamic origin (Fig. 5.27). Although shaped like a domed mosque with four surrounding minarets, it is actually a mausoleum begun in 1632 by the ruler Shah Jahan as a shrine to honor his beloved wife Mumtag-i-Mahal ("chosen one of the palace"). By inference, it is also a tribute to women. Nowhere is she portrayed, for that would have been a violation of Muslim law. Only in the serene and elegant proportions and

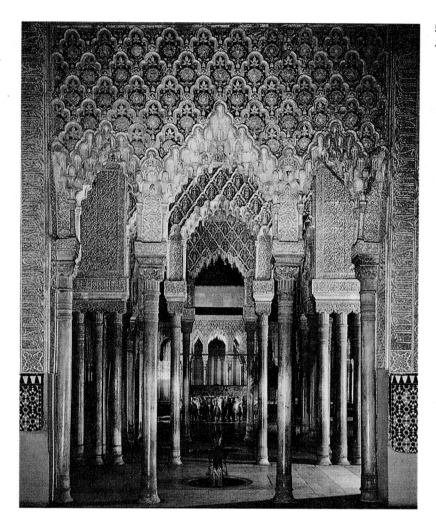

5.26 Court of the Lions, the Alhambra, Granada, Spain, 1343–1391.

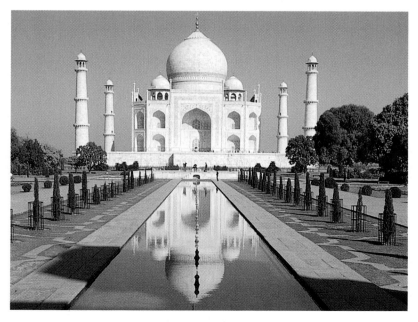

5.27 Taj Mahal, Agra, India, 1631–1648.

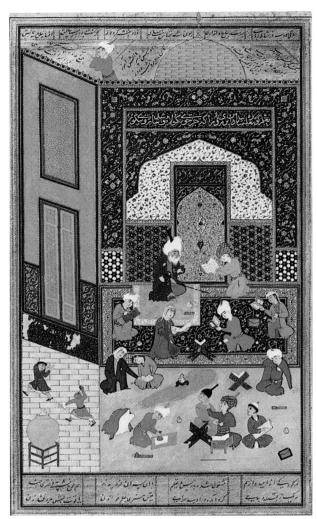

5.28 *Lalia and Majnun at School,* miniature from a manuscript of the *Khamsa of Nizami,* 1525. Ink, colors, and gold on paper. Metropolitan Museum of Art, New York.

abstract geometric decor could his love be expressed. Set in formal gardens on the banks of the Jumna River, the shapely central dome rises amid four smaller cupolas. The contours of this central dome allude to a Hindu symbol of femininity, a lotus bud rising from the water. It is the product of a team of architects, including the shah himself, who was later laid at her side. Symmetry abounds, with each of the four broader sides facing the points of the compass while combining with the four lesser sides to form an irregular octagon. The exterior is faced with mul-

ticolored marble and sandstone carved in stylized floral patterns, and the door frames quote verses from the Koran. The interior focuses on the tombs of the royal pair; the walls are carved with intricate abstract designs.

These major architectural masterpieces of Islamic art exist alongside a full range of other forms. Among them are manuscript illuminations (Fig. 5.28), drawings, paintings, carvings in ivory and wood, sculptural works for tombs, ceramic and glass objects, carpeting, textile designs, all manner of metal work, jewelry, and calligraphy. As for general decor in geometric and abstract designs, the very word *arabesque* points to a distinctive Islamic style.

IDEAS

All the surviving monuments of Early Christian art are oriented toward religion. Consequently, liturgical purposes, as well as patronage and geographic location, determine the forms of architecture, the iconography of mosaics, the designs of sculpture, and the performance practices of music.

The Early Christian and Byzantine styles were both Christian, and all the arts of the time lived, moved, and had their being within the all-embracing arms of the church. But the church's western and eastern arms pointed in different stylistic directions. The disintegration of Roman power in the West led to a decentralization of authority and allowed a wide range of local and regional styles, whereas the Byzantine emperors maintained tight autocratic control of all phases of secular and religious life. Early Christian art in the West was an expression of the people. It involved all social levels, its quality varied from crude to excellent, and it was simpler and more direct in its approach. Byzantine art, however, was under the personal patronage of a powerful and prosperous emperor who ruled as both a Caesar and a religious patriarch. Only the finest artists were employed, and the arts, like the vertical axis of a centralized church, directed attention to the highest level and tended to become further removed from the people and more purely symbolic.

Islamic art at first took on the local practices of the time and place where it developed. It later crystallized into a distinctive style of its own. As the arts of both West and East pass by in re-

view, two ideas seem offer clues to their understanding: authoritarianism and mysticism.

AUTHORITARIANISM

Ravenna in the sixth century was the scene of a three-way struggle among a barbarian king who was a champion of Roman culture, a Byzantine emperor who claimed the prerogatives of the past golden age, and a Roman pope who had little military might but a powerful influence based on spiritual authority. Conflict arose from the clash among worldly liberalism, traditionalism based on a divinely ordered social system, and a new spiritual institution with a genius for compromise.

In the course of the century, the Ostrogothic kingdom was vanquished by the Byzantine Empire. However, after a brief period of domination, Byzantine power in the West crumbled and the political and military weakness that followed became the soil that nurtured the growth of the new Rome. By the end of the century, Gregory the Great had succeeded in establishing the papacy as the authority that would eventually dominate the medieval period in the West, whereas the Eastern Roman Empire continued in its traditional Byzantine forms of organization.

The principle of authority was by no means foreign to Christianity, which grew to maturity in the latter days of the Roman Empire. With Christianity an official state religion under the protection of the emperors, Christian organization increasingly reflected the authoritarian character of the imperial government. Theologians accepted the authority of the divinely inspired Scriptures and the commentaries on them by the early church fathers. The same is true in the world of Islam, where supreme authority was vested in the Koran.

Authoritarianism also colored the educational picture. Both Cassiodorus and Boethius were major classical scholars who served as officials in Theodoric's government. Both were key figures in the transition from Greco-Roman paganism to Christianity. Boethius was especially influential, with his lucid Latin translations of treatises such as Nichomachus's on arithmetic, Ptolemy's on astronomy, and Archimedes's on physics and mechanics. All became basic texts in the schools and universities of the Middle Ages. His translation and commentary on Aristotle's *Organon* were especially important and set the

tone for logical argumentation in succeeding centuries. His own *The Consolation of Philosophy* unfolds like a Platonic dialogue in prose and poetry. In it he seeks to reconcile capricious turns of fortune and misfortune with the benevolent role of Providence in human affairs.

Over the centuries, many Greek texts, including works of Plato and Aristotle, had been lost in the West. Islamic scholars, however, preserved them and made them available to intellectuals and universities in the later Middle Ages.

The thought of the period was expressed in constant quotations and interpretations of ancient Hebrew, Greek, Latin, and Early Christian authors. No one seemed willing or able to assume complete and independent authority for a position; on all issues one had to cite established sources. The intellectual climate this reliance on precedents produced eventually paved the way for a mighty future struggle for political and spiritual authority.

AUTHORITARIANISM AND THE ARTS. Justinian, who claimed the authority and semidivine status of the Roman emperors, lived in an atmosphere so unchanging and conservative that at his court the words *originality* and *innovation* were used as terms of reproach. Yet some variety and freedom were to be found in the arts, even though the art of both church and state was under the sole patronage of the emperor. It was thus remarkable that the flowering that produced Hagia Sophia in Constantinople and San Vitale in Ravenna could have taken place. In both of these instances, the methods of construction were experimental and the solution developed in response to the architectural and decorative problems seems unconstrained and bold.

The Byzantine concept of authority was embodied in the architectural and decorative plans of both Hagia Sophia and San Vitale. The central-plan church, with its sharp hierarchical, or ranked, divisions that set aside places for men and women, clergy and laity, aristocrat and commoner, was admirably suited to convey the principle of imperial authority. The vertical axis culminated in a dome that overwhelmed Byzantine subjects by reminding them of their humble place in the scheme of things. The august imperial portraits in the sanctuary showed them that, outside the clergy, only the emperor and empress and those who occupied the top rungs of the social ladder might approach the altar.

5.29 Exterior of apse, Sant' Apollinare in Classe, Ravenna, Italy, c. 530.

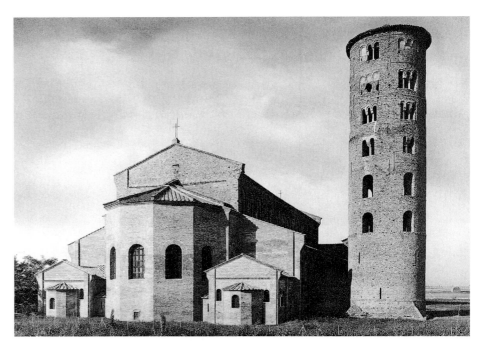

5.30 Interior of apse, Sant' Apollinare in Classe, Ravenna, Italy, c. 530.

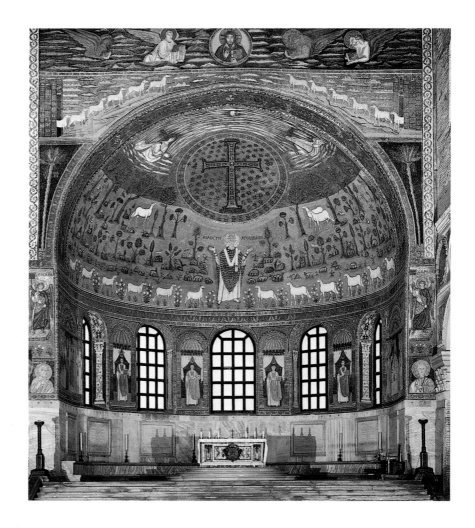

On the other hand, as typical forms of the basilica, Sant' Apollinare Nuovo and its companion, Sant' Apollinare in Classe (Figs. 5.29 and 5.30), indicated a contrasting conception of both God and humanity. As the twin rows of columns on either side of the nave marched forward, they carried the eyes of the faithful with them. The approach to the sacred precincts was encouraged rather than forbidden, and even the gift of the poor widow's pittance (Mark 12:41–42; Luke 21:2) was acknowledged in one of the mosaic panels.

MYSTICISM

The art of the sixth century in Ravenna, like that of other important centers such as Constantinople and Rome, marked the transition from classical Greco-Roman to the medieval world. Although some of the ancient grandeur remained, the accent on symbolism laid the foundation for the coming medieval styles. The physical was replaced by the psychical, the outer world of reality by the inner world of the spirit, and the rational road to knowledge by intuitive revelation.

A WORLD OF SYMBOLS. Many of the older art forms were carried over and reinterpreted in a new light. The Roman bathhouse became the Christian baptistry, where the soul was cleansed of original sin, and the public basilica was redesigned for church mysteries. Mosaics, formerly used for Hellenistic and Roman floors and pavements, became the mural medium for mystical visions. The shepherd of classical genre sculpture became symbolically the Good Shepherd. Classical bird and animal motifs became symbols for the soul and the spiritual realm. Music became a reflection of the divine unity of God and mortals, and the classical lyre, because of its stretched strings on a wooden frame, was reinterpreted by St. Augustine as a symbol of the crucified flesh of Christ. Orpheus, by means of the lyre's sounds, had descended into the underworld and overcome death. Christ as the new Orpheus is therefore often represented as playing a lyre (Fig. 5.31), and at Sant' Apollinare Nuovo, he is seated on a lyre-backed throne.

The concept of space turned from the classical three-dimensional representation of the natural world to an infinite Christian two-dimensional symbolic world. Invisible things rose in importance above those that could be seen, just as the mathematics of music was thought to surpass mere musical performance.

Whereas the classical mind regarded the world objectively from without, the Early Christian mind contemplated the soul subjectively from within. St. Augustine observed that "beauty cannot be beheld in any bodily matter." Such mystical visions were best represented through symbols. Natural science had been the foundation of ancient philosophy, but symbolic theology became the basis of Christian philosophy. Whereas Greek drama (which was a form of religious experience) had reached its climax step by step with remorseless logic, the Christian drama (as expressed in the liturgy) kindled the fires of faith and arrived at its mystical climax through suggestion and emotion. The denial of the flesh and the conviction that only the soul can be beautiful doomed the classical nude and exalted bodilessness. Instead of capturing and clothing the godlike image in flesh and blood, art now attempted to release the spirit from the bondage of the flesh. Similarly, Islam developed a complex symbolic language that permeates all its visual arts.

5.31 *Christ as Orpheus,* fourth century. Marble, height 3′4¼″. Byzantine Museum, Athens, Greece.

LITURGY AS THE EMBODIMENT OF MYSTICISM. The liturgy was an all-inclusive medium shaped to convey the otherworldly vision. The thought, action, and sequence of rites in Constantinople, Ravenna, Rome, and other cultural centers shaped the architectural plans of churches, the symbolism of mosaics, and the forms of sculpture and music. Centuries of theoretical speculation united with the practical efforts of countless generations of writers, builders, decorators, and musicians to produce the Byzantine liturgy in the East and the synthesis of Gregory the Great in the West. Removed from its primary religious association and seen in a more detached aesthetic light, the liturgy as a work of art embodies a profound and dramatic insight into the deepest longings and highest aspirations of the human spirit.

The Early Christian and Byzantine styles were responses to the need for new verbal, visual, and auditory modes of expression. In both cases there was a shift from forms designed to represent this world to those capable of conjuring up otherworldly visions. In the church liturgy, through the poetry of language, the dancelike patterns of step and gesture, and the exalted melodies of the chant, the gripping drama of humanity was enacted in awe-inspiring theaters. These sacred theaters were furnished with an impressive array of stage settings, decor, costumes, and props created by the finest craftspeople and artists of the time. The liturgy is, moreover, a continuous pageant that unfolds in a sequence of solemn and joyful feasts throughout the year.

THE ROAD NORTHWARD

In the East, the Byzantine Empire, so powerful from the time of Constantine through that of Justinian, gradually began to crumble as various parts of it fell to the armies of Islam. In the West, after the fall of Ravenna and Rome, the center of gravity gradually shifted northward and a period once known as the Dark Ages descended on Europe. Time did not stop, of course, but the spread of Christianity was accompanied by struggle and strife among contending migratory tribes and local factions, which resulted in a power vacuum. One of the first lights to shine through the prevailing disorder was the kingdom of the Franks in the Rhine valley. The Franks, who later gave their name to the whole of France, were Christians faithful to the pope as bishop of Rome. They gradually took over much of the Roman system of government.

The riches of Ravenna and the fame of San Vitale reached the court of the Frankish king, Charles the Great, known to history as Charlemagne. During his prodigious lifetime, he conquered most of Western Europe, and in 800, he was crowned Holy Roman Emperor by the pope in St. Peter's Basilica. Thereafter, his eyes turned eastward, and he established more or less friendly relations with the Byzantine Empire. He even sent ambassadors by elephant as far afield as Baghdad, to the court of Harun-al-Rashid, the famed caliph of the *Arabian Nights.* In his capital city of Aachen (Aix-la-Chapelle), he built a sumptuous palace that included the Imperial Chapel, designed by Odo of Metz (Fig. 5.32), whose plan was based on the octagonal contours of San Vitale.

In addition to his military conquests and the building of palaces and churches, Charlemagne took pleasure in the company of scholars. His cultural center at Aachen was eventually nicknamed the "Ravenna of the North." He gathered around him some of the wisest and most eminent scholars from Italy, Ireland, and England. Among them was Alcuin of York, who came to Aachen to head Charlemagne's Palatine (that is, palace) School. Here he restored a purified form of Latin

5.32 Capella Palatina (Charlemagne's Chapel), 792–805. Aachen (Aix-la-Chapelle), Germany.

as the primary literary language, systematized the curriculum, and promoted study of the liberal arts.

Charlemagne improved the education not only of the clergy but also of youth. He urged priests in every town to establish free schools for the children of the rich and poor alike. Christian doctrine, plainsong, and grammar were to be taught. Education in monastery and cathedral schools was more rigorous and elaborate, sometimes including the works of Cassiodorus (see p. 138) and Boethius (see p. 139). In effect, Charlemagne made Latin the language of an educated class that, like the Roman elite, was familiar with Roman bureaucratic structure and prepared to administer an empire. Like Rome, the Holy Roman Empire readily integrated non-Christian beliefs. For example, Christmas Day grew out of pagan German celebrations of midwinter and the lengthening of the daylight hours.

Aachen represents one kind of cultural hub, based on the centralization of political power, which in turn fostered education, book collecting, and the copying of ancient manuscripts. At the same time, another sort of cultural center had taken root in Ireland, a territory that was never directly under Roman rule. Christianity spread from England to Ireland in the fifth century. Unlike the religious scholars who were called to Aachen to study and teach, the Irish did not integrate religion and city life. Instead, they founded some of the earliest monasteries, that is, self-sufficient religious refuges isolated from worldly temptations. Their art developed in relative independence from Roman and Roman Christian traditions. Illuminated (that is, decorated) manuscripts like the *Book of Kells* (Fig. 5.33) stressed geometric intricacy and colorful abstraction rather than storytelling. However far removed they were from the Holy Roman Empire, the Irish were still

5.33 Chi-rho-iota page, folio 34 recto of the *Book of Kells,* probably from Iona, Scotland, late eighth or early ninth century. Tempera on vellum, 1′1″ × 9½″. Trinity College Library, Dublin, Ireland.

involved in continental European affairs. They had accepted the challenge of the pope to be missionaries to the Germanic tribes, and they visited the famous religious and scholarly facilities at Aachen.

Charlemagne's long and productive reign has gone down in history as the Carolingian Renaissance. It was more precisely a restoration of Greco-Roman learning and Roman authority rather than a movement that used the revival of traditional learning to chart new paths, as did the Italian Renaissance. Carolingian influence was felt not just in Germany but from the Baltic Sea to the Adriatic. Charlemagne's accomplishments, along with those of Otto the Great, who reigned as Holy Roman Emperor in the succeeding century, did much to pave the way for the future florescence of the Romanesque period.

YOUR RESOURCES

- ***Exploring Humanities CD-ROM***

 ○ Interactive Map: Europe and the Near East in Late Antiquity

 ○ Architectural Basics: The Islamic Mosque

 ○ Reading—Einhard, *Life of Charlemagne*

 ○ Images—*Mosaic from Hagia Sophia, Mosaic from Justinian I*

- ***Web Site***

 http://art.wadsworth.com/fleming10

 ○ Chapter 5 Quiz

 ○ Links

- ***Audio CD***

 ○ *Hymn of St. Ambrose*

 ○ *Alleluia*

EARLY CHRISTIAN CENTURIES, ISLAM

Rome

Key Events	Architecture	Literature and Music
306–337 **Constantine,** emperor	c. 313 **Lateran Basilica** begun on site of present San Giovanni in Laterano	
313 **Edict of Milan** legalized Christianity		
325 **First Council of Nicaea;** Arian heresy condemned	c. 324–c. 333 **Old St. Peter's Basilica** begun on Vatican Hill	
c. **340–397** **St. Ambrose,** bishop of Milan from 374	c. 330–c. 350 **Tomb of Santa Costanza,** daughter of Constantine; later rededicated as a church	**340–420** **St. Jerome;** translated Latin Vulgate Bible
402 **Rome** abandoned by Emperor Honorius as capital of the Western Roman Empire		**354–430** **St. Augustine,** bishop of Hippo (North Africa); author of *Confessions* (c. 400), *City of God* (c. 412)
410 **Visigoths** under Alaric sacked Rome	**385** **San Paolo fuori le Mura** ("St. Paul's outside the Walls") **Basilica** built; destroyed by fire 1823 and rebuilt	
476 **Odoacer** conquered Italy; fall of the Western Roman Empire		c. **524** **Boethius** wrote authoritative treatise *De musica*
590–604 **Gregory the Great** established papacy as political power	c. 432–c. 440 **Santa Maria Maggiore Basilica** begun	c. **600** **Pope Gregory the Great** codified church liturgy and chant

Ravenna, Aachen

c. **368** **Justina** becomes the second wife of Emperor Valentinian I	c. 400–450 **"Neonian" Baptistry** for Roman Christians	c. **386** **Bishop Ambrose of Milan** arranged hymns and psalms for congregational singing; body of choral music, Ambrosian chant (plainsong), is attributed to him
410 **Ravenna,** under Emperor Honorius, became capital of the Western Roman Empire	c. 425 **Mausoleum of Galla Placidia**	
476 **Odoacer** conquered Ravenna; fall of the Western Roman Empire	**493** **Church of Sant' Apollinare Nuovo** begun	**524** **Boethius** wrote *Consolation of Philosophy*
476–493 **Odoacer** established Ostrogothic kingdom in Ravenna, also ruled Italy	c. **520** **"Arian" Baptistry**	c. **540** **Cassiodorus** founded monastery at Vivarium, Italy, for preserving and copying manuscripts, wrote *History of Goths*
493–526 **Theodoric the Great** reigned as king of Ostrogoths, also ruled the Western Roman Empire	c. **526** **Mausoleum of Theodoric** built	**560–636** **Isidore of Seville** collected Greek and Latin writings
523–540 **Cassiodorus** served as prime minister to Theodoric and successors	c. **527** **Church of San Vitale** begun at Ravenna	**730** **Venerable Bede** wrote *Historia Ecclesiastica Gentis Anglorum* (Ecclesiastic History of the English People)
535 **Belisarius** invaded Italy in name of Emperor Justinian	**547** **San Vitale** completed	
546 **Maximian,** archbishop of Ravenna; ruled as Justinian's representative	c. **549** **Church of Sant' Apollinare** in Classe completed	**735–804** **Alcuin of York;** from 782 active at Charlemagne's court
732 **Charles Martel** defeated Muslims in battle of Tours and Poitiers, France	**556** **Ivory throne of Maximian** finished at Ravenna	c. **750** **Organs** powered by wind replaced water organs
768–814 **Charlemagne** ruled at Aachen; Carolingian Period		**760** **Book of Kells** (Latin Gospels) illuminated in Ireland
781 **Charlemagne** established Palace School		**790** **Schools for Church music** founded at Paris, Cologne, Soisson, and Metz
792–805 **Odo of Metz** designed and built the Palatine Chapel for Charlemagne	c. **792–800** **Centula monastery** built by Charlemagne	**870** *Musica enchiriadis,* a treatise using Latin letters for musical notation
800 **Charlemagne** crowned Holy Roman Emperor by pope in Rome	c. **796–804** **Palatine Chapel** at Aachen built by Charlemagne	

Byzantium (Constantinople)

c. **324–330** **Constantine** made Byzantium capital of the Eastern Roman Empire		**329–379** **St. Basil,** bishop of Caesarea and liturgist of Eastern Orthodox Church
325 **First Council of Nicaea**		c. **345–407** **St. John Chrysostom,** patriarch of Constantinople and liturgist of Eastern Orthodox Church
518–527 **Justin,** Eastern Roman emperor	c. **527** **Church of Sts. Sergius and Bacchus** begun	
527–565 **Justinian the Great,** Eastern Roman emperor	**532–537** **Church of Hagia Sophia** built by architects Anthemius of Tralles and Isidorus of Miletus	**529** **Justinian** issued Code of Civil Law
		c. **564** **Byzantine historian Procopius** died
570–632 **Mohammed**		

Islam

622 **Hegira,** Mohammed's flight to Yathrib, renamed Medina (city of the prophet)		
622 **Year 1** of Islamic calendar	**691** **Dome of the Rock** begun at Jerusalem	
630 **Mecca conquered,** becomes religious center of Islam, Koran (Quran) begins to be compiled	**705** **Mosque at Damascus** begun	
732 **Charles Martel** defeated Muslims in Battle of Tours, France	**785** **Mosque at Cordova** begun	
c. **750** **Islamic empire** spread from Asia Minor to North Africa, Spain	**1309–1354** **Alhambra Palace** built at Granada, Spain	
	1631–1648 **Taj Mahal** built at Agra, India	

(margin dates: 300, 600, 360, 875, 320, 570, 600, 54)

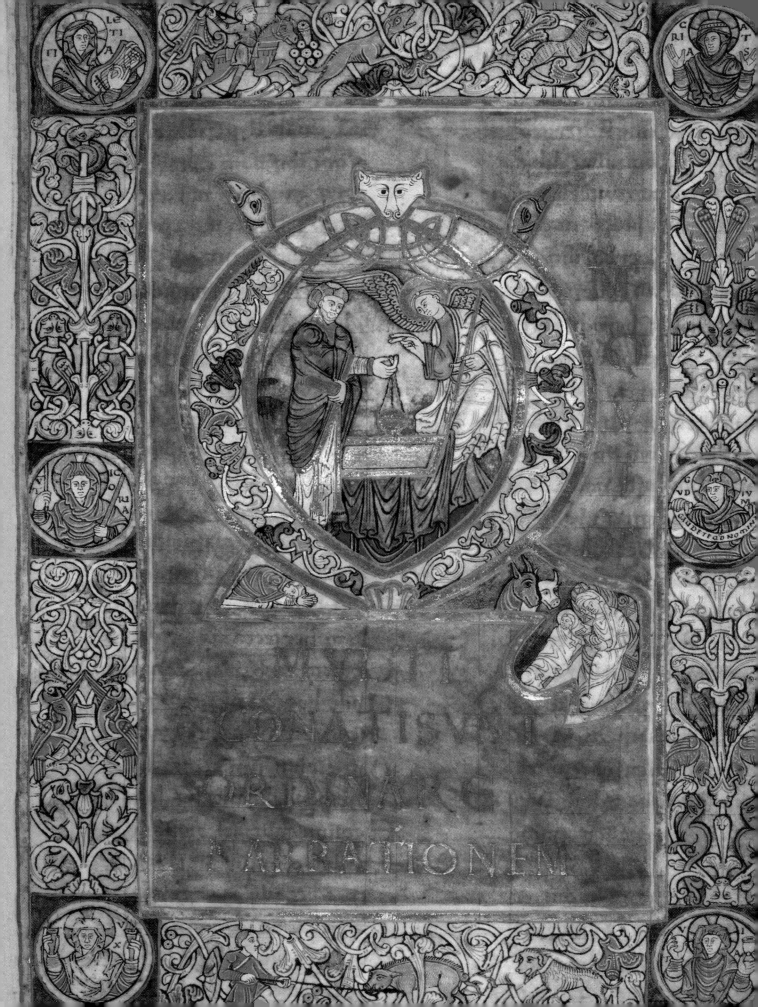

ROMANESQUE STYLE

As CHRISTIANITY SPREAD NORTHWARD AFTER the fall of the Western Roman Empire, southern classical forms met and merged with those of the northern barbarian peoples. The older, settled, newly Christianized Roman civilization, with its notions of centralized power, literacy, and organization, confronted various tribes whose migratory ways had changed to semisettled lives on the fringes of the old Roman Empire. These so-called barbarians had greater allegiance to local leaders and family affiliations than to centralized governments. Owing to their migratory customs, their art was necessarily small and portable.

Although the Roman Empire had collapsed, the Church of Rome did not. In fact, it expanded beyond the boundaries of the Roman world, bringing with it an international organization, the increased authority of the pope, and a transnational identity for believers. Indeed, in Europe the church called itself "Catholic," which means universal, in direct contrast with both the Eastern Church, centered in Constantinople, and with Islam, which was spreading in the Holy Land and North Africa.

The most significant cultural centers of the Romanesque period were the monastery and the castle. One was a refuge and sanctuary where life was a prelude to a heavenly hereafter; the other was a fortress concerned mainly with security and survival in the troubled world of the here and now. The monastic way of life dated from the Early Christian period, when hermits and groups of religious men and women rejected worldly temptations to live simply in out-of-the-way or inhospitable places. In the sixth century, after Cassiodorus had served in Theodoric's Ostrogothic kingdom, he retired to his country estate at Vivarium, where he founded a monastery that was noted for preserving and copying classical and Christian manuscripts (see p. 139). The basic rules of monasticism, codified by St. Benedict, were widely accepted by the seventh century. The movement gradually gained momentum and eventually reached its climax in Romanesque times, and with it came the development of a

typical style that reached maturity between the years 1000 and 1150. The spread of cultural centers in the form of widely scattered monastic communities lent a peculiar intensity and wide variety to the expressive forms of the Romanesque.

Lacking the security of strong central governments and not having the advantages of flourishing cities and towns, the monastic movement sought peace of mind in the abbey or monastery as a haven from the prevailing chaotic social surroundings. These centers off the beaten path were miniature worlds that contained a cross section of Romanesque life. Besides serving as religious shrines where pilgrims could gather to revere sacred relics, monasteries were the manufacturing and agricultural centers of their regions, as well as seats of learning and the places where the only libraries, schools, and hospitals of the time were to be found. Like cultural centers before them, monasteries preserved learning while inventing new forms of architecture, sculpture, and music.

SOCIAL STRUCTURE

The social structure of Romanesque society was built upon the strict hierarchical principle of feudalism. Under feudalism, every person was presumed to have a predetermined status, based primarily on the circumstances of his or her birth and only partially on individual ability. A key feature of feudalism was *primogeniture,* in which the firstborn son inherited all the family's property to prevent land from being subdivided over the generations. Younger brothers of the heir usually had just two choices: to carve out careers in the church or to enlist as soldiers of fortune.

The lives of noble and wealthy women were shaped by their families' economic and political positions. Their marriages were arranged to the best advantage of their families, and their primary duty was to bear children. If unmarried, they could stay in the family household as dependents, reside in nunneries as paying guests, or join the

ranks of nuns. Convents provided women access to education as well as other intellectual and artistic pursuits. By contrast, peasant women and women living in towns entered marriages that were understood to be economic partnerships. They were freer than the rich to choose mates, and they appear to have made more mutual decisions about family assets and businesses.

Despite legal and conventional restrictions, women were involved in a surprisingly large number of enterprises. Wealthy women administered large estates when their husbands departed, often for a decade, to fight in the Crusades. Charlemagne attempted to provide universal schooling (see p. 151) to educate boys and girls using the same curricula. Some women, usually those whose parents could spare them from household duties, went on to advanced training in the liberal arts. Convent life also encouraged teaching and learning. Secular and religious women routinely tutored children. Occasionally a townswoman worked as a full-time professional artist, but nuns were more commonly employed to copy and illuminate books. Similarly, although there were professional women musicians (see Hildegard of Bingen and the Countess de Dia, later in this chapter), most were amateurs whose achievements rose above the routine requirements of their education. Crafts such as embroidery cut across class lines. Textile- and carpet-making were family businesses in which women excelled. Rarely, as in the case of ribbon-makers living in French cities like Paris, women founded their own guilds.

The Romanesque economy was based primarily on agriculture, which made possession of land all-important. At the bottom of the social ladder were the serfs, who did most of the hard labor on the land. Technically they were not slaves, but most were tied to the soil. In the system of feudal loyalties, the serfs were responsible to tenant farmers, who rented land from the lord of the manor. He, in turn, was beholden to a regional baron, duke, or leader, whose territories were allotted him by the king. In church circles, the chain of command rose from curate or chaplain to parish priest, bishop, archbishop, and pope. In the monastery, individual monks owed allegiance to their priors or abbots, who in turn reported to the pope. Over all of them was the all-embracing figure of God the Father.

THE ROMANESQUE WORLDVIEW

During the Romanesque period, the figure of Christ changed from the Good Shepherd of Early Christian times (see Figs. 5.1 and 5.4) to a mighty king, crowned and enthroned in the midst of his heavenly courtiers and sitting in judgment on the entire world. At the French cathedral of Saint-Lazare in Autun, the **tympanum** (a half-moon-shaped space over a door) displays a chilling Last Judgment scene (Fig. 6.1). Souls are weighed and then either sent to heaven, at Christ's right hand, or thrown into hell by snarling devils, on his left. Chiseled along the bar that separates the souls of the dead from the judgment scene are words that threaten sinners with hell in the afterlife. On the same bar, the name of the tympanum's sculptor, Giselbertus, proclaims

6.1 Gislebertus. *Last Judgment,* west tympanum of Saint-Lazare, Autun, France, Autun Cathedral, c. 1130–1135. Marble, approx. 21′ wide at base.

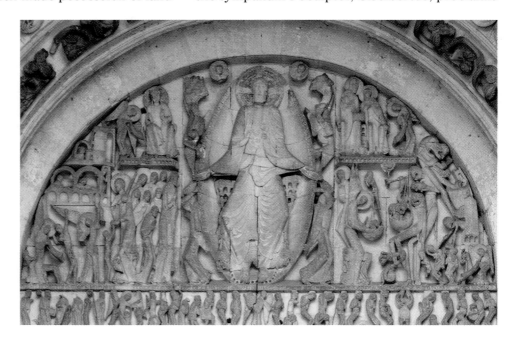

that he made the work, an unusual public assertion of artistic identity in a period when knowing one's place was paramount.

In the Romanesque worldview, all life had to be brought into an organized plan that would conform to the cosmic scheme of things. The stream of authority, descending from Christ through Peter to his papal successors, flowed out from Rome. The Holy Roman emperor received his crown from the hands of the pope; in turn, all the kings of the Western world owed him homage, as did everyone below them, from the great lords to the humblest serfs, for all had a preordained place in the great cosmic plan.

This hierarchical principle, moreover, applied not only to the social and ecclesiastical levels but also to basic thought processes. Authority for all things rested firmly in the Scriptures and interpretations of them by the early church fathers. Scholarship consisted not so much in exploring new intellectual paths as in interpreting traditional sources. For the educated, this process took the form of learned commentaries; for the uneducated, it was expressed in the cult of relics. In the arts, this veneration of the past made mandatory the continuance of such traditional forms as the Early Roman Christian basilica and the music of the plainchant.

Another key feature of the Romanesque period was the religious pilgrimage. In the broad band at the bottom of the tympanum at Autun (Fig. 6.1) are two figures on the viewer's left carrying walking staffs. They are well-traveled pilgrims (see Map 6.1 for pilgrimage routes). One has a seashell badge, symbolizing that he has visited Santiago de Compostela, and the other has a cross, signifying that he has been to Jerusalem. Thousands traveled the dusty pilgrimage roads across France to Spain to touch the revered tomb of the Apostle James at Compostela. Fewer went to Jerusalem, but that number increased in the late eleventh century with the beginning of the Crusades (see later discussion).

RELIGIOUS ROMANESQUE

The largest and grandest of all Romanesque monasteries, the abbey at Cluny, was also a major cultural center. Its appearance at the pinnacle of its

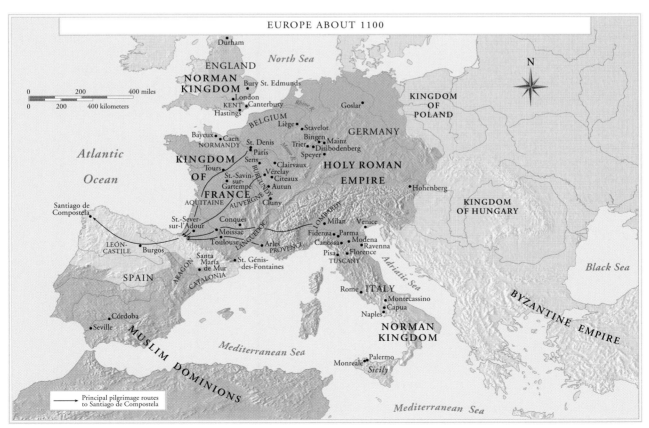

MAP 6.1

power and fame has been reconstructed in Figure 6.2. The world within these walls was populated principally by professed monks devoted to prayer and contemplation. It also housed some world-weary men of action who sought to escape life in the unsettled society outside the abbey's precincts.

By taking the triple vows of poverty, chastity, and obedience, the monk renounced such worldly pursuits as individual material rewards, the pleasures of the senses, the personal satisfactions of family life, and even the exercise of his own free will. According to the Rule of St. Benedict, the founder of Western European monasticism, a monk "should have absolutely not anything; neither a book, nor tablets, nor a pen—nothing at all . . . it is not allowed to the monks to have their own bodies or wills in their power."

To provide such a life, a monastery had to be planned such that the monks would have all that was necessary for both their bodily sustenance and their spiritual nourishment. The Benedictine Rule did not prescribe the exact form that a monastic building should take, and nominally each abbey was free to solve its problems according to its needs, the contours of its site, and the extent of its resources. But tradition often operated as rigidly as rules, and most monasteries followed a common pattern with local variations. If one allows for its exceptional size and complexity due to its status as mother house of a great order, the plan of Cluny can be accepted as reasonably typical.

Because the life of a monk was one of almost continuous religious duties alternating with periods of prayer and meditation, the soul of the

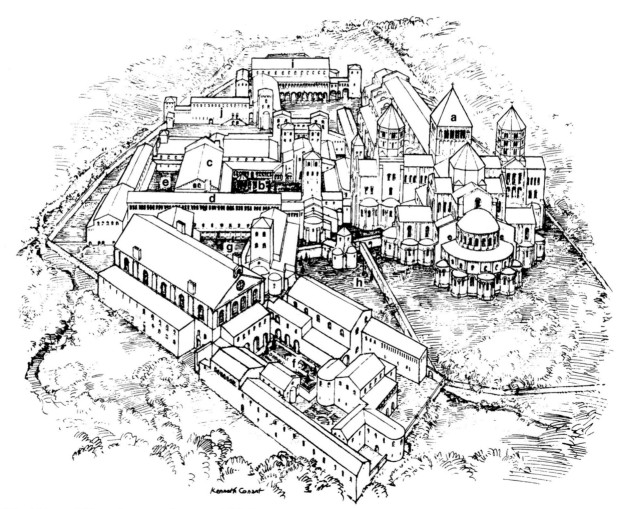

6.2 Abbey of Cluny, from southeast, c. 1157. Reconstruction by Kenneth J. Conant. Third Abbey Church, with lantern tower over crossing of nave and major transept (a); Cloister of Pontius, main cloister (b); refectory (c); monks' dormitory (d); novices' cloister (e); visitors' cloister (f); Cloister of Notre Dame (g); monks' cemetery (h); hospice (i); craftspeople's quarters and stables (j).

monastery was in its abbey church, and its heart was in its cloister. The church at Cluny, the largest in Europe, served primarily as the scene of the constant devotional activities of the monks day and night throughout the year. Only secondarily was it a shrine for the streams of pilgrims who arrived from near and far to revere relics of saints.

Cluny was rich in such relics, and on feast days of the saints, pilgrims flocked there as they did to other famous shrines, such as that of the Apostle James at Santiago de Compostela in Spain. European pilgrimage routes were traveled mainly by foot. **Hospices** (guesthouses) or inns at 20-mile intervals provided places where travelers could eat and sleep after a day's journey. Pilgrims from England had to cross the English Channel. Those from Germany traveled south by way of the Alpine passes. Pilgrims to the Holy Land went by ship from Genoa, Venice, or Sicily, with stops at Cyprus, Constantinople, or Rhodes.

Next in importance to facilities for church services was provision for the contemplative life, which centered on the cloister. Typically, a cloister was found in the center of the abbey, south of the nave of the church. The other monastic buildings clustered around it. The usual cloister was an open quadrangular garden plot enclosed by a covered arcade on all four sides. The somewhat irregular shape of the cloister at Cluny in the twelfth century resulted from the ambitious building program required by the monastery's rapid growth. Because this renowned marble-columned cloister no longer exists, the one at St. Trophîme at Arles will serve as an example (Fig. 6.3).

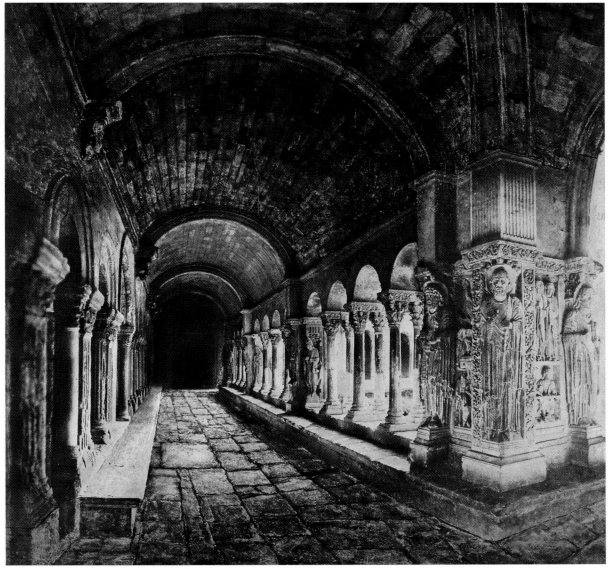

6.3 Cloister, Abbey of St. Trophîme, Arles, France, c. 1100.

A complete abbey like the one at Cluny had to provide for many functions in addition to worship and meditation. The daily life of the monks demanded a refectory, or dining room, where they could eat their meals, plus kitchens, bakeries, and storage space. Abbeys also provided a chapter hall, where they could transact their communal business, and a dormitory adjacent to the church, because services were held during the night as well as by day. Three small cloisters were included: one for the education of novices (young future members of the order); another for visiting monks and religiously inclined laymen who sought refuge from the world; and a third, near a cemetery, for aged and infirm brothers. The hospice provided accommodations for visitors, who flocked in during the pilgrimage season. There were also quarters for blacksmiths, carpenters, cobblers, and the like, as well as stables for dairy cattle and other domestic animals. Such monasteries also held large tracts of land, including forests that provided building material and wood for heat. Some of the soil was worked by the monks themselves, whereas other tracts were rented to tenant farmers.

The plan of the abbey at Cluny was a coherent system of adjoining quadrangles that embraced courts and cloisters whose variation in size and importance accommodated the differing activities they were designed to serve. Altogether, it was a highly complex yet logical plan for a complete community. It took into account the ideals, aspirations, practices, and everyday activities of a group that gathered to work physically and spiritually toward a common end.

ARCHITECTURE

Hugh of Semur, the greatest of the Cluniac abbots, succeeded to his position in 1049. Under him, Cluny attained a period of such splendor that it was described by an enthusiastic chronicler as "shining on the earth like a second sun." Taking as his model the accepted feudal organization of society, in which smaller and more dependent landowners swore allegiance to the larger and more powerful landlords in return for protection, Hugh brought many of the traditionally independent Benedictine monasteries into the Cluniac orbit. With the express approval of the popes, Hugh gradually concentrated the power of the whole order in his hands and transformed Cluny into a vast monastic empire that extended from Scotland in the north to Portugal in the west,

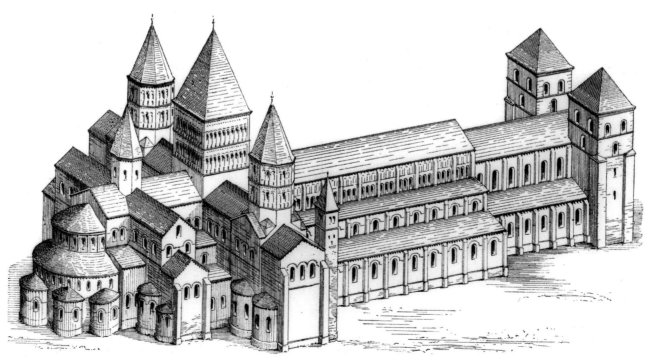

6.4 Reconstruction of the third church of Abbey at Cluny, view from the northeast, c. 1120.

Jerusalem in the east, and Rome in the south. In the church hierarchy, he was outranked only by the pope. In the secular world, he was the peer of kings. Like the feudal nobles, the monastery at Cluny amassed a vast fortune, making it influential in the worldly affairs it had originally renounced. Indeed, the church was probably the biggest landowner in Europe, owing in part to generous bequests and in part to the fact that the clergy's higher ranks were increasingly populated by wealthy individuals who brought wealth and influence with them.

Cluny figured prominently in the historical events of the day. For example, Hugh acted as an intermediary between an emperor and a pope on the famous occasion when Henry IV came to Canossa in Italy to beseech Gregory VII for forgiveness. Hugh's greatest moment, however, came when Pope Urban II, who had received training as a monk at Cluny under Hugh's personal guidance, was present to dedicate the high altar of his great new abbey church. Honor after honor was bestowed on the monastery by this Cluniac pope.

THE THIRD ABBEY CHURCH AT CLUNY. With such a rapidly expanding monastic order, Hugh had to undertake a massive building program. The ever-increasing number of Cluniac monks and the growing importance of Cluny as a pilgrimage center made the older second church inadequate. To rival the legendary temple of Solomon and eclipse all other churches in Western Christendom, Hugh and the monk Hezelo, whom some believe was the architect for the project, began the immense Third Abbey Church. It became the largest church in Christendom.

In contrast to the Early Christian basilicas, Romanesque abbey churches show remarkable extensions before and beyond the nave (Fig. 6.4). The three-aisled narthex entrance grew to the size of a large church. It was, in fact, called variously the "church of the pilgrims" and the "minor nave." Besides accommodating visitors, the narthex was the assembly place for the clergy who marched in the grand processions on high holidays, such as feast days of saints.

The spacious five-aisled nave allowed pilgrims and townspeople to gather for religious services, whereas the space beyond was expanded for the large monastic community. Instead of a single transept, there were now two. Extending outward from both the major and minor transepts were chapels dedicated to various saints, each the size of a small church. In addition, the apse was enlarged to accommodate the huge high altar, and an **ambulatory,** or passage for pilgrims and processions, was provided to reach the **apsidal chapels** that radiated outward from the apse. An exterior view of the apsidals is shown in Figure 6.5.

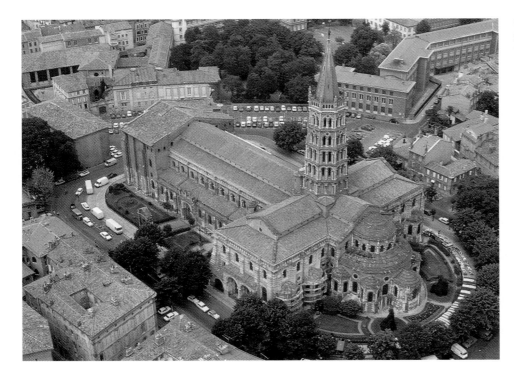

6.5 Aerial view from the southeast, St. Sernin, Toulouse, France, c. 1080.

On entering the nave (Fig. 6.6), one noticed at once the mighty proportions of the huge basilica. The entire horizontal axis from front to back, including the narthex, reached an overall length of 615 feet. The nave itself had eleven **bays,** or arched units, between the supporting columns. Each bay was separated by a group of columns clustered around supporting piers.

Early Christian basilicas were horizontally directed, whereas Romanesque churches had a more vertical emphasis. Gradually the vertical space increased, creating new areas for architectural innovation and decoration. At Cluny, a double row of windows above the nave served as the clerestory for illumination.

The nave at Cluny was spanned by ribbed barrel vaults, 32 feet wide, supported by slightly pointed arches. Rising a full 98 feet above the pavement, the vaults were the highest that had been achieved up to this time. Sadly, the emotional drive to achieve height outran the engineering knowledge needed to maintain it, and a part of the Cluny vaulting soon collapsed. Out of this accident came experimentation with **buttressing,** or external supports. When the vaults were rebuilt, a

range of buttresses with open round arches was placed outside. With its high nave vaults supported by external buttressing and its pointed arches, the great abbey church at Cluny set the stage for future Gothic cathedrals, which would bring these features into a unified, systematic whole.

The decorative plan of the church was carried out on a scale comparable in quality to the grandeur of its spatial dimensions. More than 1,200 sculptured capitals surmounted the columns of the structure, and carved moldings outlined the graceful pointed arches of the nave arcade. Most of the sculpture was painted in rich colors that gave an added glow to the splendor of the interior, and mosaic floors inlaid with images of saints and angels or with abstract designs paved the entire church.

All this magnificence did not go unchallenged. St. Bernard, a vigorous opponent of the Cluniac order, disapproved violently of such extravagances. By expressing his disapproval in writing, he inadvertently left a firsthand account of the glory of Hugh's church soon after it was finished. In a letter to one of the Cluniac abbots, Bernard deplored (with Cluny in mind) "the vast height of your churches, their immoderate length, their superfluous breadth, the costly polishings, the curious carvings and paintings which attract the worshiper's gaze and hinder his attentions." His feeling was that "at the very sight of these costly yet marvelous vanities men are more kindled to offer gifts than to pray. . . . Hence the church is adorned with gemmed crowns of light—nay, with lustres like cart-wheels, girt all round with lamps, but no less brilliant with precious stones that stud them. Moreover we see candelabra standing like trees of massive bronze, fashioned with marvelous subtlety of art, and glistening no less brightly with gems than with the lights they carry. What, think you, is the purpose of all this? The compunction of penitents, or the admiration of beholders?"

Cluny Abbey stood proudly until the tumultuous years following the French Revolution, when a wave of anticlericalism led to the sacking and burning of the abbey. In 1809, most of the buildings, except for a single transept wing, were blown up by gunpowder, and the rubble was sold as common building stone. Some sculptural fragments survive, and the spirit of the great monastery lives on in the influence it exerted on related structures, such as St. Trophîme at Arles (Fig. 6.3), St. Sernin in Toulouse (Fig. 6.5), and La Madeleine at Vézelay (Figs. 6.7, 6.8, and 6.9).

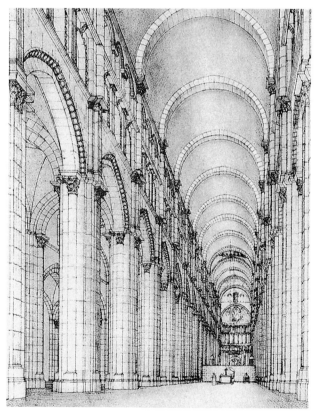

6.6 Nave, Third Abbey Church of Cluny, 1088–1130. Reconstruction by Kenneth J. Conant.

SCULPTURE AT VÉZELAY

Some of the first sculpture dating from the period of Cluny's grandeur is found in the abbey church of La Madeleine at Vézelay. The nave and narthex are contemporary with Hugh's church at Cluny, and restoration in the nineteenth century by the French archeologist Viollet-le-Duc accounts for their present good condition. Although its proportions are considerably smaller than those of the great basilica at Cluny, La Madeleine today is the largest Romanesque abbey church in France. Rich in historical associations, in medieval times it attained its principal fame as the repository of the relics of St. Mary Magdalene. Of chief interest at Vézelay, however, is its wealth of sculptured capitals. Unlike the statuary of antiquity, which was made of marble or bronze, French Romanesque capitals were usually of soft sandstone and limestone. The plasticity of these materials responded more quickly to the imaginative demands made on them than a harder stone could have. Above all, the relief compositions over the three internal portals leading from the narthex into the nave and side aisles illustrate the historical and symbolic significance of La Madeleine. Here Pope Urban II proposed to launch the First Crusade. Bernard of Clairvaux urged a Second Crusade here. The Third Crusade, launched by Richard the Lionhearted of England in conjunction with King Philip Augustus of France, set out from Vézelay in 1190.

Unlike the plain exteriors of Byzantine churches (see pp. 122 and 129), important sections of Romanesque churches were decorated with sculpture. A visitor entering the main door of the narthex of La Madeleine could look up at the tympanum and its surrounding **archivolts,** the series of arches that frames the tympanum, and be visually reminded of the power of Christ and of the church's long association with the Crusades.

THE TYMPANUM. The splendid semicircular tympanum over the central portal of the narthex at Vézelay (Fig. 6.7) dates from the first quarter of the twelfth century. Here as elsewhere, Romanesque designers and sculptors looked for their subjects in the drawings and miniature paintings that illustrated the texts of the Scriptures in monastic libraries. Such illuminated manuscripts provided convenient models that the monks could show to the sculptors who were to carry out the projects. At Vézelay, the robes of Christ and the apostles reveal a pattern of clear, sharp, swirling lines that derive from pen drawings in manuscripts of the time.

The interpretation and iconography of the tympanum scene may be discovered in the vision of St. John as recorded in Revelation (22:1–2):

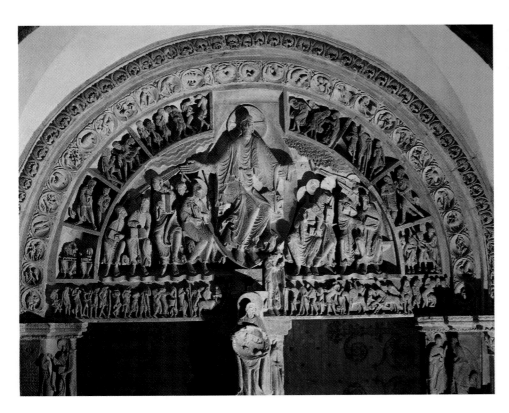

6.7 Tympanum of the center portal of the narthex, La Madeleine, Vézelay, France, c. 1120–1132.

"And he showed me a pure river of water of life, clear as crystal, proceeding out of the throne of God and of the Lamb. In the midst of the street of it, and on either side of the river, was there the tree of life, which bare twelve manner of fruits, and yielded her fruit every month: and the leaves of the tree were for the healing of the nations."

The figure of Christ dominates the composition; he is seated, as St. John says, on "a great white throne," but not so much to judge mortals as to redeem them. The streams issuing from his fingers descend on the barefoot apostles, who bring spiritual understanding through the books they hold and physical healing through the divine mercy they transmit to humanity. On one side of Christ's head, the water referred to in the quotation flows forth, whereas on the other are the branches of the tree. The mission of the apostles to convert heathens would also have been read by visitors as a reference to the goal of the Crusades to capture the Holy Land.

The Crusades and the mission of the apostles are also alluded to in the eight compartments of the archivolts surrounding the tympanum. At the top left, next to the head of Christ, appear two strange dog-headed men, whom the Spanish scholar Isidore of Seville, in his *Etymologies,* called the "Cynocephaloi," a tribe that was supposed to have inhabited India. The corresponding compartment on the right side shows the crippled and bent figure of a man and that of a blind woman taking a few halting steps as she is led forward. The other compartments depict the lame supported on crutches, along with lepers who point toward their sores.

Along the lintel below, a parade of the nations converges toward the center. Among these peoples who populate the remote regions of the Earth are a man and woman (in the far right corner) with enormous ears and feathered bodies. Next to them is a group of dwarfs or pygmies so small that they have to mount a horse by means of a ladder. On the far left, half-naked people hunt with bows and arrows, and toward the left center some heathens are shown leading a bull to sacrifice.

THE ARCHIVOLTS. The twelve fruits, one for each month of the year, are found among the twenty-nine medallions in the middle band of archivolts. A figure treading grapes, for example, represents September; October is symbolized by a man gathering acorns for his pigs. The months themselves, besides being connected with such labors, are symbolized by the signs of the zodiac, which were intended to remind Christians of the very limited time they have in which to attain salvation. A few

of the other medallions picture strange beasts taken from **bestiaries,** books that recounted lore about animals, both actual and fabulous. A survival from antiquity can be noted in the medallion (lower right) that depicts a centaur.

CAPITALS. At Vézelay, the imaginative scope displayed in the abundance of sculptured capitals is breathtaking. Biblical scenes, incidents from the lives of the saints, allegorical commentaries, and the play of pure fantasy are found throughout the narthex and the nave. One of the capitals shows the angel of death striking down the eldest son of Pharaoh (Fig. 6.8). Another shows a bearded figure pouring grain into a hand mill being turned by a barefoot man (Fig. 6.9). The real meaning of this scene would be lost to posterity were it not for a chance remark in the writings of Suger, the abbot of St. Denis near Paris, who visited Cluny and Vézelay before rebuilding his own abbey church. He noted that the corn is the old law, which is poured into the mystic mill by an ancient Hebrew prophet, probably Moses, and ground into the meal of the new law by St. Paul.

Romanesque sculpture remained an integral part of architectural design and is inseparable from the whole. The walls, ceiling, portals, col-

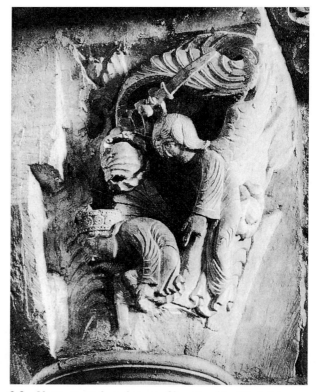

6.8 Nave capital sculpture, Church of La Madeleine, Vézelay, France, c. 1130. Angel of Death Killing Eldest Son of Pharaoh.

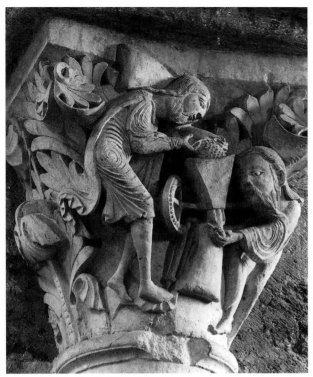

6.9 Nave capital sculpture, Church of La Madeleine, Vézelay, France, c. 1130. Mystic Mill: Moses and St. Paul Grinding Corn.

6.10 Initial page with letter Q, from Evangeliary of Abbey at St. Omer, c. 1000. Manuscript illumination. The Pierpont Morgan Library, New York.

umns, and capitals were not merely mute structural necessities. They were places where carved images communicated messages and meanings, where stone spoke to monk, nun, and pilgrim alike in the eloquent language of form, line, and color.

PAINTING

At one extreme of the art of painting in the Romanesque period were miniatures of modest proportions on the parchment pages of books; at the other were monumental murals in the apses of abbey churches. The one craft that the monks are known to have consistently practiced is the copying, illustrating, and binding of books, activities that took place in a large communal room called the **scriptorium.** This tradition, which dates from the time of Cassiodorus, was followed by all Benedictine houses, and those in the Cluniac order fostered it with both diligence and enthusiasm.

Although the Cluniac copyists were known for the beauty of their lettering and the accuracy of their texts, a monk who was skilled in his craft would certainly not have been content merely to copy letters all his life. A blank place in the manuscript provided both the opportunity and the challenge to fill it in. At first these areas contained

nothing more than fanciful little pen drawings or elaborate initial letters at the beginning of a paragraph. Gradually the drawings grew into miniature paintings, and the initial letters became highly complex designs.

The development of this art of illustrating, or *illuminating,* manuscripts seems to have been one compensation for the austerity of Benedictine life. As the practice became more widely accepted, specialists in the various phases were designated. A painter of small illuminated scenes was called a **miniator,** whereas one who did initial letters was known as a **rubricator.**

Cluniac manuscripts were illustrated with the utmost delicacy. Miniatures were painted in many colors, and the halos of saints or crowns of kings were made with thin gold leaf. The letter Q in an evangeliary from St. Omer is an intricate example of the illuminator's art (Fig. 6.10).

Convents offered a unique environment for female artists, who were also involved in manuscript illumination. A remarkable example was Hildegard of Bingen, who was educated in a Benedictine double monastery (that is, one providing facilities for

nuns as well as monks) and later became the abbess of a convent near Bingen. She wrote Latin poetry and composed words and music for more than seventy hymns. Her morality play, *Ordo virtutum,* dramatizes a contest between the virtues and the devil to gain a Christian soul. Her vision of heaven in seven circles was illustrated by artists under her supervision (Fig. 6.11). Mary is its majestic queen, holding the orb and scepter. Just below, an angelic choir is singing, while other circles enclose patriarchs, prophets, apostles, and saints.

Flourishes of the pen by expert copyists and the gradual refinement of the art of illumination had effects far beyond the medium for which either was originally intended. They became the models for the large murals that decorated the walls and apses of churches and for the sculpture that embellished the spaces above portals and columns.

Later they became the prototypes for the design of stained-glass windows in Gothic cathedrals.

Contrasting with the diminutive illuminations in manuscripts were the huge frescoes painted on the surfaces of the barrel-vaulted ceilings, arches, and semidomed apses of churches of the Romanesque period. Except for a few fragments, all the large paintings at Cluny itself have disappeared. Notable examples are found elsewhere, however. In a chapel at nearby Berzé-la-Ville (a residence built for Hugh in his last years), there is an apse mural modeled after the one in the Third Abbey Church (Fig. 6.12). Christ is clothed in a robe of white, over which is draped a red mantle. With his right hand he blesses the surrounding apostles and saints, while with his left he gives St. Peter a scroll containing the law. The heavenly setting is suggested by the dark blue background of the

6.11 Hildegard of Bingen's vision of heaven in seven circles. Manuscript illumination.

mandorla, an almond-shaped halo or glory, which is studded with golden stars, and by the hand of God the Father, which hovers above Christ, holding a crown.

MUSIC

Odo of Cluny, who served as the second abbot from 927 to 942, brought the monastery its earliest musical distinction by actively fostering choral music. Documents tell of more than 100 psalms being sung at Cluny daily in his time. On his tours of inspection to other monasteries, he devoted much of his energy to the instruction of choirs. His great success made it necessary for his teaching methods to be written down, and from this circumstance, something about the early status of music at Cluny can be ascertained.

THE DEVELOPMENT OF NOTATION. Odo's great accomplishments include arranging the tones of the scale into an orderly progression from A to G, an early system of Western musical notation. Odo's method, as expounded in a treatise often ascribed to him, included the mathematical measurement of **intervals,** the difference in pitch between tones, on a musical instrument called a **monochord.** Consisting of a single string stretched over a long wooden box with frets for varying the length of the string, the monochord made it possible to demonstrate the relationships between string lengths and intervals.

Before Odo's time, the chants used in the sacred service had to be learned laboriously by rote. If any degree of authenticity was to be achieved, chants had to be taught by a graduate of the Schola Cantorum, the school for teaching chants that had been founded by Pope Gregory I in Rome. Odo's treatise declares that when singers were taught to perform by reading notes, they soon "were singing at first sight and extempore and without a fault anything written in music, something which until this time ordinary singers had never been able to do." Odo's system of notation made songbooks possible and enabled the transmission of music from one generation to the next.

In the eleventh century, another monk, Guido of Arezzo, refined Odo's method. His treatise, which was in the library of Cluny, made it clear that he embraced the Cluniac musical reforms. He also freely acknowledged his debt to the Abbot Odo, "from whose example," he said, "I have departed only in the forms of the notes." This slight departure by Guido was actually the invention of the basis for modern musical notation on a staff of lines, where tones of the same pitch always appear on the same line or space. Odo's work also led to

Guido's system of **solmization,** which assigned certain syllables, derived from a hymn to St. John, to each degree of the scale. Later the syllable *si,* compounded from the first two letters of the Latin form of "St. John" *(Sancte Ioannes),* was added as the seventh degree of the scale. In France, these syllables are still used as in Guido's time. In Italy and elsewhere, the first note, *ut,* was replaced by the more singable, and familiar, *do.*

Musical Example 6.1
Hymn to St. John the Baptist Guido of Arezzo

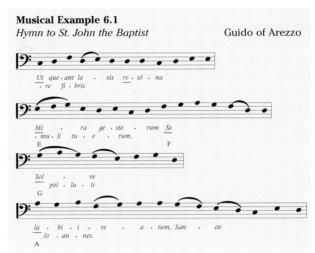

6.12 *Christ in Majesty,* c. 1103. Fresco (apse mural), height 13′. Chapelle des Moines, Berzé-la-Ville, France.

The most remarkable fact about Odo's and Guido's treatises is that both describe music as an art designed to praise the Creator and enhance the beauty and meaning of prayer. Previously, Boethius, along with most early writers on music, had considered music a branch of mathematics that could reveal the secrets of the universe. Guido, however, made a poi6.2 nt of stating that the writings of Boethius were "useful to philosophers, but not to singers." Both Odo and he intentionally omitted heavenly speculations. Cluny, therefore, emerged as a center of practical music-making rather than as a place where scholars pondered music only as a theoretical science.

MUSIC PICTURED IN SCULPTURE

The story of music at Cluny was also told with compelling beauty in sculptured capitals that survive from the apse of Hugh's great church. In the sanctuary, the architectural climax of the whole edifice, was a series of columns grouped in a semicircle around the high altar. One capital portrayed on its four faces the theological virtues; another, the cardinal virtues. On a third were pictured the cycles and labors of the monk's year in terms of the four seasons. His hopes for the hereafter were portrayed by the four rivers and trees of Paradise. Finally, his praise for the Creator was expressed with figures to symbolize the eight tones of sacred psalmody.

On the first of the eight faces of these twin capitals (Fig. 6.13) is inscribed, "This tone is the first in the order of musical intonations." The figure is that of a solemn-faced youth playing a lute. Here the symbolism of the stringed instrument stems from the belief in the power of music to banish evil, as David had cast out Saul's evil spirit when he played to him. Another figure (Fig. 6.14) shows a young man playing a set of chime bells. The accompanying inscription notes that he is playing a lament. The Latin word *planctus* denotes a funeral dirge. The practice of ringing bells at burials is pictured in the contemporary representation of the burial procession of Edward the Confessor in the Bayeux Tapestry, in which the figures accompanying the bier carry small bells.

EARLY FORMS OF POLYPHONY

Gregorian plainsong was a purely melodic style and continued to be practiced as such, but during the Romanesque period the choral responses began to show variations in the direction of singing in several parts at different levels of pitch. The ninth, tenth, and eleventh centuries thus saw the tentative beginnings of the **polyphonic,** or "many-voiced," style that was to flourish in the Gothic period and in the Renaissance.

Unfortunately, the polyphonic practice of the pre-Gothic period is known only through theoretical treatises. However, from the rules they give for the addition of voices to the traditional chant, some idea of the early forms of polyphony can be determined. As might be expected, mathematics and Pythagorean number theory influenced the musical usages of the time (see pp. 51 and 58). The perfect intervals of the octave, fifth, and fourth

6.13 Side of ambulatory capital, Great Third Abbey Church of Cluny, 1088–1095. *First Tone of Plainsong.*

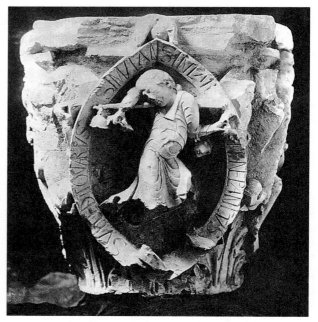

6.14 Other side of ambulatory capital, Great Third Abbey Church of Cluny. *Fourth Tone.*

were preferred over all others, because their mathematical ratios indicated a closer correspondence with the divine order of the universe.

PARALLEL ORGANUM (TENTH CENTURY)

In a treatise from the beginning of the tenth century, the type of choral response known as **parallel organum** is discussed. The original Gregorian melody was maintained intact. However, the principal voice was paralleled at pitch levels of the fourth, fifth, and octave above and below by so-called organal voices. Parallel organum, like buttresses in architecture, built a mighty fortress of choral sound around the traditional Gregorian line of plainsong. By thus enclosing it within the stark but strong perfect intervals, parallel organum achieved a massive and solid style quite in the spirit of the other Romanesque arts.

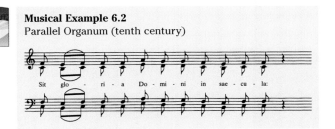

Musical Example 6.2
Parallel Organum (tenth century)

Sit glo - ri - a Do - mi - ni in sae - cu - la:

The music of this time was yet another expression of the praise of God. When related to the great buildings, the richly carved sculpture, the illuminated manuscripts, and painted murals, it fits into the picture as a whole. Consequently, when the choir section of a monastic church was being planned, every effort was made to provide a resonant, acoustically vibrant setting for the perpetual chant. Hugh's great church was especially famous for its acoustics. The curved ceiling vaults and the great variety of angles in the wall surfaces of the broad transepts and cavernous nave gave the

chant there a characteristic tone color that can be reproduced only in a similar setting. The effect of a monastic choir of several hundred voices performing joyous songs must have been overwhelming.

Cluny's sculptured capitals depicting the tones of plainsong represent an obvious synthesis of the arts of sculpture, music, and literature into an appropriate architectural setting. Their expressive intensity, moreover, bespeaks both the motion and the emotion typical of Romanesque style in general. As such, they are representative products of a people capable of the long and difficult pilgrimages and fantastic effort associated with the organization of the First Crusade. These sculptures reveal something of that unconquerable energy, and especially a vigorous attitude toward the act of worship that must have been channeled into a performance style that was emphatic in feeling. They are, in fact, the embodiment of the spirit expressed by St. Augustine, who called upon the faithful to "Sing with your voices, and with your hearts, and with all your moral convictions, sing the new songs, not only with your tongue but with your life."

WORLDLY ROMANESQUE

Whereas a monastery was a haven of peace, a feudal manor was an armed fortress. And whereas the monk was a man of prayer, the landed baron was a man of war.

The treasures of a monastery or cathedral were always under the watchful eye of the clergy, and religious restraints against raiding church property usually were strong enough to prevent wanton destruction. The same cannot be said for secular property. Feudal castles were constantly subject to siege, and those that survived often were remodeled in later centuries according to the changing fortunes of their successive owners. Among the best preserved of these Romanesque residences are the Imperial Palace near Goslar, Germany (Fig. 6.15),

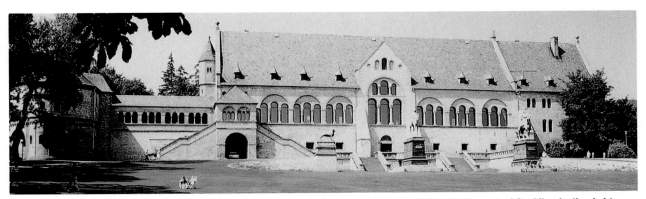

6.15 Imperial Palace at Goslar, Lower Saxony, Germany, begun 1043, rebuilt 1132. Chapel of St. Ulrich (far left), eleventh century.

and parts of the Palace of the Normans in Sicily, notably the Dining Hall of Roger II, with its emblematic animals and traditional symbols of feudal heraldry (Fig. 6.16).

Towns grew up in the protective shadows of castles, monasteries, or cathedrals, but only a few urban dwellings remain, such as those at Cluny (Fig. 6.17). Their arched doorways facing the street were sometimes decorated by sculptured hunting scenes or representations of an artisan's trade—a cobbler bending over his workbench, for example, or a merchant showing cloth to a customer. Of interior decorations—mural paintings, wall hangings, furniture, and the like—almost nothing is left. And because poetry and music were intended to be heard rather than read, little of either was written down.

History, however, is filled with accidents. For example, the single large-scale example of secular pictorial art, the famous Bayeux Tapestry, survives because it was designed for a church instead of a castle. The only French epic poem before the Crusades, the *Song of Roland,* owes its present existence to some monastic scribe who happened to write it down, either for a minstrel with a poor memory or because he wanted to preserve it after it had ceased to be sung. The one authentic melody to which such poetry was chanted exists because it was included as a jest in a thirteenth-century musical play. The so-called Tower of London, a **keep,** or fortress, that William the Conqueror constructed, is still intact because of its later use as a royal residence and prison and because it housed an important chapel.

THE BAYEUX TAPESTRY AND THE NORMAN CONQUEST

The most nearly complete example of pictorial art is the Bayeux Tapestry, which tells the story of how the English crown was won by William the Conqueror at the Battle of Hastings in 1066. Not a

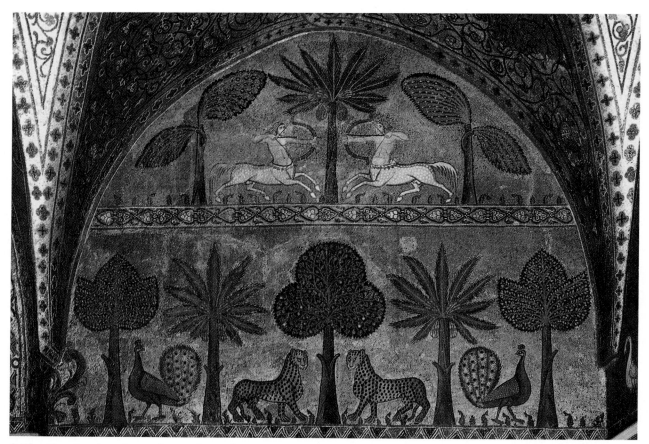

6.16 Mosaic of centaurs, leopards, and peacocks from Dining Hall of Roger II, c. 1132. Palace of Norman Kings, Palermo, Italy.

true tapestry but a work of embroidery, it presents a vivid picture of the life and attitudes of the feudal period. Such cloth decorations were used to cover the bare stone walls of castles. The work's extraordinary dimensions—1 foot, 8 inches high and 231 feet long—and its possession over the centuries by the Bayeux Cathedral indicate that it was intended to cover the plain strip of masonry over the nave arcade of that building. The designer remains unknown, but it was probably embroidered by skilled women in one of the renowned workshops of the period. Apparently it was completed about 20 years after the great battle it so vividly describes. As a continuous narrative, the Bayeux tapestry resembles Trajan's Column (see Figs. 4.10A, 4.11, and 4.12), which recorded relatively recent history from the point of view of the victor.

On the English side of the Channel, Harold, an English duke, claimed the throne on the recommendation of Edward the Confessor and his election by the Saxon barons. Besieged in the north by the Danes, he had won a complete victory near York less than 3 weeks before he had to face William in the south at Hastings. The long, forced march tired his men, but they still fought from dawn to dusk on that fateful day. The Saxon foot soldiers were both outnumbered and outmaneuvered by the swift Norman cavalry. In the course of the battle, Harold's two brothers were killed and Harold himself was fatally struck by a chance arrow, leaving the English side leaderless. By nightfall the English had retreated, and William had won one of the most momentous battles in history.

The tapestry tells the story from the Norman point of view. The central figure is, of course, William the Conqueror, who indelibly stamped his powerful personality on the north European scene throughout the second half of the eleventh century. The span of time is from the closing months of the reign of Edward the Confessor to

6.17 Romanesque house, Cluny, France, c. 1159.

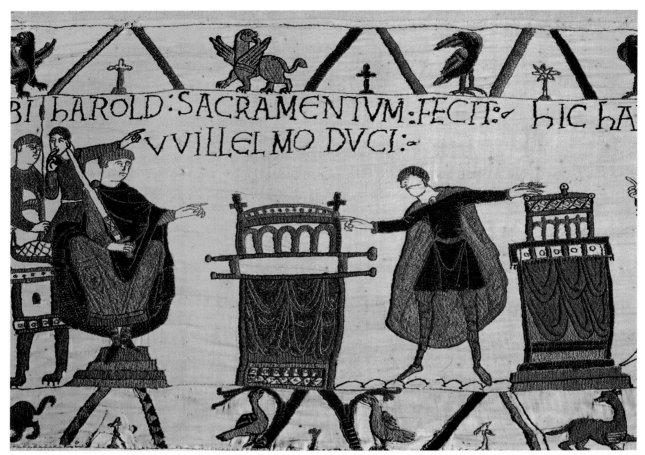

6.18 *Harold Swears Fealty to William,* detail of Bayeux Tapestry, c. 1073–1088. Wool embroidery on linen, height 1'8″, entire length 231'. Musee de la Tapisserie, Bayeux, France.

the day the Conqueror made good his claim to the throne at the Battle of Hastings.

In its surviving state, the Bayeux Tapestry is divided into seventy-nine panels, or scenes. The first part (panels 1–34) is concerned with William's reception of Harold, whose mission to Normandy allegedly was to tell William that he would succeed Edward the Confessor as king of England. In one of these scenes, William and Harold are shown at Bayeux (Fig. 6.18), *where Harold took an oath to Duke William.* (The italics here and later are literal translations of the Latin inscriptions that run along the top of the tapestry above the scenes they describe.) Placing his hands on the reliquaries that repose on the two altars, Harold seems to swear to uphold William's claim, although the exact nature of the oath is left vague. This is, however, the episode that later be-

came William's justification to make war on England, because Harold, contrary to his supposed sworn word, had himself crowned king.

In the upper and lower borders of these early panels, a running commentary on the action continues a tradition begun in manuscript illuminations. Here the commentary is in the form of animal figures that were familiar to people of the time from bestiaries and folktales. Others allude to certain fables of Aesop. The choice of the fox and crow, the wolf and stork, and the ewe, goat, and cow in the presence of the lion all have to do with deception and violence. They point out the supposedly treacherous character of Harold.

The main course of the action in the Bayeux Tapestry moves like the words on a printed page— from left to right. At times, however, it was necessary to represent a pertinent episode apart from the

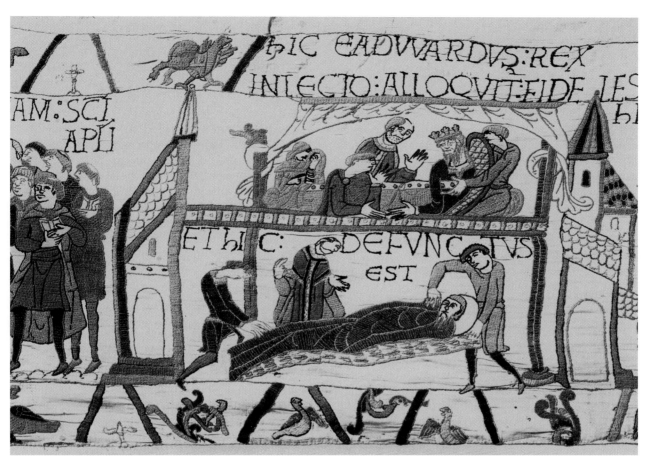

6.19 *Burial Rights for Edward the Confessor,* detail of Bayeux Tapestry, c. 1073–1088. Wool embroidery on linen, height 1′8″, entire length 231′. Musee de la Tapisserie, Bayeux, France.

principal action. In these instances the pictorial narrator simply reversed the usual order and moved the scene from right to left, thus, in effect, achieving a kind of visual parenthesis and avoiding confusion with the flow of the story.

Such a reversal is used in the scene depicting the death and burial of the Confessor (Fig. 6.19). On one side of the king's bed is a priest; Harold is on the other, while the queen and her lady-in-waiting are mourning at the foot of the bed.

When William received word that Harold had been crowned king, he immediately resolved to invade, and the second part of the tapestry (panels 35–53) is concerned with the preparations for his revenge. After all was in readiness, he set sail. The ships seen in the tapestry are similar to those in which William's restless Viking ancestors invaded the French coast two centuries be-

fore. It was in just such ships that Leif Eriksson and his fellow mariners apparently reached the eastern coast of North America earlier in the same century.

After the landing, the grand finale begins with the assembling of forces for the great battle (panels 54–79). The Norman side has both archers on foot and knights on horseback, whereas the English infantry fight in close formation with immense battle-axes, small spears, and clubs with stone heads. The Normans move in from left to right and the English from the opposite direction. The climax of the battle is reached in a wild scene at a ravine, where men and horses are tumbling about while the *English and French fall together in battle.* Shortly after, Harold is killed, and the fighting concludes with *English turned in flight.* The lower border in these scenes spares none of the horrors of warfare.

Dismembered limbs are strewn about, scavengers strip coats of mail from the bodies of the fallen, and naked corpses are left on the field.

The design of the Bayeux Tapestry is dominantly linear and, like the illuminated manuscripts of the time, is rendered in two dimensions, with no suggestion of spatial depth. The coarseness of the linen and the thickness of the wool, however, create interesting textural contrasts. The eight shades of woolen yarn—three blues, light and dark green, red, buff yellow, and gray—make for a vivid feeling of color, which is not used for natural representation but to enliven the design. Some men have blue hair, others have green hair, and horses often have two blue legs and two red ones. Faces are merely outlines, although some attempt at portraiture is made in the various likenesses of William (Fig. 6.20).

Details such as costumes, armor, mode of combat, and deployment of troops in battle are, by contrast, done with great accuracy. For this reason, the tapestry is a never-ending source of amazement and one of the most important sources of information about life in the eleventh century—so much so that its historical value is often allowed to overshadow its quality as a work of art.

The Bayeux Tapestry is a work of infinite variety. After a slow beginning with frequent digressions, the designer went on in the middle panels to the rather feverish preparations that culminated in the breathless climax of the battle. In both tempo and organization, the tapestry can stand up to comparison with the best works in narrative form, visual or verbal. The details, whether in the main panels or in the upper or lower borders, are handled so imaginatively that they not only embellish the design but also add visual accents, comment on the action, and advance the flow of the plot. Scenes are separated from one another by buildings that figure in the story and by such devices as stylized trees, which are mere conventions. So skillfully are these arranged that the continuity of the whole is never halted, and the observer is hardly aware of their presence.

THE SONG OF ROLAND

Epic poems were popular sagas based on the mighty deeds of legendary heroes, replete with blood feuds, gory vengeance, and black magic. The Anglo-Saxon *Beowulf* and the Germanic *Nibelungenlied (Song of the Nibelungs),* which Richard Wagner revived for his *Ring* cycle of music dramas in the nineteenth century (see pp. 497–498), were set in dark forests populated with lurking dragons

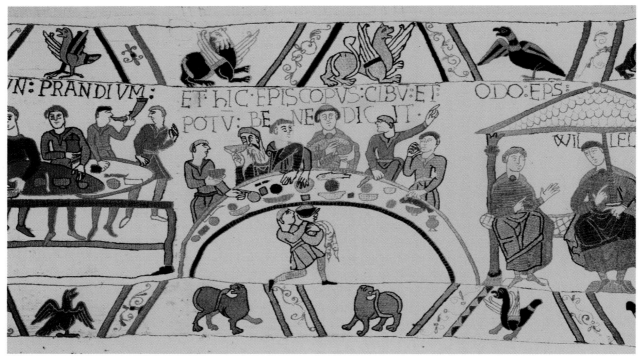

6.20 *William's Feast,* detail of Bayeux Tapestry. Musee de la Tapisserie, Bayeux, France.

and bloodthirsty monsters. Their French counterpart, the *Chanson de Roland (Song of Roland)* is cast in the mold of a **chanson de geste,** or song of deeds, an action story in poetic form derived from tales told by storytellers long ago and sung by a minstrel accompanied by a viol or lyre. It was written in Old French, the vernacular medieval language of the French people, rather than in scholarly Latin. Narrated in an abrupt, direct manner, the transitions between episodes are sudden and unexpected. A warlike atmosphere surrounds the characters, including the fighting Archbishop Turpin and the Archangels Gabriel and Michael, who, like the Valkyries in the *Song of the Nibelungs,* swoop down onto the battlefield to bear the souls of fallen warriors to heaven.

Although set in an earlier time (the actual event took place in 778), the *Song of Roland* is, both in form and spirit, a product of the warlike eleventh century. In fact, various recorders of historical events of that time mention it in connection with the Battle of Hastings. Guy of Amiens, one of William the Conqueror's courtiers, was the author of a Latin poem about a **jongleur,** or singing actor, by the name of Taillefer. This "minstrel whom a very brave heart ennobled," Guy relates, led William's forces into the battle throwing his sword in the air, catching it again, and singing a song of Roland. The English historian William of Malmesbury, writing about 50 years after the battle, relates that William began to sing the *Song of Roland* "in order that the warlike example of that hero might stimulate the soldiers."

The *Song of Roland* is an action-packed story set in the time of Charlemagne. It relates incidents from the campaign in northern Spain, where that emperor had been battling the Islamic armies and the troublesome Basques for 7 years. Roland, Charlemagne's favorite nephew, and the twelve peers, the flower of French knighthood, have been left in charge of the rear guard, while Charlemagne and the main body of the army are crossing the Pyrenees back into France. Roland is betrayed by his own stepfather, the wicked Ganelon, who has violated his vow of fidelity to Charlemagne and loyalty to his own family. The situation would have been read by the Normans as William's betrayal by Harold. Roland is attacked near Roncesvalles by overwhelming Muslim forces. The outnumbered rear guard is cut to pieces, and Roland, before dying a hero's death, sounds his ivory horn, summoning his uncle and his army from afar.

The latter part of the poem speaks of Charlemagne's vengeance, just as the corresponding section of the Bayeux Tapestry relates that of William. All is action and heroism, with swords flashing, helmets gleaming, drums beating, horns blowing, banners snapping, and steeds prancing. The story of the battle proceeds in what amounts to a blow-by-blow account, echoing frequently with such statements as "fierce is the battle and wondrous grim the fight."[1]

First one hears the preparations in the camp of Charlemagne. Using a cumulative technique, the poet describes the ten battalions one by one. Knight is added to knight, battle group to battle group, weapon to weapon, in order to build up the monumentality of the occasion in the listeners' imaginations. The forces of Western Christendom are eventually drawn up on Charlemagne's side—the French, Normans, Bavarians, Germans, Bretons, and so on. The virtues of the men invariably are bravery, valor, and hardiness. They have no fear of death, they never flee the battlefield, and their horses are swift and good.

Suddenly, and without any transition, the reader is in the midst of the attacking Saracens, whose battalions are described. To show how the Christians were outnumbered, yet another ten are added to the twenty battalions of the opposition. The fearsomeness of the enemy, however, is due not to their numbers alone but to their ferocious character. The only admirable quality allowed them is that of being good fighters; otherwise, they are hideous to behold, fierce and cruel, and lovers of evil. Yet despite this, the poet can say of both forces, "Goodly the armies."

The physical appearance of the people from these strange lands is fantastically exaggerated, as it was at Vézelay (Fig. 6.7). The Myconians, for instance, are men "Upon whose backs all down the spine in rows, / As on wild boars, enormous bristles grow." Of the warriors of the desert of Occian, it is said, "Harder than iron their hide on head and flanks, / So that they scorn or harness or steel cap." Later, during the battle, these same men of Occian "whinny and bray and squall," whereas the men of Arguille "like dogs are yelping all."

The religious life of the enemy is scorned as much as their appearance. They are represented

[1]All quotations from *Song of Roland* translated by Dorothy L. Sayers, published by Penguin Books. © Executors of Dorothy L. Sayers, 1937, 1957.

as polytheists who worship as strange an assortment of gods as was ever assembled—Apollyon, Termagant, and Mahound. When things are not going well from their point of view, they upbraid these gods. The statue of Apollyon is trampled underfoot; Termagant is robbed of his carbuncle, a precious stone; and Mahound is cast "into a ditch . . . For pigs and dogs to mangle and befoul." Later, when Marsilion, the king of Spain, dies, the listener hears that he "yields his soul to the infernal powers." Such fanciful descriptions could not have been written after the Crusades had brought Western warriors into contact with Muslim culture. Like the foreigners depicted on the Vézelay tympanum, the imagery of the *Song of Roland* is filled with naïve ethnocentrism.

With the lines of battle thus drawn, the setting is described in a single line: "Large is the plain and widely spread the wold." Then, as the conflict begins, battalion falls on battalion, hewing and hacking. Christian knights hurtle against Muslim knights throughout the day until the battle is reduced to a personal encounter between Charlemagne and his opposite, Baligant the Emir:

> At the Emir he drives his good French blade,
> He carves the helm with jewel-stones ablaze,
> He splits the skull, he dashes out the brains,
> Down to the beard he cleaves him through the face,
> And past all healing, he flings him down, clean slain.
> After this the pagans flee, and the day is won.

The lines of the original Old French proceed according to a rhyming scheme of **assonance,** in which the final syllables of each line correspond roughly in sound:

> Carlon the King, our Emperor Charlemayn,
> Full seven years long has been abroad in Spain.
> He's won the highlands as far as to the main;
> No castle more can stand before his face,
> City nor wall is left for him to break,
> Save Saragossa in its high mountain place;
> Marsilion holds it, the king who hates God's name,
> Mahound he serves, and to Apollyon prays:
> He'll not escape the ruin that awaits.

Much of the direct character and rugged strength of the poem is due to rigid avoidance of literary embellishment. Nothing is allowed to block the progress of these sturdy military monosyllables. So consistent is this quality of starkness throughout the poem that it even extends to the portrayal of the

characters themselves. Each is the embodiment of a single ideal and human type: Ganelon is all treachery and hatred; Roland is bravery to the point of rashness; Oliver, Roland's close companion, is reason and caution; and Charlemagne, outstanding in his solitary grandeur, represents the majesty of both church and state. Through each of these devices singly and combined, the poem as a whole rises to the heights of epic art. Its language, style, and form thus fit the brave deeds of the heroic men with whom its narrative is concerned.

Under the patronage of the feudal nobility, Gothic poetry and music bloomed from the eleventh through thirteenth centuries. Courtly tournaments, brave knights winning fair ladies, and aristocratic poets making music with minstrels also enlivened the nobles' entertainments (Fig. 6.21). The jongleurs were not of noble birth, as were most of the later troubadours and their northern French and German counterparts, the **trouvères** and **minnesingers,** who were welcomed in every castle and abbey. The most famous of the latter was the early thirteenth-century minnesinger and poet Walter von der Vogelweide ("Walter the Birdcatcher"). The Crusades spawned many musical works designed to stir men to join the cause. One such is von der Vogelweide's *Palestine Song,* whose twelve verses encourage military bravado. It marches onward, eloquently articulating the joys felt at the first sight of the city of Jerusalem, with its rich heritage for "Christians, Jews and Heathens."

Records reveal that some women were included in the ranks of jongleurs and troubadours. Little is known about the life of the Comtessa de Dia, a French composer. Nevertheless, the one song and melody that remain show that the theme of lovesickness, which pervaded this courtly art, was not strictly limited to male singers.

Secular music forms that emerged in the eleventh century were no doubt modeled on formulas used in the performance of church music. The simple repetitive melodies used to recite the epic secular chansons de geste melded with the insistent rhythms of the poetry and must have had much in common with the litany, although, of course, the subject matter differed radically. At the end of each poetic stanza was a melodic appendage that served as a refrain, much like the *alleluias* between the verses of psalms and hymns. The best-known *chanson,* the *Song of Roland,* has been preserved only in its text version; no music survives. Although jongleurs could refresh their memories of longer epics from the manuscripts

they carried with them in leather pouches, these manuscripts included no musical parts. It is assumed that the melodies were so simple that there was little need to write them down.

NORMAN ROMANESQUE ARCHITECTURE

The architecture of the Normans, the descendants of the Norsemen or Vikings, was sufficiently distinctive to give one aspect of the Romanesque style the name Norman. The building done in eleventh-century Normandy, in northwestern France near the English Channel, had a lasting effect on that region and reached a logical conclusion in the fortresses, castles, abbeys, and cathedrals that the Normans later built in England. Because the Romanesque style in England dates from the Norman Conquest, it is still referred to there as the Norman style.

Norman architecture, like many other facets of Norman culture, resulted from the union of Viking themes and ideas with the Christian remnants of the disintegrated Carolingian empire. Their architecture is noted for its blunt strength and forthright character.

Both the Carolingian and Viking societies were seminomadic. Charlemagne and his successors, as well as the dukes of Normandy down to William's time, frequently shifted their residences. Moreover, the insecurity of the times discouraged large

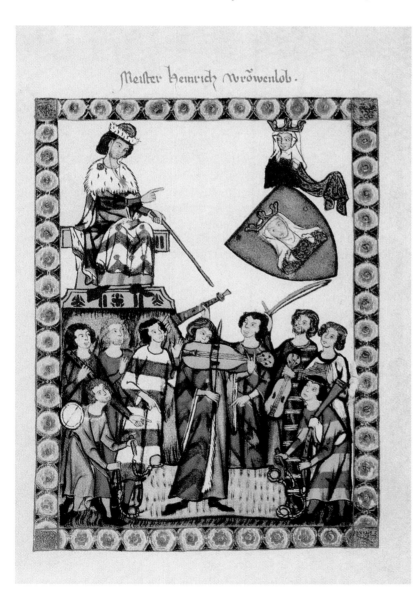

6.21 *Heinrich Frauenlob Directing a Minstrel Performance,* from the Manesse Manuscript of German minnesingers, fourteenth century. University Library, Heidelberg, Germany.

6.22 Tower of London, aerial view, c. 1078–1097.

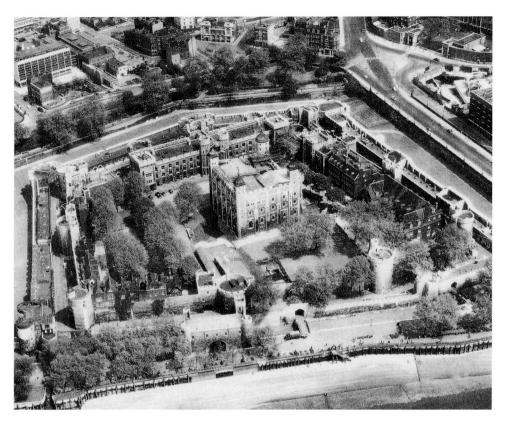

building schemes. But as the feudal system reached its mature stage and a more settled order became possible, instead of seeking further conquests, the Norman conquerors developed the vast new lands they had acquired. Earlier, William had discouraged the construction of castles and sanctioned only monasteries; now he proposed to impress his new subjects with solid and unconquerable fortresses as well as feats of arms. In other words, William's policy shifted from offensive to defensive.

6.23 (A) Tower of London (White Tower), c. 1078–1097. Height 92′. (B) Plan of the White Tower. (a) Banqueting hall; (b) Presence chamber; (c) Chapel.

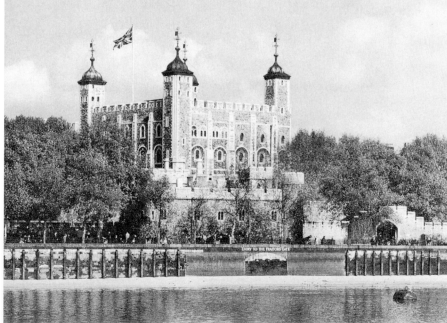

THE TOWER OF LONDON. The Tower of London (Fig. 6.22), or more specifically the White Tower (Fig. 6.23A), was begun by William the Conqueror in about 1078 and finished by his successor; its purpose was to defend and dominate the town. Its form was that of a Norman keep, and as such it was something new to England. The White Tower is simply a massive, square, compact stone building divided into four stories that rise 92 feet, with a turret at each corner. A glance at the plan (Fig. 6.23B) reveals some of its many irregularities. Its four sides, for instance, are unequal in length, and its corners therefore are not exactly right angles. Three of its turrets are square, and one is round. The walls vary from 11 to 15 feet in thickness. In addition, a wall that runs from north to south divides the interior into two unequal parts.

The bareness of its original exterior, which has been changed over the centuries, was well suited to the White Tower's function as a fortress. The austerity of the interior offers a glimpse of the general lack of physical comforts in medieval life. The tower was divided into four stories by means of wooden floors, and its darkness was relieved only by narrow, slitted, glassless windows that were more important as launching sites for arrows than as sources of light and air.

After Norman times, other buildings were added until the whole became a system of outward-spreading fortifications with the old Norman keep as its heart. From William's time on, the tower has been in continuous use as a fortress, palace, or prison.

The main floor of the White Tower has three divisions: a large council chamber that doubled as a banqueting hall, a smaller presence chamber, and the well-preserved St. John's Chapel (Fig. 6.24). Like

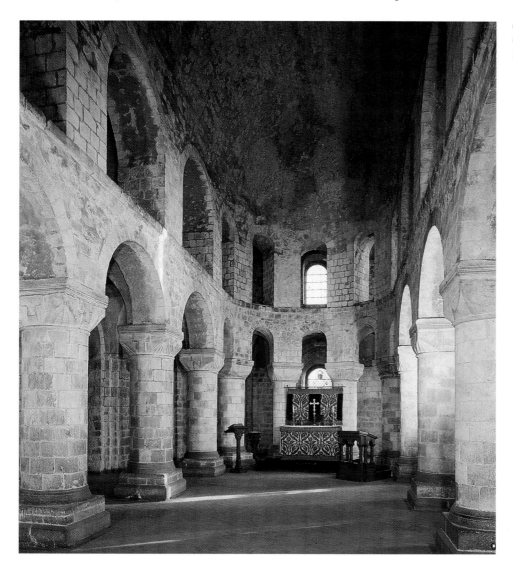

6.24 Interior, St. John's Chapel, White Tower, London, England, 1078–1097.

a miniature church, this chapel has a barrel-vaulted nave with four bays. On either side are aisles that command interest because of their early use of cross vaulting. The columns of the nave arcade are thick and stubby, and the cushionlike capitals have only simple scalloped carving by way of decoration. Above is a triforium gallery that was used by the queen and her ladies. Its slitlike windows serve as a clerestory.

THE ABBEY CHURCHES AT CAEN. At Caen, in Normandy, two buildings were under the personal protection of William and Queen Matilda and desig-

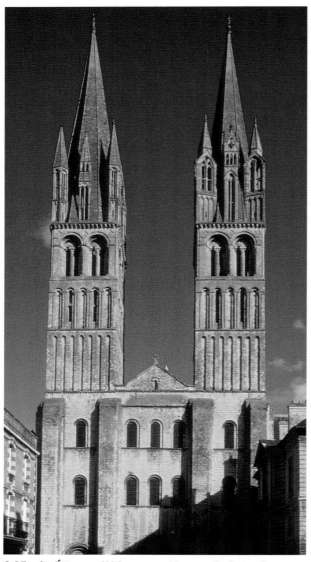

6.25 St. Étienne (Abbaye-aux-Hommes), Caen, France, c. 1067–1135. Nave 157′6″ × 32′1″, height of towers 295′.

nated as their respective burial places: St. Étienne (Abbaye-aux-Hommes; Fig. 6.25) and Ste. Trinité (Abbaye-aux-Dames). Because both were abbey churches, they properly belong in a discussion of the monastic Romanesque style. They were, however, not commissioned by the church itself but rather by two worldly donors.

Begun just before the Norman Conquest, St. Étienne has a well-proportioned west facade. Four prominent buttresses divide the section below the towers into three parts that correspond to the central nave and two side aisles of the interior. Vertically, the facade rises in three stories, with the portals matching the level of the nave arcade inside. The two rows of windows above are at the gallery and clerestory levels, respectively. The windows, mere openings, are quite undistinguished. The functional honesty in this correspondence between the exterior design and interior plan was a Norman innovation that came into general use during the Gothic period.

The twin towers belong to the original design, but their spires are later additions. As with the usual Norman church, the towers are square and in three stories. Thus, they repeat on a higher level the triple division of the facade below. The first story is of solid masonry. The second has alternating blind (that is, blank) and open arches. The greater open space of the third story contributes to its function as a belfry and relieves the general heaviness of the structure. The bareness of the exterior is a fitting prelude to the gloomy grandeur of the interior (Fig. 6.26). The church as a whole is as rugged as its founder and typifies the spirit of the Norman people and their forceful leader.

Lack of decoration was a conscious part of the design of St. Étienne and the Tower of London. One facade impresses by its bold outlines, sturdiness, and straightforward honesty; the other, by its strength and bluntness. Nevertheless, in their churches, although the clerestory windows were small, the Normans achieved better lighting than in previous Romanesque structures. In addition, the Normans achieved more unified interiors by connecting the three levels of the nave arcade, gallery, and clerestory with single vertical shafts running from floor to ceiling. Both these features, as well as the harmonious spatial divisions of a facade like that of St. Étienne, were incorporated into the Gothic style.

On the other hand, when the work of the Normans is placed alongside that of their Burgundian contemporaries, it seems crude by comparison. The Normans were as blunt and brash as the Cluniacs were ingenious and subtle. The difference, in short, is that between action and contemplation. Soon the Norman accent on structure rather than embellishment would be altered by Islamic influences (see pp. 141–145) brought back by the Crusaders.

IDEAS

The key to understanding the Romanesque as a living and active art style is knowledge of the opposing forces that created it. As Christian influence spread northward, its conservative reiterations of classical sources encountered the more asymmetrical, restless art forms that originated with the former barbarian tribes, which they incorporated in their art when they converted to

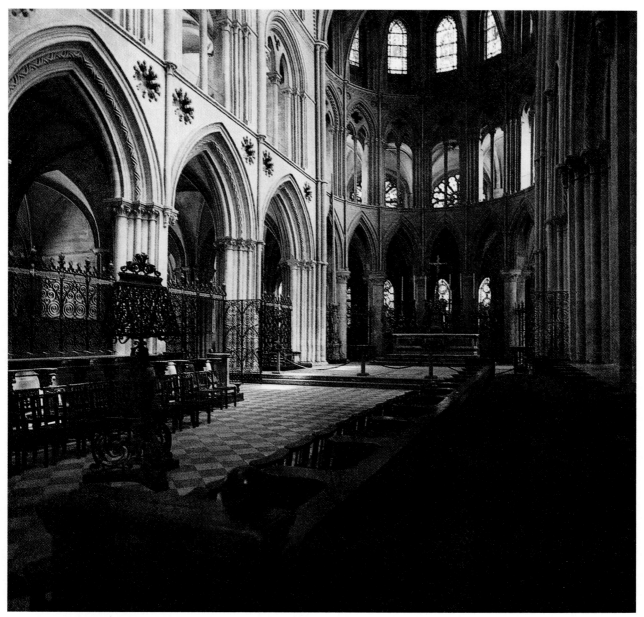

6.26 Interior, St. Étienne, Caen, France.

Christianity (Fig. 6.27). In effect, a church that respected and admired tradition and encouraged an unchanging order was absorbing peoples who preferred new twists and turns in forms that seemed to break out of their frames.

For example, builders combined the horizontal Early Christian basilica with northern towers and spires, taking the first step toward Romanesque architecture. A musical counterpart was formed when the Mediterranean tradition of singing one melody in unison met the northern custom of singing in several parts. The result was the experimentation with counterpoint and harmony that characterized the music of the Romanesque period.

This meeting of southern unity with northern variety slowly matured over the centuries and was ultimately responsible for the first truly pan-European (all-European) art style: the Romanesque. As Romanesque art took shape, two opposing ways of life evolved: sacred and secular, otherworldly and worldly. In fact, the underlying themes of the Romanesque cluster around these divisions. The religious side found its ful-

fillment in contemplation, whereas the secular aspect was expressed mainly in action.

THE CONTEMPLATIVE LIFE

The monastic way of life demanded the seclusion of the countryside as an escape from the distractions of the world. Because the monk conceived earthly life as only a stepping stone to the life beyond, living in this world required only the barest essentials. Rural isolation was nonetheless enhanced by the reading and copying of books. The very severity of monastic life stimulated imaginative experience at the same time that individual self-denial reinforced communal energies. The turn away from the world found architectural expression in plain exteriors. The rich interiors of monastic churches symbolized the wealth of spiritual life.

Two favorite Cluniac saints were Paul and Anthony, who, in Early Christian times, had gone into the forbidding African desert, where they had the most fantastic visions and the most dreadful and horrifying temptations. The arts, conse-

6.27 Example of Merovingian script, probably written at Canterbury, c. 1120.

6.28 *Isaiah,* west portal, Church of Notre Dame, Souillac, France, c. 1110.

quently, were not intended to mirror the natural world or to decorate the dwelling place of an earthly ruler but rather to conjure up otherworldly visions of divine majesty and hellish monsters. The arts found common ground in their attempts to depict aspects of the world beyond.

At first the cloistered monks and nuns developed an art of elaborate symbolism addressed to an educated community that was familiar with sophisticated and intricate allegories. The growth of such a symbolic language—whether in architecture, sculpture, painting, or music—could have been promoted only by an abbot like Hugh, who favored higher learning. By contrast, the succeeding Gothic arts were directed more toward the unlettered people in the growing towns. The sculpture and stained glass of the Gothic cathedrals were destined to become the Bible portrayed in stone and glass for the poor. This does not mean that Romanesque art was overly intellectualized and remote from the experience of those to whom it was addressed. On the contrary, it was very directly related to the intensity of the inner life and the visionary otherworldly focus of the religious communities that developed it.

Greco-Roman sculpture was successful in its way precisely because the classical mind had conceived of the gods in human form. When godhood was conceived of as an abstract principle, a realistic representation of it became essentially impossible. Mathematical proportions were of no help to the Romanesque mind, because it was considered impossible to understand God fully through the intellect. God had to be felt through faith rather than comprehended by the mind. Only through the intuitive eye of faith could His essence be grasped. Physical substance was sec-

ondary and soul primary, but the latter could be depicted only in the imagination.

A life so abstractly oriented and motivated by such deep religious convictions could never have found its models in the natural world. The eccentric treatment and distortions of the human body in Romanesque sculpture, the unnecessarily elaborated initials in the manuscript illuminations, and the ornate melismas added to the syllables of the chant all signified a rejection of the natural order of things and its replacement by the supernatural. The most admired book of the Bible was Revelation, containing as it does the apocalyptic visions of St. John. It is not surprising, then, that the pictorial element in sculpture and painting in both large and small forms reflected Romanesque emotions with such intensity that the human figures sometimes seem to be consumed by the inner fires of their faith. Reason seeks to persuade through calm or serene attitudes, but such animated figures as those of the prophets at Souillac (Fig. 6.28) and Moissac seem to be performing spiritual dances in which their slender forms stretch to unnatural heights with gestures more convulsive than graceful.

The Romanesque monks and nuns dwelt in a dream world where the trees that grew in Paradise, the angels who populated the heavens, and the demons of hell were more real than anyone or anything in everyday life. Indeed, the monsters whose fearsome characteristics were described in the bestiaries and represented in manuscripts and sculptures had a moral and symbolic function far more real than any animal of mere physical existence. All these imaginary creatures existed together in a rich jungle of the imagination where the abnormal was the normal and the fabulous became the commonplace (Fig. 6.29).

6.29 *Demon of Luxury,* nave capital sculpture, Church of La Madeleine, Vézelay, France, c. 1130.

A strict hierarchical social structure of society prevailed throughout the Romanesque period. It was as rigid in its way inside the monastery as was the feudalism outside the cloistered walls. It supported a worldview grounded in the assumption of a divinely established order of the universe and the church's authority to interpret it. The majestic figure of Christ in Glory carved over the entrance portals of the Cluniac abbey churches proclaimed this concept. As if to lend emphasis to this doctrine, St. Peter, said to have been the first pope, is seen at Berzé-la-Ville receiving a scroll containing the divine laws from the hands of Christ. The papacy of medieval days found its most powerful support in the Cluniac order, and through such aid, it succeeded in establishing a social order based on this mandate from Christ.

The authority of the church was nowhere better expressed than in these monumental sculptural and mural compositions, which warned those who beheld them of their position on the road to either salvation or damnation. The milestones marking the path were placed there by the church, whose clergy alone could interpret them and assure the penitent that he or she was on the way to the streets of gold instead of the caldrons of fire. The frequency with which the apocalyptic vision of St. John was represented, with apostles and elders surrounding the throne of Christ, was evidence of the reverence for the protective father image in the form of the bearded patriarch.

The Romanesque abbey church was organized according to a rigid hierarchical plan that mirrored the strict order of precedence in the liturgical processions for which it was the setting. Through its insistence on visible proportions, it signified the invisible plan of a divinely ordered world. The monastic buildings that surrounded it were similarly significant in their regularity. They were designed to enclose those who were willing to conform to such a regulated life and thus to reflect the divinely established plan for salvation.

The very spaciousness of the abbey church was far in excess of anything that was needed to accommodate the few hundred people who normally worshiped there. It was, however, the monument that mirrored the unshakable religious convictions of the Romanesque mind, and as the house of the Lord and Ruler of the universe, it became a palace surpassing that of any king on the face of the Earth. In the insecurity of the feudalistic world, Romanesque people built fortresses for their faith that were designed to withstand the attacks of heretics and heathens as well as the more elemental forces of wind, weather, and fire. Moreover, the abbey church was the place where the heavenly Monarch held court; it was where his subjects could pay Him homage in the divine services that went on day and night, year in and year out.

Romanesque structures, whether churches or castles, never became types, as Greek temples, Byzantine churches, and the later Gothic cathedrals did. Each building and each region sought its own solutions. Through constant experimentation, Romanesque architects found the key to new structural principles, such as their vaulting experiments. By gradually achieving command of their medium, they progressed in their building techniques from earlier heavy, fortresslike structures to later edifices of considerable elegance.

Meanwhile, the decorators slowly groped toward restoring monumental sculpture and mural painting. The need for larger and better choirs likewise led to the invention of notational systems, and the emotional exuberance in worship led to many modifications of the traditional chant, which eventually culminated in the art of counterpoint. In all, the creative vitality exhibited in each of the Romanesque arts is a constant source of astonishment.

THE ACTIVE LIFE

The virtues of the active life were courage and loyalty to both peers and superiors. Whatever one's station in life, everybody was a vassal of some lord, a relationship that involved mutual obligations. As a vassal, one was bound to swear an oath of *fealty,* or fidelity, that promised loyalty to the immediate superior. Central governments were weak, and the main function of kings was to raise armies to defend their realms against foreign invaders. Local governments were powerful in enforcing laws, raising taxes, and settling disputes.

Factional and regional confrontations involving treachery or defection from the feudal code had to be decided by personal combat or on the field of battle, with God awarding victory to the righteous cause. Enemies, however, were granted the distinctions of honor and bravery; otherwise, it would have been socially impossible to do battle with them. In the *Song of Roland,* no one below the rank of baron figures with any prominence; similarly, the abbeys of William and Matilda were intended primarily for men and women of rank, and by founding these churches, the royal pair pledged their feudal oath to God.

Both the Bayeux Tapestry and the *Song of Roland* are set in a masculine world of clear-cut

loyalties and moral and physical certainties. In each, chivalry is based on the ways of fighting men. The code of Roland was clearly, "My soul to God, my life to the king, and honor for myself." It remained for the Gothic period to add, "My heart to the ladies." Roland's dying thoughts, for instance, are occupied with his family and lineage; his king, Charlemagne; his country, France; and his sword, Durendal. Typically, he makes no mention of the woman he has promised to marry, the Lady Aude.

Earlier, his exasperated friend Oliver reproached Roland for his rashness in not summoning aid sooner, and at that time he swore:

> Now by my beard . . . if e'er mine eyes
> Again behold my sister Aude the bright,
> Between her arms never you think to lie.

No true or courtly love is this, but only the feudal baron bestowing his female relatives, like his goods and property, on those whose faith and courage he has cause to admire. Later, after Charlemagne returns to France, the poor Lady Aude inquires about the fate of her fiancé. The king tells her of his heroic death, and as a consolation prize, he offers her the hand of his son, Louis, whereupon the lady falls dead at his feet. Whether she dies of grief for Roland or the indelicacy of Charlemagne's suggestion is left open to conjecture. Because scarcely more than a dozen of the 4,000-odd lines of the poem are devoted to her, the historian Henry Adams was fully justified in observing, "Never after the first crusade did any great poem rise to such heroism as to sustain itself without a heroine."

Curiously enough, on the Islamic side, after the king of Spain is incapacitated, the queen takes an important part in the affairs of state. Nowhere on the Christian side is a woman given anything close to similar status. In the Bayeux Tapestry, a woman is mentioned by name in one place only—the enigmatic inscription *Where a cleric and Aelfgyva*, which was apparently introduced to provide a motive for the minor episode describing an invasion of Brittany. Although a few female figures are found in the borders and in attendance at the death of the Confessor (Fig. 6.19), none has any prominence. Both works are thus as bold and direct as the poetry and art of the coming Gothic period was delicate and subtle. Roland and his counterparts in the tapestry fought for king and country. In later literature, the knightly hero entered the list of war recruits in exchange for a loving glance from his lady's eyes, a fleeting smile, or a fragrant rose tossed from his lady's chamber.

The Romanesque in general, and its worldly side in particular, were characterized by the process of forming, experimenting with, and reaching out toward new modes of expression. The emphasis in the tapestry on representations of castles, fortifications, and specific buildings, like the Bayeux Cathedral and the abbey churches at Caen, suggests that the Romanesque created a busy builder's world, full of innovation. The forthright, direct narration of deeds in the *Song of Roland* and the Bayeux Tapestry finds its architectural counterpart in the functional honesty of the White Tower and William's church at Caen. Just as the action-filled stories of the *Song of Roland* and the Tapestry take precedence over literary form and decorative flourish, so the structural honesty of the building process, as exemplified by the White Tower and St. Étienne, becomes the leading characteristic.

The Norman secular world inherited the Viking adventurer's clear-headed and boisterous outlook. The Normans caught on quickly to any progressive development of the time, whether it was the discarding of their rather inflexible mother tongue in favor of the more expressive French or the adopting of many of the Cluniac moral and architectural reforms. Whatever the Normans did, they did with characteristic determination and energy. Thus, the rugged man of action, William the Conquerer, finds a parallel in the military monosyllables of the *Song of Roland,* the frank, almost comic-strip directness of the Bayeux Tapestry, and the rough-hewn stones of the White Tower. Each was concerned with forms of action, and whether in picture, word, or stone, the epic spirit is present. Deed on deed, syllable on syllable, stitch on stitch, image on image, stone on stone—each builds to a robust presence.

TRADITION AND INNOVATION

The veneration of past traditions figured strongly in Romanesque thought. The divine order of their world had been handed down in the Scriptures, where the word of God was manifest. Curiously enough, this traditionalism never led to stagnation or uniformity. In making learned commentaries on the Scriptures, the writers unconsciously, and sometimes consciously, interpreted them in the light of contemporary views. And as the untaught populace traveled about Europe on pilgrimages and later went to the Near East on the Crusades, they absorbed new ideas that eventually were to transform the provincialism of feudal times into a more dynamic social structure.

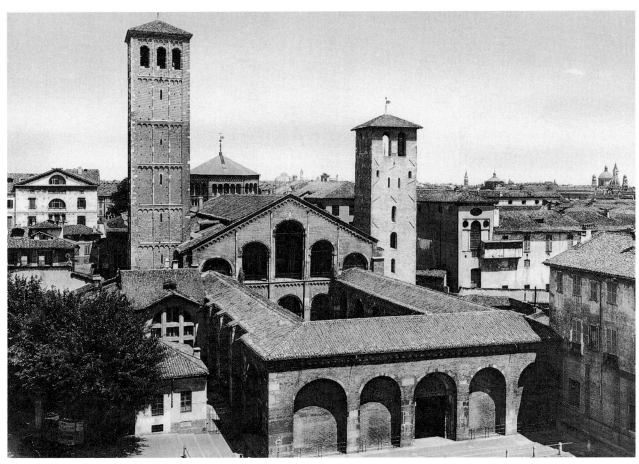

6.30 Sant'Ambrogio, Milan, Italy, from west, c. 1181. Length, including atrium, 390′; width 92′.

Diversity rather than unity was the rule of Romanesque architecture. Regional building traditions and the availability of craftspeople and materials contributed to the varied pattern. St. Mark's in Venice (see Fig. 12.1) combines the multidomed Byzantine style with Greek cross ground plans. Moorish influence was felt in Spain. In northern Italy, Sant'Ambrogio in Milan (Fig. 6.30) has the rich red brickwork and square belfry towers typical of Lombardy. In central Italy, the Romanesque was characterized by zebra-striped exteriors composed of alternating strips of dark green and cream-colored marbles, as at the Baptistry of Florence and the Cathedral of Pisa. In sum, all the arts of the period exhibited extraordinary inventiveness and such rich variety as to make the Romanesque one of the most spontaneous and original periods in history.

YOUR RESOURCES

- **Exploring Humanities CD-ROM**

 ○ Interactive Map: Europe about 1100

 ○ Architectural Basics: The Romanesque Portal

 ○ Readings—*Song of Roland*

- **Web Site**

 http://art.wadsworth.com/fleming10

 ○ Chapter 6 Quiz

 ○ Links—Online Reading: *Beowulf*

- **Audio CD**

 ○ *Hymn to St. John*

 ○ *Parallel Organum*

 ○ Vogelweider, *Palestine Song*

THE ROMANESQUE PERIOD

Key Events	Architecture and Visual Arts	Literature and Music
c. 480–c. 547 **St. Benedict,** founder of Western monasticism; c. 540 formulated monastic rules	c. 529 **St. Benedict** built abbey at Monte Cassino, Italy	
841 **Vikings** invaded and colonized northern France 910 **Abbey of Cluny** in Burgundy, France, founded	c. 820 **St. Gall** (Switzerland) monastery, plan drafted	c. 800–850 *Beowulf,* epic poem composed; earliest manuscript c. 1000 840–912 **Notker Balbulus,** poet and hymn writer 927–942 **Odo,** abbot of Cluny, reputed author of musical treatises 980 **Organ with 400 pipes** constructed at Winchester, England c. 995–c. 1050 **Guido of Arezzo,** author of musical treatises; inventor of staff notation
c. 1000 **Leif Eriksen,** Viking navigator, reached North America (?) 1035 **William** (c. 1027–1087) succeeded as Duke of Normandy after father's death on pilgrimage to Jerusalem 1041–1066 **Edward the Confessor,** king of England 1049–1109 **Hugh of Semur,** abbot of Cluny 1051 **Duke William** visited England; probably received promise of English succession from Edward the Confessor 1053 **William** married his cousin Matilda, daughter of Count of Flanders, who traced lineage from Alfred the Great 1057 **Normans** arrive in southern Italy 1059 **Pope** granted dispensation for marriage of William to Matilda 1064 **Duke Harold of England** visited Normandy; presumably upheld William's claim to English throne 1061–1091 **Norman** conquest of Sicily under Roger I (1031–1101) 1066 **Death of Edward the Confessor;** coronation of Harold as successor; invasion of England by William the Conqueror; Battle of Hastings, Harold killed; William crowned king of England 1066 **William, Duke of Normandy** conquered England 1066–1087 **William the Conqueror** reigned as king of England 1077 **Emperor Henry IV** bowed to Pope Gregory VII at Canossa; Abbot Hugh of Cluny mediated 1085 **Domesday Survey,** census and land as basis for taxation 1088–1099 **Urban II of Cluny** became pope; 1095 preached First Crusade 1095 **First Crusade** 1098 **Cistercian order** founded by St. Bernard of Clairvaux; principal opposition to Cluniac order	1037–1066 **Abbey Church of Notre Dame** at Jumiège built in early Norman Romanesque style 1043 **Imperial Palace** of Holy Roman emperors built near Goslar 1065 **Westminster Abbey** in Norman style dedicated by Edward the Confessor; later rebuilt in Gothic style 1063 **Pisa Cathedral** begun; 1153 Baptistry added c. 1064 **Church of St. Étienne** (Abbaye-aux-Hommes) begun at Caen, under patronage of William; Church of Ste. Trinité (Abbaye-aux-Dames) begun at Caen under patronage of Matilda c. 1075 **Pilgrimage church** at Santiago de Compostela, Spain, begun c. 1073–1088 **Bayeux Tapestry** embroidered in English workshop 1078 **Tower of London** begun by William c. 1080 **Church of Sant'Ambrogio** begun in Milan c. 1088–1160 **Church of St. Sernin** built at Toulouse, France 1088–1130 **Great Third Church at Cluny** built under Hugh of Semur, perhaps by architect Hezelo; 1088–1095 capitals depicting tones of plainsong carved; 1095 apse dedicated by Pope Urban II 1093 **Durham Cathedral** begun; Norman style with high ribbed vaulting 1096–1120 **Abbey Church of La Madeleine** at Vézelay built; 1096 church begun, 1104 Romanesque choir and transept dedicated, 1110 nave finished, 1120 narthex begun and nave revaulted after fire, c. 1130 tympanum over central portal of narthex carved, 1132 dedicated	c. 1000 **Minstrels** convened during Lenten season at Fécamp, Normandy c. 1050 **Beginnings of polyphonic singing** 1098–1179 **Hildegard of Bingen,** poet and composer
1101–1154 **Roger II** ruled Sicily 1147–1149 **Second Crusade**	c. 1100 **Sculptures of Abbey of St. Trophîme** carved c. 1130–1135 **Gislebertus** carved sculptures at St. Lazare, Autun 1168–1188 **Matteo** carved Portico de Gloria at Cathedral of Santiago de Compostela, Spain	c. 1100 *Song of Roland,* epic poem, written in Old French c. 1100 **Music school of St. Martial** at Limoges founded; developed polyphonic style 1110 **Earliest record of miracle play** being performed c. 1200 *Nibelungenlied,* German epic poem, written c. 1237–1288 **Adam de la Halle,** author and composer of *Le jeu de Robin et Marion* (c. 1280), pastoral play with sole surviving example of chanson de geste melody

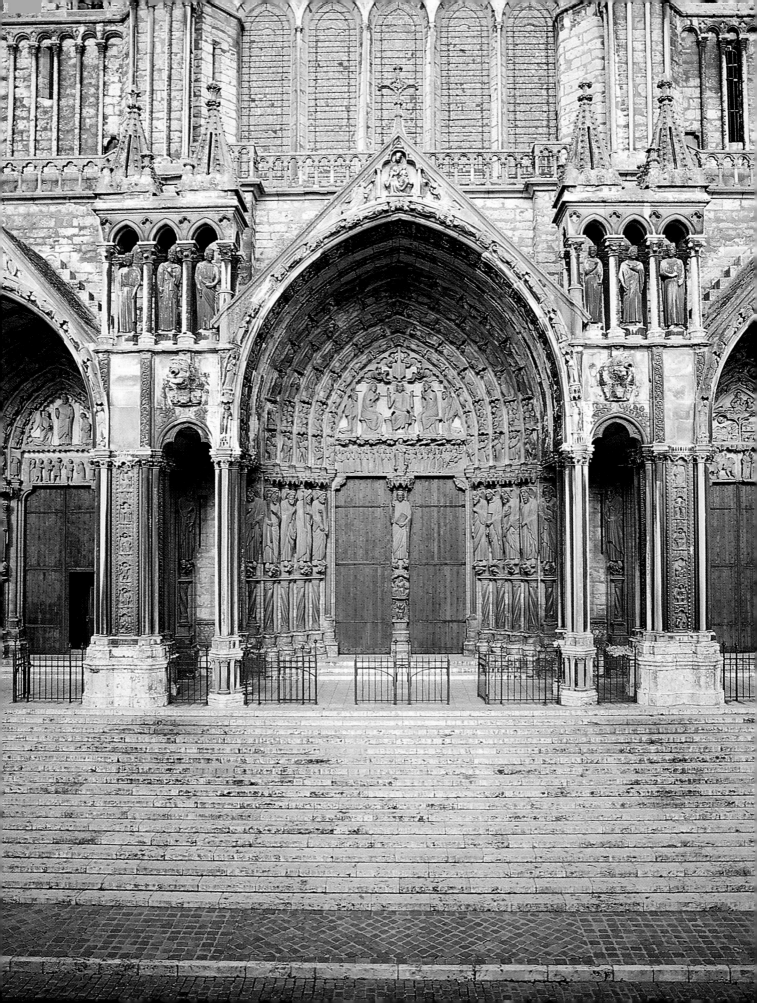

G O T H I C S T Y L E

IN CONTRAST TO THE SHORES of the Mediterranean, where centers of culture such as Athens, Alexandria, Antioch, Constantinople, and Rome flourished for centuries, northern Europe had been little more than a rural region with a few Roman provincial outposts and, later, a scattering of castles, monasteries, and villages. Before the thirteenth century, not one medieval center north of the Alps could properly have been described as a city. Yet town life flourished from the eleventh century on, as strong regional political figures emerged and the responsibility of a king to maintain order became more accepted by the nobles. The greater civil stability was enforced by religious and secular authorities to accommodate pilgrims who increasingly traveled to towns like Chartres, where important relics were kept. Similarly, the Crusades enlarged international trade and encouraged the development of commercial centers that widened the influence of towns and boosted their patronage of the arts. As the towns grew, townspeople developed a sense of their distinctiveness in relation to the nobles and the church. Sometimes nobles were persuaded to grant charters to the towns, thereby enhancing the municipalities' political and financial independence.

PARIS AND ITS SURROUNDINGS

Toward the end of the twelfth century, Philip Augustus, king of France, set out to promote Paris as his capital. He ordered that the city be enclosed with walls and directed that some of its streets be paved with stone. His palace at the heart of the city eventually became the Louvre museum. The work continued under his successors, and by the end of the thirteenth century, Paris was the capital of a kingdom with growing financial, commercial, and cultural influence. With its splendid Cathedral of Notre Dame; its university famed for the teaching of Abelard, Albertus Magnus, Thomas Aquinas, and Bonaventura; and its flourishing mercantile

trade capable of supporting about 150,000 inhabitants, Paris could well claim the status of a capital city. Like other expanding urban areas, it rapidly became a cultural center. In particular, education shifted from the monasteries of the countryside to the universities and cathedral-sponsored schools of the cities and towns.

The growth of Paris was far from an isolated instance. For a full century the town as a social unit and cultural center had been gaining importance over the manorial estate. The literature of the time mentions Ghent with its turreted houses, Lille and its cloth, Tours and its grain, and how all engaged in commerce with distant lands. Above all, the vibrancy of town and city life was symbolized by the building and decoration of Gothic cathedrals.

In the eleventh and twelfth centuries, people did not refer to their cathedrals as Gothic, but simply called them "new." The term *Gothic* came into use later, during the Italian Renaissance, as a term of contempt for architecture that seemed coarse because it excluded the elements of Roman classicism. To Renaissance eyes, the Gothic cathedrals were barbarian at heart, crude imitations of the towering German forests. Later interpreters, especially in the nineteenth century (see pp. 491–494) transformed the Renaissance insult into praise for the Gothic spirit of liberty that rejected the restrictive and shopworn rules of Rome.

In fact, traces of Roman, Early Christian, and Romanesque basilicas (see pp. 95 and 125) are still evident in the Gothic cathedral's nave, aisles, and transept. What is strikingly new, and long associated with the idea of northern European independence, is the soaring height of the Gothic cathedral, which could be seen for miles towering over the city or town that built it. The cathedrals were grand displays of community, encapsulating the physical effort, religious exaltation, and emotional and intellectual forces of the people who created them. Because the building process often spanned several centuries, few were finished according to their original builders' plans. They were,

PAST AND PRESENT

What Is a Goth?

Goths were members of a Germanic tribe who took advantage of the weakening of the Roman Empire and invaded Italy in the fifth century (see p. 117). The term *gothic* as applied to architecture only indirectly derives from the Goths. The term was first used by Renaissance scholars, looking back at the architecture of the north, which they considered inferior to classical buildings. In the seventeenth and eighteenth centuries, the word's meaning broadened to identify rude, cruel, and uncivilized behavior. For example, Ben Franklin used it to describe the British troops during the Revolutionary War. Similarly, in the early twentieth century, critics of the work of artists Henri Matisse and André Derain called them wild beasts (see pp. 557–558).

At the beginning of the 1980s, Goth subculture emerged in Britain as part of the punk rock scene. It quickly spread throughout Europe and North America. With their black clothing, body piercings, unique hairstyles, and interest in medieval-themed fantasy games such as Dungeons and Dragons, Goths were judged to be crude outsiders who renounced middle-class values. In fact, Goth culture, which persists into the twenty-first century, is composed of people whose looks do not indicate the wide variety of their ideas. Some are pacifists, whereas others are drawn to art and music that dwells on despair. Such "civilized" authors as the Renaissance poet Dante, author of the *Divine Comedy* (see pp. 232–234), and the Romantic poet Lord Byron (see p. 449) have found a new and enthusiastic audience among contemporary Goths.

in a sense, works in progress, manifestations of an ongoing struggle and dynamic urge to reach upward to embrace infinity.

ST. DENIS

The prototype of the Gothic cathedral is found in the abbey church of St. Denis, just outside Paris. This monastery was under the direct patronage of

the French kings and was their traditional burial place. Around the middle of the twelfth century, its abbot was Suger, a man whose talents were as remarkable as his origins were humble. The trusted confidant of two kings, he ruled France as regent while Louis VII was away on a Crusade. When he undertook the rebuilding of his abbey church, his great personal prestige, as well as its importance as the royal monastery and burial

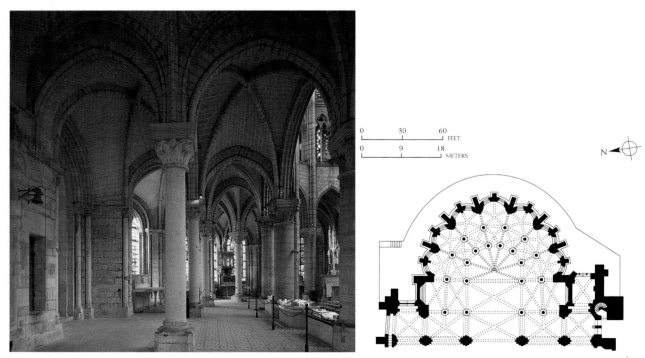

A B

7.1 (A) Choir and ambulatory of Abbey Church of St. Denis, near Paris, France, 1140–1144. (B) Plan of Choir, Abbey Church of St. Denis.

place, enabled him to call together the most expert craftspeople from all parts of the kingdom. Suger's church became a synthesis of all the ideas that Romanesque builders had tried and found successful.

The abbot's enthusiasm for his project inspired him to write extensively about it, and his book is an invaluable source of information about the architectural thought of the time. In 1130, when St. Denis was in the planning stage, Abbot Suger made a prolonged visit to Cluny (see pp. 160–165) to learn about its recently completed church. His commentary on the iconography of the windows and sculpture of St. Denis suggests that he was directly involved in this part of the project. Yet he makes no mention of the architect or master mason who carried out the plan. Many late Cluniac Romanesque churches had used the pointed arch and the ribbed vault (see Fig. 6.26), but when Suger rebuilt the choir at St. Denis the elements were brought together in a dynamic structural interplay (Fig. 7.1).

We can only speculate on the circumstances that prompted Suger and his team of architects and designers to concoct their design. No doubt

Suger's insistence on stained glass influenced the decision to heighten the walls to let in more light. Also, the use of stained glass might have suggested the idea of thinner walls, because the windows look best when they are not set deep in thick masonry. St. Denis was one of many early twelfth-century buildings where older forms were being replaced by the "new" architecture. Suger's writings reveal that he was competitive and ready to seize the moment to create something fresh at St. Denis.

THE ÎLE-DE-FRANCE AND ITS CATHEDRAL TOWNS

The Île-de-France (see Map 7.1), with Paris as its center, was the setting in which the Gothic style originated and where, over a period approximately from 1150 to 1300, it reached the climax of its development. The name of this region referred to the royal lands under the direct control of the French king. The rest of what is now France was still under the dominion of various feudal lords. Through heredity, marriage, conquest, and purchase, the Île-de-France gradually grew into

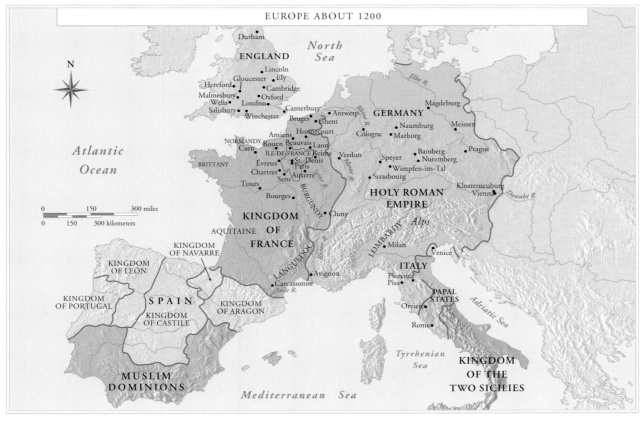

MAP 7.1

the nucleus of the future French nation. Like a wheel with Paris as its hub, it radiated outward about 100 miles, with spokes extending toward the cathedral towns of Amiens, Beauvais, Rheims, Bourges, Rouen, and Chartres.

The spires of the Gothic cathedrals rose above the rooftops of those towns and could be seen from great distances. Unlike an abbey church, a cathedral was primarily in a populated area under the administration of a bishop, whose official seat it was. Whereas the subdued exterior of an abbey church suggested lack of interest in the material world, the intricate carving on the outside of a cathedral awakened curiosity and invited entrance. As the center of a cloistered life, a monastic church was richest in its dim interior. By contrast, the elaborate exterior decoration of a

cathedral helped integrate the church into the life of the city. The tall towers of the Gothic cathedral beckoned the distant traveler and directed the weary steps of the peasant homeward after a day in the fields. The bells pealed to regulate the life of an entire town and its surrounding countryside. They told of weddings and funerals and marked the times for work, rest, and prayer.

A cathedral was, of course, primarily a religious center, but in a time when spiritual and worldly affairs were closely interwoven, the religious and secular functions of a cathedral were intermingled. Its nave was not only the setting for religious services but also on occasion a town hall where the entire populace could gather for a meeting. The rich decorations that clothed the body of the cathedral told both the

7.2 Chartres Cathedral, from the air, Chartres, France, c. 1194–1260.

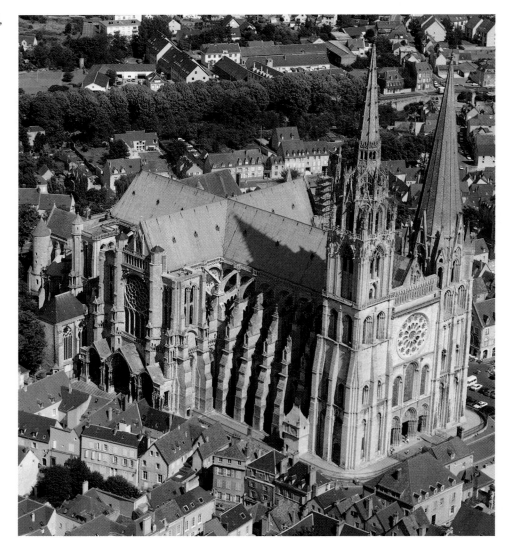

story of Christianity and the history of the town and the activities of its people.

The iconography of a cathedral dedicated to Notre Dame (Our Lady) was concerned mainly with religious subjects. Because the Virgin Mary was also the patron of the liberal arts, her cathedral often constituted a visual encyclopedia whose subjects ranged over the entire field of human knowledge. The pulpit was not only the place from which sermons were preached but also a podium for lectures and instruction. The sanctuary became a theater in which a constantly changing religious drama was enacted. The choir was the setting for liturgical song, but like a concert hall or opera house, it was also a place where intricate polyphonic choral works could be performed and the melodies of the religious dramas chanted.

Outside, the deep-set portals provided stage sets for mystery plays appropriate to the season, and the porches became platforms from which minstrels and jugglers could entertain their audiences. The stone statues and stained glass served as useful illustrations for sermons but also functioned as picture galleries to stimulate the imagination.

CHARTRES CATHEDRAL

Chartres (Fig. 7.2), unlike Paris, was never a center of commerce but rather a small town of fewer than 10,000 in the midst of a rural district southwest of Paris. Its great attraction and growth as a cultural center came from its shrine to the Virgin Mary. Thousands of people annually congregated from far and wide to celebrate the feasts of the Virgin in the grand celebrations that were unique to the Cathedral of Chartres.

Here as elsewhere, the cathedral was not only the spiritual center of the lives of the townsfolk but also the geographic center of the medieval town. Towering over all, its great shadow fell across clustering church buildings that included the bishop's palace, the cathedral school, a cloister, a hospice or lodging for travelers, and an almshouse to aid the poor. Its west facade faced one side of the marketplace, and from the cathedral square radiated the narrow streets on which were located the houses and shops of the townspeople. As members of guilds (associations of craftspeople), the people of the town contributed their labor and products to the cathedral when it was being built, and through their guilds donated windows and statuary. They filled continuing needs, such as candles for the altars and bread for the communion service.

As years of labor and treasure were poured into a cathedral, tensions rose among leading town groups. Church-imposed taxes created lasting resentments and led to demonstrations and resistance. Nevertheless, the cathedral itself was a huge group effort of stonecutters, masons, carpenters, glassmakers, and metalworkers, all of whom gave of their time, skill, and wealth to build it. It was the greatest single product a town could produce. Appropriately, a cathedral usually could hold all the town's residents.

As a great civic monument, a cathedral was the pride of the community, and the ambitions and aspirations of citizens determined its character and contours. In those days the importance of a town could be measured by the size and height of its cathedral, as well as by the significance of the religious relics it housed. Civic rivalry thus was involved when the vaulting of Chartres rose about 120 feet. Next came the cathedral at Amiens, which achieved a height of about 140 feet. Finally Beauvais became the tallest of all, with the crowns of its high vaults soaring to about 157 feet.

The extraordinary religious enthusiasm that prompted the undertaking and construction of these immense projects is described by several medieval writers. Allowing for the enthusiasm of a religious zealot, as well as for the probably symbolic participation of the nobles in manual labor, Abbot Haimon's observations in England convey the spirit of these times:

> Who has ever heard tell, in times past, that powerful princes of the world, that men brought up in honor and wealth, that nobles, men and women, have bent their proud and haughty necks to the harness of carts, and that, like beasts of burden, they have dragged to the abode of Christ these waggons, loaded with wines, grains, oil, stone, wood, and all that is necessary for the wants of life, or for the construction of the church? . . . When they have reached the church, they arrange the waggons about it like a spiritual camp, and during the whole night they celebrate the watch by hymns and canticles. On each waggon they light tapers and lamps; they place there the infirm and sick, and bring them the precious relics of the Saints for their relief.

THE ARCHITECTURE OF CHARTRES

WEST FACADE. When one first observes the west facade of the Cathedral of Notre Dame at Chartres (Fig. 7.3A), it is difficult to imagine that so solid a monument is actually the end result of fire salvage, a long process of growth, and a good amount of improvisation. Four centuries, in fact, separate the earliest parts from the latest. The interval between saw rapid construction in times of prosperity, slower progress in times of poverty, work inspired by religious ardor, and cruel destruction by fire.

The stylistic difference between the two spires is one of the most striking features of the Chartres facade. The supporting towers, part of the previous church, are approximately contemporary. The upper part and the spire on the right, however, date from the time the later parts of the Romanesque abbey church at Cluny were being finished. The spire on the left came more than 300 years later.

Close inspection reveals some minor flaws, such as the discrepancy between the proportions of the portals and the scale of the facade as a whole, the slightly off-center rose window, and the awkward joining of the gallery and arcade of kings above it with the tower on the right. Despite these differences, the facade bears out the initial impression of unity surprisingly well. Its space is logically divided and predicts the layout of the interior (Fig. 7.3B). Horizontally, the three entrance portals lead into the nave, while the flanking towers face the aisles. Vertically, the portals correspond to the nave arcade within, the lancets to the triforium gallery, and the rose window to the clerestory level. By this means, the spatial composition maintains a close relationship between the inner and outer aspects of the structure.

Rising above the twin towers are the tall, tapering spires that seem a logical and necessary continuation of the vertical lines of the sup-

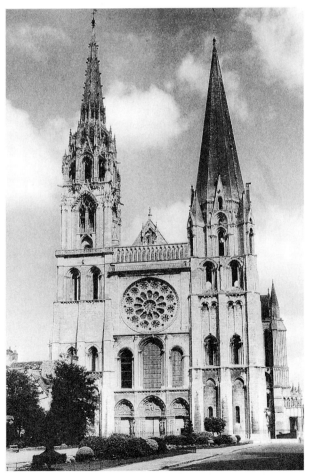

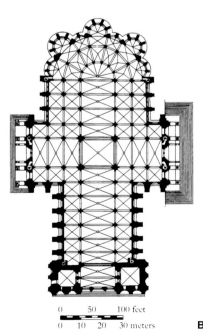

A **B**

7.3 (A) West facade, Chartres Cathedral. Portals and lancet windows, c. 1145; south tower (right), c. 1180, height 344′; north spire (left), 1507–1513, height 377′. Length of cathedral 427′, width of facade 157′. (B) Plan of Chartres Cathedral.

porting buttresses below and a fitting expression of the Gothic spirit of aspiration.

THE INTERIOR. Upon entering Chartres Cathedral through the central portal, one sees the broad nave extending toward the transept. On either side are amply proportioned aisles flanked by stained-glass windows that allow a flood of colored light to flow throughout the entire structure (Fig. 7.4). The plan reveals that in comparison with the abbey church at Cluny, the walls are thinner and the building relies more on buttresses. Instead of running parallel to the nave, the buttresses at Chartres are at right angles to it and the area between is bridged over with vaults. This provides open space for glass to light the interior at both the ground and clerestory levels.

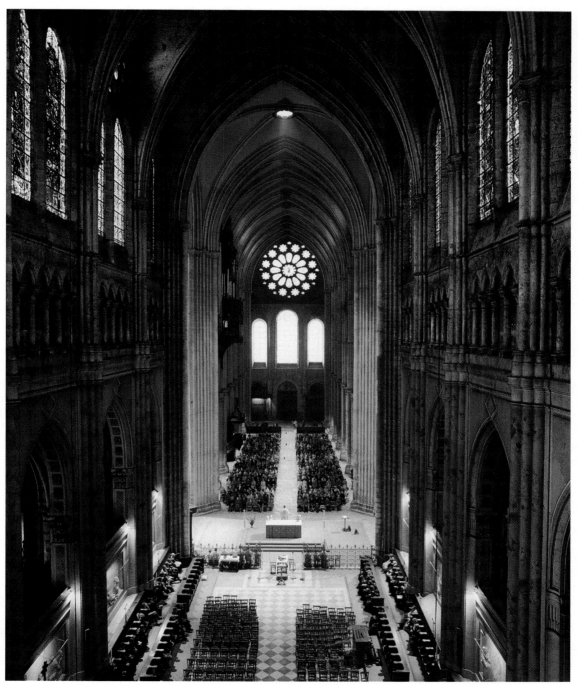

7.4 Nave and rose window, Chartres Cathedral, c. 1194–1260. Length of nave 130′, width 53′, height 122′.

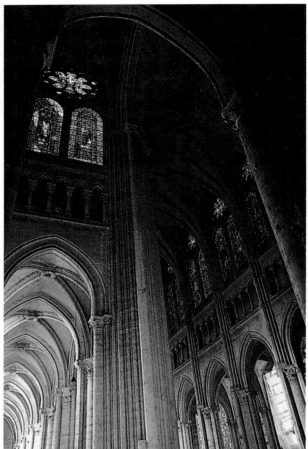

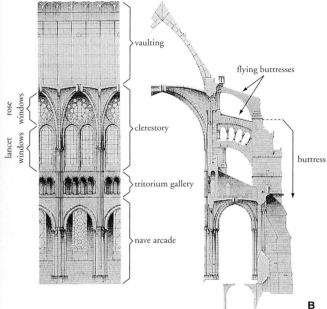

7.5 (A) South clerestory wall of nave, Chartres Cathedral, c. 1194–1260. (B) Transverse section of nave (left) and diagram of vaulting (right), Chartres Cathedral. Drawing by Goubert.

Through the language of form and color and in representations of religious subjects, the wall space communicates visually with the worshipers. As the sun moves across the sky, beams of tinted light emerge from the stained-glass windows and transform the floor and walls into a constantly changing mosaic of color. Together with the clerestory windows, the shafts of mysterious light accent the structural system of arches, piers, and vaults and contribute to the illusion of infinite size and upward straining. Because the eye is naturally drawn to light, the interior gives the impression of being composed entirely of windows (Fig. 7.5A).

From the center of the nave, attention is drawn to the arcade of six bays marching majestically toward the crossing of the transept and the choir beyond. Each immense **pier** consists of a strong central column with four attached **colonnettes** of more slender proportions clustered around it. As Figure 7.5A shows, piers with cylindrical cores and attached octagonal colonnettes alternate with piers with octagonal cores and attached cylindrical colonnettes. An interesting rhythm of procession and recession is set up, and further variation

is provided by the play of light on the alternating round and angular surfaces of the piers.

The space above the graceful pointed arches of the nave arcade is filled by a series of smaller open arches that span the space between the bays (Fig. 7.5B). Behind them runs the triforium gallery, a passage using the space above the internal roofing over the aisles and under the slanting external roof that extends outward from the base of the clerestory. Above the triforium runs the clerestory level, which now fully accomplishes its purpose. The triple pattern of two tall, pointed **lancet windows** below and a circular one above provides a maximum of open space for glass and a minimum amount of masonry.

The triumph of the Gothic builders was engineering the vault to cover the nave. At Chartres the broad *quadripartite,* or four-part, vaulting (Figs. 7.4 and 7.5B) rises about 120 feet above ground level. It is this principle of vaulting that underlies all Gothic architecture and, in turn, explains all the supporting facts of shafts, colonnettes, clustered columns, buttresses, and pointed arches. Each of these plays a role in directing the descending weight of the in-

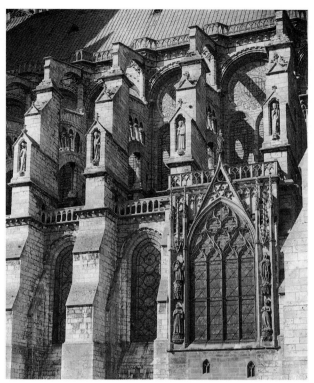

7.6 South nave exterior, Chartres Cathedral, c. 1194–1260.

ing is organized to achieve a gradual crescendo. It proceeds from the dark violet and blue lancets and rose window in the west through the brighter tones of the aisle and clerestory windows of the nave, past the flaming reds of the transept rose windows, to the high intensity of the five red and orange lancets in the apse. These apsidal windows soar above the altar and capture the rays of the morning sun.

Romanesque abbey churches were lighted mainly from within by lamps and candles, whereas Gothic interiors were illuminated by sunlight transformed through stained glass into a myriad of mysterious prismatic colors. The light activated the interior masses and voids, producing a flowing harmonious whole.

THE EXTERIOR. At Chartres, each of the interior members has an opposite number (Fig. 7.6). The purpose of the flying buttress is to carry the thrust of the vaulting at specific points over the aisles to the outer buttresses that are set at right angles to the length of the nave. From the observer's point of view, just as in the interior of the cathedral the eye is drawn irresistibly upward by the rising vertical lines, on the outside it follows the rising vertical piers to the pinnacles, along the procession of the flying buttresses toward the roof of the transept, and on to infinity.

The extensive use of the pointed arch also becomes clearer when one observes the exterior. At Cluny, it was used mainly as a decorative motif to promote a feeling of height and elegance (see Fig. 6.6), but the Gothic architects pointed their arches to raise the crowns of the intersecting ribs of the vaulting and thus achieve a uniform height with great structural stability. A round arch tends to spread sideways under the gravitational force of the weight it bears. By contrast, a pointed arch, being steeper, directs the thrust of its load downward onto the upright supporting members (Fig. 7.7B).

tersecting ribs of the vaults toward the ground as efficiently as possible. The heavier transverse ribbing is carried past the clerestory and triforium levels by the large central shafts, while the smaller cross-ribs are borne by the groups of slender colonnettes that extend downward and cluster around the massive central piers of the nave arcade below.

Gothic interiors need little decorative detail other than the vertical lines of the structural members, the variety of representations in stained glass, and above all, the flow of light. At Chartres the light-

7.7 The pointed arch and ribbed groin vault are fundamental to Gothic architecture, making it a light and flexible building system that permits generous openings in walls for large, high windows. The result is well-illuminated interior spaces. Whereas the less stable, lower round arches spread the load laterally (A), pointed arches, being more vertical, thrust their load more directly toward the ground (B). Also, pointed arches can rise to any height, but the height of semicircular arches is governed by the space they span. In (C) and (D) the space, or *bay,* that has been vaulted is rectangular in shape, rather than square. In (C) the round arches create a dome-shaped vault whose forms and openings are irregular and restricted. In (D) the pointed arches rise to a uniform height and form a four-part Gothic vault with ample openings.

Through the ever-increasing skill with which they used the pointed arch, Gothic builders were able to achieve constantly increasing heights. This, in turn, led to loftier vaults and more ethereal effects.

When all these various devices—pointed arch, rib vault, flying buttress, triforium gallery, walls maintained by spacious arcades, window spaces maximized at all levels—came together in a working relationship, Gothic architects were able to bring dead masses of masonry into an lively equilibrium of weights and balances. Gothic architecture is thus a complex system of opposing thrusts and counterthrusts (Fig. 7.6) in which all parts exist in a logical relationship to the whole.

THE TRANSEPT, CHOIR, AND APSE. At Chartres the wings of the transept terminate in triple portals (Fig. 7.8) that in size and magnificence surpass those of the western facade, parts of which had survived from the previous church. The north and south portals in the thirteenth-century style are framed by row upon row of richly sculptured receding archivolts that bring a maximum of light and shadow into play. The shape of such sections was determined in part by the tastes of individual donors. The north transept, with its portals, porch, and stained glass, was the gift of the royal family of France, primarily Blanche of Castile and her son Louis IX; its southern counterpart was donated by their arch-rival, the Duke of Brittany. When the cathedral was dedicated in the year 1260, Louis IX (later canonized as a saint) was present with an immense assembly of bishops, canons, princes, and peasants.

Beyond the transepts extend the spacious choir and sanctuary, surrounded by a double-aisled ambulatory that gives easy access to the apse and its necklace of radiating chapels. The increasingly elaborate Gothic liturgy demanded the participation of more and more clerics, and the

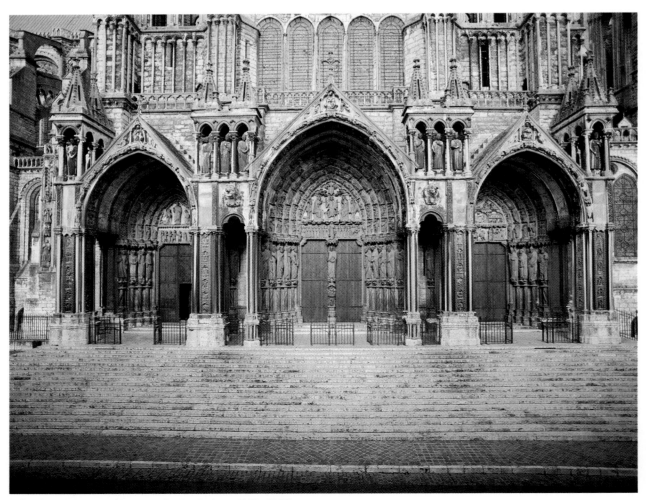

7.8 South Porch, Chartres Cathedral, c. 1210–1215.

cavernous recesses of the huge structure were needed to accommodate an ever-growing number of choristers. The apsidal chapels are also a distinctive feature of a developed Gothic plan. They provided access to the various altars where the revered relics of saints were kept in reliquaries.

The Cathedral of Notre Dame at Chartres was closely associated with the cult of the Virgin Mary, as were earlier churches that stood on the same site. Its most famous relic was the legendary veil of the Virgin, which, by tradition, had been presented to Charlemagne by the Byzantine empress Irene. Another chapel enshrined the skull of St. Anne, the Virgin's mother, which was brought back by crusaders and given to the church in 1205. This relic explains the many representations of St. Anne in statuary and stained glass and the pilgrimages in her honor, which were second only to those of the Virgin herself.

The most notable chapel in Gothic cathedrals was the *Notre Dame* (Lady Chapel), devoted to Mary, whose importance grew throughout the eleventh and twelfth centuries. She was prominently represented on tympanums and in these specially dedicated chapels. The Lady Chapel was usually placed on the main axis of the nave beyond the center of the apse, with chapels of other saints grouped on either side. All these considerations caused the parts beyond the cathedrals' transepts to expand to unprecedented proportions.

SCULPTURE AT CHARTRES

The sculptural and pictorial representations whose themes and locations contributed to the church's significance and meaning were as important to the medieval mind as the structure of the cathedral itself. In a Romanesque monastic church, sculptural elements were found in the carved tympanums over the narthex portals, on the capitals of the columns throughout the interior, and in wall paintings, especially at the apsidal end. Because such representations were designed for people who led cloistered lives, they were placed inside and the variety, subtlety, and multiple meanings of their subjects make it clear that they were meant to be pondered and carefully studied.

By contrast, Gothic sculpture faced the outside world, where it clustered around and over the porches and entrance portals to form an integral part of the architectural design. The exterior of Chartres has more than 2,000 carved figures distributed among the west facade and the north and south porches of the transepts. Sculpture at Chartres and elsewhere was closely allied with its architectural framework. Because most of it was located out of doors, the play of light and shade at different times of the day had to be considered. And although there was plenty of variety in the subjects chosen, the figures found their unity in a preconceived iconographical, or pictorial, program.

ICONOGRAPHY. A Gothic cathedral, with the all-embracing activities it housed and the all-encompassing subject matter of its sculpture and stained glass, has often been likened to a **summa,** a comprehensive summary of law, philosophy, and theology written by medieval scholars that covers both religious and secular knowledge. Cathedrals have also been described as the Bible in stone and glass or as the books of the illiterate. Nevertheless, they must also be viewed as visual encyclopedias for the educated. The key to the iconography of Chartres is the encyclopedic character of medieval thought as found in the *Speculum Majus* of the French Dominican scholar Vincent of Beauvais. He divided all learning into Mirrors of Nature, Instruction, History, and Morality. The Mirror of Nature is seen in the plant and animal forms, which are represented in comprehensive fashion. Instruction is present in the personifications of the seven liberal arts and the branches of learning taught in the universities. History is found in the story of humanity from Adam and Eve to the Last Judgment. Finally, Morality can be seen in the figures depicting virtue and vice, the wise and foolish virgins, the saved and the damned in the Last Judgment, and the hovering saints and angels and fleeing gargoyles and devils.

The sculpture is logically organized and presents a sequence of events with a beginning, middle, and end. Starting with the west facade, the life of Christ commences with his ancestors and continues through his birth, ministry, death, and ascension. The facade of the north transept is concerned with the Virgin Mary, from her ancestors to her heavenly coronation. The south transept is faced with a profusion of figures signifying human redemption. It begins with the foundation of the church; continues with its saints, great popes, abbots, and bishops; and concludes with the Last Judgment.

Each of the three porches has approximately 700 carved figures clustered in the three tympanums over the portals, the archivolts that frame them, and the columns below and galleries above. In addition to scriptural scenes and lives of the saints, the designers found a place for ancient lore and contemporary history, for prophecy and fact, for fabulous animals and the latest scientific

knowledge, for portraits of princes and merchants, and for beautiful angels and grotesque gargoyles, some of which function as water spouts to drain the roof, whereas others symbolize demons fleeing from the sacred precincts of the church.

The iconography at Chartres thus stems from three principal sources: the dedication of the cathedral to Our Lady, an honor that was shared with other Notre Dame cathedrals, such as those at Paris, Rheims, Rouen, and Amiens; the presence of a cathedral school, an important center of learning, for Mary was also the patron of the liberal arts; and the preferences of such patrons as the royal family, the lesser nobility, the clergy, and the local guilds, who donated so many of the sculptures and windows.

It must also be borne in mind that sacred and secular elements in a medieval town and manor were so closely interwoven that every spiritual manifestation had a worldly counterpart. So the cathedral, as the court of Mary, Queen of Heaven, had to surpass in magnificence the grandeur that surrounded any mere earthly queen.

THE WEST FACADE OR ROYAL PORTAL. The sculptures and doorways of the west facade at Chartres are called the Royal Portal (Fig. 7.9). The central tympanum encloses the figure of Christ in Majesty surrounded by the four symbolic beasts of the

Evangelists and the twenty-four elders of the Apocalypse. The tympanum over the left portal depicts the close of Christ's days on Earth and his ascension. On the right is the tympanum of the Virgin Portal (Fig. 7.10), depicting the beginning of the Savior's earthly life.

The story of the Virgin is told in three rising panels. Starting in the lower left is the Annunciation, with the figures of the Angel Gabriel and Mary. The next pair shows the Visitation. The Nativity is in the center. The shepherds in the midst of their sheep are coming from the right for the Adoration, just as their successors came in from the fields near Chartres to worship at Mary's shrine. The middle panel depicts the presentation of the young Jesus in the temple. His position on the altar foreshadows his later sacrifice. Friends approach from both sides bearing gifts. In the top panel the Virgin sits crowned and enthroned, holding her divine son and being attended by a pair of archangels. She is shown frontally, as a queen accepting the homage of the humble, who enter her court through the portal below.

THE SEVEN LIBERAL ARTS. Of great interest are the figures in the archivolts that frame the tympanum. These figures symbolize Mary's attributes. Like Athena of old, the Virgin was the patron of the arts and sciences. The German philosopher Albertus

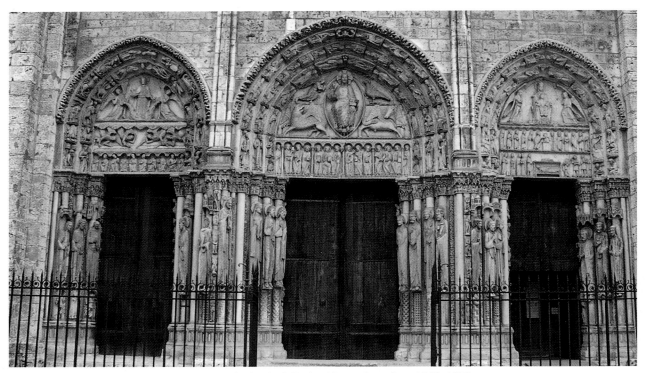

7.9 Royal Portal, west facade, Chartres Cathedral. Right, Virgin Portal, c. 1145–1170.

Magnus declared in his *Mariale* that the Virgin was perfect in the arts, and in his *Summa Theologiae,* the Italian theologian Thomas Aquinas included among his propositions the question of "Whether the Blessed Virgin Mary possessed perfectly the seven liberal arts," which he triumphantly affirmed. These representations are also reminders that this was an age that produced great scholars. Intellectual inquiry accompanied faith on the road to salvation. Indeed, Chartres was the location of one of the great cathedral schools. Before the founding of the University of Paris, Chartres shared with Rheims the distinction of being one of the best-known centers of learning in Europe.

The curriculum of the cathedral school was, of course, the seven liberal arts. These were divided into the *trivium,* which dealt with the science of words in the three subjects of grammar, rhetoric (speech), and dialectic (logic), and the higher faculty of the *quadrivium,* which was concerned with the science of numbers through the study of arithmetic, geometry, astronomy, and music.

On the archivolt, these seven arts are symbolized abstractly by female figures, somewhat akin to the ancient Muses, and below them are found their most famous human representatives. Beginning with the lower left corner of the outside archivolt, Aristotle is seen dipping his pen into an inkwell. Above him is the thoughtful figure of Dialectic. In one hand she holds a dragon-headed serpent, which symbolizes subtlety of contemplation, and in the other, she holds the torch of

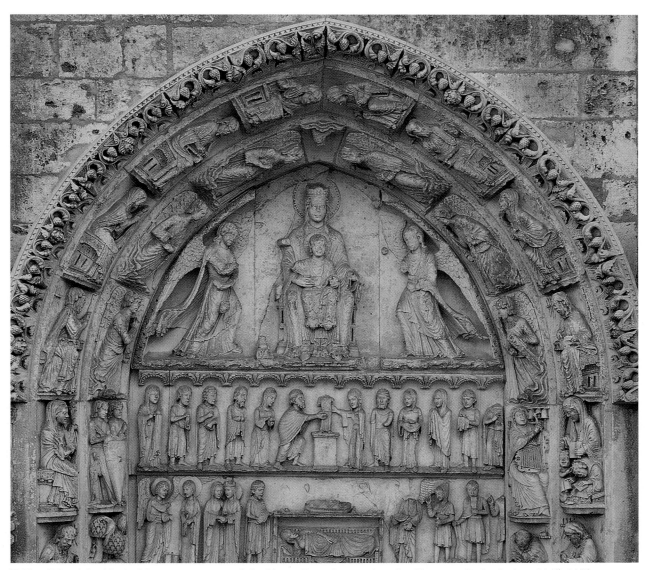

7.10 *Life of the Virgin Mary,* tympanum of the Virgin Portal, west facade, Chartres Cathedral, c. 1145–1170.

knowledge. Then comes Cicero, the great orator, and over him the figure of Rhetoric making a characteristic oratorical gesture. The next pair are Euclid and Geometry, both absorbed in calculations. In the same band, moving now from the top downward, is Arithmetic, probably personified by Boethius. Next is the stargazing figure of Astronomy, who holds a bushel basket that signifies the relationship of her science to the calendar, so important in a farming district like Chartres. Ptolemy, to whom the medievalists ascribed the invention of the calendar and the clock, is Astronomy's human representative.

The figures on the lowest level are Grammar and Donatus, the ancient Roman grammarian. Grammar (Fig. 7.11) holds an open book in one hand and a disciplinary switch in the other over two young pupils, one laughing and pulling the other's hair.

The last pair in the series of seven is adjacent to those in the inner archivolt. Below is Pythago-

7.11 Details, Virgin Portal tympanum, west facade, Chartres Cathedral, c. 1145–1170. Music appears on the left; Grammar, on the right.

ras, the reputed founder of music theory, who is shown writing in medieval fashion with a desk over his knees. Above him is the figure of Music surrounded by instruments. At her back is a monochord, used to calculate musical intervals and to determine accuracy of pitch. A psaltery rests on her lap, and a three-stringed viol hangs on the wall. Music is striking a set of three chime bells, an allusion to the Pythagorean discovery of the mathematical ratios of the perfect intervals—the octave, the fifth, and the fourth. Both Gerbert of Rheims and his pupil, Bishop Fulbert of Chartres, are known to have taken an active interest not only in the theory of music but in its performance as well. The two figures, showing Pythagoras as the thinker and Music as the performer, signify that Chartres was an important center for the theoretical and practical aspects of music.

THE NORTH AND SOUTH PORCHES. The north porch is far more elaborate in scope and less restrained in decorative detail than the west facade. With its three portals, it stretches to a width of 120 feet, thus spanning the transept completely. A gift of the royal family of France, its construction and decoration took place during the first 75 years of the thirteenth century, from the reign of Louis VIII and the regency of his queen, Blanche of Castile, through the reign of their son Louis IX. The north porch is dedicated to the Virgin and expands the theme of the Virgin Portal on the west facade to encyclopedic proportions. Her history, from the Annunciation and Nativity through the childhood of Jesus, is found on the left portal. The scenes of her death and assumption are depicted on the lintel over the central door, and those of her enthronement and coronation are in the tympanum above.

Mary's attributes are revealed in the archivolts through several series of cyclical representations, such as those of the fourteen heavenly beatitudes and twelve feminine personifications of the active and contemplative lives. Especially fine is the single figure of her mother, St. Anne, holding the infant Mary in her arms (Fig. 7.12). She adorns the ***trumeau,*** the post or pillar that supports the lintel and tympanum of the central portal. From the harmonious lines of the folds of her drapery to her dignified and matronly face, the work is one of the most satisfying examples of the mature Gothic sculptural style.

The arches of the portals on the south porch (Fig. 7.8) are more highly pointed than those of the west facade (Fig. 7.3A). Moreover, they are enclosed by triangular gables that further emphasize their verticality. The deep recession of the

porch allows for a much greater play of light and shade on the statuary that covers every available space from the bases of the columns to the peak of the gable.

The figures on both the north and south porches, in comparison with the earlier ones on the west facade, have bodies that are more naturally proportioned; their postures show greater variety and informality, and their facial expressions have far more mobility. The representations of plants and animals are considerably closer to nature, and in comparison with the impersonality of those on the west front, many of the human figures are so individualized that they seem like portraits of living people. In the change of style, however, something of the previous symbolic meaning and monumentality has been lost, as well as the closer relationship with the architecture.

STAINED GLASS AT CHARTRES

Time has taken its toll on the exterior sculptures of Chartres. The flow of carved lines remains, and the varied play of light and shade relieves the present browns and grays, but only traces of the original colors and gilt are left to remind the observer that here was once a feast of color. In the interior, however, where the stained glass remains undimmed, the full color of medieval pageantry still exists. The wealth of pure color in the 175 surviving glass panels hypnotizes the senses. Through the medium of multicolored light, one can sense something of the emotional exaltation that inspired medieval people to create such a temple to the Queen of Heaven.

Although Chartres must share architectural and sculptural honors with its neighboring cities, the town was especially well known as the center of glassmaking. With the highest achievements of its glaziers exemplified in their own cathedral, Chartres is unsurpassed. The great variety of jewellike color was achieved chemically through the addition of certain minerals to the glass while it was in a molten state. When cool, the sheets were cut into smaller sections, and the designer fitted these into a previously prepared outline. Details, such as the features of the faces, were applied in the form of metal oxides and made permanent by firing in a kiln. Next, the glass pieces of various sizes were joined together by lead strips. Finally, the individual panels making up the pattern of the whole window were fastened to the iron bars already embedded in the masonry. When seen against the light, the glass appears translucent, and the lead and iron become opaque black lines that outline the figures and separate the colors to prevent blurring at a distance.

ICONOGRAPHY AND DONORS. The iconographical plan of the glass at Chartres, like that of the exterior sculptures, is held together mainly by the dedication of the church as a shrine of the Virgin. There is never any doubt on the part of those who enter that they are in the presence of the Queen of Heaven, who sits enthroned in majesty in the central panel of the apse over the high altar. Grouped around her in neighboring panels are the archangels, saints, and prophets; emblems of the noble donors; and symbols of the craftspeople and tradespeople—almost 4,000 figures in all, who honor her and make up her court. Below, on her feast days, were the crowds of living pilgrims who gathered in the nave and chapels.

An interesting commentary on the changing social conditions of the thirteenth century can be read in the records of the donors of the windows. In the lowest part of each is a "signature" indicating the individual, family, or group who bore the

7.12 *St. Anne with the Virgin,* trumeau of Center Portal, north porch, Chartres Cathedral, c. 1250.

expense of the glass. Only a royal purse was equal to a large rose window, as evidenced by the fleur-de-lis insignia so prominent in the north rose window (see Fig. 7.14). Within the means of members of the aristocracy and the church hierarchy, such as bishops and canons, were the lancet windows of the nave and choir. The status and prosperity of the guilds of craftspeople and merchants, however, were such that most of the windows were donated by them.

Although the royal family of France and the Duke of Brittany were content with windows in the transepts, the most prominent windows of all, the 47-foot-high center lancets of the apse, were given by the guilds. Each guild had a patron saint, and a window under a guild's patronage was concerned with the life and miracles of its special saint. In the case of the nobility, the family coat of arms was sufficient to identify the donor; with a guild, the "signature" took the form of a craftsman engaged in some typical phase of work. In the windows of Chartres, some nineteen

7.13 *Bakers.* Detail of stained glass window, Chartres Cathedral.

different guilds are shown; the one over the high altar was the gift of the bakers (Fig. 7.13).

THE ROSE WINDOWS. The great rose window of the west facade dates from the early thirteenth century and thus is contemporary with the majority of examples in the rest of the church. The three lancets below it, however, like the portals and surrounding masonry on the exterior, originally were part of the previous church (Fig. 7.8). Their origin has been traced to the school that did the windows for Suger's church at St. Denis. Overall, the work on these lancets was finer grained and more jewellike, with infinite care lavished on the geometric and arabesque patterns in the borders. They are dominated by their vibrant blue background, whereas the figures and abstract patterns have been done in several shades of red, emerald green, yellow, sapphire, and white.

The great rose window of the north transept (Fig. 7.14), like the sculpture on the porch outside, glorifies the Virgin Mary. Together with its lancets, the composition shares with other thirteenth-century glass a preference for red backgrounds instead of the earlier blue. The individual panes are larger and the borders more conventionalized. Its greatest effect comes from the large splashes of warm color that contrast with the cool tones of the lancet windows of the west facade, as well as that of the earlier glowing panel known as *Notre Dame de Belle Verrière (Our Lady of the Beautiful Window)* (Fig. 7.15).

In the Gothic period, the art of stained glass replaced the mosaics and mural paintings of the Early Christian and Romanesque churches. It was the ultimate stage in the dematerialization of interior space. Because it gives form and meaning to light, the art of the glazier is perhaps better adapted to the expression of transcendental concepts than any other artistic medium. By transforming raw sunlight into a spectrum of brilliant colors, the architect directed the interior lighting. It could be caused to flow in any manner the architect wished. This material control over an immaterial medium allowed the architects and iconographers to shape light to their structural, pictorial, and expressive needs. Here is how Abbot Suger expressed the ecstasy felt by medieval men and women in the contemplation of the precious stones that adorned the altar and the jeweled glass of the windows:

> Thus, when—out of my delight in the
> beauty of the house of God—the loveliness
> of the many-colored gems has called me
> away from eternal cares, and worthy

meditation has induced me to reflect, transferring that which is material to that which is immaterial, on the diversity of the sacred virtues: then it seems to me that I see myself dwelling, as it were, in some strange region of the universe which neither exists entirely in the slime of the earth nor entirely in the purity of Heaven; and that, by the grace of God, I can be transported from this inferior to that higher world in an anagogical manner.

MUSIC

Massive and magnificent as the Gothic cathedral is, it can be considered the highest achievement of its time only when associated with the many activities it was designed to house. Most important, of course, is the liturgy. As the space it enclosed increased, the cathedral grew into a vast auditorium that hummed with collective voices at communal prayer, resounded with readings and exhortations from the pulpit, and reverberated with the chanting of solo and choral song from the choir. The Île-de-France, the site of the most significant developments in architecture in the twelfth and thirteenth centuries, was also the scene of the most important musical innovations of the Gothic period. Specifically, these were the more sophisticated practices of **polyphonic,** or "many-voiced," music and their relationship with the still universally practiced **monophonic,** or unison, art of plainchant.

The practice of singing in parts originated in the north, in contrast to the prevailing Mediterranean style of singing in unison. Moreover, part singing in folk music apparently predates by several centuries its incorporation into church music. Just as the Gothic cathedral was the culmination of the long process of reconciling the northern urge for verticality with the southern horizontal basilica form, so Gothic music emerged from the union of the northern tradition of multivoiced singing and the southern single-voice tradition to form a new style of church music.

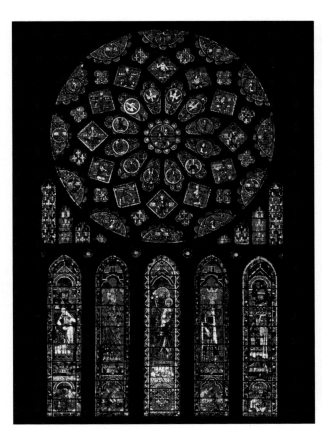

7.14 North rose window, Chartres Cathedral, c. 1220. Diameter 43′.

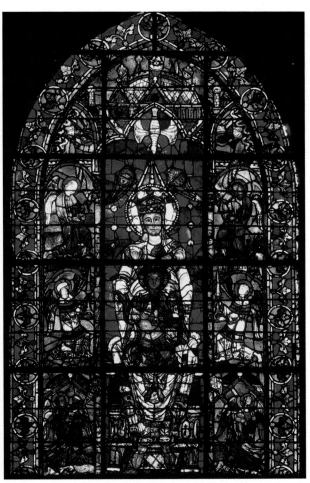

7.15 *Notre Dame de Belle Verrière,* stained glass window, Chartres Cathedral, c. 1170, with thirteenth-century side panels, 16′ × 7′8″.

MUSIC AT THE SCHOOL OF NOTRE DAME IN PARIS

Just as the builder of St. Denis brought together many principles that had been developed separately elsewhere and used them in a systematic whole, so too were elements of music fused into a new whole. As the growing capital of the French kingdom, Paris was the logical place for the pieces to be fitted together. The **contrapuntal,** or polyphonic, forms and textures developed in monasteries such as Cluny and in cathedral schools such as Rheims and Chartres, as well as the tradition of folk singing in several parts, were systematically organized for the first time at the School of Notre Dame in Paris.

The first great achievement of Gothic music was the *Magnus Liber Organi* (The Great Collection of Organum) by Léonin, dating from c. 1163. As its name implies, it was a great book that brought together a collection of music in two parts, arranged cyclically to provide appropriate music for all the feast days and seasons of the calendar year.

THE TENOR OR CANTUS FIRMUS. In the traditional rendering of the plainchant, some parts were sung by a soloist and answered responsorially by a chorus singing in unison. In the Gothic period, the choir still chanted the way it had for centuries, but the solo parts began to be performed simultaneously by two or more singers. Notre Dame in Paris, for example, employed four such singers. The distinction between solo voice and choir hence was replaced by the opposition of a group of individual singers and a massed chorus. With several skilled soloists available, the way was open for an art of much greater complexity than ever before.

Because the music was still intended for church performance, the traditional sacred melodies had to be used. A special part called the **tenor,** a term derived from the Latin *tenere,* meaning "to hold," was reserved for this melody, which was also known as the **cantus firmus,** or "fixed song," implying that it could not be changed. The development of Gothic music involved taking the cantus firmus as an established basis and adding one by one the other voices, called, in ascending order, the **duplum, triplum,** and **quadruplum.** Because these voices were superimposed one above the other, a definite concept of verticality is implied; this contrasted strongly with the horizontal succession of tones that characterized the older monophonic chant. The growing complexity of singing in several parts led by necessity to a new type of time notation to define the rhythmic ratios and hold the various polyphonic voices together.

The earliest forms of Gothic polyphony are almost as rigid in their way as the old parallel organum of the Romanesque period, but they are based on the new principle of **punctus contra punctum,** that is, "note against note," or point counterpoint. *Mira Lege* illustrates one of the strictest applications of this idea. The plainchant melody is in the lower part, whereas the counterpoint above moves as much in opposition to it as possible. Although parallel movement is not against the rule, and from time to time does occur, contrary motion is preferred. A treatise written at the beginning of the twelfth century declares, "If the main voice is ascending, the accompanying part should descend, and vice versa." The name given to this newly created melodic line was the **discantus,** or descant, referring to the idea of singing against the established melody, a practice that has continued in religious and secular music.

Musical Example 7.1
Mira Lege (twelfth-century descant)

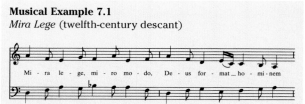

THE TWO-PART CHANT. In addition to such examples, Léonin's *Magnus Liber Organi* contains another type of counterpoint known as the **organum duplum.** The plainsong cantus firmus is found in the lower voice, but the individual tones are stretched out to extraordinary lengths. The descanting, or duplum, voice moves in free counterpoint consisting of ornate melismas over what has in effect become a relatively fixed base.

Musical Example 7.2
Organum Duplum (c. 1175; in Léonin's style)

The greater melodic and rhythmic freedom that the descant assumed called for expert solo singers, and much of the descanting of Gothic times is known to have been improvised. The practice of such a freely flowing melodic line over a relatively fixed bass points to a possible origin in folk singing. Survivals are found in the instrumental music of the Scottish bagpipers, where a tune like "The Campbells Are Coming" is heard over the steady accompaniment of a droning bass note.

In performance, the slowly moving tenor, or cantus firmus, may have been sung by the choir while the soloist sang a freely moving duplum part over it. Or perhaps the tenor was played on the organ, an instrument known to have been in use at time. The organ keyboard was a thirteenth-century Gothic innovation, and many manuscript illustrations from the period point to the wide use of organs. The term *organ point,* moreover, continues to be used to refer to a musical passage in which the bass tone remains fixed while the other parts move freely over it.

THE THREE-PART MOTET

Another significant development was the addition of a third part above the other two, known as the **triplum,** from which the term *treble* is derived. This step was taken by Pérotin, who was active in Paris in the late twelfth and probably the early thirteenth centuries. In his revision of the work of his predecessor, Léonin, Pérotin moved away from polyphonic improvisational practices toward an art based on stricter melodic control and clearer rhythmic definition. By thus achieving a surer command of his material and evolving a logical technique for manipulating it, he was able to add a third voice to the original two, and in two instances there is even a fourth part. These compositions, known as ***motets,*** were independent works designed for performance in the liturgy but not part of the regular mass.

The three-part motet, like its predecessors, still had its cantus firmus in the tenor, which was the lowest part and held the *mot* (word), from which the term *motet* is probably derived. Over it, the contrapuntal voices wove a web with two different strands, each singing its independent melodic line. In the hands of Pérotin the three-part motet became the most favored and characteristic practice of thirteenth-century Gothic music.

Besides achieving ever-greater melodic independence, the two contrapuntal voices even had their own separate texts. A three-part motet thus had three distinct sets of words that were sung simultaneously: the tenor, with its traditional line, and usually two contemporary hymnlike verses over and above it. Intended as they were for church performance, the words customarily were in Latin. However, around the middle of the thirteenth century, it was not uncommon for one of the voices to sing its verses in French.

During the thirteenth century the **vernacular,** or local language, came into more frequent use in music and literature, and so did popular melodies. Above the stately tenor it was possible to have a hymn to the Virgin in Latin and a secular love song in the vernacular French being sung at the same time. Through the simple expedient of replacing the sacred melodies with secular tunes, a fully developed musical art independent of the church was not only possible but by the end of the thirteenth century had become an accomplished fact.

Gothic music exists in such close unity with other manifestations of the Gothic style that it can scarcely be understood as a thing apart. The subjects of the new hymns, especially those with the words of St. Bernard and the melodies of Adam of St. Victor, were mainly devoted to the Virgin, as were most of the cathedrals and the iconography of the sculpture and stained glass. Instead of a monolithic choir chanting in unison or in parallel organum, Gothic listeners now heard a small group of professional singers. In the case of a three-part motet, they could choose, according to their temperament or mood, to follow, or "tune into," the solemn traditional melody, the Latin commentary above it, or the French triplum in their everyday mode of speech. This allowance for diversity of musical taste is part of the general shift from the homogeneity of monastic life to the heterogeneity of city life, expressed by the cathedral. The new melodic, rhythmic, and textural variety implied a congregation of people from all walks of life, as did the diversified imagery of the sculpture and stained glass.

Musical Example 7.3
Triplum (thirteenth century; in Pérotin's style)

Individual voices were superimposed one above the other, yielding an *aural,* or listening, impression of verticality. The ear, like the eye, needs fixed points to measure rises and falls. In Musical Example 7.1 *(Mira Lege),* the intervals in the lower part established the point over which the descant moved in contrary motion. In the case of the *Organum Duplum* (Musical Example 7.2), the soaring upward and plunging downward movement of the melody could be heard above and against the long sustained tenor. In addition to this vertical feeling, all types of counterpoints achieved a sense of rhythmic progress. Against a relatively static or stable point, other voices measured rapid movement. Melodies and intervals clashed as separate texts were sung at the same time. Thus, Gothic music was able to build a sense of mounting tension that set it apart as a distinctive new style.

IDEAS

In the century between the dedication of the Romanesque abbey church at Cluny (1095) and the beginning of Chartres Cathedral (1194), much more than a change in artistic styles occurred. A mighty shift in social and political institutions and in basic modes of thought took place. The resulting changes in church, secular, and artistic life brought into the open sharp divisions of opinion. Old conflicts, long restrained by the medieval divinely ordered social structure, now burst into flames, and new ones as well. Intellectual disputes grew hot and bitter as emotional tensions deepened.

In this critical situation, the rational methods of scholastic philosophy were brought to bear to evaluate the strong points of opposing arguments. In fact, the Gothic is best summarized as a clashing and dissonant style in which opposite elements were maintained in a state of uneasy equilibrium. With the eventual dissolution of the Gothic synthesis in the following century, the basic oppositions became so impossible to reconcile that some of them led to the battlefield. Others resulted in schisms, that is, divisions within the church, and produced growing philosophical and artistic conflicts.

GOTHIC OPPOSITIONS AND DIVISIONS

In the Gothic era, the age-old struggle between church and state, evident in Romanesque times in the endless quarrels between popes and Holy Roman emperors, shaped up as a conflict between traditional ecclesiastical authority and the growing political power of northern European kingdoms, especially France and England.

The prevailing monastic and feudal organizations of Romanesque times tended to separate society into widely scattered cloisters and manors, isolating many of the sources of social strain. In the Gothic era, the towns began to grow into cities and differing worldviews were brought into a common center, making confrontation possible. Also, tensions mounted between the landed aristocrats and the volatile urban groups, as well as between the monastic orders and the growing secular clergy. In the towns, residents saw at close range the bitter rivalries between abbot and bishop, lord and burgher, clergy and laity.

For the common people, a strong contrast had always existed between the squalor in which they lived and the luxury of their lords, bishops, and ab-

7.16 Gothic half-timbered house, Rouen, France, fifteenth century.

bots. This disparity was amplified by the gap between the poverty of their daily lives and promises of heavenly glory.

DUALISM AND THE ARTS

The arts were also torn by conflicting aspirations. Artists accepted a relatively anonymous status in the service of God, yet through the guilds and other activities, they actively competed for worldly recognition and rewards. Aristocratic and church patrons had to contend with the increasingly influential and affluent middle class and guilds. The rising power of the middle class is well illustrated by their dwelling places, such as the Gothic half-timbered houses at Rouen (Fig. 7.16) and the splendid residence of the banker Jacques Coeur at Bourges (Fig. 7.17).

In architecture, strong opposing forces produced a new visual vitality, especially the interplay of interior and exterior in Gothic cathedrals. Masses and voids played against one another, as did the thrust and counterthrust of vaults and buttresses. In sculpture, the conflict between the par-

ticular and the universal was expressed in the remarkable feeling for human individuality that contrasted with the dignified impersonality found in rows of saints and prophets who lined the doorways of churches. At Chartres, these opposing tendencies are apparent in the lifelike figures of Grammar and Donatus on the Virgin Portal tympanum (Fig. 7.11), whose rounded high relief stands out against the stiffly posed ***jamb,*** or doorway, figures of Old Testament kings and queens on the west facade (Fig. 7.9).

In literature, the cleavage between Latin and the vernacular languages was increasingly evident in the developing distinction between sacred and secular musical styles. In music, abstract academic discussions about the hypothetical nature of the music of the spheres contrasted with the escalating importance of the actual sounds heard in the choirs of the churches. Similarly, the singing of monophonic choruses alternated with groups singing polyphonically. In short, Gothic music displayed all the inherent oppositions of an art based on the principle of point counterpoint.

7.17 Hotel Jacques Coeur, courtyard, Bourges, France, 1443–1451.

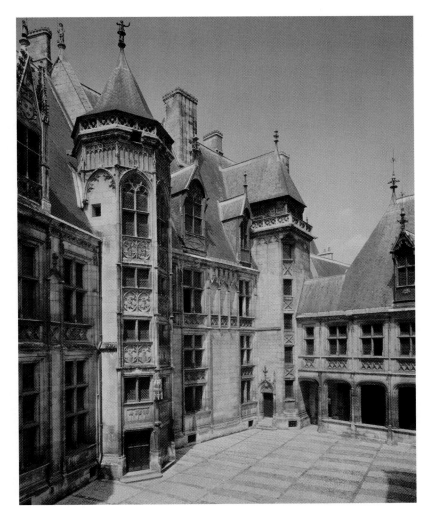

SCHOLASTIC SYNTHESIS

In the face of so many differences, it seems astonishing that the Gothic style was able to effect even a momentary synthesis. In fact, a method for keeping differences in suspension was devised by scholars, a kind of pro-and-con dialogue followed by a resolution. To the scholastic philosopher, God, as the Creator of a world based on principles of reason, was approachable through the logical power of the mind. Hence, the key to understanding the universe was in the exercise of the rational faculties. Philosophical truth or artistic value was determined not by factual evidence but by how well an idea fitted into a logically ordered system. The results of this dialectical thought infiltrated the Gothic monarchy, university, encyclopedia, summa, and even the cathedral.

Abelard's *Sic et Non (Pro and Con)* was an early manifesto of Gothic dualistic thinking and a prime example of scholasticism at work. Abelard posed one pertinent question after another, then lined up authorities from the Scriptures and church fathers for and against each. His purpose was to expose some of the fissures in the thought of sanctioned authorities. However, Abelard contradicted scholastic practice and did not reconcile his oppositions.

THOMAS AQUINAS'S *SUMMA THEOLOGIAE*. The scholastic successors of Abelard debated whether ultimate truth was to be found through faith or reason, blind acceptance of authorities or the evidence of the senses, determinism or free will. In their search for a synthesis, Thomas Aquinas and others found an answer in the dialectical method of argument. Thomas's synthesis, as demonstrated in his **Summa Theologiae *(Summation of Theology)*,** was a comprehensive attempt to bring together all Christian articles of faith into a rational system.

Thomas faced the problem of how to adapt Aristotle's philosophy to Christian theology. He also tried to harmonize such differences as truth revealed by God in the Scriptures and truth arrived at by human learning, the classical and Christian traditions, and the mystery of faith and the light of reason. He proposed to reconcile Abelard's pros and cons through a subtle intellectual maneuver.

His *Summa Theologiae* was as intricately constructed as a Gothic cathedral and had to embrace the totality of a subject, systematically divided into propositions and subpropositions, with inclusions deduced from major and minor premises. Every logical proposition was fitted exactly into place like each stone in a Gothic vault. If one of the premises were to be disproved, the whole structure would fall like an arch without its keystone.

AESTHETICS AND NUMBER THEORY

From Aquinas's highly rationalistic viewpoint followed a scholastic definition of beauty. He said that the mind needed order and demanded unity above all other considerations. Even though seeing and hearing played an increasingly important role in art and music, mathematical calculation and symbolism had to be called upon.

In the cathedral schools and later in the universities, music was studied mainly as a branch of mathematics. Bishop Fulbert of Chartres emphasized theory in the training of singers, saying that without it "the songs are worthless." His view was generally held throughout the Gothic period. As one theorist put it, a singer who is ignorant of theory is like "a drunkard who, while he is able to find his home, is completely ignorant of the way that took him home." The academics tended to suppress the sensuous beauty of tone and emphasize the mathematical, theoretical, and symbolic aspects of the musician's art.

At Chartres, as at other cathedral schools, arithmetic, geometry, music, and astronomy—the quadrivium of the seven liberal arts—were carefully and closely studied. Plato's theory of the correspondences between visual proportions and musical harmony (see p. 50) was kept alive in Early Christian times by both St. Augustine and Boethius in their books on music. In his *De Musica,* Augustine wrote that both architecture and music are the children of numbers. For him, architecture was the mirror of the cosmos, whereas the tonal art was the echo of the music of the spheres. These two books, along with parts of Plato's *Timaeus,* were widely studied in medieval monasteries and universities.

The mystical number 3 played a major role in music, architecture, and philosophy. Since antiquity, uneven numbers had been considered male and even numbers female. The number 1 was the symbol of the progenitive force and creative principle, and the number 2 was the female equivalent. The two joined together to form the first whole—or complete—number, 3. In addition, the number 3 was associated with Plato's trinity of truth, goodness, and beauty. Its Christian symbolism of Father, Son, and Holy Spirit would have been obvious to all. The number 3 also referred to the three parts of creation: hell below, the Earth, and the heavens above.

In the plan and cross section of Chartres Cathedral (Figs. 7.3B and 7.5B) the number 3 was all-pervasive. There are the triple entrance portals. The facade rises in three steps, from the level of the doorways, through the intermediate story, to the rising towers intended to elevate the thoughts of the

worshipers and direct their aspirations heavenward. In the interior there are three corresponding levels: the nave arcade, the triforium gallery, and the windowed clerestory. In the clerestory itself, each bay has two lancets and one rose window. Then there is the tripartite division of the floor plan into the nave, transepts, and choir sections; the three semicircular chapels in the apse; and so on indefinitely.

In philosophy, encyclopedias and summas were divided into three parts. The triple rhyming plan of Latin poetry, as in the *Dies Irae* (p. 231) and the **terza rima** stanzas that Dante wrote in the *Divine Comedy* (pp. 232–234), serve as literary examples. In music, Gothic composition favored the three-part motet and the **ternary,** or three-beat, rhythm, which was called the **tempus perfectum** because of its Trinity symbolism.

Whereas the number 3 designated the spirit, the number 4 stood for matter, because the material elements composing the universe were considered to be fire, earth, air, and water. The sum of the two numbers is 7, which symbolized the human being, whose dual nature was made up of spirit and matter, soul and body. At Chartres, the number 7 also referred to Mary as the patron of the seven liberal arts. The number 9 was also a Marian symbol, because the Virgin was considered the seat of wisdom, and by analogy, knowledge was the root of power (3 being the square root of 9). As Dante wrote, "The Blessed Virgin is nine, for she is the square of the Trinity." Chartres has nine entrance portals, three in the facade and three in each of the transepts. According to the original plan, the cathedral was to have had nine towers—pairs on the west facade and on each of the transepts, two flanking the apse, and one over the crossing of the nave and transepts. In sum, numbers were thought to be the key to the divine plan and the link between the seen and the unseen.

THE FEMININE IN GOTHIC THOUGHT

Hovering above all these earthly concerns was the figure of Mary. The worship of Mary also had its worldly counterpart, as Gothic chivalry and courtliness partially replaced the might-makes-right code of Romanesque feudalism. Just as the clergy sang the praises of Notre Dame, the knights praised their ladies in particular and Our Lady in general. The high place of womanhood in secular circles was the courtly parallel of the religious cult of the Virgin.

In the poetry of the time, a knight's ladylove is always a paragon of feminine virtue and charm. To woo and win her, he had to storm the fortress of her heart by techniques far more intricate and

subtle than those needed to take a castle. When successful, he became the vassal of his mistress and she his liege lady to command him as she would. As one of the troubadours sang, "To my lady I am vassal, lover, and servant. I seek no other friendship but the secret one shown me by her beautiful eyes." The concept of romantic love originated in the Gothic period and came to full flower in the complex code of chivalry.

SOME BROADER RESOLUTIONS

The rise of national monarchies in France and England began to limit the international authority of the papacy and to curb the provincial power of the feudal lords by increasing the centralization of civil authority. In England, a political resolution between king and nobles and between nobles and commoners was made in the Magna Carta, a document that not only outlined civil liberties but also became the basis for parliamentary government. In France, the establishment of a working relationship between the king and the urban middle class accomplished a similar purpose. King Louis IX of France was so skillful at strengthening his own kingdom while maintaining good relations with the popes that he was canonized. In the cities the guilds brought patrons and craftspeople together; meanwhile, the system of apprenticeships and examinations ensured a high standard of quality and workmanship.

The Gothic universities were set up as institutions to bring together diverse disciplines and controversial personalities and to fit all the various intellectual activities into a single universal framework. Scholasticism became the common mode of thought and its dialectic the common method of solving intellectual problems.

The structural uniformity of Gothic vaulting and buttressing was, in effect, the Gothic builder's answer to Romanesque experimentation. Ample allowance for urban diversity was made in the iconography of each cathedral and in the differences between cathedrals in different towns and countries.

Gothic architecture tried to synthesize the interior and exterior of the cathedral. Externally, the eye follows the numerous rising vertical lines to the spires and pinnacles and then to the sky. Inside, the experience is similar: the vertical lines rise to the window levels and from these through the glass to the space beyond. By contrast, the inward-turning monastic church was based on the notion of excluding the outside world. The Gothic cathedral attempted an architectural union of the inner and outer worlds as the exterior and interior

flowed together through the glass-curtained walls. The thrust and counterthrust of the interior vaulting was paralleled on the outside by that of the piers and flying buttresses; the sculptural embellishments of the exterior were repeated in the iconography of the glass in the interior. Through the medium of stained glass, the iconographers transformed physical light into metaphysical and mystical illumination.

The various European languages and dialects found a place in secular literature, but Latin was championed by the church and universities as the language of scholarship. In music, Latin and the language spoken by the common people were reconciled in the multiple texts of the motet. Gothic music also attempted a synthesis of theory and practice. Through these separate manifestations, the Gothic spirit was revealed, whether in the systematic logic of St. Thomas, in the heightened sense of time achieved by the musicians, or in the visual aspirations and linear tensions of the builders.

No one of these resolutions was final, and the Gothic style must be viewed as a dynamic process rather than an end result. By contrast, a Greek temple or even a Romanesque abbey is a completed whole, and in the observer's eye can eventually come to rest. The appeal of the Gothic lies in the restlessness that prevents this sense of completion. The observer is caught in the stream of movement and from the initial impulse desires to continue it. The completion, however, can occur only in the imagination, because each cathedral lacked something, such as a tower or a spire.

The nineteenth-century French archeologist Viollet-le-Duc once conjectured what a complete cathedral would look like. He gave it seven spires— one pair on the west facade, others on the north and south transepts, and a climactic spire over the crossing of the nave and transept (Fig. 7.18). None of the real cathedrals was completed to this degree. Incompleteness was not limited to architecture: Vincent's encyclopedia and Thomas Aquinas's *Summa Theologiae* were never finished.

Gothic unity is therefore to be found mainly in such methods and procedures as the use of dialectic in philosophy, strict structural principles in architecture, and techniques of writing in literature and music. No more effective processes could have been devised to deal with the specific inconsistencies that confronted the Gothic mind. They were, in fact, the only ways to reconcile the seemingly irreconcilable, to arrive at the irrational by ingenious rational arguments, and to achieve the utmost in immateriality through material manifestations.

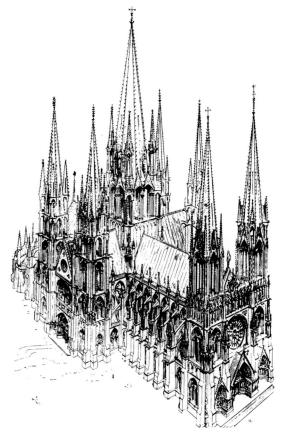

7.18 Eugène Viollet-le-Duc. Drawing of a Gothic cathedral with full set of seven spires.

YOUR RESOURCES

- ***Exploring Humanities CD-ROM***
 - ○ Interactive Map: Europe about 1200
 - ○ Architectural Basics: The Gothic Rib Vault
 - ○ Readings—Peter Abelard, Prologue to *Sic et Non;* Thomas Aquinas, Part 1, Question 2, Article 3 of *Summa Theologiae*

- ***Web Site***
 http://art.wadsworth.com/fleming10
 - ○ Chapter 7 Quiz
 - ○ Links

- ***Audio CD***
 - ○ *Mira Lege*
 - ○ *Organum Duplum*
 - ○ *Triplum*

GOTHIC PERIOD IN FRANCE

Key Events	Architecture	Literature and Music
c. 1088 **University of Bologna** founded		
1095–1291 **Crusade period;** Christians and Muslims fought over Holy Land; trade routes opened		
1100		
1137 **Louis VII King of France;** married Eleanor of Aquitaine	c. 1136 **Abbey Church of St. Denis,** prototype of Gothic cathedrals, begun by Abbot Suger	c. 1130 **Abelard** (1079–1142) wrote *Sic et Non,* taught at School of Notre Dame, Paris
1140		
		c. 1149 **Abbot Suger** (1081–1151) wrote account of building and decoration of St. Denis
c. 1150 **University of Paris** founded		c. 1150 **Adam of St. Victor** wrote hymns with St. Bernard of Clairvaux
		c. 1150 **Troubadours** flourished
		c. 1150 **Léonin** active as composer at Cathedral of Notre Dame, Paris
1160		
c. 1163 **Oxford University** founded	1163–1235 **Cathedral of Notre Dame** in Paris built	
		1170 *Lancelot and Perceval,* romance of courtly love, by Chrétien de Troyes
1180		
1180–1223 **Philip Augustus** reigned as king of France; enclosed Paris with walls; Paris became capital city		c. 1183 **Pérotin** active as composer at Cathedral of Notre Dame, Paris
		c. 1185 *Tristan et Iseult,* Celtic epic, written
	1194–1260 **Chartres Cathedral** built after fire destroyed earlier Romanesque cathedral; 1260 new cathedral dedicated by Louis IX	
1200		
1200 **Cambridge University** founded	1210 **Rheims Cathedral** rebuilt	
1215 **Magna Carta** signed by King John in England	1220 **Amiens and Rouen cathedrals** begun	
1223 **Louis VIII** crowned king of France	1225 **Beauvais Cathedral** begun; 1272 choir finished	
1226 **Louis IX** king of France under regency of mother, Blanche of Castile, until 1234		
		1236 *Roman de la Rose* written
	1243 **Ste. Chapelle,** royal chapel of French kings, begun in Paris	
		c. 1250 **Vincent of Beauvais** (died 1264) wrote encyclopedic *Speculum Naturale, Historiale, Doctrinale*
		1250 **Albertus Magnus** (c. 1193–1280), scholastic philosopher, taught at University of Paris
		1273 *Summa Theologiae* written by Thomas Aquinas (1225–1274)
		1275 **Scholastic philosophy** at height
		c. 1280 **Adam de la Halle** (c. 1237–1288), author and composer of *Le Jeu de Robin et Marion,* pastoral play with music
1300		
	1334–1362 **Palace of Popes** built at Avignon	

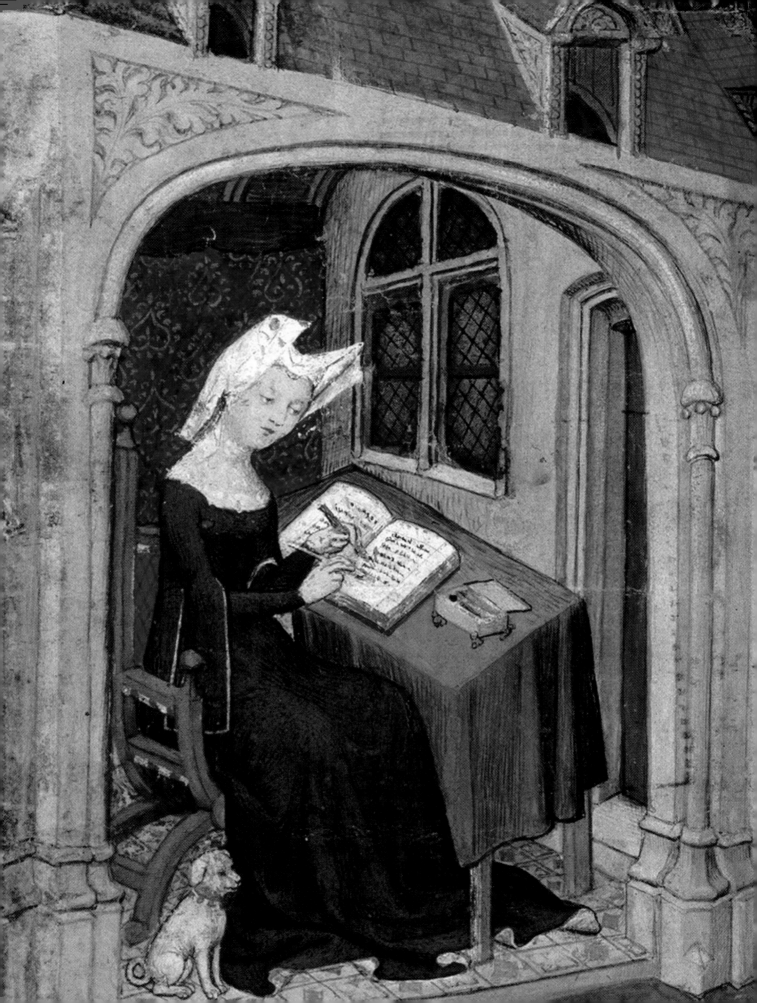

INTERNATIONAL STYLES IN THE LATE MEDIEVAL PERIOD

THE GREAT GOTHIC BUILCING WAVE that engulfed central France soon became an international style. Even while Chartres and other Île-de-France cathedrals were still being built, some of the French schools of stonemasons crossed the English Channel to work on building the great cathedral complexes at Canterbury and Salisbury in England. Thereafter the Gothic moved across the Rhine River into Germany, over the Alps into Italy, and across the Pyrenees into Spain. As the Gothic style spread, it encountered new social, political, religious, and cultural forces that were destined to give all the arts new shapes and directions. The French Gothic oppositions that had been maintained in a state of uneasy equilibrium (see pp. 208–209) by the application of scholastic logic and strict structural balances were to break into open conflict during the fourteenth century.

THE DEVELOPMENT OF INTERNATIONAL GOTHIC

While Gothic cathedrals were still being built in the north, classical art was reinvigorated in the south. Thunderous threats of fire and brimstone and fear of the Lord were hurled from church pulpits one day, only to be followed the next day by comforting Franciscan parables and assurances of divine love and mercy. University professors still argued with the icy logic of scholastic philosophy, whereas the followers of St. Francis were persuading people with simple human truths. Some painters designed images of doomsday filled with warring angels and demons while others portrayed biblical stories as seen through the eyes of simple folk. People wondered whether the world they lived in was a moral trap set by the devil to ensnare the unwary, or a pleasant place that a loving Creator designed for their enjoyment.

The new Franciscan and Dominican orders rarely kept to their cloisters. Instead, they took to the road as itinerant preachers to all who would gather and listen. The great Italian writers Dante and Petrarch became exiles from their native cities, and their works were written during extended stays in half a dozen centers. Like them, the great painters were journeymen, traveling to wherever their work called them. Giotto, the leader of the Florentine school, painted *fresco* cycles that occupied him for several years in Rome, Assisi, and Padua, as well as in his home city. Simone Martini was active in Siena, Naples, and Assisi; he spent his last years at Avignon. Internal church dissensions were such that even the popes had to flee from their traditional seat in Rome to hold court in widely scattered residences, most notably at Avignon in southern France. Here the papal court attracted the best and most progressive writers, artists, and musicians from all of Europe. Indeed, Avignon became one of the main centers of the International Gothic style in the fourteenth century. Instead of a single dominant cultural center, as had existed during the Roman era, many cultural centers emerged in prosperous towns and cities throughout Europe. In these areas the clashes that were developing between and among townspeople, church people, and the nobility were to become louder and more insistent.

THE ENGLISH TRANSFORMATION OF GOTHIC

Salisbury (Fig. 8.1) is unique among English cathedrals because it was substantially finished within a short period, from its beginning in 1220 to its consecration in 1258. All the others were in a constant state of construction and alteration, depending on the changing fortunes and needs of their constituent cities. Set in a magnificent park on the banks of a river, the structure gives the impression of unity from every angle. If one imagines the church before the grand central tower (404 feet), still the loftiest in England, was added in the four-

teenth century, its differences from the French Gothic style become apparent. In its breadth and hefty masses, Salisbury recalls the Norman Romanesque (see Fig. 6.23A). The towers and spires of its west facade seem to hug the Earth more than soar toward heaven. In sum, despite the international popularity of the Gothic style and its positive associations with royalty and learning, different regional and cultural values shaped it in regions outside the Île-de-France. At Salisbury, for instance, the English liturgy's reliance on stately processions was accommodated by a long nave of ten bays (compared with six at Chartres). Behind the wall that extends from the facade are an at-

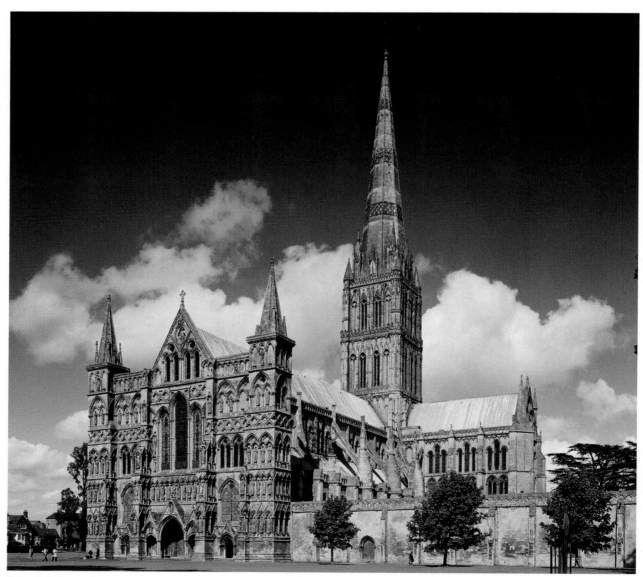

8.1 Salisbury Cathedral, 1220–1258. Length 473′, width 230′, height of spire 404′.

8.2 Exterior view of Haddon Hall, Derbyshire, England.

tached cloister and chapter house to serve a monastic community, a typical architectural practice in England.

The Gothic style was recast as "English architecture" in that country, partly to acknowledge its differences from French Gothic and partly to distinguish it from the earlier Norman style. With various mutations (known as the Early English, the Decorated, the Perpendicular, and the Tudor), the Gothic continued as the dominant mode of construction, permeating English life into the seventeenth century. There were Gothic chapels, parish churches, castles, manor houses, schools, colleges such as those at Oxford and Cambridge, guildhalls, market halls, inns, hospitals, townhouses, country cottages, bridges, fortifications, castles, and even barns, stables, and furniture.

Haddon Hall in Derbyshire is a manor house in the English Gothic tradition. Its similarity to the sturdy Tower of London is apparent (see Fig. 6.23A). Set on the side of a hill amid pastoral surroundings, the house overlooks verdant fields where sheep and cattle graze (Fig. 8.2). Its spacious banqueting room (Fig. 8.3), with its timbered ceiling, large arched windows, and huge fireplace, is particularly impressive. The rest of the stately structure includes a long gallery, a chapel the size of a small church, ample living and sleeping quarters, and exterior terraces and extensive gardens.

Entertainment in the courtly banqueting halls of Europe during the internationalization of Gothic was illustrated on the January page of the richly illustrated *Book of the Hours,* created by the Limbourg Brothers for the Duke of Berry, brother

8.3 Haddon Hall Banqueting Hall, fourteenth century.

to the king of France (Fig. 8.4). The scene is a celebration of Epiphany, or Twelfth Night, the day the Three Wise Men, following the star of Bethlehem, found the infant Jesus in the manger and brought gifts of gold, frankincense, and myrrh. The Duke of Berry, in a rich robe and fur hat, turns to receive greetings and gifts. The large, circular, gold-colored fire screen behind him resembles a halo. It

is as if the artist has put him in the place of the Christ child, but in an elegant setting much removed from the poverty of the Nativity stable. Incidentally, the central figure with the monk's tonsured head is thought to be a self-portrait of the artist, Paul de Limbourg.

In the English countryside, where trees were plentiful, a modest type of wooden domestic

8.4 January: The Feast of the Duke of Berry. Illuminated manuscript page from *Les Très Riches Heures de Duc de Berry,* 1416. Ms. 65; folio 1V. Musée Condé, Chantilly, France.

dwelling also developed along Gothic lines. This house style—with raftered ceilings and steep-pitched Gothic gabled roofs—traveled to America with the early colonists, who built the kinds of homes they knew and remembered best.

The arts of sculpture and stained glass were also incorporated into English architecture, but never to the extent of their French counterparts. Both arts suffered considerable destruction during the break from Roman Catholicism in the time of Henry VIII, and much of what remained was destroyed during Cromwell's Puritan revolution in the seventeenth century. The fragments that survive show that these arts were similar in quality and character to those in thirteenth-century France.

ENGLISH LITERATURE: GEOFFREY CHAUCER

London resident Geoffrey Chaucer painted a vivid verbal picture of fourteenth-century life in the verses of his *The Canterbury Tales*. The time is spring and the place a London tavern. A varied group of people, ranging from a knight to a plowman, gather before setting out on a pilgrimage to honor the martyred saint Thomas à Becket, the archbishop who had been murdered in the cathedral at Canterbury.

> And specially from every shire's end
> Of England they to Canterbury wend,
> The holy blessed martyr there to seek
> Who helped them when they lay so ill and weak.

Pilgrims, according to tradition, told tales to amuse one another during their long treks. Chaucer lets his pilgrims talk in conversational English as it was spoken in his day. The stories range from moral tales and fables to outright farce. Religious beliefs are treated with a sophisticated slant and good-humored irony. In the General Prologue, Chaucer introduces an amiable cross section of medieval society. The group includes the bawdy wife of Bath, who has buried five husbands and is still looking for another; a poor Oxford student; an earthy miller; a fraudulent doctor; a flamboyant young squire with a roving eye for the ladies; a rich, busybody lawyer; a fastidious prioress whose inclinations are far more worldly than a nun's should be; and finally a knight, who draws the shortest straw and thus gets to tell the first tale:

> He said: "Since I must then begin the game,
> Why, welcome be the cut, and in God's name!
> Now let us ride, and hearken what I say."

Unlike today, when reading is usually a private and silent activity, Chaucer's poetry was read aloud, usually to a group. Indeed, he fashioned *The Canterbury Tales* for listeners, carefully describing locations, pacing the language for maximum emotional effect, and contriving characters who not only tell tales but also reveal their personalities in conversation with other pilgrims. Sadly, Chaucer died before he was able to finish the vast work he planned. Until time obscured the accessibility of the English in which he wrote, he was considered one of England's greatest poets.

GOTHIC ART AND ARCHITECTURE IN GERMANY

In Germany the new Gothic style had to battle for acceptance with the traditional Romanesque style that became thoroughly entrenched during the Holy Roman Empire (see pp. 150–151). Slow in evolving, German Gothic ultimately acquired a distinctly national character of its own.

The builders of the Cathedral at Ulm (Fig. 8.5), a prosperous and politically influential German city,

8.5 Ulm Cathedral, Ulm, Germany, begun 1377; tower designed 1482; spire nineteenth century.

eventually abandoned the balanced, two-tower design common to the west facade of earlier Gothic churches, such as Chartres (see Fig. 7.3A). An extravagant, thickset single tower and spire achieved an unprecedented height of 620 feet. The spectacular structure seems to be not only leaping into the heavens but also pushing the bulky church into the ground. The west tower had to wait for its final flourishes until the nineteenth century, when its builders could use cast-iron construction.

The Cathedral at Ulm is often cited as the tallest church tower in the world. Similarly, the great cathedral complex at Cologne, planned to rival the height and size of French Gothic cathedrals, had a long, drawn-out history. Begun in 1248, its choir and transept stood for centuries at one end of the site, with the stubs of the two facade towers at the other end and a yawning chasm between. The cathedral was not completed until 1880, after interest in medieval architecture led to the discovery of the original building plan. The new wealth of Cologne during the Industrial Revolution finally provided the funds for the cathedral's completion.

German Gothic sculpture also shows a distinctive regional character. In the choir of the Naumburg Cathedral, the donors and founders are depicted in solemn procession (Fig. 8.6). The figures portrayed were from the historical past, but the skillful sculptor created them with great particularization of features, as if they had modeled for their likenesses. The stocky Margrave Ekkehard, military governor of the region, appears as a self-confident, haughty aristocrat whose hand is never far from his sword. Uta, his beautiful wife, is regally poised.

8.6 Ekkehard and Uta, c. 1249–1255. Limestone, approx. 6′2″ high. Naumberg Cathedral, Naumberg, Germany.

8.7 *Bamberg Rider,* 1235–1240. Sandstone, 7′9″ high. Bamberg Cathedral, Bamberg, Germany.

With graceful gestures, she draws her collar across her face with one hand while gathering the ample folds of her gown with the other. As with classical sculpture, the curves of the arm and modeling of the breast reveal how the artist distinguishes the drapery from the body beneath. Both statues retain bits of pigment that hint at the extensive use of color that once graced Gothic cathedral sculptures. Likewise, at Bamberg Cathedral the so-called Bamberg Rider, in a niche on the exterior, is splendidly carved and lifelike (Fig. 8.7). The rider's facial features and physique suggest that this might be a portrait. Sitting high in the saddle, this Gothic knight might be preparing to participate in some medieval tournament or to leading his victorious soldiers into some vanquished city.

GOTHIC ART AND ARCHITECTURE IN ITALY

When the Gothic reached Italy, it underwent a radical transformation. The tall spires found in French and Gothic churches were rejected. Italian churches were conceived of as cool retreats from the southern sun, so there was less need for illuminated interiors than in the north. Stained glass never played a major role in the Italian interpretation of Gothic. The Italians favored the mural arts of mosaic making and fresco painting, which still flourished in the decoration of Italian churches and public buildings. Surrounded by the remains of classical civilization, Italian artists had models from antiquity to inspire them. Nevertheless, northern influence on architecture, sculpture, and the handling of pictorial space is evident in many instances. The Milan Cathedral (Fig. 8.8) seems to have synthesized the linear thrusts of French Gothic and the horizontal sturdiness of English models, such as Salisbury Cathedral, with the Italian heritage, especially the basilica form.

Although the elements of Gothic were introduced in Italy by members of the Cistercian monastic order, the style's emphasis on structural equilibrium, visible both within and outside of French Gothic cathedrals, was not highly influential there. For example, the Doge's Palace, the center of government in the wealthy city of Venice, used

8.8 Milan Cathedral, Duomo, Milan, Italy. Begun 1386. Height 350′.

pointed arches, ribbed arches on the ground level, and a conglomerate of French and Islamic elements on the floor above. Together with the pink-and-white pattern marble of the upper stories, the effect is of a delicate, airy confection far removed from the gray chill of northern Gothic (see Fig. 12.1). Likewise, at Assisi, the large thirteenth-century basilica of St. Francis incorporated pointed arches and ribbed vaults, yet the aesthetic effect and the structural relationships differ greatly from the French prototype.

THE BASILICA OF ST. FRANCIS AT ASSISI

The town of Assisi was built on a rocky hill in the midst of a gentle and lush countryside. This provincial location would never have emerged as a cultural center if Francis, one of the most beloved medieval saints, had not been born there. After the completion of Assisi's great pilgrimage basilica in the midthirteenth century, many of the outstanding artists of the age came to decorate its walls.

A large city might have produced a great orator and organizer, capable of moving minds to bring about a new social order. Francis of Assisi, however, recognized the dangers of inflammatory oratory. Francis accomplished his pastoral mission with the sweet persuasion of simple parables and the eloquence of his own exemplary life. Whereas the mature life of Francis fell within the thirteenth century, the collection of tales that made him a living legend, as well as the full development of the Franciscan movement, belongs to the fourteenth century. Formerly, the clergy who received their training in the universities and the scholarly orders of monks had never influenced a broad segment of society. The Franciscans, however, found a way into the hearts and minds of the multitudes by preaching to them in their own language, rather than Latin, and in the simplest terms. Franciscan voices were heard more often in village squares than in the pulpits of churches.

The essence of the Franciscan idea is contained in the mystical marriage of the saint to Lady Poverty, the subject of one of the Assisi frescoes. When a young man approached Christ and asked what he should do to ensure eternal life, the answer came, "Go and sell that thou hast, and give to the poor, and thou shalt have treasure in heaven: and come and follow me" (Matthew 19:21). Francis took this directive literally. In his will he described his early life and that of his first followers. "They contented themselves," he wrote, "with a tunic, patched within and without, with the cord and breeches, and we desired to have nothing more. . . . We loved to live in poor and abandoned churches, and we were ignorant and submissive to all." He then asked his followers to "appropriate nothing to themselves, neither a house, nor a place, nor anything; but as pilgrims and strangers in this world, in poverty and humility serving God, they shall confidently go seeking for alms."

Had St. Francis's vow of complete poverty been followed strictly, no great art movement would have developed at Assisi. A building program involved the accumulation and expenditure of large sums, and immediately after Francis's death, this matter created dissension among those who had been closest to him. Brother Elias wanted to build a great church as a fitting monument to his friend and master. Others believed that Francis should be honored by the closest possible adherence to his simple life pattern. Erecting the monument Brother Elias had in mind would require a vast treasure, and many of his fellow friars were shocked when Elias set up a marble vase to collect offerings from pilgrims who came to Assisi to honor Francis. Yet only 2 years later, at the very time he was declared a saint, a great basilica and monastery were begun on the hill where Francis had wished to be buried. No doubt, Pope Gregory IX's interest and funds hastened the construction of the project, which was built in a state under papal control.

Taking advantage of the natural contours of the site, the architects designed a structure that included two churches, one above for pilgrims and one below for the Franciscan monks. At Assisi, the differences from French Gothic are easily seen. Despite their comparatively large size, both the upper and the lower churches lack side aisles, which were common in northern examples. The central naves of the upper and lower churches terminate in apses beyond small transepts. The large interior areas are spanned by spacious quadripartite ribbed vaults, partially supported by rows of columns that are set against the walls rather than freestanding, as in French Gothic. Italian Gothic, contrary to the northern style, did not accent well-lighted interiors in which the walls were almost completely replaced with stained-glass windows. The southern sun made shade more welcome, and the interiors were refuges from the brightness of the world outside.

In both the upper and lower churches at Assisi, the absence of a nave arcade and side aisles and the small number of stained-glass windows allowed ample wall space for the brightly colored fresco paintings that cover them. Lighted principally by the clerestory, the walls of the up-

per church are decorated with scenes from the life of St. Francis. More than anything else, it is these murals that bring the twin churches their most special distinction. The names of the artists who worked here read like a roster of the major painters of the period: Cimabue and Giotto of Florence and Simone Martini and Pietro Lorenzetti of the Sienese school.

GIOTTO

On the walls of the nave of the upper church at Assisi are a series of frescoes depicting the life of Francis (Fig. 8.9). These are attributed to Giotto, but the attribution has long been debated. Although his exact role remains unknown, it seems safe to say that if Giotto did not actually paint at Assisi, either he supervised assistants or his approach was adopted by those who worked there. The date generally assigned to the work is the

4-year span just before the jubilee year of 1300. Knowing that more pilgrims than ever before would be traveling to Rome for the celebrations, the artists at Assisi made every effort to cover the bare walls of the upper church in time. The frescoes for the friars' own lower church were not completed until the midfourteenth century.

Like other master artists of his period, Giotto learned to work in a variety of techniques. In addition to frescoes, he did mosaics, painted altarpieces in tempera on wood, and was a sculptor. Several years before his death, he was named the chief architect of Florence, and in this capacity he designed the **campanile,** or bell tower, of the cathedral (see Fig. 9.1), still popularly called "Giotto's Tower." Giotto's greatest and most enduring fame, however, rests on the three fresco cycles in Assisi, Padua, and Florence.

The fresco medium calls for the rapid and sure strokes of a steady hand and for vibrant, colorful

8.9 Nave, Upper Church of St. Francis, Assisi, Italy, 1228–1253.

designs that harmonize with the architectural scheme. After first covering the entire wall with a layer of rough plaster and allowing it to dry thoroughly, the artist makes a preliminary drawing in charcoal, called a *cartoon,* on the surface. Then, selecting an area that can be finished in a single day, the artist smoothes on a thin layer of wet plaster and, if necessary, retraces the original drawing. Next, earth pigments (colors) are mixed with water, combined with egg white as a binder, and applied directly to the fresh plaster—hence the term *fresco,* meaning "fresh."

The pigments and wet plaster combine chemically to produce a permanent surface. Artists sometimes paint over the surface after it is dry, but this repainting usually flakes off in time. If corrections are necessary, the entire section must be knocked out and redone. Fresco, therefore, is a medium that does not encourage time-consuming, subtle types of expression. It is best adapted to bold designs and simple compositions. The emotional depth, the communicative value, and the

masterly execution Giotto achieved in his fresco cycles rank them among the highest achievements in world art.

THE ASSISI SERIES. Even though it is unclear whether Giotto actually painted at Assisi, the first two panels of the series seem inspired by his methods. On the right, after one passes through the entrance portals, is the *Miracle of the Spring* (Fig. 8.10), and on the left is the well-known *Sermon to the Birds.* These two images were placed on either side of the entrance, probably to impress pilgrims at the outset with the most popular Franciscan legends. One shows the saint ministering to the poor and humble; the other demonstrates his kinship with all God's creatures, including those he called his "brothers the birds."

The literary source for the *Miracle of the Spring* is the *Legend of the Three Companions,* which tells of Francis's journey to the monastery of Monte la Verna. A fellow friar, a peasant, and his donkey accompanied him, but the way was steep and the day hot. Overcome by thirst, the peasant cried out for water. Kneeling in prayer, the saint turned to him, saying, "Hasten to that rock and thou shalt find a living water which in pity Christ has sent thee from the stone to drink." Pilgrims entering the church were thirsty for spiritual refreshment, and the placement of this picture assured them that they had arrived at a spring that would nourish the soul.

The composition is as simple as it is masterly. St. Francis is the focal center of two crisscrossing diagonal lines like the letter X. The descending light from the rocky peak in the upper right reveals the contours of the mountain in a series of planes. It reaches its greatest intensity in its union with Francis's halo, diminishing in his shadow, where his two companions and the donkey stand. The dark mountain at the upper left moves downward toward the shadowy figure of the drinking peasant at the lower right, as if to say that he is still in spiritual darkness. But because Francis is also on this diagonal line, the way to enlightenment is suggested.

Perhaps the most dramatic of the series is *St. Francis Renouncing His Father and Worldly Goods* (Fig. 8.11). In his haste to abandon the material world, Francis casts off his garments and stands naked before the townspeople, saying to his father, "Until this hour I have called thee my father upon earth; from henceforth, I may say confidently, my Father who art in Heaven, in whose

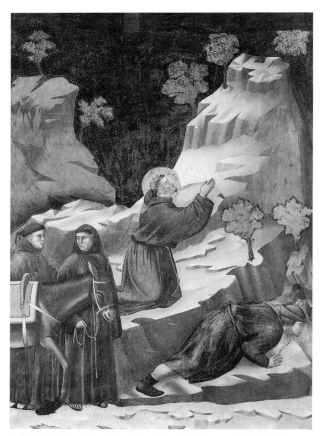

8.10 Giotto (?). *Miracle of the Spring*, c. 1296–1300. Fresco. Upper Church of St. Francis, Assisi, Italy.

hands I have laid up all my treasure, all my trust, and all my hope." The bishop covers Francis with his own cloak and receives him into the church.

The gestures and facial expressions of the various figures make this fresco a study of contrasting human attitudes. The angry father has to be physically restrained by a fellow townsman, yet his face shows the puzzled concern of a parent who cannot understand his son's actions. His counterpart on the other side is the bishop, who becomes the new father of the saint in the church. Disliking such a scene, his glance shows both embarrassment and sympathy. These opposing figures are supported respectively by the group of townspeople, behind whom is an apartment house, and by the clergymen, behind whom are church buildings. Giotto concocted a pictorial geometry to unify the picture and resolve the tension. The two opposing groups, symbolizing mate-

rial pursuits and spiritual aspirations, become the base of a triangle. Between them, the hand of Francis points upward toward the apex, where the hand of God emerges through the clouds.

On September 27, 1997, an earthquake shook the Basilica of St. Francis. Part of the vaulting collapsed, taking with it frescoes by Giotto or his assistants and students. It will take decades to restore the dust and fragments to an approximation of their original condition.

THE ARENA (OR SCROVEGNI) CHAPEL IN PADUA. Unlike the frescoes in the Basilica of St. Francis in Assisi, Giotto's work in Padua is well documented. Padua, a prosperous city-state in northeast Italy, had flourished since Roman times as an agricultural, banking, and commercial center. One measure of Padua's wealth is reflected in the chapel built by Enrico Scrovegni next to his palatial residence. Not since

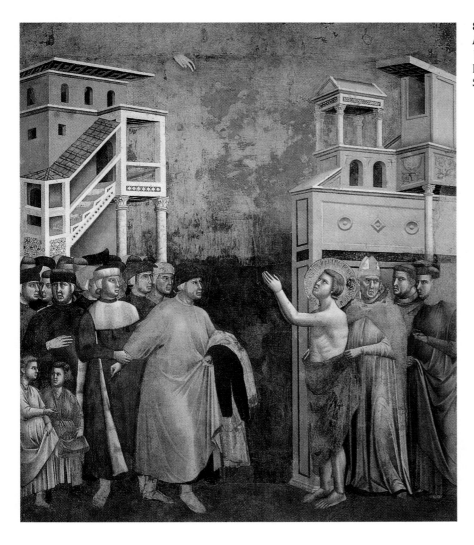

8.11 Giotto (?). *St. Francis Renouncing His Father and Worldly Goods*, c. 1296–1300. Fresco. Upper Church of St. Francis, Assisi, Italy.

Roman emperors paid for religious art out of their own pockets (assuming their togas had pockets) had a citizen lavished so much on a private place of worship. The church and the nobility were the usual patrons of art, followed by towns and cities.

Giotto and his patrons seem to have been fond of marvelous mountains, such as those that form the background of *Joachim Returning to the Sheepfold* (see Fig. 8.21), the *Flight into Egypt,* and the *Pietà* (Fig. 8.12). Structurally, the mountains advance and recede to form niches for the figures. Their hardness and heaviness complement the figures' compassion and expressiveness. The mountains and architectural backgrounds are not naturalistically correct; rather, they exist to form volumes and masses in Giotto's pictorial designs. Scattered trees, looking like bouquets of artichokes, serve mainly as spatial accents.

Giotto's spatial proportions are psychologically rather than actually correct. As they did in Byzantine representation, human beings loom large against their backgrounds, in keeping with their greater expressive importance. Splashed with light that seems more theatrical than natural, the principal figures in the *Pietà* fully occupy their foreground stagelike space. The deeply shadowed folds

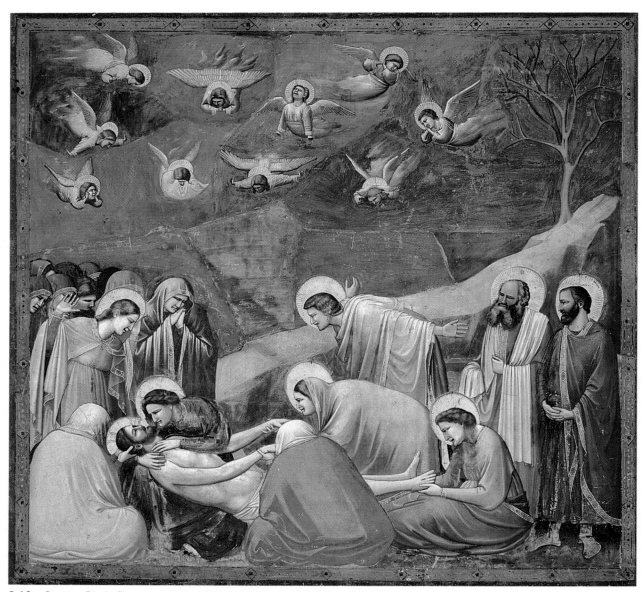

8.12 Giotto. *Pietà (Lamentation),* 1305–1306. Fresco, 6′6¾″ × 6′6¾″. Arena Chapel, Padua, Italy.

of their garments not only model their bodies but also enhance the grief that creases their faces. By contrast, the ashen figure of the dead Christ is limp. In the sky, a company of angels weep. More miserable than the rest, the central angel, dressed in white, strains upward, as if calling on God to reverse the dreadful scene below.

SCULPTURES OF NICOLA AND GIOVANNI PISANO

At the cathedral complex in Pisa, two outstanding sculptors carved impressive pulpits. That of the father, Nicola Pisano, stands in the baptistry, whereas a generation later, that of his son Giovanni graces the nave of the cathedral. The panels of both depict scenes from the New Testament. Contrasting the work of the father with that of the son reveals both the enduring influence of classical sculpture in Italian art and the adaptation of late Gothic aesthetic qualities.

Nicola's panel of the *Annunciation and Nativity* (Fig. 8.13) clearly draws on the classical relief sculpture that he knew so well from his formative years spent near Rome (see Figs. 4.3, 4.4, 4.11, and 4.12). The Virgin, wearing Roman dress and coifed in a Roman hairdo, appears as a dignified Roman matron. In the upper left, Gabriel, the angel of the Annunciation, is posed against a classical temple and dressed in a Roman toga, as are many of the figures. To tell the story of the Annunciation, the Nativity, and the Adoration of the Shepherds, Nicola uses the simultaneous mode of narration. The Virgin makes appearances in the Annunciation scene in the upper left; in the Adoration of the Shepherds (damaged) in the upper right; and in the central scene, which shows the Christ child being washed. The relief as a whole projects a mood of monumental calm. It is interesting to note that Nicola, who designed the pulpit, also signed and dated his work.

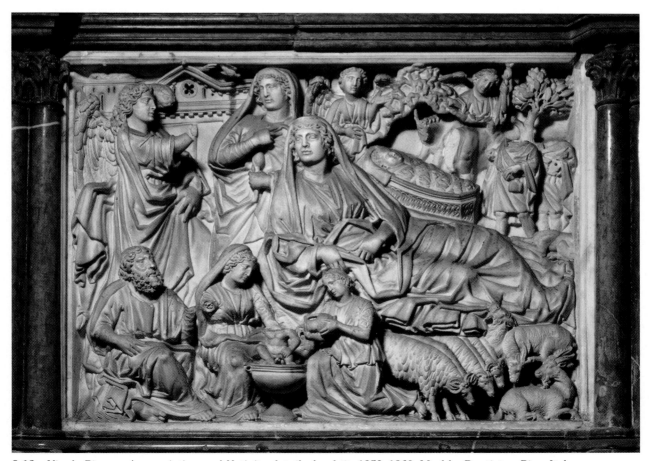

8.13 Nicola Pisano. *Annunciation and Nativity,* detail of pulpit, 1259–1260. Marble. Baptistry, Pisa, Italy.

The work of Nicola's son, Giovanni, seen in his *Nativity and Annunciation of the Shepherds* (Fig. 8.14), moved away from his father's classicism into the late French Gothic style. His figures are slim and smaller in scale. They fit more naturally into their surrounding space. Greater animation and agitation of line replace the serene repose of the father's style. The virgin's slender form, her youthful, smiling face, and the muted S-curve of her reclining body show late Gothic influences. Nevertheless, the panels by both father and son display a sense of human warmth and response and closely resemble the spirit of Giotto's frescoes.

PATRONAGE AND PAINTING IN THIRTEENTH-CENTURY ITALY

Two rival cultural centers, Florence and Siena, both enjoyed prosperity in the thirteenth century. Florence was a stronghold where power was held by rich merchants and craftsman guilds. In Siena, by contrast, most of the wealth and patronage was in the hands of the aristocracy, who owned the fertile countryside. The openness of Florentine leaders to change and innovation—the result, perhaps, of the flexibility required of traders and bankers—promoted a similar outlook among artists who worked in Florence. Siena, however, remained a bastion of tradition. Two worlds, the realm of agriculture plus the land-based wealth of the aristocracy and the church, alternately collaborated with and opposed the realm of the city, whose wealth was based on commerce.

Cimabue, the leading Florentine artist of the late thirteenth century, was succeeded by the formidable figure of Giotto, whose painting points clearly to the coming Renaissance. In Siena, the great Duccio was followed by Simone Martini and the Lorenzetti brothers, who continued in the more conservative Byzantine tradition that had been introduced into Italy many centuries earlier via such cultural centers as Ravenna and Venice. Despite its ongoing respect for tradition, the Sienese school was able to combine the old medieval and late Gothic styles in a final flowering of Italo-Byzantine painting.

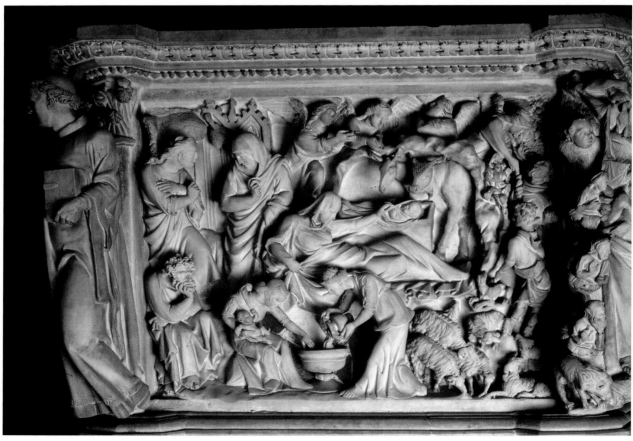

8.14 Giovanni Pisano. *Nativity and Annunciation of the Shepherds,* detail of pulpit, 1302–1310. Marble. Cathedral, Pisa, Italy.

Four altarpieces for Florentine churches—similar in purpose, theme, and form but different in style—illustrate these integrations. Cimabue's *Madonna Enthroned with Saints and Prophets* (Fig. 8.15), designed for the high altar of Santa Trinità in Florence, demonstrates that in addition to classical influences, Byzantine aesthetics persisted in Italy. The predominant use of gold recalls the mosaics of Ravenna (see Figs. 5.15 and 5.16). The Byzantine heritage is also apparent in the Madonna's frontal pose and the linear quality achieved by the use of gold streaks to emphasize the folds of her garment and that of the infant. The Christ child conforms to the theological image of the miniature patriarch born knowing all things. At the same time, Gothic verticality governs the two-story composition, with four solemn prophets be-low displaying their scrolls and the ascending ranks of eight angels above. Cimabue also suggests recessive space in the shadowing of Mary's wooden throne, which is painted to look as if it were inlaid with gems.

Duccio, the great Sienese master, painted the so-called Rucellai Madonna (Fig. 8.16) for the Florentine church of Santa Maria Novella in a lighter, more buoyant, and decorative vein. Although Duccio undoubtedly knew Cimabue's monumental style, his kneeling angels are airier, as if they were gently settling down after a heavenly flight. In this picture the grace and elegance characteristic of the courtly late Gothic style merge with Byzantine elements. The deeply folded, heavy textile backdrop may allude to the wool industry of Florence. The undulating edges of the Madonna's robe; the slightly off-center angle of the throne; and the gauzy transparency of the Child's mantle, which has casually slipped down, all produce a late Gothic linear delicacy.

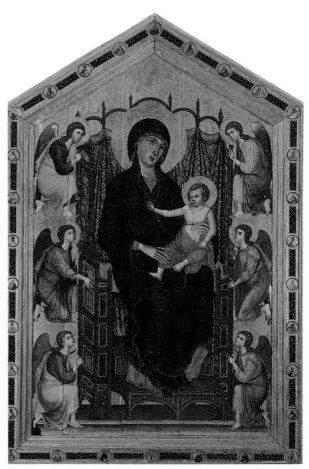

8.15 Cimabue. *Madonna Enthroned with Saints and Prophets*, c. 1280–1290. Tempera on wood, 12′7″ × 7′4″. Galleria degli Uffizi, Florence, Italy.

8.16 Duccio. *"Rucellai" Madonna,* 1285. Tempera on wood, 14′9″ × 9′6″. Galleria degli Uffizi, Florence, Italy.

Duccio's student Simone Martini fused the Byzantine and the Gothic in his elegant *Annunciation* (Fig. 8.17). The slim, flat, pointed arches and miniature spires are as elegant as they are far removed from the rugged, soaring sense of earlier northern forms. The regal Madonna is draped in a French-style blue gown, rendered in pigment made from powdered lapis lazuli. Disturbed in her reading by the sudden appearance of the Archangel Gabriel, his robes and wings aflutter, the startled Virgin recoils in fear and astonishment as she hears the words that appear in relief: "Hail Mary . . . the Lord is with thee." The composition is a masterly combination of vivid colors and curvilinear design, as revealed in the folds and swirls of the costumes, the angel's transparent wings, and the vase of curving white lilies that symbolize Mary's purity.

The fresh direction that the early Renaissance would take is foreshadowed in Giotto's *Madonna Enthroned* (Fig. 8.18), which was painted for the Church of Ognissanti about 20 years after the work of Cimabue and Duccio. The gold background and pointed arches of the roofed throne occupied by the Madonna harken back to the Byzantine and the Gothic. At the same time, Giotto fashioned a forward-looking illusion of depth. The two kneeling angels in the foreground serve a function similar to that of the bulky robed figures in the immediate foreground of his *Pietà* (Fig. 8.12). Their rounded shapes appear three-dimensional, and they seem to "push" the main subject backward into space. The angels of the heavenly choir are placed one in front of the other to create a sense of space expanding into the distance. Similarly, two of the six somber saints in the background are visible

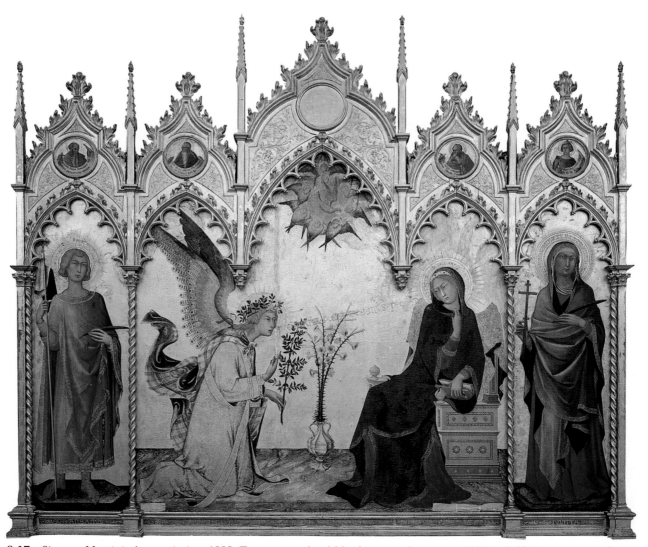

8.17 Simone Martini. *Annunciation*, 1333. Tempera and gold leaf on wood, approx. 10′1″ × 8′8¾″ (center panel). Galleria degli Uffizi, Florence, Italy.

through the arches of the Madonna's throne. The Madonna is not aloof but meets the gaze of her beholders. Her figure is heavier than a Byzantine figure would be, and her breasts are prominent, because the Madonna's robe is modeled in light and shadow to delineate the flesh beneath. In addition, the Child is in a more natural posture.

LATE MEDIEVAL MUSIC AND LITERATURE

The contrast between the gloomy, threatening medieval worldview, evident in the tympanum at the Cathedral of Autun (see Fig. 6.1), and the joyful Franciscan spirit is illustrated by two thirteenth-century songs. The *Dies irae,* which reflects the prevailing medieval spirit, is traditionally attributed to the great Latin stylist Thomas of Celano, who may have written it a few years before he met St. Francis and became one of his friars. Thomas entered the

Franciscan order about 1215 and enjoyed the friendship of St. Francis for several years. Pope Gregory IX chose him to write the official biography of Francis shortly after he was declared a saint in 1228. The second song, the *Canticle of the Sun,* is by St. Francis himself.

THE *DIES IRAE*

In the triple stanzas and fifty-seven lines of the *Dies irae,* the medieval Latin poetic style reaches a high point. Its content invokes the vision of the final dissolution of the universe, the sounding of angelic trumpets calling forth the dead from their tombs, and the overwhelming majesty of the coming of Christ as king to judge the living and the dead. The grandeur of its language and the perfection of its poetic form are equal to this solemn theme. The images and moods range from anger and terror to hope and bliss before coming to a close with a plea for eternal rest. A sense of its vivid verses can be gained from the following stanzas:

> Day of Wrath! O day of mourning!
> See fulfilled the prophets' warning,
> Heaven and earth in ashes burning!
> Wondrous sound the trumpet flings;
> Through earth's sepulchres it rings;
> All before the Throne it brings.
> Guilty, now I pour my moaning,
> All my shame with anguish owning;
> Spare, O God, Thy suppliant groaning!
> While the wicked are confounded,
> Doomed to flames of woe unbounded,
> Call me, with Thy saints surrounded.

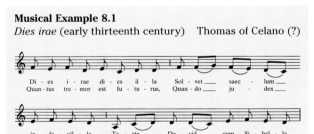

Musical Example 8.1
Dies irae (early thirteenth century) Thomas of Celano (?)

Although the colorful language and verbal rhythms of the Latin original have a music all their own, the *Dies irae* is inseparable from its melodic setting. Both the poem and its melody found their way into the liturgy as important parts of the mass for the dead. Later this melody was to become famous as a symbol of medieval hellfire in the nineteenth-century Romantic Movement (see p. 495–497).

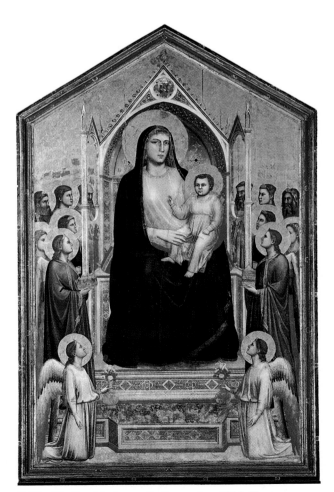

8.18 Giotto. *Madonna Enthroned,* c. 1310. Tempera on wood, 10′8″ × 6′8″. Galleria degli Uffizi, Florence, Italy.

LAUDS AND THE *CANTICLE OF THE SUN*

The most characteristic Franciscan contribution to poetry and music is found in a body of informal hymns called **laudi spirituali**—songs of praise, or simply "lauds"—that are traceable directly to St. Francis and his immediate circle. The practice of spontaneous hymn singing continued from his time onward, and in the fourteenth century, it was firmly established as the most popular form of religious music.

In music, as in his religious work, Francis drew together the sacred, courtly, and popular traditions. The lauds thus were a poetic bridge between the traditional music of the church, the music of the castle, and the music of the streets. The words always had a religious theme. Often they were mere variations of psalms and prayers sung to popular tunes. Above all, they were music and poetry that the people could both sing and feel with their hearts.

Contrapuntal choral music, whether in the form of a church motet or a secular **madrigal,** was a sophisticated musical medium that required the voices of skilled professionals. By contrast, the lauds were folklike in spirit, were simple and direct in their appeal, and were sung either as solos or with others in unison. Just as the skilled monastic choir was characteristic of the Cluniac movement and the contrapuntal chorus the musical counterpart of the northern Gothic spirit, the lauds became the characteristic expression of the Franciscans.

The Canticle of the Sun by St. Francis is at once the most sublime of all the lauds and the most original. Legend has it that when St. Francis was recovering from an illness in a hut outside the convent of St. Clare, the nuns heard from his lips this rapturous new song. The informality, even casualness, of its composition and its rambling rhythms and rhymes make it as simple and unaffected as the dialect of Umbria (the region of central Italy, including Assisi) in which it is written. Sincerity and deep feeling dominate the unequal stanzas of St. Francis's songs of praise, rather than any attempt at learned communication or poetic elegance. It goes, in part:

> Praised be my Lord God with all his creatures, and especially our brother the sun, who brings us the day and who brings us the light; fair is he and shines with very great splendor; O Lord, he signifies to us Thee!
> Praised be my Lord for our sister the moon, and for the stars, the which He has set clear and lovely in heaven.

> Praised be my Lord for our sister water, who is very serviceable unto us and humble and precious and clean.
> Praised be my Lord for our brother fire, through whom thou givest us light in the darkness; and he is bright and pleasant and very mighty and strong.

Although the original melody of the *Canticle of the Sun* is lost, countless lauds survive, some dating back to shortly after St. Francis's time. Jacopone da Todi, a Franciscan monk who died in 1306, was one of the greatest writers of lauds. His most famous hymn is the *Stabat Mater Dolorosa,* which was officially incorporated into the liturgy in the eighteenth century to be sung on the Feast of Seven Sorrows. This remarkable man, like St. Francis before him, was of Umbrian origin, and after a succession of such diverse careers as lawyer, hermit, and Franciscan preacher, he became a poet and composer. His hymns readily found their way into the texts of the early miracle plays, which dramatized episodes in the life of a miracle-working saint or martyr, and his music became the foundation of the laudistic tradition. The following example is a part of one of his lauds. Its rhythmic complexity, emotional intensity, and stylistic character mark it as typical of the early Franciscan movement.

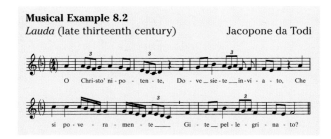

Musical Example 8.2
Lauda (late thirteenth century) Jacopone da Todi

O Chri-sto' ni - po - ten - te, Do - ve_sie-te__in-vi - a - to, Che si po - ve - ra - men - te____ Gi - te_pel - le - gri - na - to?

DANTE'S *DIVINE COMEDY*

At the summit of the Middle Ages, Dante Alighieri composed the soaring verses of his *Divine Comedy.* This *summa* of diverse philosophical, theological, and political worldviews became at once a great human document, the outstanding book of the medieval period, and a prophecy of the Renaissance. In one stroke, Dante established the Italian spoken by the common people as an expressive language and gave his country its most enduring literary masterpiece. The work is not only a synthesis of scholastic and Franciscan philosophy but also a summation of the thought of the medieval period and of Greco-Roman antiquity as its author knew it. Classical figures such as Aristotle, Cicero, Ovid,

and Virgil rub shoulders with Boethius, Thomas Aquinas, St. Francis, and Giotto himself, who in turn portrayed Dante in a *Paradiso* of his own, painted in the Chapel of Palazzo del Podèsta in the Bargello at Florence (Fig. 8.19).

Although the poem is elaborately allegorical, full of symbolism, and meant to be read on more than one level, the reader should not be intimidated. Dante tells a broad, compelling story, as well as stories within stories. Allegory, after all, interprets experience by means of visual and verbal images and symbols. Symbols are just generally agreed-on signs that stand for something else, as $ stands for "dollar."

The form of the poem is divided into a three-part structure—Hell, Purgatory, and Heaven—and one of its building blocks is the medieval mystical number 3: Each stanza has three lines, and the rhyming scheme is the melodious *terza rima*: aba, bcb, and so on. In turn, Dante is terrified by three animals personifying the three sins he must overcome to progress upward. Each time, he is saved by the mediation of three holy women. To enter the three realms, he must pass through three gates. Each section contains thirty-three cantos, the number of Christ's years on Earth. The introductory canto, added to the 3 times 33 others, brings the total to an even 100—that number having the quality of wholeness and perfection. Nine as the multiple of three also plays its part. Hell and Purgatory each have nine circles while in Paradise there are nine categories of angels in their nine different spheres.

The allegorical journey through these vast spaces symbolizes the soul in its quest for self-knowledge and spiritual illumination. The path, which passes from Hell to Heaven, also runs the gamut from despair to hope, sin to grace, hate to love, ignorance to enlightenment. Dante's vision is concerned not only with life after death but with the course of human life from birth in original sin, through the purgative process of experience, to the knowledge of ideal goodness, truth, and beauty. As Dante says in the opening lines, "Midway in our life's journey, I went astray from the straight road and woke to find myself alone in a dark wood."

From this dark and sunless forest, he plunges into the depths of the Inferno, where he encounters the fearsome inscription, "Abandon All Hope Ye Who Enter Here":

Here sighs and cries and wails coiled and
 recoiled
on the starless air, spilling my soul to
 tears.
A confusion of tongues and monstrous accents
 toiled.

In the lowest pit of Hell he encounters the monstrous body of Lucifer, who, as his name implies, is the fallen angel of light now dwelling in eternal darkness. From this point onward, Dante begins the ascent from darkness to light.

The next state is Purgatory, where light begins to dawn:

Now shall I sing of that second kingdom given
the soul of man wherein to purge its guilt
and so grow worthy to ascend to Heaven.

Here he glimpses the pure radiance of the eastern star while encountering a strange spirit, who asks:

Who led you? or what served you as a light
in your dark flight from the eternal valley,
which lies forever blind in darkest night?

Up to this point, Dante has been guided by the Roman poet Virgil, who must now leave him because only Christians may enter the sacred precincts of Paradise. From here onward, his guide will be Beatrice, his lifelong love, inspiration, and spiritual ideal. In real life, Dante met Beatrice only a few times, but in the poem, she becomes the "blessed and glorious Beatrice," the personification of divine grace.

8.19 Giotto (?). *Portrait of Dante,* detail of fresco, c. 1325. Chapel of Palazzo del Podèsta, Bargello, Florence, Italy.

Dante then climbs the mount of Purgatory, where sunrise and sunset are transitory phases before progression into the ultimate realm, the presence of God, where sunlight never fades.

> The glory of Him who moves all things rays
> forth
> through all the universe, and is reflected
> from each thing in proportion to its worth.
> I have been in that Heaven of His most light,
> and what I saw, those who descend from there
> lack both the knowledge and the power to write.

Not only was Dante a gifted writer, but he also had a musician's ear for sound. His verses have a music of their own. He also had a painter's eye for detail. His images are a feast for the inner eye of the imagination. Although spiritual light concerned him most, he nonetheless conjured up its vision in familiar everyday impressions. He sings of sunlight, firelight, starlight; the sparkle of precious stones; the gleaming rays of a lamp in the darkness; the translucent effects of light filtered through water, wine, glass, and jewels; rainbows and the colored reflections from clouds; the ruddy glow of infernal flames and the pure radiance of Paradise; the light of the human eye and that of halos surrounding the heads of saints. As a result,

light becomes the divine spark that leads from reason to revelation. Finally, each of the three cantos of the poem ends on the word *stelle* (stars). The last words of the Paradise mirror the ultimate, ineffable vision of divinity as "[t]he love that moves the sun and other stars."

THE BLACK DEATH AND ITS IMPACT

All went well in Italy during the first third of the fourteenth century. Townspeople prospered, and the arts flourished. Beginning in 1340, however, a series of disasters occurred, starting with local crop failures and continuing with the miseries of famine and disease. The climax came in an outbreak of plague in France and Italy during the catastrophic year 1348. The so-called Black Death killed more than half the population of such cities as Florence, Siena, and Pisa. A chronicler of Siena, after burying five of his children, said quite simply, "No one wept for the dead, because everyone expected death himself." In due course, the plague swept through Germany, middle Europe, Scandinavia, and Britain. It recurred throughout Europe for almost 30 years.

An event so calamitous was bound to have a deep effect on social and cultural trends. Many survivors found themselves suddenly made poor or, through unexpected inheritances, vastly enriched. Eventually, thousands of residents in the relatively safe countryside flocked into the cities to take the places of those who had died. The lives of individuals underwent radical changes. For some, it was the "eat, drink, and be merry" philosophy, exemplified in Boccaccio's *Decameron;* for others, it was moral self-accusation and repentance, as seen in the purgatorial vision of the same author's later *Corbaccio.*

Driven by fear and a sense of guilt, people felt that something had gone disastrously wrong and that the Black Death, like the biblical plagues of old, must have been sent by an angry God to chastise humanity and turn people from their wicked ways. In the literary world, both Boccaccio and Petrarch adopted this view after having penned earlier, more worldly writings. What was true of literature was true also of painting.

REACTION TO THE PLAGUE

The response to the plague may have been illustrated in one of the frescoes on the inner wall of the Camposanto in the Pisa Cathedral group. *The Triumph of Death* (Fig. 8.20), whose post-1348 date has been disputed, is nonetheless an epic statement with much detail crowded into every bit of space. Like the sermons of the time, some parts warned of the closeness of death and the terrors of hell if the soul was claimed by the devil. Others showed the bliss of being carried off by angels.

On the left, a group of mounted nobles sets out for the hunt, but instead of the game they were pursuing, they find only death. Inside three open coffins, serpents consume the corpses of the onetime great of the Earth. In a poem also titled "Triumph of Death," the contemporary poet Petrarch speaks of death as the great leveler when he notes that neither "the Popes, Emperors, nor Kings, no enseigns wore of their past hight but naked show'd and poor," and then asks, "Where be their riches, where their precious gems? Their miters, scepters, robes and diadems?"

Near the coffins a bearded hermit monk unfolds a prophetic scroll that warns them to repent before it is too late. The only relief from the scene of horror and desolation is found in the upper left, where some monks are gathered around a chapel, busying themselves with their duties. Apparently only those who renounce the world can find relief from its general turmoil and terror of death. The

8.20 Master of the Triumph of Death. *The Triumph of Death*, c. mid-1330s (partially destroyed, 1944). Fresco. Campo Santo, Pisa, Italy.

sheer horror and desolation of this scene harken back to the carved Last Judgments in earlier medieval churches.

The long-lasting psychological effects of the plague were not illustrated as clearly as the physical effects of the disease. Nevertheless, the plague ravaged worldviews as well as villages. The medieval ideal of a neatly stacked social order was challenged as it became increasingly apparent that neither the rich, the royal, nor the wealthy could stand against the catastrophe. Fear replaced fealty, doubt challenged faith, and civil unrest pitted region against region and class against class.

IDEAS

The late medieval period had one foot planted in the Middle Ages and the other in the emerging Renaissance. These opposing worldviews were reflected in a number of situations, especially the power struggle between the landed aristocracy and the growing cities; the incompatibility of Gothic architecture and the Classical/Byzantine heritage in Italy; the presence of medieval devils and genuine human types in Giotto's frescoes; the opposing visions of the Inferno and Paradise in Dante's *Divine Comedy;* and the different attitudes expressed in poetry and painting before and after the Black Death.

The tug-of-war between and among differing ideas found expression in the life of St. Francis, whose otherworldly self-denial contrasted with his worldly love of natural beauty. For him, fire was created not to roast the souls of sinners in hell but to offer light in darkness and warmth on a cold night.

The Romanesque St. Peter Damian had said, "The world is so filthy with vices, the holy mind is befouled by even thinking of it." In contrast, the Gothic encyclopedist Vincent of Beauvais exclaimed, "How great is even the humblest beauty of this world!" In his *Canticle of the Sun,* St. Francis found evidence of God's goodness everywhere—in the radiance of the sun, in the eternal miracle of springtime. He saw all nature as a revelation of divinity, and his thought foreshadowed a departure from the medieval dualism that opposed the flesh and the spirit. After a lifetime of self-denial and self-inflicted pain, St. Francis humbly begged pardon of the body for the suffering he had caused it to endure.

LATE MEDIEVAL NATURALISM

In both the north and south of Europe, the abstractions of the scholastic mind found a new challenge in the down-to-earth reasoning of philosophers who called themselves **nominalists.** Late scholasticism had, in fact, become a strained exercise in logical gymnastics. It disregarded the real world and the facts necessary to give substance to thought.

On their road to knowledge, the nominalists turned the scholastic ways upside down. They insisted that generalities must be built from the bottom up, first by gathering data and sorting out particular things and events, then by putting like with like. Only in this way, they said, was it possible to classify things and give a name to those that grouped together (hence the term *nominalists,* from the Latin word meaning "to name"). The question was whether to start with an assumption determined beforehand and then look for the supporting data, as the scholastic thinkers did, or to assemble the facts first. These two methods approximate the difference between deductive and inductive thought, the latter pointing toward the experimental method of modern science.

As it gained a foothold, the nominalist viewpoint weakened medieval authoritarianism, in which the word of Aristotle and the church fathers was accepted without question. Correspondingly, it initiated the modern practice of finding facts through firsthand observation. Particular things became more important than universal forms. For example, a plant was a vegetable or flower that grew in a garden rather than the manifestation of a universal idea of a plant existing in the mind of God.

The result of this new mental orientation was a renewed interest in a tangible reality that would have important consequences in art and scientific inquiry. In the fifteenth century it would lead to the representation of figures in natural surroundings, the rendering of the body with anatomical accuracy, the modeling of figures three-dimensionally by means of light and shadow, and the working out of laws of linear perspective for foreground and background effects.

While these systems of logic were being argued in the universities, the friars of St. Francis were bringing his message to town and country folk. With them, religious devotion became a voluntary, spontaneous relationship between human beings and God rather than an imposed obligation. Religion, they asserted, should be based on love rather than on fear. The Franciscans also sought to establish a common bond between individuals, whatever their station in life, thus implementing the golden rule, "Love thy neighbor as thyself." Franciscan ideas represent an important

shift from the vertical feudal organization of society, in which individuals were related to those above and below them by a hierarchical authority, to a horizontal or level ethical relationship that bound people to one another.

NOMINALISM AND THE ARTS

St. Francis saw evidence of God's love in everything, from the fruits and flowers of the Earth to the winds and the clouds in the sky, a concept that was to have great consequences for the arts. The birds to which St. Francis preached, for instance, were the birds that were heard chirping and singing every day, not the symbolic dove of the Holy Spirit or the apocalyptic eagle of St. John.

Although this tendency toward naturalism was already noticeable in the thirteenth-century sculpture of Chartres and elsewhere, it became widespread in the fourteenth century. As this view of the natural world gained ascendance over the supernatural, it released the visual arts from the perplexing problems of how to represent the unseen. The love of St. Francis for such simple things as grass and trees, which could be represented as they were observed in nature, opened up new subjects for artists to explore.

St. Francis's message was taught in parables and simple images of life that all could understand. Giotto succeeded in translating these into pictorial form. In this favorable naturalistic climate, both found a balance between the abstract and the concrete, between divine essence and human reality.

Giotto moved away from medieval mysticism. To him, the saints were not remote ethereal spirits but human beings who felt all the same emotions, from joy to despair, as the people in the Italian towns he knew so well. Even his contemporaries could see that Giotto was blazing new trails. Although Giotto undoubtedly showed a love of nature, he never accentuated it to the point where it might overshadow or weaken his primary human emphasis. His interest was less in nature for its own sake than in its meaning in the lives of his subjects.

In viewing a picture by Giotto, one does well to begin with the people and be concerned only secondarily with their natural surroundings. His subjects create their own environment through their expressive attitudes and dramatic placement. Although his work shows an increasing concern with problems of natural space, space is less important than his expressive intentions. His use of color and shading gives his figures a sense of depth and volume that brings them to life. In this way, both human nature and nature as such achieve an intimate and distinctive identity in Giotto's art.

FRANCISCAN HUMANITARIANISM

Long before the trend toward naturalism, the monastery at Cluny had changed the character of monasticism by uniting cloistered life with feudalism. The new orientation of the Franciscan order was no less revolutionary. St. Francis did not confine his monks in cloisters but sent them out into the world. The idea of evangelical poverty, humility, and love for humanity expressed through living and working with simple people resulted in a union with, rather than a withdrawal from, society. The Franciscans did not avoid the world as much as they avoided worldly pursuits. The Cluniacs were, in the proper sense of the word, an *order;* that is, their discipline required a strict hierarchical organization. By contrast, the Franciscans were, in every sense of the word, a *movement.*

The frigid intellectualism of the late medieval universities was bound to thaw in the warmth of Franciscan emotionalism and attention to nature. Also, self-denial held little appeal for an increasingly prosperous urban middle class. The mathematical elegance of Gothic structures began to yield to more informal types of buildings. The logical linear patterns of the surviving Byzantine pictorial style gave way to the physical fullness and emotional warmth of Giotto's figures. The stylized faces of Byzantine saints paled in the light of the human tenderness found in a smiling mouth or tearful eye in a Giotto picture. The formal architectural sculpture and abstract patterns of Gothic stained glass were replaced by the colorful informality of mural paintings in fresco. In his music, as in his religious work, St. Francis drew the sacred and popular traditions closer together, and in the lauds he encouraged people to sing. He gave people a music that they could feel in their hearts without having to understand it with their brains.

HUMANITARIANISM AND THE ARTS

When Dante declared that Giotto's fame outshone that of Cimabue and Boccaccio proclaimed that Giotto revived painting after it had "been in the grave" for centuries, they were recognizing in his art a new spirit and style. This new spirit was also apparent in Boccaccio's *Decameron,* which mocks

the manners and ways of Gothic knights, abbots, and monks and the outmoded feudal ideal to which they clung.

Likewise, new feeling was apparent in music. In France, Philippe de Vitry published a musical treatise in 1316 with the title *Ars Nova (New Art),* which he opposed to the *ars antiqua,* or "old art," of the Gothic thirteenth century. He ardently promoted the idea of bringing lively new dancelike rhythms into church music. His book gained such popularity that it attracted the anger of conservative church leaders in the form of a papal criticism issued by Pope John XXII in 1325.

A new spirit of freedom was in the air, a release from tradition. St. Francis had earlier struck out in a new religious direction, and Giotto, by translating the saint's life into pictures, avoided the traditional biblical subjects and their traditional stylized treatment. Giotto was working on an almost contemporary subject, as well as rendering it in a new manner. In addition, he painted subjects that came within the iconographic tradition, such as *Joachim Returning to the Sheepfold* (Fig. 8.21) and the *Pietà* (Fig. 8.11), far more dramatically than others. In general, his figures moved about in the space he created for them with greater suppleness than those in earlier pictures. His world was marked by a new, emotional relationship between human beings, their natural environment, and God.

Portrayals of Christ as a human infant in the arms of his mother began to replace the image of Christ in majesty from the Gothic period. Along with growing interest in the cycle of Christ's infancy, legends of Mary's life became increasingly prominent. The emotional element in the Passion was largely conveyed through compassion for the Virgin as the mother of sorrows. This was as true for Giotto's cycle in Padua, as for Jacopone da Todi's *Stabat Mater Dolorosa.*

The adoption of the language of ordinary people in literature, the informal treatment of fresco painting, and the folk spirit in music all make it apparent that works of art were being addressed to a new group of patrons. Furthermore, one of Giotto's statements reveals the artist's new conception of himself. Each man, he said, "should save his soul as best he can. As for me, I intend to serve painting in my own way and only so far as it serves me, for the sake of the

8.21 Giotto. *Joachim Returning to the Sheepfold,* 1305–1306. Fresco. Arena Chapel, Padua, Italy.

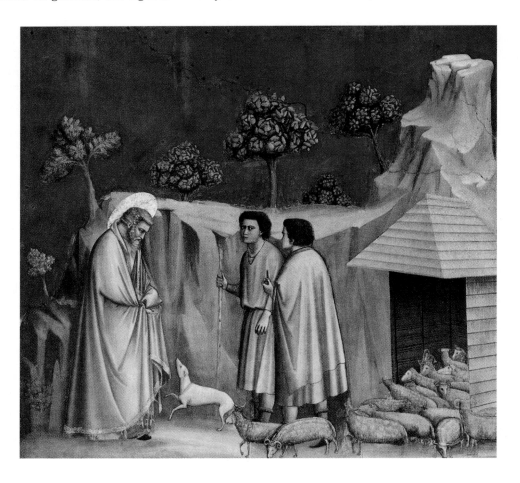

lovely moments it gives at the price of an agreeable fatigue." Because it claimed so many lives, even the horrific Black Death had some beneficial effects for artists after Giotto's time. It decreased authority in many realms, including the conservative guilds, and thereby allowed the younger masters to assert their independence and develop new ideas and techniques.

THE SURVIVAL OF CLASSICISM

A renewed interest in classical antiquity began to be seen, heard, and read in the works of the artists and writers of the fourteenth century. The panels of Nicola Pisano's pulpit show the classical Roman influence of sarcophagi and narrative reliefs such as Trajan's Column (see Fig. 4.11). However, what seems to be a revival of Roman classical forms is also a survival of those forms. Nicola Pisano's sculpture certainly seems to be closer to the art of ancient Rome than to the Gothic. Because Roman sculpture was present everywhere in Italy, no Italian sculptor could avoid seeing it. Likewise, because Dante was writing an epic poem, his obvious model was Virgil's *Aeneid,* which had never ceased to be read.

Although a growing consciousness of the classical in the works of Dante and his contemporaries should not be overlooked, it must be seen from the fourteenth-century point of view—as a continuation of a cultural tradition rather than as a sudden rebirth of classicism. The influence of the classical authors and classical art was not as neglected or dead as many historians have supposed. Virgil, Cicero, and certain works of Aristotle were as widely read and written about in medieval times as they were in the fourteenth and fifteenth centuries.

This is not to deny that a new spirit of curiosity enlivened the search, begun by Petrarch and Boccaccio, in monastic libraries for manuscripts by other Greek and Roman authors besides those who bore the sacred approval of church tradition. This probing went hand in hand with the discovery in Rome of some long-buried antique sculpture and with the study of Roman building methods.

Even though Petrarch was crowned in Rome with the laurel wreath, the ancient token of immortal fame, and even though he wrote his cycle of *Triumphs* with the Roman triumphal arch in mind, it is doubtful that he or Dante or Boccaccio did more than bring the ancient world a little closer to their own time. Even though Giotto spent some time in Rome, the joyous humanistic spirit that permeates his work is much closer

to the new Franciscan outlook and the continuous tradition of Roman relief sculpture and fresco painting than to any conscious reappraisal of classical culture as such. It is necessary, then, to dissociate fourteenth-century Franciscan humanitarianism from the more self-conscious, text-based revival of Greco-Roman antiquity that would characterize developments in fifteenth-century Florentine and early sixteenth-century Roman humanism.

Especially in the late fourteenth century, the weakness of classicism allowed new perceptions to take hold. For example, Boccaccio was among the first modern writers to recognize and describe the feats of accomplished women in history. His popular *Of Famous Women* (1362), inspired by Petrarch's *Lives of Famous Men,* told the stories of 106 women. Moreover, he deliberately addressed the book to female readers. Some versions of the work contained illustrations of legendary and historical figures, such as Marcia, who was, according to tradition, a painter and a Roman Vestal Virgin (Fig. 8.22). Interestingly, the illustrator chose

8.22 Giovanni Boccaccio. *Marcia.* Illustration for *Of Famous Women.* Ms. 33; folio 37v, France, c. 1470. The New York Public Library, New York.

8.23 *Christine de Pisan Writing in Her Study,* frontispiece to her *Livre de la Mutacion de Fortune,* early fifteenth century. Harl. 4431; folio 4 Min, France. British Library, London, England.

to depict her not in classical garments but in early fifteenth-century dress. In France, Christine de Pisan, daughter of an Italian doctor, wrote the *Book of the City of Ladies* (1405) (Fig. 8.23). The book not only celebrated talented women but also argued for the equal education of women and men. It imagined an ideal place, the city of women, where women lived their lives fully.

Of course, these texts did not instantly reverse existing assumptions about gender, but they did broadcast intriguing, fresh ideas before the revival of classicism in the Renaissance brought with it a heritage that intensified gender roles and differences. When Renaissance intellectuals examined the Roman historian Plutarch's book, *Lives of Virtuous Women,* and found classical authority for the notion that women could work in traditionally male professions without losing their femininity, they did so with recent precedents in mind. Like so many other Gothic challenges to received ideas and established authority, feminism was a product of the progressive towns, and like these challenges, it was a phenomenon that would not go away.

YOUR RESOURCES

- **Exploring Humanities CD-ROM**

 ○ Readings—*The Decameron,* Introduction; *The Divine Comedy: Inferno,* Cantos 1–5, *Paradiso,* Canto 33

- **Web Site**

 http://art.wadsworth.com/fleming10

 ○ Chapter 8 Quiz

 ○ Links

- **Audio CD**

 ○ *Dies irae*

LATE MEDIEVAL PERIOD

Key Events	Architecture	Visual Arts	Literature and Music
c. 1140 **War begins** between the Guelphs (supporters of papal sovereignty) and Ghibellines (supporters of the German emperor); at root was a struggle between the newly minted middle class and aristocratic power	1174–1184 **Canterbury Cathedral choir** built by William of Sens		1170–1220 **Wolfram von Eschenbach** ❏, poet, Minnesinger
1182–1226 **St. Francis of Assisi;** 1210 founded Franciscan order, 1223 confirmed by pope, 1228 declared saint			c. 1200 **Walther von der Vogelweide** ❏, poet, Minnesinger
1198–1216 **Innocent III,** pope; church reached pinnacle of power			

1200

			1203 **Wolfram von Echenbach** wrote *Parzifal*
	1220–1258 **Salisbury Cathedral** built	c. 1220–1284 **Nicola** (d'Apulia) **Pisano** ●	c. 1214–1294 **Roger Bacon** ○, Franciscan monk and scientist
	1228–1253 **Basilica of St. Francis** built at Assisi	1230–1240 **Bamberg Rider** carved	c. 1225–1274 **Thomas Aquinas** ○, scholastic philosopher
	1248 **Cologne Cathedral** begun, finished in nineteenth century	1240–c. 1302 **Giovanni Cimabue** ▲	1225 **St. Francis** wrote *Canticle of the Sun*
		1250–1260 **Ekkehard** and **Uta** carved at Naumburg Cathedral	1229 **Thomas of Celano** wrote *Life of St. Francis*
	1278–1283 **Campo Santo** at Pisa built by Giovanni di Simone	c. 1250–c. 1317 **Giovanni Pisano** ●	1262 **St. Bonaventura** wrote *Life of St. Francis*
		c. 1255–1319 **Duccio di Buoninsegna** ▲	1265–1321 **Dante Alighieri** ◆
		c. 1260 **Pulpit in Pisa Baptistry** carved by Nicola Pisano	c. 1285–c. 1349 **William of Occam** ○, Franciscan monk and nominalist philosopher
		c. 1266–1337 **Giotto di Bondone** ▲	1291–1361 **Philippe de Vitry** ❏
		c. 1285–1344 **Simone Martini** ▲	
		c. 1290–c. 1349 **Andrea Pisano** ●	
		c. 1296 **Frescoes on life of St. Francis** painted at Assisi	

1300

1309–1376 **Popes** in residence at Avignon		c. 1305–1309 **Giotto** painted frescoes on life of Virgin at Padua	1304–1374 **Petrarch** (Francesco Petrarca) ◆
		1305–1348 **Pietro Lorenzetti** ▲ active	1306 **Jacopone da Todi** ❏ died
		1308–1311 **Duccio** painted Maestà altarpiece, Siena Cathedral	1313–1375 **Giovanni Boccaccio** ◆
		c. 1320 **Giotto** painted Bardi Chapel frescoes in Santa Croce, Florence	1314–1321 **Dante** wrote *Divine Comedy*
		1321–1363 **Francesco Traini** ▲ active	1316 *Ars Nova,* treatise on new music written by Philippe de Vitry
		1317–1348 **Ambrogio Lorenzetti** ▲ active	c. 1325–1397 **Francesco Landini** ❏, organist-composer at Florence
		1330–1336 **Bronze doors of Florence Baptistry** cast by Andrea Pisano	1332 *Little Flowers of St. Francis* compiled
		c. 1334 **Andrea Pisano and Giotto** collaborated on sculpture for Florence Cathedral	c. 1340–1400 **Geoffrey Chaucer** ◆
1348 **Black Death** swept Europe	c. 1350 **Haddon Hall** built	c. 1350 **Triumph of Death** painted in Campo Santo, Pisa, by Traini	1341 **Petrarch** crowned poet laureate in Rome
			1348–1353 **Decameron** written by Boccaccio
			c. 1354 *Triumph of Death* written by Petrarch
1378–1417 **Great Schism** between rival popes	1377 **Ulm Cathedral** begun		1364–c. 1430 **Christine de Pisan** ◆, French writer who promoted women's participation in the arts.

❏ - Musician ▲ - Painter ○ - Philosopher ● - Sculptor ◆ - Writer

1200

Franciscan Order founded, 1209
Dante, 1265–1321, *The Divine Comedy*

1300

Black Death, 1348–mid-1350s
Hundred Years' War, 1337–1453

1400

Columbus arrives in West Indies, 1492
Invention of movable metal type by Johann Gutenberg, c. 1445
Conquest of Constantinople by Turks, 1453
Medici expelled from Florence, 1494

1500

Protestant Reformation begins, 1517
Council of Trent, 1545–1563

RENAISSANCE AND REFORMATION

The Renaissance was a period of commercial and cultural exploration and expansion that took many new directions: the advancement of humanistic and scientific knowledge, the discovery of new worlds by navigating the globe, the continued growth of towns and cities, increasing wealth in the hands of the merchant class, the development of national states, and an unparalleled outburst of productivity in the arts.

During the Renaissance, humanistic scholars thought of themselves as participating in a vast intellectual awakening, following a long medieval period of darkness. They searched the monasteries for neglected volumes and freed themselves intellectually to study the Greco-Roman classics without the pretext of looking only for Christian values. After the fall of Constantinople, many Greek scholars found refuge in Italy, bringing with them their learning and ancient manuscripts. The humanists rediscovered the beauties of life in the here and now, rather than in the hereafter. Their outlook changed to a more human-centered one, reaffirming the ancient belief that "nothing is more wonderful than man." In the midfifteenth century, the invention of printing made books more readily available, aiding in the spread of knowledge. Merchants and bankers rapidly increased the numbers of middle-class people, whose wealth and influence was self-made, and books enlarged the ranks of people who had access to the power of learning. In the 50 years after Gutenberg first published his Bible in 1456, more books were printed than had been copied by hand in the previous 1,000 years.

More broadly, humanism promoted a revival of interest in the affairs of the everyday world, reasserted people's faith in themselves, and reinforced the role of individuals in all spheres. Writers, dramatists, visual artists, and musicians flourished. Architects were inspired by the geometric clarity and harmonious proportions of the ancient Roman style. Sculptors and painters studied geometry, optics, and anatomy to achieve accurate three-dimensional representation of the world, objects, and human figures as the eye beholds them.

In northern Europe, Renaissance humanism expressed itself less in a revival of antiquity and more in scientific observation and careful study of natural phenomena. In the arts, this meant a shift away from heavenly visions toward the integration of symbols in careful representations of the natural world, and even the study of nature for its own sake.

The position of the church, both as a powerful political force and as an institution increasingly concerned with worldly affairs, came under close scrutiny. Abuses among the clergy set the stage for the Reformation, as did the papal interest in winning victories on the battlefield rather than caring for human souls. Led by Martin Luther, John Calvin, and others, the "Protestant" reformers rejected the central authority of the church and the mediation of the priesthood. They held that by reading the scriptures, individuals could know and interpret the word of God for themselves.

In Europe during the Renaissance, the merchant and artisan classes rose to challenge the entrenched position of the nobility. The expansion of the urban middle class was strengthened by the increase of trade that followed in the wake of exploration. The increasingly wealthy merchant families demanded and received greater political power in business organization, city government, and church circles.

In these momentous developments in thought, science, religion, exploration, statecraft, and the arts, we can recognize the beginnings of the modern era.

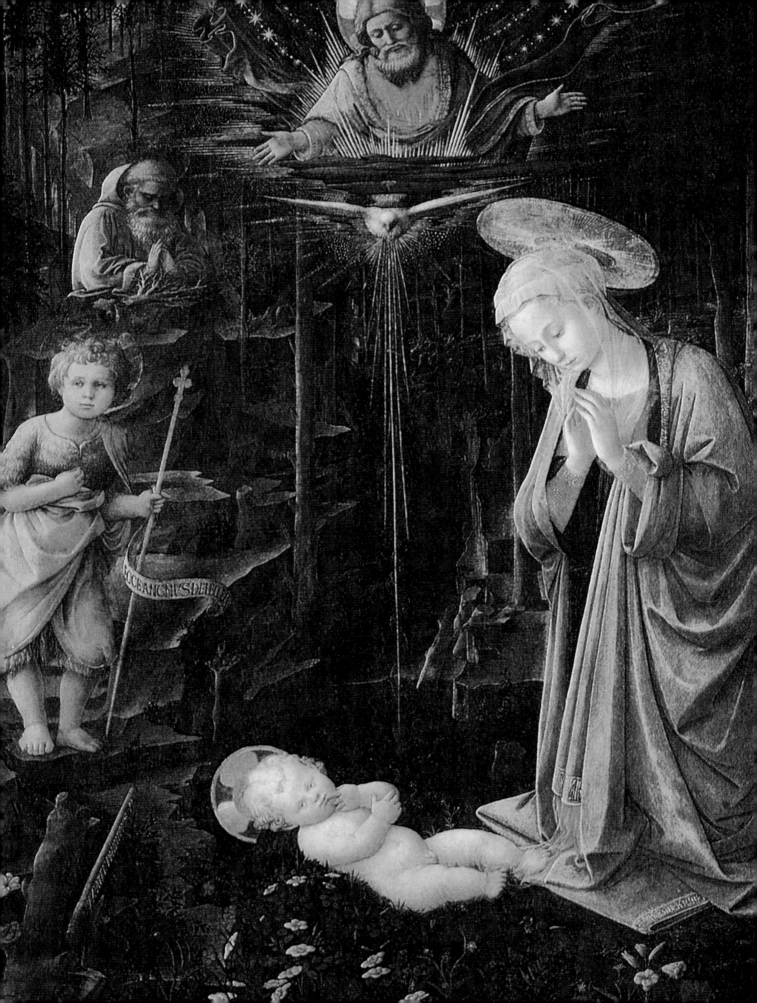

CHAPTER

FLORENTINE
RENAISSANCE STYLE

LIVELY FESTIVALS WERE THE DELIGHT of all Florentines, but March 25, 1436, was a special occasion that would linger long in the memory of these prosperous people. The dedication of Florence's newly completed cathedral (Figs. 9.1A and 9.2A) brought together an unprecedented number of church dignitaries, statesmen, and diplomats. In their wake were famous artists, poets, scholars, and musicians. The white-robed Pope Eugene IV, crowned with the triple tiara and attended by seven cardinals in bright red and no fewer than thirty-seven bishops and archbishops in purple vestments, made a triumphal progress through the banner-lined streets, accompanied by city officials and guild leaders with their honor guards.

Appropriately enough, the cathedral was christened Santa Maria del Fiore (Holy Mary of the Flower), because Florence (derived from the word

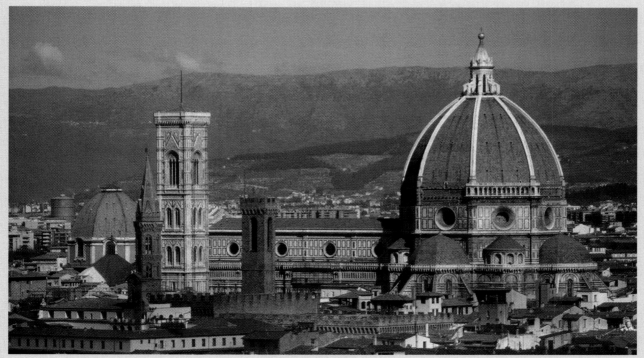

9.1 (A) Florence Cathedral group. Cathedral begun by Arnolfo di Cambio, 1296; dome by Filippo Brunelleschi, 1420–1436; present facade, 1875–1887. Length of cathedral 508′; height of dome 367′. Campanile begun 1334 by Giotto, continued by Andrea Pisano, 1336–1348; height 269′. Baptistry (lower right), 1060–1150. (B) Plan of Florence Cathedral.

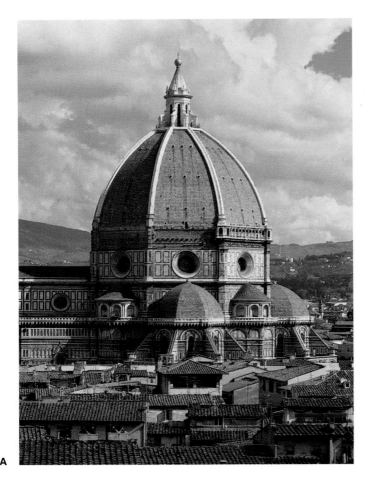

A

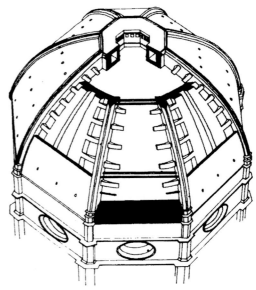

B

9.2 (A) Filippo Brunelleschi. Dome of Florence Cathedral, Florence, Italy, 1420–1436. (B) Internal structure of Brunelleschi's Dome, Florence Cathedral.

flora) was the city of flowers. March 25 was also the Feast of the Annunciation, and the Annunciation and the Nativity were favorite subjects of Florentine art.

FLORENCE IN THE FIFTEENTH CENTURY

The colorfully costumed citizens of this flourishing Tuscan town lined the streets for the grand procession and crowded into the vast nave of the cathedral. At a time when many feudal aristocrats still dwelled in cold, fortresslike castles, Florentine patrician families lived in a style that could well have been the envy of kings. The working members of the population belonged to the various guilds and trade organizations, of which the most important were those dealing with the carding, weaving, and dyeing of wool and silk for the internationally famous Florentine textile industry. Metal crafts and stonework followed in importance, and so on down to the butchers, bakers, and providers of goods for everyday life. The masters of the principal guilds were the influential citizens from whose ranks the members of the Signory, or city council, were chosen and from which many merchant and banking families emerged.

The most renowned of these families was the Medici, whose head at this time was Cosimo. Through a combination of political understanding and keen financial ability, he dominated the government of the city. Cosimo never assumed a title or other outward sign of authority. Instead, he was the political boss, ruling from behind the scenes with the support of the guilds, which knew that a stable government and peaceful relations with their neighbors (see Maps 9.1 and 9.2) were the best safeguards of their prosperity.

The Medici were the papal bankers and received deposits of church funds from England, France, and Flanders. From their branch offices in London, Lyon, and Antwerp, they lent this money at high rates of interest to foreign heads of state. With the papal revenues, they bought English wool, had it processed in the Netherlands, shipped it to Florence to be woven into fine fabrics, and exported these at a handsome profit. It was Cosimo who made the florin the soundest currency in Europe.

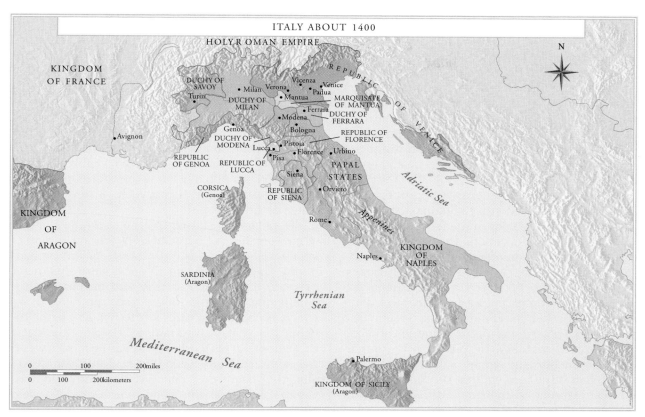

MAP 9.1

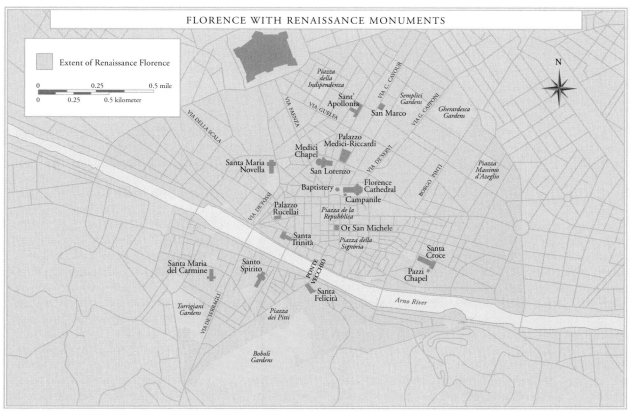

MAP 9.2

But political power and high finance were not the only pursuits of this ambitious banker. A serious student of Plato, Cosimo became one of the founders of the Neoplatonic Academy—not a school as such, but a circle of scholars, intellectuals, and artists that had enormous intellectual influence. From all the parts of Europe where his financial interests extended, he commissioned works of art. At home, he gathered a library of rare manuscripts, which he made available for study and translation.

Through Cosimo's generosity, a group of Dominican monks moved into the monastery of San Marco, which was rebuilt for them by his personal architect, Michelozzo. Among the monks was Fra Angelico, whom Cosimo encouraged to decorate the monastery walls with his famous frescoes. Other artists also benefited from Cosimo's patronage. Filippo Lippi, the future teacher of Botticelli, looked to him for commissions. Cosimo also took the advice of the sculptor Donatello and collected antique statuary. He placed it in his gardens and encouraged young sculptors to work there. Small wonder, then, that the Signory voted him the posthumous title *Pater Patriae,* "Father of His Country."

THE CATHEDRAL OF FLORENCE

On the day of the cathedral's dedication, the eyes of all Florentines were directed upward to the mighty **cupola,** which still gives the city its characteristic profile. Although begun in the late thirteenth century, the building's construction had long been delayed because no architect possessed the necessary knowledge to span such an enormous (140-foot wide) octagonal space (Fig. 9.2B).

BRUNELLESCHI'S DOME

It is unclear whether Filippo Brunelleschi, the architect who solved the problem, had ventured to Rome to study the Pantheon and other ancient monuments, where he might have observed the construction of domes. Yet it appears that he was aware of the basic principles of dome construction. Starting at a level some 180 feet above ground, he boldly sent eight massive ribs soaring skyward from the angles of the supporting octagon to a point almost 100 feet higher, where they converged at the base of a lantern, that is, a small turretlike tower. Concealing them from external view, he added two minor radial ribs between

each pair of major ribs, twenty-four in all, to make the inner shell. After reinforcing these with wooden beams and iron clasps at key points, he had the necessary support for the masonry of his inner and outer shells. The structure is, in effect, an eight-sided Gothic vault. By concealing the functional elements and shaping a smooth external silhouette, Brunelleschi abandoned a central tenet of Gothic functionalism—that the structural elements of a building must be visibly logical. Brunelleschi's dome became the prototype for all massive domes and a bridge to a new Renaissance architecture.

Opposite the facade of the cathedral is the older Romanesque baptistry (Fig. 9.1, lower right), which was adorned with Ghiberti's gilded bronze doors. The handsome north doors were already in place, and the sculptor was well on his way to completing the east doors (see pp. 252–254), which Michelangelo was later to hail as worthy of being the "Gates of Paradise." Helping him cast these doors in his workshop at various times were the architect Michelozzo, the sculptor Donatello, and the painters Paolo Uccello and Benozzo Gozzoli. At about the same time, Donatello was working on a series of statues of prophets to be placed in niches on the exterior of both the cathedral and the campanile, known as "Giotto's Tower" (see pp. 223–224).

In Pope Eugene's company at the dedication of the cathedral were some of the leading Florentine humanists, including the artist-scholar Leone Battista Alberti, who had just completed his book *On Painting* and was working on his influential study *On Architecture.* On hand to provide music for the occasion was the papal choir, whose ranks included the foremost musician of his generation, Guillaume Dufay, who composed the commemorative motet for the occasion. Antonio Squarcialupi, an organist at the cathedral and a private master of music in the Medici household, is thought to have composed the solemn High Mass.

An eyewitness account of the procession noted the perfume of the flowers and incense and the bright-robed company of viol players and trumpeters, "each carrying his instrument in hand and arrayed in gorgeous cloth of gold garments." In appropriately flowery language, the observer recorded that "the whole space of the temple was filled with such choruses of harmony, and such a concert of diverse instruments, that it seemed (not without reason) as though the symphonies and songs of the angels and of divine paradise had been sent forth from Heaven to whisper in our ears an unbelievable celestial sweetness."

THE DOME AND THE DEDICATION MOTET

The eyewitness was referring in part to Guillaume Dufay's dedicatory motet, *Nuper rosarum flores* (Flowers of Roses). In this choral work the cathedral is praised as "this mighty temple" and its dome as a "magnificent artifice" and a "marvel of art."

Brunelleschi and Dufay were the most important representatives of their crafts in Florence during the first half of the fifteenth century. Brunelleschi's first biographer, Manetti, states that he had studied Vitruvius (see p. 104) and that he thought in terms of the ancient musical proportions. Both the dome and the motet were constructed using late medieval methods. The dome included Gothic elements, and the music used **isorhythmic** symmetries incorporating strict rhythmic progressions and formal proportions. Isorhythmic motets consist of a series of sections that are unified by the use of identical rhythmic relationships but not necessarily the same melodic patterns. Such music was not intended only to please the ear or stir the emotions; rather, in the manner of ancient music theory (see pp. 49–50), it aimed to mirror the hidden harmonies of the universe. In Dufay's conception, however, the universe was populated with shapely melodies, warm harmonic colors, and a rich variety of rhythmic forms. Dufay clothed the austere skeletal structure of the composition with smooth melodic lines and a fluency of sound that made it a joy to the ear as well as to the mind.

THE PAZZI CHAPEL

The analogy that Renaissance theorists drew between audible and visual proportions was an undercurrent in all their designs. It bore witness to their profound belief in the harmonic–mathematical basis of creation. Music also had a strong attraction for Renaissance architects, because it had always been considered a mathematical science and had been studied as such in antiquity and in the medieval universities. Mathematical relationships are easy to see in Brunelleschi's Pazzi Chapel, where he had complete control of the whole plan (Fig. 9.3A). The central axis, as seen in the ground plan (Fig. 9.3B), is based on three circles signifying the domed spaces above, and the relationship of the two smaller circles to the larger one is in the ratio of 2:1. Similarly, the two smaller squares above have an octaval relationship (based on the number eight) to the large square surrounding the central dome.

The fruits of Brunelleschi's studies of ancient Roman buildings are even more in evidence in the facade, where the break with the Gothic tradition is complete. The harmonious spacing of the columns of the porch, the treatment of the walls as flat surfaces, and the balance of horizontal and vertical elements make his design the prototype of the Renaissance architectural style. The entablatures above the columns and below the roof give further evidence of classical influence. The curved pattern above comes directly from ancient Roman sarcophagi, whereas the elegant carving

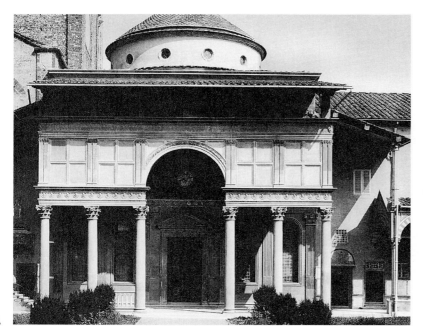

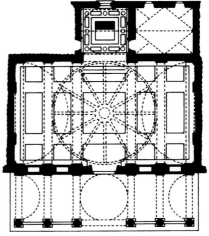

9.3 (A) Filippo Brunelleschi. Facade, Pazzi Chapel, Cloister of the Church of Santa Croce, Florence, Italy, c. 1429–1433. (B) Plan of Pazzi Chapel.

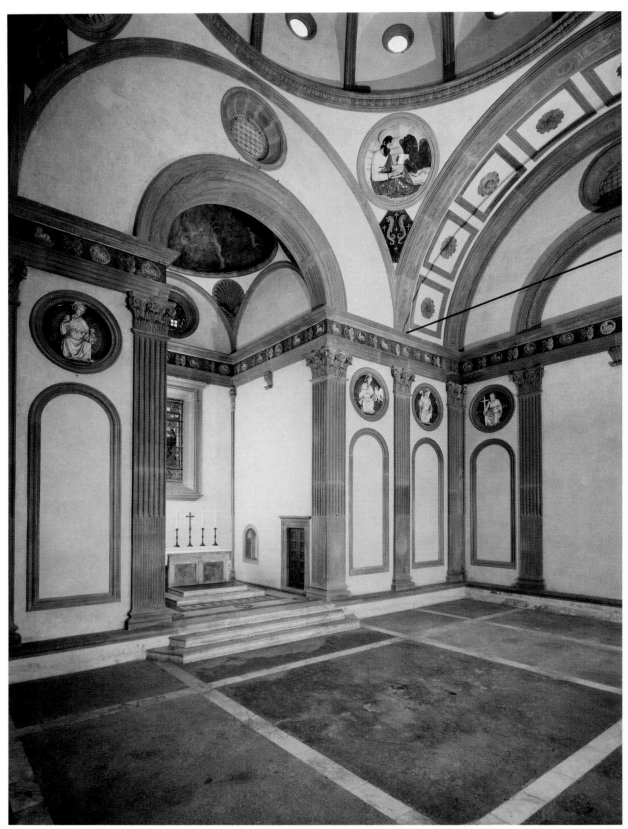

9.4 Filippo Brunelleschi. Interior, Pazzi Chapel, Cloister of the Church of Santa Croce, Florence, Italy, c. 1440. Length 59′9″, width 35′8″.

of the Corinthian capitals, the Composite pilasters, and other design details reveal Brunelleschi's early training as a silversmith and his interest in authentic Roman originals.

The interior continues the classical theme (Fig. 9.4). Lacking Gothic mystery, height, and shadowy indefiniteness, the pilastered walls give the viewer a cool, crisp, lucid impression. Frames of dark-colored stone divide the surfaces into clear geometric forms. Barrel vaults (see Fig. 4.22C) cover the rectangular room, and a low dome on pendentives (see Fig. 5.11) rises in the center at the point of intersection. The simplicity of its design made the Pazzi Chapel a highly influential prototype throughout the Renaissance. The unity of its centralized organization under a unifying dome became the point of departure for the later church plans of Alberti, Bramante, and Michelangelo.

THE MEDICI–RICCARDI PALACE

When Cosimo de' Medici decided to build a new house, he is said to have rejected a grand plan submitted by Brunelleschi with the shrewd observation that envy is a plant that should not be watered. For the Medici–Riccardi Palace (Fig. 9.5), he chose instead a less pretentious design submitted by Brunelleschi's disciple Michelozzo. (The palace has a dual name because it was bought from the Medicis by the Riccardi family in the seventeenth century.)

Like many buildings of its type, the palace was a continuation, rather than a revival, of the multi-storied ancient Roman city apartment house. The heavily **rusticated** masonry of the first story (many of the rough-cut stones protrude more than a foot) has the threatening aspect of a medieval fortress. But as the eye moves upward, the second and third floors present an increasingly elegant appearance. The accent on horizontal lines, seen in the molding strips that separate the three stories and in the boldly projecting cornice at the roof level, is neither Roman nor medieval. A classical motif can be seen in the semicircular arches that frame the windows (the pediments over those on the lower story are a somewhat later addition). Details such as the colonnettes of the windows on the second and third floors, as well as the egg-and-dart pattern and the dentil range that appear in the cornice frieze just under the roof, are derived from the classical patterns adapted by Renaissance architects and builders.

Cosimo's worries about public display stopped with the palace's exterior; inside the doors everything was on a princely scale. Frescoes by Benozzo Gozzoli and an altarpiece by Filippo Lippi decorated its second-floor chapel. Easel paintings by Uccello and Botticelli hung on salon walls. Antique and contemporary bronze and marble statues stood in the courtyard and gardens. Collections of ancient and medieval carved gems and coins filled cabinets. Precious metal vessels and figurines adorned tables. Priceless manuscripts, including the works of Dante, Petrarch, and Boccaccio, could be found in the library. In effect, the Medici–Riccardi Palace was one of the first and richest museums in Europe.

Cosimo's palace was also the meeting place of the Neoplatonic Academy, where authors, philosophers, and artists discussed new ideas and gave expression to them in their works. Briefly, Neoplatonism was an interpretation of Plato's notion of the eternal forms (see p. 56). It held that the eternal absolutes of truth, goodness, and beauty existed only in the divine mind. Such absolutes are not wholly within human grasp. Nevertheless, through learning, observation, and creativity, mortals could catch occasional hints of them. Truth was pursued through scientific knowledge. Goodness might be glimpsed in the performance of good deeds and through the experience of physical and, more important, spiritual love. Beauty was sought in nature and the experience of great works of art.

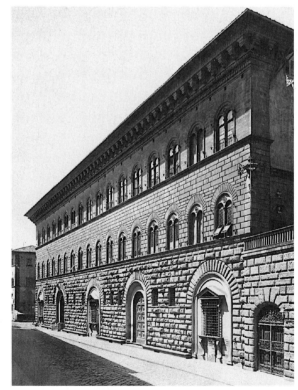

9.5 Michelozzo. Facade, Medici–Riccardi Palace, Florence, Italy, 1444–1459. Length 225′, height 80′.

AN ART CONTEST: GHIBERTI VERSUS BRUNELLESCHI

In the year 1401, the Wool Merchant's Guild held a competition to determine who should be awarded the contract for the new north doors of the baptistry. As in the earlier south doors by Andrea Pisano, the material was to be bronze, and the individual panels were to be enclosed in the **quatrefoil,** or four-lobed, pattern. For the purpose of the contest, the subject was to be the Sacrifice of Isaac. Some half-dozen sculptors were invited to submit models; among them were Brunelleschi and Lorenzo Ghiberti.

Both men were in their early twenties and were skilled workers in metal and members in good standing of the Goldsmiths' Guild. Despite these shared characteristics, their work reveals many significant differences of viewpoint and technique (Figs. 9.6 and 9.7). Brunelleschi's composition shows the influence of Gothic verticality in the way the design is built in three rising planes. Ghiberti's composition is almost horizontal, and his two scenes are divided diagonally by a stylized mountain in the manner of Giotto (see Fig. 8.12). Brunelleschi's panel is crowded, and his figures spin out toward the sides of the frame. By contrast, Ghiberti's is uncluttered, and all his figures and details converge toward a center of interest in the up-

per right, formed by the heads of the principal figures. Brunelleschi accents dramatic tension, with Abraham seizing the screaming Isaac by the neck and the angel staying his hand at the last moment. Ghiberti sacrifices intensity for poise and decorative elegance. Brunelleschi shapes Isaac's body as a series of angular and awkward bends. Ghiberti models it with the smooth lines and grace of a late Greek or Hellenistic statue. In fact, Ghiberti's *Commentaries,* arguably the first autobiography by an artist in Western culture, mention the discovery near Florence of the torso of an ancient classical statue, on which he modeled his Isaac. Finally, Brunelleschi cast his relief in separate sections, mounting these on the bronze background plate. Ghiberti, with greater technical command, cast his in a single mold. The decision in Ghiberti's favor showed the way the aesthetic winds were blowing at the dawn of the fifteenth century. Ghiberti set to work on the twenty panels of the north doors, which were to occupy the major part of his time for the next 24 years.

GHIBERTI'S EAST DOORS

Ghiberti's north doors were no sooner in place than he was commissioned, this time without competition, to execute another set. The famous east doors (Fig. 9.8), on which he worked from 1425

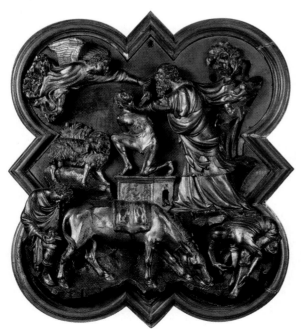

9.6 Filippo Brunelleschi. *Sacrifice of Isaac,* 1401–1402. Gilded bronze, 1′9″ × 1′5″. Museo Nazionale del Bargello, Florence, Italy.

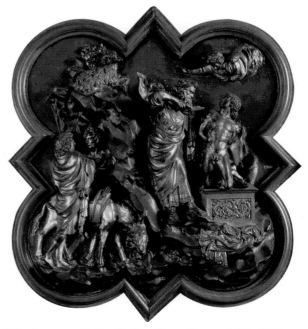

9.7 Lorenzo Ghiberti. *Sacrifice of Isaac,* 1401–1402. Gilded bronze, 1′9″ × 1′5″. Museo Nazionale del Bargello, Florence, Italy.

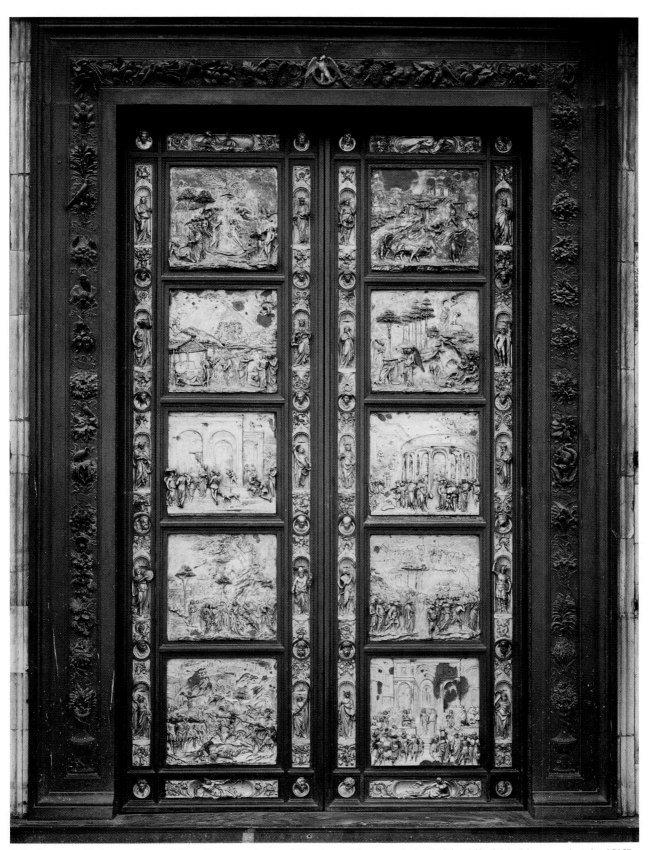

9.8 Lorenzo Ghiberti. *Gates of Paradise,* east doors of Baptistry, Florence, Italy, 1425–1452. Gilded bronze, height 18′6″.

to 1452, tell their own tale. The Gothic quatrefoil frames of the competition panels had become a thing of the past. In addition, whereas his north doors were conceived of in terms of their architectural function, the east doors served as a convenient framework for decoration. They disregard techniques appropriate to the three-dimensional medium of relief sculpture and are more like pictures painted in gilded bronze.

Ghiberti attempted daring perspectives far in advance of the painting of the period. Some figures, such as those in the center panel of the left door, are in such high relief as to be almost completely in the round. In the Adam and Eve panel at the top of the left door (Fig. 9.9), he uses three receding planes. The high relief in the lower foreground tells the story of the creation of Adam (lower left) and Eve (center) and the expulsion from the Garden of Eden (right). The immediate past is seen in the half-relief of the middle ground showing the Garden of Eden. In the low relief of the background, God and his accompanying cloud of angels seem to be dissolving into the thin air of the remote past.

On either side of the pictorial panels Ghiberti included a series of full-length figurines alternating with heads that recall Roman portrait busts (see Fig. 4.15). Hebrew prophets on the outer sides are set opposite pagan sibyls, all of whom were supposed to have foretold the coming of Christ. The figure beside the second panel from the top on the right door is that of the biblical strongman

Samson, but his stance and musculature are those of a Hellenistic Hercules. Ghiberti mentions in his *Commentaries* how he sought to imitate nature in the manner of the ancient Greeks when molding the plant and animal forms of these door frames.

The care and delicate craftsmanship Ghiberti lavished on these and other details make the east doors a high point in the metalworker's art. The influence of Ghiberti's Goldsmiths' Guild was felt in many aspects of Florentine art, not only in such door moldings but also in pulpits, wall panels, window brackets, columns, pilasters, and cornices, all of which were executed with a wealth of fine detail.

DONATELLO

Donatello's personality and career contrast strongly with Ghiberti's. A man of fiery temperament and bold imagination, Donatello scorned the fussy details that allied Ghiberti's work with that of a jeweler. Whereas Ghiberti studied local examples of antique sculpture and read Vitruvius's books, Donatello journeyed to Rome to study the finest surviving classical statuary.

Ghiberti remained a specialist in bronze, whereas Donatello was at home with all materials: marble, wood, painted terra-cotta, and gilded bronze. He was equally comfortable in all mediums—relief and in the round, small scale and heroic size, architectural embellishment and independent figure—and in all subjects—sacred and secular, historical scenes and portraiture. Whereas Ghiberti had a single personal style, Donatello had many. His tremendous power of epic expression, enormous energies, sweeping passion, and impetuosity make him the representative sculptor of his period and the immediate artistic ancestor of Michelangelo.

The Prophet (Fig. 9.10), also known as *Lo Zuccone,* which means "pumpkin head" or "bald pate," is one of a series of marble statues that Donatello was commissioned to sculpt for the Florence Cathedral in 1424. Designed for a third-story niche of the campanile, it was intended to be seen about 55 feet above ground level. Consequently, the deep-cut drapery and lines of the face took into account the distance from the viewer as well as the angle of vision and the lighting. Donatello sought to produce a powerfully expressive figure rather than a handsome one. He achieved this through the boniness of the huge frame, the powerful musculature of the arms, the convulsive gesture of the right wrist, the tension of the muscles of the neck, and the intensity of the face.

The statue represents an Old Testament prophet (either Habakkuk or Jeremiah). The figure

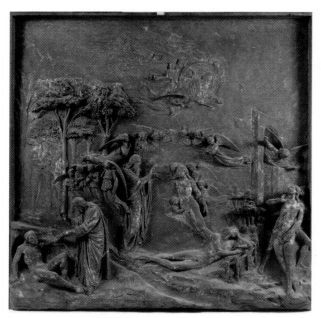

9.9 Lorenzo Ghiberti. *The Creation of Adam and Eve,* detail of east doors, Baptistry, Florence, Italy, c. 1435. Gilded bronze, 2′7¼″ square.

is full of inner fire and fear of the Lord; it portrays a seer who was capable of fasting in the desert, dwelling alone on a mountaintop, or passionately preaching to an unheeding multitude from his niche. The classical influence is seen in the heavy folds of drapery, an adaptation of the toga, and in the rugged features and baldness, which recall realistic Roman portraiture. With *Lo Zuccone,* Donatello created a unique figure of strong individuality, not one of the traditional iconographic types.

In his bronze *David* (Fig. 9.11), Donatello worked in a more lyrical vein. As a figure meant to be seen from all angles, *David* departs from the Gothic

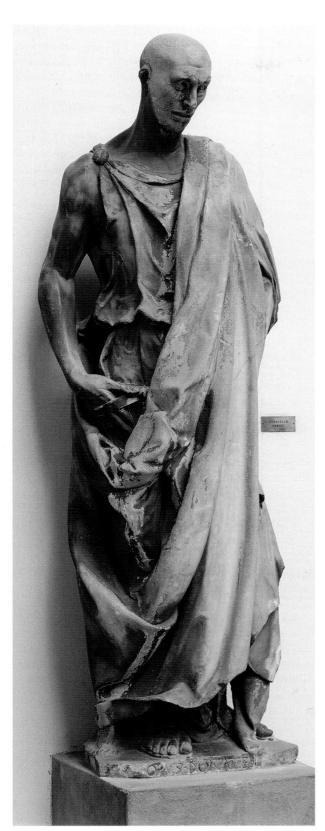

9.10 Donatello. *The Prophet (Lo Zuccone),* from campanile, Florence Cathedral, 1423–1425. Marble, height 6′5″. Original in Museo dell'Opera del Duomo, Florence, Italy.

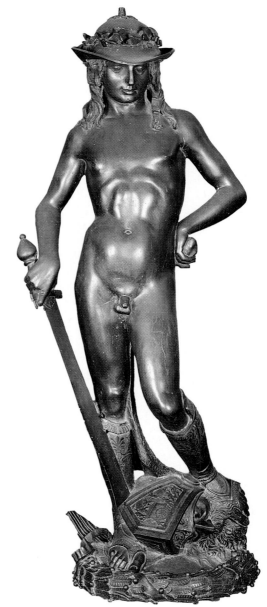

9.11 Donatello. *David,* c. 1430–1432. Bronze, height 5′2¼″. Museo Nazionale del Bargello, Florence, Italy.

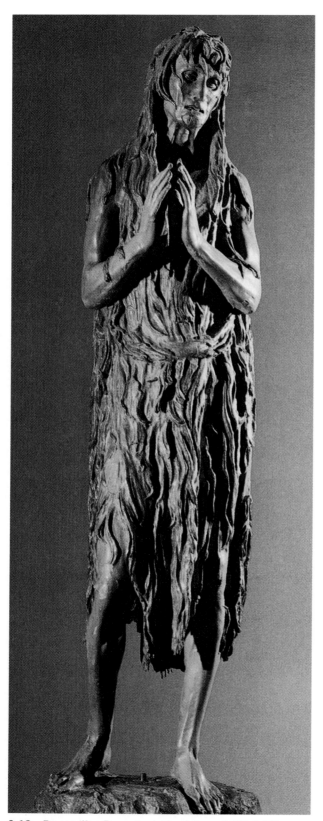

9.12 Donatello. *Repentant Magdalene,* 1454–1455. Wood, height 6′2″. Museo dell'Opera del Duomo, Florence, Italy.

tradition of sculpture in niches and as architectural embellishment. *David* was the first life-size bronze nude in the round since antiquity, and as such, it marks the revival of classical nude statuary.

David stands alone in the confident attitude of the victor over the vanquished, a sword in his right hand, a stone in his left. His weight rests on his right foot, whereas the left foot is on the severed head of the conquered Goliath. The curving posture is familiar from Greco-Roman antiquity (see Fig. 2.21 [Doryphorus]). The serenity of the classical profile, together with the languid stance and modeling of the youthful body, also shows the sensual awareness of Hellenistic culture. A local touch is provided by the Tuscan shepherd's hat, which throws the smooth, delicate-featured face into strong shadow and serves to accentuate the adolescent body. From its first days in the courtyard of the Medici Palace, Donatello's *David* raised eyebrows and provoked questions. In commissioning the statue, did the Medici family seek to display a symbol of their power, taking into their private domain a Biblical figure associated with the city of Florence? Is *David,* the savior of his people, an allusion to the youthful promise of Cosimo's grandson, Lorenzo? More intimately, is the daringly nude *David* an allusion to Donatello's sexual preference?

At the opposite end of Donatello's emotional range—and far less ambiguous—is the wraithlike *Repentant Magdalene* (Fig. 9.12). The emaciated, cadaverous figure originally stood in the Florence Baptistry as a reminder of the original sin that is washed away by baptism and of the universal presence of death among the living.

HUMAN ANATOMY INVESTIGATED: POLLAIUOLO AND VERROCCHIO

Quite another attitude is revealed in the work of the next generation, especially Antonio Pollaiuolo and Andrea del Verrocchio. The work of Pollaiuolo is dominated by scientific curiosity, especially in regard to human anatomy. He is known to have dissected corpses in order to study musculature and bone structure. Trained in his father's goldsmith shop, he specialized in athletic figures such as the cast-bronze *Hercules and Antaeus* (Fig. 9.13), of which he made both painted and sculptural versions.

Legends about ancient strongmen like Hercules provided excellent subjects, permitting the artist to bring out the musculature of the male figure in action. In this instance, Hercules overcomes his enemy, the giant Antaeus, by raising him off the Earth, the source of his strength. Antaeus struggles des-

perately to release the stranglehold Hercules has on him. The muscles in Hercules's legs noticeably bear the weight of both bodies. Pollaiuolo also painted a series of pictures depicting the Labors of Hercules. Like his works in bronze, they are studies of muscular tension, full of athletic energy and unrelieved by gracefulness.

Verrocchio, a contemporary of Pollaiuolo, was frequently given commissions from the Medici family. For this powerful family he designed everything from tournament trophies and parade gear to portraits and tombs. Verrocchio paid homage to the city of Florence with his bronze statue of David (Fig. 9.14). Verrocchio's *David* contrasts with that of Donatello (Fig. 9.11) in a number of ways. The clothed Verrocchio version is a self-assured adolescent athlete, proud of his victory over the giant, whose severed head lies at his feet. The youth's developing musculature is accurately

observed to the very veins in his arms and hands. In Verrocchio's interpretation, David looks with satisfaction on the gratitude of his audience. His self-assurance is apparent in his open, outgoing stance. Donatello's *David* is more meditative and psychologically unavailable, with his eyes half-hidden under his hat. One portrayal emphasizes physical action; the other, contemplation.

Like Pollaiuolo, Verrocchio was also a painter at a time when sculpture led the field in experiments with perspective, anatomy, and light and shadow. Whereas Ghiberti and Donatello had been more classically oriented, Pollaiuolo and Verrocchio were primarily scientifically minded. Leonardo da Vinci trained in Verrocchio's workshop and carried on the searching scientific curiosity of his master, whereas it remained for Michelangelo, stimulated by Donatello's art, to carry the humanistic ideal into the next century.

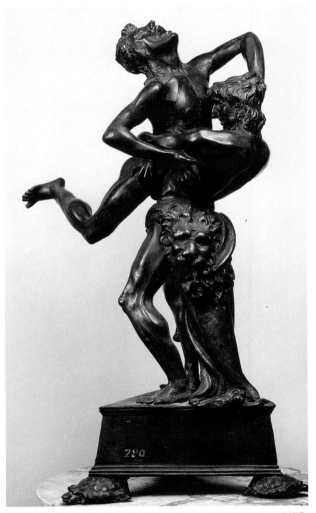

9.13 Antonio Pollaiuolo. *Hercules and Antaeus,* c. 1475. Bronze, height approx. 1′6″. Museo Nazionale del Bargello, Florence, Italy.

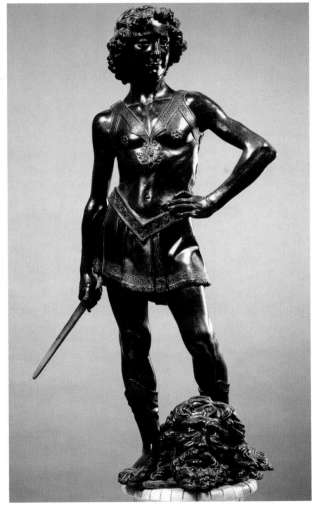

9.14 Andrea del Verrocchio. *David,* c. 1465. Bronze, height approx. 4′1″. Museo Nazionale del Bargello, Florence, Italy.

PAINTING

THE PREMATURE LOSS OF THE GENIUS OF MASACCIO

With Brunelleschi and Donatello, the third member of the trio of early fifteenth-century innovators was Masaccio. The importance of his series of frescoes in the Brancacci Chapel of the Church of Santa Maria del Carmine, where he worked with his older and more conservative colleague Masolino da Panicole, can hardly be overestimated. In the *Expulsion from the Garden* (Fig. 9.15), he chose one of the few subjects in which the nude human body could be portrayed in churches.

By defining the light as coming diagonally from the right and having Adam and Eve approach it, Masaccio invented a way to show them casting natural shadows. In addition, he surrounded his figures with soft, hazy light, thereby situating them in the space. Moreover, he modeled them in light and shadow as a sculptor would, so that they appear as if seen in the round with all the weight and volume of living forms. Masaccio thus achieved one of the most important innovations in painting: **atmospheric perspective.**

Masaccio seems well aware of the drama inherent in the expulsion from Paradise. The full force of this first moral crisis in human history is expressed by the body alone, with almost no reliance on surrounding details. Eve, aware of her nakedness and sensing her future, cries aloud, while Adam, ashamed to face the light, expresses his remorse by covering his face. Even the avenging angel who drives them out of the garden reflects the tragedy of the fall from grace with an expression of human concern and compassion so unlike the passive angels and fiendish devils of medieval sculpture (see Fig. 6.1). The curved line of Adam's right leg may have been drawn to indicate the hurried motion of the expulsion, but the proportions of his arms and the drawing of Eve's lower hand are anatomically incorrect. Such flaws, however, are minor when one considers the impact of Masaccio's treatment of light, which puts figures in a new, vital relationship to their spatial environment.

The Tribute Money (Fig. 9.16), another of the Brancacci Chapel frescoes, further illustrates the principle of atmospheric perspective. The figures are well modeled in light and shade, and each occupies its appointed space in the front and middle planes with ease and assurance. Approached by the tax collector, Peter and his fellow apostles question the propriety of Christian believers paying tribute to the Roman authorities, whereupon

Jesus responds, "Render therefore unto Caesar the things that are Caesar's; and unto God the things that are God's" (Matt. 22:21). Jesus then tells Peter that the first fish he catches will have a coin in its mouth. The simultaneous mode of presentation is used, with St. Peter appearing first in the center, then at the left fishing, and finally at the right paying the debt.

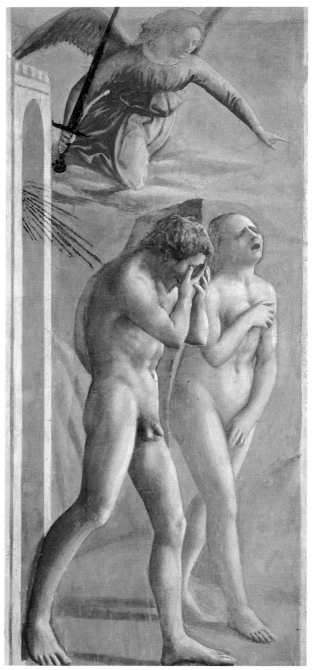

9.15 Masaccio. *Expulsion from the Garden,* c. 1425. Fresco, 7′ × 2′11″. Brancacci Chapel, Santa Maria del Carmine, Florence, Italy.

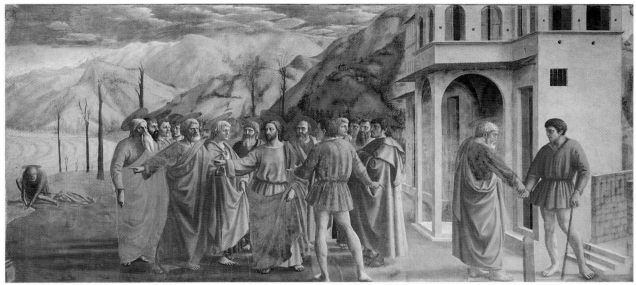

9.16 Masaccio. *The Tribute Money,* c. 1427. Fresco, 8′1″ × 19′7″. Brancacci Chapel, Santa Maria del Carmine, Florence, Italy.

Masaccio's colors, the bulky forms, and the placement of a figure in the immediate foreground remind one of Giotto's pioneering techniques (see Fig. 8.12). Yet Masaccio created greater psychological depth and differentiation in his figures. Moreover, he subjected his picture to a rigorous formulation of perspective. All the **orthogonals**—that is, lines leading to the vanishing point—end not at a point on the horizon but at the head of Christ (the orthogonals and the vanishing point can be revealed by placing a ruler along the angles

of the projecting roof on the building at the right in Fig. 9.16). Masaccio's death at the age of 27 cut short the promise of his innovative career.

LINGERING GOTHIC: FRA ANGELICO

Fra Angelico was in many respects a late Gothic artist who never painted anything but religious subjects. But although he dwelt lovingly on the older forms, he often treated them within the new frame of reference. His *Annunciation* (Fig. 9.17), painted for

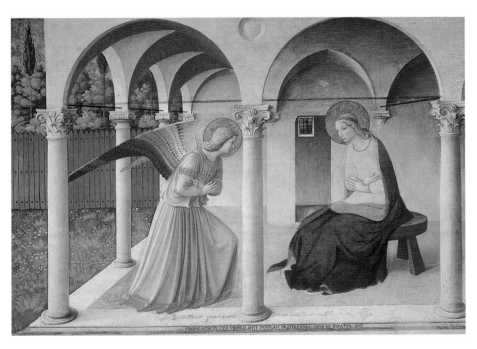

9.17 Fra Angelico. *Annunciation,* c. 1445–1450. Fresco, approx. 7′6″ × 9′9″. From former Monastery of San Marco, Florence. Museo di San Marco, Florence, Italy.

the upper corridor of the monastery of San Marco in Florence, is a blend of old and new elements.

Fra Angelico seemed to have found angels as real and interesting as human beings. Although he always painted with the deepest religious sentiment, the figures in the *Annunciation* appear within the new conception of space. The perspective and the fifteenth-century architectural details are so exact that the event could well be taking place in a corner of the San Marco cloister that Michelozzo recently had rebuilt. Moreover, the native Tuscan flowers seen in the garden are depicted accurately enough to satisfy a botanical expert. The lighting, however, is far from the natural illumination of Masaccio. Fra Angelico's rendering of the Virgin's form retains the late Gothic fascination with line. The Archangel Gabriel's mul-

ticolored wings recall those of the angels who surround the throne of Cimabue's *Madonna* (see Fig. 8.15). Yet the archangel's robes are modeled in light and shade, suggesting that the friar looked to Roman sculpture or the illusionistic techniques being explored in Florence.

AT HOME IN THE WORLD: BENOZZO GOZZOLI AND FILIPPO LIPPI

Unlike Fra Angelico, his principal pupil, Benozzo Gozzoli, was focused firmly on this world. With Cosimo's son Piero as his patron, Benozzo painted the *Journey of the Magi,* a favorite subject for pomp and pageantry. Here his talents were more than equal to their task: a fresco cycle on three walls of the chapel in the Medici Palace.

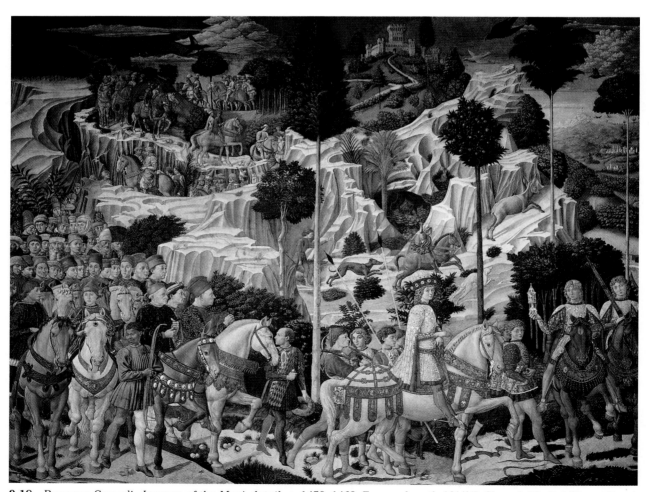

9.18 Benozzo Gozzoli. *Journey of the Magi,* detail, c. 1459–1463. Fresco, length 12′4¼″. Chapel, Medici–Riccardi Palace, Florence, Italy.

In the detail (Fig. 9.18), a richly costumed young Wise Man sits astride a splendid horse. At the head of the retinue, Benozzo portrays three generations of the Medici family. Patrons sometimes were painted in attendance at a scene, yet they were more clearly differentiated from the religious story. Here the Medici and the Magi mingle as equals.

At the far right, Piero de' Medici (in profile) appears at the head of the procession. Displayed on the lower part of the harness of his white horse is the motto *Semper* (Forever), a part of the Medici coat of arms, each letter appearing in the center of one of the jeweled rings that make a continuous chain. Beside him is the elderly Cosimo (also in profile) seated on a gray mule, with a black groom at his side. The youthful Giuliano and his older brother, the future Lorenzo Il Magnifico (the Magnificent), are on horseback at the extreme left. Bringing up the rear are various intimates and retainers of the Medici court, with the artist himself in the second row back, identified by a cap band that reads *Opus Benotii* (Work of Benozzo). Other faces may represent the philosopher Pico della Mirandola, the poet Poliziano, and Fra Angelico.

The procession winds through mountains reminiscent of Giotto's choppy peaks, yet tall umbrella pines and needle cypresses recall the Tuscan landscape. The convoy terminates at the fourth wall of the chapel, where Fra Filippo Lippi's altarpiece, the *Adoration* (Fig. 9.19), is situated. The linear emphasis of Lippi's drawing,

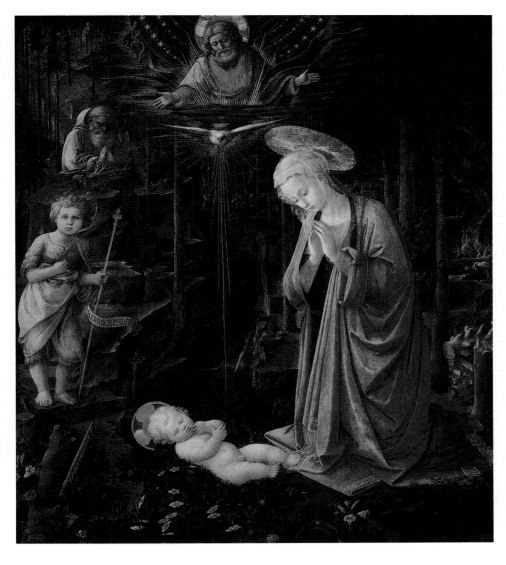

9.19 Filippo Lippi. *Adoration,* c. 1459. Tempera on wood, 4′2″ × 3′10″. Staatliche Museen zu Berlin, Berlin, Germany.

softened by pastel hues, had a decisive influence on the art of his famous pupil, Botticelli. In his *Adoration,* the pictorial space is divided symmetrically by the Trinity, with God the Father imparting a blessing on his Son through the descending rays of the Holy Spirit. The rays find an earthly echo in the vertical lines of the tree trunks that rise by steps in the background, thus creating niches for the figures of the Madonna on the right and the youthful St. John. Farther up the mountain, St. Bernard of Clairvaux is shown bowing in prayer. His Nativity sermons provide the keys that help unlock the picture's complex iconography.

THE PURSUIT OF LINEAR PERSPECTIVE: PAOLO UCCELLO AND PIERO DELLA FRANCESCA

To decorate one of the rooms of the Medici Palace, Cosimo called on Paolo Uccello. As a student of spatial science, Uccello tried to solve the problem of **linear** perspective, that is, the formula for arranging lines on a two-dimensional surface so that they converge at a vanishing point on the horizon, thereby promoting the illusion of recession in depth. One of his three scenes in his *Battle of San Romano* (Fig. 9.20), a skirmish in 1432 in which the Florentines put the Sienese army to flight, shows his pioneering effort in applying Euclidean geometry to pictorial mechanics.

Uccello laid the lances and banners out on the ground as if on a chessboard. He was evidently so absorbed with his lines that his bloodless battle is staged more in the manner of a dress parade than a clashing conflict. Also, he did not delve into the possibilities of modeling with light and shade, so his merry-go-round–like horses, despite the variety of their postures, remain as flat as cardboard cutouts. For all his scientific curiosity and intellectual effort, the solution to the linear problem eluded him. In this respect, he was always a pupil and never a master.

Another artist interested in perspective, Piero della Francesca, was also in Florence during the 1440s. As an assistant to Domenico Veneziano (whose last name indicates that his family was from Venice), he absorbed lessons in perspective as well as in the richness of color that characterized Venetian painting. By studying the work of Masaccio, he learned about atmospheric perspective and how to model figures in light and

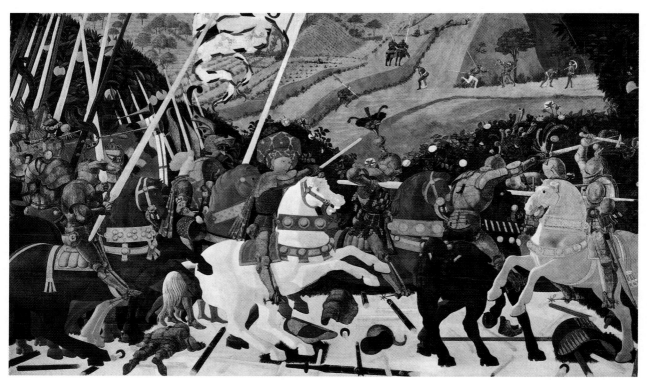

9.20 Paolo Uccello. *Battle of San Romano,* c. 1455. Tempera on wood, 6′ × 10′5″. National Gallery, London, England.

shade. Through his association with Ghiberti, Brunelleschi, Alberti, and Paolo Uccello, he eventually became a master of linear perspective and later wrote an essay on the subject.

Piero's *Resurrection* (Fig. 9.21), painted for the chapel of the town hall of his native Umbrian town of Borgo San Sepolcro, is one of his most sophisticated works. His clarity of design is seen in the compact pyramidal composition that builds up from the sarcophagus and the sleeping soldiers (the second from the left is generally thought to be a self-portrait) to the figure of Christ, which was modeled like a classical statue, holding a triumphant banner.

Color contrasts, as well as light and shade, play important roles in both the pictorial mechanics and the symbolism of this Resurrection. The somber tones of the soldiers' costumes are offset by the radiant pink of Christ's robe. Furthermore, the dark-clad soldiers, paralleled by the shadowy earth, set up an alternating rhythm with the flowing figure of Jesus against the Easter dawn. The barren earth on the left yields to the springtime rebirth of the fields on the right. The brightening sky above and the radiant spirit of Christ, with his piercing, almost hypnotic gaze, are reflected on the faces of the soldiers below.

CLASSICISM AND COLOR: BOTTICELLI

In creating a signature style of his own, Sandro Botticelli became the representative artist of humanistic thought at the end of the fifteenth century. Botticelli enjoyed the patronage of the Medici

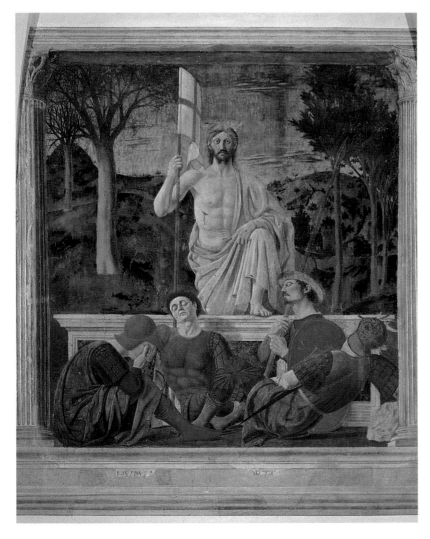

9.21 Piero della Francesca. *Resurrection,* c. 1463. Fresco, 7′5″ × 6′6½″. Pinacoteca, Palazzo Communale, Borgo San Sepolcro, Italy.

family, and in his *Adoration of the Magi* (Fig. 9.22), he portrays the clan engaged with religious figures, as had his predecessor, Benozzo Gozzoli (Fig. 9.18). Among the admirably arranged figures one finds the elderly Cosimo kneeling at the feet of the Christ child. Also kneeling are his two sons, Piero and Giovanni. To their right, standing against the ruined wall, is the profiled figure of Giuliano, the handsome grandson of Cosimo and the younger brother of Lorenzo the Magnificent, who is to be found in the extreme left foreground. His opposite number at the right, looking intently at the viewer, not at the Holy Family, has been identified by some as Botticelli himself.

Although the colors are bright—ranging from the cool sky blue of the Virgin's robe and the dark green and gold embroidery of Cosimo's costume to the ermine-lined crimson cloak of the kneeling Piero and the bright orange of Botticelli's mantle— they create a harmonious pattern. The Roman ruins in the background and the coffered ceiling of the shed where the Holy Family is sheltered indicate not only Botticelli's attention to the classical heritage but also his interest in symbolizing the end of the Roman Empire, foreshadowed by the birth of Christ.

Botticelli was not a popular painter of pageants like Benozzo Gozzoli and his contemporary Ghirlandaio, but he was a member of the sophisticated group of humanists who gathered around the Medici. In this circle, which included the poet Angelo Poliziano, the philosophers Marsilio Ficino and Pico della Mirandola, as well as Lorenzo the Magnificent and his cousin Pierfrancesco di Lorenzo de' Medici, classical myths were constantly discussed and interpreted. The dialogues of Plato, the collected works of the Roman philosopher Plotinus (known as the *Enneads*), and Greek musical theory were all thoroughly explored. As in Botticelli's *Adoration,* references to ancient works were frequent.

LA PRIMAVERA. Botticelli's *La Primavera,* or *Allegory of Spring* (Fig. 9.23), is one of the most eloquent, intricate, and ultimately mysterious expressions of Renaissance thought. It was probably painted for the wedding of a young cousin of Lorenzo de' Medici, who numbered among his tutors Poliziano and Ficino. The eight figures, with Venus in the center, form an octaval relationship, that is, one consisting of eight forms. Together they run a gamut of mythological references and metaphors, which are more or less clear individually, even if the ultimate collective meaning of the work is obscure. The narrative reads from right to left. The gentle, blue-toned south wind, Zephyr, pursues the shy nymph of springtime, Chloris. As he impregnates her, flowers spring from her lips, and she is transformed into Flora in an appropriately flowery robe. This figure also refers to Florence, an allusion that was not lost on the citizens of the city of flowers.

9.22 Sandro Botticelli. *Adoration of the Magi,* c. 1475. Tempera on wood, 3′7½″ × 4′4¾″. Galleria degli Uffizi, Florence, Italy.

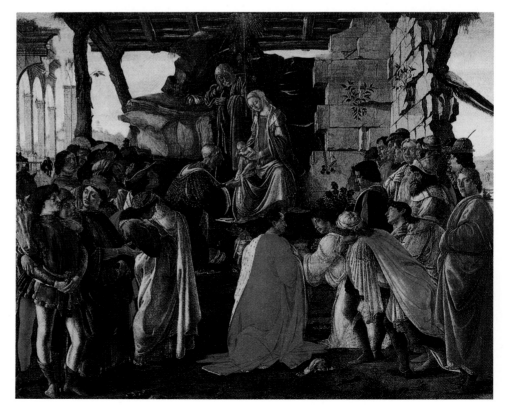

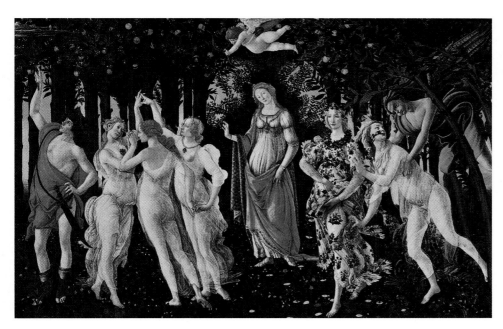

9.23 Sandro Botticelli. *Allegory of Spring (La Primavera),* c. 1478. Tempera on wood, 6′8″ × 10′4″. Galleria degli Uffizi, Florence, Italy.

Above, the blind Cupid shoots an arrow toward Castitas (Chastity), the youthful central dancer of the three graces. Her partners are the bejeweled Pulchritudo (Beauty) and Voluptas (Passion). Their transparent, gauzy drapery vibrates with the movements of their dance and creates rhythmic flowing lines. (In his *Pagan Mysteries of the Renaissance,* historian Edgar Wind saw this dance as the initiation rites of the virginal Castitas into the fullness of beauty and passion.) At the far left stands Mercury, both the leader of the Three Graces and the fleet-footed god of the winds. Lifting his magic staff, the Caduceus, he completes the circle by directing Zephyr to drive away the wintry clouds and make way for spring. Symbolically, Mercury dispels the clouds that veil the intellect to allow the light of reason to shine through. Presiding over the entire story, whose meaning is much disputed, is the figure of the goddess of love.

THE BIRTH OF VENUS. Botticelli painted another aspect of the goddess of love in his *The Birth of Venus* (Fig. 9.24). This composition was inspired by ancient descriptions of a lost masterpiece, *Venus Anadyomene,* by Apelles, the famous Greek painter who is said to have done portraits of Philip of Macedon and his son, Alexander the Great (see pp. 63–64). Here there are four figures instead of eight. Venus's nudity and modest posture express the dual nature of love, the sensuous and the chaste. These motifs are carried out on the left by the blowing winds, which Poliziano called amorous zephyrs. Flora reappears, wearing a flowery dress and carrying a flower-strewn robe forward toward Venus.

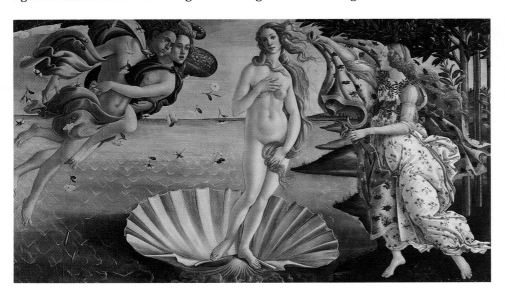

9.24 Sandro Botticelli. *The Birth of Venus,* c. 1482. Tempera on canvas, 5′8″ × 9′1″. Galleria degli Uffizi, Florence, Italy.

Venus seems to be floating gently across the green sea on her pink shell. The fluttering drapery of the side figures creates a sense of lightness and movement and leads the eye toward Venus's head, which is surrounded by an aura of golden hair. The clarity of outline, the balletlike choreography of lines, and the pattern of linear rhythms, especially in the lime-green waves, recall the techniques used in gold work and shallow relief sculpture.

In this painting, Botticelli demonstrated his profound connection with the Florentine Renaissance humanists, who were concerned with the revival of classical forms, figures, and imagery. Botticelli's break with the past is not quite complete. The composition of his *Allegory of Spring* echoes with the traditional Christian iconography of the Madonna surrounded by saints and angels. Also, *The Birth of Venus* hints at the baptism of Christ as he stands in the Jordan River with St. John on one side and an angel on the other. On the other hand, the artist's break with the painterly present is remarkable. It is as if he absorbed recent experiments with natural light and the rendering of three-dimensional figures on the picture plane, only to reject further naturalism as too limiting to the imagination. His graceful, elongated figures with their sweetly ideal faces have

a trace of late Gothic styles, but they are still his invention, as is the sensuous appeal of color that helped make him famous.

MASTERMIND: LEONARDO DA VINCI

Trained in Verrochio's workshop, Leonardo da Vinci rejected the classical humanistic scholarship that prevailed in Florence in favor of firsthand investigation, observation of nature, and constant experimentation. Many of his theories and speculations pushed at the frontiers of contemporary knowledge. A music lover and performer, he was first received at the court of Milan as a lute player and singer. In a letter to the Duke of Milan, he outlined his skills, noting that he could "vie successfully with any in the designing of public and private buildings, and in conducting water from one place to another. . . . I can carry out sculpture in marble, bronze, or clay." He then casually men-

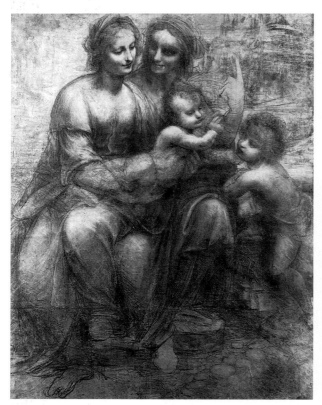

9.25 Leonardo da Vinci. Cartoon for *Madonna and Child with St. Anne and the Young St. John,* c. 1505–1507. Charcoal and white chalk on paper, approx. 4′6″ × 3′3″. National Gallery, London, England.

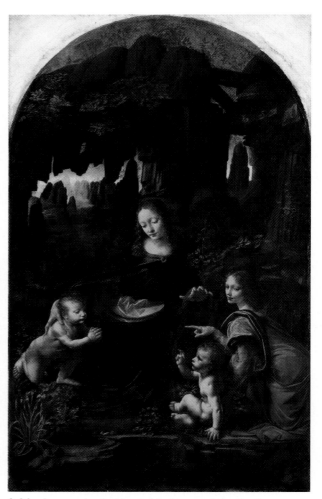

9.26 Leonardo da Vinci. *Madonna of the Rocks,* begun 1483. Oil on panel (transferred to canvas), approx. 6′3″ × 3′7″. Louvre, Paris, France.

tioned that "in painting I can do as well as any man." The voluminous notebooks he kept throughout his long life testify to his wide-ranging interests, including the flight of birds, the flow of water, the force of winds, the movement of clouds, and the invention of machines. His elegant, precisely observed drawings in all these fields and in human anatomy qualify him as the founder of modern scientific illustration.

Leonardo's point of departure in painting was not the graceful linear approach of Botticelli but the natural lighting, atmospheric perspective, and sculpturesque modeling of Masaccio. His treatise on painting advises artists to observe faces and figures in the softer light of dawn, dusk, and cloudy weather rather than in full daylight. This yielded greater delicacy of expression and a special quality of warmth and intimacy. In his masterly cartoon (preliminary drawing) for the *Madonna and Child with St. Anne and the Young St. John* (Fig. 9.25), all sharp lines are eliminated. He used the technique of modeling shapes in shades of dark and light, called *chiaroscuro,* so subtly that it became a language of its own through which he could suggest fleeting intuitions and states of mind. In this portrayal of three generations, the grandmotherly St. Anne becomes the personification of benign tranquility, whereas Mary is the image of grace and maternal concern. Although children, Christ and St. John exhibit the thoughtful gravity of those on whom the salvation of the world will depend.

MADONNA OF THE ROCKS. In *Madonna of the Rocks* (Fig. 9.26), the forms seem to emerge out of the surrounding darkness. Diffused rays of light shape the bodies three-dimensionally and illuminate the landscape background. More important than mere physical light, however, is the spiritual illumination that shines from each face. Here Leonardo carries chiaroscuro one step further, into what is called **sfumato,** whereby all hard lines disappear and the figures are revealed in a hazy, almost smoky atmosphere. The central part of the picture is built three-dimensionally like a pyramid, one of Leonardo's most significant contributions to pictorial form. The Madonna's head becomes the apex, and the two children give just the right weight and volume to the base. The hands play an expressive part as Mary embraces the young St. John, the representative of humanity in need of protection. Her other hand seems to hover in space as it forms a halo for the infant Jesus. The hand of the angel points to St. John as the forerunner of Christ, while that of the infant Jesus is raised in blessing.

Leonardo's great interest in nature plays a prominent role in this painting. Around the pool in the foreground and throughout the cave are flowers, grasses, and plants that are observed and painted with minute accuracy. The stalagmites, stalactites, and other rock formations are rendered with the precision of an expert in geology. The overall tone of the grotto setting is melancholy, seeming to foreshadow the tomb that awaits the Savior at the end of his earthly mission.

THE *LAST SUPPER.* The *Last Supper,* a fresco on the wall of the monks' refectory, or dining hall, at Santa Maria delle Grazie in Milan (Fig. 9.27), is a masterpiece of dramatic power and pictorial

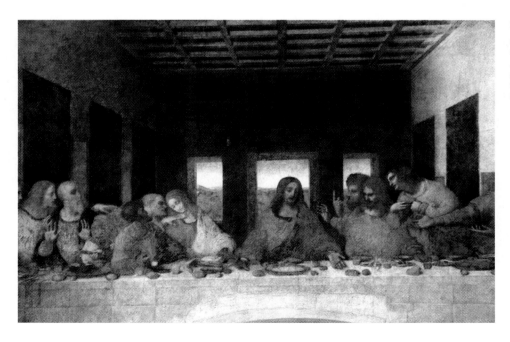

9.27 Leonardo da Vinci. *Last Supper,* 1495–1498. Oil and tempera on plaster, 14′5″ × 28′¼″. Refectory, Santa Maria delle Grazie, Milan, Italy.

9.28 Diagram of Leonardo da Vinci's *Last Supper* showing vanishing point (one-point) perspective.

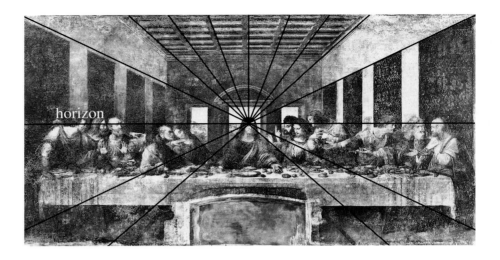

logic. Leonardo has chosen to depict the moment when Jesus said, "Verily I say unto you, that one of you shall betray me." The apostles "were exceeding sorrowful, and began every one of them to say unto him, Lord is it I?" (Matt. 26:21–22). The reactions run the gamut of human feeling, from fear, outrage, and doubt to loyalty and love. As each apostle responds, his mental and emotional state is reflected in searching facial ex-

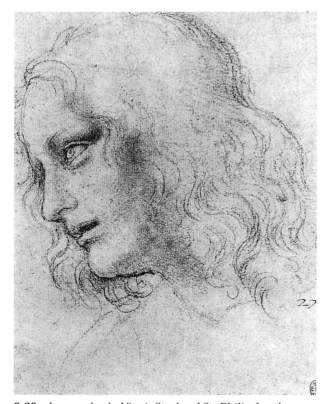

9.29 Leonardo da Vinci. Study of St. Philip for the *Last Supper,* c. 1495–1496. Black chalk on paper. Royal Library, Windsor Castle, London, England.

pressions and eloquent gestures (see Fig. 9.27). In the process, the defiant Judas is isolated. He draws back, his face in deep shadow, his hand clutching the moneybag containing the fatal thirty pieces of silver. Of him Jesus said, "Behold, the hand of him that betrayeth me is with me on the table" (Luke 22:21).

To contain this highly charged scene, Leonardo devised a setting of spaciousness and stability. As in Masaccio's *The Tribute Money* (Fig. 9.16), all the lines of the walls and ceiling beams converge in the exact middle, directly behind the head of Christ, in perfectly realized linear perspective (Fig. 9.28). The light from the center window with the curved pediment above functions as a halo around his head. At the table, the revealing gestures of the hands also focus attention toward the center. As an underlying motif, Leonardo draws on the Florentine understanding of harmony as expressed in numbers—in this case, the symbolism and properties of the number 12. The twelve apostles appear in four groups of three on either side of the lonely central figure. There are four wall hangings on each side and three windows, alluding to the four gospels and the Trinity. Twelve also relates to the passage of time—the hours of the day and months of the year—in which human salvation is to be sought.

Always thoughtful and deliberate in his working methods, Leonardo found the usual fresco technique of rapid painting on wet plaster uncongenial. Instead, he experimented by mixing oil pigments with tempera to lengthen the available painting time, to obtain deeper colors, and to produce more shadow effects. Unfortunately, the paint soon began to flake off the damp wall. Over the years it has been restored and repainted so often that only a shadow of the original remains.

Nevertheless, it is still possible to admire the overall design, the dramatic gestures of the figures, and some of the color tones. The original intensity of the facial expressions can be glimpsed through the few preparatory drawings that have survived. The profile of Philip, who is standing third to the right of Christ (Fig. 9.29), is particularly poignant.

Leonardo's ambitions, conceptions, and projections far exceeded his capacity to realize them in tangible form. None of his buildings progressed beyond the planning stage, his sculptures have all perished, and only about seventeen generally accepted paintings remain. These include four that are unfinished, and the others exist in varying states of preservation, restoration, and repainting.

POETRY AND MUSIC

LORENZO AS POET AND PATRON

The principal poets of the Florentine Renaissance were Lorenzo de' Medici and Poliziano. In retrospect, Lorenzo's title, Il Magnifico, seems to recognize his activities not only as an international banker but as a poet; humanist; philosopher; discoverer of genius; patron of the arts and sciences; and advisor to writers, sculptors, painters, and musicians (see Fig. 9.31).

Under the guidance of his grandfather Cosimo, Lorenzo was educated by Pico della Mirandola and other scholars to be the type of philosopher-ruler Plato had described in the *Republic.* Social conditions, however, had changed considerably since Cosimo's time. Whereas his grandfather had been a banker with intellectual and artistic tastes, Lorenzo became a powerful leader whose power rested on philosophical prestige and leadership in matters of taste as well as on his banking fortune.

Lorenzo maintained embassies at all the principal courts to which he made loans. He was willing to finance foreign conflicts, provided that he saw a substantial profit. By having the services of the greatest humanists under his command, he ensured that he could also fight a war of words in the form of elegantly turned phrases, veiled threats, and verbal thunderbolts.

As the fifteenth century progressed, conditions affecting the arts and artists changed significantly. During the early decades, Ghiberti had been employed by the Signory and his work was intended for public view. Later, the major commissions came from a few wealthy families. Under Lorenzo, the arts took on a more courtly character

and the audiences grew correspondingly smaller and more elite. Some painters were able to make a living outside the charmed circle, depicting scenes of births and marriages for a growing upper-middle-class clientele, but pictures like those of Botticelli, with their intricate classical references, were meant mainly for the humanistic intellectuals of the time.

RENAISSANCE FESTIVALS

Although he was a political, business, and intellectual leader, Lorenzo had the instincts of a popular ruler. He participated actively in the Florentine festivals (see Fig. 9.18 for a glimpse of the pageantry) by composing new verses for traditional folk tunes, encouraging others in his circle to do the same, and holding competitions among composers for better musical settings of the songs.

Lorenzo thus gave new impetus to popular literature in the native dialect. In a commentary on four of his own sonnets, he went to considerable lengths to defend the expressive possibilities of Tuscan Italian. After comparing it with Hebrew, Greek, and Latin, he found that its harmoniousness and sweetness outdid all the others. Although he continued to write sophisticated sonnets, Lorenzo also wrote popular verses that have, in addition to their beauty and literary polish, the spontaneous freshness, humor, and charm of folk poetry. He even uses the rustic dialogue of true country folk in some of his pastoral poems. Few poets could rival the lyricism of his *canti carnascialeschi,* or "carnival songs," one of which contains these oft-quoted lines:

> Fair is youth and free of sorrow,
> Yet how soon its joys we bury!
> Let who would be, now be merry:
> Sure is no one of tomorrow.

THE MUSIC SCENE IN FLORENCE

Popular music-making in Florence and other Italian cities was as much a part of the good life as any of the other arts. Yet it was mainly an art of performance; little music was ever written down. When the time came to appoint a successor to Squarcialupi as private master of music in the Medici household after his death in 1475, Lorenzo chose the rapid and productive composer Heinrich Isaac, a native of Flanders. Florence immediately became a second home to this cosmopolitan figure, who combined native Italian idioms with elements from his own background and training.

PAST AND PRESENT

Listening to Music

Lorenzo de Medici and his circle were unusual in their attraction to folk tunes (see p. 269). Outside of church, kings, courtiers, and commoners typically listened to different kinds of music. The royals and the wealthy seldom heard what the people heard, and the people did not have access to the music heard by the upper classes. The rich and the powerful employed composers and requested music to be played at special events, such as weddings, funerals, and state dinners. This music was written down, which made it possible to circulate to distant courts. As a consequence, music produced in Italy or France could dominate court taste in other European countries.

Peasant music tended to remain local, with regional variations in tune and lyrics. Love songs, for instance, were sung and played by friends at family gatherings or in taverns. Instruments, like music, were locally made. District languages and dialects prevailed in lullabies, children's songs, and the chants sung by workers while gathering agricultural crops.

Today, more than a century since the invention of recorded sound, rich and poor alike are able to listen to the same music. Moreover, recordings of local and national musical styles from around the world have increasingly influenced each other. The rhythms and sounds of traditional Indian music, known as *ragas,* can be heard in Western music. Afro-pop, a blend of African music and rock, is popular worldwide. Music is no longer linked solely to formal occasions or to work but can be heard at all hours of the day, every day, and wherever listeners choose to listen.

Isaac's duties included those of organist and choirmaster at the Florence Cathedral as well as at the Medici Palace, where Lorenzo is known to have had no fewer than five organs. Together with Poliziano, he was also the teacher of Lorenzo's sons, one of whom was destined to be the music- and art-loving Pope Leo X. Most important, Isaac collaborated with Lorenzo on songs written for popular festivals. He thus became co-creator of one of the many kinds of popular secular music that eventually led to the sixteenth-century **madrigal.** The madrigal, often about love and designed for home performance and entertainment, was a well-liked type of vocal chamber music in the polyphonic style.

Dufay's settings of Lorenzo's verses have been lost, but many by Isaac still exist. In one of these he shows the tendency away from complex counterpoint and toward simple harmonic texture. He created music in the style of the Florentine **frottola,** a carnival song for dancing as well as singing. The collaboration of Lorenzo and Isaac resulted in both a meeting of minds and a merging of poetic and musical forms. Lorenzo's verses were a union of the courtly **ballata** and popular poetry, whereas Isaac succeeded in Italianizing the Burgundian *chanson,* or song. In this instance, Italianizing meant simplifying, omitting all artificiality, and enlivening a rather stiff form with graceful Florentine folk melodies and rhythms. This cultural tendency worked both ways, raising the level of popular poetry while simultaneously giving new life to more sophisticated poetic and musical forms through popular idioms.

IDEAS

The Florentine Renaissance clustered around three concepts: classical humanism, scientific naturalism, and Renaissance individualism. In their broadest meanings, these concepts were far from new. When classical humanism first took shape in Italy, it was as much the survival of ancient influences as a true revival in the sense of a reinterpretation and new adaptation of older Greco-Roman forms.

Naturalism, in the sense of faithfulness to nature, appears in a well-developed form both in northern Gothic sculpture and in the poetry of St. Francis. By the fourteenth century, representations of people and nature alike had lost their primary value as otherworldly symbols. Rather than being content with describing the world as seen by the eye alone, fifteenth-century naturalism took a noticeably scientific turn. Careful observation of natural events and the will to reproduce objects as the eye sees were evidence of a developing empirical attitude. Likewise, dissection of corpses to see the structure of the human body revealed a spirit of free inquiry. In addition, the study of mathematics to put objects into proper perspective involved a new concept of space. Clearly, a new scientific spirit was stirring.

The distinctive features of Florentine individualism were largely attributable to the access this small city-state gave to artists, who could come into immediate contact with their patrons and audience. Competition was keen; desire for personal fame was intense; and a high regard for individual

personality is seen in the portraiture, biographies, and autobiographies of patrons and artists.

Humanism in the humanitarian Franciscan sense was a carryover from the thirteenth and fourteenth centuries (see p. 237). Naturalism stemmed from late Gothic times, and, of course, some form of individualism is almost always present in any period. It should therefore be clear that the Florentine Renaissance was characterized by no sharp division from the past and that its special flavor lies in the quality of its humanism, in the direction of its naturalism, and in the distinctive nature of its individualism.

CLASSICAL HUMANISM

The term *Renaissance,* implying as it does a rebirth, is a source of some confusion. To the early sixteenth-century historian, it meant an awakening to the values of ancient classical arts and letters after the long medieval night. But just what, if anything, was reborn has never been satisfactorily explained. Because all the principal ideas were present in the Gothic period, one might do better to speak of the cultural conditions that encouraged the maturing of certain tendencies that were present in late medieval times. Yet there was a specific drive that gave an extraordinary stimulus and color to the creative life and thought of this small Tuscan city-state in the fifteenth century. It is important to discover what specific factors gave humanism in Florence its special flavor.

Although Florentine humanism evolved from the Franciscan spirit, it took on a consciously classical coloration that was not part of the Franciscan outlook. Here again, however, a word of caution is necessary when speaking of a "rebirth" of the spirit of antiquity. In Italy, much more than in northern Europe, the classical tradition had been more or less continuous. Roman remains were everywhere in evidence. Many Roman arches, aqueducts, bridges, and roads were still in use, and fragments of ancient buildings were reused as building materials.

In the late thirteenth century, Nicola Pisano's sculptural models were the Roman remains he saw all around him. By the fifteenth century, the revival of the classical male nude as an instrument of expression was seen in the work of Ghiberti, Donatello, Pollaiuolo, and Verrocchio. At the beginning of the sixteenth century, Michelangelo had developed such a formidable sculptural technique that his *David* (Fig. 9.30) rivaled the work of ancient sculptors such as Praxiteles (see Fig. 2.22).

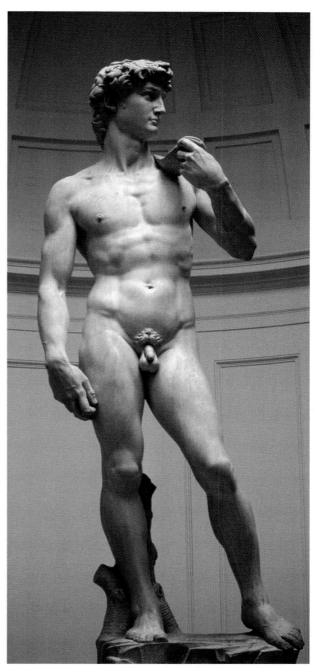

9.30 Michelangelo. *David*, 1501–1504. Marble, height 18′. Galleria dell'Accademia, Florence, Italy.

Aristotle was studied, and ancient musical theory continued to be taught. What was new to Florence was the study of the Greek language, the use of Roman Latin rather than medieval church Latin, and a passionate interest in Plato. Despite a concern for antique books and works of art, however, the net result was less a revival of things

past than a step forward. The Renaissance was a search for past examples to justify new practices.

Much has also been written about the pagan aspect of the appeal to antiquity. Here again it was less anti-Christian than it seems on the surface. Florentine interest in Plato was a conscious departure from scholastic thought, but it was mainly a substitution of the authority of Plato for that of Aristotle. Marsilio Ficino spoke of Plato as the Athenian Moses. He added "Saint" Socrates to the litany of saints and may have burned a candle before a bust of Plato. In this light, his thought appears more as a reinterpretation of Christianity in Platonic terms than a revival of paganism as such.

When the Florentine philosopher Pico della Mirandola said that "there is nothing to be seen more wonderful than man," he was picking up exactly where the ancient Greek thinkers had left off (see p. 58). Pico's famous *Oration* exalted human dignity. He placed humanity at the center of the universe and considered the human being "the intermediary between creatures, the intimate of higher beings and the king of lower beings, the interpreter of nature by the sharpness of his senses, by the questing curiosity of his reason, and by the light of his intelligence, the interval between eternity and the flow of time." According to Pico, humans have the possibility of descending to the level of brute beasts or the power to rise to the status of higher beings, which are divine. This confident picture of human potential and destiny animates the spirit of the great humanistic artists Botticelli, Michelangelo, and Raphael, and it is one of the most important keys to the interpretation of their works.

SCIENTIFIC NATURALISM

The two basic directions taken by the naturalism of the fifteenth century led to a new experimental attitude and a new concept of space. A close partnership between art and science developed, with architects needing to be mathematicians, sculptors becoming anatomists, painters learning geometry, and musicians studying acoustics.

The spirit of free inquiry was by no means confined to the arts. It penetrated all the progressive aspects of life of the time, from a reexamination of the forms of secular government to Machiavelli's candid reflections on how people behave under certain political circumstances. This searching curiosity reached its full fruition in the early years of the sixteenth century in Machiavelli's political handbook *The Prince.* Like Thucydides, the Athe-

nian historian he admired, Machiavelli attempted to create a dispassionate, chronological account of near-contemporary events and underlying causes in his *History of Florence* (see p. 274). The scientific observations in Leonardo's notebooks, which cover everything from astronomy to zoology, show a similar passion for inquiry.

Well within the fifteenth century, the same spirit continued to manifest itself. Ghiberti's *Commentaries* pointed to the mathematical proportions of the human body as the basis of its beauty, and he wrote the first essay in Italian on optics. Brunelleschi, a diligent student of the Roman architect Vitruvius, was concerned with the mathematical and harmonic proportions of his buildings. Alberti, in his books on painting, sculpture, and architecture, stressed the study of mathematics as the underlying principle of all the arts. Leonardo also took up this theme by demonstrating the geometric proportions of the human body in his well-known drawing (see Fig. 2.39).

The sculptors and painters who followed the leadership of Antonio Pollaiuolo and Verrocchio were animated by the desire to express the structural and muscular forms of the body beneath its external appearance. Their anatomical studies opened the way to the modeling of the movements and gestures of the human body. The result was the reaffirmation of the expressive power of the nude.

In painting, naturalism meant more faithful representations based on detailed and accurate observation. Even Fra Angelico showed an interest in the exact reproduction of Tuscan botanical specimens in the garden of his *Annunciation.* Under the influence of Pollaiuolo and Verrocchio, Botticelli combined the objective examination of nature with imaginative subjects. The culmination of this line of thought was reached in the work of Verrocchio's pupil Leonardo da Vinci, who considered painting a science and sculpture a mechanical art. Leonardo's scientific probing went beyond the physical and anatomical into the metaphysical and psychological aspects of human nature.

In music, interest in Greek theory continued, coupled, however, with experiments. The compositions of Dufay and others of the northern school applied mathematical laws to such aspects of composition as rhythmical progressions, formal proportions, and the development of technical devices.

The exploration of geographic space that began with the voyages of Columbus, led to the development of trade routes and commerce and the

tapping of distant sources of wealth. In architecture, the concentration on space is reflected in the raising of Brunelleschi's cupola almost 370 feet high. In painting, it is seen in a number of advances. Among them are the placing of figures in a more normal relationship to the space they occupy and the use of landscape settings. Other steps forward include Masaccio's development of atmospheric perspective, in which figures are modeled in light and shade, and the working out of rules for linear perspective, whereby the illusion of depth on a two-dimensional surface is achieved by defining a point at which lines converge. **Foreshortening,** the reduction in the size of figures and objects in direct ratio to their distance from the **picture plane,** is yet another element of progress toward more naturalistic portrayals.

Because the subject matter of medieval art was drawn from the spiritual world, naturalistic representation was not a major goal. But during the Renaissance, art entered a new phase of self-awareness as artists began to ponder purely aesthetic problems, modes of presentation, and pictorial mechanics. In medieval music, the emphasis had been on perfect intervals and mathematical rhythmic ratios to please the ear of God. Renaissance musicians were willing to render sounds that would delight the human ear. The new spirit was also heard in the extension of the range of musical instruments into both higher and lower registers, thus broadening the scope of tonal space. The development of pleasant harmonic textures, the softening of dissonances, and the writing of singable melodies and danceable rhythms all contributed to the period's new outlook.

In the trend toward scientific naturalism, the arts of painting and sculpture became firmly allied with geometric and scientific laws, a union that lasted until twentieth-century Expressionism and abstract art. Indeed, the fifteenth-century Florentine artists reveled in the perspective, optical, and anatomical discoveries of their day. When the basic research, experiments, and discoveries were decisively under way, it was left for their successors—Leonardo da Vinci, Michelangelo, and Raphael—to explore the full possibilities.

RENAISSANCE INDIVIDUALISM

In the Renaissance, the desire for personal prestige through art was a prime concern. Wealthy families and individuals commissioned artists to build memorial churches and chapels and to create statues and paintings. The high regard for

individual personality was also mirrored in the number and quality of portraits painted during this time. Because artists were so eagerly sought after, their social status rose accordingly, and sculptors and painters became important thinkers who developed distinctive styles.

Private patronage began to rival church patronage. Brunelleschi built the Pazzi Chapel, Masolino and Masaccio decorated the Brancacci Chapel, and Benozzo Gozzoli and Fra Filippo Lippi did the paintings for the Medici Chapel, all on commission from private donors as memorials to themselves and their families. San Lorenzo, the parish church of the Medici, was rebuilt and redecorated by Brunelleschi and Donatello—but the money came from Cosimo, not from the church. Fra Angelico decorated the corridors of the monastery of San Marco, which was under the protection of the Medici family, and Squarcialupi and Isaac were on the payroll of the Medici when they played the organ in the cathedral, in a church, or in the family palace. Piousness and the desire for spiritual salvation were not the only motives for such generosity. The donor's lasting fame depended on building monuments and choosing distinguished artists to decorate them.

Certain technical considerations within the arts themselves point toward individualization and recognition of the viewer. The development of perspective drawing, for example, implied that the subject in the picture—whether a Madonna, a saint, or an angel—was definitely placed in this world rather than symbolically in the next. Hence, the figure was on a more equal basis with the observer. The unification of space through the convergence of all the lines at one point on the horizon tended to flatter the spectator. Through its clear organization of lines and planes, linear perspective makes it seem that everything is seen from a single optical vantage point—that of the observer. The artist visually implies that nothing of importance lies outside the painting and that the entire picture can be taken in at a glance.

Human figures, whether rendered as prophets or as portraits, tended to become more personal and particularized. Each statue by Donatello, be it *Lo Zuccone* or his *David,* was an individual person who made a powerful, unique impression. Even the pious Fra Angelico gave that most ethereal of creatures, an angel, the bodily weight of a gravity-bound human. Whether the medium was marble, terracotta, paint, words, or sounds, a new emphasis was placed on human individuality. Whether the picture was a barely disguised family group, like Botticelli's *Adoration of the Magi,* or a personal portrait, like

Verrocchio's bust of Lorenzo (Fig. 9.31), the figures were differentiated personages rather than stylized abstractions. Even though Lorenzo de' Medici was the most powerful political figure in Florence, Verrocchio saw him as a man.

The high social status of Florentine artists was evident in the inclusion of self-portraits in such paintings as that of Benozzo Gozzoli in his *Journey of the Magi* and the prominent position Botticelli allowed himself in his *Adoration of the Magi.* Ghiberti's personal reminiscences in his *Commentaries* were probably the first autobiography of an artist in history. His inclusion of the lives and legends of his famous fourteenth-century predecessors were the first biographies of individual artists. He also included a self-portrait in one of the round medallions in the center of his famous doors. Signatures of artists on their works were becoming the rule, not the exception. The culmination of this trend came when Michelangelo realized that his style was so highly individual that he no longer needed to sign it. The desire for personal fame grew to such an extent that Benvenuto Cellini no longer was content to let his works speak for him and wrote a lengthy autobiography filled with self-praise. The painter Giorgio Vasari likewise took up the pen to record the lives of the artists he knew personally and by reputation.

In late medieval and early Renaissance times, artists were mostly seen as practitioners of crafts. They were trained as apprentices to grind pigments, carve wooden chests, make engravings, and prepare wall surfaces for frescoes, as well as to carve marble reliefs and paint pictures. In the late fifteenth and early sixteenth centuries, however, handwork was not enough for artists. They had to know the theory and history of art and the place of art and the artist in the intellectual and social atmosphere of their period.

RENAISSANCE SELF-IMPROVEMENT BOOKS: CASTIGLIONE AND MACHIAVELLI

Two Italian literary works published early in the sixteenth century round out the picture of Renaissance humanism and individualism: Machiavelli's *The Prince,* written in 1513 and published in 1532, after his death, and Castiglione's *Book of the Courtier* (1518). One is a handbook for achieving success as a political leader; the other is a manual of courtly manners and etiquette. Niccolò Machiavelli's very name has become a part of our language. To act in a "Machiavellian" manner denotes devious and manipulative behavior. This negative ascription, however, overlooks Machiavelli's monumental intellectual honesty and his status as one of the founders of modern political science. Since its appearance, *The Prince* has remained high on the list of recommended reading for every would-be politician, political observer, and entrepreneur.

Machiavelli declared that "a prince must not keep faith when by doing so it would be against his self-interest." But he also pointed out that "the voice of the people is the voice of God." Like a good scientist, Machiavelli isolated his subject from extraneous considerations to study and describe it more precisely. In practice, this meant divorcing politics from ethical and religious considerations. As a pragmatist, Machiavelli held that whatever works in the power game is good and whatever fails is bad. Well versed in the classics, Machiavelli had as a starting point Aristotle's dictum that "man is a political animal." From his own experience as a diplomat for his native Florence and from his keen powers of observation, he concluded that people are primarily self-seeking and basically evil. In matters of statecraft, he held

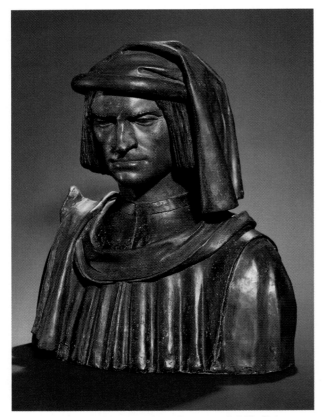

9.31 Andrea Del Verrocchio, *Lorenzo de' Medici,* c. 1478. Terra-cotta, 2′1⅛″ × 1′11¼″ × 1′⅛″. National Gallery of Art, Washington, D.C., Samuel H. Kress Collection.

that the end justifies the means and that what is morally right or wrong is beside the point. He believed that a ruler must be cunning as a fox and fierce as a lion: "The one who knows best how to play the fox comes out best, but he must understand well how to disguise the animal's nature and must be a great simulator and dissimulator. So simple-minded are men and so controlled by immediate necessities that a prince who deceives always finds men who let themselves be deceived." Machiavelli counseled that "it is much safer for a prince to be feared than loved."

In any state, the rights of the people are important if domestic peace and stability are to be maintained. However, when dissenters appear, the people can be managed only by a hardheaded ruler who knows how to utilize factions to his own best advantage. Divide and conquer was Machiavelli's guiding principle. He also believed that princes needed to maintain a style befitting their position. He saw the arts as useful to propaganda, and writers, painters, and musicians as valuable instruments to impress a ruler's rivals as well as his own subjects.

Baldassare Castiglione's *Courtier* was written at the glittering court of Urbino. In the form of a lively dialogue recalling Plato's *Symposium,* its subject is the deportment and accomplishments expected of the lords and ladies who participated in courtly life. Courtiers, Castiglione wrote, should be persons of wide humanistic learning. Unlike Machiavelli, he also required of them high ethical standards. In addition to mastery of martial arts and physical skills, a courtier should be a connoisseur of the arts; a wise and witty conversationalist; a poet; and a graceful dancer, singer, and musician. Some of these qualities shine through Raphael's dignified portrait of Castiglione (Fig. 9.32). Castiglione also explored the role of women in high social circles. He held that men and women should be equally educated except in the arts of war and that women should be able to lift their voices in song, participate in discussions, and be knowledgeable about literature and painting.

In many ways, the lot of Renaissance women resembled that of women in ancient Rome. Marriages of noble and upper-class women were used to forge political and commercial alliances. The rich costumes, jewelry, and other paraphernalia in marriage portraits of wealthy women catalogued the assets as well as the gentility they would bring to the union. The education of women was increasingly deemed necessary for the role of mother. As in medieval times, women in religious orders often had access to large libraries. Women of means influenced political and business decisions and were

sometimes patrons of the arts in their own right, as well as with their spouses. Of course, poor women continued to serve as caregivers and co-workers in family businesses and farming. In the arts, the female figure presented an ideal of beauty.

Nevertheless, the narrow scope of women's collective presence and the widely accepted disparaging attitude toward women's abilities prompted scholars of the late twentieth century to pose the question, "Did women have a Renaissance?" Women were largely excluded from the animated humanism of Pico della Mirandola and Machiavelli, both of whom encouraged men to use their willpower to improve themselves and broaden their interests. Generally speaking, exertions of this very kind would have been judged unsuitable or even dangerous to a woman's femininity.

Nevertheless, in the sixteenth century, notions of self-improvement through the humanities began to be applied to highborn women. Among a few noble and wealthy families, women not only studied but occasionally wrote about the arts. Science and mathematics, cornerstones of Renaissance art, were still considered too masculine for the feminine sensibility. In the northern Italian town of Cremona, the talented daughter of a noble

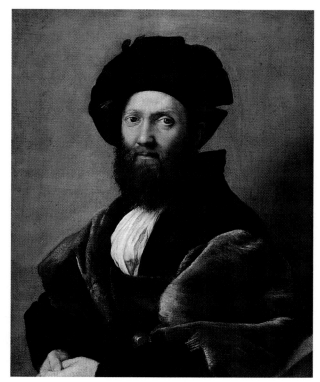

9.32 Raphael. *Baldassare Castiglione,* 1514–1515. Oil on panel (transferred to canvas), approx. 2′6¼″ × 2′2½″. Louvre, Paris, France.

family, Sofonisba Anguissola, and her sisters were educated in music and painting. While raising some conventional doubts about the coexistence of femininity and talent, Vasari dubbed her a *virtuosa*—that is, an exceptional woman. Her eye-teasing self-portrait, presenting herself as if she were being painted by a male artist, highlights her confidence and ability (see Fig. 12.17). She achieved an international reputation as a court painter to King Phillip II of Spain, where her social class and education allowed her to serve as a lady in waiting to the queen.

One of the qualities most admired by Castiglione and other Renaissance writers was *virtù*. Virtù revealed itself in the confidence, stamina, and self-actualizing ability that led to the achievements of a Lorenzo the Magnificent or the breathtaking conceptions of a Michelangelo. To achieve virtù, Renaissance artists could no longer be completely satisfied with a single specialty; rather, they sought to become universal in their interests and activities. For example, in addition to being one of the leading lights of Renaissance architecture, Brunelleschi was also a goldsmith, sculptor, engineer, and mathematician.

Castiglione articulated the Renaissance ideal of the **uomo universale,** the universal man, who embodied all the aspects of Renaissance humanism and individualism in one person. An artist who approached this ideal was Leon Battista Alberti, who in his youth excelled in feats of athletic strength and extraordinary horsemanship. In maturity, he mastered mathematical skills and scientific knowledge. He was a noted Latin stylist and a practicing musician, painter, sculptor, architectural designer, and city planner. His work was summed up in three influential treatises on painting, sculpture, and architecture, which provided the foundation of the Renaissance theory of art.

Alberti believed that all people can do all things if they have the will to do so. He was not only a universal man himself but the prototype for his high Renaissance successors, Leonardo da Vinci and Michelangelo. In Leonardo, Renaissance universality reached a peak. Michelangelo shunned courtly life in favor of his studio, preferring to deal with popes and princes as equals and rejecting all offers of noble titles. He realized his potential by becoming the ranking sculptor, painter, poet, and architect of his day. When people began calling him "the divine," the cycle was complete.

The later years of the fifteenth century were dark ones for Florence. After Lorenzo's death in 1492, his son and heir Piero (aptly called "the Unfortunate") made a series of political blunders that led to the conquest of Florence by the French king Charles VIII. In 1494, Piero was forced to leave the city. In his wake, the fiery monk and reformer Savonarola came to power. He held bonfires on a regular basis to burn earthly vanities, including priceless manuscripts and works of art. For several years, Florence waned as a center of cultural invention. All its major artists with the exception of Botticelli, whose ties to the Medicis continued for decades, fled to other centers, particularly to Rome, where the popes were embarking on ambitious building projects that demanded all manner of sculptural and painterly embellishments.

YOUR RESOURCES

- ***Exploring Humanities CD-ROM***

 ○ Interactive Map: Italy around 1400, Renaissance Florence

 ○ Readings—Niccolò Machiavelli, *The Prince,* selected chapters

- ***Web Site***

 http://art.wadsworth.com/fleming10

 ○ Chapter 9 Quiz

 ○ Links—Online readings: *Book of the Courtier*

FIFTEENTH-CENTURY FLORENCE

Key Events	Architecture	Visual Arts	Literature and Music
	1377–1446 **Filippo Brunelleschi**	1374–1438 **Jacopo della Quercia** ●	1304–1374 **Petrarch (Francesco Petrarca)** ◆
	1396–1472 **Michelozzo di Bartolommeo**	1378–1455 **Lorenzo Ghiberti** ●	1313–1375 **Giovanni Boccaccio** ◆
		1386–1466 **Donatello** ●	
		c. 1395–1455 **Fra Angelico** ▲	
		1397–1475 **Paolo Uccello** ▲	

1400

Key Events	Architecture	Visual Arts	Literature and Music
1406 **Pisa** comes under Florentine rule	1404–1472 **Leone Battista Alberti**	c. 1400–1461 **Domenico Veneziano** ▲	1400–1474 **Guillaume Dufay** ❏
1434 **Pro-Medici government** elected; Cosimo de' Medici began rule	1420–1436 **Brunelleschi** built dome of Florence Cathedral	1400–1482 **Luca della Robbia** ●	c. 1410–1497 **Jean de Ockeghem** ❏
1434–1443 **Pope Eugene IV** resided in Florence	c. 1429 **Pazzi Chapel** begun by Brunelleschi	1401–1428 **Masaccio** ▲	1416–1480 **Antonio Squarcialupi** ❏
1439–1442 **Council of Florence** nominally united eastern and western churches	1436 **Florence Cathedral** dedicated by Pope Eugene IV (begun 1298)	1401 **Competition for Florence Bapistry** north doors held	1433–1499 **Marsilio Ficino** ○
1447 **Parentucelli,** Florentine humanist elected as Pope Nicolas V	1444–1459 **Medici–Riccardi Palace** built by Michelozzo	c. 1402 **Donatello** studied ancient sculpture in Rome	1436 **Dufay** wrote choral motet for dedication of Florence Cathedral
		1403–1424 **Ghiberti** worked on Bapistry north doors	1440–1521 **Josquin Desprez** ❏
		c. 1406–1469 **Filippo Lippi** ▲	1449–1492 **Lorenzo de' Medici** ◆
		c. 1416–1492 **Piero della Francesca** ▲	
		c. 1419–1457 **Andrea del Castagno** ▲	
		1420–1497 **Benozzo Gozzoli** ▲	
		1425–1452 **Ghiberti** worked on Florence Bapistry east doors ("Gates of Paradise")	
		c. 1432–1498 **Antonio Pollaiuolo** ●	
		1435–1488 **Andrea del Verrocchio** ●	
		1444–1510 **Sandro Botticelli** ▲	
		1449–1494 **Domenico Ghirlandaio** ▲	

1450

Key Events	Architecture	Visual Arts	Literature and Music
1453 **Constantinople** falls to Ottoman Turks; end of Eastern Roman Empire		c. 1450–1523 **Perugino** ▲	c. 1450–1517 **Heinrich Isaac** ❏
1464–1469 **Piero de' Medici** ruled after Cosimo's death		1452–1519 **Leonardo da Vinci** ▲	1454–1494 **Angelo Poliziano (Politian)** ◆
1469–1492 **Lorenzo de' Medici** ruled		c. 1457–1504 **Filippino Lippi** ▲	c. 1457–1505 **Jacob Obrecht** ❏
1478 **Pazzi** family's unsuccessful revolt against Medici; Giuliano de' Medici died, Lorenzo consolidated power		1475–1564 **Michelangelo Buonarroti** ▲	c. 1460–1480 **Lorenzo de' Medici** wrote poetry, including carnival songs
1489 **Savonarola** (1452–1498) preached moral reform	c. 1485 **Alberti's treatise** *On Architecture* printed	c. 1485 **Alberti's treatises printed;** *On Painting* (1436), *On Sculpture* (1464)	1462 **Cosimo de' Medici** founded Platonic Academy
1490 **Aldine Press** in Venice began printing works of Plato and Aristotle		1489 **Michelangelo** apprenticed to Ghirlandaio	1463–1494 **Pico della Mirandola** ○
1492 **Lorenzo de' Medici** died			1466–1482 **Marsilio Ficino's** translations of Plato's *Dialogues*
1494 **Medici** exiled from Florence; government dominated by Savonarola			1467 **Squarcialupi** organist in Florence and music teacher to Medici household
1497 **Bonfires** of "Vanities"			1469–1527 **Niccolò Machiavelli** ○
1498 **Savonarola** burnt at stake			1478–1529 **Baldassare Castiglione** ◆
			c. 1480 **Heinrich Isaac** succeeded Squarcialupi as organist at Florence Cathedral; also served as court composer for Lorenzo de' Medici and teacher of his children

1500

Key Events	Architecture	Visual Arts	Literature and Music
		1501–1504 **Michelangelo** carved *David*	1518 **Baldassare Castiglione** wrote *The Courtier*
			1532 **Machiavelli** published posthumously *The Prince*

❏ - Musician ▲ - Painter ○ - Philosopher ● - Sculptor ◆ - Writer

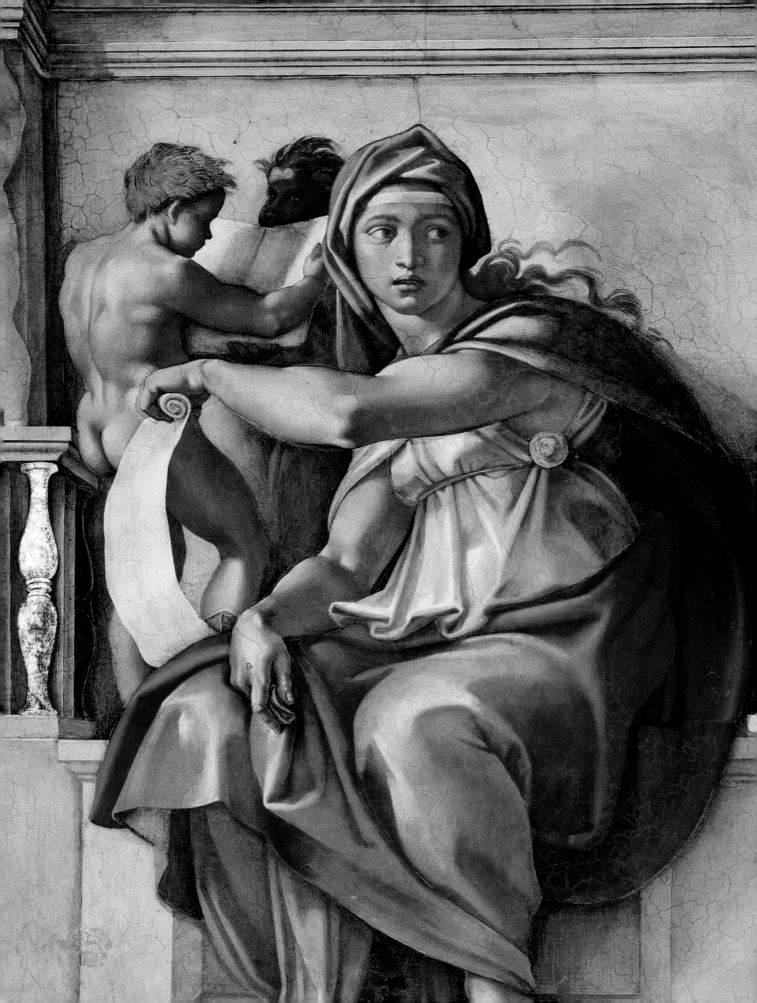

CHAPTER

10

ROMAN RENAISSANCE STYLE

ON APRIL 18, 1506, WHEN the foundation stone of the new Basilica of St. Peter was laid (Fig. 10.1), Rome was well on its way to becoming the major artistic, intellectual, and cultural capital of the Western world. Pope Julius II was gathering about him the foremost artists in all fields, and together they continued the transformation of the Eternal City from its medieval past into the brilliant Rome of today.

Donato Bramante, originally from Urbino but educated in Lombardy, was the architect at work on the plans for the new St. Peter's, the cen-

tral church of the Christian world. Michelangelo Buonarroti from Florence was collecting the marble for a monumental tomb for Pope Julius and was about to begin painting the Sistine Chapel ceiling. Soon Raffaello (Raphael) Sanzio of Urbino would be summoned from Florence to decorate rooms in the Vatican Palace. At about the same time, the Florentine Andrea Sansovino was carving a cardinal's tomb in one of Julius II's favorite Roman churches, Santa Maria del Popolo, where the Umbrian Pinturicchio was covering the choir vaults with a series of frescoes. The

10.1 St. Peter's Basilica and the Vatican, Rome. Apse and dome by Michelangelo, 1547–1564; dome completed by Giacomo della Porta, 1588–1592; nave and facade by Carlo Maderno, 1601–1626; colonnades by Gian Lorenzo Bernini, 1656–1663. Height of facade 147′, width 374′, height of dome 452′.

singer-composer Josquin Desprez, who had been a member of the papal choir for 8 years, recently left to become choirmaster to the king of France.

The papal court under Julius II and his successor, Leo X, was such a powerful magnet that for 3 years the three greatest figures of the Renaissance—Leonardo da Vinci, Michelangelo, and Raphael—were working for the Vatican. In 1517, however, the aged Leonardo left Rome to join the court of Francis I of France.

The flight of the Medici from Florence in 1494 (see p. 276) had signaled a general exodus of artists from that city. Many found temporary havens in the ducal courts of Italy, but Rome proved an irresistible attraction. Hence, during the days of the two great Renaissance popes, Julius II and Leo X, the cultural capital shifted from Florence to Rome. Because Leonardo, Andrea Sansovino, Michelangelo, and Pope Leo were from Florence and because Bramante and Raphael had absorbed the Florentine style and ideas during extended visits there, Florentine influence was felt in the art of Rome. At the same time, the shift from Florence to Rome encouraged artists to branch out.

Large projects such as the building of the world's biggest church and the construction of Julius II's tomb, as well as the painting of the Sistine ceiling and of the Vatican Palace walls, were found only in Rome. The cardinals, who maintained Roman palaces that rivaled the brilliance of the papal court, were also generous patrons of the arts. Nowhere else were commissions of such magnitude available.

The interest in antiquity animated many other Italian cultural centers, but as the Renaissance got under way in Rome, it was, so to speak, on home soil. When antique statues were excavated elsewhere, they caused a considerable stir. In Rome, however, many renowned ancient monuments were still standing. Moreover, as a result of the revived interest in archeology, a veritable treasure trove was revealed. First the *Apollo Belvedere* (see Fig. 3.20) and then the *Laocoön Group* (see Fig. 3.17) came to light and stimulated the work of Michelangelo and other sculptors. The frescoes from Nero's Domus Aurea and the Baths of Titus provided the first important specimens of ancient painting. Although the art of painting on fresh plaster had never died out, the techniques

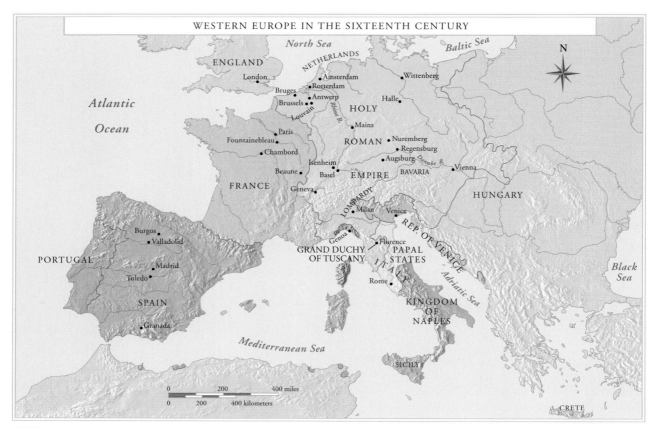

MAP 10.1

and themes in these ancient Roman fragments gave fresco painting a new impetus.

Julius II had received most of his training in diplomacy and statecraft from his uncle, Pope Sixtus IV. Fortunately, a passionate love of the arts was included in his education. It was Sixtus who had built the chapel that subsequently carried his name, and who had installed there the group of papal singers that has ever since been known as the *Cappella Sistina,* or Sistine Chapel Choir. It remained for Julius to establish a chorus to perform in St. Peter's—one that still bears his name, the *Cappella Giulia,* or Julian Choir. This latter group corresponded to the Early Christian Schola Cantorum (school for singers) and prepared the singers for the Sistine Choir. Both received strong papal support.

Essentially a man of action, Julius II was an expert with the sword as well as the bishop's staff. The spectacle of the pope riding into battle had a demoralizing effect on his enemies. As one of the principal architects of the modern papacy, he also saw the need for a setting on a scale with the importance of the church founded by St. Peter, and he made it a matter of policy to command artists as well as soldiers. At the end of his career,

Julius II became the subject of one of Raphael's most penetrating portraits, showing the Pope bent down by time and the stress of rebellion among his cardinals and bishops (Fig. 10.2).

When Leo X ascended the papal throne, a popular saying went, "Venus has had her day, and Mars his, now comes the turn of Minerva." Venus symbolized the reign of the Borgia pope, Alexander VI; Mars, of course, referred to Julius II; and Minerva, the Roman equivalent of Athena, was Leo. As the son of Lorenzo the Magnificent, he brought to Rome the intellectual spirit of Florence, a latter-day Athens. Michelangelo, whom Leo had known since his childhood at the Medici palace, was unfortunately bound by the terms of his contract to serve the heirs of Pope Julius. Fortunately, the suave and worldly Raphael was available, and he was more congenial to the personal taste of Pope Leo than the gruff Michelangelo. Once again, Raphael served as papal portraitist in a diplomatically adept yet frank study that shows the pope with two cardinals who are, not coincidentally, his nephews (Fig. 10.3).

Heinrich Isaac, Leo's old music teacher, wrote the six-part motet that commemorated his accession. In turn, Isaac's pupil became one of the most

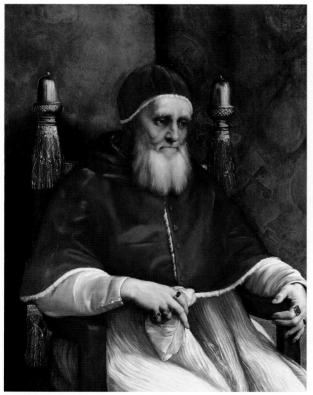

10.2 Raphael. *Pope Julius II,* 1511–1512. Oil on wood, 2′½″ × 2′7½″. National Gallery, London, England.

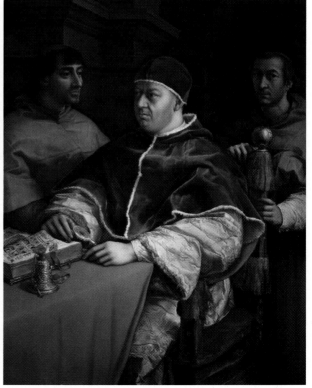

10.3 Raphael. *Leo X with Two Cardinals,* c. 1518. Oil on wood, 5′⅝″ × 3′8⅞″. Galleria degli Uffizi, Florence, Italy.

liberal of all Renaissance patrons of music. Other princes of Europe had difficulty keeping their best musicians because the Pope's love of music was so well known. Leo collected lute and viol players, organists, and the finest singers. Chamber music was avidly cultivated at the papal palace, and a wind ensemble performed at papal dinners. Leo's encouragement of music put it on a par with literary pursuits, causing irritated murmurings among poets and writers. As a competent composer in his own right, Leo knew the art from the inside as few patrons knew it. As a philosopher, writer, and collector, his patronage, like that of his father, Lorenzo the Magnificent, was accompanied by active participation in many of the pursuits that he sponsored.

SCULPTURE: MICHELANGELO

Despite his many masterpieces in other media, Michelangelo always thought of himself first and foremost as a sculptor. He undertook other projects reluctantly. On the contract for the painting of the Sistine Chapel ceiling, for example, he pointedly signed *Michelangelo scultore* (Michelangelo the sculptor) as a protest. His first visit to Rome at the age of 21 coincided with the discovery of some ancient statuary, including the *Apollo Belvedere* (see Fig. 3.20). His most important statues from this early period illustrate the pull of pagan and Christian ideals that affected his aesthetic thought throughout his long career.

10.4 Michelangelo. *Pietà,* 1498–1499. Marble, height 5′9″. St. Peter's Basilica, Rome, Italy.

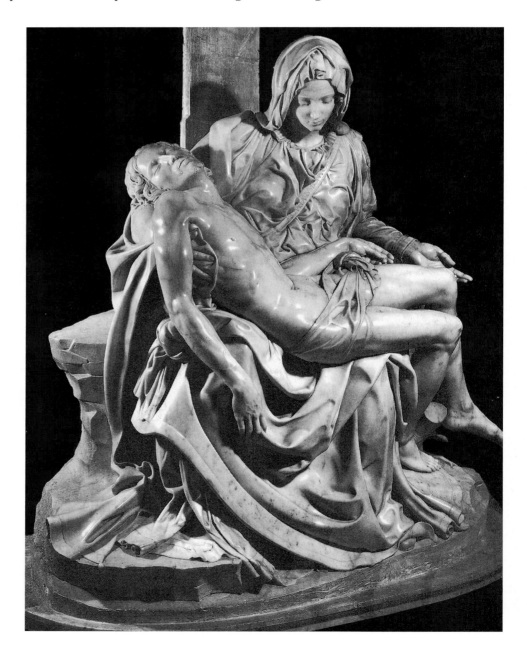

THE *PIETÀ*

The *Pietà* (Fig. 10.4), now in St. Peter's, was commissioned in 1498 by Cardinal Villiers, the French ambassador to the Vatican. Its beauty of execution and delicacy of detail reveal Michelangelo's debt to the Florentine Renaissance. Its pyramidal composition follows a type worked out by Piero della Francesca (see Fig. 9.21) and by Leonardo da Vinci, seen in his drawing for *Madonna and Child with St. Anne and the Young St. John* (see Fig. 9.25). Michelangelo uses the voluminous folds of the Virgin's drapery as the base of the pyramid and her head as the apex.

Michelangelo cast the figure of Christ in the form of a Greek god. The Madonna, although overwhelmed by grief, maintains a classical composure. No tears, no outcry, no gesture mar this conception of Mary as the stoic mother of sorrows. Yet Michelangelo broke with classical ideas when he took symbolic liberties with the proportions of his figures to heighten their expressive effect and enhance the harmony of design. The extensive drapery exists to increase the brilliant execution of folds and sweeping lines. The horizontal body of Christ is far shorter than that of the vertical Madonna, but the disproportion makes the composition more compact. The triangular shape, as a self-sufficient form, holds the attention within the composition and makes external framing devices such as niches or architectural backgrounds unnecessary. In a sense, the *Pietà* is a sculptural declaration of independence, and it bears the distinction of being the only work Michelangelo ever signed (see the sash in Fig. 10.4).

A TOMB FOR A POPE

After finishing the *Pietà,* Michelangelo went home to Florence, where he worked on his *David* (see Fig. 9.30). In 1505, however, he was summoned back to Rome by the imperious Julius to discuss a project for a colossal tomb. In the original conception of this gigantic composition, the artist's imagination for once met its match in his patron's ambitions. Julius's monument was conceived as a small temple within the great new temple—St. Peter's—that was being built. It was to rise pyramidally from a massive quadrangular base and include more than forty statues (Fig. 10.5).

When Julius died in 1513, only parts of the project had been finished and a new contract with his heirs had to be negotiated. Further revisions were made later, each reducing the proportions of the project and eliminating more of the unfinished statues. In its final form of 1545, the monument had shrunk to the relatively modest wall tomb now in the aisle of the church of San Pietro in Vincoli.

Tombs of the popes, like the triple tiaras with which they were crowned, were traditionally

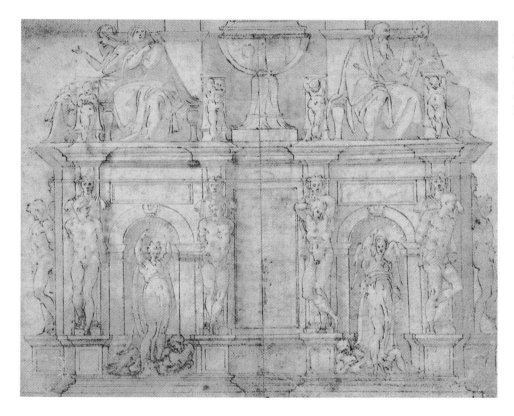

10.5 Michelangelo. Projected Tomb of Julius II. Drawing. Gabinetto dei Disegni e delle Stampe, Gallerie degli Uffizi, Florence, Italy.

constructed in three rising zones symbolizing earthly existence, death, and salvation. For the original project, Michelangelo translated these divisions into Neoplatonic terms that represent the successive stages of the liberation of the soul from its bodily prison. For the final project, the monument lapsed into more traditional stages. In the original scheme, the lowest level was to have figures symbolizing those who are crushed by the burden of life and those who rise above the bonds of matter. This idea was retained in some of the later revisions. Six of the so-called Slaves or Captives and one so-called Victory survive in various stages of completion.

On the second level of the original project there were to have been heroic figures of the leaders of humanity, those who pointed the way toward the divine goal of reunion with God. Moses and St. Paul were to represent the old and new laws, whereas Rachel and Leah would personify the active and contemplative ways of life. Of these, only the *Moses* was finished by Michelangelo himself.

The three figures that date from the years 1513 to 1516, when Leo X was pope, are the two Slaves now in the Louvre, and the *Moses*. *The Bound Slave* (Fig. 10.6) is the more nearly finished of the two, and it seems to represent a sleeping adolescent tormented by a dream rather than the "dying captive" it is sometimes called. The imprisoned soul, tortured by the memory of its divine origin, has found momentary peace in sleep. The cloth bands that bind the figure are only symbolic, because Michelangelo was not concerned with the visible aspect of captivity but rather with the internal torment. Here is the tragedy of the human race, limited by time but troubled by the knowledge of eternity; mortal but with a vision of immortality; bound by the weight of the body yet dreaming of a boundless freedom.

This tragedy of the tomb was understood only too well by Michelangelo himself, who had the conception of his great project in mind but was doomed to see only a few fragments of his dream completed.

In a later version of the tomb, Michelangelo sustained the Platonic idea of the human soul confined in the bonds of flesh (Fig. 10.7). In the *Captives,* the imprisonment of the spirit by matter is almost total. Unconscious, clasped in stony wombs, they struggle and writhe to emerge from their bondage. Their unfinished state offers an interesting glimpse into Michelangelo's methods, which resemble techniques used to create relief sculpture. To Michelangelo, the finished statue was a potential form hidden in the block of marble awaiting the hand of the master sculptor to re-

lease it. "The greatest artist has no single concept which a rough marble block does not contain already in its core," he wrote in a sonnet. The artist-creator, he continues, must discover, "concealed in the hard marble of the North, the living figure one has to bring forth. (The less of stone remains, the more that grows)." The Neoplatonic implication is clear: the soul is entombed in the body and can be perfected into pure being only by a higher creative power.

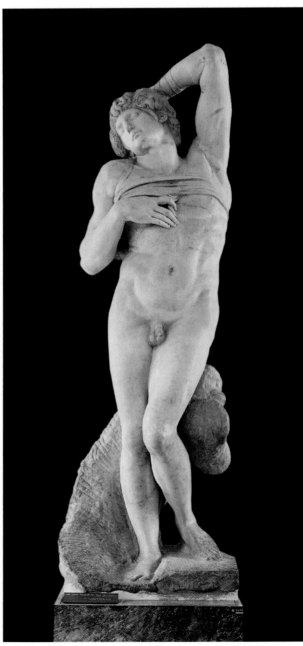

10.6 Michelangelo. *The Bound Slave,* 1513–1516. Marble, height 7′5″. Louvre, Paris, France.

Moses (Fig. 10.8) is the only statue completed entirely by Michelangelo to find its place in the finished tomb. Both Julius II and Michelangelo possessed the quality of **terribilità,** or "awesomeness," that is embodied in this figure. Julius was known as *il papa terribile,* meaning the "forceful pope" or "powerful pope." Michelangelo conceived his *Moses* as the personification of Julius's commanding will. It was also an idealized portrait of the determined Julius, who, as the formulator of a code of church laws, had something in common with the ancient Hebrew lawgiver Moses. In addition, Moses seems to be portrayed as the personification of elemental natural forces. He is the human volcano about to erupt with righteous wrath, the dead center of a hurricane of emotional fury, the messenger of those thunderous "Thou shalt nots" of the Ten Commandments. The smoldering agitation revealed through the drapery, the powerful musculature of the arms, the dominating intelligence of the face, the fiery mood, and the twisting of the body are characteristic of Michelangelo's style. An interesting detail is the carved irises of the eyes, found earlier in his *David* (see Fig. 9.30), which Michelangelo did to express a look of fixed determination. When he wanted to convey the qualities of dreaminess, gentleness, and resignation, as in his Madonnas, he left the eyes untouched. The curious horns on Moses's head were an iconographic tradition from medieval days. They stem from a mistranslation in St. Jerome's Latin version of the Old Testament, which should have read "rays of light."

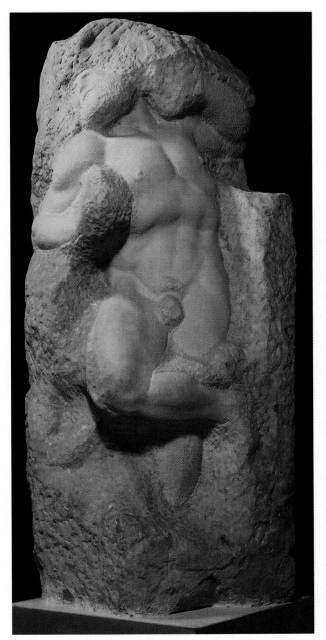

10.7 Michelangelo. "Boboli Captive," c. 1530–1534. Marble, height 7′6½″. Galleria dell'Accademia, Florence, Italy.

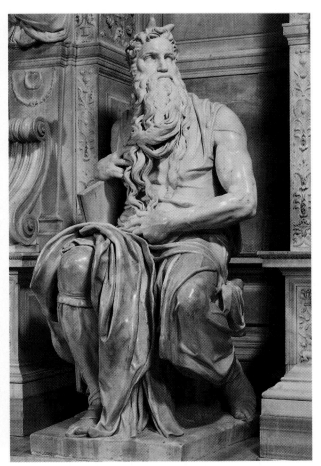

10.8 Michelangelo. *Moses,* 1513–1515. Marble, height 8′4″. San Pietro in Vincoli, Rome, Italy.

Michelangelo worked when examples of antique statuary were being unearthed and admired, and his work was often compared favorably with that of the classical sculptors. Michelangelo, like the Greco-Roman artists, saw men and women as the monarchs of creation, yet he was indifferent to their natural environment. His early art affirmed the supreme place of humanity in the universal scheme of things. His world was populated by godlike beings at the peak of their physical power, full of vitality, creativity, and self-confidence.

As Michelangelo's art matured, the men and women he portrayed were beset with quite unclassical tensions, doubts, and conflicts. Unlike those of antiquity, his figures are armed with mental and moral powers that imply the hope of victory in the struggle against fate. Having successfully rivaled the art of the Greco-Roman sculptors as well as that of his own time, not only in his technical mastery but in his expressive power, Michelangelo was regarded with awe by his contemporaries. In his biography of the artist, Giorgio Vasari wrote, "The man who bears the palm of all the ages, transcending and eclipsing all the rest, is the divine M. Buonarroti, who is supreme not in one art only but in all three at once."

PAINTING

MICHELANGELO PAINTS THE SISTINE CEILING FRESCOES

When Michelangelo left Rome out of frustration over the plans for Julius II's tomb, the pope resorted to every means from force to diplomacy to

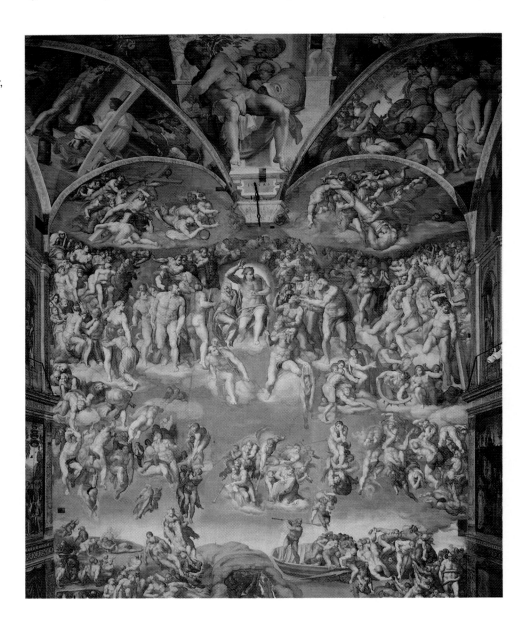

10.9 Sistine Chapel, viewed toward Michelangelo's *Last Judgment* over the altar, 1473–1480. Height of ceiling 68′. Vatican Palace, Rome, Italy.

get him to return. Knowing he had a restless genius on his hands, Julius conceived some interim projects to keep Michelangelo busy until the problems with his tomb could be solved. Thinking it could be done quickly, the pope set Michelangelo to paint the ceiling of the Sistine Chapel.

THE SISTINE CEILING. The building itself, whose roof can be seen paralleling the nave on the right of St. Peter's in Figure 10.1, was built by Julius's uncle, Pope Sixtus IV, as the private chapel of the popes. The interior consists of a single rectangular room 44 feet wide and 132 feet long (Fig. 10.9). Frescoes painted by the foremost fifteenth-century artists, including the Florentines Ghirlandaio (one of Michelangelo's teachers), Botticelli, and Perugino (the teacher of Raphael), decorated the walls.

Six windows were above the frescoes in the side walls. Overhead, the barrel-vaulted ceiling extended 68 feet above the floor, with 700 square yards of surface available for decoration. Using the traditional fresco technique (see pp. 223–224), Michelangelo set to work.

The artist conceived the Sistine ceiling as an organic union of philosophy and design (Fig. 10.10). Its iconography is a fusion of traditional Hebrew–Christian theology and the Neoplatonic philosophy that Michelangelo knew from his days in the Medici household. The ceiling space is divided into painted geometric forms, such as the triangle, circle, and square, which in Plato's philosophy were the eternal forms that furnish clues to the true nature of the universe. Next is a three-way division into zones, the lowest consisting of eight concave triangular

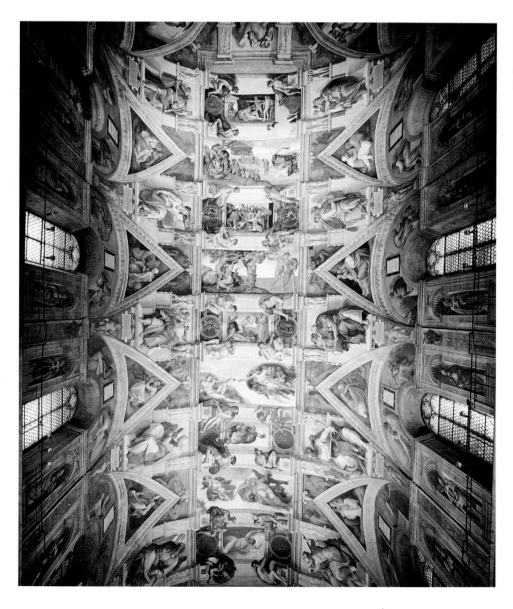

10.10 Michelangelo. Ceiling, Sistine Chapel, 1508–1512. Fresco, 44′ × 128′. Vatican Palace, Rome, Italy.

spaces above the windows and four domed corner spaces. The intermediate zone includes all the surrounding space except that given to the nine center panels, which in turn form the third zone.

Symbolically, these divisions correspond to the three Platonic stages: the world of matter, the world of becoming, and the world of being. Plato also thought in threes when he divided society into classes: workers, free citizens, and philosophers, symbolized by brass, silver, and gold, respectively. Each stratum had its characteristic goal: the love of gain, the development of ambition, and the pursuit of truth. Learning was similarly broken down into the three stages of ignorance, opinion, and knowledge. In addition, Plato's theory of the human soul was tripartite in nature, consisting of the appetitive, emotional, and rational faculties, located in the abdomen, breast, and head, respectively. Of these only the rational part could aspire to immortality.

On the lowest outside level, Michelangelo placed unenlightened men and women imprisoned by their physical appetites and unaware of the di-

vine word. In the intermediate area are the inspired Old Testament prophets and pagan sibyls, whose writings and prophecies impart knowledge of the divine will and who act as intermediaries between humanity and God. In the central section are the panels that tell the story of men and women in their direct relationship to God.

THE LOWER AND INTERMEDIATE LEVELS. The eight border triangles tell the dismal tale of people without vision, who, as St. Luke says, "sit in darkness and in the shadow of death," awaiting the light that will come when the Savior is born. In the four corners are depictions of the heroic men and women whose acts secured temporary deliverance for their people: David slaying Goliath, Judith beheading Holofernes, Haman's punishment through Esther, and Moses's transformation of his rod into a serpent that devoured the similarly transformed rods of the Egyptian priests.

These figures serve as an introduction to the representations of the seven Hebrew prophets, who

10.11 Michelangelo. *Delphic Sybil,* detail of Sistine Chapel ceiling, 1509. Fresco. Vatican Palace, Rome, Italy.

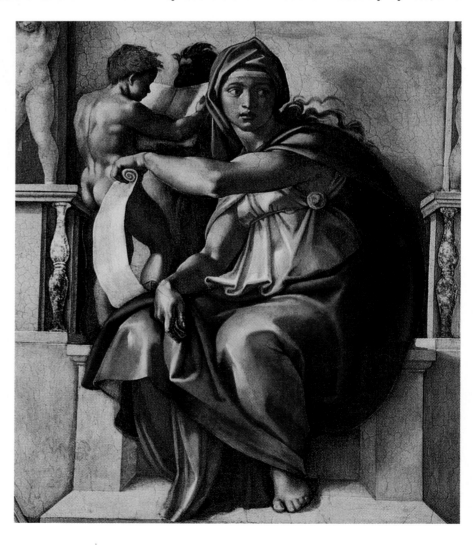

alternate with five pagan sibyls. The *Delphic Sibyl* is the first of the series (Fig. 10.11). In the Greek tradition, she was the priestess of Apollo at Delphi. As Michelangelo depicts her, she is a young woman possessed by the spirit of prophecy. In the grip of divine fury, she turns her head toward the voice of her inspiration. Although she is clothed in classical Greek garments, her beauty recalls that of Michelangelo's early Madonnas.

Above each of the prophets and sibyls and framing the central panels are ***ignudi*** (nude youths), seen in Figure 10.10. In the Christian tradition, these figures would have been represented as angels. In the Platonic view, however, they personify the rational faculties of the sibyls and prophets, by means of which they contemplate divine truth and are able to bridge the gap between the physical and spiritual, or earthly and heavenly, regions. Thus, all the prophets and sibyls have a single figure below to denote the body, a pair of nudes behind them to signify the will, and a heroic *ignudo* to personify the immortal soul. These three levels correspond to Plato's three-part conception of the soul—the appetitive, the emotional, and the intellective faculties. Aesthetically, these symbolic figures also serve to soften the contours of the architectural design.

THE CENTER PANELS. Instead of starting at the beginning and proceeding chronologically as in Genesis, Michelangelo conceives the story of creation in reverse order, as the ascent of humanity from its lowest estate back to its divine origin. In this return to God, the soul in its bodily prison gradually becomes aware of God and moves from finiteness to infinity, from material bondage to spiritual freedom. Immortality, in this sense, is not the reward for a passive and pious existence but the result of a tremendous effort of the soul struggling out of the darkness of ignorance into the light of truth.

The first of the histories in the nine central panels is *The Drunkenness of Noah.* As in the Slave figures of the Julius tomb, the picture of Noah is that of a mortal man in an abysmal condition, the victim of bodily appetites. Noah's servitude is symbolized on the left, where he is seen tilling the parched soil. He is still strong physically, but his spirit is overwhelmed by the flesh. His sons, powerfully built adolescents, do not seem to be discovering their father's nakedness, as related in the Bible. Instead, they are subject to the tragic fate of all mortals, who must work, grow old, and die. Noah's reclining posture recalls that of the ancient Roman river gods, but in this instance his head has sunk forward on his chest in what seems to be a premonition of death. After this picture of Noah as the prisoner of his own baser nature, the next panel represents *The Deluge,* which shows the plight of men and women when beset by forces of nature beyond their control. In the third panel, *Noah's Sacrifice,* human dependence on God is implied for the first time.

The story of *The Fall and Expulsion from Paradise* follows. The last five panels show various aspects of God's divine nature. In *The Creation of Eve,* God appears as a benign paternal figure closed within the folds of his mantle. In *The Creation of Adam* (Fig. 10.12), God is seen in the skies, with his mantle surrounding Him like a cloud as

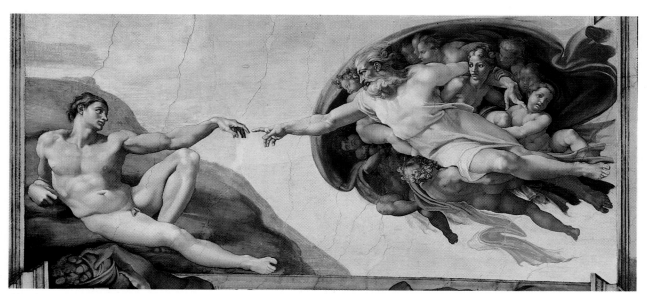

10.12 Michelangelo. *The Creation of Adam,* detail of Sistine Chapel ceiling, 1511. Fresco, approx. 18′8″ × 9′2″. Vatican Palace, Rome, Italy.

He moves downward toward Earth and the inert body of Adam. The creative force is likened to the divine fire that flashes like lightning from the cloud to Earth. Adam's body is one with the rock on which he lies, not unlike the unfinished *Slaves* of the Julius tomb. In keeping with the Platonic idea of life as a burden and imprisonment, Adam is awakening to life reluctantly rather than eagerly. With his other arm, God embraces Eve, who exists at this moment as an idea in the mind of God. She resembles Michelangelo's Madonna types and looks with fear and awe on this act of creation. God's fingers point to the coming Christ child, whereas behind Him are the heads of unborn generations of human beings.

After *The Gathering of the Waters* comes *The Creation of the Sun and Moon* (Fig. 10.10, right). Here the figure of God becomes a personification of the creative principle, whereas in *God Dividing the Light from Darkness* (Fig. 10.10, far right), the final panel of the series, the light of pure being is attained. Here clarity emerges from chaos, order from the void, existence from nothingness. Light is the symbol of enlightenment and the knowledge that brings

freedom from the darkness of ignorance and bondage. Only through the light of wisdom can an individual attain the highest human and divine status. "You shall know the truth and the truth shall make you free," says the Bible (John 8:32); "Know thyself," the Delphic oracle told Socrates.

Explanations for the total program of images and idea in the Sistine Chapel ceiling run from the practical (Michelangelo adjusted the size of his figures in midcourse to make them more visible from the chapel floor) to the psychosocial (through religious imagery, the iconography of the ceiling expresses the subtle power alliances of church and worldly powers as Michelangelo perceived them). Michelangelo's absorption with merging Christianity and Neoplatonism may also clarify the order and significance of the images.

The conception of God progresses from the paternal human figure of *The Creation of Eve,* to a cosmic spirit in the intervening panels, and then to a swirling abstraction in the realm of pure being. The Neoplatonic goal of the union of the soul with God has been achieved through gradual advancement from the bondage of blind humanity,

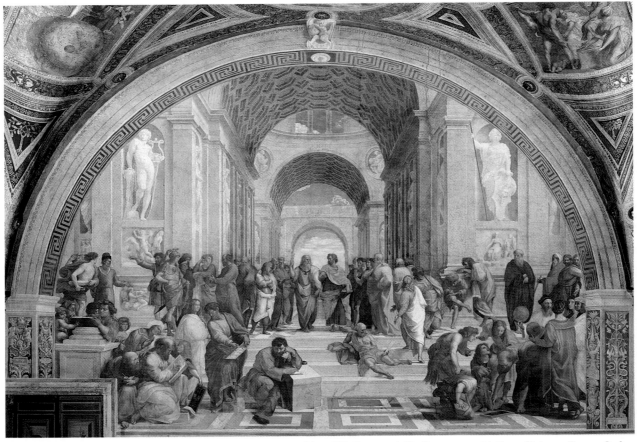

10.13 Raphael. *School of Athens,* 1509–1511. Fresco, 19′ × 27′. Stanza della Segnatura, Vatican Palace, Rome, Italy.

through the prophetic visions of the seers and the ascent of the ladder of the histories into the pure light of knowledge, to the point of dissolving into the freedom of infinity. In the words of Pico della Mirandola, the human being "withdraws into the center of his own oneness, his spirit made one with God." The weight of expression, story content, and philosophical meaning are carried entirely by Michelangelo's placement and treatment of more than 300 human figures in a great variety of postures.

Although he later returned to the Sistine Chapel to paint the *Last Judgment* on the altar wall (Fig. 10.9) and worked on another group for the Pauline Chapel in the Vatican, Michelangelo never succeeded in recapturing the optimism and creative force of the Sistine ceiling frescoes.

RAPHAEL'S FRESCOES FOR THE VATICAN WALLS

At the same time that Michelangelo was painting the Sistine ceiling, his younger contemporary Raphael was working on the murals of the Vatican Palace. In *School of Athens* (Fig. 10.13), Raphael presents a visual philosophy that places him in league with Michelangelo as an artist-scholar. Raphael's fresco is full of both intellectual and pictorial complexities. Yet because of the deepening and widening of the space and the skillful arrangement of the more than fifty figures, the design is clear and uncluttered. Raphael placed Plato and Aristotle on either side of the central axis of the fresco, with the vanishing point slicing backward between them. The book Plato holds in his hands is his *Timaeus,* and he points skyward to indicate his idealistic worldview. Aristotle carries his *Ethics* and indicates by his earthward gesture his greater concern with the real world.

In the spacious hall the various schools of thought argue or ponder the ideas put forth by the two central figures. On Plato's side, a niche contains a statue of Apollo, patron of poetry. On Aristotle's side there is one of Athena, goddess of reason. This division of the central figures balances the picture, with the metaphysical philosophers on Plato's side and the physical scientists on Aristotle's.

Spreading outward on either side are groups corresponding to the separate schools of thought within the two major divisions, each carrying on the philosophical arguments for which they were famous. The figure of Plato is thought to be an idealized portrait of Leonardo da Vinci. In the group at the lower right, Raphael portrayed his architect

friend Bramante as Euclid demonstrating on his slate a geometric proposition. At the extreme right, Raphael painted a self-portrait in profile next to his friend, the painter Sodoma. The intriguing figure near the left center is sometimes identified as the Greek philosopher Heraclitus. Legend has it that it is also a portrait of Michelangelo. In *School of Athens,* Raphael captured the intellectual atmosphere and zest with which Renaissance ideas were argued.

THE DOME OF ST. PETER'S

The cornerstone of the new St. Peter's (Fig. 10.1) was laid in 1506, when Michelangelo was starting work on the plans for Pope Julius's tomb. Comparatively little progress had been made in the stormy years that followed, despite the succession of brilliant architects working on the project. Michelangelo favored the centralized church plans of Brunelleschi and Alberti, just as his predecessor Bramante had done. The latter's design, however, was to have culminated in a low dome, modeled after that of the Pantheon (see Fig. 4.20A), but with a series of columns at the base and a lantern tower on top.

Michelangelo accepted Bramante's Greek cross ground plan with a few alterations of his own (Fig. 10.14), but he projected a loftier dome rising over the legendary site of St. Peter's tomb. This cupola was to be of such monumental proportions that it would not only unify the interior spaces and exterior masses of the building but also serve as a symbol of the liturgical, religious, and artistic forces united by Roman Catholicism.

Michelangelo's first problem was an engineering challenge: determining whether the masonry

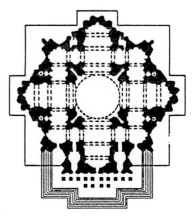

10.14 Michelangelo. Plan of St. Peter's.

was strong enough to support such a dome. He concluded that it was not and set about reinforcing the four main piers until each was a massive 60 feet square. This square understructure was encircled by pendentives, upon which the cylindrical drum was placed. Meanwhile, Michelangelo made a large model of the dome itself so that it could be built by others in case of his death. He lived just long enough to see the drum finished. After his death, two of his associates completed the dome (see Fig. 10.17) without making substantial alterations.

At about this time, there were calls for reforms within the church itself, along with a new spirit of conservatism that frowned on anything that might be considered pagan. A new wave favored a return to traditional Latin cross planning. In the early seventeenth century, Carlo Maderno undertook the lengthening of the nave (Fig. 10.15) and the design of the facade (Figs. 10.1 and 10.16).

Liturgically, the new nave provided more space for grandiose processions. Practically, it provided room for larger congregations. Historically, it absorbed all the area formerly occupied by Constantine's basilica, which was demolished to make way for the new structure. Aesthetically, however, the proportions suffered, and the climactic effect of the great dome was lessened. Nevertheless, the scale of the interior had been steadfastly set by Michelangelo's huge piers beneath the dome, and Maderno was bound to continue the same proportions. The vaulting thus rises a little more than 150 feet above the pavement, and the enormous interior covers more than 25,000 square yards.

The exterior of the church Michelangelo planned can best be seen from the apse and the interior from beneath the dome, where it still looks like the compact unified structure he wanted. From the apse of the completed church (Fig. 10.17), where the lengthened nave does not detract, the effect is still substantially as Michelangelo intended it to be. From this vantage point, the building seems like a great podium for the support of the vast superstructure. From ground level to the base of the dome, there is a rise of about 250 feet. The cupola then continues upward to the top of the

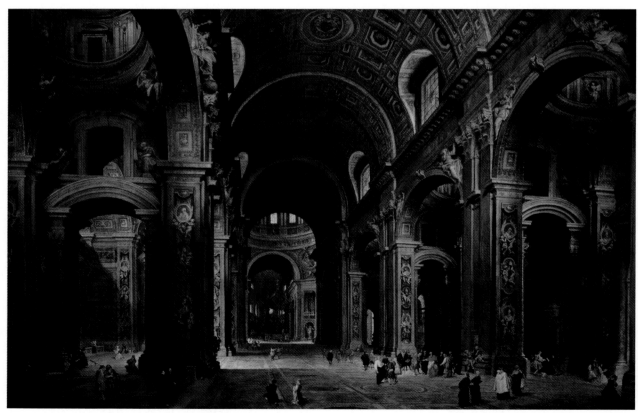

10.15 Giovanni Paolo Pannini. *Cardinal Melchoir de Polignac visiting the basilica of Saint Peter's, Rome,* 1730. Oil on canvas, approx. 5′¾″ × 6′5½″. Louvre, Paris, France.

lantern tower, where its ultimate height of 452 feet is attained.

JOSQUIN DESPREZ AND THE SISTINE CHAPEL CHOIR

In a book on Dante published in 1567, a Florentine literary historian wrote,

> I am well aware that in his day Ockeghem was as it were the first to rediscover music, then as good as dead, just as Donatello discovered sculpture in his; and that of Josquin, Ockeghem's pupil, one might say that he was a natural prodigy in music, just as our own Michelangelo Buonarroti has been in architecture, painting, and sculpture; for just as Josquin has still to be surpassed in his compositions, so Michelangelo stands alone and without a peer among all who have practiced his arts; and the one and the other have opened the eyes of all who delight in these arts, now and in the future.

Almost half a century after his death, Josquin Desprez was regarded as a figure comparable to Michelangelo. A Florentine could bestow no higher praise. This opinion, moreover, was also held by musicians. The distinguished theorist Glareanus wrote that the work of Josquin was "the perfect art to which nothing can be added, after which nothing but decline can be expected." The so-called ***ars perfecta,*** or "perfect art," rested on the

assumption that the most advanced level of development has been achieved by the arts in antiquity. The Renaissance composers sought to regain the perfection of ancient music.

Italians took great pride in the achievements of their own architects, sculptors, and painters. Nevertheless, they universally acknowledged the supremacy of the northern composers. The spread of the northern polyphonic art dated from the period when the papacy was centered in Avignon. Later, the taste for polyphonic music led to the establishment of the Cappella Sistina in 1473, which was dominated by Flemish, Burgundian, and French musicians. Their influence spread over the entire Christian world. From this time forward, the contrapuntal writing of these artists became the standard of perfection.

Under Pope Sixtus IV, church music had progressed from its status as a modest servant of the liturgy to a position of major importance. The grandeur of the Roman liturgical displays called for music of comparable magnificence. Owing to the prevailing taste of the time, musicians from the great singing centers of Antwerp, Liège, and Cambrai flocked to Rome. The highest honor for a musician was an appointment to the Sistine Choir, which performed on occasions when the pope officiated.

10.16 St. Peter's. Plan of present complex.

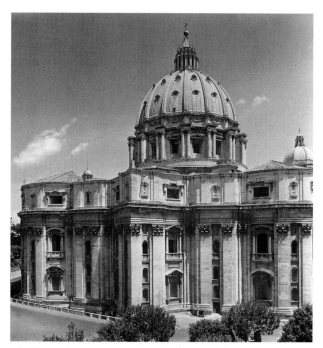

10.17 Michelangelo. View of apse and dome, St. Peter's, Rome, Italy, begun 1547. Height of dome 452′.

Membership in the Sistine Choir was highly selective, totaling from sixteen to twenty-four singers, except during the time of Pope Leo, who increased it to thirty-six. These singers were divided into four parts: boy sopranos, male altos, tenors, and basses. Normally they sang **a cappella**—that is, "in the chapel manner," without instrumental accompaniment—a practice that was considered exceptional rather than usual at the time.

The quality of this choir can be deduced from the list of distinguished people who made their reputations in its ranks. In the archives are numerous masses, motets, and psalm settings composed by Josquin Desprez during his service there from 1486 to 1494. Giovanni Palestrina, who studied Josquin's contrapuntal technique, became a member in 1551 and brought the organization to the pinnacle of technical perfection.

In Josquin's compositions the stark, barren intervals of Gothic polyphony and all traces of harshness in the harmonies are eliminated. He allows dissonance to occur only on weak beats or as suspensions on the stronger ones. His rhythms and forms are based on strict symmetry and mathematically regular proportions. Like much music stemming from northern traditions, his writing is characterized by imitation of a melody by successive voice parts, in the manner of a **canon,** as well as other complicated contrapuntal constructions. He manages these devices masterfully, and his tremendous compositional technique never intrudes on the expressive content.

Although Josquin was at home in all Renaissance musical forms, he excelled in his motets and in his solo and choral songs. In Rome, where his talent was influenced by the warm, liquid smoothness of Italian lyricism, Josquin's music mellowed until it achieved a level of incomparable beauty, clarity, and expressiveness.

Josquin's four-part motet *Ave Maria* is an admirable illustration of his art. Like Michelangelo's early *Pietà* (Fig. 10.4), it has a perfectly self-contained form, emotionally restrained and full of luxuriantly flowing lines. Even the short excerpt reproduced in Musical Example 10.1 shows his love of canonic imitation between the voices and the smoothness of contour that comes with stepwise melodic motion.

Josquin treats all four voices with balanced impartiality but prefers to group them in pairs, as in the example, to achieve a transparency of texture and purity of sound. Darker sides of Josquin's emotional spectrum can be found in his requiem masses and his setting of the psalm *De Profundis.*

Although Josquin enjoyed universal acclaim as the greatest musical mind of the early sixteenth century, the very perfection of his art implied that it was on the verge of becoming outdated. A number of composers in the succeeding generation carried his art to its logical conclusion. Palestrina served as master of St. Peter's Julian choir and enjoyed the title of "Master of Composition" to the papal chapel until his death later in the century. Meanwhile, Tomás Luis de Victoria carried the style to Spain, William Byrd brought it to England, and through Philippe de Monte and Orlande de Lassus, it spread throughout France and Germany. In the seventeenth century, although the art was still studied, it became known as the "antique style," in contrast to baroque music, which was called the "modern style." Within its limitations the style has never been surpassed.

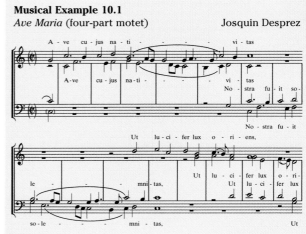

Musical Example 10.1
Ave Maria (four-part motet) Josquin Desprez

IDEAS: HUMANISM

REVIVAL OF CLASSICAL FORMS

Florentine humanism and its Roman aftermath rested on a reappraisal of the values of Greco-Roman antiquity. An attempt was made to reconcile pagan forms with Christian practices, to reinstate the philosophy of Plato, and to reinterpret that of Aristotle. Above all, Renaissance humanists used antiquity to discover the nature of this world and human values. They were not primarily religiously or scientifically minded and tended to substitute the authority of respected classical writers for that of the Bible and church dogma. They found more convenient and convincing precedents in the civilizations of Greece and

Rome than in the medieval past. Lorenzo de' Medici, for instance, saw a new orientation for secular government in Plato's *Republic.* Niccolò Machiavelli found a model for writing history in Thucydides's accounts of his own time. Bramante made a new adaptation of the Greco-Roman temple for Christian worship.

Bramante's Tempietto (Fig. 10.18) was a conscious revival of the rounded structures of antiquity (see Figs. 4.20A, 4.21, and 4.25). This temple in miniature, coming as it did at the outset of the sixteenth century, became the architectural prototype for the Roman Renaissance, just as Brunelleschi's Pazzi Chapel (see Figs. 9.3 and 9.4) had been for the fifteenth-century Florentine Renaissance. Placed in the cloistered courtyard of the Church of San Pietro in Montorio, the little temple rests on the site where St. Peter is supposed to have been crucified.

Bramante chose the simple yet monumental Doric architectural order. He held to the classical principle of the module, whereby all parts of the building are either multiples or fractions of the basic unit of measure. He also promoted the feeling of balance and proportion by making the height and width of the lower floor equal to that of the upper story. The only formal decorative element is in the Doric frieze, with regular triglyphs alternating with metopes that employ a shell motif.

Above all, Bramante wished to demonstrate the cohesiveness and compactness of the centralized plan under the unifying crown of a cupola. Later, when Pope Julius entrusted him with the design of the new St. Peter's, Bramante had a chance to build on a monumental scale. Here again he turned to antiquity for inspiration and is reputed to have declared, "I shall place the Pantheon on top of the Basilica of Constantine."

The humanists preferred purer versions of classical art forms to the adaptations that had been made in the thousand-year period between the fall of Rome and their own time. The members of the Florentine humanistic circle learned to read and speak ancient Greek under native tutors. Marsilio Ficino translated the dialogues of Plato, and Angelo Poliziano translated Homer from the original Greek into Italian and wrote essays in Latin on Greek poetic and musical theory. Other scholars catalogued and edited books for the Medici library, and Squarcialupi compiled the musical compositions of the preceding century.

The interest in cataloguing, editing, translating, and commenting was pursued with such enthusiasm that it all but blotted out the production of new literature. The Latin of Renaissance schol-

ars was that of the Roman orator Cicero rather than medieval Latin, which they believed had become corrupted over time. The architects read Vitruvius and preferred central-plan churches modeled on the Pantheon to the rectangular basilica form that had evolved over the centuries. They revived the classical orders and architectural proportions in more authentic forms. Decorative motifs were derived directly from ancient sarcophagi, reliefs, and carved gems. Sculptors reaffirmed the possibilities of the nude, and it became the chief expressive vehicle of Michelangelo's art. Painters, lacking major models from antiquity, used mythological subjects and literary descriptions of ancient works.

Musicians reinterpreted Greek musical thought, and some actually attempted to put into practice the theories expounded in Euclid's essay on music. The Greek assertion that art imitates nature was universally acknowledged, but in architecture and music this had to be applied in the general sense of nature as an orderly and regular system conforming to mathematical proportions and laws. Josquin Desprez was hailed as a modern Orpheus who had regained the perfect art of antiquity, although the

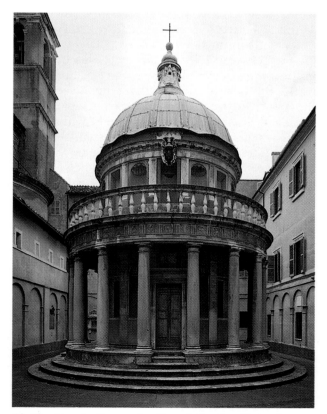

10.18 Donato Bramante. Tempietto, San Pietro in Montorio, Rome, Italy, 1502(?). Marble, height 46′, diameter of colonnade 29′.

Greeks and ancient Romans would have been bewildered by his musical style. Josquin's less enthusiastic admirers pointed out that the trees and stones did not follow him the way they had followed the Orpheus of mythology. His art, however, like that of Michelangelo, was thought by the humanists to be a path back to a classical paradise.

PAGAN VERSUS CHRISTIAN IDEALS

Both Botticelli and Michelangelo set out to produce works in the classical spirit. The literary ancestry of Botticelli's *Allegory of Spring (Primavera)* and *The Birth of Venus* (see Figs. 9.23 and 9.24) has been traced through the poetry of Poliziano back to that of the Roman poets Lucretius and Horace. Their philosophical ancestor, however, is the Plato of the *Symposium,* who deals with the nature of physical and spiritual love and the function of beauty. According to Plato's theory, human beings have forgotten their divine origin. Falling in love with a beautiful person reminds them of their natural affinity for beauty. From physical attraction and fleeting loveliness they are led to thoughts of the lasting beauty of truth and, finally, to contemplation of the eternal verities of absolute beauty, truth, and goodness. Venus is, of course, the image of this transcendent beauty, and the way to approach it is through love.

Michelangelo's Plato, however, was the Plato of the *Timaeus,* who dwells on the creation of the world, the spiritual nature of the human soul, and the return to God. Unlike Botticelli, who had a dream of fragile beauty, Michelangelo had a vigorous vision of the creative process itself. When Botticelli came under the influence of the fiery moralist Savonarola, with his resurgence of medievalism, he repented of his paganism and painted only religious pictures.

Botticelli never tried to combine paganism and Christianity as Michelangelo did; for him, they remained separate compartments. Michelangelo, however, had the mind to assimilate Platonic abstractions, the overwhelming urge to express his ideas, and the technical skill to translate them into dramatic visual form. But the voice of Savonarola spoke loudly to him, too, and Michelangelo wrestled with the two essentially irreconcilable philosophies for the rest of his life. Leonardo da Vinci, by contrast, kept the religious themes of his painting and his scientific inquiries in separate intellectual compartments.

Michelangelo's Madonnas reveal the accord between mortal beauty and eternal beauty, his *Moses* links human moral power with eternal goodness, and his organic compositions connect the truth of historical time with eternal truth. His triple divisions symbolizing the Platonic stages of the soul as it progresses from its bodily tomb to its liberation and reunion with God are a constantly recurring theme. Even in the abstract architectural forms of St. Peter's this concern with the progress of the soul is apparent. The pilasters, like imprisoned columns, are the "slaves" held down by the weight of the heavy burden they must carry. Overhead soars the lofty dome in the geometric perfection of the circular form, symbolizing the paradise that humanity has lost and must somehow regain. The whole building is thus conceived of as an organic system of upward pressures and tensions, reaching its highest point at a cupola that ascends toward the divine realm.

YOUR RESOURCES

- ***Exploring Humanities CD-ROM***

 ○ Interactive Map: Europe in the Sixteenth Century

 ○ Readings—Vasari, excerpts from *Life of Michelangelo,* excerpts from *Life of da Vinci*

- ***Web Site***

 http://art.wadsworth.com/fleming10

 ○ Chapter 10 Quiz

 ○ Links—Online Readings: Tasso, *Jerusalem Delivered*

- ***Audio CD***

 ○ Josquin Desprez, *Ava Maria*

LATE FIFTEENTH-CENTURY AND EARLY SIXTEENTH-CENTURY ROME

Key Events	Architecture	Visual Arts	Literature and Music
			c. 1440–1521 **Josquin Desprez** ❏
	c. 1444–1514 **Donato Bramante** ★	c. 1450–1523 **Luca Signorelli** ▲	
	1473–1480 **Sistine Chapel** built	1452–1519 **Leonardo da Vinci** ▲	
		1452–1513 **Bernardino Pinturicchio** ▲	
		c. 1467–1529 **Andrea Sansovino** ●	1469–1527 **Niccolò Machiavelli** ◆
1471–1527 **Roman Renaissance;** art and humanism at climax	1475–1564 **Michelangelo Buonarroti** ★	1475–1564 **Michelangelo Buonarroti** ●▲	1474–1533 **Ludovico Ariosto** ◆
1471–1484 **Sixtus IV** (della Rovere) pope		1481–1482 **Sistine Chapel** side-wall frescoes painted by Rosselli, Ghirlandaio, Botticelli, Perugino, Signorelli, Piero di Cosimo	1478–1529 **Baldassare Castiglione** ◆
1484–1492 **Innocent VIII** (Cibò) pope			1483–1546 **Martin Luther** ◆
1492–1503 **Alexander VI** (Borgia) pope		1493–1506 **Ancient Roman** frescoes and statues uncovered; *Apollo Belvedere, Laocoön Group* excavated	1483–1520 **Raphael (Raffaelio Sanzio)**
		1496–1501 **Michelangelo** in Rome working on *Bacchus* and *Pietà* statues	1486–1492 **Josquin Desprez** in Sistine Chapel choir

1500

Key Events	Architecture	Visual Arts	Literature and Music
1503–1513 **Julius II** (della Rovere) pope		1500–1571 **Benvenuto Cellini** ●	
	1506 **New Basilica of St. Peter** begun by Bramante; Old St. Peter's razed	1505–1545 **Michelangelo** worked on Julius II's tomb	
		1508–1511 **Raphael** painted Vatican Palace frescoes	1511–1574 **Giorgio Vasari** ◆
		1508–1512 **Michelangelo** painted Sistine Chapel ceiling	1513 **Capella Giulia** founded to perform in St. Peter's
		1513–1516 **Leonardo da Vinci** in Rome	1515 **Ludovico Ariosto** wrote *Orlando Furioso (Madness of Roland)*
1513–1521 **Leo X** (Medici) pope			1515–1564 **Michelangelo** wrote sonnets and other poems
1517 **Protestant Reformation** began in Germany with Luther's 95 Theses			c. 1521–1603 **Philippe de Monte** ❏
1521 **Luther** excommunicated		1523 **Michelangelo** worked on Medici tombs in Florence	c. 1525–1594 **Giovanni da Palestrina** ❏
1523–1534 **Clement VII** (Medici) pope			1528 **Baldassare Castiglione's** *The Courtier* published
1527 **Rome** sacked by Emperor Charles V; Pope Clement VII imprisoned			c. 1532–1594 **Orlande de Lassus** ❏
1534–1549 **Paul III** (Farnese) pope		1534–1541 **Michelangelo** painted *Last Judgment* fresco in Sistine Chapel	1532 **Niccolò Machiavelli's** *The Prince* published
1534 **Church of England** separated from Rome; reaction to Renaissance humanism began		1542 **Michelangelo** painted frescoes in Pauline Chapel	1534 **Reaction to Renaissance humanism** began
	1546 **Michelangelo** named architect of St. Peter's		1544–1595 **Torquato Tasso** ◆
	1556–1629 **Carlo Maderno** ★		1548–1600 **Giordano Bruno** ◆
			1550 **Giorgio Vasari's** *Lives of the Most Eminent Painters, Sculptors, and Architects* published
	1590 **St. Peter's dome** completed by Giacomo della Porta		c. 1550 **Philippe de Monte** in Rome; first book of madrigals published 1554
	1607–1614 **Carlo Maderno** completed nave and facade of St. Peter's		1551 **Orlande de Lassus** in Rome
			1562 **Torquato Tasso** wrote *Rinaldo*
			1575 **Tasso** wrote *Jerusalem Delivered*

★ - Architect ❏ - Musician ▲ - Painter ● - Sculptor ◆ - Writer

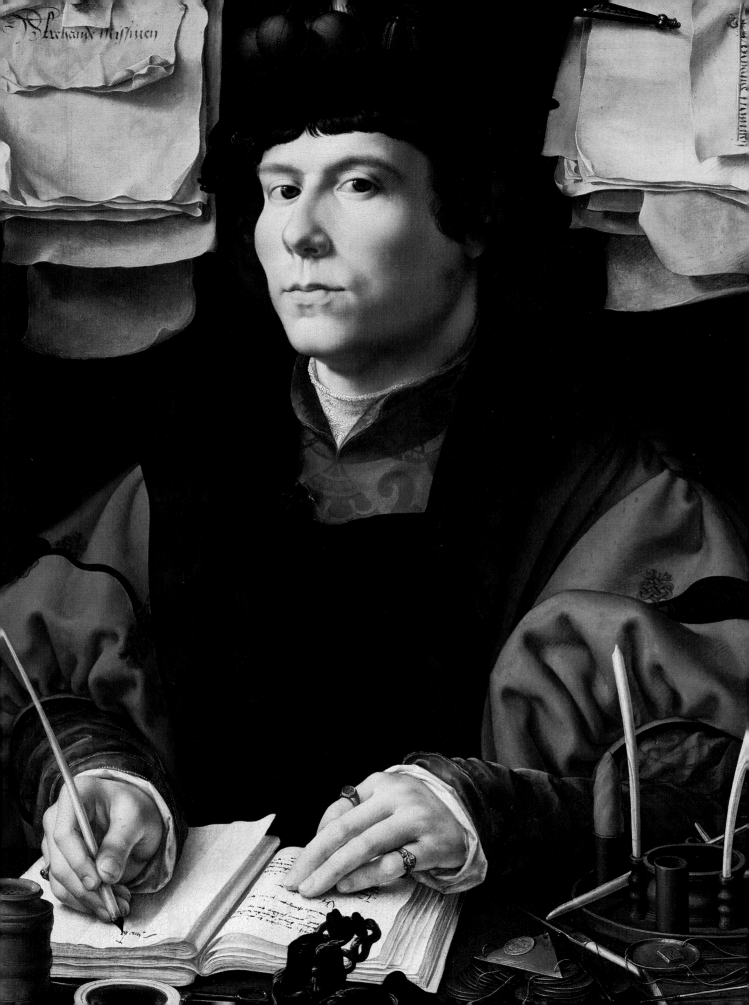

NORTHERN RENAISSANCE AND REFORMATION STYLES

THE RENAISSANCE DEVELOPED MORE GRADUALLY and diffusely in the northern countries than in the South. There were no sudden, distinctive regional manifestations of a new style, as there had been in Florence. Nor did the North experience the presence of classical antiquity as a foremost inspiration, as did Italy. Renaissance thought and action in the North was a selective maturation of ideas present in the late Middle Ages, such as the use of symbols to enhance the meaning of an image. In the North, artists tended toward increased awareness of the natural environment and acute observation of the visible world. They were fascinated with what the eye could see, the mind could comprehend, and the heart could feel and attempt to represent. Also, women painters in the North were somewhat freer to join guilds and to pursue a full-time profession in art. For example, Caterina van Hemessen, who was trained by her father, a painter, emerged as a prominent figure in Antwerp, and eventually at the Spanish court (Fig. 11.1). She was adept at bringing out the rich tonalities and luster that oil paints, a Northern invention, brought to the visual experience of art.

The early fifteenth century saw a variety of reactions against the excesses and worldly interests of the upper echelon of church officials. The so-called modern devotion, a lay movement with its roots in the fourteenth century, gripped parish priests and believers. It proclaimed that individuals could and should interpret the Bible for themselves rather than relying solely on the clergy. In addition, modern devotion questioned the need for the Virgin and the saints to intercede with God on behalf of sinners. This "protestant" faction produced leaders like Martin Luther and John Calvin, who challenged the church to reform itself. In the North, strong feelings about how reform should take place resulted in civil unrest and open conflict. Ultimately, the Church of Rome lost its hold on much of Northern Europe and England. The Eu-

ropean religious unity that had prevailed for many centuries collapsed, and a new outlook on humans' relationship to God and authority emerged.

The church reacted with its own reform movement, formulated at the Council of Trent, a city in northern Italy. In a series of meetings beginning in 1545 and lasting until 1563, church officials attempted to wipe out abuses of power and money. At the same time, they reinforced the necessity for priests and the sacraments. Moreover, they underscored the importance of the Virgin and the saints. The Council of Trent concluded that the arts should function within a narrow scope, literally

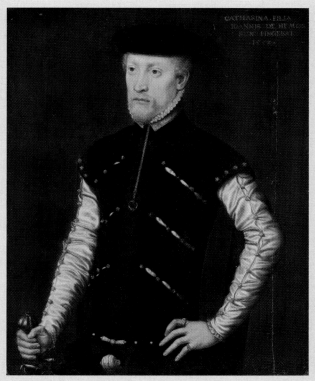

11.1 Caterina van Hemessen. *Portrait of a Man,* c. 1550. Oil on wood, approx. 1′2″ × 11½″. National Gallery, London, England.

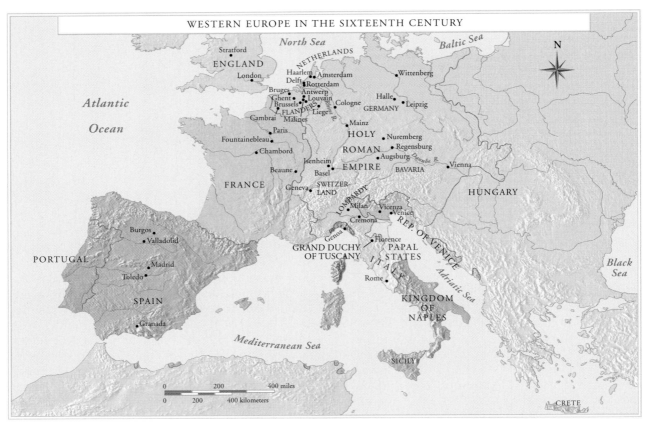

MAP 11.1

depicting Bible stories and other sacred texts. In 1542, even before the Council of Trent, a church commission that became known as the Inquisition set about rooting out heresy. Soon it turned to trials and torture to enforce religious conformity. In large part, the orthodoxy of the Council of Trent and the violence perpetrated by the Inquisition further severed the North from the South.

The center of gravity of northern Europe was in the Low Countries, especially in Flanders. Because of the discovery of America, as well as the establishment of Atlantic trade routes to Asia, commercial activity began to shift from the Mediterranean to the Atlantic coast. Through a combination of fortuitous circumstances and political skill, Philip the Good, the Duke of Burgundy, had brought most of this territory under his rule. His decision to make the Flemish seaport city of Bruges his capital was a momentous one, both for commerce and for the arts. Soon the term *Flemish* came into common usage to describe all the peoples of the Low Countries, including the schools of painters and musicians for which the region was so famous. Later in the sixteenth century, through a series of dynastic marriages and territorial consolidations, the Low Countries came under the dominion of the formidable Emperor Charles V, who was also the king of

Spain, lord of the Spanish overseas empire, ruler of Germany and Austria, and conqueror of Italy. Meanwhile, England under Henry VII and Henry VIII had already achieved nationhood, with London as its flourishing political and cultural center.

THE NORTHERN SCENE

Northern artists and composers lived in an adventuresome age. As journeymen seeking commissions, they traveled all over Europe. The Flemish painter Jan van Eyck was active at the courts of both John of Holland and Philip of Burgundy. The German artist Albrecht Dürer's home was in Nuremberg, but he traveled extensively in Italy and the Low Countries. His countryman Hans Holbein the Younger, who was born in Augsburg, made his career in Switzerland and at the court of Henry VIII in England. John Dowland, the English lutenist and foremost songwriter of his time, worked mainly in London, but he traveled widely in Italy and Germany and held posts at the courts of the Duke of Brunswick and the king of Denmark. The great Flemish-born composer Orlande de Lassus was a complete cosmopolitan, active in Sicily, Naples, Rome, and Antwerp before settling at the ducal court at Bavaria.

THE COMMERCIAL REVOLUTION IN THE NORTH

The importance and prosperity of the Low Countries stood on two main pillars. First was the flourishing textile trade, evidenced by the fine wool and linen cloth that was sent all over Europe. On a more limited and luxurious level, the region was also renowned for its tapestries, lace, rugs, cloth of gold, and costly glazed pottery and dishes. Next, its sea and river ports were busy scenes of shipping, distribution, and bartering for goods from all over the known world. With the rapid growth of the northern cities, the commercial center of gravity began to shift from the Mediterranean ports of Venice, Genoa, Marseilles, and Barcelona to those of the North Sea. For example, Dutch merchant ships carried their cargoes south to Lisbon, where they picked up spices and imported goods from India and Africa and transported them back north. The cities of Bruges, Antwerp, and Cologne were the main marketplaces for the exchange of goods, and as a result, they were the principal financial centers of northern Europe.

The accumulation of wealth by the merchant class began to reduce the importance of land ownership as the primary source of wealth. Of course, land continued to produce the food supply and raw materials, but commercial growth favored the merchants. The large fortunes amassed by some families gave them both increasing political importance and the means to become patrons of the arts.

The growing importance of the commercial revolution is graphically captured by Jan Gossaert in his *Portrait of a Merchant* (Fig. 11.2). Pen in hand, the merchant works on a ledger. Nearby are the tools of his trade: an inkpot, scissors, scales to weigh the coins, some sealing wax, and extra quill pens. Miscellaneous letters are seen above and left on the wall, and on the right are various business drafts. The painting itself reveals the deep coloring of the oil medium, which was being developed in the North.

EXPANDING HORIZONS

In the northern universities, scientists and humanistic scholars were freer in their inquiries and speculations than their counterparts in Italy and Spain, where the church imposed stricter controls. The beginnings of scientific geography, for instance, received great impetus from the expansion of northern commerce and the opening of new trade routes, and particularly from the discoveries of the great navigators. Observing the winds and sea currents, mapping shorelines and landmarks, studying the

11.2 Jan Gossaert. *Portrait of a Merchant,* c. 1530. Oil on panel, 2′1″ × 1′6¾″. National Gallery of Art, Washington, D.C.

stars and developing mathematics, and inventing mariners' instruments were all activities related to a vastly expanding experience of the world.

The spread of such learning by means of the new printing presses that sprang up in southern Germany, Bruges, Amsterdam, and London became one of the crowning achievements of the Northern Renaissance. The production of books soon became an industry. Gutenberg's beautiful Bible was printed around 1456. The English printer William Caxton published the first book in English at Bruges in 1474. Through printing, *Imitation of Christ,* probably written by Thomas à Kempis, became Europe's most popular book after the Bible. Printing also quickly spread scientific knowledge. In 1543, Flemish scientist Andreas Vesalius revolutionized the study of anatomy with his book *On the Structure of the Human Body.* In the same year, the astronomer Copernicus turned the reigning worldview inside out by showing in his book *On the Revolution of the Celestial Bodies* that Earth was but one of several planets revolving around the sun, instead of vice versa. Of course, the major revolution brought on by printing was a quiet one: education by means of books gave more people access to knowledge and hastened the development of a middle class.

Printing by means of wooden blocks or metal casts was invented in China and Korea centuries before it appeared in Europe. It is unclear whether

11.3 Claus Sluter. *Well of Moses,* detail
of Moses, 1395–1403. Height 10′6″,
height of figures approx. 6′. Chartreuse
de Champmol, Dijon, France.

printing was developed independently in Europe
or whether it was learned through contact with
Asia. Similarly, the compass and gunpowder are
Asian inventions that Europeans used extensively.
The compass enabled northern sailors to set out
on distant oceans, and cannons and firearms sup-
ported the expansion of trade and the establish-
ment of colonies.

Turbulent times shaped the Northern Renais-
sance. Although artists from the North and the
South continued to view each other's work, in gen-
eral the North affirmed cultural independence
from the dominance of the Mediterranean South,
which had begun in Greco-Roman times and con-
tinued through the Middle Ages, augmented by the
power of the Church of Rome. In commerce, the
North wrested control of shipping and trade from
the southern ports. In addition, tensions grew be-
tween the prosperous towns and the feudal land-
holding nobles. In political life, the international
outlook of the Church of Rome (and its secular

11.4 Robert Campin (Master of Flémalle). *Merode Altarpiece* (open), c. 1425–1428. Tempera and oil on wood,
center panel approx. 2′1″ × 2′1″. Metropolitan Museum of Art, New York, Cloister Collection Purchase.

arm, the Holy Roman Empire) confronted the rising tide of national movements in the Low Countries and England. In religion, a tumultuous series of splits among the various Protestant movements in Germany, the Low Countries, and England set factions against one another and against those loyal to Rome. Bitter as they were, these tensions and conflicts did not stifle the arts. The Flemish and German painters Jan van Eyck, Hugo van der Goes, and Albrecht Dürer and the Flemish composers Guillaume Dufay, Josquin Desprez, and Orlande de Lassus became powerful influences all over Europe, including France, Italy, and Spain.

Architecture continued to develop along late Gothic lines, influenced only minimally by the striking innovations associated with the Italian Renaissance. Painting also flourished in a unique way, especially in the artists' acute and accurate observations of nature. Except in the case of Dürer, there were few traces of southern classicism. The important technical breakthrough of oil painting, however, swept all before it. With oils, painters could achieve deep, glowing colors; intense tonalities; and striking lighting effects. Northern oil techniques soon spread far and wide, especially to various Italian centers. Flemish paintings were also in demand in international centers, including Italy, where collectors included the ducal courts of Naples, Ferrara, and Urbino as well as Lorenzo de' Medici in Florence. Productivity in literature, except in England, was more restricted. The struggle between the reformers and Roman Catholics led to tight censorship of printed materials under the Spaniards and the Holy Roman emperors. In music, Flemish composers were the acknowledged leaders throughout Europe. Throughout the period, central tensions arose from a new critical humanism, itself a product of the Reformation movement.

ART IN THE NORTH

When Philip the Bold, the Duke of Burgundy and grandfather of Philip the Good, founded a Carthusian monastery outside his capital city of Dijon, he summoned skilled craftspeople throughout Europe. Among them was Claus Sluter from Haarlem in Holland, who brought the carver's art to new heights of expression. His works include a group of life-size figures surrounding a well in the middle of a courtyard (Fig. 11.3). This so-called *Well of Moses* consists of a group of Old Testament prophets who carry scrolls foretelling the Passion and Death of Christ. The carving reveals an extraordinary receptiveness for naturalistic detail. Likewise, the voluminous, deep-cut drapery creates a rhythm of curved lines that animates the surrounding space. The prophets' grave, expressive faces are not generalizations but rather seem like portraits of living individuals. When originally painted in lifelike colors (one of them had actual gold-framed eyeglasses), the figures must have created an overwhelming impression. The monumentality and grandeur of Sluter's work sets him apart as a figure comparable to Donatello (see Fig. 9.10). His work was known throughout the Low Countries, and his influence on painting was as profound as it was on sculpture.

PAINTING IN FLANDERS

The vigilant political management enforced by Philip the Good and his successors on Flanders's rich commercial centers did not extend to control of the visual arts. Outstanding among fifteenth-century works is the *Merode Altarpiece* (Fig. 11.4), long identified with the anonymous Master of Flémalle, a town in the region. It is now generally

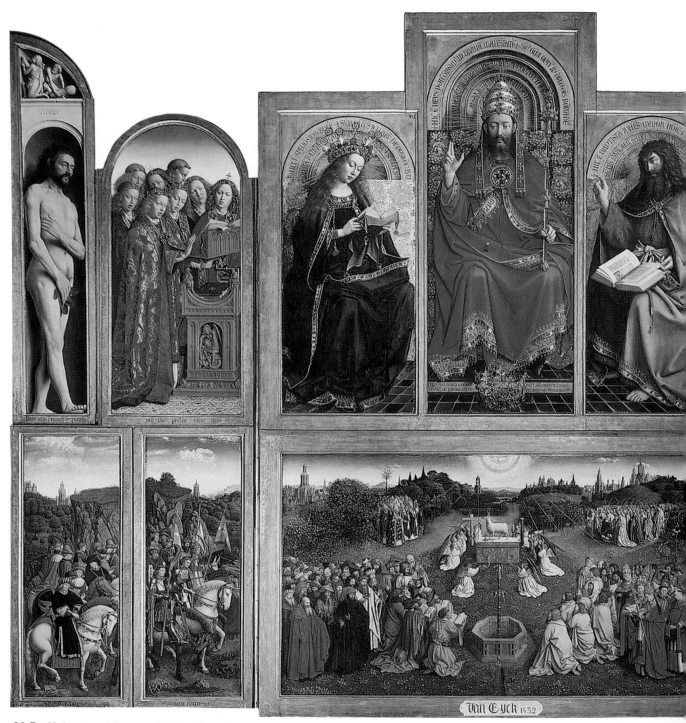

11.5 Hubert and Jan van Eyck. *Ghent Altarpiece* (open). "Adoration of the Lamb," detail, completed 1432. Oil on wood, approximately 11′6″ × 15′1″. Cathedral of St. Bavo, Ghent, Belgium.

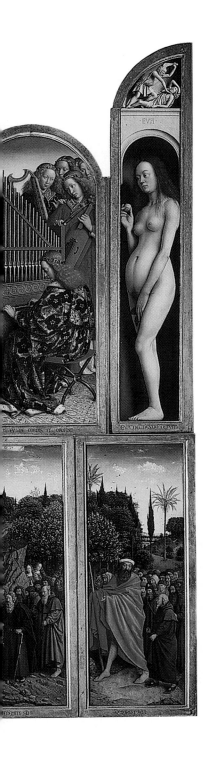

attributed to the painter Robert Campin. The subject is the Annunciation, as seen in the center panel. Mary is absorbed in her reading, seemingly not yet aware of the angel's presence. On the left in a courtyard garden are the kneeling donors, who look through the open door to view the event occurring within. On the right panel, Joseph is portrayed in his carpenter shop next door. The central scene is set in a comfortable middle-class chamber with soft light flowing in through the windows. The painter has succeeded in representing a supernatural event in familiar, contemporary surroundings. Even the conventional haloes have been omitted.

Yet beneath the apparent story is a subtle, extensive program of religious symbols that originated in medieval times but were brought up to date in an everyday domestic setting by the artist. For example, the lily-filled vase on the table refers to Mary's purity, and the rosebush and flowers in the courtyard are also sacred to the Virgin. Part of the program is derived from Isaiah, the Old Testament prophet who foretold the coming of the Messiah. It is from this book that the Madonna seems to be reading the words, "Behold a virgin shall conceive and bear a son" (Isaiah 7:14). The water jug and towel on the back wall denote the Virgin as the "vessel most clean" and may also allude to baptism.

On the right, Joseph has an ax, a rod, and a saw, which are noted in Isaiah 10:15. The ax "laid into the root of the trees" refers to the fate of sinners (Matthew 3:10); the rod is Joseph's, the one that bloomed miraculously in the Temple to signify that he was chosen to be Mary's spouse. The saw refers to the grisly death of Isaiah himself. Thus, the picture can be appreciated on many different levels.

A CHALLENGE TO NATURE: JAN VAN EYCK

The continuing exchange between Northern and Southern artists was verified by Giovanni Santi, a painter and the father of the Italian master Raphael, who remarked that the art of Jan van Eyck "challenges nature itself." Indeed, van Eyck's fame rests on his sensitivity to color, his eye for precision, his exquisite description of the minutest detail, and his technical innovations in the oil medium. He was fortunate to enjoy the patronage and friendship of Philip the Good, for whom he executed delicate diplomatic missions as well as commissions for paintings. He also received commissions from Joos Vijd, a minor noble who earned his wealth from the wool trade. Vijd sponsored the *Ghent Altarpiece.*

This magnificent altarpiece, signed by Jan van Eyck and his brother Hubert, is housed at the Cathedral of St. Bavo in Ghent (Fig. 11.5). The

genesis of the work is still a matter of scholarly controversy, but the evidence seems to point to Hubert as the sculptor of the sumptuous Gothic tabernacle that once surrounded it, whereas Jan painted the twenty panels. Hubert's framework was demolished in the religious strife of the late sixteenth century. Forewarned, the clergy hid the painted panels, which have survived. Shorn of its frame, the work still stands in its original place, the memorial chapel sponsored by its donor and his wife. The form is that of a **polyptych** with many hinged panels that open and close like the pages of a book. The glowing luminosity and technical brilliance of the painting are undiminished by time. Like the *Merode Altarpiece,* it is simultaneously a visual feast and an intellectual exercise in church doctrine and symbolism.

When the great altarpiece is open, deep, radiant hues greet the viewer's eye with the Adoration of the Lamb in the lower middle section. The overall theme is the union of God and humanity as in the apocalyptic vision of St. John: "Behold, the tabernacle of God is with men, and he will dwell with them, and they shall be his people" (Revelation 21:3). The upper level is on the heavenly plane, whereas the lower represents the New Jerusalem of the book of Revelation. Above is the dominating figure of Christ. Robed in rich scarlet with gold trim and sparkling jewels, He wears a triple tiara like that worn by the pope. The three-part crown also indicates the three-part nature of God and His dominion over heaven, Earth, and the underworld. At his feet is a golden crown signifying that He is lord of lords and king of kings. The Virgin Mary, enthroned at his right, is clothed in bright blue with a crown of twelve stars from which spring lilies and roses, symbols of purity and love. John the Baptist is at his left, with an emerald green cloak over his camel hair undergarment. Spreading outward on both sides are choirs of angels in brocaded velvet gowns, singing and playing the organ, harp, and other instruments. It is unusual to find Adam and Eve on the heavenly level, but here, splendidly modeled, they represent redeemed humanity and God's love for humankind.

On the central axis, reading downward from God the Father, is the dove of the Holy Spirit in the sky below; the Lamb on the altar, connoting the redeeming sacrifice of Jesus, completes the Trinity. Then come the Fountain of Living Waters and the stream that flows through the green, flower-bedecked meadow: "And I John saw the holy city, new Jerusalem, coming down from God out of heaven . . . [and the angel showed me] a pure river of water of life, clear as crystal, proceeding out of the throne of God and of the Lamb" (Revelation 21:2–22:1).

From the four corners of Earth come the faithful, moving toward the altar of the Lamb. In the side panels are delegations symbolizing the four cardinal virtues: the judges stand for Justice; the knights on horseback, Fortitude; the pilgrims, Prudence; and the hermits, Temperance. Around the Fountain of Life on the left are the kneeling apostles and a group of red-robed martyrs. On the right are the evangelists with their gospel books and a group of prophets. The holy virgins come from the right background and the holy confessors from the left, while a chorus of angels encircles the altar. Taken as a whole, van Eyck's realization of the New Jerusalem is the summation of Christian aspirations.

A MARRIAGE OF NORTH AND SOUTH

Jan van Eyck's *The Marriage of Giovanni Arnolfini and Giovanna Cenami* (Fig. 11.6) is a reminder of the close ties between North and South. The shrewd and calculating Arnolfini, the Bruges agent of the Medici of Florence, was active in business and banking circles. He had risen to the rank of counselor to the Duke of Burgundy, who was also one of van Eyck's patrons. Both he and his bride were from the Italian town of Lucca in Tuscany. The picture is a record of their marriage vows. Before the Council of Trent made it one of the seven sacraments, marriage could be contracted in pri-

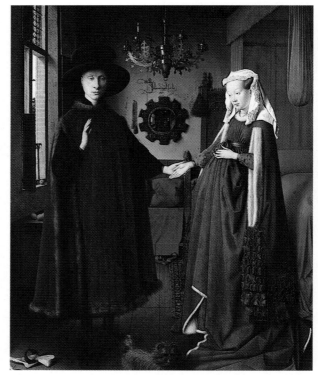

11.6 Jan van Eyck. *The Marriage of Giovanni Arnolfini and Giovanna Cenami,* 1434. Oil on wood, 2'8″ × 1'11½″. National Gallery, London, England.

vate by joining hands and pledging faith. The artist himself was a witness, as his beautifully lettered signature on the wall testifies: *Jan de Eyck fuit hic. 1434* (Jan van Eyck has been here, 1434).

At first glance, the picture seems to be a straightforward double portrait of nearly photographic realism. The meticulous rendering of every detail; the deft handling of perspective; and the contrasting textures of cloth, wood, fur, and metal are all depicted with naturalistic precision. Warm light coming from the open window accents the faces and hands of the subjects as well as the black velvet and apple green of their fashionable Burgundian costumes and the highly polished brass candelabrum and mirror. Gradually the light fades into the shadowy background. Van Eyck draws the viewer into the room with the device of the convex mirror that reflects the backs of the figures and two witnesses (one perhaps a self-portrait of the artist). Behind them, the doorway and wall complete the intimacy of the enclosed space.

Beyond this surface play, however, is an intricate and intriguing program of symbolism. In one influential interpretation, the dog stands for fidelity (*fides* in Latin; hence the popular name Fido). The apples refer to Adam and Eve in the Garden of Eden, the fall of man, and original sin. The ten miniature scenes surrounding the mirror tell of Christ's Passion, His death, and human salvation. The whisk broom represents domestic care. The statuette above the chair at the back is of Margaret, the patron saint of childbearing women (note that Giovanna's left hand is over her womb). The single lighted candle in the chandelier not only represents a Flemish marriage custom but also signifies the all-seeing eye of God, the light of the world.

In recent years, historical investigations have chipped away at the conventional view, pointing out that some of the symbolic references were not current at the time the picture was painted. As to the persistent question about whether the bride was pregnant, neither the conventional nor the new interpretations find any justification for it. In the custom of the time, the bride would have been a virgin. She has lifted her voluminous outer garment, whose extravagance indicated her wealth, perhaps to signal her consent to the marriage and its consummation.

A MEDICI TRIPTYCH: THE WORK OF HUGO VAN DER GOES

In the latter half of the fifteenth century, Tommaso Portinari, a shipowner and representative of the Medici banking interests in Bruges, commissioned an altarpiece for the Portinari Chapel in Sant'Egidio, Florence. Hugo van der Goes, the artistic heir of van Eyck, painted it in the form of a **triptych** (Fig. 11.7). In the left wing, he portrays the donor and his two sons kneeling and praying. Over them loom the large-scale figures of their patron saints, Anthony and Thomas, in melancholic and brooding attitudes. On the right side in similar postures are his wife and daughter with their saints, Margaret and Mary Magdalene.

The central panel depicts the adoration of the shepherds. Like van Eyck, Hugo closely observed naturalistic details, from the weather-beaten faces of the shepherds to the rich brocaded cloth of the angels' robes. The artist, however, created some spatial discrepancies to achieve dramatic effect: The floor tips slightly upward to project the figures forward. Hugo also observed the practice of depicting important people on a large scale. In this work, Mary, Joseph, and the shepherds in the middle ground loom larger than the angels in the foreground.

11.7 Hugo van der Goes. *Portinari Altarpiece,* c. 1476. Oil on wood, 8′3½″ × 10′ center panel, 8′3½″ × 4′7½″ each wing. Galleria degli Uffizi, Florence, Italy.

For Hugo, like van Eyck, details have symbolic significance. The building behind Mary is the palace of David, identified by the harp carved in the tympanum over the doorway. It refers to the fact that Mary and Jesus stemmed from the house of David. The presence of spring flowers in the dead of winter casts a miraculous atmosphere over the event. The sheaf of wheat alludes to Bethlehem, which means "house of bread" in Hebrew. The reference is also to the bread of the Eucharist, while the jar refers to the wine. The white lilies symbolize Mary's purity, the red roses refer to blood and suffering, and the irises ("swordflowers" in northern parlance) point to the pierced heart of the Madonna as the mother of sorrows. A psychological intensity characterizes the picture as a whole. Especially through the reading of symbols, the joyousness of Christ's birth is dampened by a sense of foreboding that foreshadows His sacrifice on the cross.

When the altarpiece reached Florence, its realism and depiction of human expression excited the painters who saw it. Domenico Ghirlandaio even adapted van Eyck's depiction of the humble shepherds for one of his pictures of the Nativity.

ART AND ALCHEMY: HIERONYMUS BOSCH

Hieronymus Bosch took his name from the last syllable of s'Hertogenbosch, the Flemish town where he was born and worked all his life. His was a time of social tension and religious unrest, a period in which people believed in witchcraft, sorcery, alchemy, and the coming of the antichrist. Bosch's art holds up a mirror not to nature but to humanity. It reflects the subconscious desires and drives that motivate human behavior. For the sources of his bizarre imagery, scholars have searched many sources, including the Bible, the lives of the saints as told in Jacobus de Voragine's *Golden Legend,* bestiaries, mystery plays, the writings of the mystics, Flemish proverbs and folklore, books on alchemy, drawings in manuscripts, and the fiery sermons and moralistic tracts of his time. His pictures have been interpreted as pre-Freudian psychoanalytic dreams, as premonitions of surrealism and fantastic art, and as satiric commentaries on the vanities and follies of his time. These enigmatic images can also be enjoyed for the way they delight the eye and challenge the imagination.

In the triptych *Garden of Earthly Delights* (Fig. 11.8), the viewer enters a world of magic and mystery conjured up by Bosch's inexhaustible imagination. When the wings are closed, one sees a giant sphere enclosing the world as it was on the third day of creation, when the dry land had been divided from the waters and the earth had brought forth grass, herbs, and trees. The colors are neutral grays and greens. In the upper left-hand corner, God is seen uttering the words, "For he spake and it was done" (Psalm 33:9). When the triptych is open, the spectator beholds a bright-colored vision, a phantasmagoria of fascinating forms. In the left panel, God has created Eve and brings her to the awakening Adam with the words, "Be fruitful, and multiply, and replenish the earth" (Genesis 1:28). Around them is a Noah's ark of

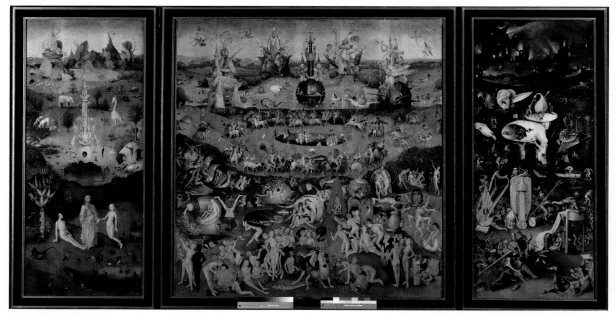

11.8 Hieronymus Bosch. *Garden of Earthly Delights* (open). *Creation of Eve* (left wing), *Hell* (right wing), 1505–1510. Oil on wood, 7'2⅜" × 6'4¾". Museo del Prado, Madrid, Spain.

animals, some natural, others imaginary. A spiraling flock of blackbirds flies out of a strange hollow rock; a dragon fights with a wild boar. The Fountain of Life, shaped like an intricately carved tabernacle, yields its waters, and a wise owl peers out from the pupil of the eye below. Nearby is a palm tree encircled by a serpent.

The garden of love that gives the triptych its name is depicted in the center panel. God's command to Adam and Eve to be fruitful and multiply is abundantly realized. Nude young men and women disport themselves in the crystal-clear light, making love in the alluring pastel-tinted spring landscape. They eat luscious fruits and gigantic strawberries, such as might have been imagined to exist at the beginning of the world. In the center, male riders, mounted on exotic animals as on a carousel, circle a pool filled with maidens who await their amorous advances. Strange, hornlike rock structures are silhouetted against the sky. Crustaceans, birds, and fish of both normal and monstrous size abound. Curiously enough, there are no children.

A grim and awesome day of reckoning is portrayed in the right panel, depicting Hell, where the lush dreams have now become arid nightmares. Here all nature is dead, and the spectral barkless trees accent the lifeless atmosphere. Below are the objects of sin: dice, cards, a backgammon board, a brothel scene, and a drunken brawl. Above are enormous musical instruments, allusions to the seductive power of music and dance, which have become objects of torture. One naked soul is tied to a lute, another enmeshed in the strings of a harp, and still another crammed into the bell of a large

horn. The image of a man with an egg-shaped torso with decaying tree trunks for legs and boats for shoes is terrifying. On his head is a bagpipe, an obvious sexual symbol. On the far right, a devil makes a pact with a man who is goaded on by a monster whose legs are attached to his helmet. Nearby a man is tempted by a sow clothed in a nun's veil. Above, two huge ears are pierced by a lance with a projecting knife blade.

Although its format recalls that of a church altarpiece, the picture was obviously intended for a sophisticated lay patron, much as Sandro Botticelli's pagan classical allegories were in Florence (see Figs. 9.23 and 9.24). Philip II of Spain was one of Bosch's greatest admirers, and in 1593 this work was added to the royal collection.

THE WORK OF "PEASANT BRUEGEL"

Pieter Bruegel the Elder was the heir to Bosch's style, and many of his early paintings were directly inspired by the older master. Bruegel's main fame, however, rests solidly on the vivid scenes of rustic life that gave him his nickname, "Peasant Bruegel." Far from a peasant himself, he was a well-educated, prosperous painter who was welcome at the imperial court and numbered the cardinal-archbishop of Malines among his many patrons. His pictures depicting the pleasures and activities of farming people helped establish genre scenes as an important category of painting, one that carried over into the Dutch School of the seventeenth century.

The Peasants' Wedding (Fig. 11.9) is set in a barn stacked with hay. The bride sits on the right,

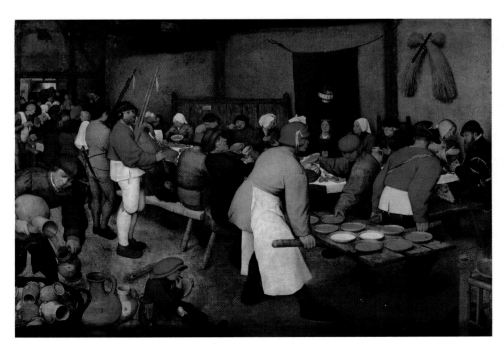

11.9 Pieter Bruegel the Elder. *The Peasants' Wedding*, c. 1568. Oil on wood, 3′8⅞″ × 5′4⅛″. Kunsthistorisches Museum, Vienna, Austria.

under a paper crown and against an improvised cloth of honor that is hung from a rope and fastened on the left by a pitchfork stuck in the hay. Grooms at such Flemish weddings were less important, and this bridegroom could be the figure stuffing himself in the center background. More likely he is the young man seated at the end of the table serving bowls of cereal from the unhinged door that serves as a tray. (It was the custom at the time for the groom to wait on the bride's family on such occasions.) The entertainers are playing bagpipes, the typical peasant instrument; one of them stares at the food with hungry eyes. At the far right, the bearded man in a black costume with a sword at his side has sometimes been identified as a self-portrait of the artist, based on resemblance to an earlier engraving. The crowded scene with its deep diagonal accent captures all the sturdy, stolid, and earthy qualities of people who live close to the soil.

Peasant life, however, was only one aspect of Bruegel's complex personality. He also devoted much attention to intricately constructed landscapes, such as *Hunters in the Snow* (Fig. 11.10), one of a projected series that would have depicted all the months. The bleak open spaces are enlivened by the interplay of sporting activities, with the tired hunters and their dogs in the foreground and skaters on frozen ponds in the background. In addition, Bruegel painted penetrating religious and moral allegories such as the *Fall of the Rebel Angels, The Deadly Sins,* and the grim *Triumph of Death,* as well as fantastic scenes dwelling on human folly such as *The Blind Leading the Blind.* He also pioneered the field of printmaking with many etchings and engravings.

PAINTERS IN GERMANY

In southern Germany, painters of great originality, imagination, and individuality rose to command international acclaim. Among them were Albrecht

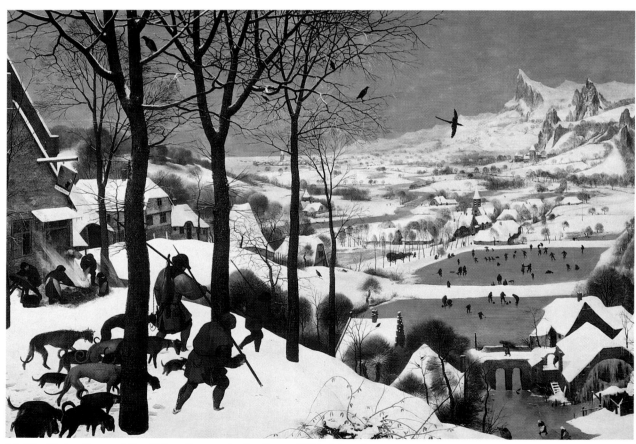

11.10 Pieter Bruegel the Elder. *Hunters in the Snow,* 1565. Oil and tempera on panel, approx. 3′10″ × 5′4″. Kunsthistorisches Museum, Vienna, Austria.

Dürer from Nuremberg; Matthias Grünewald, who was active in Mainz and other centers; and Hans Holbein the Younger, who worked in Switzerland and England.

INTERNATIONAL STUDY AND FAME: ALBRECHT DÜRER. Many German artists were attracted to the twin cultural centers of Bruges and Ghent, but in addition to studying the art of the North, Dürer blazed a trail over the Alps into Italy. He emerged as the primary interpreter of the classical Renaissance in the northern countries. His enormous productivity after his return from Italy is reflected in the woodcuts and engravings that poured from his own presses and led him to international fame.

Dürer created his first self-portraits as a teen, and he continued the practice throughout his life. His *Self-Portrait* (Fig. 11.11) bears the legend, "I made this according to my appearance when I was 26." His long curly hair frames his serious, searching expression. Dürer depicts himself against a background that is closed on one side; the other side opens out into a landscape painting with high mountains. Are these the Alps over which he traveled to study art in Venice? Or do they suggest a more sinister symbolism, perhaps of Germany itself, which endured a tortured century of peasant wars, internal dissents, and religious reformation? In either case, Dürer reveals himself not only as a confident, successful young master but also as thinker and writer concerned with meaning and subtlety.

Dürer's lifelong preoccupation with the accurate rendering of nature is seen in his *The Great Piece of Turf* (Fig. 11.12), in which he depicted a mundane clump of new spring vegetation at about life size. He resisted any urge to glamorize or dramatize this subject, which was literally below the gaze of most artists and viewers. The dandelions are a few days past their showy peak. Some strands of grass and a few broad furry leaves seem mired in the muddy clod, which Dürer has not disguised or excluded.

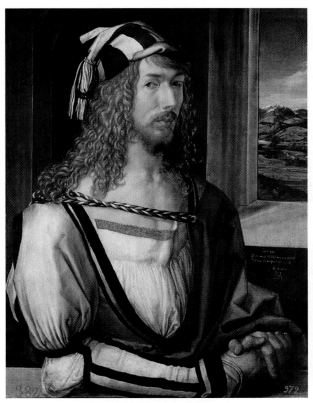

11.11 Albrecht Dürer. *Self-Portrait,* 1498. Oil on wood, 1′8½″ × 1′4⅛″. Museo del Prado, Madrid, Spain.

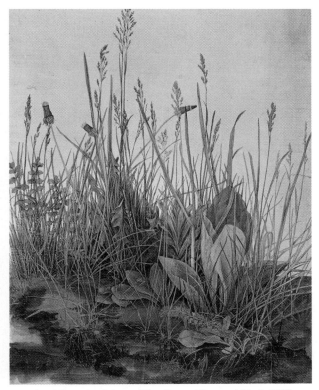

11.12 Albrecht Dürer. *The Great Piece of Turf,* 1503. Watercolor and tempera on paper, 1′4″ × 1′½″. Graphische Sammlung Albertina, Vienna, Austria.

Dürer's mature masterpiece, *Four Apostles* (Fig. 11.13), can be read as a visual manifesto of the Reformation. The governing board of Nuremberg, like those of other towns and cities, had to resolve the religious crisis between Roman Catholicism and Protestantism. When it adopted Lutheranism, Dürer presented the two panels to be hung in the city hall as his legacy to his native town and as a memorial to himself.

The artist revered Martin Luther as "that Christian man who has helped me out of great anxieties." Several quotations from Luther's German translation of the New Testament are found beneath the figures. Dürer once told Philipp Melanchthon, the Protestant humanist and close associate of Luther, "When I was young I craved variety and novelty; now, in my advanced years, I have come to see . . . that simplicity is the ultimate goal of art." In *Four Apostles,* he purged extraneous detail and superfluous ornamentation so that the individuality and integrity of the characters could shine through with the utmost clarity and conviction. The over-life-size figures represent John the Evangelist and St. Peter on the left, with Mark and Paul on the right. St. John was Luther's favorite evangelist. Interestingly, St. Paul was viewed as the spiritual father of

11.13 Albrecht Dürer. *Four Apostles,* 1526. Oil on wood, two panels, each 7′1″ × 2′6″. Alte Pinakothek, Munich, Germany.

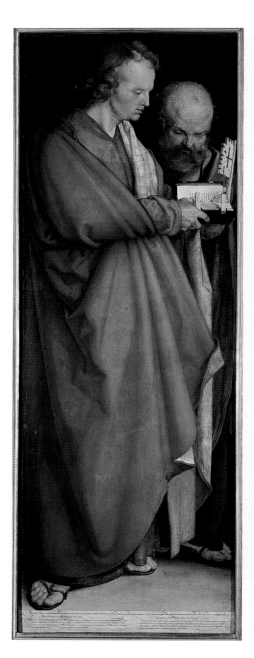
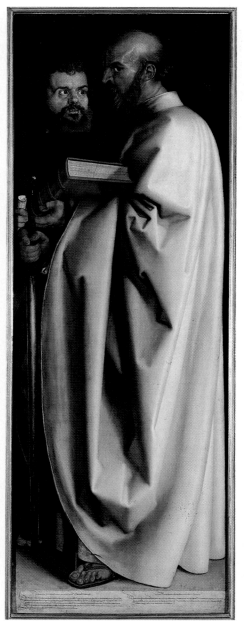

the Protestant movement, so much so that Catholic theologians referred to the Reformationists as the Paulines. Peter, with his keys to the Kingdom, the oldest of the apostles and the one most associated with Roman Catholicism, is still present, though now in the background.

The balanced composition is replete with naturalistic detail down to the stitches and layers of leather in the sandals. But far more important is the powerful psychological portrayal of these religious leaders. Johann Neudörfer, Dürer's friend, colleague, and early biographer, noted that the four apostles stand for the four temperaments. St. John, with his ruddy complexion and glowing red robe, is the warm, outgoing **sanguine** type. The white-robed St. Paul, with his symbolic sword

as soldier of Christ, stands as his opposite number in the psychological as well as the pictorial sense. He represents the **melancholic** side with his piercing hypnotic eye and stern, unyielding demeanor. The bowed head and downcast eyes of Peter and his withdrawn and resigned attitude bespeak the **phlegmatic** character. St. Mark, with his rolling eyes and fiery visionary look, represents the **choleric** temperament. Together they constitute the four basic aspects of religious experience, and the picture itself becomes a monument to Reformation thought.

FEAR AND TRIUMPH: MATTHIAS GRÜNEWALD'S *ISENHEIM ALTARPIECE.* Grünewald completed the celebrated *Isenheim Altarpiece* (Figs. 11.14 and 11.15) for the

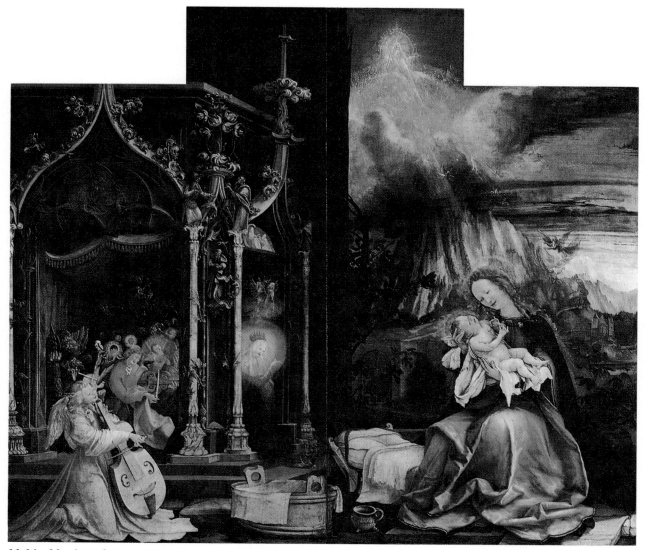

11.14 Matthias Grünewald. *Nativity,* center panel, front opening of *Isenheim Altarpiece,* completed 1515. Oil on wood, approx. 8′6″ × 21′4″. Musée d'Unterlinden, Colmar, France.

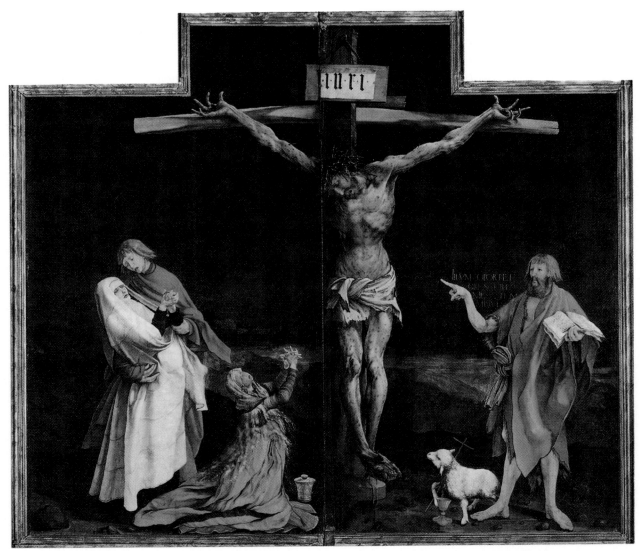

11.15 Matthias Grünewald. *Crucifixion,* center panel exterior of *Isenheim Altarpiece,* completed 1515. Oil on wood, approx. 8'6" × 21'4". Musée d'Unterlinden, Colmar, France.

monks of St. Anthony, a religious order that maintained hospitals for the sick and the poor. The work consists of a cycle of scenes painted on the front and back of two sets of folding panels, with immovable side wings, paired one behind the other. This intricate form resembles a book, opening leaf after leaf so that the stories of the Christian calendar can pass in review. Earthly, heavenly, and infernal beings alike are present to worship, witness, horrify, and tempt. The moods range from the ecstatic joy of the music-making angels in the Nativity panel to the depths of despair in the Crucifixion. The narrative extends from the Annunciation and Nativity, through the Passion and Entombment of Jesus, to the fantastic ordeals of St. Anthony, the legendary prophet of Christian monasticism.

The unusual and obscure iconography is derived from a number of sources, including the scriptures, the mystical writings of St. Bridget of Sweden, and pictures by Grünewald's contemporaries, not the least of whom was Dürer. The strange *Nativity* (Fig. 11.14) omits the traditional St. Joseph, the crib, the animals, and the shepherds. The *Crucifixion* (Fig. 11.15) includes St. John the Baptist, rare in this context. In this Nativity, Mary appears twice, on the right as the more familiar Madonna with Child, and on the left kneeling in prayer in a Gothic templelike chapel. Her head is surrounded by heavenly light. St. Bridget described such a scene in her *Revelations.* The allusion also suggests the Magnificat in St. Luke (1:46–55), in which the Virgin prays, "My soul doth magnify the Lord, and my spirit hath rejoiced in God my Saviour." The images of the prophets and musicians as well as the Venetian glass pitcher at her feet may point to the Revela-

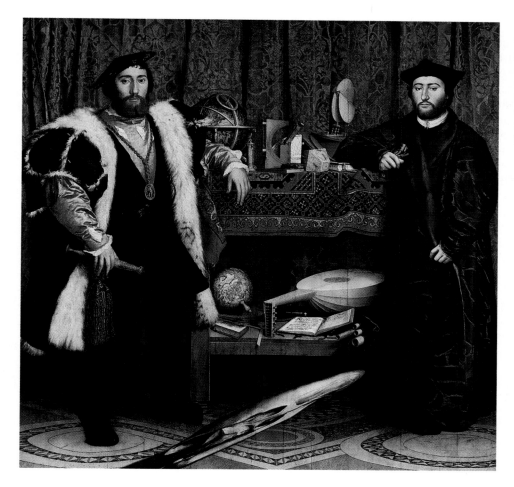

11.16 Hans Holbein the Younger. *Jean de Dinteville and Georges de Selve* ("The Ambassadors") 1533. Oil and tempera on wood, approx. 6′8″ × 6′9½″. National Gallery, London, England.

tion of St. John, in which the twenty-four elders of the Apocalypse appear with jars to symbolize their prayers and with musical instruments to signify their praises of the Lord.

In his *Crucifixion* (Fig. 11.15), Grünewald depicts the Baptist on the right side of the cross, St. John the Evangelist on the left, and Sts. Sebastian and Anthony on the side wings. With this plan he managed to include the interceders for the principal maladies treated at the hospital: St. Sebastian for the plague, the two Johns for epilepsy, and St. Anthony for St. Anthony's fire (thought to be the feverish, infectious inflammation of the skin known as *ergotism,* a disease caused by eating contaminated grain). No gentle Italian harmonies soften the grim agony of the crucified Christ. Festering sores and dried blood cover the ghastly dying flesh. Such vivid details may have been naturalistic, but they bear little relation to southern Renaissance practice. Grünewald, like Hugo van der Goes, followed the ancient way of proportioning his figures according to their religious or dramatic importance. Compare the size of the kneeling Magdalene's hands with those of the Savior.

The Temptation of St. Anthony, with its ghoulish and monstrous apparitions, reminded the suffering patients of the horrible ordeals endured by their patron saint. With its all-encompassing range of human feeling, Grünewald's altarpiece is one of the most moving documents in art history. In the late nineteenth and early twentieth centuries, the painting's vivid imagery helped inspire the Expressionist movement (see pp. 551–557), as well as Paul Hindemith's opera and symphony *Mathis der Maler* (Mathias the Painter).

PAINTING IN ENGLAND

THE COURT OF HENRY VIII. With Hans Holbein the Younger the scene shifts to Tudor England. He served as painter at the court of Henry VIII, where poetry, drama, and music flourished. Among Holbein's surviving portraits are those of Henry's son, the future Edward VI, and three of Henry's wives: Jane Seymour, Anne of Cleves, and Catherine Howard.

Jean de Dinteville and Georges de Selve ("The Ambassadors") (Fig. 11.16) is one of Holbein's most courtly, subtle, and intriguing works. It portrays a

pair of envoys bringing a letter from the French king to Henry VIII. Underlying the surface play of elegant costumes, rich drapery, and still-life objects is a profound interplay of signs and symbols. Reading from bottom to top, each figure stands on the tiled marble pavement with one foot in a circle, indicating his spiritual aspirations, and the other foot in the central square, denoting the worldly realm and humanity's physical nature. The objects in the middle are arranged on two levels. On the terrestrial plane are a globe of the world, a compass, some flutes, a lute, and a hymnal open to Luther's translation of the hymn *Veni creator spiritus*. Above them are a spherical map of the skies, some navigational instruments, and some geometric forms, including a square and a circle, which echo the pattern on the floor. Together they signify various attributes of the traditional seven liberal arts, particularly the quadrivium—mathematics, geometry, music, and astronomy—which were the humanistic pursuits of the scholarly gentlemen represented.

There is, however, a more somber side to the painting, because all these things are but vanities when viewed under the aspect of eternity. The theme seems to be *sic transit gloria mundi* (thus passeth worldly glory). The richly costumed subjects and their attributes represent the wealth and power of the state and church, whereas the sundial and the lute with its broken string indicate the brevity of life and the inevitability of death. Confirming this interpretation are a medallion with a skull in the left figure's cap, and a strangely distorted image of a skull on the floor, which can be seen only when viewed from the extreme lower left of the picture. It is a *memento mori* (remember you must die)—a reference to death as the great leveler. It comes as a chilling footnote to the human dignity and achievement that are depicted above.

MUSIC

"The man that hath no music in himself, nor is not mov'd with concord of sweet sounds, is fit for treasons, stratagems, and spoils . . . let no such man be trusted.—Mark the music." Shakespeare's words testify to the high esteem in which music was held in the northern countries. Music, in fact, was closely woven into the fabric of daily life for all social classes, from the rustic bagpipers in Bruegel's *Peasant Wedding Feast* (Fig. 11.9) and the wind players in town bands available for civic occasions, to middle-class house music, to courtly

entertainments. Very little music was written down, and most of what was has been lost. A great impetus to the spread of music was the invention and development of printing. Published anthologies made songs and dances readily accessible. Printed music also stimulated composers to write for wider audiences.

The greatest body of surviving music is, of course, music for churches, which was performed where everyone might hear it. Outside the church, however, printed collections of solo and group songs with lute accompaniment (Fig. 11.17), madrigals, rondos, and motets for special celebrations (such as state visits, military victories, births, marriages, and other ceremonies) became available. These works were mainly for professional performers or educated amateurs.

The Courtier, Baldassare Castiglione's popular etiquette book (see pp. 274–275) was translated and published in England in 1561. It makes the point that "music is not only an ornament, but also necessary for a courtier." Besides knowing how to read music at sight, Castiglione advised that every gentleman should also be a musician and "have skill on sundry instruments." Gradually the pleasures of such music making were adopted in middle-class households, where music after dinner became a popular form of entertainment. Each household had its own printed or hand-copied scores. Music masters were called on for instruction in reading notes or playing on the lute, recorder, keyboard, and viols. The Elizabethan madrigal composer Thomas Morley chronicled the story of a young man at a social gathering who was called upon to sing a part. When he protested that he could not, everyone surmised that he had been badly brought up.

FLEMISH COMPOSERS

The great fame of the Flemish composers of this period spread throughout Europe in church and courtly circles. Among others, Guillaume Dufay was the dominating force in early fifteenth-century Italy (see pp. 248–249), as was Josquin Desprez later in the century (see pp. 293–294). Orlande de Lassus completed the illustrious line that practiced what was called the "perfect art" of polyphony in the sixteenth century. Trained in his native Flanders and in Italy, he was active all over the Continent. Eventually he settled in Munich, where he was ennobled by Emperor Maximilian II and enjoyed every honor fame could bestow—including such accolades as "prince of musicians" and "the divine Orlande." Lassus was adept at

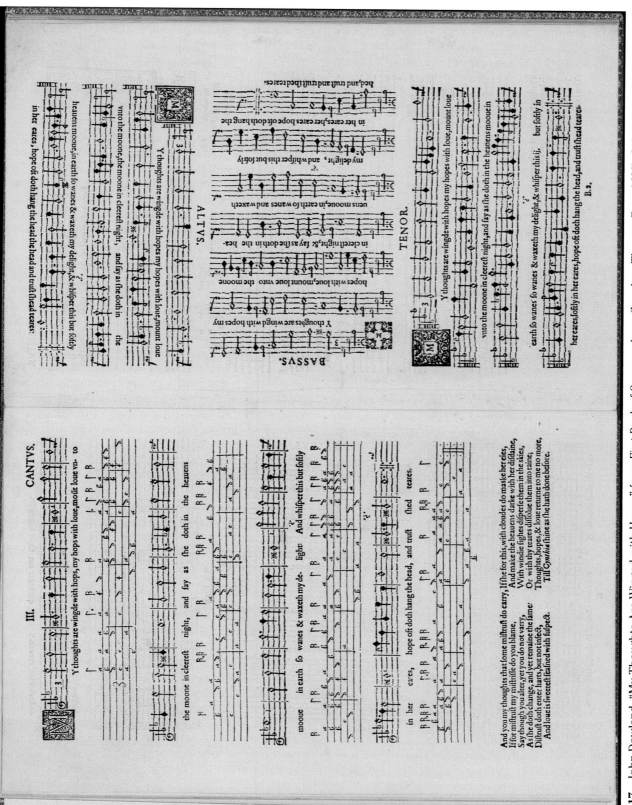

11.17 John Dowland. "My Thoughts Are Winged with Hopes" from *First Book of Songs or Ayres* (London: Thomas Este, 1600). Solo voice with lute accompaniment in tablature (left), optional arrangement for voices (right).

writing in any style and could set texts in French, Italian, and German. He took special delight in the sounds of particular words and was sensitive to every nuance of his text. Musically, his writing is characterized by purity of sound, close knitting together of the various voices, clever use of imitations, and clarity of texture. The moods of his chansons range from bawdy burlesque to profoundly moving serious sentiments. "Susanne un jour" and "Bonjour mon coeur," the one derived from the Old Testament story of Susanna and the Elders, the other a touching love song, were the most popular of his many-voiced songs during his lifetime. They have since been arranged in every way, from solo lute and voice settings to madrigals and full choruses.

COMPOSERS IN TUDOR ENGLAND

Henry VIII—himself a composer—attracted the best Flemish, Italian, and English composer-performers to his court. His son Edward VI played the lute, and his daughter Elizabeth I was an expert performer on the virginal, a small harpsichord-like instrument. England also had its share of great contrapuntal composers, chief among them Thomas Tallis and William Byrd. The crowning achievement of the period was the madrigal, a type of part-song for several individual voices, and the **ayre,** or solo song, in which lyric poetry and melody combined to create a delicate and appealing art form.

John Dowland was outstanding among composer-poets. His ayres range in mood from plaintive lamentation to passionate intensity and dramatic power. The published arrangement of Dowland's "My Thoughts Are Winged with Hopes" (Fig. 11.17) shows how they were printed for home music making.

The book opened so that the performers could be seated at a table. In this case, the principal singer and lute player would sit together, as shown in the left-hand score. The music can also be sung by two voices, with the second singer seated around the table at the right. Many such songs were arranged for vocal quartet with a lute accompaniment that duplicated the three lower parts, allowing great flexibility in performance.

Depending on the number of available singers, these arrangements could be sung as solos with lute accompaniment, a cappella (that is, for four voices without accompaniment), as duets, as lute solos, as instrumental pieces with viols instead of voices, as a combination of voices and viols, as instrumental ensembles with doublings of the parts, with wind instruments substituting for the voices and viols, and so on. Indeed, music had to be adaptable to the size, skill, and instrumental capabilities of any group that might gather for an evening of musical pleasure in the home. These works were the popular music of the period.

DRAMA: SHAKESPEARE

The towering achievement of the Renaissance in England was in the field of drama. By the midsixteenth century, plays emerged as a popular form of entertainment for both the nobility and the general public. The growing demand led to the formation of traveling troupes of actors who played in the provinces as well as in London. The usual place of performance was the courtyard of an inn. When more permanent theaters, such as the old Globe Playhouse in London (Fig. 11.18), were built, their design recalled the layout of a courtyard inn, with its open-air center surrounded by roofed galleries. People of all classes attended these performances; the more prosperous were seated in the galleries with a view of the stage, whereas others stood in what was called the *pit* or *ground.* The stage itself had doorways for the entrances and exits of the players; otherwise, it was quite barren of scenery. The poetry of the text described the setting and carried on the action of the play. The Globe was the playhouse of William Shakespeare and others until it burned down in 1613 during a performance of Shakespeare's *Henry VIII.*

Born in the provincial town of Stratford-upon-Avon, Shakespeare's early life is clouded in obscurity. Like that of most great artists, however, his biography is found in his life's work—nearly 40 plays and some 150 sonnets. At the end of the reign of Queen Elizabeth I, he was associated with a group of players known as the Lord Chamberlain's Men. Such groups performed not only in public places but also in aristocratic households, including the royal court. A number of Shakespeare's plays were performed before Queen Elizabeth, whom he gracefully referred to in *A Midsummer Night's Dream* as "a fair vestal throned by the west." Queen Elizabeth is said to have been so delighted with the character of Sir John Falstaff in the *Henry IV* dramas that she expressed the wish to see a play with Falstaff in love. The result was *The Merry Wives of Windsor.* After 1603, Shakespeare's plays were often performed at the court of James I, who was flattered by Macbeth's allusions to his writings on witchcraft. Under James I, Shakespeare's actors were honored as the King's Men, with the title of Grooms of the Chamber.

The scope of Shakespeare's early plays ranges from the rollicking *Comedy of Errors* and *Taming of*

the Shrew, through the tragedy *Romeo and Juliet,* to such great comedies as *Much Ado about Nothing* and *Twelfth Night.* The historical dramas range from ancient Roman times in *Julius Caesar* to the reigns of various English monarchs. The climax of Shakespeare's prodigious output was attained in his mature years with the tragedies *Hamlet, Othello, Macbeth,* and *King Lear,* all profound works that examine the perennial questions of life and death, love and hate, sanity and madness, ambition and human error. In later plays, he still sought new dramatic directions and explored the borderline between comedy and tragedy.

Shakespeare's stage not only mirrored the values and customs of the Elizabethan era but also rendered a vision of human qualities and flaws that would appeal to subsequent generations. Because his works can be read on so many different levels, new meanings and interpretations are constantly brought to light. There are as many Shakespeares as there are actors, directors, scholars, critics, historians, and audiences, as each interprets, appraises, and enjoys the plays in his or her own way. As his contemporary and fellow dramatist Ben Jonson summed it up, "He was not of an age, but for all time."

BEAUTY AND THE BEAST: SHAKESPEARE'S *THE TEMPEST*

The Tempest is one of Shakespeare's last plays, and its construction borders on technical perfection. The classical unities of time, place, and action are observed, and it follows the five-act form of ancient Roman drama. Essentially, it is a pastoral play, concerned with the opposition of nature and art. One of the central characters, Prospero, is a man of learning, with power over the environment and over himself. In Shakespeare's time, Prospero's magic would have been understood as the special knowledge derived from books, such as Francis Bacon's *Advancement of Learning* (1603).

By contrast, Caliban, like the shepherds in pastoral plays, is a man of nature, akin to the ignorant beasts of the field. It is Caliban, however, against whom all the other figures are measured. He is portrayed as existing at the simple level of the senses, feeling pleasure without knowledge, experiencing lust without love, and being unable to distinguish good from evil. The "civilized" characters, beneath their polished exteriors, have within themselves in varying degrees some of Caliban's baser instincts.

The fairy-tale plot tells of Prospero, the rightful Duke of Milan, who is exiled with his lovely daughter Miranda to a tropical island. The only other inhabitants are Caliban—"a freckled whelp . . . not honor'd with a human shape"—and the "ayrie spirit," Ariel. Learning through his magic powers that his old enemies are sailing past, Prospero conjures up a tempest that shipwrecks their boat and scatters the survivors about the island. There Ferdinand, the handsome young prince of Naples, finds Miranda. After many trials, plots, and subplots, the lovers are united and their marriage celebrated. Prospero regains his dukedom, and forgiveness and reconciliation prevail.

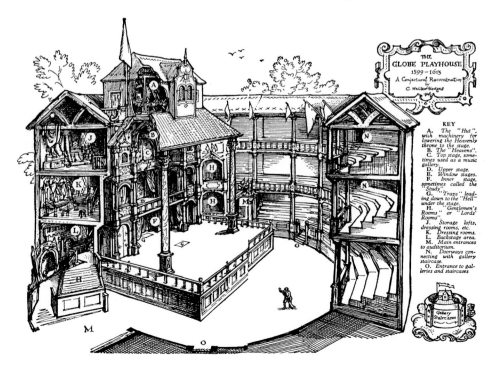

11.18 Globe Playhouse, London, England. Conjectural reconstruction by C. Walter Hodges.

THE GLOBE PLAYHOUSE
1599 – 1613
A Conjectural Reconstruction
C. Walter Hodges

KEY
A. The "Hut", with machinery for lowering the Heavenly throne to the stage.
B. The "Heavens".
C. Top stage, sometimes used as a music gallery.
D. Upper stage.
E. Window stages.
F. Inner stage, sometimes called the "Study".
G. "Traps" leading down to the "Hell" under the stage.
H. "Gentlemen's Rooms" or "Lords' Rooms".
J. Storage lofts, dressing rooms, etc.
K. Dressing rooms.
L. Backstage area.
M. Main entrances to auditorium.
N. Doorways connecting with gallery staircase.
O. Entrance to galleries and staircases

Gallery Staircases

Interpretations of *The Tempest* abound. In recent years there have been productions playing up the adversarial relationship between Prospero and Caliban as representing the colonial powers exploiting the natives of distant lands. This view is not without some justification. Elizabethan England was already a major rival of Spain in the colonization of the New World. Walter Raleigh's and Francis Drake's accounts of their voyages had already been published. Just at the time of *The Tempest*'s first performance in 1611, the public was enthralled by the adventures of a group of colonists who had been shipwrecked in Bermuda on their way to the yet unnamed state of Virginia.

The religious and ethical implications of the meeting of settlers and natives were the subject of hot debate. Shakespeare certainly knew about these developments. The name *Caliban,* for instance, is almost an anagram for *cannibal,* which at the time referred to the natives of the Caribbean, not to eaters of human flesh.

In other views, the drama is seen as symbolizing the four elements, with Caliban as Earth and brute force, Prospero as the fire of imagination, Ariel as the fancy-free spirit of air, and the sea as the environmental waters that surround them. It can also be interpreted as an allegory of fall and redemption, revenge and resolution.

The rhythm and musicality of Shakespeare's verse became an open invitation and challenge to composers from his time to the present. In fact, the plays contained songs, such as the touching "Willow Song" in *Othello.* An anonymous setting from the time survives, but there is no way of knowing whether it was actually performed in a Shakespeare production. The first known setting of a Shakespeare lyric is Robert Morley's "It was a lover and his lasse" from *As You Like It,* but again there is no record of its performance in the play. Shakespeare's contemporary Robert Johnson's settings of two lyrics from *The Tempest*—"Full fathom five" and "Where the bee sucks"—survive and are generally thought to have been composed for the production of 1611, although they were not printed until 1660.

The Tempest's alliance with music is illustrated by the inclusion in Act IV of a full-scale **masque.** These spectacles predate opera and were designed for courtly entertainment. This masque's second known performance was in 1613, for the betrothal of James I's daughter Elizabeth to an important German prince. It was performed by the King's Men, the royal acting troupe of which Shakespeare was a member. The masque, a play within the play, begins with a prologue to set the theme, in this case reconciliation and forgiveness. It continues with songs, dances, and instrumental interludes and finally with the revels, in which the audience participates. The reconciliation is completed in the last act of *The Tempest,* in which Miranda speaks the oft-quoted lines, "O brave new world, / That has such people in't." Even Caliban joins in with the words, "I'll be wise hereafter / And seek for grace."

One of the most intriguing interpretations of the play is that Prospero is Shakespeare himself. His lines toward the end of the masque may function as Shakespeare's farewell to the theater, when he was leaving London for retirement at Stratford:

> Our revels now are ended. These our actors,
> As I foretold you, were all spirits and
> Are melted into air, into thin air:
> And, like the baseless fabric of this vision,
> The cloud-capp'd towers, the gorgeous palaces,
> The solemn temples, the great globe itself,
> Yea, all which it inherit, shall dissolve
> And, like this insubstantial pageant faded,
> Leave not a rack behind. We are such stuff
> As dreams are made on, and our little life
> Is rounded with a sleep.

IDEAS

CRITICAL HUMANISM

The new learning in England, France, and the Low Countries, evidenced by the books of Thomas More, François Rabelais, and Desiderius Erasmus, was pursued vigorously in the early sixteenth century. Inevitably it became entangled in Reformation theological controversies. Italian thinkers, too close to Rome for comfort, had to veil some of their criticism of the church. They deflected attention by projecting a past golden age in antiquity and reviving Plato in opposition to Aristotelian scholasticism. Northern scholars could view church and social abuses more openly and objectively. They also tended to fix on the observation of nature and the world about them. In Northern thought, criticism of the church and the inherited social order assumed two main directions. One way led to the projection of imaginary idealized societies on the model of Plato's *Republic,* the other to holding up the mirror of satire and ridicule to the outmoded medieval heritage.

Thomas More, a lawyer by profession, rose to become Lord Chancellor of England under Henry VIII. When he refused to recognize Henry as head of the English church, he was tried and executed for treason. His widely read *Utopia* was a disguised exposé of the injustices of his time. In *Utopia,* which means "no place," all property was held in

common, because only without personal property could there be social equality. All towns had the same plan, all houses were exactly alike, and all religions were tolerated. Each family made its own clothing, yet all men and women dressed alike. A chosen few, like the Platonic Guardians (see p. 26), were called to pursue learning. Those who governed were picked from this group. There was a kind of representative democracy modeled on the parliamentary system and a ruler chosen by indirect election. The ruler served for life but could be deposed if he turned to tyranny. Life in More's *Utopia* may have been an improvement on the present, but it certainly was dull.

Far more lively reading was provided by the satirists. In France, Rabelais was a professed monk of broad humanistic learning who took up the pen to ridicule the stagnant, lingering medieval outlook of his period and human folly in general. In his *Gargantua* and its sequel, *Pantagruel,* the bawdiness and ribaldry of his tales and his unbridled zest for living sometimes obscure his essentially serious concerns with politics, education, and philosophy. His real purpose was to liberate men and women from their foolishness so that they could realize their higher potential as human beings.

The most influential thinker of all was Erasmus of Rotterdam, who was universally admired for his great knowledge, sharp wit, and brilliant writing style, as well as for the breadth of his humanistic worldview. He was also a connoisseur of art and a

friend of Holbein the Younger, who painted several portraits of him and illustrated many of his books. Erasmus lived and worked in Germany, France, and England. His many letters serve as records of his era, and his *Colloquies* take up popular issues.

In "The Godly Feast," one of his *Colloquies,* Erasmus discusses how nature and art complement each other in two gardens—one real, the other painted. "In one we admire the cleverness of nature, in the other the inventiveness of the painter." In *In Praise of Folly,* Erasmus's biting wit cuts into the pretensions and hypocrisies of his time. Folly narrates the book. Her satire targets people in all walks of life. All are dependent on her, for who can marry or mate without Folly? Held up to ridicule are the monks who "compute the time of each soul's residence in purgatory," the theologians with their endless disputes about the Trinity and incarnation, and the friars who calculate "the precise number of knots to the tying of their sandals." Bishops, cardinals, and popes are castigated for having little religion in them, and it is suggested that even religion is a form of folly.

Visual artists also engaged in satire. Holbein's *Dance of Death,* a series of woodcuts portraying humanity from the Creation to the Last Judgment, is really a comedy about life. Everyone from popes and emperors to common sailors and peasants is eventually leveled off by Death, who appears as a skeleton. Holbein also did a series of drawings for the 1515 printing of Erasmus's *In Praise of Folly.* On the last page (Fig. 11.19), Folly, dressed in a

11.19 Hans Holbein the Younger. Marginal drawing for the last page of Erasmus's 1515 Basel printing of *In Praise of Folly,* facsimile reproduced from the original in the Offentliche Kunstsammlung Basel (H. Oppermann, 1931). The George Arents Research Library at Syracuse University.

joker's cap and bells, has been preaching to her audience of fools. She descends from the pulpit, saying, "And now fare ye well, applaud, live, and drink, ye votaries of Folly."

An ordained priest, Erasmus nonetheless opposed pilgrimages, papal indulgences, the mediation of saints, the power of the clergy, the sacramental system, and the literal interpretation of the Bible. Thus, the road to the Reformation was paved by the northern humanists, whose articulation and advocacy of reason in human affairs served to underscore the corruption of the Church of Rome. Erasmus hoped that his reforms would lead to a new golden age of the arts, but, as has been remarked, he laid the egg that Luther hatched. When he beheld the chick, Erasmus remarked bitterly that "wherever Lutheranism reigns there is the death of letters." He resolved (as did More and Rabelais) to stay with the Church of Rome, and it remained for Luther to sharpen the issues and bring the Reformation to a head.

LUTHER AND THE REFORMATION

The reforms initiated by Martin Luther became the dominating force of the sixteenth century. Luther did not merely change the map of Europe; he also transformed the way people thought of themselves, their associates, and the world about them. During the dark days of his inner struggle to clarify his beliefs, he was struck by St. Paul's words, "The just shall live by faith." Justification by faith became Luther's motto, but it was a faith that every person had to find for himself or herself. Luther held that the individual conscience was the ultimate moral authority and proclaimed the priesthood of all believers. By this he meant that through prayer each believer could address God directly without the mediation of priestly authority, the Roman Catholic Church, or the intercession of the saints.

The word of God, Luther taught, was not necessarily to be found in the writings of the church fathers or in Roman Catholic doctrine, but in the Bible itself. Consequently, it became imperative to translate the Scriptures from Latin into the languages ordinary people knew. Again, the development of printing played a major role in spreading both the Gospel and the writings of the reformers. No longer were the Bible and other books the private preserve of the clergy, the learned, or the well-to-do. Luther held that the Bible spoke directly and clearly. Learning to read and understand was the necessary prelude to faith and salvation. Although Luther was motivated by religious ideas, others promoted the use of vernacular languages to create national awareness. For instance, François I of France made French the official language of politics and business in his realm.

The psychological impact of Lutheranism lay in shifting the burden of thinking from the authority of the priesthood to the individual. Although Luther himself wrote many commentaries, he allowed ample scope for individual opinion and interpretation.

THE EFFECTS ON THE ARTS. The Reformation had an enormous impact on the arts. At first, there was a disruption in the sources of patronage. Funds from the Roman Church for architectural projects, complete with sculptural and decorative programs, were no longer forthcoming in the Reformation countries. However, with the rise of nation-states and the growing power of merchant and shipping families, a reorientation of the patronage system gradually took place.

Architecture also had to take the new religious direction into account. For the most part, the Church of England retained elaborate liturgies, so the heritage of the Gothic structures continued to suffice. On the Continent, however, the Protestants objected to ceremonial pomp. They redecorated their churches and reoriented their services. At first, Protestants on the Continent simply took over and adapted existing Roman Catholic churches, tearing out the sculpture and paintings, whitewashing the walls, and keeping decorative details to a minimum. When new churches were built, they tended to resemble university lecture halls because of a new emphasis on preaching.

Lutheranism recognized only two sacraments: communion and baptism. The communion altar was retained, but it no longer displayed relics of the saints and was no longer the center of attention. The baptismal font also remained, but no longer in a separate chapel. The new order focused on the pulpit, with appropriate seating for the congregation and a prominent place for the choir and organ loft.

In the representational arts, sculpture suffered the most because its lifelike three-dimensionality was believed to bring it close to idol worship and because graven images were forbidden by the second commandment. Painted altarpieces were also out of the question.

One of the darkest aspects of sixteenth-century history was the wholesale destruction of church art. Protestant extremists in England, France, and Germany smashed stained-glass windows, demolished statuary, decapitated sculptured figures on Gothic porches and facades, and destroyed choir screens that they believed separated the faith-

ful from the altar. Paintings were ripped out and burned. Fortunately, Luther disapproved of this wanton destruction and warned his more zealous followers that it was not necessary "to swallow the Holy Ghost feathers and all."

The views of Reformation leaders on the proper place for the arts varied from partial acceptance to total exclusion. John Calvin, a leader of the Reformation in Switzerland, initially said, "I approached the task of destroying images by first tearing them out of my heart." He modified his position somewhat by saying that crucifixes and images of the saints were "praiseworthy and to be respected," but for memorial purposes only. However, he remained rigid in his disapproval of works of art and the worship of images.

Luther scorned the worship of icons and images, but he was not an iconoclast, that is, someone who promotes the destruction of images. "If it is . . . a good thing for me to bear the image of Christ in my heart," he asked, "why should it be a sin to have it before my eyes?" He sat for innumerable portraits (Fig. 11.20) and numbered the painter Lucas Cranach the Elder among his friends

and Dürer and Bruegel among his admirers. In general, though, Luther was more sensitive to the spoken word and music than to the visual arts.

In the pictorial arts, new themes and a new iconographic tradition gradually emerged. Up to the Reformation, the emphasis had been on history painting, with mainly biblical and mythological subjects. The Reformation brought other categories to the fore. Iconography shifted from universals to particulars. Luther's reorientation of religion toward the subjective, private individual favored the development of portraiture. Genre scenes telling of everyday experiences, personal feelings, and reactions received new impetus. Dürer's engravings and Bruegel's paintings of peasant life are cases in point.

Another major change was the increased attention to landscape for its own sake rather than merely as a background for figures. For the Reformationists, landscape was a reflection of increasing interest in the exploration of nature as such, an expression of God's bounteous creation, and a confirmation that God exists in a simple clod of earth like that painted by Dürer (Fig. 11.12). Albrecht Altdorfer's view of the Danube (Fig. 11.21)

11.20 Lucas Cranach the Elder. *Luther as Augustinian Friar,* 1520. Copper engraving, 5⅞″ × 4⅝″. British Museum, London, England.

11.21 Albrecht Altdorfer. *Danube Landscape near Regensburg,* c. 1522–1525. Panel, 11″ × 8⅝″. Alte Pinakothek, Munich, Germany.

combines keen observation of color and light with a perception of nature infused by the supernatural. Still life also began to come into its own. The new middle class took special delight in the tangible objects that represented the good life, but their consciences demanded a moral message. Thus, representations of crockery, mirrors, jewelry, and the like were meant to recall a well-known phrase from the Bible (*vanitas vanitatus, omnia vanitas*; Ecclesiastes 1:2), which stresses the delusion of worldly riches. Flowers, fruit, dead animals, and skulls were classed as memento mori, reminders of the passage of time, the brevity of life, and the inevitability of death.

Above all, a lively market developed for prints, both alone and as illustrations in books. These were media that had not before been associated with idolatry or popery. Indeed, book illustration soon became an art in its own right, one that was acceptable in both Protestant and Catholic circles and one that would attain importance.

The Reformation also opened up many possibilities for music. Luther himself wrote the stirring words and perhaps the music for "A Mighty Fortress Is Our God," the anthem that became the marching song of the Reformation. His reorganization of the German Mass opened the doors to new directions in choral and organ music and to the forms of the cantata and oratorio (see pp. 408–409 and 428–430).

Both congregational and professional singing were woven into the Mass.

In general terms, the Reformation was a conflict between North and South, the Germanic and Latin cultures, nationalism and internationalism, personal conviction and hierarchically organized religion. No one side could be declared the winner. In the long run, the principal casualty would be the Renaissance style in both the North and the South. The stage would soon be set for an adjustment of the arts in an era of spiritual conflict and mannerism.

─────── **YOUR RESOURCES** ───────

• *Exploring Humanities CD-ROM*

 ○ Interactive Map: Europe in the Sixteenth Century

 ○ Readings—Shakespeare Modules: *A Midsummer Night's Dream, Henry IV, The Merry Wives of Windsor, Twelfth Night, Hamlet, Othello, King Lear, The Tempest,* Erasmus, *In Praise of Folly*

• *Web Site*

 http://art.wadsworth.com/fleming10

 ○ Chapter 11 Quiz

 ○ Links

NORTHERN RENAISSANCE

Key Events	Visual Arts and Reformers	Literature and Music
1337–1453 **Hundred Years' War** between England and France	c. 1324–1327 **Jean Pucelle** active ▲	
	c. 1330–1384 **John Wycliffe** ✚	
	1369–1415 **John Huss** ✚	
	c. 1375–c. 1425 **Limbourg Brothers:** Pol, Herman, and Jehanequin ▲	
	c. 1378–1444 **Robert Campin** (Master of Flémalle) ▲	
	1379–1471 **Thomas à Kempis** ✚	
	c. 1379–1406 **Claus Sluter** active ●	
1384 **Philip of Burgundy** acquired Flanders	c. 1385–1426 **Hubert van Eyck** ▲	
	c. 1390–1441 **Jan van Eyck** ▲	c. 1390–1453 **John Dunstable** ❏
1414 **Council of Constance** began church reform; declared church councils as supreme authority, not pope; John Huss condemned as heretic	c. 1400–1464 **Rogier van der Weyden** ▲	1400–1474 **Guillaume Dufay** ❏
	c. 1405–c. 1445 **Conrad Witz** ▲	1427 **Thomas à Kempis,** probably wrote *Imitation of Christ*
1420–1436 **Philip the Good** of Burgundy made Bruges his capital	c. 1415–1475 **Dick Bouts** ▲	c. 1430–1495 **Johannes Ockeghem** ❏
	c. 1420–1481 **Jean Fouquet** ▲	c. 1440–1521 **Josquin Desprez** ❏
1429 **Joan of Arc** defeated English at Orleans; Charles VII crowned at Rheims	c. 1430–1494 **Hans Memling** ▲	c. 1446–1506 **Alexander Agricola** ❏
	c. 1435–1498 **Michael Pacher** ▲	1450–1505 **Jacob Obrecht** ❏
1440 **Johannes Gutenberg** developed press with movable type; 1456 Gutenberg Bible printed	c. 1440–1482 **Hugo van der Goes** ▲	c. 1450–1517 **Heinrich Isaac** ❏
	c. 1450–1491 **Martin Schongauer** ▲	1470 **Voragine's** *Golden Legend* (Lives of Saints) first printed in Cologne
1455–1485 **Wars of Roses** in England; 1485 Henry VII (Tudor) ascends throne	c. 1450–1516 **Hieronymus Bosch** ▲	1473–1543 **Nicholas Copernicus** ◆
	c. 1460–1523 **Gerard David** ▲	1478–1535 **Thomas More** ◆
1474 **Caxton** printed first book in English (*Histories of Troy*) at Bruges	c. 1460–1531 **Tilman Riemenschneider** ●	c. 1490–1553 **François Rabelais** ⁂
	c. 1465–1530 **Quentin Metsys** ▲	c. 1497–1563 **Johann Neudörfer** ⁂
1488 **Diaz** rounded Cape of Good Hope	c. 1465–1524 **Hans Holbein the Elder** ▲	c. 1505–1585 **Thomas Tallis** ❏
1492 **Columbus** reached America	1466–1536 **Erasmus of Rotterdam** ✚	1509 **Erasmus** wrote *In Praise of Folly*
1493–1519 **Holy Roman Emperor Maximilian I** ruled; patron of Dürer	1471–1528 **Albrecht Dürer** ▲	1514–1564 **Andreas Vesalius** ⁂
	1472–1553 **Lucas Cranach the Elder** ▲	c. 1521–1603 **Philippe de Monte** ❏
1497–1499 **Vasco da Gama** voyaged to India	c. 1475–1528 **Mathias Grünewald** ▲	1521–1531 **Luther** translated Bible into German
1500–1700 **Overseas empires** created by Spain, Portugal, Holland, England, and France	c. 1475–1532 **Jan Gossaert** ▲	c. 1532–1594 **Orlande de Lassus** ❏
	c. 1480–1538 **Albrecht Altdorfer** ▲	1533–1592 **Michel de Montaigne** ◆
1517 **Luther** posted 95 Theses condemning church practices	1483–1546 **Martin Luther** ✚	1536 **Calvin** published *Institutes of Christian Religion*; 1541 founded Protestant church at Geneva
1519 **Charles I of Spain** elected emperor; until 1555 ruled Spain, Low Countries, Germany, Austria, Italy as Charles V	1484–1531 **Ulrich Zwingli** ✚	1543–1623 **William Byrd** ❏
	c. 1485–c. 1540 **Jean Clouet** ▲	1543 **Copernicus** published *On the Revolution of the Celestial Bodies;* **Vesalius** wrote *Structure of the Human Body*
1519–1522 **Magellan's expedition** circumnavigates globe	1489–1556 **Thomas Cranmer** ✚	
1521 **Diet of Worms** convened; Luther refuses to retract teachings, declared outlaw by Charles V's Council; Luther excommunicated by Pope Leo X, burns papal bull, translates New Testament into German	c. 1497–1543 **Hans Holbein the Younger** ▲	1546–1601 **Tycho Brahe** ⁂
	1497–1560 **Philipp Melanchthon** ✚	1549 **Cranmer** compiled first *Book of Common Prayer,* revised 1552
1524–1525 **Peasants' revolt** in Germany	c. 1508–1575 **Pieter Aertsen** ▲	c. 1552–1599 **Edmund Spenser** ◆
1534 **Church of England** founded under Henry VIII	1509–1564 **John Calvin** ✚	1554–1586 **Philip Sidney** ◆
1545–1563 **Council of Trent** called to reform church from within; censorship of books begun; Inquisition established to try to condemn heretics	c. 1510–c. 1565 **Jean Goujon** ●	
	c. 1525–1590 **Germain Pilon** ●	
	c. 1527–1569 **Pieter Bruegel the Elder** ▲	
	1528–1587 **Caterina van Hemessen** ▲	
1555 **Diet of Augsburg** convened by Charles V; ordered Protestants to state beliefs; Augsburg Confession became Lutheran creed; each ruler could decide faith of his people		c. 1557–c. 1602 **Thomas Morley** ❏
		1561–1626 **Francis Bacon** ◆
1555 **Charles V abdicates;** son Philip II ruled Spain, Low Countries, Mexico, Peru; brother Ferdinand ruled Austria, the Germanys		1561 **John Knox's** *Book of Discipline* established church constitution for Scotland
		c. 1563–1626 **John Dowland** ❏
1572 **Dutch war of liberation** begun; 1576 Provinces of Netherlands united		1564–1593 **Christopher Marlowe** ◆
1572 **St. Bartholomew Day Massacre** of Huguenots (French-Calvinists)		1564–1616 **William Shakespeare** ◆
		c. 1565–1640 **Giles Farnaby** ❏
1577–1580 **Drake** sailed around world		1567–1620 **Thomas Campion** ❏
1583 **William of Orange** became ruler of northern Netherlands		c. 1570–1638 **Francis Pilkington** ❏
		1571–1630 **Johannes Kepler** ⁂
1588 **Spanish Armada** defeated by British		1572–1637 **Ben Jonson** ◆
1598 **Edict of Nantes** gave Huguenots freedom of conscience, private worship, and civil rights		1582–1616 **Beaumont** and **Fletcher** active ◆
		1583–1625 **Orlando Gibbons** ❏
1603 Elizabeth I succeeded by **James I**		1594–1613 **Shakespeare** wrote plays
		1604 **Francis Bacon** published *Advancement of Learning*
		1611 **Bible** appears in King James Version

❏ - Musician ▲ - Painter ✚ - Religious Reformer ⁂ - Scientist ● - Sculptor ◆ - Writer

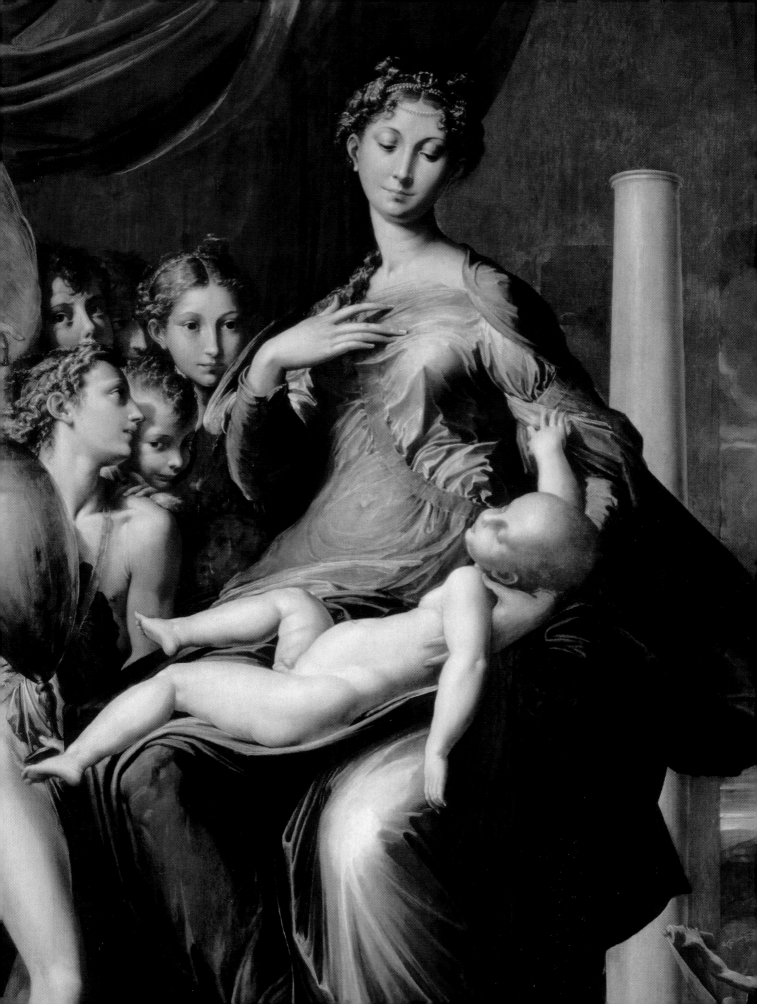

THE VENETIAN RENAISSANCE AND THE RISE OF INTERNATIONAL MANNERISM

A GLIMPSE OF VENICE AS it looked at the threshold of the sixteenth century can be seen through the eyes of the painter Gentile Bellini. His reporting in *Procession in St. Mark's Square* (Fig. 12.1) is so accurate that architectural historians can make reconstructions of buildings long since destroyed and researchers can study the mosaics and sculptures of St. Mark's Basilica as they were before later restorations.

St. Mark's Basilica proclaims Venice as a cultural center where East and West met. Begun in the tenth century, it is the product of centuries of community effort. Indeed, an early law required every Venetian ship to bring back materials for the construction or decoration of the church. As a result, fragments from many Mediterranean countries can be found somewhere in its fabric—from the Greco-Roman bronze horses of the first century CE over the central portal (Fig. 12.2) to the many-colored marble columns from Alexandria

and the Greek alabaster windows. The plan is that of a Greek cross, with smaller domes covering each of the four wings and a large cupola in the center.

To the right in Bellini's painting is a corner of the Doge's Palace where the doge—the chief official of Venice—and his guests are seated on the second-story arcade. This striking variation of a Gothic town hall rises in two stories of open pointed arches surmounted by a third story notable for its diamond-shaped design in brilliant pink marble tiling. Across the square on the left is the old library, from which many spectators are watching the activities. This building, with its curious chimney pots, also dates from medieval times.

As remarkable as the library's architecture is the institution itself. Donors chose Venice as a safe repository for books because the water-bound city was less at risk of fire than other places. Venice

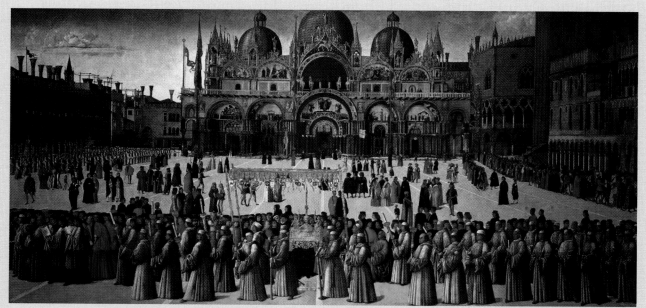

12.1 Gentile Bellini. *Procession in St. Mark's Square,* 1496. Oil on canvas, 12′ × 24′. Galleria dell'Accademia, Venice, Italy.

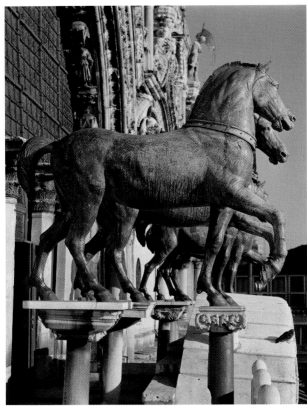

12.2 Four horses of Greek origin. First century CE.
Gilt bronze, life-size. St. Mark's Basilica, Venice, Italy.

treasured the great collections of books that had
been bequeathed by the poet Petrarch, the Greek
scholar Cardinal Bessarion, and others. In addition
to these collections, the library housed all the spec-
imens of the city's elegant printing and bookmak-
ing industry. They included fine but inexpensive
editions of classics, which were published here for
the first time by the famous Aldine Press and con-
tributed to the spread of learning throughout the
educated world. In the sixteenth century these col-
lections were transferred to the handsome building
across the square, designed by Sansovino espe-
cially to house them (Fig. 12.3).

VENICE IN
THE SIXTEENTH CENTURY

Bellini depicted not only the look of St. Mark's
Square but also the feeling of public life and the
freedom of social movement found in Venice dur-
ing the sixteenth century. The independence of
Venice and the prosperity of its citizenry were due
in many respects to the city's unusual situation.
Built on a group of island lagoons at the head of
the Adriatic Sea, Venice was what a Florentine

poet described as "a city in the water without
walls." Reasonably secure from attack either by
land or sea as a result of possessing the largest
navy then in existence, Venice carried on an active
commerce that afforded its citizens a quality of life
unrivaled in its time for comfort and luxury.

The fall of Constantinople to the Turks in 1453
and the rising power of the Ottoman Empire pro-
duced competition for Venice's commercial em-
pire. Also, the traditional shipping upon which the
Venetian economy rested was upset by the ben-
efits gained by regions along the Atlantic coast
from the findings of Spanish, Portuguese, Dutch,
and English navigators and explorers. Despite the
unsettled world situation, the Venetians were pre-
paring to reassert their economic and cultural
supremacy. They embarked on an ambitious pro-
gram of building and decorating to enrich their
city while impressing their competitors.

ARCHITECTURE

A NEW LIBRARY FOR THE CITY. Jacopo Sansovino
was awarded the commission to build the new Li-
brary of St. Mark (Fig. 12.3). Trained in both sculp-
ture and architecture in his native Florence, he had
been active in Tuscany and Rome before settling in
Venice in 1527. His library design recalls such Ren-
aissance city palaces as those built for the wealthy
families of Florence and Rome (see Fig. 9.5), but
with an important difference. Instead of relying on
flat surfaces, rusticated masonry, and fortresslike
facades, Sansovino molded his masses and voids as
if they were sculpture. The structure has two sto-
ries, with a spacious foyer below and a great stair-
case leading to a well-lighted reading room above.

The dignified Doric arcade of the lower story
serves as a base for the increasingly rich adornment
of the upper parts. The deep-set arched windows
of the second floor are unified by the regularity of
the Ionic columns, and the poses of the sculptured
nudes in the spandrels provide variety. A high-relief
frieze of cherubs holding garlands runs above, al-
ternating with small, deep-set windows. At the top
a **balustrade**—a row of short posts topped by a
rail—encircles the roof and supports a line of stat-
ues silhouetted against the skyline. The overall
impression is one of spaciousness and openness
that invites entry and promises an equally signifi-
cant interior.

THE THEORY AND PRACTICE OF ARCHITECTURE.
Sansovino's designs influenced Andrea Palladio,
the greatest architect associated with the Vene-
tian style. The author of the highly influential *Four
Books of Architecture,* first published in Venice in

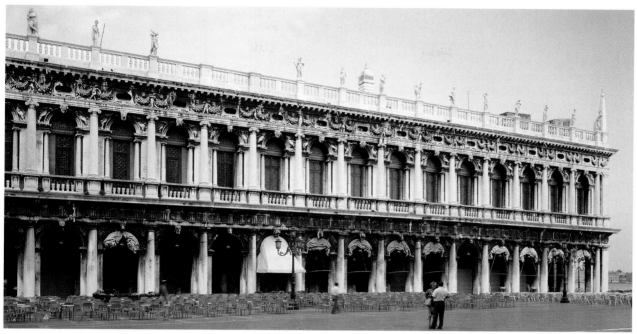

12.3 Jacopo Sansovino. Library of St. Mark, Venice, Italy, begun 1536. Length 290′, height 60′.

1570, Palladio left a detailed discussion of his philosophy. In the preface to this work, Palladio paid eloquent tribute to his ancient Roman guide Vitruvius, whose writings stimulated his study of the classical buildings in Rome. "Finding that they deserved a much more diligent Observation than I thought at first Sight," he noted, "I began with the utmost Accuracy to measure every minutest part by itself."

Palladio's *Four Books of Architecture,* with their sketches and drawings, was more influential in France, England, Ireland, and America than were his buildings. The English translation, published with notes by his disciple Inigo Jones, helped establish the Georgian tradition in England (see Fig. 14.16).

In the United States, Thomas Jefferson carried on Palladio's insights in the designs he prepared for his residence at Monticello and the Rotunda of the University of Virginia (see Fig. 17.11), both of which are adaptations of Palladio's Villa Rotonda (Fig. 12.4A). Jefferson also wanted to build the White House in Washington, D.C., using the same plan, but his proposal, submitted anonymously, was rejected. However, even in its present form, the White House has a Palladian design, with a classical Ionic entrance portico in the center and two equal wings spreading outward.

Palladio's ideas were based on both Roman classical architecture and some of the more progressive trends of his Renaissance contemporaries.

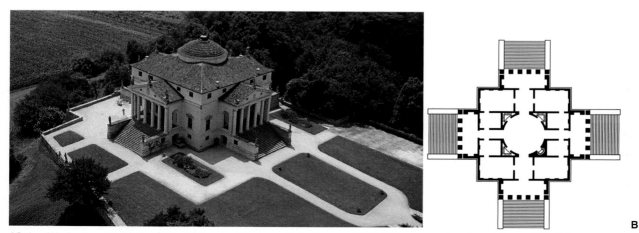

A B

12.4 (A) Andrea Palladio. Villa Rotonda, Vicenza, Italy, begun 1550; 80′ square, height of dome 70′. (B) Plan of Villa Rotonda.

He also saluted his immediate predecessor, Sansovino, whose library he praised as "perhaps the most sumptuous and the most beautiful edifice . . . since the time of the Ancients."

Palladio's architecture can be studied in Vicenza, then a part of the Venetian Republic's holdings on the mainland. Just outside Vicenza is the Villa Rotonda (Fig. 12.4A), a country house in the grand style and the prototype of many later buildings. The plan is a cube enclosing a cylindrical core surmounted by a low saucer dome (Fig. 12.4B).

On four sides, grand flights of steps lead to Ionic porches that project forward. The pediments are those of a classical temple, with statues on either side and above. Each porch provides entrance into the imposing round reception room that gives the villa the name **Rotonda.** This central salon is as high as the house itself and rises to the cupola above. Alcoves left over from the parts between the round central hall and the square sides of the building allow space for four winding staircases and for no less than thirty-two rooms in the adjoining corners, all lighted both from the outside and from the eight round windows at the base of the cupola. Below, a basement includes ample storerooms, servants' quarters, and kitchens. Palladio thus designed a house that is spacious but simple in plan.

As with Brunelleschi and Alberti in Florence (see p. 248), musical proportions played a major role in Palladio's spatial thinking. The ground plan (Fig. 12.4B) is a marvel of geometric clarity, with the central circle signifying the dome. Grouped around the dome are reception rooms; the larger of which are positioned on the corners and designed in a rectangular shape. Palladio insisted that the harmonic ratios be preserved in the relationships of each room to the others. He also designed an additional harmony between length, width, and height.

Palladio was thoroughly conversant with the musical ideas of his contemporary, Gioseffo Zarlino, the Venetian theorist who synthesized all knowledge of music in a famous sixteenth-century compendium. In this great age of counterpoint, Zarlino based his system on the **hexachord,** or six-note scale from do to la. The number 6 also comes to the fore as the basic module in Palladio's thought. For example, if a room is 6 feet wide, then the length would be 12 feet and the height would be the mean between them (that is, 9 feet). Palladio also favored rooms measuring 18 by 30 (both divisible by 6) or 12 by 20 (both divisible by 4), each making a ratio of

12.5 (A) Andrea Palladio. Il Redentore, Venice, Italy, 1576–1592. (B) Plan of Il Redentore.

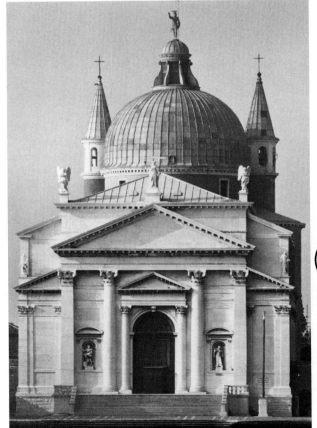

A

B

3:5. Musically, 3:5 comes out as the interval of the major sixth. "Such harmonies," wrote Palladio, "usually please very much without anyone knowing why, apart from those who study their causes."

When advancing years limited Sansovino's activities, Palladio was called to Venice to construct several buildings, among them the Church of Il Redentore, "The Redeemer" (Fig. 12.5A). Palladio challenged himself to reconcile the Greco-Roman temple with the traditional oblong Christian basilica plan (Fig. 12.5B). Because a classical temple is of uniform height with a simple shed roof, whereas a Christian basilica has a Latin-cross ground plan with a central nave rising high above two side aisles, his solution to this age-old problem shows great ingenuity.

The central part of the facade of Il Redentore becomes the portico of a classical temple complete with columns and pediment, which faces the central nave. The acute angles of a fragmentary second pediment face the side aisles. The pediment theme is repeated in the small triangle above the entrance and in the side angles at the roof level, making in all two complete and two incomplete pediments. This **broken-pediment** motif would later appear in much baroque architecture. To create the feeling of deep space, Palladio alternated square pilasters with round columns and arranged the pediments in a complex intersecting design.

To create the impression of spatial depth in the interior of Il Redentore (Fig. 12.6), Palladio

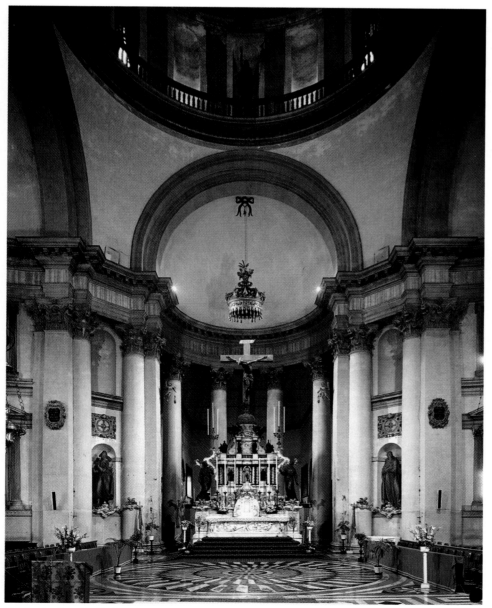

12.6 Andrea Palladio. Interior, Il Redentore, Venice, Italy, 1576–1592.

eliminated the solid-walled apse that usually closes the space around the altar. In its place he used a semicircular open colonnade against clear glass windows. The effect leads the viewer's eye past the altar and into the distance.

The last building Palladio undertook was the Olympic Theater at Vicenza (Fig. 12.7). He had only begun this project the year he died, and Vincenzo Scamozzi finished the construction using Palladio's designs. Palladio's design called for the use of an ingenious device to give the feeling of deep space: a ramp. The ramp is flanked by building facades and rises through the central arch from which actors made their entrance. Although the ramp recedes only about 50 feet, it creates the illusion of a long avenue leading to an open city square in the distance. Inspired by ancient Roman amphitheaters, the Olympic has, in turn, been the inspiration for many later theaters, including one of London's largest, the Palladium.

A NEW KIND OF PAINTING

Venice has always been a visual paradise. Palaces rise like lace out of the waters. The mercurial movements of the winds and clouds cast constantly changing reflections and colors on the canals. There seems to be no borderline between dream and reality. Venice's fulfillment as a major visual arts center, however, awaited the development of oil paints.

Mosaics served well in Byzantine times, but they were not adaptable to the subtler aspects of Renaissance art. Fresco murals painted on plaster were too impermanent in such a damp climate. Tempera on wood panels also proved to be short-lived. When the technique of oil on canvas was developed in the north, particularly in Flanders in the middle and late fifteenth century, the Venetians quickly took it up and made it their own.

The oil medium opened up many new possibilities. In contrast to the hard resins used by the Flemish painters, the Venetians mixed their pigments with oil and flexible resins, giving themselves greater freedom of brushwork. This new technique also made it possible to work directly on canvas without having to make extensive preliminary drawings, either on paper or on the canvas itself. Also, the range of color and blended color was vastly increased. Dramatic use of high intensities to spotlight principal figures and deeper shadow for subordinate ones became more attainable. In addition, subtle modeling of figures, softness of contours, and various atmospheric effects came under greater control.

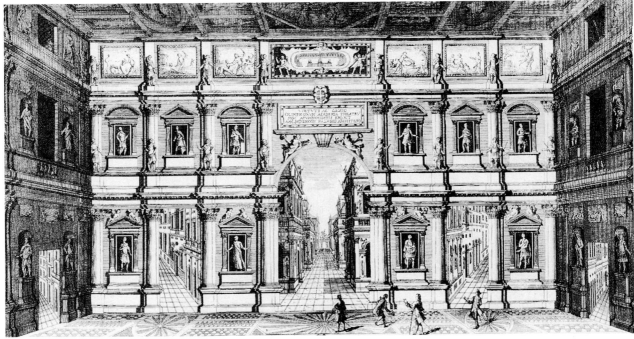

12.7 Andrea Palladio. Interior, Teatro Olimpico, Vicenza, Italy, 1580–1584.

The success of the Venetian mode of painting spread throughout Europe. It was quickly taken up in Italy, and El Greco carried it with him to Spain (see pp. 377–380). Peter Paul Rubens brought it to northern Europe. From there, both Rubens and Anthony Van Dyck introduced the technique to England, from whence it traveled to America.

A STAR IN THE FAMILY BUSINESS: GIOVANNI BELLINI. When the young German painter Albrecht Dürer first visited Venice in 1495, Gentile Bellini was working on his *Procession in St. Mark's Square.* His brother Giovanni was doing a series of altarpieces for Venetian churches. Of all the Venetian painters,

Giovanni Bellini's work commanded Dürer's highest admiration. This first impression was confirmed on a later trip in 1506, when he praised Giovanni as "still the supreme master."

The root of Giovanni Bellini's art was a harmonious blend of his father Jacopo's early-Renaissance heritage and the special contributions of his brother Gentile and his brother-in-law Andrea Mantegna of Mantua. But the beautiful branches of this family tree were Giovanni's own paintings, which embraced an emotional range from the silent suffering of his *Pietàs,* through the melancholy meditations of saints and hermits (Fig. 12.8), to the lyrical grace and joyous maternity of his

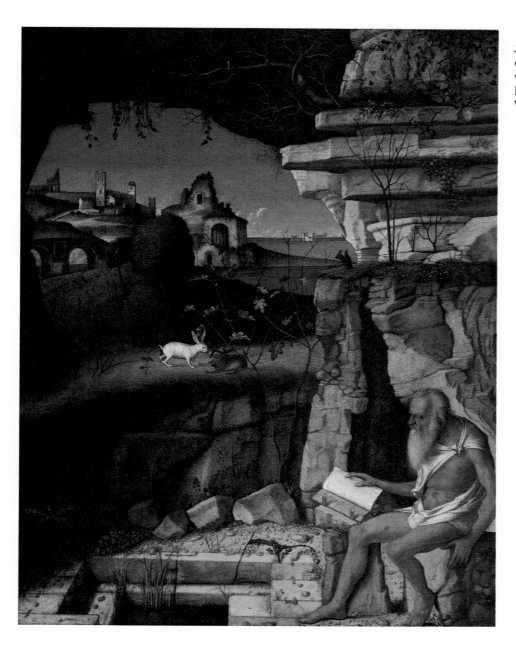

12.8 Giovanni Bellini. *Saint Jerome Reading,* c. 1480–1490. Oil on wood, 1′7¼″ × 1′3½″. National Gallery of Art, Washington, D.C.

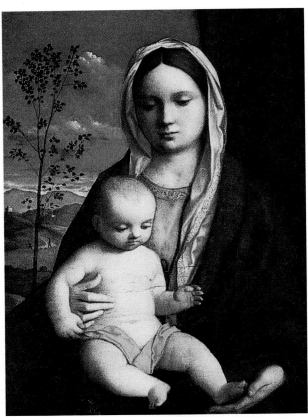

12.9 Giovanni Bellini. *Madonna and Child,* 1505. Oil on wood, 1′7⅝″ × 1′4⅛″. Galleria Borghese, Rome, Italy.

Madonnas (Fig. 12.9). All are set in poetic landscapes filled with the soft, golden light that brings all of nature into a warmly glowing unity.

Giovanni Bellini developed a special treatment of space, dividing the viewer's attention between the closed setting of foreground figures and a receding landscape background. Like the gentle, warm light he used, this spatial treatment became a distinctive part of the Venetian artistic vocabulary. In fact, for later painters it was to become practically a formula for religious subjects and portraiture.

POETRY OF COLOR: GIORGIONE AND TITIAN. The full development of Venetian painting is evident in the poetic pictures attributed both to Giorgione and to his close associate, Titian. In the *Concert Champêtre,* or *Pastoral Concert* (Fig. 12.10), the eye is first attracted to the quartet of figures on the picture plane, then led leisurely toward the middle ground, where a shepherd is tending his flock. The eye finally comes to rest on the gleaming water of the distant horizon. This pastoral idyll, or interlude, is enlivened by several oppositions of figures. Among them are the clothed male figures and the female nudes; the pairing of the polished courtier and stately lady on the left with the rustic shepherd and shepherdess on the right; the attitudes of the two women—one gazing intently at

12.10 Giorgione? Titian? *Concert Champêtre (Pastoral Concert),* c. 1510. Oil on canvas, 3′7¼″ × 4′6⅜″. Louvre, Paris, France.

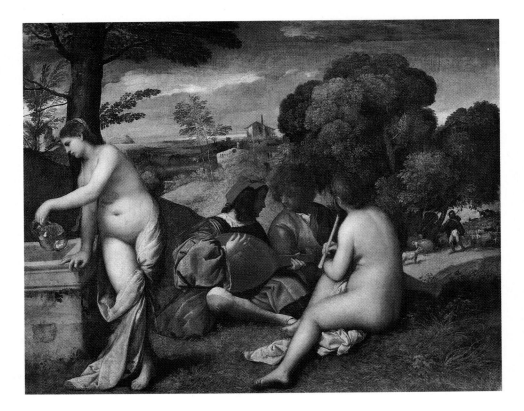

her lover, the other turning gracefully away; the lute, symbolizing lyric poetry; and the flute, pastoral poetry.

The Tempest (Fig. 12.11) is even less concerned with storytelling and more with pictorial construction than the *Concert Champêtre.* A sunny foreground and human figures define the picture plane. Iconographically, a soldier usually personifies fortitude, whereas a seated mother nursing her child represents love or charity. But the main interest of this work lies in the landscape, which reveals itself as the eye is led in receding planes into deep space and the threatening sky in the

distance. Stability is maintained through the careful balance of vertical (standing figure, broken columns, trees, buildings) and horizontal (unfinished wall, bridge) lines.

Both the *Pastoral Concert* and *The Tempest* create a mood rather than communicate a specific story or meaning. A puzzle, perhaps, to contemporaries who were accustomed to the usual iconographic subjects, the paintings may be more understandable to the modern observer, who is used to seeing a picture as complete within itself rather than as an illustration of a religious or literary theme.

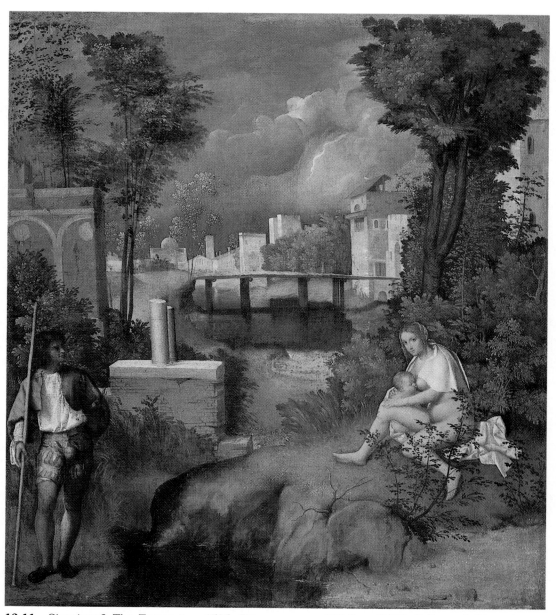

12.11 Giorgione? *The Tempest,* c. 1505. Oil on canvas, 2′8¼″ × 2′4¾″. Galleria del'Accademia, Venice, Italy.

Unlike the modest-sized *Pastoral Concert* and *The Tempest,* Titian's large altarpiece *Assumption of the Virgin* (Fig. 12.12), an altarpiece for the church of Santa Maria dei Frari, is filled with heroic-sized figures. It was intended to catch the attention of anyone entering through the nave portal about 100 yards away. The painting's dynamic vertical movement fits well into the Gothic style of the church.

In this dramatic composition, heavenly and earthly spheres converge momentarily. The apostles are grouped below, in deep shadow; they are raising their arms toward the intermediate zone and the ascending Madonna, whose gesture, in turn, directs the eye to the dazzling brightness above. The upward motion is arrested by the descending figure of God surrounded by angels. Titian skillfully adapted linear movement and gradations of light, as well as transitions of color from somber shades to light pastel hues, to convey the idea of a human spirit soaring triumphant over the gravitational pull of earthly considerations. In this work, Titian created a new pictorial type that was to have a profound influence on the painter El Greco (see Figs. 13.18, 13.19, and 13.20), the baroque sculptor Gian Lorenzo Bernini (see Fig. 13.11), and a number of seventeenth-century painters.

Titian's rich coloring also became the model for later Venetians, such as Tintoretto, and for baroque masters, such as Rubens and Velázquez. In *Bacchus and Ariadne* (Fig. 12.13), Titian depicts the god's return from India accompanied by his mixed band of revelers. On seeing the lovelorn Ariadne, who has been deserted by her lover Theseus, Bacchus leaps from his panther-drawn chariot, his pink drapery aflutter, to wed her. A fascinating visual rhythm based on the repetition of the V-shaped tree near the center pervades the composition. In inverted form, it is echoed in the limbs of Bacchus and Ariadne. The pattern continues across the canvas with the legs of the leopard, the dog, the young faun, and each of the dancing bacchantes.

Titian devised a slashing diagonal direction for the sharp downward plunge of Bacchus. A subtle touch of visual counterpoint can be seen in the sky, where the incident is reenacted by clouds whose shapes echo the drapery and gestures of the principal figures and where the starry crown of immortality awaits Ariadne.

The frenzied Bacchus contrasts with the serene modern goddess of love whom Titian created for the Duke of Urbino (Fig. 12.14). Although she is called Venus, it is more likely that she was a fashionable courtesan, fully at home in her sensuality and her luxurious surroundings. The warm, winey tones of the painting, including the color of Venus's hair, which has for centuries been called *titian red,* introduce a world like that portrayed in *Bacchus and Ariadne,* where the moral concerns of mortals are absent but not missed.

THE ORIGINS OF MANNERISM: TINTORETTO. The paintings of Titian's younger colleague, Tintoretto, added a new dimension to the sensuous qualities of Venetian tones. Tintoretto wedded the vigor of Michelangelo's drawing to the color range of Titian. His violent contrasts of light and dark, together with his off-center diagonal directions, moved away from the harmonious Renaissance composition of a work like Titian's *Assumption.* Tintoretto also rejected the

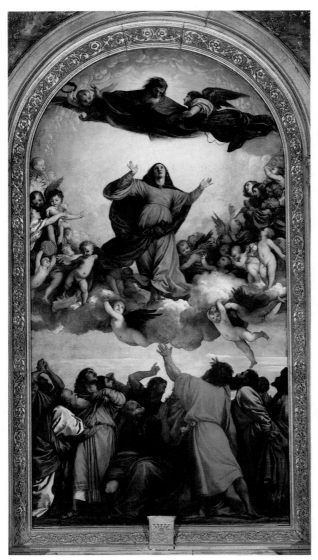

12.12 Titian. *Assumption of the Virgin,* 1516–1518. Oil on canvas, 22′6″ × 11′8″. Santa Maria dei Frari, Venice, Italy.

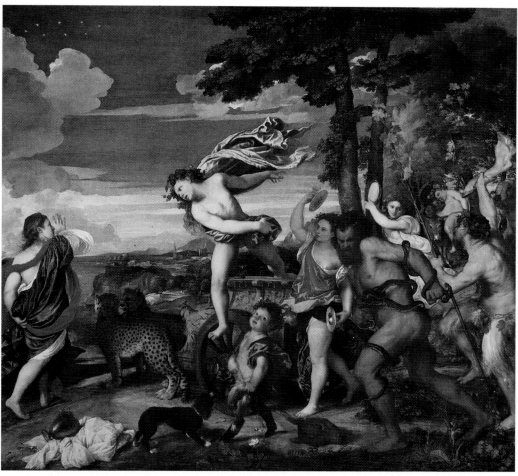

12.13 Titian. *Bacchus and Ariadne,* c. 1520. Oil on canvas, 5′8″ × 6′7⅛″. National Gallery, London, England.

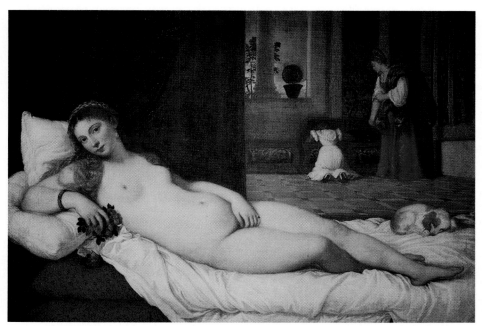

12.14 Titian. *Venus of Urbino,* 1538. Oil on canvas, 4′ × 5′6″. Galleria degli Uffizi, Florence, Italy.

Renaissance notion that an image should be reasonable, that is, that it should appear clear, orderly, and directly legible to a viewer. He teased viewers by placing principal figures on the edge of the action and contriving intricate space-penetrating designs that directed the eye along several different routes. Similarly, he favored a dramatic interplay of the natural and the supernatural, the earthly and the unearthly, the human and the divine.

In his *Last Supper* (Fig. 12.15), Tintoretto represents the miraculous moment when Jesus offers the bread and wine as the sacrificial body and blood of human redemption. To depict this unfathomable mystery of faith, Tintoretto bathes his canvas in a supernatural glow that seems to come partly from the figure of Christ and partly from the flickering flames of the oil lamp. The smoke is transformed into a hovering angelic choir and ends in a burst of light around the head of Christ. The drastic diagonals of the floor are paralleled by those of the table, but instead of directing the eye to the head of Christ, as they would in Renaissance paintings like those of Masaccio (see Figs. 9.15 and 9.16), the lines lead to an indefinite point in the upper right and to space beyond the picture.

Tintoretto's design for *The Marriage of Bacchus and Ariadne* (Fig. 12.16) is more lyrical yet equally complex. He created a rotating movement in which the figures seem to be floating weightlessly in space.

In this work the seated Ariadne personifies Venice, crowned with the stars of immortality. Bacchus represents the good life, providing the fruits of the earth that flowed from the city's prosperous maritime trade. The hovering Venus, goddess of love, binds both together. The ship on the horizon recalls the grand aquatic ceremony that took place each year, when the doge cast a golden ring into the water to symbolize Venice's marriage to the sea.

This is one of four panels originally painted for the ambassadorial waiting room in the Doge's Palace. It is likely that each conveyed a political message to visitors. One depicts Vulcan in his forge producing armor, to signify Venice's industrial might. In another, Minerva with her wisdom repulses the war god Mars to proclaim Venice's love of peace. A third shows the doge between figures symbolizing peace and justice.

It is interesting to note that Tintoretto trained his talented daughter, Marietta Robusti, as a painter. Unlike Sofonisba Anguissola (Fig. 12.17), whose education was shaped by her noble family's implementation of suggestions for the education of women outlined in Baldassare Castiglione's *Book of the Courtier* (see pp. 274–276), Robusti received an education typical of that given to male painters in the midsixteenth century. Similarly, Lavinia Fontana, who studied with her father Prospero, achieved a reputation in her own right.

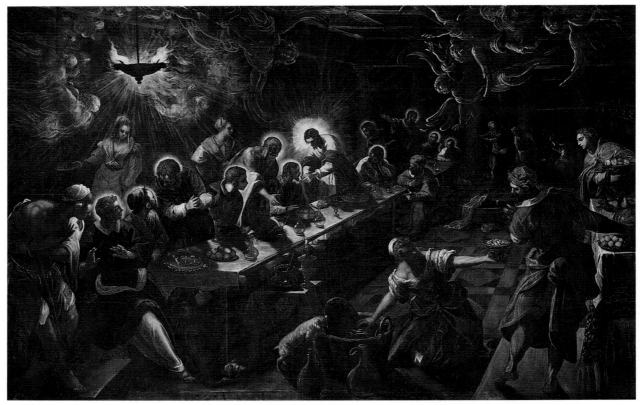

12.15 Tintoretto. *Last Supper,* 1592–1594. Oil on canvas, 12′ × 18′8″. San Giorgio Maggiore, Venice, Italy.

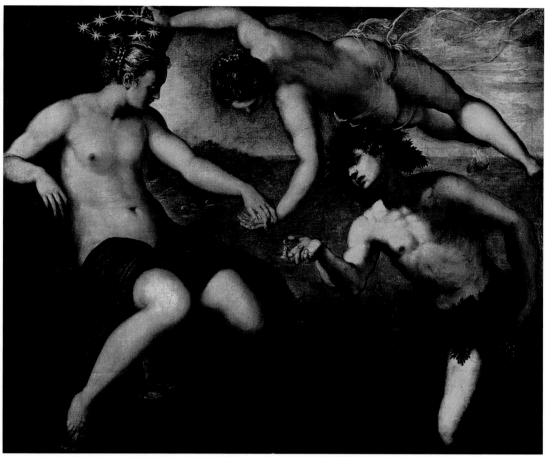

12.16 Tintoretto. *The Marriage of Bacchus and Ariadne,* 1577–1588. Oil on canvas, 4′9″ × 5′5″. Doge's Palace, Venice, Italy.

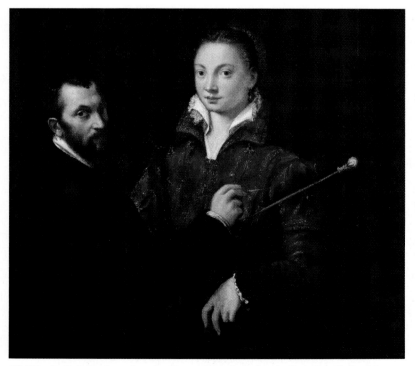

12.17 Sofinisba Anguissola, *Bernadino Anguissola Painting Sofonisba Anguissola,* late 1550s.

Her gender prevented her from attending an art academy, but she found ample work painting portraits and creating religious art (Fig. 12.18). Although few in number, successful sixteenth-century women artists, and the activities of women patrons like the formidable Isabella d'Este, marchioness of Mantua, may have helped other women think not only of making art but also of making money while making art.

A PAINTER'S PAINTER: VERONESE. Paolo Cagliari, known as Veronese, did not scale the heights and plumb the depths as did his colleagues Titian and Tintoretto. Instead, his searching eye sought out the rich and varied surface play of the Venetian scene around him. A painter's painter, Veronese is known for his bravura with the brush, the sensuousness of his surfaces, and the tactile strength of his drawing. In his *The Dream of Saint Helen*

12.18 Lavinia Fontana, *Consecration to the Virgin,* 1599. Musée des Beaux-Arts, Marseilles, France.

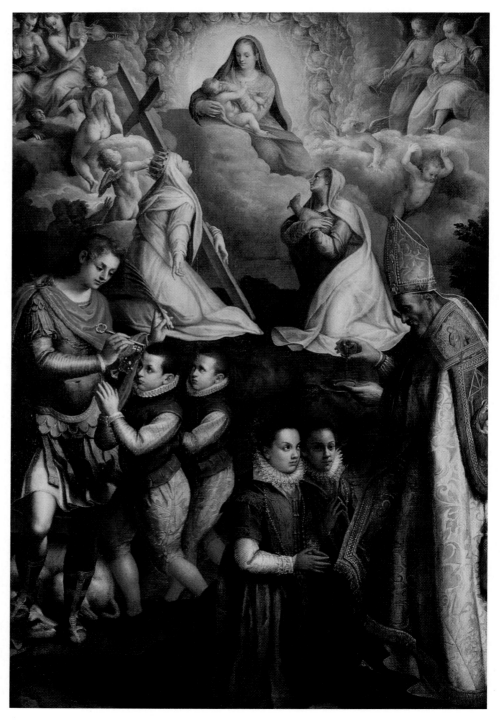

(Fig. 12.19), he is not so much concerned with her inner vision as he is with the colorful splendor of his canvas. Helen was the mother of the Emperor Constantine, who converted to Christianity in 313. According to tradition, it was she who first found a relic of the true cross of Christ and in a vision beheld the location of the Holy Sepulchre. As Veronese portrays her, she is clad in a queenly robe of satin brocade and wears a bejeweled crown. Veronese revels in the play of light and shadow around the rich folds of the drapery, the glow of the golden crown, and the shimmer of the pearls. He excels in rendering the contrasting textures of the marble column, the gilt-bronze figure in the niche, the wood of the cross, and the nude flesh of the angel.

Of all his subjects, the most congenial to Veronese's approach was celebration. Painted with the primary object of engaging and entertaining vision, his canvases succeeded in capturing an important part of Venetian life: the pleasure and

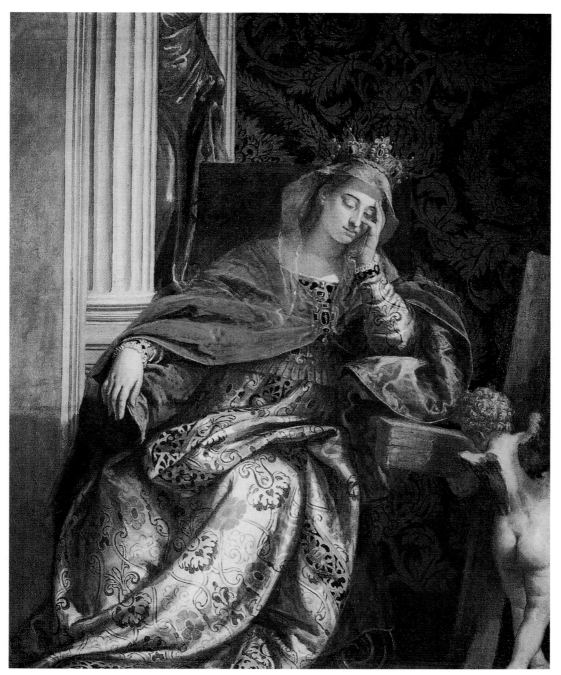

12.19 Paolo Veronese. *The Dream of Saint Helen,* c. 1580. Oil on canvas, 5′5⅓″ × 4′4¾″. Vatican, Pinacoteca, Italy.

amusement of large social gatherings and the love of rich surroundings embellished with fruits, flowers, animals, furniture, draperies, and jesters. *The Feast in the House of Levi* (Fig. 12.20) was originally painted as a Last Supper for the refectory of a Venetian monastery. The composition is held in tight control by the three arches of the loggia setting, which Veronese adapted from the designs Sansovino had made for the interior of the library and the Loggetta at the base of the campanile in St. Mark's Square (Fig. 12.1).

Questions were soon raised about the propriety of the painting's content. By tradition, a Last Supper scene portrayed only Christ and the twelve apostles, but Veronese had included more than fifty figures (including the twelve apostles). This departure from tradition resulted in his being brought before the court of the Inquisition (see p. 362). The inquisitors were disturbed not only by the number of figures but also by the presence of a dog and a cat, which Veronese painted in the foreground. Even more troublesome was the inclusion of German soldiers sitting on the staircase at the very time when the Roman Catholic Church was experiencing a theological confrontation with the Lutheran Reformation in Germany. One of the most remarkable documents in the history of painting—a summary of the painter's actual testimony intended to justify his work—reveals much about this picture and about Veronese's conception of art in general:

> Question. Did anyone commission you to paint Germans, buffoons, and similar things in that picture?
> Answer. No, milords, but I received the commission to decorate the picture as I saw fit. It is large and, it seemed to me, it could hold many figures.
> Q. Are not the decorations which you painters are accustomed to add to paintings or pictures supposed to be suitable and proper to the subject and the principal figures or are they just for pleasure—simply what comes to your imagination without any discretion or judiciousness?
> A. I paint pictures as I see fit and as well as my talent permits.
> Q. Does it seem fitting at the Last Supper of the Lord to paint buffoons, drunkards, Germans, dwarfs and similar vulgarities?
> A. No, milords.
> Q. Do you not know that in Germany and in other places infected with heresy it is customary with various pictures full of scurrilousness and similar inventions to mock, vituperate, and scorn the things of the Holy Catholic Church in order to teach bad doctrines to foolish and ignorant people?
> A. Yes, that is wrong; but I return to what I have said, that I am obliged to follow what my superiors have done.
> Q. What have your superiors done? Have they perhaps done similar things?
> A. Michelangelo in Rome in the Pontifical Chapel painted Our Lord, Jesus Christ, His Mother, St. John, St. Peter, and the Heavenly Host. These are all represented in the nude—even the Virgin Mary—and in poses with little reverence.[1]

[1] Elizabeth G. Holt, ed., *Literary Sources of Art History: An Anthology of Texts from Theophilus to Goethe* (copyright © 1947, 1975 by Princeton University Press). Reprinted by permission of Princeton University Press.

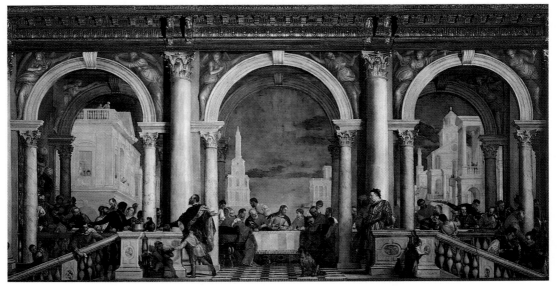

12.20 Paolo Veronese. *The Feast in the House of Levi,* 1573. Oil on canvas, 18′2″ × 42′. Galleria dell'Accademia, Venice, Italy.

In a Last Supper, the figures seated with Jesus at the table should be the twelve apostles, but Veronese could specifically identify only two. He pointed out St. Peter on Christ's right, in robes of rose and gray, who according to the painter is "carving the lamb in order to pass it to the other end of the table," and St. John on Christ's left. When questioned about the other figures, Veronese claimed that he could not recall them, given that he had "painted the picture some months ago." Yet only 10 months had passed, and the iconography of the Last Supper was very well known.

The Inquisition's verdict required Veronese to make certain changes in the picture. Rather than comply, he simply changed the title to *The Feast in the House of Levi,* thereby placing it outside the iconographic tradition of Last Supper pictures. This controversy is a landmark in art history. In defending his work, Veronese raised aesthetic and formal values above those of subject matter.

MUSIC

The peak of Renaissance musical development was the polyphonic style of the Netherlandish composers. The general admiration for this art at the beginning of the sixteenth century was summed up by the Venetian ambassador to the court of Burgundy, who remarked that three things were of the highest excellence in the area: first, the finest, most exquisite linen of Holland; second, the tapestries of Brabant, most beautiful in design; and third, the music, which certainly could be said to be perfect. With such sentiments being expressed in official circles, it is not surprising to find that in 1527 a Netherlander and a leading representative of the polyphonic art, Adrian Willaert, was appointed to the highest musical position in Venice: choirmaster of St. Mark's.

This admiration for northern musical forms is another instance of the internationalism of the Venetians. Under Willaert and his successors, Venice became a center of musical progress while Rome remained a fortress of tradition. Its relative freedom from religious authority predisposed it to new developments, and among the results were a number of new musical forms and radical changes in older ones. In vocal music, this meant promotion of the madrigal, modification of the church motet, and development of the **polychoral style,** which made simultaneous use of two, three, and sometimes four choirs. Instrumental music found new forms in the organ **intonazione** (short prelude), **ricercare** (contrapuntal composition), and **toccata** (brilliant showpiece) for keyboard solo and in the **sinfonia** and early **concertato** and **concerto** forms for orchestra.

In Venice, the "modern style" was linked with Giovanni Gabrieli and his organ music, with early orchestral writing, and with the development of the polychoral style. In Florence, it was associated with Vincenzo Galilei, Peri, and Caccini and their solo songs and early opera experiments. In Rome, it was associated with Girolamo Frescobaldi and his virtuoso organ works. In Mantua and Venice, the madrigals and operas of Claudio Monteverdi became the basis of the new baroque music.

MUSIC AT ST. MARK'S CATHEDRAL. The musical development begun by Willaert culminated in the work of Giovanni Gabrieli, who held the position of first organist at St. Mark's from 1585 until his death in 1612. His principal works were published under the title *Symphoniae Sacrae* in 1597 and 1615.

The domed Greek cross plan of St. Mark's, with its choir lofts placed in the transept wings, seems to have suggested some unusual acoustic possibilities to composers. When a choir was concentrated in the compact space beyond the transept, as in the traditional Latin-cross church, the body of sound was unified. When it was divided into two or more widely separated groups, as at St. Mark's, the interplay of sound led to experiments that resulted in the so-called polychoral style. In effect, it dissolved the traditional choruses and heralded a new development in the choral art.

These **chori spezzati**—literally, "broken choruses"—as they were called, added the element of spatial contrast to Venetian music, and a variety of new effects were created. One of these effects was the echo device, which became central to the baroque tradition. Composers could alternate two contrasting bodies of sound, such as chorus against chorus, single line versus full choir, solo voice opposing full choir, or instruments pitted against voices. Instrument groups could be contrasted, high and low voices alternated, soft sound played against loud sound, fragments played against a continuous musical line, and block chords made to stand out against a flowing counterpoint.

The resultant principle of duality, based on opposing elements, is the basis for the concertato or concerting style. The word appears in the title of some works Giovanni Gabrieli published jointly with his uncle Andrea in 1587: *Concerti. . . per voci e stromenti* (Concertos . . . for voices and instruments). The term later came to be widely used, with such titles as *Concerti Ecclesiastici* (Church Concertos) appearing frequently.

The motet *In ecclesiis,* written as the second part of the *Symphoniae Sacrae,* is an example of Gabrieli's mature style. Although the specific occasion for which it was intended is unknown, the motet is of the processional type and as such is appropriate music for ceremonies similar to that depicted in Bellini's picture (Fig. 12.1). Moreover, the choirs arranged in groups, as well as a brass ensemble, are similar to Bellini's details (Fig. 12.21).

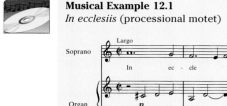

Musical Example 12.1

In ecclesiis (processional motet) Giovanni Gabrieli

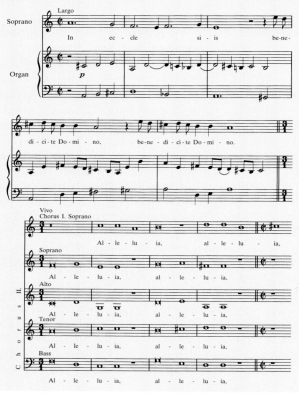

The structure of Gabrieli's motet is based on the word *alleluia,* which functions as a **refrain,** or recurring section, and acts as a divider between the verses. The alleluias also are set in the more stationary triple meter, suggesting a pause in the procession, whereas the stanzas have the more active beat of footsteps, as in march time.

A gradual buildup of volume can be heard in the sequence of sopranos and full chorus; tenors and full chorus; the instrumental sinfonia, first alone, then in combination with tenors and altos; and the instrumental color against the chorus with organ support. The cumulative climax is

brought about by the final grandiose union of all vocal and instrumental forces, ending in a solid cadence radiating with musical color and producing the huge sonority necessary to bring the mighty work to its close.

THE MUSICAL EXPERIMENTS OF MONTEVERDI. Although Gabrieli's tonal works became the precedent for the later *colossal baroque,* it remained for his successor, Claudio Monteverdi, to probe the inner spirit of the new style. With Monteverdi, the transition to the baroque becomes evident. Appointed master of music of the Most Serene Republic of Venice in 1613 after serving as court composer at Mantua for 23 years, Monteverdi achieved a working combination of Renaissance counterpoint and all the experimental techniques of his own time.

At Mantua, Monteverdi had already written his *Orfeo* (1607), a complete opera in the modern sense, with overture, choruses, vocal solos and ensembles, instrumental interludes, and ballet sequences. At Venice, where the first public opera house was established in 1637, he continued with a series of lyrical dramas, of which only the last two survive: *Return of Ulysses to His Homeland* (1641) and *The Coronation of Poppea* (1642). Today all three operas remain in the repertory of international opera houses and can be seen and heard through visual and aural media.

In addition, Monteverdi gave a new twist to the Renaissance madrigal, a type of music for two or more singers, each of whom has a separate part. The madrigal with lyrics devoted to the delights of love and the beauties of nature reached a high point of popularity in sixteenth-century Italy and in the England of Queen Elizabeth. With Monteverdi, however, the madrigal took on a special emotional and dramatic character that paralleled developments in visual mannerism (discussed in the next section).

The new emotional orientation is stated in Monteverdi's *Eighth Book of Madrigals* (1638):

> I have reflected that the principal passions or affections of our mind are three, namely, anger, moderation, and humility or supplication; so the best philosophers declare, and the very nature of our voice indicates this in having high, low, and middle registers. The art of music also points clearly to these three in its terms 'agitated,' 'soft,' and 'moderate' [**concitato, molle,** and **temperato**].

The collection has the significant subtitle "Madrigals of War and Love." Monteverdi declared

that he wanted to depict anger, warfare, entreaty, and death as well as the sounds of brave men engaged in battle. According to Monteverdi, vocal music of this type should be "a simulation of the passions of the words." Descriptive melodies in this **representative** style reflected the imagery of the poetic text. In Monteverdi's madrigal "Zefiro torna" (Return, O Zephyr), the word *l'onde* (waves) is expressed by a rippling melody, whereas *da monti e da valli ime e profonde* (from mountains and valleys high and deep) is rendered by sharply rising and falling lines.

Musical Example 12.2
"Zefiro torna" (Return, O Zephyr) Monteverdi

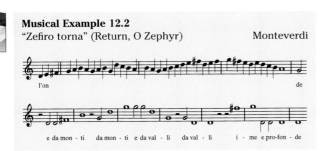

MANNERIST EUROPE IN THE SIXTEENTH CENTURY

In the sixteenth century, Europe was in a state of acute crisis. A series of catastrophic events shocked major cultural centers. Every aspect of life—religious, scientific, political, social, economic, personal, aesthetic—was destined to undergo reexamination and radical change.

In England, Henry VIII broke with Rome and established the Church of England. On the Continent,

the moral zeal and desire for reform of Martin Luther, John Calvin, and others divided Europe into Reformation and Counter-Reformation camps. Territorial ambitions and the lust for conquest resulted in a clash of wills between Emperor Charles V and King Francis I of France. Feeling his country caught in a giant squeeze play, Francis tried to fortify his position by invading northern Italy, but the king proved to be no match for the powerful Holy Roman Emperor.

The voyages of the great navigators and the exploits of the colonizers who followed in their wake had brought much of North, Central, and South America under Spanish control. With a monopoly on the Asian spice trade and with the gold and silver mines of the New World pouring fabulous riches into its treasury, Spain was rapidly emerging as the most powerful country in the world. With the Spanish crown on his head and the lordship of Holland, Flanders, Germany, and Austria firmly in his grasp, Charles next turned his attention to Italy. One by one the formerly independent Italian duchies and city-states came under his domination.

Opposition from any quarter was not tolerated. In 1527, Charles's mercenaries marched on Rome, sacking and plundering. Eight days later the Eternal City was a smoking ruin, the Vatican a barracks, St. Peter's a stable, and Pope Clement VII a prisoner at Castel Sant'Angelo. The Sack of Rome was a psychological and a physical blow to its citizens, who believed that they no longer lived at the thriving center of the Western world. Many took the fact that the Eternal City could be vanquished as a portent of worse things to come. It seemed to be a sign that the city and the church

were being punished for indulging in worldly vices. Resident artists fled; among them were Sansovino (to Venice), Parmagianino (to Parma), and Benvenuto Cellini (to France).

The pope had no choice but to submit to Spanish policy. A Spanish viceroy ruled in Naples, and a Spanish government was installed in Milan. Through the Gonzagas in Mantua, the Estes in Ferrara, and the Medici in Florence, the Spaniards controlled all important commercial and cultural centers. With Spanish rule came Spanish severity and religiosity mixed with etiquette and courtly elegance, all of which quickly began to shape Italian cultural life. The new scientific theories and discoveries were equally unsettling. In 1543, the astronomer Copernicus brought out his book *On the Revolution of the Planets in Their Orbits,* a work that was destined to change the conception of the cosmos from an Earth-centered to a sun-centered universe. Shock and anger followed the publication as people began to realize that they inhabited one of several planets whirling through space and were no longer at the center of creation. (Almost 75 years later, the Italian astronomer Galileo was tried for heresy because he made a similar claim. He was sentenced to prison and released only when he disavowed his teachings and writings.) The combined effect of Copernicus's claim and other scientific findings weakened the prevailing belief in miracles and divine intervention in human affairs.

Peasant revolts, invasions by the Ottoman Turks, piracy at sea, trials by the dreaded Inquisition, the burning of heretics, and religious and civil wars completed the turbulent picture. Such a seething of currents and crosscurrents, new and old directions, and inner anxieties and contradictions was bound to find expression in the arts.

THE DEVELOPMENT OF MANNERISM

As a historical phenomenon, **mannerism** ran an erratic course from about 1530 to 1590, sandwiched between the fading Renaissance and the emergence of the baroque style. Like the crisis it incorporated, mannerism points in many directions. Any discussion of mannerism should probably refer to *mannerisms,* because so many different cultural centers, conflicting trends, varieties of patrons and personalities, and individual idioms were involved. The word itself has several meanings. *Maniera* in Italian denotes "manner" or "style." In English, *mannered* indicates a somewhat derogatory, idiosyncratic, affected, or exaggerated mode of behavior. In the arts, *mannerism* implies fluency, virtuosity of execution, a high degree of sophistication, and a sense of stylishness, which often leads to overrefinement and self-consciously contrived attitudes.

Living in the shadow of such unrivaled masters of the immediate past as Leonardo da Vinci, Michelangelo, and Raphael created a dilemma for the younger generation of painters. They were very much aware that a golden age had preceded them and that there was little hope of their improving on the concepts and craft of their famous predecessors. These young artists found themselves at a crossroads. Following the old paths meant selecting certain ideas and techniques of their precursors. Striking out in new directions meant taking for granted such perfected technical achievements as linear and atmospheric perspective, mathematically correct foreshortening, and anatomically correct renderings—if only to deliberately and visibly break these rules with telling and dramatic effects.

The first course required working "in the manner" of the giants of the past. In part, the reverence for the past led to the founding of academies to transmit the traditional techniques to young artists. When Giorgio Vasari, a disciple of Michelangelo, used the term *de maniera,* he meant working in the manner of Leonardo, Michelangelo, and Raphael. By reducing their art to a system of rules, he could work quickly and efficiently. His fondest boast was that whereas it took Michelangelo 6 years to finish one work, he could complete six works in 1 year.

Some artists accepted the fact that the era of experimentation was over and the era of fulfillment was at hand. This was not a time of eccentric genius or soul-searching prophecy, only a period of competent craftsmanship. Such was the course followed by Vasari, Palladio, and Veronese. In Florence, Vasari was instrumental in founding an academy of design in 1561. At Bologna in 1585, the Carracci family established an institute with the word *academy* in its name, where courses in art theory and practice were offered.

The mannerist artists did not turn to nature for their models, as Leonardo had done, but rather studied great works with the thought of mastering the artistic vocabularies of the late Renaissance geniuses. Art, in other words, did not hold up a mirror to nature but rather reflected the art of the past. At the lowest level, this implied well-schooled technicians and a style based on conventions—a free borrowing and reassembling without the original creative synthesis. At the highest level, this approach could lead to virtuosity of execution. In no way did it rule out inspiration. In the work of the Florentine mannerist Rosso Fiorentino, who followed in the footsteps of Michelangelo, the results are evident. Rosso's tumultuous *Moses Defending the Daughters of Jethro* (Fig. 12.22), with its muscular male nudes, is a typical example of this aspect

of mannerism. The development of mannerism can, in fact, be traced to some of Michelangelo's late work, such as the *Last Judgment* (see Fig. 10.9), and the architecture of the Medici Library in Florence.

With the architecture of Palladio, a more academic mannerism came to terms with the classical orders of Vitruvius. By adapting Roman architectural forms to his contemporary needs, he cooled the Venetian love of lavishness and curbed the excesses of overdecoration. Similarly, through the symmetry of his designs, his closed forms, and the organizing function of his architectural backgrounds, Veronese was able to handle large crowds and bustling movement without detracting from his pictorial unity, as in *The Feast in the House of Levi* (Fig. 12.20). Although Gabrieli's music broke up the unity of the Renaissance choir—encompassing and increasing the scope of musical space—his support of the traditional Renaissance polyphony kept his work under strict control.

Thus, one important type of mannerism was an extension, codification, and academic adaptation of the ideals of the High Renaissance. The more striking aspect of mannerism, however, is found in its strong reactions to and bold, dramatic departures from Renaissance rules and decorum. Loyal followers of the Renaissance saw this trend as the collapse of an ideal order and the adoption of an "affected manner" by highly idiosyncratic artists. The rapid rise of Mannerism's popularity in the courts of Italy and France suggests that the style appealed to those who wanted to show their superior taste and connoisseurship.

The second type of mannerism was originated by artists who, unlike their Renaissance forebears, were no longer excited by the mathematics of linear perspective or the challenge of finding the proper size and relationship of figures to their surrounding space. Instead, they discovered excitement in breaking established rules and violating Renaissance assumptions. In their work, naturalism gave way to the free play of the imagination. Classical composure yielded to nervous movement, which would emerge as a hallmark of the baroque style. Clear definition of space succumbed to a jumble of picture planes crowded with twisted figures. Renaissance symmetry and focus on the central figure were replaced by off-balance diagonals that made it difficult to find the protagonist of the drama amid the numerous directional lines. Backgrounds no longer contained the picture but were instead vaguely defined or nonexistent. Also, the norms of body proportion were distorted by the unnatural elongation of figures. **Chiaroscuro,** the art of modeling with light and shade, now served to create optical illusions, violent contrasts, and theatrical lighting effects. Finally, strong, deep colors and rich

costumes faded to pastel hues and gauzy, fluttering drapery. In short, the Renaissance dream of clarity and order became the mannerist vision of anxious, warped space. Some of these tendencies had been present in the late High Renaissance. Giorgione's puzzling pictures (Figs. 12.10 and 12.11) broke with iconographic tradition and confused his contemporaries. In Leonardo's *Madonna and Child with St. Anne and the Young St. John* (see Fig. 9.25), the figures are uncomfortably superimposed on each other; how St. Anne supports the weight of the Madonna and what they are sitting on is left to the viewer's imagination. The symbolism of the work, which shows the genealogy of Christ and His ancestry in the developing cult of St. Anne, is overwhelmed by the powerful, naturalistic representation. In the black terror and bleak despair of Michelangelo's *Last Judgment* (see Fig. 10.9), clarity of space no longer exists: there are crowded parts and bare spaces, the size of figures is out of proportion, and one cannot even be sure who are the saved and who the damned.

What was the exception in the High Renaissance became the rule under mannerism, which quickly, although briefly, was taken up in several international cultural centers. Florentine mannerists such as Rosso Fiorentino and Benvenuto Cellini

12.22 Rosso Fiorentino. *Moses Defending the Daughters of Jethro,* 1523. Oil on canvas, 5′ × 4′. Galleria degli Uffizi, Florence, Italy.

12.23 Jacopo Pontormo. *Joseph with Jacob in Egypt,* 1518. Oil on canvas, 3'2″ × 3'7⅛″. National Gallery, London, England.

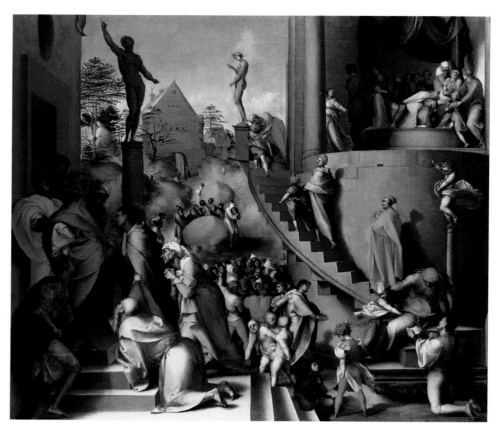

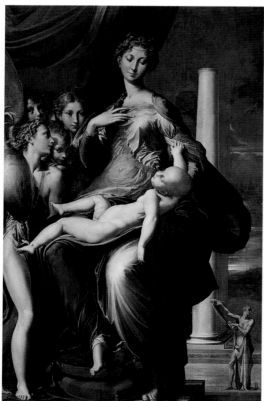

12.24 Parmigianino. *Madonna with the Long Neck,* 1534–1540. Oil on wood, 7'1″ × 4'4″. Galleria degli Uffizi, Florence, Italy.

were summoned to Paris to become court artists of Francis I. Raphael's prolific pupil Giulio Romano was appointed the official architect of the Duke of Mantua.

Despite their desire to dazzle and their whimsically contrived tricks, these artists had no intention to deceive. Their complicated art was addressed to the sophisticated few who were well aware of the new practice and could enjoy the witty turns and startling twists. This courtly phase of the mannerist style, however, was too restricted to a single class and too refined and self-conscious in its aestheticism to endure for long.

PAINTING: PONTORMO, PARMIGIANINO, AND BRONZINO

Pontormo's *Joseph with Jacob in Egypt* (Fig. 12.23) was painted on commission for a bedroom in a Florentine palace. The appropriately dreamlike canvas is a picture puzzle, the parts of which do not quite fit together. The story is told in three scenes, with Pharaoh's dream in the upper right, the finding of the cup in Benjamin's sack in the center, and Joseph's reconciliation with his brothers at the left. The Renaissance traditions of unified space and diminution of figures as they recede from the picture plane are deliberately violated. The kneeling figure in the right foreground is half the size of

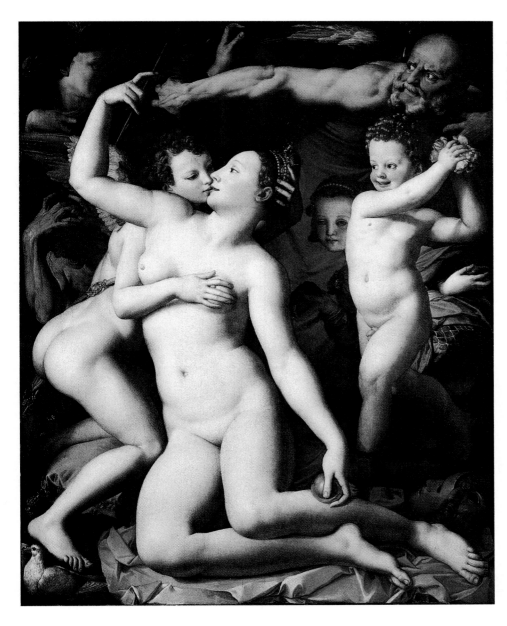

12.25 Bronzino. *Allegory of Venus,* c. 1550. Oil on wood, 4′9″ × 3′9″. National Gallery, London, England.

his counterpart on the left. The winding staircase that goes nowhere, the statues that gesticulate like actors on stage, and the capricious flickering of light and shadow over the surface of the picture all add to the strange, enigmatic atmosphere.

Gracefulness, elegance, and extreme refinement characterize Parmigianino's *Madonna with the Long Neck* (Fig. 12.24). The artist may have been inspired by a hymn to the Virgin that compares her neck to an ivory column. Even though the painting is unfinished, its oddness seems to contradict its original intent as an altarpiece. The Madonna's elongated neck is paralleled by the strange rising column that supports nothing. The exaggerated length of her hand, the delicate tapering of her fingers, and the stretched-out body of the child provide balancing

horizontal accents at the expense of naturalistic representation. The serpentine posture of Mary terminates in the unnatural elongation of her right foot and left leg. The prophet on the right (St. Jerome?) in a calculated violation of normal perspective completes this surprising excursion into artistic license. Unmistakably, Renaissance concern with clarity and accurate depiction of the human figure have been sacrificed to create a more stylish, if strange, picture.

Bronzino came by his mannerism through his training with Pontormo, who portrayed him as the boy sitting on the steps of the middle foreground of Figure 12.23. He is best known for the icy formalism of his elegant portraits of the local aristocracy. In his *Allegory of Venus* (Fig. 12.25), he makes an excursion into mythological metaphor. The

number of figures is enough to fill a large-scale mural, but here they are intertwined and crowded into a cramped, claustrophobic space. The muscular arm of Time at the top, aided by Truth, is drawing a curtain to expose the **tableau vivant** below. Along with Venus's legs and the standing figures of Cupid and Folly, the arm frames the picture. The ardent caresses of Cupid certainly exceed the usual demonstrations of affection by a son to his mother. Behind them the old hag Envy clutches her hair despairingly while turtledoves bill and coo below. The innocent face of the figure identified as Fraud or Inconstancy lurks in the right background. She holds a honeycomb in a left hand that is grafted onto her right arm. Further deception is seen in her lion's legs and her coiling, scaly serpent's tail. The masks in the lower right cast the whole scene as a theater piece, perhaps creating an amoral dream world like that envisioned by Titian.

MANNERISM IN SCULPTURE

Today, Benvenuto Cellini's reputation rests more on his flamboyant, swaggering autobiography than on his surviving works. Probably as much fiction as fact, the autobiography portrays Cellini as a soldier of fortune, a statesman, and an ardent lover, as well as a sculptor. He provides an eyewitness account of Charles V's sack of Rome, where he was imprisoned because of his involvement in a violent crime. After a spectacular escape, he fled to France. Although he was first and foremost a goldsmith, only one work in gold survives that can be attributed to him, a saltcellar executed for Francis I (Fig. 12.26). The workmanship shows the overly refined side of mannerist art. Referring to the two figures, Cellini writes that Earth, the figure on the right, is "fashioned like a woman with all the beauty of form, the grace and charm,

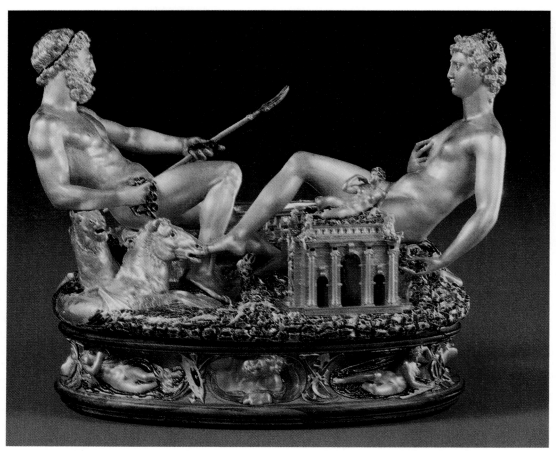

12.26 Benvenuto Cellini. Saltcellar of Francis I. 1540–1543. Gold, chased and partially enameled, base made of ebony, 10¼" × 1'1". Kunsthistorisches Museum, Vienna, Austria.

of which my art was capable." As Earth's limbs become erotically entwined with her opposite, Water, the two meet and merge with a promise of future fertility. Cellini also described the large-scale bronze-casting methods he used in his larger-than-life-size freestanding statue, *Perseus with the Head of Medusa* (Fig. 12.27). He chose the gruesome moment just after the decapitation, when Perseus holds high the head with its coiling, snaky locks as blood gushes forth in intricate patterns.

Elegance of design, polished craftsmanship, and fluency of line also mark the sculpture of Giovanni Bologna, also known as Giambologna. *Winged Mercury* (Fig. 12.28), with its delicate balance and extraordinary technical dexterity, was once used as the gleaming symbol of the twentieth-century communications industry. Born in Flanders and trained

12.27 Benvenuto Cellini. *Perseus with the Head of Medusa,* 1545–1553. Bronze, height 18′. Loggia dei Lanzi, Florence, Italy.

12.28 Giovanni da Bologna. *Winged Mercury,* c. 1574. Bronze, height 5′9″. Museo Nazionale del Bargello, Florence, Italy.

in northern Europe, Bologna worked mainly in Florence, where he became a dominating force in Italian sculpture. He was, in fact, the link between Michelangelo and the baroque sculptor Bernini, and thereby between the Renaissance and baroque styles.

For the group that was later called *Abduction of the Sabine Women* (Fig. 12.29), Bologna set himself the task of probing the limits of motion and emotion that could be expressed in marble. The writhing, serpentine movement spirals upward from the crouching elderly male figure through the twisting tension of the young man's muscular body to the wildly outflung arms of the girl. Despite the violent centrifugal motion, the action is contained within an open cylindrical space. The obvious precedent is the ancient *Laocoön Group* (see Fig. 3.17), but unlike this classical model, which is frontally oriented, Bologna's work was meant for an outdoor setting where it could provide variety and interest when seen from any angle.

MANNERISM IN ARCHITECTURE: ROMANO, SCAMOZZI, AND ZUCCARI

In architecture, mannerism assumed many and varied shapes. Giulio Romano built the Palazzo del Tè, or "Tea Palace" (Fig. 12.30), outside Mantua in northern Italy for the ducal family. To enclose the formal garden, he constructed a wall of heavily rusticated masonry that was far too massive for its function. Sturdy Doric columns rise upward only to support the frieze. This dramatic overstatement, however, pales in comparison with the somewhat unnerving effect of the frieze itself, in which every third triglyph slips downward a notch, thus creating a lively syncopated visual rhythm. Small frameless windows are crowded between the closely spaced columns at the top, whereas the heavily pedimented windows below are blind. Romano's handling of the classical orders and detail recalls an aphorism in a letter to him from the witty Venetian writer Pietro Aretino, who said of his style, "Always modern in the antique way and antique in the modern way." The Tea Palace was obviously an architectural fantasy for the delight of his sophisticated clients.

In Venice, meanwhile, Scamozzi, the younger collaborator of both Sansovino and Palladio, was commissioned in 1584 to add a wing to Sansovino's library. Extending the side toward St. Mark's Square, the wing would house the Procuratie Nuove, the new civic agencies (Fig. 12.31). Scamozzi's design

12.29 Giovanni da Bologna. *Abduction of the Sabine Women,* 1583. Marble, approx. 13′6″ tall. Loggia dei Lanzi, Florence, Italy.

12.30 Giulio Romano. Interior courtyard facade, Palazzo del Tè, Mantua, Italy, 1525–1535.

12.31 Vincenzo Samozzi. Detail of facade, Procuratie Nuove, Venice, Italy, 1584.

shows the usual Palladian sharp angularity, but he turned to Michelangelo for the alternation of semicircular and angular window brackets. He inserted a touch of manneristic whimsy in the insecurely perched nudes on top of the third-story window brackets, which he borrowed directly from Michelangelo's tombs for the Medici dukes in Florence.

In Rome, Federico Zuccari built himself a house that he described as a poetic caprice, one that carried mannerism over the edge into the grotesque. The windows, doors, and monstrous entrance portal (Fig. 12.32) broke the boundaries of expected shape.

IDEAS

DYNAMICS OF SPACE AND TIME

In both Venetian Renaissance art and mannerism, a quickening of pace and an increased sense of action became apparent. Venetian space is

12.32 Federico Zuccari. Palazetto Zuccari, Rome, Italy, c. 1593. Detail, entrance portal.

never in repose but is restless and teeming with action. Sansovino's and Palladio's buildings, with their open **loggias,** or galleries, recessed entrances and windows, and pierced, deep-cut masonry, invite entry. Their spacious interiors allow for freedom of movement. Action is also implicit in the lively contrasts of structural elements and decorative details, such as rectangularity side by side with roundness, and the intersection of complete and broken pediments. Palladio's churches, with their open semicircular colonnades around the altar and windows in the apse, allow the eye to continue into the space beyond. The reflection of facades in the rippling waters of canals and the use of mirrored interior walls serve to activate the heavy masses of masonry and increase the perception of light and space.

Similarly, the composition of some Venetian paintings broke up Renaissance compositional unity. Dynamic design replaced stable space. Forms and figures opposed each other both on the picture plane and in the receding planes of a composition. These devices can be seen in Giorgione's *Concert Champêtre* and *The Tempest* (Figs. 12.10 and 12.11). Also, space was energized by the rising planes of a vertical organization, as in Titian's *Assumption,* and by the wheel-like rotary movement Tintoretto set up in his *Marriage of Bacchus and Ariadne* (Fig. 12.16). A dramatic diagonal slashes from the upper right to lower left in Titian's *Bacchus and Ariadne* (Fig. 12.13). In the pictures of Tintoretto and Veronese, fractures in the unity of central perspective produce a fragmentation that leads the eye simultaneously in several directions.

A comparable expression is heard in Gabrieli's "broken choirs" when parts of one group contrast with the full sound of an entire chorus. The sequence of contrasting sound progressively builds to ever-larger volumes until the climax is reached in the union of them all. The tossing back and forth of contrasting, unequal sound masses in the concerting style; the alternation of loud and soft dynamic levels of opposing groups; and the contrast of high and low parts all intensify the emotional effects of music.

A TENDENCY TOWARD THE MONUMENTAL AND THE GRANDIOSE

The increase in spatial and temporal dimensions in all the arts is also striking. Palladio's villa interiors are designed for large gatherings and to im-

press visitors by their spaciousness, so necessary to the grand manner of living to which his clients aspired. His preference for central plans in private dwellings, such as the Villa Rotonda, and for church buildings is, he says, because "none is more capacious than the round."

The growth in the size of paintings by Titian, Veronese, and Tintoretto is a phenomenon in itself. The dimensions alone predispose them to monumental portrayals. (The finished version of Tintoretto's colossal *Paradise* mural in the Doge's Palace includes more than 500 figures and measures about 72 by 23 feet.) The grandeur of sound produced by the vast musical resources that Gabrieli marshaled for his polychoral motets exceeded anything before their time. The Venetian ideal of the human figure is likewise large and ample. All these instances point in the direction of the grandiose.

In addition, dynamism is pervasive in the work of the mannerists, upsetting the heritage of Renaissance equilibrium. The canvases of Pontormo teem with activity, and the figures seem to be moving in all directions at once. In the crowded compression of Bronzino's allegory, the characters almost burst their bonds. Giovanni Bologna's *Mercury* speeds along with lightning swiftness, whereas his *Abduction of the Sabine Women* writhes and turns. The very space around his statues seems to be in pulsating motion.

ROADS TO THE BAROQUE

From Venice, as well as from Rome and other cultural centers where international mannerism flourished, the roads to the baroque fanned out in all directions. The thriving painting industry ensured the circulation of Venetian ideas. The writings of Palladio, as translated into English with commentary by Inigo Jones, led to the architecture of Christopher Wren and the Georgian styles and from there to the colonial and Federal styles in America. The printing of musical scores assured Venetian composers widespread prominence. By avoiding strong commitments to either side, Venetian diplomacy paved the way for the acceptance of aspects of the Venetian Renaissance and mannerist styles in both Reformation and Counter-Reformation countries.

Venetian innovations in architecture and painting were eagerly adopted in the church and court circles of Spain and France. Both the church hierarchy and the aristocracy required the impressive splendor of the arts to enhance their exalted positions. The more monumental the buildings, the more lavish the decorations, the more grandiose the musical entertainments, the better the arts served their social purpose: to impress spectators.

El Greco absorbed the Venetian and Roman versions of mannerism in his early travels and was eventually accepted by the church and court in Spain, where his art made a deep impression. Rubens spent eight years in Italy, much of the time making copies of Titian's pictures. He then took the Venetian techniques with him to his native Flanders and later to France. In turn, Rubens and his pupil van Dyck transmitted them to England, and ultimately they reached America.

In the Counter-Reformation countries, such as Italy, Spain, France, and Austria, church music remained more attuned to the Roman tradition, but Venetian music was readily accepted in secular circles. For Holland, Scandinavia, and northern Germany, which were centers of the Reformation, the greater liturgical freedom of Venetian musical forms proved adaptable to Protestant church purposes precisely because of their departure from Roman models.

J. P. Sweelinck, who studied the works of both Andrea Gabrieli and Gioseffo Zarlino, carried the Venetian keyboard style to Amsterdam. His great reputation brought him organ students from Germany, who later taught the generation of Johann Pachelbel and Dietrich Buxtehude, both major influences on the style of Johann Bach and George Handel. Francesco Cavalli, Monteverdi's successor at the Venetian opera, was called to Paris to write the music for the wedding festivities of Louis XIV. Heinrich Schütz, the greatest German composer before Bach and Handel, was a pupil of both Giovanni Gabrieli and Monteverdi. In sum, the Venetian style evolved as part of the basic vocabulary of baroque art.

During the early years of the seventeenth century, the architect Baldassare Longhena broke from the stiff rectilinear style of Palladio and Scamozzi and transformed Venetian architecture with his Church of Santa Maria della Salute (Fig. 12.33). As the name implies, the church was dedicated to the Virgin to implore her help with the health of the populace. Specifically, Venice was enduring the plague, brought on by a flourishing rat population. The church's ground plan

12.33 Baldassare Longhena.
Santa Maria della Salute,
Venice, Italy, 1631–1656. Length
200′, width 155′.

is octagonal, like a baptistry. The main entrance (on the right of the figures) is like a Roman triumphal arch with a classical triangular pediment above it. Each of the other seven sides echoes this motif. Supporting the high-pitched dome are buttresses in the form of ornamental scrolls, or volutes. The elaborately decorated exterior is held together by the good composition of the design as a whole. This building was far more to the taste of the Venetians than the restrained Palladian style, and it is one of the finest examples of the emerging early baroque.

Venice was not only a productive cultural center but also the stylistic clearinghouse for currents of thought flowing from the Italian South, the Mediterranean East, and the European North. Flemish and German merchants established trade connections and resident communities in Venice and commerce prospered. The traffic in artists and musicians was equally active. In effect, Venice moved slowly and consistently from the glow of its Byzantine dawn through a Renaissance high noon and the brief thunderstorm of mannerism to an ornate baroque sunset.

--- **YOUR RESOURCES** ---

- **Web Site**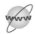

 http://art.wadsworth.com/fleming10

 ○ Chapter 12 Quiz

 ○ Links

- **Audio CD**

 ○ *In ecclesiis*

 ○ *Zefiro torna*

VENETIAN RENAISSANCE AND INTERNATIONAL MANNERISM

Key Events	Architecture	Visual Arts and Music	Mannerists
		c. 1429–1507 **Gentile Bellini** ▲ c. 1431–1516 **Giovanni Bellini** ▲	

1450

Key Events	Architecture	Visual Arts and Music	Mannerists
1453 **Turks** conquered Constantinople; Venetian commerce challenged 1492 **Geographical discoveries** by Spanish and Portuguese navigators weakened Venetian maritime trade 1495 **Aldine Press** began publishing inexpensive editions of Greco-Roman classics	1486–1570 **Sansovino** (Jacopo Tatti) ★	c. 1456–c. 1526 **Vittore Carpaccio** ▲ c. 1477–1510 **Giorgione** (Giorgione da Castelfranco) ▲ c. 1485–1576 **Titian** (Tiziano Vecellio) ▲ 1490–1562 **Adrian Willaert** ❏, 1527–1562 choirmaster at St. Mark's	1494–1540 **Rosso Fiorentino** (Giovanni Battista di Jacopo) 1494–1556 **Pontormo** (Jacopo Carucci) c. 1499–1546 **Giulio Romano** (Pippi)

1500

Key Events	Architecture	Visual Arts and Music	Mannerists
1501 **Odhecaton,** anthology of vocal and instrumental works by Josquin Desprez, Obrecht, Isaac, and others printed in Venice by Petrucci 1517 **Protestant Reformation** began 1527 **Sack of Rome** by Charles V; artists flee; beginning of mannerist style 1543 Copernicus published *On the Revolution of the Planets in Their Orbits* 1545–1563 **Council of Trent** initiated Counter-Reformation	1508–1580 **Palladio** (Andrea di Pietro) ★ 1536 **Library of St. Mark** built by Sansovino 1540 **Loggetta** at base of campanile built by Sansovino 1546–1549 **Basilica at Vicenza** built by Palladio 1548–1616 **Vicenzo Scamozzi** ★	1510–1592 **Bassano** (Jacopo da Ponte) ▲ 1517–1590 **Gioseffo Zarlino** ❏, composer, theorist, 1565–1590 choirmaster at St. Mark's 1519–1594 **Tintoretto** (Jacopo Robusti) ▲ 1528–1588 **Veronese** (Paolo Cagliari) ▲ 1532–1625 **Sofonisba Anguissola** ▲ c. 1532–1585 **Andrea Gabrieli** ❏, composer, 1566–1585 organist at St. Mark's	1500–1571 **Benvenuto Cellini** 1503–1540 **Parmigianino** (Francesco Mazzola) 1503–1572 **Bronzino** (Angelo de Cosimo di Mariano) 1511–1574 **Giorgio Vasari** 1529–1608 **Giovanni Bologna** (Giambologna) c. 1540–1609 **Federico Zuccari**

1550

Key Events	Architecture	Visual Arts and Music	Mannerists
1571 **Naval Battle of Lepanto;** Venice and Spain defeated Turks 1573 **Veronese** called before Inquisition	1550 **Villa Rotonda** near Vicenza begun by Palladio 1565 **Church of San Giorgio Maggiore,** Venice, built by Palladio 1570 **Palladio** published *Four Books of Architecture* 1576–1578 **Church of Il Redentore,** Venice, built by Palladio 1579–1580 **Olympic Theater,** Vicenza, built by Palladio 1584 **Procuratie Nuove,** continuation of Sansovino's design of St. Mark's Library, built by Scamozzi 1589 **Olympic Theater,** Vicenza, dedicated with performance of Sophocles's *Oedipus* (music by A. Gabrieli) 1596–1682 **Baldassare Longhena** ★	1552–1614 **Lavinia Fontana** ▲ 1554–1590 **Marietta Robusti** ▲ c. 1554–1612 **Giovanni Gabrieli** ❏, composer, 1586–1612 organist at St. Mark's 1567–1643 **Claudio Monteverdi** ❏, 1613–1643 choirmaster at St. Mark's	1555–1619 **Ludovico Carracci** 1560–1609 **Annibale Carracci**

1600

Key Events	Architecture	Visual Arts and Music	Mannerists
	1631 **Santa Maria della Salute** begun	1602–1676 **Francesco Cavalli** ❏, opera composer	

★ - Architect ❏ - Musician ▲ - Painter

GLOSSARY

A

abacus In an architectural column, the uppermost member of the capital; the slab upon which the architrave rests.

abstraction In the visual arts, the process of subordinating the real appearance of forms in nature to an aesthetic concept of form composed of shapes, lines, colors, values, etc. Also the process of analyzing, simplifying, and distilling the essence from nature and sense experience. See *nonrepresentational.*

a cappella Italian for "in chapel style." Choral music without instrumental accompaniment. The music supporting soloist or group of performers; music subordinate to the melody.

acro From the Greek meaning "high," as in *acropolis,* or "high city."

acropolis The upper, often fortified, hilltop of an ancient Greek town or city.

agora In ancient Greek cities, an open marketplace where the population could assemble and hold meetings.

aleatory From the Latin meaning "dice," a music that is uncontrolled or left to chance. Whatever the elements introduced by the composer, their arrangement is left to the performer or to circumstance.

ambulatory A covered passage for walking found around the apse or choir of a church, in a cloister, or along the peristyle of an ancient Greek temple.

amphitheater From the Greek meaning "two" or "both," plus theater. In Roman architecture, a round or oval building used for public events.

antiphony and antiphional psalmody Music in which two or more groups of voices or instruments alternate with one another; *antiphonal psalmody* refers to verses sung alternately.

antiquarianism Concern with things old and rare.

apse A large nichelike space—usually semicircular in shape and domed or vaulted—projecting from and extending the interior space of such architectural forms as Roman and Christian basilicas. Most often found at the eastern end of a church nave and serving to house the high altar.

apsidal chapel Chapels created within apses.

arcade A series of arches supported by piers or columns; a passageway with an arched roof.

archetype A universal pattern or model.

architrave In post-and-lintel architecture, the lintel, or lowest, division of the entablature that rests directly on the capitals of columns.

archivolt The molding that frames an arch.

aria An elaborate solo song with instrumental accompaniment used usually in cantatas, oratorios, and operas. A da capo aria has the basic ternary form ABA. The first section (A) concludes on the tonic and is followed by the second section (B), which is contrasting in key and character. The singer then returns to the beginning (da capo), repeating the A section, usually with some improvisation. A *continuo aria* is an aria with continuo accompaniment.

ars perfecta Latin for "the perfect art." A name used to describe the music of Josquin Desprez and other fifteenth-century Flemish composers.

art deco A style of art and decoration from the 1920s. Uses flat shapes, curves, and geometric shapes.

assemblage The technique of creating three-dimensional works of art by combining a variety of elements, such as found objects, into a unified composition.

assonance In literature, the use of similar sounds or words.

atmospheric perspective See *perspective.*

atomism The belief that all elements in the universe are reducible to small, indivisible parts.

atonality A type of music in which no particular pitch serves as the tonic, or key, note.

atrium An open court constructed within or in relation to a building; found in Roman villas and in front of Christian churches built from late antiquity through Romanesque times.

auditorium In ancient Rome, a public meeting place often used for performances of music or drama.

aulos In ancient Greece, a flutelike instrument.

avant-garde Vanguard or advance guard; a term used to designate innovators whose experimental art challenges the values of the cultural establishment or even those of the immediately preceding avant-garde styles.

ayre, or **air** In music, a simple, often popular song.

B

background In pictorial arts, that part of the composition that appears to be behind forms represented as close to the view; the most distant of the three zones of recession in linear perspective.

ballata, or **ballad** A narrative song usually set to relatively simple music.

balustrade An architectural form that is a continuous row of abbreviated shafts (balusters) surmounted by a handrail to make a low fence.

barrel vault A vault, or room, whose upper portion is created in the shape of an arch.

basilica A rectangular-plan building, with an apse at one or both ends, originating in Roman secular architecture as a hall and early adopted as the form most suited to the needs of Christian architecture.

bay In architecture, the space defined at four corners by the principal upright structural members, with the character of the space usually established by the need to sustain aloft the great weight of a vault.

bestiary, or **bestiaries** A collection or collections of stories using animals as principle characters.

broken pediment A pediment in which the top part of the triangular structure has been omitted for decorative affect.

buttress, buttressing A support, usually an exterior projection of masonry or wood for a wall, arch, or vault, that opposes the lateral thrust of these structural members.

C

cadenza In music for solo voice or instrument, a free or florid passage inserted by the composer or improvised by the performer, usually toward the end of an aria or movement, whose purpose is to display the performer's technical brilliance.

camera obscura A device used since the Renaissance to aid drawing. Originally a room-sized structure, it was reduced in size in subsequent centuries. It consists of a box, a small lens opening, and a section of translucent glass upon which an image is cast by a mirror.

campanile In Italy, a bell tower, especially one that is free-standing, often next to but separate from a church building.

canon A body of principles, rules, standards, or norms; a criterion for establishing measure, scale, and proportion. In music, a type of strict imitative counterpoint, wherein the melody stated by one voice is imitated in its entirety by a second voice, which enters before the previous one has finished.

cantata Italian for music that is "sung," as opposed to music that is played, which in Italian goes by the term *sonata.* In the seventeenth-century sense of Bach, Scarlatti, and Handel, a multimovement composition for solo voices, chorus, and orchestra consisting of recitatives and arias for performance in church or chamber. Briefer than oratorio but, like oratorio, differs from opera in being mainly nontheatrical.

cantilever In architecture, a lintel or beam that extends beyond its supports.

cantus firmus Latin for "fixed song," a preexisting melody that medieval and Renaissance composers used as the basis for polyphonic pieces in which they added new melodies above and/or below the cantus firmus.

capital The upper member of a column, serving as transition from shaft to lintel or architrave.

cartoon A full-scale preparatory drawing for a pictorial composition, usually a large one such as a wall painting or a tapestry. Also a humorous drawing or caricature.

caryatid A sculptured female figure standing in the place of a column.

catacombs In ancient Rome, underground burial places.

cathedra An episcopal throne, or throne for a bishop; also known by its Latin name *sedes,* meaning "see."

cathedral The official church of a bishop containing his cathedra, or throne; a church that traditionally has been given monumental and magnificent architectural form.

cella An enclosed windowless chamber, the essential feature of a classical temple, in which the cult statue usually stood.

central plan In architecture, an organization in which spaces and structural elements are ordered around a central point.

chamber music Music for small groups.

chambre From the French for "room," it is used to define art, like chamber music, intended for small rooms rather than large auditoriums.

chanson de geste French for "song of heroic deeds"; an epic poem written in Old French during the eleventh to thirteenth centuries and designed to be performed by minstrels and jongleurs.

chant A single liturgical melody for voice or chorus that is monophonic, unaccompanied, and in free rhythm. Various types are Byzantine, Gregorian, Ambrosian, Milanese, Visigothic (Mozarabic), and Gallican.

chapelle, or **chapel** A small church or compartment within a church, castle, or palace containing an altar consecrated for ritual use.

chiaroscuro The art of modeling figures or objects in light and shade to achieve a three-dimensional effect on a two-dimensional surface.

choir An organized group of singers or instrumentalists of the same class. In church architecture, the complex at the east end beyond the crossing, which could include apse, ambulatory, and radiating chapels.

choleric In medieval and subsequent theories of alchemy, an irritable human disposition.

choral That having to do with chorus.

chorale A hymn tune introduced in the German Protestant church by Martin Luther, who frequently wrote the texts and sometimes the melodies.

chord Any combination of three or more tones sounded simultaneously.

chori spezzati From the Italian, meaning broken choruses. In Venetian music, the practice of placing choruses in different parts of a building to create an echo effect.

chorus In ancient Greek drama, a group of singers and dancers commenting on the main action. In modern times, a choir or group of singers organized to perform in concert with one another. Music composed for such a group.

chromaticism Raised or lowered notes introduced into diatonic music, or used instead of the normal diatonic degrees of the scale, are called chromatic notes; chords involving their use are chromatic chords; harmony saturated with chromatic chords is chromatic harmony; and music overgrown with chromaticism is chromatic music. The chromatic scale is a twelve-note scale dividing the octave into twelve half-tone intervals—the seven diatonic tones plus the five altered degrees, as C, C-sharp, D, D-sharp, E, F, F-sharp, G, G-sharp, A, A-sharp, and B.

cithara In ancient Greece, a musical instrument similar to a lyre.

citharoedus A musician who plays a cithara while singing.

churrigueresque An ornate Spanish baroque style named for José de Churriguera.

clerestory A row of windows in the upper part of a wall; also, in church architecture, the upper portion of the interior walls pierced by windows for the admission of light.

cloister A monastic establishment; more particularly, a covered passage, usually arcaded, at the side of or surrounding a courtyard within a monastery.

coda Italian for "tail"; a section at the end of a movement of a composition that serves as a "summing up" by using previously heard thematic material. A short coda is often known as a codetta.

coffer In architecture, a recessed panel in a ceiling. Coffering can lighten both the actual and apparent weight of a massive ceiling and provide a decorative effect.

collage From "papiers collés," French for "pasted papers"; a composition deriving from Cubism and made by pasting together on a flat surface such originally unrelated materials as bits of newspaper, wallpaper, cloth, cigarette packages, and printed photographs.

colonnade A row of columns usually spanned or connected by lintels.

colonnette A small column that serves both a decorative and structural function.

column A cylindrical post or support that often has three distinct parts: base, shaft, and capital.

comedy A light and amusing play or other literary work whose purpose is to arouse laughter in the beholder.

composite A classical order of temple architecture combining elements from Ionic and Corinthian orders, as the acanthus leaf motif of the Corinthian order topped by the volutes of the Ionic.

composition An organization or arrangement imposed upon the component elements within an individual work of art.

concertato In baroque music, the style of groups of instruments playing against each other.

concerto An instrumental composition featuring a soloist (violin, piano, cello, flute, etc.) pitted against a full orchestra and usually written in three movements.

concerto grosso An orchestral composition in which the instruments are divided into two contrasting tonal bodies: a large (ripieno, or grosso) and a small (concertino) ensemble.

concitato An instruction to a musician to play a section of music in an agitated manner.

connoisseurship A discriminating knowledge of the qualities of art works and their styles.

Constructivism A twentieth-century art movement that arose in Russia; it emphasized geometric shapes and urges the use of industrial materials.

continuo (basso continuo) A contrapuntal concept favored by baroque composers. It is a continuous bass line defined sharply enough to function as a clearly distinguishable level within the musical complex. The continuo bass line is commonly played on a keyboard instrument by the left hand while the right hand supplies filler parts improvisationally. Because numbers are often placed beneath the bass line to guide the player in realizing the filler parts, the continuo is also called figured bass. The continuo is a bass complex, so other bass instruments (lute, viola da gamba, cello, bassoon) usually supplement (or may substitute for) the keyboard.

contrapuntal The adjectival form of counterpoint.

contredanse, or **contredance** A dance in which the participants face each other, as in a square dance. Also the music for such a dance.

convention A formula, rule, or practice developed by artists to create a usage or mode that is individual to the artist yet communicable to the culture of which he or she partakes. Conventions exist in both form and subject matter, and they constitute the vocabulary and syntax of the artist's language.

Corinthian The classical order of temple architecture characterized by slender fluted columns topped by highly carved, ornate capitals whose decorative forms derive from the acanthus leaf.

cornice Any horizontal architectural member projecting from the top of a wall; in classical architecture, the crowning member of the entablature.

cornu A Roman instrument like a tuba.

corporation picture counterpoint The combination of two or more independent melodic lines into a single musical fabric; polyphony.

crescendo A continuous increase in loudness.

crossing In a cruciform church, the space formed by the intersection of nave and transept.

cross vault, or **cross vaulting** A vault composed of two tunnel vaults intersecting each other at right angles.

cruciform Arranged or shaped like a cross.

crypt A vaulted chamber wholly or partly underground; it usually houses a chapel and is found in a church under the choir.

cuneiform The wedge-shaped characters of ancient writing in Mesopotamia, Assyria, and Persia.

Cubism A twentieth-century art movement in which natural forms are reduced to geometric shapes and planes.

cuirass A piece of medieval armor that protected the body from the neck to the waist.

cupola A small structure on top of a building or dome, which houses bells, lights, or serves to provide a good view

D

da capo Italian for "from the beginning"; return to or repetition of the beginning.

da capo aria See *aria.*

Dada A post–World War I European art movement whose adherents emphasized nihilism.

daguerreotype An early form of photograph in which the image is produced on a silver-coated plate.

dance A rhythmic and patterned succession of bodily movements, usually performed to music.

deism A belief in God founded on rational sources rather than faith.

demos Greek for "people," in the sense of populace.

dentil, dentil range From the French for "small tooth"; one of a series of small decorative blocks projecting just below the cornice of an Ionic or Corinthian entablature.

deus ex machina Latin for "a god from a machine"; a device in ancient Greek and Roman drama whereby a god is introduced by means of a crane to solve a plot that has thickened to such an extent that human solutions are impossible. Figuratively, any sudden and contrived solution to what appears to be an impossible situation.

development See *sonata form.*

diakonikon Greek for a side chapel on the south side of a Byzantine church. Also known as a vestry.

diatonic The seven tones of a major (or minor) scale that correspond to the piano's white keys in an octave. Diatonic chords are chords built of diatonic notes; harmonies composed mainly of such chords are diatonic harmonies. The opposite of chromatic.

diminution Decreasing (usually halving) the note values of a phrase or section to achieve a quickening effect.

discantus (also **discant** and **descant**) A melody, often sung above a musical theme.

dissonance A discord or interval that creates a feeling of tension that demands resolution.

dome A hemispherical vault; theoretically, an arch rotated on its vertical axis.

Doric the oldest of the classical styles of temple architecture; characterized by simple, sturdy columns that rise without a base to an unornamented, cushionlike capital.

dramatis personae Actors or characters in a drama.

dramma giocosa Literally, "comic drama."

drawing A process of visualization by which an artist, using media such as pencil, chalk, or watercolor, delineates shapes and forms on a surface, typically paper or canvas.

drum or drums In architecture, a cylindrical component of a column; in music, a percussion instrument.

duplum The second voice part counting upward from the tenor or cantus firmus in medieval organum.

E

echinus The round cushionlike part of a Doric capital.

eclecticism The practice of selecting from various sources, usually to form a new system or style.

empirical, empiricism Based on experiments, observation, and practical experience without regard to theoretical conjecture.

engraving A form of printmaking in which grooves cut into a metal plate are filled with ink and the plate is pressed against absorbent paper after its surface has been wiped clean.

ensemble A group of two or more musicians performing the same composition.

entablature In architecture, that portion of a building between the capitals of the columns and the roof, including in classical architecture the architrave, frieze, cornices, and pediment.

entasis The slight convex curving of classical columns to correct the optical illusion of concavity, which would result if the sides were left straight.

epic poem A long narrative poem that tells the tale of a hero.

epilogue Greek for the closing section of a play or other work of art.

etching A form of printmaking in which a metal plate coated with an acid-resistant wax is scratched to expose the metal to the bite of the acid. Lines eaten into the plate by the acid are subsequently filled with ink and transferred to paper after the surface of the plate has been wiped clean of excess ink.

ethos Greek meaning "character." In art, that which gives a work tone or character and distinguishes it from other works. Also understood to mean the ideal or an ethical character.

evangelist One of the authors of the four Gospels in the Bible: Matthew, Mark, Luke, and John. Respectively, their symbols are an angel, a lion, an ox, and an eagle.

ex cathedra Literally, "from the bishop's chair." See *cathedra.*

exedra (pl. *exedrae*) From the Greek meaning a recess in a wall or similar structure.

exodus A mass movement of people; in the Bible, the movement of the Israelites from Egypt under the direction of Moses.

exposition See *sonata form.*

expression Having to do with those factors of form and subject that together give the work of art its content and meaning.

Expressionism A late nineteenth- and early twentieth-century art movement that stressed the emotional content of an art work.

expressive content The fusion of form and subject that gives art its meaning and significance.

F

facade Usually the front of a building; also the other sides when they are emphasized architecturally.

fasces In Roman culture, a bundle of wood and an ax, used as a symbol of official power. Adopted by the French Revolutionaries at the end of the eighteenth century.

fauves Literally, "the wild beasts." A term used to describe early twentieth-century artists known for their vivid use of color.

fealty A medieval concept referring to a vassal's loyalty to a lord.

ferroconcrete A building material composed of concrete with rods or webs of iron or steel embedded in it. Also known as reinforced concrete.

finale The final movement of a large instrumental composition; in opera, the ensemble terminating an act.

flower painting As the term implies, the rendering of flowers. It became popular in the seventeenth century.

fluting Vertical channeling, concave in shape, used principally on columns and pilasters.

flying buttress A masonry support or segment of an arch that carries the thrust of a vault to a buttress positioned away from the main portion of the building; an important element of structure in the architecture of Gothic cathedrals.

foreground In the pictorial arts, that part of the composition that appears to be closest to the viewer. See *middle ground, background,* and *picture plane.*

foreshortening The effect of three-dimensionality made in two dimensions by basing representation on the principle of continuous decrease in size along the entire length of a form whose bulk is intended to be seen as receding in space.

French overture An introductory instrumental piece first used at the seventeenth-century French courts and characteristically in two sections: a slow stately march with dotted rhythms in duple meter and a livelier mood with fugal texture and triple meter.

fresco (pl. **frescoes**) A process of painting on wet or dry plaster wherein the pigments are mixed with water and become one with the plaster; a medium perfected during the Italian Renaissance.

frieze The central portion of the entablature between the architrave and the cornice; any horizontal decorative or sculptural band.

frottola A carnival song for dancing and singing.

Futurism An early twentieth-century art movement, originating in Italy, that stressed the dynamic quality of industry and machines.

fugal See *fugue.*

fugue A polyphonic composition characterized primarily by the imitative treatment of a single subject or subject complex.

G

gallery A long and narrow room or passage, such as that in the nave walls above the aisles of a church. See *triforium.*

genre, genre scene In the pictorial arts and sculpture, the casual representation of everyday life and surroundings. Also a type, style, or category of art.

Gesamtkunstwerk German for a "complete," "total," or "consummate work of art"; a term Richard Wagner coined in the late nineteenth century to characterize his music dramas, in which he brought about an alliance of all the arts—music, literature, theater, and the visual arts—to realize a program of ideas.

glaze In oil painting, a transparent film of paint laid over dried underpainting; in ceramics, a thin glassy coating fused to a clay body by firing in a kiln.

Gospels Ascribed to Matthew, Mark, Luke, and John, the four biblical accounts of the birth, life, death, and resurrection of Jesus Christ.

Grande Écurie Military band; Consisted mainly of the wind ensemble and was available for parades, outdoor festivities, and hunting parties.

graphic Demonstration and description by visual means.

Greek cross A cross in which all arms are the same length.

groin vault See *barrel vault.*

ground A coating, such as priming or sizing, applied to a support to prepare the surface for painting; also background.

ground bass See *ostinato.*

gymnasiarch The chief educator in an ancient Greek city, such as Pergamon.

H

hall of justice A place where courtroom and other legal offices are housed.

happenings A spontaneous or barely planned event, often taking place in a public area.

harmony The vertical or chordal structure of musical composition; the study of all relationships that can exist between simultaneously sounding pitches and the progressions of chords.

hedonism The theory that pleasure is the principal goal and greatest good in life, a doctrine held by the Epicurean philosophers.

hexachord From the Greek word for "6," a series of six tones, with a semitone between the third and fourth tones.

hexameter From the Greek word for "6," a line of verse with six beats.

hierarchy A system of persons or things that has higher and lower ranks.

hieroglyphic A picture or a symbol of an object standing for a word, idea, or sound; developed by the ancient Egyptians into a system of writing.

high relief See *relief.*

history scenes, history painting Paintings devoted to great events.

Hospice (pl. **Hospices**) A place of lodging for travelers, often run by a religious order.

humanism An emphasis in art and thought on individual creativity and capability.

hue The property of color that distinguishes one color from another as red, green, violet, etc. See *value.*

hymn A religious song meant to give praise and adoration.

hypostyle In Egyptian temple architecture, columns with a flat roof resting directly on them to create a hall.

I

icon Greek for "image"; used to identify panel paintings made under Greek Orthodox influence that represent the image of a holy person—Christ, Mary, or a saint; such works often imbued with sanctity.

iconography In the pictorial arts and sculpture, the meaning of the images and symbols depicted; subject matter.

iconostasis In Byzantine church architecture, a wall or screen separating the altar from those who attend mass; often highly decorated or housing icons.

ideal The representation of objects, individuals, and events according to a stylized, perfected, preconceived model; a kind of aesthetic distortion of perceived reality.

idealize See *ideal.*

idée fixe French for "fixed idea." Berlioz's name for a recurring melodic motif identified with the heroine in his *Fantastic Symphony.* In each movement, the motif varies slightly to coincide with the musical and programmatic circumstances.

idol A representation or symbol of a deity used as an object of worship.

ignudi A nude figure.

imperator An ancient roman commander or emperor.

illusion See *illusionism.*

illusionism The attempt of artists to represent as completely as their formal means permit the visual phenomena of a palpably real world, even if imaginary, as in a scene of muscular and voluptuous bodies floating high in the sky.

image A representation of an object, an individual, or event. An image may also be an evocation of a state of being in representational or nonrepresentational art.

imagery In the visual arts, the particular subjects and objects chosen by an artist for depiction in a work; or, in the instance of totally abstract or nonrepresentational art, the particular forms and shapes with which the artist has composed a work.

Impressionism A nineteenth-century art movement originating in France. Impressionist painters dwelled on the affect of light on shapes and solid forms.

improvisation On the spur of the moment, spontaneous musical composition for voice or an instrument. Also, in the performance of music, adding to the basic composition decorative embellishments such as chords and new melodies; a major aspect of baroque music and jazz.

individualism A belief in the rights and responsibilities of the individual human being.

instrument In music, a mechanism capable of generating the vibrations of musical sound.

instrumental See *instrument.*

intensity In the visual arts, the relative purity or brilliance of a hue. In music, the relative softness or loudness of a tone.

interval In music, the distance between two notes as determined by pitch. A melodic interval occurs when two notes are sounded successively; a harmonic interval occurs when two notes sound simultaneously.

intonazione Italian for "intonation." The sixteenth-century name for a prelude in which organists, before a motet was sung, established the pitch and mode for the choir by running their fingers rapidly over the keys and coming to a definite chordal cadence.

intrinsic Belonging to a thing by its very nature.

introduction In literature and music, a beginning that announces the themes of the work.

inversion In musical composition, a means of imitation by which the original ascending (or descending) voice is imitated by a descending (or ascending) voice at an equivalent intervallic distance.

Ionic One of the Greek classical styles of temple architecture. It was developed in Ionia and Asia Minor and is distinguished by slender, fluted columns and capitals decorated with volutes or scrolls.

isocephaly In pictorial composition, figures arranged so that all heads align at the same level.

isorhythmic Polyphonic music in which the forms are compounded of sections unified by an identity of rhythmic relationships but not necessarily of melodic patterns.

J

jamb The upright piece forming the side of a doorway or window frame; on the portals of Romanesque and Gothic church architecture, the place where sculptural decorations sometimes appear.

jazz A type of American music, originating in the black community early in the twentieth century. Players impro-

vise on a melodic theme, expressing it in a highly personal way with syncopated rhythms and contrapuntal ensemble playing.

jongleur See *minstrel.*

K

ka In ancient Egypt, the belief in an aspect of the self that is immortal.

katharsis, or **catharsis** In ancient Greek drama, affecting the purgation of emotion in a view.

keep A fortress, secure area, or prison in a castle.

keyboard The arrangement of keys on instruments such as the piano, spinet, and organ; therefore, "keyboard instruments."

keystone The wedge-shaped central stone of an arch that hold all the other stones in place.

L

lancet window A tall, narrow, pointed window used in Gothic architecture.

Ländler An Austrian peasant dance similar to a waltz and popular in the late eighteenth and early nineteenth centuries.

landscape In the pictorial arts, the representation of scenery in nature.

lantern tower A tower added above a dome to light the interior.

Latin cross A cross in which the vertical arm is longer than the horizontal arm, through whose midpoint it passes.

laudi spirituali A hymn of praise.

leitmotif German for "leading motif"; a melodic theme introduced by Richard Wagner into orchestral writing to characterize an individual, idea, inanimate object, etc., and developed to reflect transformations in the person, idea, or thing, recalling the past, prophesying the future, or explaining the present.

Lied An art song in the German language.

line A mark left in its path by a moving point, or anything, such as an edge, boundary, or horizon, that suggests such a mark; a succession of notes or ideas, as in a melodic line or a line of thought. The linear might be considered one-dimensional, as opposed to the spatial, which is either two- or three-dimensional.

linear See *line.*

linear perspective See *perspective.*

lintel In architecture, a structural member that spans an opening between posts or columns.

lithograph, lithography A printmaking process based on the antipathy of grease and water. A grease crayon or waxy liquid is used to draw on a slab of grained limestone or on a grained metal plate. The drawing is treated chemically so that each grain of the plate touched by the drawing medium can accept a greasy ink and each untouched grain can accept water and repel the ink. When the place

has been wetted and charged with ink, an image in ink is retained that essentially reproduces the drawing. The printmaker then covers the plate with a sheet of paper and runs them both through a press, which offsets the drawing onto the sheet, thus producing the print.

liturgy A rite or body of rites prescribed for religious worship.

loggia A gallery open on one or more sides, sometimes with arches or with columns.

low relief See *relief.*

lyric Of or relating to the lyre, such as a song to be performed to lyre accompaniment. In a modern sense, that which is intensely personal, ecstatic, and exuberant—even poetic. Also (in the plural) words or verses written to be set to music. The lyric theater is that involving words and music, such as opera and musical comedy.

M

madrigal In the early fourteenth century, a secular two- or three-voice song with a fixed form: two or three verses set to the same music plus a concluding two-line ritornello with different music. The upper voices are usually in a florid style, with the lower notes written for longer values. In the sixteenth century, a secular four- or five-voice composition based on love poetry or lyrics, with no set form but highly imitative and often homophonic in passages.

mandorla An almond-shaped halo that surrounds a religious figure.

Mannerism a late Renaissance art movement characterized by exaggerated figures and confusing spatial relationships.

masonry In architecture, stone or brickwork.

masque In drama, a play in which actors wear masks.

mass In the visual arts, the act or implied physical bulk, weight, and density of three-dimensional forms occupying real or suggested spatial depth. Also the most solemn rite of the Catholic liturgy, consisting of both sung and spoken sections. It combines sections of the Ordinary (texts that do not change) in alternation with sections of the Proper (texts that vary for certain occasions or seasons). The sung sections of the Ordinary are Kyrie, Gloria, Credo, Sanctus, and Agnus Dei. The sung sections of the Proper are Introit, Gradual, Alleluia or Tract, Offertory, Communion, and Post-Communion. A cyclical mass contains sections of the Ordinary structurally coordinated by the presence of the same melody (i.e., cantus firmus) in the tenor. A polyphonic mass is the Ordinary set to music with two or more voice parts. The requiem mass is the mass for the dead.

matroneum Gallery for women in churches, especially those of the Byzantine style.

mausoleum A shrine or burial chapel.

measure A standard of comparison; in musical composition, a regular division of time, set off on the staff by vertical bars. In rhythm and metrics, *measured* means slow and stately.

medium (pl. **media**) In general, the process used by the artist; in a more strict sense, the binding substance or binder used to hold pigments together, such as linseed oil for oil paint.

megalith A large stone, usually found in a Neolithic site.

melancholic A sad or depressed state, once through to be caused by an excess of black bile.

melismatic See *melisma*.

melodic See *melody*.

melody Single tones organized successively to create a musical line.

melodrama A play or film that emphasizes emotional effects.

meter In poetry, the scheme of accented and unaccented beats. In music, the basic grouping of beats and accents into measures (e.g., the triple meter of a waltz is recognized by recurring patterns of three beats with an accent on the first beat).

metope Square slabs with or without sculpture that alternate with the triglyphs that form the frieze of a Doric temple.

middle ground In the pictorial arts, that part of the composition that appears to exist between the foreground and the background; the intermediate of the three zones of recession in linear perspective.

mimesis Greek for "imitation," as in the imitation of nature.

miniator The person who painted small pictures in medieval manuscripts.

minnesingers Middle German for "love singers"; German musicians of the aristocratic class who composed love songs in the medieval period. See *jongleur, troubadours, trouvères*.

minor In music, a type of diatonic scale in which the interval between the first and third notes or pitches contains three semitones (as opposed to four in a major scale). A key or tonality based on such a scale.

minstrel In the twelfth and thirteenth centuries, a professional singing actor or mime in the service of a castle or wandering from town to town and from castle to castle. Also known as jongleur; in an expanded meaning, refers to troubadours, trouvères, and minnesingers.

minuet An elegant seventeenth-century French dance in moderate triple meter incorporated first into the suite and eventually into the sonata, symphony, or string quartet as the third movement. In the latter usage, a minuet is in ternary form (ABA) employing a middle section called a trio, which is followed by a repeat of the minuet.

mobile A constructed sculpture whose components have been connected by joints to move by force of wind or motor.

mode A particular form, style, or manner. In music, the ordering of pitches into a scale pattern; also a pattern of rhythm.

model See *modeling*.

modeling The shaping of three-dimensional forms in a soft material such as clay; also the representation on a flat surface of three-dimensional forms by means of variations in the use of color properties.

Modernism An inexact term generally referring to the current time rather than tradition. In the arts, Modernism embraces a variety of cultural movements, such as Expressionism and Cubism, ranging from the midnineteenth century to the midtwentieth century.

mode (pl. **modes**) In music, an arrangement of tones in an octave.

modulation Movement from one key to another.

module A standardized two- or three-dimensional unit that is intended as a unit of measure in architecture or sculpture.

molle Latin meaning "soft," referring to the note fa.

monastery A dwelling place where monks live in a community for spiritual purposes.

monastic That having to do with monks and monasteries.

monochord A musical instrument consisting of a single string stretched over a long wooden box with frets for varying the length of the string.

monochrome A single color or the value variations of a single hue.

monophonic See *monophony*.

monumental A work of art or architecture that is grand, noble, timeless, and essentially simple in composition and execution, whatever its actual size.

mosaic A decorative surface for a floor or wall made of small pieces of glass, shell, ceramics, or stone set in cement or plaster.

motet A composition that developed in the thirteenth century when words (mots) were added to the duplum (which became known as the motetus) of a melismatic organum. In the usual three-voice motets, the tenor retained fragments of the original plainchant melody, and to each of the two upper voices, new and different Latin texts were added. The sixteenth-century Renaissance motet is a four- or five-voice sacred composition developed by the Flemish composers and based on a Latin text. The musical texture is usually polyphonic, with imitation between voice parts.

motif In music, a melodic or rhythmic fragment of theme capable of being developed into different and larger contexts. In the visual arts, the subject or idea of an artwork, such as a still life or landscape, or an individual feature of a subject or form, usually one that recurs or predominates in the composition.

movement A self-contained section of a larger piece of musical composition, such as a symphony.

mural A painting on a wall, usually large in size.

mystical Having a spiritual meaning or reality that can be known only by intuition, insight, or similar subjective experience.

myth A legend or story that seems to express the world-view of a people or explain a practice or historical tradition.

N

narthex The porch or vestibule of a church.

nave The great central space in a church; in rectangular plans, the space extending from the entrance to the apse, or to the crossing or choir; usually flanked by aisles.

Neoclassical Literally, "new classical." Refers to a revival of Greek or Roman ideas, as well as a renewed interest in ancient architecture and the visual arts.

Neolithic The new Stone Age. The period during which agriculture was developed and settled communities were established.

niche A hollow recess or indentation in a wall for a statue or other ornament.

nominalist a person who believes in nominalism, the idea that there are no universal or abstract entities.

nonobjective A synonym for nonrepresentational art, or art without recognizable subject matter.

nonrepresentational In the visual arts, works so abstract as to make no reference whatever to the world of persons, places, and the objects associated with them; art from which all identifiable subject matter has been eliminated.

notation The system and process for writing out music in characters and symbols so that it can be read for performance.

note A musical sound of a certain pitch and duration; the sign in written music for such a sound; a key on an instrument such as the piano or organ that, when pressed, makes a specific musical sound.

O

octave The interval from one note to the next of the same pitch name (as from C to C), either higher or lower, which is a span of eight diatonic notes.

oculus A round eyelike opening or window.

oil painting The process of painting with a medium formed of ground colors held together with a binder of oil, usually linseed.

opera Theater in which music is the central dramatic agent. A typical opera involves a drama or play with scenery and acting, with the text usually sung to the accompaniment of an orchestra. Various types exist: opera buffa (It.) is characterized by a light, simple plot with prominent comedic elements and spoken dialogue; opera seria (It.) normally employs recitative in place of spoken dialogue and involves a dramatic or serious plot; number operas employ a sequence of self-contained musical "numbers" (arias, duets, choruses, etc.); music drama is the term used for Wagnerian operas, which substitute a continuous chain of music for musical numbers.

oratorio A musical composition written for soloists, chorus, and orchestra and usually based on a religious story or text. The latter may involve a plot or be purely meditative and non-narrative. Oratorios are usually performed in concert halls or churches, without scenery, staging, or costumes.

orchestra In Greek theaters, the circular space before the proscenium used by the chorus. Also a group of instrumentalists, including string players, joined together to perform ensemble music.

orchestration The art and technique of arranging or scoring a musical composition for performance by the instruments of an orchestra or band.

order In classical architecture, a style represented by a characteristic design of the column and its entablature; see *Doric, Ionic, Corinthian, Composite*. Also the arrangement imposed on all elements within a composition; in addition, a harmonious arrangement. To arrange or organize something; to give it order.

organic That which is living, such as plants; that which is integral to the whole; a system in which all parts are coordinated with one another.

organum From the ninth through the thirteenth centuries, the earliest form of polyphonic music, in which one or more lines of melody sound simultaneously along with the plainsong. In parallel organum (c. 800–900), an added voice runs exactly parallel and below the plainsong melody. In free organum (c. 1050–1150), the main melody occurs in the lower voice while the upper voice moves in a combination of parallel and contrary motion. In melismatic organum (c. 1150–1250), a few notes of the main chant or melody are prolonged and sustained in the lower voice while the upper voice moves freely through the melismatic melody with numerous notes occurring for each note in the main chant. Two-part organum is known as organum duplum; three-part organum as organum triplum; and four-part organum as quadruplum.

organum duplum, triplum See *organum*.

orthogonals In creating the illusion of depth in a picture, the lines imagined to span the picture plane and meet at a vanishing point.

ostinato Italian for "obstinate," which in musical composition is the persistent repetition, usually in the bass, of a clearly defined musical figure or phrase, while other parts or voices change around and above it. Also called basso ostinato or ground bass.

overture Instrumental music that typically precedes an opera, oratorio, or ballet. It may be an entity unto itself or directly related to the music that follows.

P

painterly Painting in which the buttery substance of the medium and the gestural aspect of paint application constitute a principal aspect of the art's quality.

painting Traditionally, painting has been thought of as an art form in which colors are applied through a liquid medium to a flat surface, called a ground or support. A dry powder called pigment is the coloring agent in painters' colors, and depending on the binding agent or

binder used, pigments can produce media of paint such as oil, tempera, watercolor, fresco, encaustic, casein, and acrylic resin. These can be worked on grounds or supports such as paper, canvas, wood panel, and plaster. If the support has been given a preparatory coating by priming and sizing, the surface thus formed is considered the ground, which intervenes between the painting and its support.

Paleolithic The Old Stone Age, a period characterized by nomadic or seminomadic existence.

palette A tray or shaped planar surface on which a painter mixes colors; also the characteristic range and combination of colors typical of a painter or a style of painting.

panel Any rigid, flat support for painting, such as wood, usually prepared, with a ground. Any flat, slablike surface, usually rectangular.

pantheon Greek meaning "all the gods of a people"; a temple dedicated to them; a public building containing tombs or memorials of the illustrious dead.

parallel organum See *organum.*

part In musical composition, the writing for a single instrument or voice or a group of them; also a section of a composition.

Parthenon A Doric temple on the Athenian acropolis.

paten A shallow dish used during the mass to carry the Eucharist.

pater patriae Latin meaning "father of a country"; a title given to national heroes.

paterfamilias Latin meaning "father of a family."

pathos Greek meaning "the experience of emotion, grief, or passion." In art, an element that evokes pity or sympathy.

Pax Romana Latin meaning "Roman peace."

pediment In architecture, the triangular space or gable at the end of a building formed in the entablature by the sloping roof and the cornice.

pendentive In architecture, the triangular segment of masonry whose plane is hemispherical, four of which can form a transition from a square to a circular base of a dome.

peplos An ancient Greek garment that resembles a shawl.

personifying, personification To be the embodiment of a quality.

performing arts The arts that have their full existence only in time and that to realize full existence must be played: music, dance, and drama.

perspective A pictorial technique for simulating on a flat, two-dimensional surface, or in a shallow space, the three-dimensional characteristics of volumetric forms and deep space. During the Renaissance in Italy, a quasimathematical scheme called linear perspective developed from the fact that parallel lines moving away from the viewer must be seen as converging toward a single point on the horizon (called the vanishing point). Placed, in this system, at

intervals along the assumed and converging parallels, objects are scaled in their sizes to diminish in relation to their distance from the picture plane. At about the same time in northern Europe, painters developed a perspective system known long before to the Romans and the Chinese. Called atmospheric or aerial perspective, the system used blurred outlines, loss of detail, alteration of hues toward the cool colors, and diminution of color saturation and value contrast—all in proportion to the distance of the object from the viewer. See *foreshortening.*

phlegmatic Possessing a serene or imperturbable character.

photomontage Combining photographically derived images, often from mass-media print sources.

Photorealism A late twentieth-century art movement, mostly in painting, that stressed the depiction of detail.

piano Italian for "soft" (p); pianissimo (pp) means "very soft"; pianissimo (ppp), "extremely soft."

pictorial That having to do with the flat arts of painting and drawing and, to a certain extent, with the art of low relief in that its three-dimensional subject matter and imagery are composed in relation to a flat rear plane physically parallel to and only slightly behind what would be a picture plane and whose edges constitute a frame or format of specific shape like that of a picture. Picture or pictorial space is that of the support, which is a flat surface defined by a specific shape, usually rectangular. To achieve here, at the picture plane on the support, the appearance of deep space, the artist must use illusionistic devices such as modeling, foreshortening, and perspective so that, in a still life or landscape, for instance, objects and forms seem to rest firmly on a ground plane at intervals beginning in the foreground and moving through the middle ground to the background and beyond.

picture plane An imaginary vertical plane assumed to be at the front surface of a painting. See *pictorial.*

picturesque A pictorial situation that awakens thoughts of the sublime, magnificent, quaint, vivid, or rugged as opposed to the orderly, symmetrical, or beautiful.

pier A mass of masonry rising vertically to support an arch, vault, or other roofing member.

pietà A devotional image of the sorrowing Virgin holding the dead Christ.

pigment Finely powdered coloring matter mixed or ground with various vehicles to form paint, crayons, etc.; also a term used loosely to mean color or paint.

pilaster In architecture, a shallow, flat, vertical member projecting from a wall surface and, like a column, composed of base, shaft, and capital; usually more decorative than structural.

pillar Any vertical architectural member—pier, column, or pilaster.

pitch A musical tone, or its relative highness or lowness as fixed by the frequency of the vibrations occurring per second within it.

plainchant From early medieval Christian worship, a type of sacred music or liturgical chant, monophonic in style and set to a Latin text.

plainsong Another term for plainchant.

plan An architectural drawing that reveals in two dimensions the arrangement and distribution of interior spaces and walls, as well as door and window openings, of a building as seen from above.

plane A surface that is defined and measurable in two dimensions.

plastic That which is capable of receiving physical form; therefore, the visual arts. More narrowly, that which is pliant and malleable enough to be modeled; therefore, the material of sculpture.

plasticity The three-dimensional quality of a form; its roundness and apparent solidity; the capability of material for being shaped, modeled, and manipulated.

play A literary text consisting of dialogue composed to be acted out in dramatic form for the benefit of an audience.

player One who performs.

plot In literature, the plan or scheme of the story and its unfolding actions.

podium A platform, base, or pedestal for a building or a monument.

pointillism A painting technique in which color is applied to the canvas in small dots, which blend when seen from a distance.

polychoral style Compositions in this style employ a chorus (with or without orchestra) divided into two or more groups that sing and play in alternation (antiphonally). Venetian music at the end of the sixteenth century featured this style.

polychrome Several colors rather than one (monochrome).

polyphony, polyphonic A texture created by the interweaving of two or more melodic lines heard simultaneously. Counterpoint is the technique used for composed polyphonic music.

polyptych A series of painting, often on wood, joined together by hinges.

Pop Art An art movement originating in the 1950s and 1960s that used themes and images from popular culture.

portal An imposing door and the whole architectural composition surrounding it.

portico A porch with a roof supported by columns and usually with an entablature and a pediment.

portraiture The practice of making portraits of people.

post-and-lintel In architecture, a structural system employing two uprights or posts to support a member, the lintel or beam, which spans the space between the uprights.

Post-Impressionism Literally, "after Impression." A word coined to describe the diverse styles that followed Impressionism in Europe.

prelude A musical composition designed to introduce the main body of a work—an opera; a separate concert piece for piano or orchestra, usually based on a single theme.

primary colors Colors that in various combinations are capable of creating any other color or hue. In artists' pigments, these are red, yellow, and blue; in natural or "white" light, they are red, green, and blue.

Primitivism A recurring idea of Western culture that emphasizes the purity of perception and response in people outside the developed world.

prologue An introduction or preface.

program music Broadly speaking, music that consciously imitates sound effects (bird calls, bells, etc.), describes natural or social events (thunderstorms, hunting scenes, etc.), or narrates a sequence of dramatic episodes derived from poetic and dramatic sources. In the nineteenth century, it refers principally to instrumental music based on a series of actions or a sequence of episodes designed to make narrative or dramatic sense and declared by the composer to be subject to some sort of literary, pictorial, or philosophic interpretation.

proportion The relation, or ratio, of one part to another and of each part to the whole with regard to size, height, width, length, or depth.

prosody The art of setting words to music. Also a particular system or style of versification.

protagonist A principle character in a play.

prothesis A side chapel on the north side of a Byzantine church. The Eucharist is prepared there.

prototype An original model, archetype, or primary form from which other artists make copies or adaptations.

psalter A book of the psalms (hymns) found in the Bible.

punctus contra punctum Latin meaning "point counterpoint."

putti (sing. ***puto***) An angelic small child, usually male, who often appears in Renaissance paintings.

pylon In Egyptian architecture, a monumental gateway shaped in profile like a truncated pyramid and leading to the forecourt of a temple.

Q

quadruplum See *organum*.

quatrefoil A stylized flower with four petals.

R

raking cornice See *cornice*.

rationalism The belief that reason is the source for human understanding of the world.

realism A midnineteeth-century style of painting and sculpture based on the belief that the subject matter of art and the methods of representation should be true to life without stylization or idealization.

recapitulation See *sonata form*.

recitative In opera, oratorio, and cantata, a form of declamation that, although highly stylized and set to music, follows the pitch and rhythms of speech more than a melodic line. Recitative tends to serve a narrative function and often leads into an aria or connects arias and ensembles.

refrain In music, a phrase or passage that is repeated.

regent families In Dutch seventeenth-century history, powerful families whose members ruled like governors.

register A range (upper, middle, lower) within the capacity of the voice, human or instrumental.

reinforced concrete See *ferroconcrete.*

relief A plane that exists three-dimensionally as a projection from a background. Also sculpture that is not freestanding but projects from a surface of which it is a part. When the projection is relatively slight, it is called bas-relief or low relief; when the projection is very pronounced, it is called high relief.

reliquary A small box, casket, or shrine for keeping sacred relics, usually made of and decorated with precious materials.

representation The depiction or illustration by the graphic means of the visual arts (lines, values, colors, etc.) of forms and images in such a way that the eye would perceive a correspondence between them and their sources in the real world of empirical experience.

representative style In music, a type of word painting by which the descriptive imagery of the text is reflected in the shape and turn of the melodic lines.

responsorial psalmody Alternate singing between a soloist and a group or choir.

retrograde A term that indicates the employment of a theme or phrase in reverse order, starting on the last note of the melody and ending with the first.

rhythm In the visual arts, the regular repetition of a form. In music, all factors pertaining to temporal organization in music, including the comparative duration of tones, meter, and tempo.

rib In architecture, a slender arched support that in a vault system typically projects from the surface along the groins where semicircular vaults intersect each other. Ribs both reinforce the vaults and unify them aesthetically.

ribbed groin vault A groin vault reinforced with ribs.

ricercare An instrumental composition that developed in the 1500s and 1600s as a counterpart to the vocal motet. It is characterized by the periodic recurrence of the first subject, and as each subsequent subject or subject complex appears, it ushers in a new section featuring contrapuntal imitations and variation techniques. The ricercare is the prototype of the later fugue.

ritornel, ritornello Italian for "refrain"; a recurrent passage in a concerto, rondo, operatic scene, etc.

rococo An art style characterized by intricate, ornate designs.

Romantic An art style that emphasized the importance of feelings and the imagination and the narrowness of rationalism. See *rationalism.*

rondo A musical form in which one main theme recurs to alternate with other themes, making a structure that can be diagrammed as ABACADA.

rotonda A round building or a round interior room.

rubricator the person who produced elaborate initials in medieval manuscripts.

rusticate, rusticated In masonry work, to build a wall of rough-hewn stone for bold texture and strong light-and-shade contrasts.

S

sanctuary A consecrated, sacred, or holy place; in Christian architecture, that part of the building where the altar is placed; also a refuge.

sanguine In alchemy, a cheerful temperament. Sometimes associated with a red or flushed complexion.

sarcophagus (pl. **sarcophagi**) A coffin, made of stone, clay, or other materials.

satire A witty exposure of vice and folly, the purpose of which is to entertain and effect moral reform.

scale Relative or proportional size. In music, a succession of tones usually arranged in ascending or descending order and either a whole tone or a half-tone apart.

scherzo Italian for "joke"; in sonatas, symphonies, and quartets, a movement substituted for the minuet and, like the minuet, composed in triple meter but at a faster tempo. Normally, the scherzo is linked with a trio in a sequence of scherzo, trio, and scherzo repeat.

score The written version of music, with all parts indicated both separately and in relation to one another. To prepare music in written form.

scriptorium In a medieval monastery, the workroom for the copying and illumination of manuscripts.

sculpture A type of three-dimensional art in which form is created by subtractive or additive methods. In subtractive sculpture, the form is found by removing (as in carving) material from a block or mass. In additive sculpture, the form is built up by modeling in clay, by constructing with materials as a carpenter or welder might, or by assembling such preexisting forms as found objects. Whatever the method, the final form can be cast in a material, such as bronze, that modifies from a liquid state to a hard and permanent one. Sculpture can be freestanding or relief.

secular Not religious, but relating to the worldly or temporal.

sedes See *cathedra.*

sensibility In the cultural life of the late 1700s and early 1800s, an attitude that emphasized keen emotional responses to art, rather than analytical understanding.

sequence In musical composition, the repetition of a melody or motif at different pitch levels. Historically, se-

quence refers to a musical style that first came into use in the ninth century by adding text syllabically to the long melismas on the final vowel of an alleluia. Eventually the melismas were elaborated or altered musically, and the sequences became highly developed as separate compositions. All but four were banished from the liturgy by the sixteenth-century Council of Trent.

sfumato Italian for "smoked"; a misty blending of light and dark tones to create soft edges and veiled effects. A type of chiaroscuro.

shading The property of color that makes it seem light or dark. See *value*.

shape A two-dimensional area or plane with distinguishable boundaries, such as a square or a circle, which can be formed whenever a line turns or meets, as in an S or T shape.

silhouette A form as defined by its outline.

sinfonia An orchestral work; often introduces a choral work.

skene In ancient Greek theaters, which were open-air, the small building that provided for performances both a stage and a background. It is the root word for "scene" and "scenery."

skolion A Greek drinking song.

solmization The practice of using syllables to indicate notes on a musical scale—do, re, me, etc.

sonata, sonata form A structural principle used in a movement of instrumental music. It consists of three main divisions: the exposition, during which the musical materials of the movement are presented or "exposed" in the tonic key and a new key (the entire section is usually repeated); the development, in which the musical ideas of the exposition are worked out and explored in various keys to provide tension and contrast; and the recapitulation (reprise), which resolves the tension and contrast of the development by restating the exposition, but with all the themes in the tonic and usually with minor changes in orchestration or musical materials. Acoda may be added in conclusion.

song The simultaneous presentation of a literary text and a musical setting. The basic types are strophic, in which the melody is repeated over and over to different stanzas of the poem, and through-composed, in which the melody and accompaniment vary for each successive stanza.

song cycle A group or series of songs sharing a common thought, theme, or musical treatment and intended to be sung consecutively.

soprano Vocal or instrumental register with the highest range. Soloists may be designated as coloratura soprano, a vocalist with great agility in the high register, capable of performing rapid, dazzling, cadenza-like passages typical of eighteenth- and nineteenth-century operatic arias; dramatic soprano, a powerful and declamatory voice that extends downward to the mezzo region; or lyric soprano, a voice with light texture, considerable brilliance, and a capacity for sustained melodic singing.

space A volume available for occupation by a form; an extent, measurable or infinite, that can be understood as an area or a distance capable of being used both negatively and positively.

spatial That having to do with space.

spectrum The full array of rainbow colors that appear when white light (sunlight) has been refracted into its component wave lengths by means of a transparent substance, such as a prism.

squinch A device for making a transition from a square to a polygonal or circular base for a dome.

stadtholder A Dutch political leader or chief executive officer of a province.

staff The five horizontal lines and four intervening spaces on which musical notation can be written out.

stasimon In Greek tragedy, the song sung by the chorus.

stele A stone slab, often carved in relief, set upright to commemorate a person or event.

stereotype Something conforming to a fixed or general pattern.

still life In the pictorial arts, an arrangement of inanimate objects—fruit, flowers, pottery, etc.—taken as the subject of a work of art.

stoa In the agoras of ancient Greece, a one- or two-story building in the form of a colonnade or roofed porch providing space for a walkway and shops, offices, and storerooms.

stretto A narrowing or quickening process achieved by a faster tempo or diminution of the note values. In a fugue, stretto is the imitation of a subject in two or more voice parts in rapid succession so that the statements overlap, causing an increase of intensity.

string quartet An ensemble of two violins, viola, and cello; a composition in sonata form written for such an ensemble.

stringed instruments The violin, viola, violoncello (or cello), and double bass, all of which are equipped with strings capable of generating musical sound when either stroked with a bow or plucked.

Sturm und Drang From the German meaning "Storm and Stress." A late eighteenth-century cultural movement that emphasized high emotion and turmoil.

style The terms form and style, "formal analysis" and "stylistic analysis," serve interchangeably in any discussion of the way artists work or the way their art works once it has been accomplished. Both form and style are concerned with those measurable aspects of art that caused the elements, principles, and materials to come together as a composition; but they are equally concerned with the expressive content of a work. They signify a sensitive, knowing, trained, and controlled shaping and ordering of ideas, feelings, elements, and materials. Style can be the identifying characteristic of the work of a single artist, a group of artists, or an entire society or culture.

stylize To simplify or generalize forms found in nature for the purpose of increasing their aesthetic and expressive content.

stylobate In Greek temple architecture, the upper step of the base that forms a platform for the columns.

subject In the visual arts, the identifiable object, incident, or situation represented. See *iconography*. In music, the theme or melody used as the basic element in the structure of a composition, as in a fugue.

subject matter See *subject*.

sublime The representation of the violent, wild, and awesome aspects of nature as opposed to beauty, which is based on symmetry, proportion, and elegance.

suite In music, a collection of various movements without specific relationships in key or musical material. The music usually is dancelike, since suites before 1750 consisted almost invariably of four principal dance movements: the allemande, the courante, the sarabande, and the gigue. Often, simply excerpts from scores for ballet and opera.

summa An encyclopedic summation of a field of learning, particularly in theology or philosophy.

Summa Theologiae A summa (see *summa*) by Thomas More.

support In the pictorial arts, the physical material serving as a base for and sustaining a two-dimensional work of art, such as paper in the instance of drawings and prints, and canvas and board panels in painting. In architecture, a weight-bearing structural member.

suprematism An art movement originating in Russia that emphasized purity of form and emotion.

surface The two-dimensional exterior plane of a form or object.

symbol A form, image, sign, or subject standing for something else; in the visual arts, often a visible suggestion of something invisible.

syllabic A reference to the parts of a word called syllables.

symmetry An arrangement or balanced design in which similar or identical elements have been organized in comparable order on either side of an axis.

symphonic poem A term first applied by Liszt to a one-movement orchestral work of the late nineteenth century based on an extramusical idea (illustrative, literary, pictorial, etc.). The symphonic poem is a type of program music. Also called a tone poem.

symphony An orchestral composition commonly written in three or four movements. In a typical symphony, the first movement is fast and in sonata form; the second is slow and can be in sonata, binary, ternary, or variation form. The third movement (sometimes omitted) is a minuet (scherzo) and trio; the finale, usually in sonata or rondo form, is in a lively tempo.

synesthesia A combination of the senses, or an attempt to have one sense, such as sight, be stimulated by another sense, such as hearing.

syncopation Stressing a beat that normally should remain weak or unaccented.

synthesis The deduction of independent factors or entities into a compound that becomes a new, more complex whole.

T

tabernacle A receptacle for a holy or precious object; a container placed on the altar of a Catholic church to house the consecrated elements of the Eucharist.

tableau vivant From the French for living picture, the enactment of a historical event, scene from a painting, poem, or work of literature.

tempera A painting technique using as a medium pigment mixed with egg yolk, glue, or casein.

temperato An instruction to a musician to play a piece of music at a moderate speed.

tempo In music, the pace or rate of speed at which the notes progress.

tempus perfectum A three-part motet with a three-beat rhythm, thought to reflect the three-part Holy Trinity.

tenebrism The practice of painting in "the dark manner," that is, with strong contrasts between dark and light. See *chiaroscuro*.

tenor The highest range of the male voice or an instrument with this range. In medieval organum, the voice that sustains the notes of the chant or cantus firmus. More generally, the line in musical writing corresponding to the tenor range.

tensile In architecture, structure that is capable of sustaining tension.

ternary, ternary form A common three-part musical structure consisting of three self-contained sections, with the second specifically in contrast to the first and the third a repeat or modified repeat of the first: ABA or statement, contrast, restatement.

terra cotta Italian meaning "baked earth"; baked clay used in ceramics, sculpture, and architectural decoration; also a reddish-brown color similar to fired red clay.

terribilità A word often used to describe the feelings of intense excitement and formidability produced in the viewer by the works of Michelangelo.

terza rima A rhyming scheme in poetry that follows the pattern, aba, bcb, cdc.

tesserae (sing. ***tessera***) Small bits of stone, glass, or similar material used to make a mosaic.

texture In the visual or plastic arts, the tactile quality of a surface or the representation of that surface. In music, the relationship of the melodic elements and the elements that accompany them and the particular blend of sound these create.

theme In music, a short melodic statement or an entire self-contained melody; subject matter to be treated in a composition through development, imitation, contrast, variation, expansion, juxtaposition, etc.

thermae A Roman public bath.

thrust A strong continued pressure, as in the force moving sideways from one part of a structure against another.

tibia An ancient Roman musical instrument made from the leg bone of an animal.

timbre Tone color, or the particular quality of sound produced by a voice or an instrument.

toccata Italian for "touched"; music composed for keyboard instruments, written in a free style with running passages, chords, and sometimes imitative sections.

tone In music, a note; that is, a sound of definite pitch and duration. In the visual arts, a general coloristic quality, as this might be expressed in a degree of saturation and value.

tonic The first and principal note of a key, functioning as a place of rest or home base and acting as a point of departure and return.

tragedy A serious drama or other literary work in which conflict between a protagonist and a superior force (often fate) concludes in calamity for the protagonist, whose sorrow excites pity and terror in the beholder and produces catharsis.

transept In a cruciform church, the whole arm set at right angles to the nave, which makes the crossing.

treble In music, the higher voices, both human and instrumental, the notes to whose music appear on a staff identified by a treble clef (𝄞).

triforium In church architecture, an arcaded area in the nave wall system that lies below the clerestory and above the gallery, if there is one, and the nave arcade. It can be open like a gallery or sealed (blind).

triglyph A slab divided by two vertical grooves into three bands. The panels that alternate with the metopes to form the frieze of a Doric temple.

triplum In the music of medieval organum, the third voice part counting upward from the tenor or cantus firmus.

triptych A painting consisting of three panels. A two-paneled painting is a diptych; a many-paneled one is a polyptych.

triumphal arch In Roman architecture, a large, decorated archway used to commemorate an important happening, often a military victory.

troubadours, trouvères French musicians of noble lineage who flourished in the twelfth and thirteenth centuries, composing secular songs dealing with chivalry, knighthood, the Crusades, women, and historical subjects. Troubadours stemmed from southern France; trouvères, from the north. Their German counterparts were the minnesingers.

trumeau A post or pillar placed in the center of a portal to help support the lintel above; common in medieval architecture.

tuba A valved brass instrument with a wide bell.

tune A song or melody; a musical key; the correct pitch or tonality.

tunnel vault A barrel vault.

turrets Ornamental towers.

twelve-tone technique/system A twentieth-century method of composition devised by Schoenberg in which the seven diatonic and five chromatic tones are treated equally so that no tonal center is apparent. Compositions are based on an arbitrary arrangement of these twelve tones, and their sequence is known as a tone row or series. The notes of a row must always be used in the established order but may be repeated or moved from one octave position to another. The row may also be used in inversion, retrograde form, or retrograde inversion or may be transposed to any step of the chromatic scale. A series may also be arranged vertically to form chords.

tympanum In medieval architecture, the surface enclosed by a lintel and an arch over a doorway; in classical architecture, the recessed face of a pediment.

U

unison The "zero" interval that occurs when two voices or different instruments simultaneously play a note or melody at the same pitch.

unity The quality of similarity, shared identity, or consistency to be found among parts of a composition; a logical connection between separate elements in a work of art; the opposite of variety.

uomo universale Literally, "universal man."

V

value The property of color that makes it seem light or dark; shading. In music, the duration of a note. In general, the relative worth accorded to an idea, concept, or object.

vanishing point In linear perspective, that point on the horizon toward which parallel lines appear to converge and at which they seem to vanish.

variations A musical form in which the statement of a melody or theme is followed by various modifications of it.

variety Contrast and difference; the lack of sameness among separate elements in a composition; the opposite of unity.

vault A masonry or concrete roof constructed on the principles of an arch.

vernacular The language spoken by the common people.

vestibule A room situated in front of the main room of a building.

visual arts Those arts that appeal to the optical sense—painting, sculpture, drawing, printmaking, architecture, etc.

vivace Italian for "lively" or "vivacious."

voice The sound made by the human throat or by a musical instrument; the part in music written for that sound.

void A hollow or empty space.

volume Any three-dimensional quantity that is bounded or enclosed, whether solid or void.

volutes Scroll-like spirals that characterize the Ionic capital.

votive From the Latin for "vow," an offering made to God or in his name in petition, in fulfillment of a vow, or in gratitude or devotion. A votive figure stands in for a person who has visited a shrine.

voussoir A wedge-shaped block used in the construction of a true arch. The central voussoir is the keystone.

W

wall In architecture, a planelike upright structure and surface capable of serving as a support, barrier, or enclosure.

waltz A dance in moderate triple meter that developed from the Austrian Ländler in the early nineteenth century.

wind instruments See *woodwind instruments, brass instruments.*

woodwind instruments The flute, oboe, English horn, clarinet, bass clarinet, bassoon, contrabassoon, and saxophone, all of which are pipes with holes in the side and can produce musical sound when blowing causes their columns of air to vibrate. Several of the woodwinds have mouthpieces fitted with reeds.

word painting See *representative style.*

Z

ziggurat A stepped pyramid in Mesopotamian architecture.

INDEX

References are to page numbers, except for illustrations, which are also identified by figure numbers. Works have been listed under the names of their creators—composers, painters, poets, sculptors, etc. Architectural works and the paintings, sculptures, mosaics, etc., associated with them—in other words, the visual arts not collected into museums—have also been listed under the cities where they are now to be found. The purpose of this feature is to serve the reader, who may have the opportunity to travel and wish to use this book as a guide to the monuments it discussed. Many technical terms are included in the index with citations where they are defined in the text. For a complete list of terms, refer to the Glossary.